Modernism—Dada—
Postmodernism

avant-garde & **modernism studies**

Modernism—Dada—Postmodernism

RICHARD SHEPPARD

Northwestern

University Press

Evanston

Illinois

Northwestern University Press
Evanston, Illinois 60208-4210

Library of Congress Cataloging-in-Publication Data
Sheppard, Richard
 Modernism-dada-postmodernism / Richard Sheppard.
 p. cm. — (Avant-garde and modernism studies)
 Includes bibliographical references and index.
 ISBN 0-8101-1492-5 (alk. paper) — ISBN 0-8101-1493-3
 (pbk. : alk. paper)
 1. Dadaism. 2. Arts, Modern—20th century. 3. Avant-garde
 (Aesthetics)—History—20th century. I. Title. II. Series
 NX456.5.D3 S54 1999
 700'.41162—dc21 00-008031

IN MEMORY OF "MAC" (1920–99),
WHO INSPIRED SO MANY OF US AT THE
UNIVERSITY OF EAST ANGLIA 1964–82

Contents

Acknowledgments

Grateful acknowledgment is made to the following for permission to reprint previously published material: Alfred A. Knopf: Carl E. Schorske, *Fin-de-siècle Vienna.* Copyright © 1961 by Random House Inc.; Harcourt, Brace & Company: Walter Benjamin, "On Language as Such and on the Language of Man," *Reflections: Essays, Aphorisms, Autobiographical Writings,* English translation. Copyright © 1978 by Harcourt, Brace & Company. Reprinted by permission of the publisher; Harvard University Press: Walter Benjamin, *Selected Writings,* vol. 1, edited by Marcus Bullock and Michael W. Jennings, Cambridge: Harvard University Press. Copyright © 1966 by the President and Fellows of Harvard College; Hogarth Press: "The Rose Window" and "The Tower," from *New Poems,* by Rainer Maria Rilke, translated by J. B. Leishmann © 1964; New Directions Publishing Corporation: Rainer Maria Rilke, "The Rose Window" and "The Tower," copyright © 1964 by the Hogarth Press. Used by permission of New Directions Publishing Corporation; Macmillan Press Ltd.: A. Huyssen, *After the Great Divide,* published by Macmillan Press Ltd.; R. Boyne and A. Rattansi, *Postmodernism and Society,* published by Macmillan Press Ltd.; Penguin USA: Hugo Ball, *Flight out of Time,* edited by John Elderfield, translated by Ann Raimes. Translation copyright © 1974 by Viking Press, Inc. Used by permission of Viking Penguin, a division of Penguin Books USA Inc.; Umbro Apollonio, *Futurist Manifestos,* translated by Marinetti/Flint. Translation copyright © 1970 by Verlag DuMont Schauberg and Gabriele Mazzotta editore. English translation © 1973 by Thames and Hudson Ltd. Used by permission of Viking Penguin, a division of Penguin Putnam, Inc.; Princeton University Press: Sanford Schwartz, *The Matrix of Modernism.* Copyright © 1985 by Princeton University Press. Reprinted by permission of Princeton University Press; Hugo von Hofmannsthal, *Selected Prose,* translated by Hottinger, Stern, and Stern. Copyright © 1952 by Princeton University Press. Reprinted by permission of Princeton University Press; Random House, Inc.: Friedrich Nietzsche, *The Gay Science.* Translation copyright © 1974 by Vintage Books. St. Martin's Press: R. Boyne and A. Rattansi, *Postmodernism and Society.* Copyright © R. Boyne and A. Rattansi. Reprinted with permission of St. Martin's Press, Inc.; S. Fischer Verlag: Hugo von Hofmannsthal, "Ein Brief," *Prosa II, Gesammelte Werke in Einzelausgaben,* copyright © 1951 by S. Fischer Verlag GmbH, Frank-

Introduction

It was not without considerable misgivings that I agreed to write this book. To begin with, the original versions of some of its chapters go back twenty years, and it has been no easy matter to revise them in order to incorporate the large amount of new primary material relating to Dada and the wealth of secondary literature on Dada, modernism, and postmodernism that has been published in the intervening period. Then again, books on Dada almost inevitably attract negative reviews from Dada's detractors because of the nature of the beast and from Dada's devotees because any attempt to place Dada and make sense of it looks like (and possibly is) a betrayal of its spirit and principles. Moreover, in order to situate Dada as a major link between modernism and postmodernism, I have had to provide compressed and schematic accounts of the complex and hotly debated phenomena as a frame for the chapters on Dada. Finally, because I am primarily a Germanist, I have devoted more space to Dada in Zurich and Germany than to Dada elsewhere. These were calculated risks, and I am aware of them.

Chapters 1 to 3 originally appeared in a much abbreviated form as "The Problematics of European Modernism," in *Essays in Critical Theory*, ed. Steve Giles (London and New York: Routledge, 1993), 1–51. Chapter 4 was written for this volume. A slightly shorter version of chapter 5 first appeared in *Modern Language Review* 92 (1997): 98–123. Chapter 6 is virtually identical with my essay on Kandinsky that appeared in *Word & Image* 6 (1990): 41–67. Chapter 7, which forms the core of the book, was first published in a less developed form in *Orbis Litterarum* 34 (1979): 175–207. Chapter 8 is a considerably shortened English version of "Dada und Futurismus," in *Sinn aus Unsinn: Dada International*, ed. Wolfgang Paulsen and Helmut G. Hermann (Berne and Munich: Francke, 1982), 29–70. Chapter 9 is a more-thought-out version of an article that was published in *Publications of the English Goethe Society* 49 (1979): 45–83. Chapter 10 is a reworked version of an essay from *Dada Spectrum: The Dialectics of Revolt*, ed. Stephen Foster and Rudolf Kuenzli (Madison, Wis.: Coda Press, 1979), 92–113. Chapter 11 originally appeared in *Forum for Modern Language Studies* 19 (1983): 116–25. Chapter 12 is an expanded version of an article from the *Journal of European Studies* 9 (1979): 39–74. Chapter 13 was written for this volume. I would like to thank the various publishers

and editors most sincerely for allowing me to make use of this material here.

As far as possible, I have provided the accepted English translations of the foreign-language material used within the text. I would have liked to include illustrations, but this was not possible for reasons of expense. Normally, the title of any foreign-language work cited for the first time is followed by the date of its composition (not publication). But the date that follows the title of the English translation denotes the year in which that translation first appeared in print. Where a translated title immediately follows the title in the original language and precedes the date of composition of the original, I have not been able to locate an English translation. Where no translation of a title is provided, the title of the English version is identical with that of the original text. All English translations throughout this book are my own, unless otherwise noted.

I would like to express my grateful thanks to those editors and publishers who have allowed me to use brief citations from published works under the "fair dealing" convention without formal acknowledgment other than the source of the relevant citation. While I have made every effort to obtain the necessary permissions, if there are any omissions or oversights, I would be pleased if the copyright holder would contact me directly. I am particularly indebted to Dr. Michael Hamburger, CBE, who generously allowed me to reproduce his translation of Ernst Stadler's poem "Fahrt über die Kölner Rheinbrücke bei Nacht" in chapter 5. As for so many of my generation, Dr. Hamburger's *Reason and Energy* (1957) was one of the principal texts that fired my interest in German modernism.

Thanks are also due to the very large number of people with whom I have worked on and discussed the topics addressed in this volume over the past two and a half decades. My former colleagues and students at the University of East Anglia (Norwich), notably Mr. Philip Conford, Mr. John Gordon, Dr. Alastair Grieve, Dr. Philip Mann, Dr. Raoul Schrott, Dr. Robert Short, Dr. Ralph Yarrow, and Professor Nicholas Zurbrugg. Also Professor Dawn Ades (University of Essex), Dr. Timothy Benson (Los Angeles), Professor Hanne Bergius (Dortmund), Herr Hans Bolliger (Zurich), Professor Christopher Butler (Oxford), Dr. Karin Füllner (Düsseldorf), Dr. Steve Giles (University of Nottingham), Dr. Malcolm Green, Ms. Jill Hughes (Taylor Institution Library, Oxford), Professor Rex Last (New Alyth), Herr Raimund Meyer (Zurich), Dr. Mark Pegrum (University of Western Australia), Mme Marthe Prévot (Limoges), Professor

David Scrase (University of Vermont), Herr Ernst Teubner (Pirmasens), Dr. Hubert Van Den Berg (Amsterdam), and the staffs of the Deutsches Literaturarchiv (Marbach/Neckar), Magdalen College Library (Oxford), the Fonds Doucet (Paris), and the Berlinische Galerie. Dr. Mary Shields (Oxford) deserves my very special thanks, since without her patience, editorial expertise, and word-processing skills, this book would never have reached the virtual world of floppy disk. Over the years, various bodies have funded my research, and I would like to thank them most warmly as well for their help: the University of East Anglia, the Alexander von Humboldt-Stiftung, the British Academy, the DAAD, Magdalen College, Oxford, and the Faculty of Medieval and Modern Languages of the University of Oxford.

By way of a conclusion, it may amuse some readers to know of the origins of this book. My interest in Dada began in the superheated atmosphere of a new British university in the mid-1970s, where everything seemed to be continually on the boil in one huge and immensely stimulating melting pot. Dada's carnivalesque spirit then helped me through the Lenten Thatcher era, when my main research interest shifted toward the grimmer topic of literature and politics in the early Weimar Republic. But I came back to Dada and wrote this book, as it was becoming clear that Mr. Blair's new happy-clappy government intended seriously to damage Britain's two oldest universities. As the writer after whom Dada's founding institution in Zurich was named might have put it, "in this country we find it pays to damage a proven center of excellence from time to time in order to encourage the others." Voltaire's irony and Dada's angry humor have certainly not lost their relevance as the millennium draws to its close.

Richard Sheppard
Magdalen College, Oxford

1. Modernism and Modernity

The Problem of Definition

Introduction

In one of the earliest attempts to come to terms with modernism as a total phenomenon, the Czech Formalist, Jan Mukařovský, began by stating that "the notion of 'modernism' is very indefinite." Thirty-five years later, Monroe K. Spears echoed that sentiment when he prefaced an important book on the same topic by observing that the whole subject was an impossible one. Shortly after that, the editors of one of the most widely disseminated anthologies of essays on modernism noted in their introduction that the phenomenon was so unclear and multifarious that it was probably impossible to be precise about "an overall style or mannerism." A decade later, two other influential commentators tacitly admitted that they were still encountering the same difficulties in finding the "core" of modernism by opting, as they were finally forced to concede, for an unsatisfactorily reductionist definition of the concept. And in a discussion of Marshall Berman's pivotal work on modernism, *All That Is Solid Melts into Air* (1983), Perry Anderson went so far as to call modernism "the emptiest of all cultural categories."[1]

Indeed, the most obvious index of the difficulties involved in discussing modernism is the lack of clear chronological boundaries. Although the broad consensus agrees on 1885 to 1935 as the period of "high modernism" in Europe, some critics set its starting date at 1870 (so as to include

I

Nietzsche and Rimbaud); Berman sees Marx's *Communist Manifesto* (from which the title of his book is taken) as "the first great modernist work of art"; and if the cultural-aesthetic concept of modernism is elided with the historical concept of modernity, then the "era of modernism" can be said to begin "with the intense activity of self-reflection associated with the philosopher Kant."[2] Conversely, other critics, notably from North America, set the end of modernism in the 1950s (in order to include the early novels of Vladimir Nabokov, the late poetry of William Carlos Williams, the Abstract Expressionists and work, especially in the architectural field, produced by or under the impact of émigré European modernists).[3] Linda Hutcheon, who has written extensively on postmodernism and so is very conscious of the problem of definition, cites several authorities who see modernism extending up to the *nouveau roman,* the *nouveau nouveau roman,* the "textes" of *Tel Quel,* American surfiction, and the works of *Gruppo 63* in Italy.[4] Indeed, it could be argued that because faith in modernity in North America was not really shaken until the Great Depression and, subsequently, the end of the economic boom that had gone on there beween 1945 and about 1970, the crisis of modernity also became a real issue there only in the late 1950s and early 1960s (i.e., the historical juncture that is often seen as the beginning of postmodernism).[5] This perspective would make Marcel Duchamp, the central figure of New York Dada, a European maverick who caused a brief but prophetic flash in an otherwise self-confident pan when, in April 1917, he posed as Richard Mutt from Philadelphia and tried unsuccessfully to exhibit a urinal as "Fountain" at the exhibition organized by the Society of Independent Artists. As we shall see in chapter 13, the North American avant-garde of the late 1950s and 1960s would take a great deal of inspiration from him in particular.[6]

Although the boundaries between modernism and postmodernism are extremely blurred, it seems to me and other commentators that the earliest text that identifies, albeit in a highly compressed form, the issues that would lie at the heart of modernism is Baudelaire's essay on Constantin Guys (1802–1892), "Le Peintre de la vie moderne" (c. 1859) ("The Painter of Modern Life," 1930).[7] Here, Baudelaire says that the beautiful is not "unique et absolu" [unique and absolute], but involves two elements. The one is "un élément éternel, invariable, dont la quantité est excessivement difficile à déterminer" [an eternal, invariable element the quantity of which it is exceedingly difficult to determine], and the other is "un élément relatif, circonstanciel, qui sera, si l'on veut, tour à tour ou tout ensemble, l'époque, la mode, la morale, la passion" (685) [a relative, circumstantial element,

which may be, as you please, in turn or simultaneously, the epoch, the fashion, morality or passion (24)]. Furthermore, Baudelaire argues, the transitory, fleeting, and contingent element of art is a direct reflection of the kaleidoscopic reality that is modernity (695, [67]). In asserting this, Baudelaire is not only saying that modernity involves a radical change of sensibility (which I shall discuss in chapter 2), he was also suggesting two ways of responding to that change: withdrawal into a realm that is, or appears to be, static and timeless, and affirmation of what is fluctuating and time-bound. The ramifications and varieties of both types of response will be discussed in chapter 3.

As a glance at three basic bibliographies reveals, the secondary literature on modernism began to snowball in the 1960s and by now it has become impossible to read everything in print on the subject.[8] But on the basis of what I have read, four things strike me. First, the publication of Jean-François Lyotard's *La Condition postmoderne* in 1979 (*The Postmodern Condition*, 1984) and the philosopher Jürgen Habermas's response to that book in his Frankfurt speech "Die Moderne—ein unvollendetes Projekt" of 1980 ("Modernity versus Postmodernity," 1981) form a watershed in the debate about modernism.[9] Second, despite the existence of such excellent interdisciplinary studies as Michael D. Biddiss's *The Age of the Masses* (1977)—which is rarely mentioned in works on literary modernism—modernism tended, until the end of the 1970s, to be the preserve of literary critics, art historians, and architectural theorists working, on the whole, independently of one another.[10] Third, these specialists tended to understand modernism in terms of pivotal concepts, cultural periodization, or the alleged opposition between modernism and the historical avant-garde(s). But, fourth, in the wake of the Habermas–Lyotard debate, there was a growing concern to understand the phenomena known as postmodernism and poststructuralism within the puzzling historical situation called postmodernity. Consequently, the debate about modernism as an aesthetico-cultural and/or philosophical phenomenon was expanded into a debate about the relationship between modernism and modernity and so changed its nature in four ways.[11] It was historicized; it became much more theoretical; under the impact of feminism, it became gendered; and it became much more interdisciplinary. In this context then, Berman's book and Fredric Jameson's much debated essay of 1984 are two early, classic examples of the new directions in which the debate would move. In other words, after 1980, during the early years of an era which would be dominated politically by Reagan and Thatcher and in which tri-

umphalist modernization was high on the public agenda all over the world, the debate about modernism gradually became what the Frankfurt School had always thought it should have been: a debate about the nature and origins of culture in the broadest sense in the context of advanced (and aggressive) capitalism. As Andreas Huyssen realized, Habermas's Frankfurt speech took the debate about (post)modernism out of the purely aesthetic arena and into a broader, sociohistorical, cultural, and political arena, permitting problems that are still with us to be included on the agenda.[12]

I shall return to these larger issues in chapter 13 and for the moment will consider three classic ways in which critics have approached (and continue to approach) the problem of aesthetico-cultural modernism. I do not do this simply as a historical exercise, but to show why these approaches no longer work very well after the theoretical debates of the last two decades. To begin with, a large number of writers have tried to "define" modernism by pinpointing one or more key features, concerns, or "common traits." These have included an "uncompromising intellectuality," a preoccupation with nihilism, a "discontinuity," an attraction to the Dionysiac, a "formalism," an "attitude of detachment," the use of myth "as an arbitrary means of ordering art" and a "reflexivism," an "antidemocratic" cast of mind, an "emphasis on subjectivity," a "feeling of alienation and loneliness," the sense of "the ever-present threat of chaos . . . in conjunction with the sense of search" and "the experience of panic terror," a particular form of irony that derives from "the rift between self and world," "consciousness, observation and detachment," a commitment to metaphor as "the very essence of poetry itself," the intuitive acceptance or anticipation of "Saussure's view of the relationship between signs and reality," and an "outright rejection of bourgeois modernity."[13]

In the early 1970s, when this strategy was most prevalent in critical literature, two Marxist critics aptly remarked: "On the question of what Modernism is, no two critics agree. . . ." Three years after that, Bradbury and McFarlane outlined the limitations of this approach and as late as 1984, the reductionism of Fokkema and Ibsch (who excluded a range of classically modernist texts from the category of modernism on the basis of an excessively narrow definition) highlighted these limitations even more starkly. But it is, perhaps, chapters 4 and 5 of *Les Avant-gardes littéraires au XXᵉ siècle* (in which a large number of allegedly defining characteristics of modernist art are isolated and discussed at great length) that bring the basic weaknesses of this strategy into the clearest relief. Once torn out of the context that generated them, it is evident that almost none of these char-

acteristics, whether formal or experiential, are exclusively specific to the modernist period.[14] It is also clear that more than one of them, depending on which author, works, or culture one selects, could arguably be privileged in any reductionist account of modernism. From this notion, it follows that if you wish to breathe life back into this collection of dead concepts, then you need to reconstruct the dynamic, not to say cataclysmic, context that generated them in their specifically modernist *combinatoire*. As one of the editors of a collection of essays on German modernism remarked in 1989, it was time both to stop "reducing modernism to this or that set of criteria" and to pose "the question of history and politics in the [modernist] text . . . with renewed vigor."[15] In the following year, a book appeared that attempted to do just that: Boyne and Rattansi's *Postmodernism and Society*. Although the editors identified a set of key aesthetic strategies in their introduction that were allegedly central to modernism, they did so in the context of a work whose contributors sought to relate modernism to modernity; had thought long and hard about the issues raised by the Habermas-Lyotard debate; had worked across subject boundaries; and were centrally concerned with the question of how to develop political strategies in a world where foundational narratives — metanarratives — had, temporarily at any rate, been prohibited.[16]

Given the limitations of this first approach, more than a few critics felt the need to develop a second, more broadly based strategy — quite often as a spin-off from the first. Having identified one or more allegedly key features of modernism or the modernist avant-garde(s), critics then attempted to bring these into sharper focus by setting them in a linear, literary-historical, or art-historical context. Thus, modernism has been viewed as a continuation of or a reaction against Romanticism; as a reaction, in its extreme avant-garde forms, against Aestheticism; as an inversion of the conventions of Realism; and as a reaction against Naturalism. Conversely, modernism has also been viewed as both the antecedent of postmodernism and as the phenomenon to which postmodernism forms the reactive contrast.[17] While there is some truth in all these positions, the situation is, as Hutcheon rightly perceived, much more complex and paradoxical. Deconstruction has shown us that what a concept or category "claims to exclude is implicated in it," and precisely because modernism is a period of transition between Romanticism and the cultural situation of the present day, it both includes and reacts against the movements that preceded it and is both continuous and discontinuous with postmodernism. As we shall see, modernism is a deeply and multiply fissured move-

ment so that, as Huyssen realized, we need to get away from dichotomous thinking if we are to understand it.[18]

The third strategy received its classic and widely accepted formulation in Peter Bürger's 1974 book on the avant-garde. This fed into Habermas's pivotal lecture and its echoes reverberate throughout the critical literature of the last two decades.[19] Put very simply, Bürger's thesis states that "high modernism" is the culmination of a trend, whose roots are to be found in the aesthetics of Schiller and Kant, which separates art from life and beauty from sensuality. In contrast, the main aim of the historical avant-gardes, notably Dada and Surrealism, is said to be the reintegration of art and life, with "life" understood as the everyday, mass culture, the material world, and the energies of the body. Several influential critics have accepted this thesis. For instance, although Calinescu is aware that the avant-garde was not all of a piece—an argument that will be developed more fully in chapters 3, 8, and 9—he drives a wedge between "high modernists" like Proust, Joyce, Kafka, Thomas Mann, Eliot, and Pound and the movements that constitute the historical avant-garde(s).[20] Similarly, Huyssen starts from a distinction between modernism and the historical avant-garde(s) that is very close to Bürger's, and while conceding that both "avant-garde and modernism may legitimately be understood as representing artistic emanations from the sensibility of modernity," he concludes that "from a European perspective it makes little sense to lump Thomas Mann together with Dada, Proust with André Breton, or Rilke with Russian constructivism." Although Bürger's distinction was a necessary corrective to the tendency of critics, especially in North America, to use the terms avant-garde and modernism interchangeably and represented a key move in the offensive against New Criticism with its central doctrine of artistic autotelicity, it is flawed for several reasons.[21] First, as I shall show in chapter 7, Dada involves much more than the reintegration of art with life and the concomitant obliteration of the distinction between "high" and "low" art. Second, as I shall argue in chapter 3, modernism is an extremely diverse phenomenon, even if, as early protagonists of postmodernism tended to do in the 1960s and 1970s, one brackets out or suppresses the historical avant-gardes.[22] Third, if one sees modernism, as Adorno did, as dialectically related with modernity and views modernism not as the "artistic emanations" of a "sensibility" but as a complex range of responses to a complex set of problems by a variety of people in different but related historical situations, then it is possible to see deep, nonreductive affinities between artists and intellectuals across a

spectrum of disciplines who have little in common on the surface, and thus to avoid the crude "lumping together" that Huyssen rightly censures.[23]

Modernity as an Epochal Concept

Before the watershed of 1979–80, history tended to enter the debate about modernism in one of three ways: via the mass modern city; via mass politics, culture and society; and via the mechanized carnage of the Great War. And even after the watershed, excellent studies have been published on such *topoi*. But as the debate became more theoretical, so attention shifted away from such *topoi* in isolation and focused more sharply on modernity as an overarching concept that contextualizes and connects individual aspects of modernization and cultural modernism.[24] Correspondingly, the modern megalopolis, mass politics and culture, and the Great War increasingly came to be seen as complex, interrelated, and deeply disturbing manifestations of modernity that may be strikingly visible in modernist texts but that may also exist there (as in Rilke's *Neue Gedichte*, c. 1903–8 [*New Poems*, 1964], most of Kandinsky's pre-1914 visual work [see chapter 6], or E. M. Forster's *A Passage to India* [1922–24]) as their "repressed Other."

The increasingly theoretical debate about modernity generated an awareness that other, less obvious and more fundamental aspects of modernist culture could be profitably explored as manifestations of a larger process. According to Rosalind Krauss, for instance, the emergence of the public museum, the official salon, the world fair, and the private showing, all of which enabled the work of art to represent its "own space of exhibition" (i.e., its autotelicity), was an aspect of modernity that helped to generate what has become known as the history of modernism. In a direct response to the English version of Habermas's speech, Anthony Giddens noted how recent work in the philosophy of time, social history, and urban theory had converged upon industrial capitalism's commodification of time-space; and two years later, Linda Dalrymple Henderson and Stephen Kern published brilliant studies of the way in which modernity allowed non-Euclidean geometry to impact on the avant-garde and fundamentally altered perceptions of space and time. Similarly, in 1984, Perry Anderson refined Berman's thesis by stressing the importance for modernism of "a highly formalized *academicism* in the visual and other arts," "the still incipient, hence essentially *novel,* emergence" of the new technolo-

gies of the second industrial revolution, and "the imaginative proximity of social revolution."[25]

So what theory of modernity could do justice to such a wide range of phenomena and permit the development of a correspondingly adequate theory of modernism? As a starting point, the debates of the last two decades have thrown up a chronological model of modernity that Zygmunt Bauman summarized as follows in 1991:

> modernity began in Western Europe with a series of profound socio-structural and intellectual transformations of the seventeenth century and achieved its maturity: (1) as a cultural project—with the growth of Enlightenment; (2) as a socially accomplished form of life with the growth of individual (capitalist, and later also communist) society.[26]

This model involves four temporal cruxes:

1. The period 1789–1800 when the impact of the French Revolution brought the modern public into being; when the "notion of 'man' as an essentialist, transcendental subject" developed; and in the wake of which Hegel, the first philosopher according to Habermas to experience modernity as a problem, evolved a comprehensive legitimizing system to reassure modernity about itself.[27]

2. The period 1848–60, which, on the one hand, saw the start of a period of unparalleled technological advance and economic growth, but which, on the other hand, experienced a wave of political revolutions that called the progressive sense of time inherited from the Enlightenment into question in many important respects. After 1848, Harvey argues, "the certainties of absolute space and place gave way to the insecurities of a shifting relative space, in which events in one place could have immediate and ramifying effects in several other places." The contradiction between the experience of modernity as progressive and the experience of modernity as chaotic is then seen to generate the cultural concept of the critical avant-garde (in one of Sainte-Beuve's *Causeries du Lundi* [*Monday Chats*, 1856]); Marx's philosophy (with its dialectical attitude to modernity), and Baudelaire's essay on Constantin Guys (with its ambiguous attitude to modernity).[28]

3. The period 1890–1914 when doubt in the project of classical modernity, particularly its faith in an absolute reason, began to collapse across broad stretches of the European (but not the North American) intelligentsia. This collapse, it is argued, was caused partly by

the economic crises of the 1890s. But it was also partly caused by the increasing consciousness of the dark, alienated side of the rapidly expanding modern city which science and technology had been unable to eradicate and of which several major nineteenth-century writers, notably Marx, Engels, Dickens, and the Naturalists, had been more or less acutely aware.[29]

4. The Great War itself which, as Spears rightly saw, intensified rather than generated the radical doubt in modernity that had pervaded the prewar period.[30]

A remarkably good summary of this chronological model was provided as early as 1973 by two Marxist critics:

> Turning then to some changes brought about by the transition to imperialism, we can say first that the ideals of the French Revolution, which had held up reasonably well during two thirds of the nineteenth century (in England and the United States, at any rate), become markedly less tenable. The same thing happens to the notion associated with Adam Smith that the existing economic system has the capacity to correct its own ills and bring about an equitable distribution of the wealth. Profound doubts now arise as to whether man has the capacity to dominate the historical process. With a suddenness that would be surprising if one knew nothing about the causes, the idea of progress collapses. When we seek an explanation for these changes, it is relevant to note how in the epoch of monopoly the decision-making process becomes invisible, the real decisions coming to be made more and more by those in command of the monopolies; ordinary people, even those in somewhat privileged positions, come to feel—and justifiably—that they lack the kind of leverage that the humanist tradition had always made one feel entitled to command. A further cause lies in the intensifying irrationalities in the existing order, the vast increase in productive capacity along with economic stagnation, technological progress, and the neglect of human needs, breathtaking scientific advances that seemed to promise a solution to the age-old problem of human want, but with no mechanism for connecting these advances with the demand which in theory they ought to be able to meet. . . . Still another cause of the new doubts about the existing order is a new kind of alienation from work. This results in part from gigantism in industrial development and corresponding efficiency in techniques for managing the work force.[31]

Modernity as a Theoretical Concept

As a result of the debates of the last two decades, it is generally accepted that modernity, whose classical phase begins with the Enlightenment, involves an escalating complex of interrelated processes that received their first comprehensive, albeit not exhaustive analysis during the early years of this century in the sociological writings of Max Weber.[32] The major aspects of this complex (which played a central role in Habermas's thinking) are usually described as (1) the increasing separating out (*Ausdifferenzierung*), institutionalization, and/or rationalization of scientific knowledge, justice, morality, and aesthetic taste; (2) the increasing bureaucratization and rationalization of all aspects of life by the state and its agencies; (3) the secularization, desacralization, or disenchantment [*Entzauberung*] of the world; and (4) the constitution of the autonomous human subject in terms of his legislative reason—i.e., his ability to create rational order out of natural or institutionalized disorder.[33] This whole process, it is then argued, was legitimized by the idea of progress—a secularized version of the grand narrative involved in the Judeo-Christian vision of history and, more immediately, of eighteenth-century providentialist theology. The apologists of classical modernity hoped that the increasing rationalization of the world would hasten social understanding and moral progress, further justice, and increase human happiness.[34] But at least one critic has argued, in a way that recalls Marx's account in section 3, chapter 24 of the first volume of *Das Kapital* (1848–67) (*Capital,* 1887) of the obsessively Faustian nature of capital accumulation, that this original purpose was gradually lost from sight. As a result, the concept of progress ultimately became an end in itself, the name of a "process which leads toward a state of things in which further progress is possible, and nothing else."[35]

Marxists and writers who have absorbed Critical Theory argue that the above account of modernity does not go far enough and so privilege the development of science over other aspects. They also stress that the whole project of modernity is driven by the acceleration and globalization of (industrial) capitalism through the competitive imperialism that would culminate in World War I, and they radicalize Weber's analysis by using the subsequent work of Lukács and Adorno.[36] But critics who subscribe to Foucault's analysis of modernity relate Weber's analysis to Nietzsche (by whom Weber was profoundly influenced) and his account of the intensifying *décadence* of Western modernity. Nevertheless, Marxists and Foucauldians alike agree that the classical, emancipatory project went badly

wrong and that rationalization of the life-world and the formation of the monadic, rationally organized, ego-centered individual of modernity are two sides of one process during which a host of elements were turned into a potentially explosive "repressed Other."[37] As we shall see, the return of this repressed is a central concern of modernism and postmodernism alike.

Modernity as the Experience of Crisis

Berman recognized that Marx, Nietzsche, and their contemporaries were writing about modernity when only a segment of the world had been modernized; and Anderson, refining Berman's argument, pointed out that modernity did not come into being all over the Western world evenly or synchronically. To begin with, in several countries where modernism flourished, a semifeudal régime coexisted more or less (un)easily with a rising middle class, with an older industrial system that showed "traces of an artisanal organization of labor" and distributed its products "by a network of small shopkeepers," and with a newer, factory-based system that mass-produced commodities.[38] In Britain, the position of the régime was secure; in Germany, it seemed secure; in Italy, it was precarious; in Russia, it was under revolutionary threat; while in Austria-Hungary it actually consolidated its power over a relatively weak liberal middle class from about 1900 onward.[39] Then again, whereas in France and Britain the liberal democratic, humanist ideal played a comparatively important role in the public domain, that same ideal had a comparatively weak hold on the public domain in Austria-Hungary, Germany, and Russia. Or again, where Britain had been industrializing gradually since the end of the eighteenth century, in Germany the same process began in earnest around about 1870 and accelerated around the turn of the century, while in Russia and Italy, it began later still. Finally, where the Great War had a politically shattering effect on countries like Austria-Hungary, Germany, and Russia, it did not produce the same social upheaval in Britain "where continuity was strongest" and where "conformity, complacency and even smugness were far more firmly established . . . than in France, let alone Germany, Italy, Austria-Hungary, or Russia."[40]

As a result, cultural modernism as a whole and the historical avant-gardes in particular formed in various ways from country to country.[41] For example, the Futurists could afford to be enthusiastic about the technology of the second industrial revolution partly because it was so new a phenomenon in a limited area of northern Italy that its dark side had

not become as apparent as it had in Britain and Germany, and partly because their art and manifestos involved "the abstraction of techniques and artifacts from the social relations of production that were generating them." If Vienna offered "in intensified form the constellation of elements which contributed to the emergence of Modernism," then London, of all the major Western cities, offered the least propitious site for the generation of a modernist culture.[42] Because London was not such an industrial city as Vienna; because, as Dagmar Barnouw has argued, the liberal democratic, humanist ideal continued to play a comparatively important role in England in the public domain throughout the modernist period; and because the process of modernization had taken place more gradually than elsewhere in Europe, the British avant-gardes (the Imagists and Vorticists) were much smaller, less radical, and less threatening than their Continental counterparts. Not only were these avant-gardes less alienated from their society than their French, Austrian, and German counterparts, several of their most important members were either foreigners (Pound, Eliot, Gaudier-Brzeska, H. D.), or had spent a significant period outside Britain (Hulme), or had been extensively exposed to continental influences (Nevinson).[43] Conversely, one of the most challenging, not to say disturbing works to come from the pen of an English-speaking writer, Oscar Wilde's *Salome* (1891), was originally written in French; owed much to the avant-garde and Symbolist theater of Paris; was translated into at least nine European languages; enjoyed great popularity on the Continental stage — but was less than popular in this country. Finally, it is particularly telling that when Kandinsky's *Über das Geistige in der Kunst* (1900–10) was first translated into English, its title was changed to *The Art of Spiritual Harmony* (1914) and its most apocalyptic passage did not feature in any of the seventeen extracts that the Vorticists included in *Blast* 1 (20 June 1914).[44]

Despite these historical caveats — and I do not pretend that the above remarks are anything more than a few preliminary observations — what Susan Rubin Suleiman has said appears to be true: there is a consensus that modernity is marked by a sense of cultural crisis.[45] Just as the French Revolution, the founding event of political modernity, rapidly went critical and turned into its opposite, the Terror, so, by the end of the nineteenth century, many artists and intellectuals across Western Europe were beginning to feel that something similar was happening to the project of modernity as a whole. Schorske has examined in detail how this perceived crisis was shockingly pictorialized in the three huge ceiling paintings that Gustav Klimt executed for the University of Vienna between 1900 and 1907. The

first, far from celebrating Philosophy, showed how "the socially supported structure of [rational] mastery had disappeared in the face of an enigmatic, omnipotent nature and the interior feelings of impotent man caught up in it."[46] In the second, whose central figure is the goddess Hygeia, "the culture of scientific progress" was again confronted "with an alien and shocking vision" (240). And the third, dealing with Justice, showed that "Law has not mastered violence and cruelty but only screened and legitimized it" (251). Here then, three concepts that were central to the value system of classical modernity were dramatically distorted to show the dialectical turn that modernity was felt to have taken. Similarly, in Georg Kaiser's major Expressionist drama *Von morgens bis mitternachts* (1912) (*From Morn to Midnight*, 1920), W[eimar], the town that is associated above all with the liberal classical ideal evolved by Goethe and Schiller, has turned into a place of imprisonment, materialism, and alienation. And when George Grosz conflated the imagery of factory, prison, barracks, and mental hospital in his lithograph *Licht und Luft dem Proletariat* (*Light and Fresh Air for the Proletariat*) (1919–20) and supplied it with the ironic subtitle *Liberté, Egalité, Fraternité*, he was showing how the founding political ideals of classical modernity had turned into their opposites under late capitalist modernity. It is also a strange fact that in December 1910, when, according to Virginia Woolf in a paper read to the Heretics in Cambridge on 18 May 1924, "human character" changed and "all human relations" shifted, the Expressionist poet Georg Heym should have first used the word *Weltstadt* in "Berlin VIII" to mean "world city"—that is, "city which has become the whole world"—and then gone on to write two of his most apocalyptic city poems, "Die Dämonen der Städte" ("The Demons of the Cities") and "Der Gott der Stadt" ("The God of the City"): the place of rational order has become the place of irrational chaos.[47]

During the "high modernist" period, depending on one's class and location, this sense of crisis seems to have moved between or simultaneously involved two poles: at one there is a sense of extreme constriction and at the other there is a sense of being swept along or assailed by raw, unleashed energy.[48] At the first pole, we find the subjects of so many of Rodin's sculptures (who seem to be trapped in the stone from which the sculptor has tried to release them); the reified desire of Marcel Duchamp's *La Mariée mise à nu par ses célibataires, même* (*The Bride Stripped Bare by Her Bachelors, Even,* also known as the *Large Glass*) (1915–23); the dystopic vision of Yevgeny Zamyatin's *My* (1920) (*We,* 1924); Breton's claim in the first

Surrealist Manifesto (1924) that we are increasingly being forced to live in a rationally constructed cage from which, "sous couleur de civilisation, sous prétexte de progrès" [under the pretense of civilization and progress], everything is banished that does not conform to convention; such paintings from the 1930s by Max Ernst as *La Ville entière* (*The City as a Whole*) (1935–36 and 1936) and *La Ville petrifiée* (*The Petrified City*) (1935); and Balász's and Bartók's opera *A Kékszakállá herceg vára* (*Duke Bluebeard's Castle*) (1911).[49] In this latter work, the triumph of rationality (gendered as male) is shown to bring immense wealth and power, but at a terrible cost. Against Duke Bluebeard's intention and despite his desire to be redeemed from his own creation by his new wife, Judith, his castle holds him more securely captive than Nature ever could. It induces in him a sense of powerlessness and turns the female and the elemental into dead things locked behind the forbidden seventh door, thereby cutting him off from powers that might save him from himself. At the second pole, we find the seething mass of falling bodies of Rodin's apocalyptic masterpiece *La Porte de l'Enfer* (*The Gates of Hell*) (1880–1917) (which one critic has explicitly compared to Baudelaire's vision of modern-day Paris);[50] the violent sense of impending apocalypse that informs Kandinsky's seven *Compositionen* (*Compositions*) (1909–13) (see chapter 5); and apocalyptic novels like Alfred Kubin's *Die andere Seite* (1908) (*The Other Side*, 1967). We also find statements like Kandinsky's comment on contemporary civilization in *Über das Geistige in der Kunst:* "Der alte vergessene Friedhof bebt. Alte vergessene Gräber öffnen sich, und vergessene Geister heben sich aus ihnen" [The old forgotten cemetery quakes. Old, forgotten graves open, and forgotten ghosts rise up out of them]. Hugo Ball, one of the founders of Dada in Zurich in February 1916, echoed this diagnosis when lecturing on Kandinsky in Zurich on 7 April 1917: "Die Titanen standen auf und zerbrachen die Himmelsburgen" [The titans rebelled and stormed the heavenly fortresses]. And in the same vein, Max Weber, who may well have known *Über das Geistige* given his interest in literary modernism, said in his lecture "Wissenschaft als Beruf" (1918) ("Science as a Vocation," 1947): "Die alten vielen Götter, entzaubert und daher in Gestalt unpersönlicher Mächte, entsteigen ihren Gräbern, streben nach Gewalt über unser Leben und beginnen untereinander wieder ihren ewigen Kampf" [The multitude of ancient gods, disenchanted and therefore in the form of impersonal forces, are climbing out of their graves, striving for power over our lives and resuming their eternal struggle with one another].[51]

But between these two poles, we can find a large number of major mod-

ernist texts in which the first experience of modernity turns or is in danger of turning into the second experience. For example, madness and the mass modern city are frequently interconnected not simply, as Bathrick suggests, because everyday modernity is felt to *cause* madness. Rather, for all its pretensions to be a rationally constructed society of people who share an ideal of order, the modern megalopolis as a whole is frequently perceived to be characterized by institutionalized insanity masquerading as order.[52] One work that graphically demonstrates this connection *in extenso* is Rilke's novel *Die Aufzeichnungen des Malte Laurids Brigge* (1910) (*The Notebook of Malte Laurids Brigge,* 1930). Here, the central character is so profoundly affected by the dislocated insanity of modern Paris that the shock uncovers the fragmentary nature and latent paranoia of his own personality: insane city and unhinged self are mirror images of one another. And within this context, just to emphasize the point, the hospital, "where supposedly people come to get well" is actually "a place for the dying."[53] Similarly, Michael Fischer in Alfred Döblin's story *Die Ermordung einer Butterblume* (c. 1905) (*The Murder of a Buttercup,* 1993), a small-scale entrepreneur; the madman in Heym's story *Der Irre* (1911) (*The Madman,* 1994), a psychopath who is associated with an industrial landscape; and Anton Gross in Franz Jung's *Der Fall Gross* (*The Case of Anton Gross*) (c. 1920), a draftsman, are metonymic. While convinced of their sanity, all three are motivated by uncontrollable pathological drives that are intimately linked with the wider context of modernity and lead them to do violence to the natural, the innocent, and the female and, ultimately, to destroy themselves.[54]

The following works involve a similar dialectical turn: Conrad's *Heart of Darkness* (1898–99); Franz Kafka's "In der Strafkolonie" (1914) ("In the Penal Settlement," 1935); Henri Barbusse's *Le Feu* (1915–16) (*Under Fire,* 1917); Georg Kaiser's *Gas* trilogy (1916–19) (translated 1924 and 1971); the concluding pages of Italo Svevo's *La coscienza di Zeno* (1919–22) (*Confessions of Zeno,* 1930); Ernst Jünger's *Der Kampf als inneres Erlebnis* (*Combat as Inner Experience*) (1925); the war paintings of Otto Dix from the 1920s and 1930s (one of which, *Flandern* [*Flanders*] [1936], was inspired by the concluding pages of *Le Feu*); Alfred Döblin's *Berge Meere und Giganten* (*Mountains, Seas and Giants*) (1921–23), especially books 1 and 2; the slaughterhouse chapters from book 4 of Döblin's *Berlin Alexanderplatz* (1927–29) (translated 1931); and chapter 40 of Robert Musil's *Der Mann ohne Eigenschaften* (c. 1924–42) (*The Man without Qualities,* 1953–60). In all nine cases, a rationally constructed system — the imperial project of con-

quering the Dark Continent in the name of Enlightenment values, a machine for executing convicts, the military-industrial complex, mechanized warfare, the technological megalopolis, a food production process, and the legal machinery of the state—has turned or is in danger of turning into an elemental, irrational system that is running out of control, treating people as though they were animals or reducing them to dead primal matter, and threatening to destroy both its creators and itself in the process. Similarly, in Robert Müller's novel *Tropen* (*Tropics*) (1915), the modern city is frequently identified with the jungle because of the chaos and elemental cruelty underlying its veneer of civilized order. This dialectic is summarized in chapter 85 of *Der Mann ohne Eigenschaften,* when its protagonist, Ulrich, during a conversation with General Stumm von Bordwehr, the embodiment and proponent of rational military order, comments explicitly on the propensity of rational order/modernity to turn into its opposite, fragment, and require new controls with the end result "daß wir immer mehr Ordnungen und immer weniger Ordnung haben" [that we have an increasing number of ordered systems and less and less order].[55]

So, to be more specific, during the modernist period, artists and intellectuals suffered, in various ways and at various levels of intensity, from various *combinatoires* of the following feelings:

1. That they were trapped or lost among the decaying debris of semi-feudal régimes that blocked out a sense of the future (see Rilke's poems dealing with parks in the *Neue Gedichte* and Austrian Expressionism in general, especially Georg Trakl's poetry [1910–14]).
2. That classical modernity, the Enlightenment project, was not only failing to fulfill its promises of emancipation, order, and scientific certainty, but had actually performed a dialectical turn (which Horkheimer and Adorno would analyze in *Dialektik der Aufklärung* [1944] [*Dialectic of Enlightenment,* 1972])[56] and become an autonomous system running madly out of control (like the Golem of Paul Wegener's Expressionist film *Der Golem* [1920] and all the other man-made protagonists of the more than one hundred Frankenstein films that have been made since 1910).
3. That Enlightenment humanism had done something similar and issued in the stifling and cruel world of bourgeois modernity (see George Grosz's visual work and the military academy in Musil's *Die Verwirrungen des Zöglings Törless* [1902–3] [*Young Törless,* 1955]).
4. That technology, harnessed by capitalism, was commodifying every-

thing, even art, and spawning a civilization of mass-produced kitsch (see Hofmannsthal's poem "Verse auf eine Banknote geschrieben" ["Lines Written on a Letter of Credit/Banknote"] [1894] and Walther Rathenau's *Zur Mechanik des Geistes* [*Towards the Mechanism of the Spirit*] [1912]).

5. That the private sphere was shrinking as the state, mass movements and technology encroached everywhere[57] (see Zamyatin's dystopic novel *My*).

6. That just as the world of Nature had been desacralized, so human beings had lost or suppressed a sense of their spirituality and become excessively cerebral cogs in a technical-bureaucratic machine (see Fritz Lang's film *Metropolis* [1925–26], Kafka's *Das Schloß* [1922] [*The Castle*, 1930], and chapter 40 of *Der Mann ohne Eigenschaften*).

7. That stable categories and relationships were being shattered by anarchic powers whose nature was hard to determine, but which could be conceptualized or pictorialized in a variety of ways—as demonic females (see Wedekind's *Der Erdgeist* [1895] and *Die Büchse der Pandora* [1903] [*Tragedies of Sex*, 1923]); as the (revolutionary) crowd or mass unconscious (see Rodin's *La Porte de l'Enfer*);[58] as the primitive Other (see Conrad's *Heart of Darkness*); as disease (see Thomas Mann, *Der Zauberberg* [1913–24] [*The Magic Mountain*, 1928]); as elemental Nature (see Kubin's *Die andere Seite*); as the chthonic powers of the unconscious (see Rilke's Third *Duineser Elegie* [1922] [*Duino Elegies*, 1939]); or as a composite image (see Picasso's *Les Demoiselles d'Avignon* [*The Maids of Avignon*, 1907], Ernst Ludwig Kirchner's *Potsdamerplatz, Berlin* [1914], or Otto Dix's visual work of the 1920s in which several or all of these elements were elided or synthesized).[59]

8. But that it was both very hard and very easy to deal with this situation depending on whether one tried to confront it in all its complexity or to simplify it and resolve it accordingly. Critics have inherited precisely the same problem and the same temptation.

It is, of course, possible to argue that this acute and complex sense of crisis was simply the result of an over- and inappropriately educated élite being thrust into a modernizing world with which they were ill equipped to deal and in which their status was endangered. As a consequence, the argument runs, they exaggerated the problems of modernity and evolved what Stauth and Turner called "the nostalgic paradigm" that dovetails to a considerable extent with the eight points listed above.[60] There is cer-

tainly some truth in this argument. Callinicos points out that "secondary education throughout nineteenth-century Europe was characterized by an *increased* stress on the classics" and interprets this trend as representing "an attempt to integrate . . . bourgeois 'Philistines' and aristocratic 'Barbarians' into a common ruling class." But this trend might equally well be interpreted as a defensive reflex of the sense that the project of modernity was going wrong and as an artificial attempt to keep that "common ruling class" in contact with what Karl Jaspers, in *Die geistige Situation der Zeit* (1930) (*Man in the Modern Age*, 1951) would identify as the primary foundation of Western civilization.[61] Renate Werner pointed out that in common with most other major artists and intellectuals in nineteenth-century Germany, most German modernists had come from one class (the *Bildungsbürgertum*—"educated middle class") and attended one educational institution (the *Gymnasium*—"classical grammar school"). This latter was dominated by "ein klassizistischer Normenkanon, die doktrinäre Verfestigung der klassisch-idealistischen Ästhetik, die Vorstellung, dem Kunstwerk als einem in sich harmonisch gegliederten Organismus komme die symbolische Repräsentanz einer göttlich geordneten Welt zu" [a quasi-classical set of norms, the canonical institutionalization of a classical-idealist aesthetic, the notion that a work of art could stand symbolically for a divinely ordered world to the extent that it itself was a harmoniously structured organism].[62] Schorske, too, notes that many Austrian writers of the nineties were "children of this threatened liberal culture";[63] that the "high value placed on *Bildung* in the public ethos of liberal Austria penetrated deeply into the private sphere as well" (296); that "a deep sense of the value of art" had been "instilled in a whole generation of upper bourgeois children," was reinforced by the *Gymnasium* and university, and had facilitated "the development by 1890 of a high bourgeoisie unique in Europe for its aesthetic cultivation, personal refinement, and psychological sensitivity" (297–98). The essays in Amann and Wallas's book on Expressionism in Austria reinforce this thesis since they very clearly indicate that Austrian Expressionists had, unlike their German counterparts, assimilated the values of both liberalism and Catholicism and had few cultural-political institutions at their disposal into which to channel their energies after the war.[64] Consequently, their sense of alienation from modernity as it was developing was far more intense than that of the German Expressionists, and their work tended much more to pathological, mystical, and apocalyptic extremes when they sought to overcome their alienation.

Then again, many major modernists were assimilated Jews, and Bau-

man points out that, in German-speaking lands, this group, in the course of their assimilation, had absorbed "idealized images of Schiller, Lessing, Goethe, Kant, Herder"; treated them "with reverence previously accorded only to the Old Testament patriarchs"; by around 1912 had become "to a very large extent" the custodians of "the German cultural heritage of that generation"; and "saw in the holy trinity of Goethe, Schiller and Lessing . . . not only the warrant for the alliance between German and Jewish cultures, but also vivid and clinching evidence that, in fact and by their own nature, the two cultures are immanently alike and guided by the same spirit."[65] With that level of commitment to a cultural ideal that is impossibly high-minded at the best of times, confrontation with late-nineteenth-century modernity could become agonizingly critical. If someone as robust as the gentile Ernst Jünger could write to his brother Friedrich Georg on 25 March 1923: "Wir sind durch eine liberale Erziehung verpfuscht und müssen sehen, wie wir uns wieder heraushelfen" [We are completely messed up by a liberal education and must see how we can extricate ourselves from it again], then it is not hard to understand why a sensitive, assimilated Jew from the remote provinces like the Expressionist dramatist Ernst Toller (who had grown up in precisely the kind of milieu described by Bauman) should have reacted so violently against the (per)version of modernity that he encountered during the Great War.[66]

Now, although this argument explains why a particular generation should have experienced the crisis of modernity so acutely, arrived at such extreme diagnoses and conclusions, and suffered from a greater or lesser sense of nostalgia, it does not completely dispose of what they had to say about modernity. First, the Great War happened—as did Hiroshima, Nagasaki, the Holocaust, and the gulags. Second, the problems of modernity did not go away when the modernist generation died out (even if some of their more extreme diagnoses and resolutions became questionable, not to say suspect). Rather, what Giddens called "the runaway, juggernaut character of modernity" was experienced by an increasingly broad mass of people until it achieved its postmodern configuration—which is why exhibitions of modernist visual work are no longer the preserve of an élite, but can attract huge numbers of visitors, even in Britain.[67] Third, it can equally well be argued that because the entire modernist generation were so saturated with the liberal values against which so many of them were in revolt, they were particularly well equipped to diagnose and try to remedy the fundamental ills of a society that subscribed to the Enlightenment project in theory while perverting it in practice. As Calinescu saw, the

prophecies of literary and artistic modernism turned out to be strangely accurate; and even Marianna Torgovnick, whose sympathies with modernism are strictly limited, concedes that the "truest greatness" of the modernists may lie "in their aspirations after ideas and alternative modes of being whose time had not yet come."[68] Finally, it can be argued even more strongly that the insights and innovations of modernism were produced by a generation that was at odds with itself. Although this generation had more or less completely absorbed the values of classical modernity, it was losing its faith in those values within a rapidly changing and multiply fissured world where the project of classical modernity was going so badly wrong that it seemed to need revolutionary correction of one kind or another. Perry Anderson caught this riven situation very accurately when he said that modernism arose "in the space between a still usable classical past, a still indeterminate technical present, and a still unpredictable political future," and "at the intersection between a semi-aristocratic ruling order, a semi-industrialized capitalist economy, and a semi-emergent, or -insurgent, labor movement."[69]

It is also worth pointing out that sociology, which grew out of the experience of modernity, found itself in exactly the same situation as literature and the arts. Indeed, Stauth and Turner maintain that the theme which linked several of the major sociologists during the modernist period was "the notion that we constantly create life-worlds which through alienation and reification negate the spontaneity and authenticity of the will and its conscious subject, Man."[70] But it is, I think, more accurate to say that like the writers and artists I have mentioned above, sociologists around the turn of the century were grappling with two experiences and ways of understanding modernity. At one pole of the debate, Emile Durkheim, in *Le Suicide* (1897) (*Suicide*, 1952) and *De la Division du travail social* (1902) (*Division of Labor in Society*, 1933), analyzed modernity in terms of the feeling of entropic chaos, anomie, which was induced by modernity's destruction of traditional communities and which Elsen explicitly connects with Rodin's *La Porte de l'Enfer*.[71] At the other pole, Max Weber saw modernity turning into a "faktisch unabänderliches Gehäuse" [de facto unbreakable (immutable) casing/shell], a "stahlhartes Gehäuse" [casing/shell which is as hard as steel]; a "Gehäuse für die neue Hörigkeit" [casing/shell for the new serfdom]; a "stählerne[s] Gehäuse der modernen gewerblichen Arbeit" [steel casing/shell of modern industrial labor], and a "Gehäuse jener Hörigkeit der Zukunft" [casing/shell of that bondage which is to come]. Indeed, in "Parlament und Regierung im neugeord-

neten Deutschland" ("Parliament and Government in a Newly Constituted Germany") (May 1918) (where the latter phrase occurs twice) and "Politik als Beruf" ("Politics as a Profession") (October 1919), Weber paints a particularly hopeless picture of contemporary modernity as a lifeless, inescapable machine inexorably moving toward a future that is very bleak indeed.[72] This vision of modernity, combined with Lukács's analysis in *Geschichte und Klassenbewusstsein* (1919–23) (*History and Class Consciousness*, 1971) of capitalist modernity as a "society in which the commodity form permeates every aspect of social life, taking the shape of a pervasive mechanization, quantification and dehumanization of human experience," would feed into Critical Theory as "a world-historical process of reification." It would then permeate Jameson's essay of 1984, which is so central to the debate about postmodernity and postmodernism.[73]

But between the two poles of Durkheim and Weber stands Georg Simmel, whose work can be seen as an attempt to mediate what Harvey would call "the dialectic of Being and Becoming" — that is, to synthesize the other two diagnoses of modernity. In both *Die Philosophie des Geldes* (1900) (the second, expanded edition of which [1907] was translated as *The Philosophy of Money*, 1978), and *Der Konflikt der modernen Kultur* (1914) (*The Conflict in Modern Culture*, 1968), Simmel analyzes modernity as a fluctuating process that rigidifies into economic, cultural, and social forms only for these to be burst apart by new socioeconomic forces that are, in Simmel's view, driven by Life itself. Indeed, in *Der Konflikt der modernen Kultur*, he claimed that at the end of the nineteenth century, the concept of *Life* was raised to a central place, uniting perceptions of reality with metaphysical, psychological, moral, and aesthetic values.[74] In other words, by putting "Life" at the center of his thinking, Simmel was fusing Marx's theory of revolution with Nietzsche's vision of existence as a dialectical interplay between Apollonian and Dionysiac forces. And behind Nietzsche there lay, surprisingly, Schiller—although not the Schiller who helped formulate the classical doctrine of the autonomous work of art, but the Schiller who, in his *Briefe über die ästhetische Erziehung des Menschen* (1793–94) (*On the Aesthetic Education of Man*, 1967), formulated the idea that there was a "ludic drive" (*Spieltrieb*) in human nature that could reconcile the "form-drive" (*Formtrieb*) with the "sense-drive" [*Stofftrieb*], Being with Becoming, and flux with identity.[75] Thus, at the first conference of German sociologists (which took place in Frankfurt/Main in October 1910 and was attended, among others, by Weber, Ferdinand Tönnies, Werner Sombart, Ernst Troeltsch, Martin Buber, Hermann Kantorowicz, and Robert

Michels, among others, and was centrally concerned with the problem of modernity), Simmel stated in the opening lecture:

> Es bleibe dahingestellt, ob der Begriff des Spieltriebes oder Kunsttriebes einen wirklichen Erklärungswert besitzt; jedenfalls weist er darauf hin, dass in jeder einzelnen spielenden oder künstlerischen Betätigung ein von den Unterschieden ihrer Inhalte nicht berührtes Allgemeines enthalten ist. . . . Ein Gemeinsames, Gleichartiges an seelischer Reaktion und seelischem Bedürfnis knüpft sich an all diese Mannigfaltigkeiten, sehr wohl zu unterscheiden von dem speziellen Interesse, das gerade ihren Verschiedenheiten gilt. In dem gleichen Sinne nun kann man von einem *Geselligkeitstriebe* der Menschen reden.[76]

> *For the moment, I shall set to one side the question as to whether the concept of the ludic drive or artistic drive possesses any real explicatory value; at any rate, it points to the fact that something general, which is unaffected by differences of content, is contained in every individual ludic or artistic activity. . . . Something common, qualitatively similar in respect of psychological reaction and need is linked with all these manifold activities and needs to be differentiated from the special interests which cause such variety. Thus, in exactly the same sense one can now speak of a human drive to communality.*

Simmel's vitalism, which became even more pronounced in his last work (*Lebensanschauung: vier metaphysische Kapitel*) (*A View of Life: Four Metaphysical Chapters*) (1918), especially its first chapter (which he wrote last), made and makes him anathema to rationalists and Marxists—especially in Germany, where all forms of irrationalism are still deeply suspect because of the link between some forms of irrationalism and Nazism. But it offers a theoretical means of understanding how Dada was able to negotiate the crisis of modernity. It also explains why Bauman should have ended his book on postmodernity by mentioning Bakhtin and Simmel together as two people who had stimulated his thinking, and by paying tribute to Simmel in particular as the person "who started it all."[77]

The Fissures of Modernism

Many earlier commentators approached modernism either from a background of New Criticism or imbued with reflectionist (that is, Realism-derived) ideas about art and literature. Consequently, it was no accident

that Bürger, who had had to free himself from both sets of assumptions to mount his defense of the avant-garde, probably wrote the first major work on modernism based on the clear understanding that the relationship between modernism and modernity involved a dialectic rather than abstraction or mimesis. Accordingly, he began by stating that the literary work did not just replicate social reality, but was the "Resultat einer Tätigkeit, die auf eine als unzulänglich erfahrene Wirklichkeit *antwortet*" [product of an activity that *responds* to a reality experienced as inadequate]. This approach then enabled him to see the historical avant-gardes as the expression of a deep-rooted angst in the face of extremely powerful and constricting social and technological systems.[78]

Thereafter, Jameson, writing in 1981, warned against viewing modernism as a "mere reflection of the reification of late nineteenth-century social life," and in a passage that indicates his familiarity with Durkheim's and Weber's analyses of modernity he, too, implied that modernism needed to be approached dialectically:

> We are first obliged to establish a continuity between these two regional zones or sections—the practice of language in the literary work, and the experience of *anomie,* standardization, rationalizing desacralization in the *Umwelt* or world of daily life—such that the latter can be grasped as that determinate situation, dilemma, contradiction, or subtext, to which the former comes as a symbolic resolution or solution.[79]

Or in other words, Jameson was arguing that modernist works are not just reflexes, transcriptions, or symptoms of a profound cultural upheaval, but, *simultaneously,* responses through which the authors of those works try to pictorialize, conceptualize, and make sense of that upheaval. Then, toward the end of the same work, Jameson broadened this dialectical conception still further by implying that modernism should be understood not as a single, unified response, but as a range of responses to the perceived crisis (225 and 236–37). By doing this, he was implying that it is possible to account for the heterogeneity of modernism that has bothered so many critics, but without falling prey to reductionism and oversimplification. Later critics such as Huyssen, Marshall Berman, Bauman, Dick Hebdige, and Russell A. Berman have developed this approach, and the dual awareness that modernism is both an active response to a seismic upheaval and a heterogeneous phenomenon is one of the major strengths of Huyssen's and Bathrick's book on German modernism. But the clearest statement of this approach known to me was made in 1985 at the ICA weekend symposium

on postmodernism when Michael Newman came up with the concept of the "heteronomy of modernism" and said that this can, to an extent, "be understood as a variety of responses, whether positive or negative, to the *urban* condition of social modernity."[80]

In chapters 2 and 3, I shall develop this approach and show that the familiar image of modernism as "Janus-faced" is far too straightforwardly binary—as is the division of modernism into "modernolatry" and "cultural despair."[81] But before doing so, it is worth pointing out that modernism is not only fissured laterally—into a variety of movements and responses— but also vertically. Precisely because so many of the modernist generation were saturated with values that were felt to be in crisis and therefore in need of conservation, modification, or jettisoning altogether, critics are increasingly seeing that both modernism as a whole and individual modernist movements, *oeuvres,* and works involve profound inner contradictions and conflicts. This not only explains why major modernist works can attract such a variety of contradictory, not to say mutually exclusive interpretations, it will also help us to understand in chapter 7 why Dada was such a breakthrough and to see in chapter 13 how postmodernism, while inheriting so much from modernism, differs from it in at least one fundamental way.

In 1939, the much-maligned Clement Greenberg perceived that "avantgarde [by which he meant high modernist] culture contains within itself some of the very Alexandrinism it seeks to overcome." In 1961, Schorske, discussing the beginnings of Austrian modernism, diagnosed it as "a collective oedipal revolt," thereby putting his finger on the mixture of dependency and rebellion that is so central to the phenomenon. In 1981, Wilde noted that the modernists were "heirs to a tradition they revolted against." In 1984, Anderson argued that academicism "provided a range of cultural values *against which* insurgent forms of art could measure themselves, but also *in terms of which* they could partly articulate themselves." In 1987, writing about modernist architecture, Welsch said that whereas the practitioners of the new denounced tradition rhetorically as an unusable wreck, they were still partially dependent upon it in practice. In 1990, Boyne and Rattansi pointed out that although modernist writers experimented with "aesthetic, philosophical and psychic strategies more complex, inventive and self-reflexive than the ones typically deployed in realist and naturalist forms," they clung to the belief—which postmodernism would discard— that "in principle the deep structure of reality is knowable."[82] And in 1994, Butler stated:

The major Modernists have an extremely respectful relationship to tradition. None of them begin their careers as confrontational or avant-garde. This innate conservatism, which only arrives at a technical breakthrough after an exploration of the past, is one of the extraordinary strengths of early Modernism.[83]

Using these insights, I shall show in chapter 6 how Kandinsky's early visual work and aesthetic theory could be simultaneously radical in terms of art history and conservative inasmuch as *das Geistige* [the Spiritual] — the quality Kandinsky was actively seeking to recover and transmit in his apparently revolutionary work—was both one of the keystones of nineteenth-century liberal thinking and a covertly religious concept.

Once one begins thinking along these lines, deep fissures start to become visible across a range of modernist movements. In chapters 5 and 8, I shall show how the Imagists and Futurists were deeply attached to certain nineteenth-century assumptions.[84] Cubism, it transpires, was pulled simultaneously toward closure *and* "Bergsonian assumptions" that tend to "destabilize any fixed notion of organic closure." The modernist "primitivism" of the early Expressionist *Die Brücke* was "rooted in eighteenth-century German idealism, notably the aesthetics of Immanuel Kant and their development by the poet-philosopher Friedrich von Schiller." The messianic humanism of so much Expressionism (with its appeals to *Geist* [spirit/mind], *Wesen* [essence], *Gemeinschaft* [community], and *Menschlichkeit* [humanity]) was a clear and often not very successful attempt to reinstate the values of classical or religious humanism amidst and in the aftermath of the horrors of the Great War (cf. chapter 9). Indeed, European "primitivism" as a whole is now seen to have had a deeply ambivalent relationship with Western imperialism, and Expressionism to have had an equally ambivalent relationship with late capitalist modernity.[85] Despite its emancipatory charge, Surrealism never completely surrendered its nineteenth-century patriarchal heritage, and although Dada was arguably the avant-garde movement that purged itself most thoroughly of nineteenth-century values and most successfully negotiated the crisis of contemporary modernity, the same charge has been laid at its door. Moreover, like all ironic modes of art, Dada trod a very fine line between subverting and reinscribing what it attacked. Thus, even its most radical gesture—Duchamp's "placement of mass-produced objects into the museum setting"—can be construed as "ambivalent and necessarily inconclusive," and in a letter to Oskar Maurus Fontana of 17 May 1949, the Dada An-

archist Franz Jung (see chapter 12) confessed that the more he rebelled against his Catholic origins—as he had always done—the more deeply he became caught by those origins.[86] Or in other words, a close inspection of the modernist avant-gardes from the perspective created by the postmodernist debate of recent years often reveals that those avant-gardes, for all their rhetoric of opposition, innovation, and revolt, dealt with the perceived crisis of modernity by failing to let go of at least some of the attitudes and values that they had inherited either from the project of modernity before it went dramatically wrong or from even older sources.

Similar ambivalences can be sensed in individual *oeuvres*. Baudelaire was at once optimistic and pessimistic about modernity, even before it had turned against itself, and resolved that ambivalence via the fragile, overstrained figure of the dandy whose way of life he described in the essay on Constantin Guys as "un soleil couchant; comme l'astre qui décline, il est superbe, sans chaleur et plein de mélancholie" [Dandyism is a setting sun; like the star in its decline, it is superb, without heat and full of melancholy]. Nietzsche was not only ambivalent about contemporary modernity, he always remained attached at a very deep level to the values of Christianity, one of his most consistent objects of attack. Milič Čapek, a historian of science, has characterized the work of the physicist Ernst Mach and the mathematician Henri Poincaré as a mixture of classical/conservative and modern/radical ideas. Callinicos points out that Freud, the product of liberal culture, was both "the thinker who did more than any other to dethrone the self-certain subject of Cartesian rationalism" and simultaneously "committed to achieving a scientific understanding of the unconscious processes he had uncovered." Hugo Ott argues that Heidegger never broke free from Catholicism and that "this inheritance remained a thorn in his flesh, ineradicable and incurable." Similarly, although he became increasingly pessimistic about contemporary modernity, Max Weber continued to advocate *Wissenschaft* [science] and an ethic of responsibility as the means of resisting its threat—albeit not in any final sense.[87]

Then again, whilst the aesthetician Wilhelm Worringer pioneered a semiotic approach that would allow pre-Renaissance and non-Western artifacts to be given the same respect as post-Renaissance Western artifacts, he never gave up the concept of Art as such. Thus, he unwittingly colluded in the aestheticization of objects that had been pillaged from cultures in which their function was opaque to the outsider and which were themselves being destroyed by colonialist modernity. Analogously, Lucien Lévy-Bruhl's major and influential ethnographic works—*Les Fonctions mentales*

dans les sociétés inférieures (1910) (*How Natives Think,* 1926) and *La Mentalité primitive* (1922) (*Primitive Mentality,* 1923) — are thoroughly schizoid about non-Western cultures. They veer startlingly between the standard, condescending, Western prejudice that such cultures were inferior because of their premodern condition and an unabashed admiration for their superior ability to exist in a state of "prelogical" symbiosis with the world — that of *participation mystique* [mystical participation]. The same applies to the work of a large number of modernist writers and artists — Gauguin, Nolde, Pechstein, Eliot, Lawrence, Blaise Cendrars, and Michel Leiris to name but a few — who were strongly attracted to ethnography, anthropology, and/or native cultures as such. On the one hand, these cultures were the Other that was in need of Western modernity and so the object of fascinated dread. On the other hand, they were deemed to have preserved a wholeness and a nonalienated relationship with Nature and their gods, which the West, precisely because of modernity, had lost. Finally, as I have argued in detail, the extremely difficult poetry of the Expressionist August Stramm (1913–15) can be seen as the fissured product of an imagination that had been deeply imbued with Idealist values but saw those values being gradually eroded when forced to confront a modernity that had turned dialectically against its fundamental values and issued in the horrors of the Great War.[88]

Similar significant fault lines can be seen in individual works. Elsen, for instance, shows how the "cascading waves of struggling forms" of Rodin's anomic *La Porte de l'Enfer* are contained by a Renaissance outline and a Gothic tympanum. Wilde's *Salome* "attacks the patriarchal establishment by showing uncommon sympathy for Salome and her subversive self-absorption" while recoiling from all the implications of an "uncontrolled and murderous sexual energy."[89] Hofmannsthal's Lord Chandos (see chapter 4) says farewell to Francis Bacon, the founding father of scientific modernity, and the logocentric worldview that he had helped to create in the most carefully constructed, classical prose. While Robert Musil's doctoral dissertation of 1907 is on one level a critique of the more radical ideas of the physicist Ernst Mach and a defense of such nineteenth-century ideas as the *Entwicklungslehre* [doctrine of development], the *Prinzip der Kontinuität* [principle of continuity], the atomic object, and *Naturgesetze* [natural laws], it also contains passages where Musil is visibly drawn to Mach's critique of precisely those ideas. But because Musil accepts Mach's rejection of mind/body dualism, the atomic ego, and space and time as absolute categories, his ability to defend the larger classical concepts in any

final sense is undermined inasmuch as all are interrelated in the Cartesian-Newtonian scheme of things. So here, in a scientific treatise, we can see a modern novelist being eased away from the certainties of classical modernity and forced to confront an energetic modernity that is akin to Heraclitus's vision of the cosmos as flux.[90]

Butler has noted that Picasso's *Les Demoiselles d'Avignon* was riven by a conflict that derived from "an internal psychological division between attraction and repulsion, classical superego and primitive libido, and results in an aggressive attack on the image of women which may disguise a deep fear"; and in Foster's view, the same painting denotes "a crisis of phallocentric culture."[91] But whichever way one reads the painting, its violence and shock derive to a considerable extent from Picasso's experience of the loss of a tradition within which he had previously been able to work but which a part of him was trying, unsuccessfully, to retain. Similar kinds of fissures have been registered in Schoenberg's *Erwartung* (*Anticipation*) (1909), with its tensions between music and text and actual and experienced time, and ambiguous attitude toward the female subject; in Schoenberg's *Pierrot Lunaire* (1912), with its regressive Symbolist text and progressive "agonized Expressionist gestures of the atonal vocal line"; and in Stravinsky's *Le Sacre du printemps* (*The Rite of Spring*) (1913), with its strange mixture of unity and asymmetry, angularity and stylization. Wyndham Lewis's novel *Tarr* (1914–15) can be read as a simultaneous promotion and debunking of Vorticist modernolatry and masculinism, out of which the softer virtues, personified by Anastasia, emerge most positively.[92] Several major modernist novels—Kafka's *Der Proceß* (1914–15) (*The Trial*, 1929) and *Das Schloß*; Thomas Mann's *Bekenntnisse des Hochstaplers Felix Krull* (1910–12; 1951–54) (*Confessions of Felix Krull, Confidence Man*, 1955); Hermann Hesse's *Der Steppenwolf* (1922–27) (translated 1929); Musil's *Der Mann ohne Eigenschaften;* Döblin's *Berlin Alexanderplatz;* and Hans Henny Jahnn's *Perrudja* (1922–29)—are simultaneously pulled toward closure after the fashion of a nineteenth-century novel and also resist closure, with the result that they are either in some sense unfinished or involve an ending that is riven with contradictions, unconvincing, or downright crazy. Kafka's *Der Proceß* is particularly interesting in this respect—partly because the final chapter was written immediately after the opening chapter, partly because there are several ways of understanding its final words, and partly because, when Josef K. is on his way to execution, he says to himself that the only thing he can do is "bis zum Ende den ruhig einteilenden Verstand behalten" [keep a hold on my calmly analytic reason right up to the end]. Not only has K.'s

Verstand been of no help to him in understanding either the ways of the courts or the nature of his alleged guilt, but a powerful case can be made for saying that Josef K.'s guilt is intimately bound up with his cerebrality.[93] Or in other words, *Der Proceß* tends toward a closure that raises as many problems as it solves, not least the place of reason, one of the central values of classical modernity, in the fully formed human personality.

Similar fissuring is visible in major examples of modernist poetry. Pound's *Cantos* (c. 1915–59) were inspired to a large extent by *The Divine Comedy* but now appear, to some critics at least, to "testify to the emergence within modernism itself of a postmodernist poetry of historical openness."[94] Eliot's *The Waste Land* (1921–22) culminates, if that is the right word, in an assemblage of fragmentary quotations (accompanied by extensive and possibly ironic footnotes to help the reader's understanding) and at least one Sanscrit word which, to the innocent English ear, suggests rollicking ricketiness rather than "the peace which passeth all understanding." Athough what is now the Fifth Elegy should have concluded Rilke's *Duineser Elegien* (since it was written last and points forward to the *Sonette an Orpheus* [1922] [*Sonnets to Orpheus,* 1936] in the hopeful imagery and quasi-sonnet form of its final twelve lines), Rilke resituated it in the middle of the sequence. And according to Michael Tratner, all Yeats's poetry from "Easter 1916" onward is marked by the contradiction that Yeats places his hope in precisely that force which, because it may destroy him, he most fears.[95] At every level then, we are seeing artists and intellectuals in a situation of crisis trying to resolve a multiply complex set of problems and either failing to do so satisfactorily, or doing so by hanging on to a belief, assumption, or concept inherited from classical modernity or religious orthodoxy, or achieving that resolution artificially and unconvincingly. Before turning to the ascetic intellectualism of his postwar work, the Expressionist poet Gottfried Benn captured that situation with a succinctness and irony designed to combat nostalgia when he wrote in *Gesänge* (*Songs*) (1913):

> Wir sind so schmerzliche durchseuchte Götter
> Und dennoch denken wir des Gottes oft.

> *We are such painful, thoroughly infected godheads.*
> *And nonetheless we're mindful oft of God.*

To argue thus is not to denigrate modernism. Although its major works may not be " 'well-wrought urn[s]' that blend and harmonize tensions and contraries into a timeless unity," it seems to me that they draw their

strength and power to fascinate from their inner conflicts, tensions, and contraries.[96] New Critics in the English-speaking world and those critics in the German-speaking world who came from the Idealist tradition have expended a lot of energy over the last half-century or so ignoring or trying to explain away such fissures — and the resultant institutionalization of an (assimilated) "high modernist" canon in North American universities in the 1950s and 1960s was, as we shall see in chapter 13, one of the major catalysts of the postmodernist revolt. But critics who have worked their way through the long and tortuous debate about postmodernity, postmodernism, and poststructuralism appear to be much more ready to give up previously unacknowledged and reassuring "high modernist" assumptions about closure and autotelicity. They are also more willing to confront the fissures of both modernism and postmodernism that were generated and are still being generated by a multiply fissured world. Dada was all about this confrontation: hence its repression and latterly its rediscovery.[97]

2. Modernism as Diagnosis

From the discussion of the last chapter, it emerges that what Linda Hutcheon said about postmodernism applies equally well to modernism: it is "not so much a concept as a problematic," a set of problems and basic issues "to which there is no easy solution." In this chapter then, using what Sanford Schwartz called a "matrix approach" that "makes it possible . . . to compare individuals who have no direct ties to one another but exhibit similar patterns of thought," I shall identify what seem to be the major "common features" of the modernist diagnosis or critique of modernity.[1]

But because we are dealing mainly with artistic works, we need to bear in mind that the concept of a "problematic" is in itself problematic. In *Pour Marx* (1965) (*For Marx*, 1977), Louis Althusser argued that any problematic as that is perceived subjectively will be more or less mismatched with the objective state of things, and so will tend to de-form, obscure, or repress factors that are not compatible with the epistemic situation of the perceiver.[2] If we apply this idea to modernism, it is easy to see why the phenomenon is so diverse. First, because of the subjective elements involved in the dialectic encounter from which any given text is generated, two texts that derive from the same objective problematic may appear to be unconnected at the surface level.[3] Second, texts will vary greatly in the way they transcribe, shape, and foreground the problematic from which they have been generated. Where some will display an "explicit consciousness of their own ideologies," others will distort, simplify, or suppress those ideologies and the set of objective problems that underpins them—"manage" them, "forget" them, drive them underground.[4] Thus, in

some modernist texts like Hugo von Hofmannsthal's poem "Vorfrühling" ("Early Spring") (1892), the early work of Gustav Klimt, or the poems of Georg Trakl (1910–14), the modernist problematic manifests itself in more or less dark intimations of an impending threat whose nature occasionally becomes more visible—in, for example, Trakl's relatively rare city poems.[5] Other modernist works, like Musil's *Törless* (written at a time in Musil's life when the revolutionary ideas of the new physics were just beginning to touch him), naturalize that problematic into something more manageable. In *Törless,* for example, all the horrific events and inexplicable problems that Törless experiences in the Cadet School—a typically modernist institution inasmuch as it is designed to create order but actually does the opposite—are finally naturalized into an adolescent crisis. But this ending does not prevent Musil's novel from displaying doubts, ambiguities, and fissures that are analogous to those we noted in his slightly later thesis on Mach. Other modernist works, like Alfred Kubin's colored ink drawing *Der Mensch* (*The Human Being*) (1900–3) (executed at a time when Kubin was avidly reading Schopenhauer), Egon Schiele's paintings *Selbstbildnis mit Lampionfrüchten* (*Self-Portrait with Chinese Lanterns*) (1912), *Mutter und Tochter* (*Mother and Daughter*) (1913), and *Liebesakt* (*Act of Love*) (1915), show terrified human figures in contorted and defensive postures but provide no background that might indicate what is causing their terror.[6] Other modernist works, like Rodin's *La Porte de l'Enfer,* Andrey Bely's *Petrburg* (1911–13) (*Petersburg,* 1959; revised and improved in 1978), Balász's and Bartók's *A Kékszakállá herceg vára,* Thomas Mann's *Der Tod in Venedig* (1911) (*Death in Venice,* 1928), or Kafka's *Der Proceß,* foreground the modernist problematic in a very powerful way, but do so in terms that are mythological, quasi-mythological, or surreal rather than overtly modern. While others, like Ludwig Meidner's *Apokalyptische Landschaften* (*Apocalyptic Landscapes*) (1913–14) or the major poetry of the German Expressionists, foreground the modernist problematic using imagery that is derived more obviously from the modern, that is, urban/technological world.

Furthermore, modernist texts vary greatly in the degree of complexity with which they present the problematic they are trying to solve. Jill Lloyd has shown that Nolde's and Pechstein's almost contemporaneous visions of the South Seas differed in richness and sensitivity, with Nolde having a far more developed sense of the debilitating effects of colonialist modernity on native cultures.[7] Some modernist texts, like the poetry of August Stramm, involve a sense that the problematic being confronted is so tangled, multi-

dimensional, and many-layered that it vitiates the very medium—in Stramm's case language—that is being employed.[8] While other texts, like the poetry of the German Activists (1914–20), D. H. Lawrence's late novel *The Plumed Serpent* (1923–25), or Heidegger's *Einführung in die Metaphysik* (1935; 2nd ed., rev., 1953) (*An Introduction to Metaphysics,* 1959), involve a problematic that is relatively simplified despite the weight of their rhetoric.[9] Finally, modernist works vary extensively in the nature and complexity of their response to the perceived problematic. Kandinsky's letters to Gabriele Münter of 20 October and 8 November 1910 make it very clear how much he preferred premodern Moscow to modern Berlin (which he described as vile), and Rilke's letter to Princess Marie von Thurn und Taxis-Hohenlohe of 27 December 1913 describes modern-day Paris as "ein Ort der Verdammnis" [a place of damnation]. Nevertheless, Rilke's complex *Neue Gedichte* (many of which were written in Paris) and Kandinsky's increasingly enigmatic visual work from 1910 to 1914 (much of which was executed in or around Murnau, a remote, premodern village [see chapter 6]) repress, conceal, and "veil" their confrontation with detested modernity to such an extent that we seem to be dealing with Art for Art's sake in its purest form.[10] At the other end of the scale, an excessively simple or one-sided perception of the modernist problematic can and indeed tends to provoke a correspondingly simplistic response which may—and very often did—generate works that are utopian or even totalitarian in one way or another.

Such variables are the often unrecognized source of critical debate along at least two axes. If modernity is so pervasive that it can generate a problematic and a response to that problematic that appear to have nothing to do with modernity, then which works belong in the modernist canon and how does one judge the importance of any given modernist work or author? Robert Hughes neatly conflated the two questions when he noted that Picasso's *Demoiselles* was exactly contemporaneous with Monet's waterlilies at Giverny and then asked, "Who can say which of them was the more modern artist?"[11] How one deals with these two questions will depend on two factors: first, whether one accepts that modernity is or has become problematic; and second, whether one accepts that any given work or *oeuvre* has been penetrated by modernity and is attempting to solve the resultant problems. If one believes in a *heile Welt,* historical continuity, and the reassuring certainties of the Kantian aesthetic, then the kind of ideas that I am discussing here will be at best irrelevant and at worst pernicious. But the fact remains that during the modernist period, a large number of

major artists and intellectuals suffered from an acute sense that contemporary European culture was experiencing what the scientist Thomas S. Kuhn would call a "paradigm shift." That is to say, in several fundamental respects and across a spectrum of apparently unrelated areas, it was felt that the "logocentric" understanding of reality on which classical modernity and the liberal humanist epoch had been based was being called into question or shattered by the experience of modernity in its contemporary configuration.[12]

Although the remotest origins of that epoch could be traced back to Aristotle, it was widely believed to have begun in earnest during the Renaissance, to have reached its apogee in the emancipatory project of classical modernity (that is, the Enlightenment), and now to be nearing its end.[13] Hugo Ball, drawing heavily on Nietzsche (whose ideas were the source for many a modernist diagnosis of the cultural situation), put it thus in his lecture on Kandinsky of 1917: "Eine Zeit bricht zusammen. Eine tausendjährige Kultur bricht zusammen. Es gibt keine Pfeiler und Stützen, keine Fundamente mehr, die nicht zersprengt worden wären. . . . Eine Umwertung aller Werte fand statt" [An epoch disintegrates. A thousand-year-old culture disintegrates. There are no columns and supports, no foundations any more—they have all been blown up. . . . The transvaluation of values came to pass].[14] The German theologian Paul Tillich recorded how, crawling across the battlefield at Verdun in 1916 amid the bursting shells and the piles of corpses, he came to the conclusion "dass der Idealismus zerbrochen war" [that Idealism was shattered].[15] Ernst Jünger wrote in *Der Kampf als inneres Erlebnis*:

> Ich habe mich sehr verändert durch den Krieg und glaube, dass es wohl der ganzen Generation so gegangen ist. Mein Weltbild besitzt durchaus nicht mehr jene Sicherheit, wie sollte das auch möglich sein bei der Unsicherheit, die uns seit Jahren umgibt.[16]

> *I've changed a great deal because of the war and believe that it's affected my whole generation in a similar way. My picture of the world no longer possesses any trace of its former security, and how should that be possible given the insecurity that has surrounded us for years.*

And commenting in 1934 on Pameelen, the central figure of his strange little drama *Der Vermessungsdirigent* (*The Director of Land Surveying*) (1916), Gottfried Benn wrote:

Hier ist tatsächlich Zersetzung der Epoche. In diesem Hirn zerfällt et-
was, was seit vierhundert Jahren als Ich galt und wahrhaft legitim für
diesen Zeitraum den menschlichen Kosmos in vererbbarer Form durch
die Geschlechter trug. . . . Die Linie, die so grossartig in cogito ergo
sum als souveränes Leben, das seiner Existenz nur in Gedanken sicher
war, begann, in dieser Figur geht sie schwerlich zu Ende. . . . Denn
das Begriffliche, das Logische, das Homosapienshafte war es ja doch,
das durch so viele Jahrhunderte von der Religion, vom philosophischen
Idealismus, von der Aufklärung, vom Humanismus als das grosse
Menschliche, Göttliche, Europäische in Tausenden von Dokumenten
hochgetrieben und gepriesen war, und nun war also auch das Irrtum,
Qual, Krampf, Röcheln, Delirium. . . .[17]

*Here is really the dissolution of the epoch. In this brain something is disin-
tegrating which was regarded as the ego for four hundred years and which
carried, quite legitimately, the human cosmos down through the generations
over this period of time in inheritable forms. . . . The line, which began
so splendidly with [Descartes's affirmation] cogito ergo sum as the sovereign
principle of life that was sure of its existence only via thoughts, laboriously
reaches its end in this figure. . . . For it was, of course, the conceptual, the
logical, the homo-sapient that had been vaunted and extolled throughout so
many centuries in thousands of documents by religion, philosophical Ideal-
ism, the Enlightenment and humanism as the magnificently human, divine,
European principle, and so now was also error, torment, spasm, death-rattle,
delirium. . . .*

More precisely, Ball's global "transvaluation of all values" involved three
major aspects: (1) a change in the concept of what constituted reality; (2) a
change in the concept of what constituted human nature; and (3) a change
in the sense of the relationship between humanity and reality.

The Changing Sense of Reality

By the last decades of the nineteenth century, mainstream European sci-
ence rested on four basic conclusions about the nature of physical reality.
First, that it was material, composed of irreducible particles of matter
(atoms). Second, that it was in a state of harmony with itself, endowed
with a certain static quality inasmuch as the amount of energy in the uni-
verse stayed constant. Third, that it worked according to the mechanical

principle of causality (i.e., regularly and predictably through the inter-action of the irreducible atoms). And fourth, that time and space were homogeneous and absolutely valid grids for measuring thought and action.[18] These assumptions derived from Newton's mechanical model of the universe and were based on the static, unchanging, three-dimensional space of Euclidean geometry. But ideas deriving from the non-Euclidean geometries of Nicolai Lobatchevsky and Georg Friedrich Bernhard Riemann (which began to appear in nonmathematical literature from the 1860s onward), James Clerk Maxwell's discovery of the electrical field of force, a phenomenon that could not be accounted for in Newtonian terms (*On Physical Lines of Force*, 1861–62), and Mach's early work put an increasingly large question mark over these assumptions during the period that falls precisely between the second and third chronological cruxes identified in chapter 1.[19] The Newtonian model of irreducibly solid bodies moving predictably through empty space according to the laws of causality and the a priori axioms of mathematics might still be valid for the "zone of middle dimensions" (the realm of everyday experience). But advances made in the areas of subatomic and astrophysics during the high modernist period by Mach, Max Planck, Albert Einstein, Louis de Broglie, Niels Bohr, Erwin Schrödinger, and Paul Dirac (which almost certainly owed something to the more global cultural and sociopolitical upheavals that were taking place as well as the impact of vitalism, especially in its Bergsonian form) showed that, beyond the apparently stable and harmonious world of classical physics, there lay a "metaworld" or "fourth dimension" that was not describable in Newtonian terms.[20] This metaworld was radically different from the unified system of solid bodies moving regularly in an inert void that had been investigated by classical physics. Instead, it was full of decentered, multidimensionally fluctuating systems of energy, each of which involved its own, relative frame of reference. One of the central ideas of Mach's physical theory was that isolated things do not exist. Accordingly, the concept of the atom, like that of the thing, was simply a mental symbol, a provisional fiction that the classical physicist had imposed on an energetic universe.[21] Moreover, in a chapter that he added to the second edition (1900) of his *Beiträge zur Analyse der Empfindungen* (1886) (*Contributions to the Analysis of Sensations*, 1897), Mach noted the extent to which disciplines other than physics had moved from an objective to an energetic view of reality within a general climate of interdisciplinary ferment:

Wir befinden uns nun in einer solchen Periode mannigfaltiger Beziehungen, und die eingeleitete Gährung der Begriffe bietet recht merkwürdige Erscheinungen dar. Während manche Physiker die physikalischen Begriffe psychologisch, logisch und mathematisch zu säubern bestrebt sind, finden sich andere Physiker hiedurch beunruhigt und treten, philosophischer als die Philosophen, für die von diesen vielfach schon aufgegebenen alten metaphysischen Begriffe ein. Philosophen, Psychologen, Biologen und Chemiker wenden den Energiebegriff und andere physikalische Begriffe in so freier Weise auf eigenem Gebiete an, wie dies der Physiker auf eigenem Gebiet kaum wagen würde. Man könnte fast sagen, die gewöhnlichen Rollen der Fächer seien vertauscht.

We are now in just such a period of manifold interrelationships, and the conceptual ferment which has been started is giving rise to very strange phenomena. While many physicists are intent on purifying physical concepts psychologically, logically, and mathematically, other physicists are unsettled by this and, more philosophical than the philosophers, are upholding the old metaphysical concepts which philosophers have to a large extent already abandoned. Philosophers, psychologists, biologists, and chemists are using the concept of energy and other physical concepts in their own fields with a freedom that physicists would scarcely venture to do in their own field. One could almost say that the customary rôles of the disciplines have been interchanged.[22]

Then again, far from being linear or continuous with itself, the metaworld being investigated by the new physics was observed to involve leaps, jerks, gaps, irregularities, and discontinuities so that the concept of causality, which, as Schiemann points out, had been the subject of a growing critique in the second half of the nineteenth century, came under intensified attack—especially during the five years following the Great War. Finally, under the impact of the special and general theories of relativity, classical space and time changed from independent and absolutely valid grids of reference into coordinates that were relative to the velocity of the object observed, the velocity of the observer, and the intensity of the gravitational field(s) in which both were situated.[23]

The opening up of this metaworld caused similar disruptions during the same period to the stable relationships of Euclidean geometry. Where it had been assumed for over two thousand years that Euclid's *Elements* gave an accurate and final picture of stable physical space, Henri Poincaré's

numerous articles during the 1890s and three major books published between 1900 and 1910 extended and popularized Lobatchevsky's and Riemann's ideas (formulated in 1829 and 1854, respectively) about the relative validity of Euclidean geometry. In *La Science et l'hypothèse* (1903) (*Science and Hypothesis*, 1905), for instance, Poincaré argued that the principles of Euclidean geometry were not a priori forms that adequately transcribed external space, but merely useful, relative conventions. As with Newtonian physics, Poincaré argued that Euclidean geometry continued to work well in terms of ordinary experience but that metaworlds existed beyond that zone where non-Euclidean geometries were "more convenient." Heisenberg would later write of this changed sense of reality: "modern physics is in some way extremely near to the doctrines of Heraclitus. If we replace the word 'fire' [for Heraclitus the basic element] by the word 'energy,' we can almost repeat his statements [about the dynamic nature of reality] word for word from our modern point of view."[24]

We do not need to look very far in other fields to see what Mach meant. In his *Philosophie des Geldes,* Simmel described the modern economy as a "Perpetuum mobile" which is "in jenem absoluten Flusse . . . auf den Heraklits symbolische Äußerungen hindeuten" [in that absolute flux that is indicated by Heraclitus's symbolic formulations] and in which things have no reality. In *Les Fonctions mentales dans les sociétés inférieures,* Lévy-Bruhl, associating himself with another ethnographer's account of the "primitive" way of looking at the world, wrote: "Il y a bien quelque chose dans les êtres et dans les phénomènes, mais ce n'est ni une âme, ni un esprit, ni un volonté. S'il faut absolument forger une expression, le mieux serait de revenir à 'dynamisme' à la place d' 'animisme' " [There is indeed something in the beings and the phenomena, but it is neither soul, nor spirit, nor will. If one absolutely must coin a term, it would be best to come back to 'dynamism' instead of 'animism'].[25]

In the areas of philosophy, art, and literature, examples of a similar change of awareness proliferate, and one can find many interesting examples of writers or artists being directly influenced by scientific advances. Linda Dalrymple Henderson has shown conclusively that the new geometries fed, especially via the writings of Poincaré, into Alfred Jarry's antipositivistic idea of pataphysics, Albert Gleizes's and Jean Metzinger's *Du Cubisme* (1912) (*Cubism*, 1964), and the visual work of the Cubists.[26] These new geometries, she argues, not only opened up a "fourth dimension" for painterly exploration, they also encouraged the Cubists to dismantle the objective space of premodernist art inasmuch as Euclidean geome-

try was tacitly based on the "irreducibility of solids" (95). F. T. Marinetti showed that he was conscious of the relevance of developments in modern physics for avant-garde art and literature when, in his manifesto of 11 May 1913 dealing with "parole in libertà" [words in freedom], he referred to "il movimento Browniano" [Brownian movements] — that is, the random, discontinuous motion of subatomic particles.[27] In *Rückblicke* (1913) (*Reminiscences*, 1982), Kandinsky described how the splitting of the atom (see chapter 6) had caused "die dicksten Mauern" [the stoutest walls] to collapse in his psyche and made everything become "unsicher, wackelig und weich" [uncertain, precarious and insubstantial] so that he would not have been surprised if a stone had melted before his very eyes and vanished.[28] Ball, who had almost certainly read *Rückblicke*, referred in his lecture on Kandinsky to the strange, dynamic effect that the new *Elektronenlehre* [electron theory] had had on all (static) planes, lines, and forms, and related this to the more general crisis described above: "Die Welt zeigte sich als ein blindes Über- und Gegeneinander entfesselter Kräfte. . . . Das Feste zerrann. Stein, Holz, Metall zerrannen" [The world showed itself to be a blind juxtapositioning and opposing of uncontrolled forces. . . . What was solid dissolved. Stone, wood, metal melted]. The peroration of Tristan Tzara's "Manifeste Dada 1918" (1918) ("Dada Manifesto 1918," 1951), which he delivered in Zurich on 23 July 1918, contains, in its characterization of Dada as "le choc précis des lignes parallèles" [the precise shock of parallel lines], an oblique reference to non-Euclidean geometry.[29] On 25 September 1920, the self-styled "Oberdada" Johannes Baader gave a (never published) lecture in Berlin linking Dada with the theory of relativity at a time when Einstein's general theory of relativity was the subject of considerable public controversy after its experimental confirmation in November 1919. And looking back on Dada after thirty years, Tzara went so far as to compare that movement with the scientists who were dismantling classical physics during the modernist period in order to construct "cet édifice monumental qu'est aujourd'hui la physique moderne" [that monumental edifice which is the modern physics of today].[30]

Philosophical and literary examples of the situation described by Mach abound. As early as the essay on Constantin Guys, Baudelaire had written: "la vie universelle entre dans la foule comme dans un immense réservoir d'électricité" [universal life enters into the crowd as into an immense reservoir of electricity], and thereafter, a host of writers and artists during the modernist period were attracted to, afflicted by, or became active proponents of the idea that reality is energetic and fluctuating.[31] Nietz-

sche's philosophy, with its central, vitalist concepts of Dionysos, the Will to Power, and the Will to Life were immensely important for European modernism—at least until the Great War sobered people's minds. Arthur Hübscher's bibliographical work indicates a growing interest in Schopenhauer's (pessimistic) vitalism during that half century when doubt was growing in the principles underpinning classical physics and Euclidean geometry; and during the prewar decade, Schopenhauer's thought enjoyed an almost equal status to Bergson's more optimistic vitalism.[32] Kern suggests that the liberating effect of reading Bergson may have helped bring about the visionary experience of January 1909 that sparked Proust's *A la Recherche du temps perdu* (1909–22) (*Remembrance of Things Past*, 1922–31), and by his own admission, the English aesthetician T. E. Hulme was an enthusiastic Bergsonian from mid-1909 to 1912 because of the liberating nature of Bergsonian vitalism.[33] It was almost certainly for the same reason that so many writers and intellectuals, especially on the Continent— Carl Gustav Jung, Döblin, and Hesse, to give only three very obvious examples—were drawn to Eastern philosophy, especially Taoism, with its central doctrine of reality as a flux of opposing forces that the individual must somehow hold in dynamic balance (see chapter 10). Simmel's thinking became increasingly vitalistic, culminating in the first chapter of his *Lebensanschauung*. The scientist Alfred North Whitehead's conversion to a vitalist conception of reality is instanced by his Gifford Lectures of 1927 (published two years later as *Process and Reality*). And Karl Jaspers's diagnosis of the ills of the modern age in *Die geistige Situation der Zeit* begins with a vision of modernity as flux.

Rimbaud's poem "Les Ponts" (c. 1872) ("Bridges," 1932) transmutes solid objects into decentered lines of energy.[34] In five years, Van Gogh's work moved from the dark, static, heavy, poverty-stricken realism of *De aardappeleters* (*The Potato Eaters*) (1885) to the elemental, nonobjective dynamism of *Boomwortels* (*Roots and Tree Trunks*) (1890)—a painting which, like most of the work that Van Gogh executed in Provence between May 1889 and his death in 1890, very clearly conforms to Kern's description of his *oeuvre* as "a continuous field of energy circuiting through mind, world, and art."[35] In 1906, Hofmannsthal wrote in "Der Dichter und Diese Zeit" ("The Poet and This Age") that "das Wesen unserer Epoche ist Vieldeutigkeit und Unbestimmtheit. Sie kann nur auf Gleitenden ausruhen und ist sich bewusst, dass es Gleitendes ist, wo andere Generationen an das Feste glaubten" [The essence of our age is polyvalence and indeterminacy. It can take its rest only on what is slipping away from under it and is con-

scious that it is slipping away where other generations believed in what was firm].[36] The Futurist manifestos hymned *dinamismo universale* [universal dynamism] from 1909 onward. The dynamic concept of *Verkehr* [traffic] is central to Kafka's novel *Der Verschollene* (1912) (*America*, 1938).[37] Much major Expressionist poetry—such as Ernst Stadler's "Fahrt über die Kölner Rheinbrücke bei Nacht" (1913) ("On Crossing the Rhine Bridge at Cologne by Night," 1962)—moves away from a noun-based syntax and toward one based on intransitive and reflexive verbs, thereby signifying that the sense that reality consists of causally related objects is being displaced by a sense that reality is flux (see chapter 5). Something similar was implied by the decapitalization of nouns in the poetry of the Dadaists and, after the Great War, of e. e. cummings.[38] Although Kandinsky retained the classical concept of *Geist* [spirit/intellect] as the centerpiece of his aesthetic theory, it is more fluid and dynamic a concept than the central, centered concept of classical aesthetics. And in the first edition of Wyndham Lewis's novel *Tarr,* the Parisian Restaurant Lejeune is depicted not realistically, but as a chaos of fluctuating energy.[39]

As we shall see in chapter 7, Dada was centrally concerned with the affirmation of reality as anarchic, multidimensional flux, and according to Henderson, three of the Dadaists—Francis Picabia, Duchamp, and Theo Van Doesburg—were affected, during formative periods of their artistic careers, by the new physics and/or non-Euclidean geometry.[40] Rilke's *Sonette an Orpheus*—especially 2.12 and 2.15—celebrate the perpetual transformations of a universe in which there is no fixity. Finally, the fluctuating, acausal, nonlinear cities that are pictorialized in such novels as Rilke's *Die Aufzeichnungen des Malte Laurids Brigge;* Musil's *Der Mann ohne Eigenschaften;* James Joyce's *Ulysses* (c. 1915–21); Hermann Broch's *Die Schlafwandler* (1929–32) (*The Sleepwalkers*, 1932); and Döblin's *Berlin Alexanderplatz* form analogues of the new physics. Just as the newly discovered physical metaworlds relativized the Cartesian-Newtonian and Euclidean paradigms, so contemporary modernity as depicted in these novels subverts the logocentric model of reality and, by implication, the Realist convention according to which a story could be narrated in a coherent, linear, and causally explicable manner.[41] So although it can be argued that the philosophical vitalists' concepts of the Will and Life mystify the bourgeois marketplace and so serve to consecrate the political status quo, the above novels, by using modern settings and defamiliarizing techniques, do at least attempt, with varying degrees of success, to demystify modernity in a critical way.[42]

Given this changed sense of reality, a large number of major modernist texts deal centrally with the penetration of the "middle zone of experience" by a fourth dimension or metaworld. Virginia Woolf was getting at this in 1919 when she contrasted the "spiritual" quality of *Ulysses* with the "materialism" of such writers as H. G. Wells, John Galsworthy, and Arnold Bennett, and compared him with the saintliness and spirituality of the great Russian novelists. In Woolf's view, Joyce disregarded "with complete courage whatever seems to him adventitious, though it be probability or coherence or any of the handrails [of realist convention] to which we cling for support when we set our imaginations free" because of his concern "at all costs to reveal the flickerings of that innermost flame which flashes its myriad messages through the brain."[43] And in 1933, Hermann Broch drew an analogy between the work of Van Gogh and that of modern novelists like Kafka, whose writing, he argued, penetrated "in jene Sphäre der traumhaft erhöhten Realität" [into that sphere of oneirically intensified reality] that was closed to those who were trapped in the assumptions of Realism.[44] But on the whole, the metaworlds of the modernist imagination do not simply coexist with commonsense bourgeois reality and accepted public codes: they irrupt into it destructively and are personified by such figures as Jarry's Ubu, Wedekind's Lulu, Anastasia in *Tarr,* and Hermine in *Der Steppenwolf.* Or they may take the form of the elemental, demonic forces like those which burst into the literary and visual works of German Expressionism and the nightmare images that suffuse and subvert the world of everyday objects in Surrealist art. Indeed, in such major modernist texts as Conrad's *Heart of Darkness,* Mann's *Der Tod in Venedig* and *Der Zauberberg,* Kafka's *Der Proceß,* D. H. Lawrence's *Women in Love* (1913–20), Forster's *A Passage to India,* and Jean-Paul Sartre's *La Nausée* (1931–33) (*The Diary of Antoine Roquentin,* 1949), various central characters suddenly discover that the "real"—conventional—world of objects and relationships in which they had thought to be securely at home is actually permeated by and subject to elemental powers over which they have no final control, but with which they have to come to terms or be destroyed. The sense that conventional reality is surrounded and permeated by a dynamic metaworld is also embodied in the surreal city that interpenetrates with the "real" St. Petersburg in Bely's novel; in the disconcertingly mysterious country of Perle in Kubin's *Die andere Seite;* in the chaotic (to K.'s way of thinking) world of the Castle and village in Kafka's *Das Schloß;* in the multilayered, ungrammatical, fluctuating discontinuities of the Dublin of Joyce's *Finnegans Wake* (1922–38), which, as Spears observed, broke

with the values of liberal humanism and conventional views of rationality in order to transmit a new and more complicated view of reality;[45] and in the topsy-turvy worlds of Mr. Nott's house in Samuel Beckett's *Watt* (1943–44) and Gonzales's *estancia* in Witold Gombrowicz's *Trans-Atlantyk* (*Trans-Atlantic*) (1953).

Like the modern scientist, all these modernist writers have a developed sense that reality is not reality as perceived and structured by the Western bourgeois consciousness. Moreover, they all sense that within and behind reality as it is conventionally understood, there lies a realm full of dynamic energies whose patterns are alien to liberal humanist or classical notions of order, and which, to the extent that they exist at all, are elusive and mysterious. Rilke glimpsed that realm in the Spanish landscape near Toledo in November 1912, and in his 27 October 1915 letter to Ellen Delp, he described his visionary experience as follows:

> Erscheinung und Vision kommen überall im Gegenstand zusammen, es war in jedem eine ganze Innenwelt herausgestellt, als ob ein Engel, der den Raum umfasst, blind wäre und in sich schaute.[46]

> *Apparition and vision came together everywhere in the object, in each of them a whole inner world was revealed as though an angel, who encompasses space, were blind and looking into himself.*

In the same letter, Rilke went on to speculate that his true poetic task might be to view the world not from the human but from the angelic perspective. But when he did so, in the *Duineser Elegien,* he discovered that the "angelic" universe was governed by awesome, superhuman, barely expressible energies in the face of which human beings inevitably felt a sense of acute dispossession. In the first of the *Elegien,* Rilke wrote "und die findigen Tiere merken es schon / dass wir nicht sehr verlässlich zu Haus sind / in der gedeuteten Welt" [and the resourceful animals already notice / that we are not very reliably at home / in the interpreted world] — a sentiment that would be echoed by Conrad's Kurtz in the heart of the Dark Continent; Robert Müller's helpless engineer-narrator in the South American jungle of *Tropen;*[47] and Brecht's alter ego amid the fragile technological constructs of modernity in his poem "Vom armen B. B." ("Concerning Poor B. B.") (1922).

Modernist painters, faced with equally strange, disturbing, and even terrible metaworlds, found themselves forced, if they were to communicate their vision, to give up the fixed point of perspective that they had

inherited from the Renaissance and that implied some kind of harmony between the divine Logos, a geometrically ordered universe, and the transcendental activities of the human logos.[48] Elsen notes that the sensual power of Rodin's *La Porte de l'Enfer* varies according to the lighting, the time of day, the perspective, and the distance from which the work is viewed, and, like Cézanne's painterly work from the mid-1880s onward, creates a multiperspectival pattern of seeing that violates the rules of linear perspective. Analogously, modernist fiction moved away from the linear sequentiality, omniscient and reliable narrators, fixed narrative relationships, and consistency of narrative mode by means of which their nineteenth-century predecessor had tried to account "realistically" for their relatively secure sense of reality.[49] Instead, modernist novelists experiment with techniques that accentuate the discontinuity between the conventional understanding of reality and the sense of reality that informs their works. These techniques include distortions of linear, causal/temporal order (as in Mann's *Der Zauberberg,* Proust's *A la Recherche du temps perdu,* and Joyce's *Ulysses*). They involve narrators whose perspective is limited, peculiar, or unreliable (like that of Kafka's short story "Ein Hungerkünstler" [1922] ["The Hunger Artist," 1938]), Marlow in Conrad's *Heart of Darkness,* Dowell in Ford Madox Ford's *The Good Soldier* [1913–14], Jason Compson in William Faulkner's *The Sound and the Fury* [1928], and Serenus Zeitblom in Mann's *Doktor Faustus* [1942–47] [translated 1949]); multiperspectivism (as in Virginia Woolf's *The Waves* [1928–31], Broch's "polyphonic novels" like *Die Schlafwandler,* Joyce's *Finnegans Wake,* and Musil's *Der Mann ohne Eigenschaften*); and elastic or elusive relationships between author, narrator, and protagonist (as in Rilke's *Die Aufzeichnungen des Malte Laurids Brigge,* Mann's *Der Tod in Venedig,* Kafka's two major novels, and André Gide's *Les Faux-Monnayeurs* [1919–25] [*The Counterfeiters,* 1928]). There are clear parallels between these literary works and the visual works by Matisse, Picasso, and Braque analyzed by Butler. But modernist novelists also use pastiche and a range of rhetorical, parodic, and intertexual devices (for example, the nine registers in *Malte* and the eighteen different styles of *Ulysses*). They also employ techniques that derive directly from aperspectival (post-Renaissance) visual modes (for example, montage in *Berlin Alexanderplatz*) and film (such as the "Wandering Rocks" section of *Ulysses,* which is, according to Kern, constructed using devices inspired by the cinema in which Joyce had been interested since the prewar years).[50]

Where aesthetic theory in the Kantian tradition stressed "disinterested

contemplation [of the art-]object considered as a work of genius," modernist art defies the urge to contemplation. Rather, it tends to foreground the writer's/artist's consciousness that there is a problematic to be confronted by forcibly drawing the reader's/viewer's attention both to the relative status of the human and material signifier and the unconventional sense of reality that is signified. In all cases, we are dealing with what the Russian Formalist Viktor Shklovsky, writing in St. Petersburg in about 1917, called *ostranneniye* [defamiliarization]—an idea that would be politicized by such representatives of the modernist Left as Erwin Piscator, Brecht, Sergey Tretyakov, and Walter Benjamin on the grounds that disruption of "the frozen patterns of sensory perception" was "a prerequisite for any revolutionary reorganization of everyday life." But most modernists were less concerned with political revolution and more concerned to break the hold over their audience's minds of conventionalized, nineteenth-century modes of perception; to shake their audiences out of the belief that everything—like the disturbing dominant seventh with which Wagner's *Tristan* (1854–59) had opened—could be resolved into consonance in an increasingly more complex world. Most modernists sought to compel their audiences to confront alternative, noncommonsensical metaworlds that they would rather ignore and thereby challenge them to rethink their epistemological *and* their ontological categories. Or to put it another way, the modernist sense that a once stable reality is running or beginning to run out of control generates texts that, through both form and content, aim to shock people into facing that realization with all its attendant consequences. When Hutcheon says that modernist art challenged the realist notion of representation to the detriment of the referent "by emphasizing the opacity of the medium and the self-sufficiency of the signifying system," she is simplifying the concerns of modernism to purely aesthetic ones. Consequently, she is doing less than justice to the urgent sense of so many modernist writers and artists that a seismic upheaval was taking place in the Western consciousness of what constituted reality, with which it was necessary, *nolens volens,* to come to terms.[51]

The Changing Sense of Human Nature

Writing in 1934, Gottfried Benn saw that the question of reality was inseparable from the question of human nature and that both questions were massive. Like his Enlightenment predecessor, the nineteenth-century liberal humanist assumed that human beings were moral by nature and

endowed with a power of rationality that enabled them to unlock the secrets of Nature, exploit them technologically, and exercise control over themselves. As such, they could by means of education—"Bildung, the training of the character in a holistic sense"—be brought to that state of autonomy [*Mündigkeit*], which, for Kant, was the whole point of the Enlightenment.[52] Having dispensed with God, the nineteenth-century liberal filled that gap with man, who was supposedly the measure of all things —at home in the world and entitled to do as he pleased with it as he was its rational, securely centered midpoint. Unfortunately, as Giddens points out, this conception depended on the secularization of the idea of Divine Providence and the replacement of "one type of certainty (divine law) . . . by another (the certainty of our senses)." Thus, bereft of a transcendental foundation to which it could appeal in times of crisis, liberal humanism inevitably found itself in considerable difficulties once the project of modernity began to go wrong, and scientists and philosophers intensified these difficulties not only by making new discoveries in the areas of anthropology, sociology, and geology, but also by systematically questioning the philosophy of consciousness with which, as we saw in chapter 1, the project of modernity was inextricably bound up.[53]

As early as 1886, Mach had gained a certain notoriety for asserting, in his *Beiträge zur Analyse der Empfindungen:*[54] "das Ich ist unrettbar" [the ego cannot be saved] (17/24)—by which he meant that "das Ich ist keine unveränderliche bestimmte scharf begrenzte Einheit" [the ego is not an unalterable, definite, sharply bounded unity] (16/24). And he developed this position in *Erkenntnis und Irrtum* when he characterized the ego as a fictional label without substance denoting clusters of sensations; criticized the idea of the ego as a monad that was isolated from the world (462/361); denied that all life was centralized in an ego-forming brain (69/49); and described human beings as "ein Teil der Welt und mitten im Fluss derselben" [a part of the world and right in the center of its flux] (462/361). But it was perhaps Nietzsche's philosophy, which made its major initial impact during the "high modernist" period, that constituted the most damaging early assault on nineteenth-century liberal assumptions about the supremacy of reason. For example, Nietzsche's jottings from the 1880s, later synthesized by his sister into *Der Wille zur Macht* (*The Will to Power*) (1909– 10) for the large octavo edition of his works (1900–26), contain several penetrating remarks to the effect that the existence of the shifter *Ich* (I) should not mislead us into thinking that a unified substance or organic cell exists that corresponds to it.[55] And in the works published during his life-

time, Nietzsche's polemic against nineteenth-century conceptions of the self is encapsulated in his attacks on such notable liberals as the theologian David Friedrich Strauss and George Eliot (who had translated Strauss's best-known work, *Das Leben Jesu* [1835–36], as *The Life of Jesus* [1846]). Nietzsche claimed that she was one of those "moral fanatics" who, having got rid of the Christian God, believed all the more tenaciously in the need to hang on to Christian morality.[56] For Nietzsche, whose views were, admittedly, based on a "pseudo-biological view of humankind," consciousness was a secondary organ, and human nature, to the extent that it was grounded at all, was fundamentally Dionysiac.[57] That is to say, it was governed by the amoral god of unreason and drunkenness who "evokes the sense of dark underground forces mysteriously stirring, from Freud's Unconscious to Marx's masses, from Lawrence's Dark Gods to the sleeping giant of Finnegans Wake and Yeats's gods and Sidhe. . . ."[58]

As this quotation suggests, similar ideas are to be found in the work of Sigmund Freud, C. G. Jung, and Alfred Adler, all of whom were more or less avowedly indebted to Nietzsche.[59] Western behavioral science had been gradually moving toward a "dynamic psychiatry" since the late eighteenth century. But it was only during the "high modernist" period, from the turn of the century onward, that the view gained wide currency in intellectual circles, largely via the psychoanalytical school around Freud, that human behavior was impelled by unconscious powers.[60] These were said to be irrational and amoral; controllable only in a limited way by conscious reason and moral imperatives; knowable, like the subatomic world, only indirectly, via dreams and neuroses; and deeply offensive to and so ignored by conventional wisdom. At a remarkably early date, Freud showed that he was to some extent aware of the analogy between the paradigm shift from the conscious to the unconscious that was taking place in the behavioral sciences and the direction in which the physical sciences were moving when he wrote, in *Die Traumdeutung* (1900) (*The Interpretation of Dreams*, 1913):

Das Unbewusste ist das eigentlich reale Psychische, *uns nach seiner inneren Natur so unbekannt wie das Reale der Aussenwelt, und uns durch die Daten des Bewusstseins eben so unvollständig gegeben wie die Angaben unserer Sinnesorgane.*

The unconscious is the true psychical reality; in its innner nature it is as much unknown to us as the reality of the external world, and it is as

incompletely presented by the data of consciousness as is the external world by the communications of our sense organs.[61]

The corrosive impact of Freud's teachings on nineteenth-century assumptions about the inherent rationality and morality of human nature would be hard to overestimate. Far from being the autonomous or transcendental ego of the post-Kantian Idealist tradition, human beings were seen to be at the mercy of basic unconscious drives whose nature could be known only imperfectly. Far from being rational, human beings were seen to be innately irrational. Far from being inherently moral, human beings were seen to be fundamentally animal. The human ego, claimed Freud, was a bundle of discrete structures without substantial unity. Correspondingly, the structures of human culture had been built over and at the cost of the repressed unconscious, which Freud described in "Das Unbewußte" ("The Unconscious") (1913) as analogous to "einer psychischen Urbevölkerung" (10:294) [an aboriginal population of the mind (14:195)] — a highly revealing image given the connections made in chapter 1 between modernity and the age of imperialism. Far from being a god in his little world, western man, Freud argued, was at the mercy of more primitive divinities whom, in his hubris, he thought he had abolished or chose to ignore. And the result of this decision was, Freud concluded, the Great War in particular and a profound unease in general. In "Zeitgemäßes über Krieg und Tod" ("Thoughts for the Time on War and Death") (1915), he claimed, personifying death, that one of the major psychological reasons for the senseless and apparently unstoppable slaughter of the Great War was "die Störung des bisher von uns festgehaltenen Verhältnisses zum Tode" (10:341) [the disturbance that has taken place in the attitude which we have hitherto adopted toward death (14:289)].[62] But precisely because we have ignored death, Freud continued, Death has returned all the more violently to force his reality onto us via the war: "Der Tod lässt sich jetzt nicht mehr verleugnen; man muss an ihn glauben" (10:344) [Death will no longer be denied; we are forced to believe in it (him) (14:291)]. After the war, in *Jenseits des Lustprinzips* (1919–20) (*Beyond the Pleasure Principle*, 1922), Freud turned death from a personified abstraction into the concept of Thanatos, the death instinct, the urge to aggression and destruction, and postulated that it was one of the two fundamental drives in the human personality, the other being Eros or the life instinct (13:57/18:53). Not only were these two instincts in conflict with one another, but, according to Freud, the derepression of Eros inevitably involved the de-repression of Thanatos. Con-

sequently, human nature was caught in an unresolvable double bind, and although humanity might try to disguise the resultant psychic suffering from itself through sublimations like religion, culture, and the pursuit of knowledge, such displacement activities were ultimately powerless. Thus, in *Das Unbehagen in der Kultur* (1929–30) (*Civilization and Its Discontents*, 1930), Freud came to the following, wry conclusion:

> Nun hat [der Mensch] sich der Erreichung dieses Ideals sehr angenähert, ist beinahe selbst ein Gott geworden. . . . Im Interesse unserer Untersuchung wollen wir aber auch nicht daran vergessen, dass der heutige Mensch sich in seiner Gottähnlichkeit nicht glücklich fühlt. (14:450–51)

> *To-day [Man] has come very close to the attainment of this ideal, he has almost become a god himself. . . . But in the interests of our investigations, we will not forget that present-day man does not feel happy in his Godlike character.* (21:91–92)

It was precisely Freud's belief in the power of Thanatos and the inability of Eros to overcome it in any final sense that prevented him from developing any great belief in "human society as nourishing as well as constraining—as a place of reciprocal self-fulfillment as well as a mechanism for keeping us from each other's throats."[63]

Ironically, given Freud's attitude to religion, modernist theology runs parallel to psychoanalysis on the question of human nature. Nineteenth-century liberal Christianity had tended on the one hand to divinize humanity, stressing its ethical potential and the godlike nature of the human character, and on the other hand to humanize God, ignoring those facets of Christian teaching that did not fit this rapprochement. But modernist theology, as instanced above all by the work of Rudolf Otto and Karl Barth, drew attention to the "numinous," the nonrational, the awe-inspiring, and the metaethical aspects of religious experience. In *Das Heilige* (1917) (*The Idea of the Holy*, 1923), Otto described "das Unterste und Tiefste in jeder starken frommen Gefühlsregung" [the deepest and most fundamental element in all strong and sincerely felt religious emotion] in irrationalist, Dionysiac terms, claiming that it can lead people "zu Rausch, Verzückung und Ekstase" [to intoxicated frenzy, to transport, and to ecstasy].[64] And in the (completely rewritten) second edition of his commentary on St. Paul's Epistle to the Romans (1921), where the influence of Kierkegaard, Dostoevsky, and Nietzsche is particularly marked, Barth also

described the divine-human encounter in irrationalist, almost Expression-
ist terms. Far from informing mankind of its divinity or telling it how it
might become divine, God is said to irrupt cataclysmically into the human
world in order to convict humanity of its smallness and impotence, to
bring it to a more appropriate awareness of its place in the scheme of
things, and thereby, paradoxically, to make it anew.[65] Both the psycho-
analysts who followed Freud and the dialectical theologians who followed
Barth were, for all their differences, in agreement over one essential point:
human beings were governed by and at the mercy of irrational, primitive
powers. These might be psychological or metaphysical, but to ignore or
defy them was to court disaster since their nature was at best ambiguous
and at worst destructive. As the Jewish philosopher Martin Buber said in
the last sentence of his introduction to *Ekstatische Konfessionen* (*Ecstatic
Confessions*) (1903–7), an anthology of ecstatic mystical extracts from a di-
versity of cultures: "Wir horchen in uns hinein—und wissen nicht, welches
Meeres Rauschen wir hören" [We listen into ourselves—and do not know
what ocean's surging we are hearing].[66]

Once again, modernist art and literature provide extensive parallels—
often from the work of writers whose sense of the irrational, even violent
basis of human nature ultimately pushed them toward the order promised
by the political Right. Schorske remarks that although Klimt began "with a
cheerful revolt on behalf of the instinctual—especially the erotic—life," he
very soon "became obsessed with the pain occasioned by the return of the
repressed" and "limned in allegorical and symbolic language the suffering
psyche of modern man impotently caught in the flow of fate" and "a world
without secure coordinates." Kubin's fantastic ink drawing *Der Mensch*
shows an androgynous being on a pair of two wheels hurtling uncontrol-
lably down a railway line that curves away into nothingness. The beast- or
masklike heads on the female bodies in Picasso's *Les Demoiselles d'Avignon*
speak, among other things, of the modernist sense that the logos (conven-
tionally located in the head) and ego-identity (conventionally located in
the face) are illusions covering a more primitive, more bestial, nonhuman-
ist reality. The same applies, according to Rosalind Krauss, to those fre-
quent images in avant-garde visual work of the 1920s where the human
head is replaced by a gas mask or mechanical mask: such substitutes "call
to mind not higher stages in the evolution of the species but much, much
lower ones. . . . What should be the sign of [man's] highest faculties, his
mind, his spirit, has become lowly, like the crushed spider, or the earth-
worm."[67] Partly as a result of his war experiences, T. E. Hulme found

humanism's belief in man's natural goodness profoundly unsatisfactory and stated, in a posthumously published essay:

> I hold quite coldly and intellectually as it were, that the way of thinking about the world and man, the conception of sin, and the categories which ultimately make up the religious attitude are the *true* categories and the *right* way of thinking.[68]

As a direct result of his four-year-long war experience, Ernst Jünger, making explicit reference to the title of Leonhard Frank's much-read collection of antiwar stories *Der Mensch ist gut* (*Man Is Good*) (1916–18), emphatically denied that this was so and stated that "[der Mensch] ist das gefährlichste, blutdürstigste und zielbewussteste Wesen, das die Erde tragen muss" [(people) are the most dangerous, bloodthirsty and single-minded beings that the earth must bear]. Georges Bataille celebrated acephalic—headless—man, the libidinal energy of the body, and an excremental universe. Müller's engineer, like Conrad's Kurtz, finds the jungle and the horror of primal violence within as well as around himself and divests himself of the "Weltmittelpunkt, der in mir lag" [the midpoint of the world that lay within me]. This whole complex of sentiments is encapsulated in the opening lines of Gottfried Benn's poem "Der Arzt II" ("The Doctor II") (c. 1912): "Die Krone der Schöpfung, das Schwein, der Mensch—: / geht doch mit anderen Tieren um!" [The crown of Creation, the swine, mankind—: / has commerce with the other beasts indeed!] [69] and the lines from Ezra Pound's eighty-first Pisan Canto (written in a prison camp near Pisa in 1945): "The ant's a centaur in his dragon world. / Pull down thy vanity, it is not man / Made courage or made order or made grace." In their different ways, both Benn and Pound are saying that human beings can no longer be regarded as the moral center of a rationally ordered world, as creatures who are ontologically distinct from and in some sense above it. Like the "ant" in his "dragon world," people may labor under the self-centered illusion that they are semisuperior to the rest of Creation—"centaurs" who are half animal and half something else. But in fact, they are just another animal species and as such, subject to nonrational drives beyond their control.

In his lecture on Kandinsky, Hugo Ball was even more explicit about the effects of modernity on the humanist estimation of human nature:

> Der Mensch verlor sein himmlisches Gesicht, wurde Materie, Zufall, Konglomerat, Tier, Wahnsinnsprodukt abrupt und unzulänglich zuckender Gedanken. Der Mensch verlor seine Sonderstellung, die ihm die

Vernunft gewahrt hatte. Er wurde Partikel der Natur, vorurteilslos ge-
sehen ein Wesen frosch- oder storchenähnlich, mit disproportionierten
Gliedern, einem vom Gesicht abstehenden Zacken, der sich "Nase"
nennt, abstehenden Zipfeln, die man gewohnt war "Ohren" zu nennen.
Der Mensch, der göttlichen Illusion entkleidet, wurde gewöhnlich,
nicht interessanter als ein Stein es ist, von denselben Gesetzen aufgebaut
und beherrscht, er verschwand in der Natur, man hatte alle Veranlas-
sung ihn nicht zu genau zu besehen, wenn man nicht voller Entsetzen
und Abscheu den letzten Rest von Achtung vor diesem Jammer-Abbild
des gestorbenen Schöpfers verlieren wollte.

*Man lost his divine countenance, became matter, chance, an aggregate, ani-
mal, the lunatic product of thoughts quivering abruptly and ineffectually.
Man lost the special position that reason had guaranteed him. He became a
particle of nature, seen (without prejudice) as a froglike or storklike creature
with disproportionate limbs, a wedge jutting out of his face (called "nose"),
and pointed flaps protruding from his head (which people used to call "ears").
Man, stripped of the illusion of godliness, became ordinary, no more inter-
esting than a stone; he vanished in nature; one had every reason to avoid
giving him too close a look, unless one wanted to lose, in terror and disgust,
the last remnant of respect for this desolate reflection of the dead Creator.*[70]

This passage reads like an anticipation of Beckett's *Watt* in its sense that
the human(ist) subject has been radically "decentered." And that sense
had, in the first place, two major complementary effects on modernist lit-
erature. Although Beebe saw these effects as a contradiction, they are more
accurately regarded as two sides of the same erratically spinning (decen-
tered) coin. Where some modernist writers investigate the extent to which
human beings are motivated by lower (animal) or higher (metaphysical)
irrational powers, others are centrally concerned with the problem of con-
sciousness. Or to put it epigrammatically, Rimbaud's famous dictum in his
13 and 15 May 1871 letters to Georges Izambard and Paul Demeny — "JE
est un autre" [I is another] — tends to open up three routes. The modernist
explorer could investigate either the "JE" that had become problematic, or
the nature of the mysterious "autre," or, as Buber thought he was doing in
his *Ekstatische Konfessionen,* both simultaneously.[71]

Accordingly, the very titles of a large number of major modernist texts
denote a move beyond the well-defined and apparently secure world of
nineteenth-century bourgeois reality in which human beings, apparently
governed by reason, consciousness, and free will, seemed to be in moral

control of their actions, and into that *ungeborgen* [exposed, unprotected] realm of unsayable experiences that Rilke evoked in his untitled poem, written just after the outbreak of war, "Ausgesetzt auf den Bergen des Herzens . . ." ("Exposed upon the Mountains of the Heart . . .") (1914). Mann's Hans Castorp enters this realm when he goes to the Berghof Sanatorium in *Der Zauberberg;* Benn's Dr. Rönne is thrust into it in the stories comprising *Gehirne (Brains)* (1915–16); Müller's engineer explores it in *Tropen;* and the giant mole in Kafka's short story "Der Bau" (1923) ("The Burrow," 1933) is pathologically afraid of it encroaching on his heavily fortified world.[72] Where the titles of many major nineteenth-century novels consist in the familiar names of people or humanly created places (for example, *Madame Bovary, Daniel Deronda, Effi Briest, La Chartreuse de Parme, Oblomov, Mansfield Park, Die Chronik der Sperlingsgasse*), the titles of many major modernist novels have a more obscurely metaphorical resonance (*Heart of Darkness, Melanctha, Der Proceß, Die andere Seite, My*), signalling their author's awareness that there is more to human nature and the environment in which it has to exist than can be easily determined, appropriated, named, and explained. As Mark Anderson put it, modernist texts are frequently "traveling narratives" that work to destabilize the identity of the protagonist as well as the structures of genealogy and property with which this identity is bound up.[73] This is why, presumably, neither Conrad, Kafka, Musil, nor Elias Canetti located *Heart of Darkness, Der Proceß, Der Mann ohne Eigenschaften,* or *Die Blendung* (1930–31)(*Auto da Fé,* 1965) in a precisely named context even though, from the point of view of Realism, they are demonstrably set in the Congo, Prague, and Vienna (twice), respectively.

In an essay of 1914, Alfred Adler attributed the ills of Western culture to a hubristic fixation on rational domination and the concomitant neglect of the affective sides of the personality. As if in confirmation of this, Conrad's Kurtz, Döblin's Michael Fischer and Franz Biberkopf, Mann's von Aschenbach, Kafka's Josef K., Wyndham Lewis's Tarr, Benn's Dr. Rönne, Lawrence's Gerald Crich (in *Women in Love*), Woolf's Percival (in *The Waves*), Canetti's "Professor" Peter Kien (in *Die Blendung*), Sartre's Roquentin, and Camus's Meursault are all characters who have constructed what initially looks like a secure and stable identity by neglecting, repressing, or doing violence to the shifting, spontaneous, natural, unconscious sides of their beings. All are characters who have become overcerebral, overconfident, overmasculinized, and/or overconventionalized. All labor under the illusion that they are centaurs in their dragon worlds. And all are, in conse-

quence, brought low and in some cases transformed by a series of encounters with mythological beings or "low" elemental powers—that is, with the objective correlatives of their own repressed unconscious drives. These are, in the strict sense, more primitive and so more powerful than what D. H. Lawrence, in a 5 June 1914 letter to Edward Garnett in which he grudgingly acknowledged an affinity with Marinetti's sense of reality, called "the old stable *ego*—of the character."[74]

But precisely because "the old stable *ego*" is felt to be under so great a threat from Ball's "Anarchie der befreiten Dämonen und Naturmächte" [anarchy of liberated demons and natural forces], many modernists, as several critics have pointed out, make the preservation of consciousness their chief concern.[75] In "Mon Coeur mis à nu" (c. 1859–63) ("My Heart Laid Bare," 1930), Baudelaire had written: "De la vaporisation et de la centralisation du *Moi*. Tout est là." [Of the vaporization and centralization of the *Ego*. Everything is there].[76] Given his analysis of modernity in the roughly contemporaneous essay on Constantin Guys, he is here identifying a crucial problem of modernity: the need to recenter the "I" precisely because it is felt to be in danger of evaporating. Hence the importance for Baudelaire of the melancholy Dandy who must live and sleep in front of a mirror (1:678/62) to assure himself that he is really there; who is the perfect "flâneur" (2:691/48); and who is able to observe the world, be at the center of the world, and yet remain concealed from the world (2:692/48)—who is, in short, able to maintain a sense of selfhood only by means of studied self-control. It is possible that Simmel knew Baudelaire's work, for in a pioneering essay of 1903 entitled "Die Großstadt und das Geistesleben" ("The Metropolis and Mental Life," 1936), he singled out the attitude of blasé intellectuality as the most appropriate stance for the modern city dweller who wishes to preserve the integrity of his or her person in the face of the continuous shocks of city life.[77]

Echoes of this position can be heard in many modernist texts. The centrality for Svevo's *La coscienza di Zeno* of the individual consciousness that tries to protect itself from outside pressures in order to observe the world from an Archimedean point; T. E. Hulme's move away from Bergsonianism and toward a commitment to the "dry classical spirit"; Benn's rejection of everything symbolized by "Höhlen, Himmeln, Dreck und Vieh" [caverns, heavens, filth and beast] in his poem "Synthese" ("Synthesis") (1917) and advocacy of "das Formale" [the formal], "die Reinigung des Irdischen im Begriff" [the purification of the chthonic/earthly in the concept], and "Intellektualismus" [intellectualism] in a world where the Christian and

the Greek gods were dead;[78] the Cubists' and Imagists' concern with controlled, analytical impersonality; the Vorticists' advocacy of monumental machine art; Prufrock's tortured self-irony;[79] the excoriating analysis of the threatened self that leaps out from so many Expressionist self-portraits, such as Otto Dix's ironic self-stylization as a modern version of the armored knight from Dürer's *Ritter, Tod und Teufel* (*Knight, Death and Devil*) (1513) in his *Selbstbildnis mit Muse* (*Self-Portrait with Muse*) (1924); and the obsessively repetitive, cruciform faces that the Russian Expressionist Aleksey Jawlensky produced, often with titles relating to extreme emotional states or religious-mythological events, between about 1918 and about 1937 are all responses to "the burden of subjectivity" in a situation where the symbiotic relationship between stable self and ordered world has been fractured.[80] In such a destabilized situation, the individual consciousness, painfully aware of the relativity of its perspective and always, as in Ludwig Meidner's self-portrait *Ich und die Stadt* (*I and the City*) (1913), under radical threat, is left either desperately asking *what* it is; or, like the voice of so many Expressionist poems and the heroes of so many Expressionist *Ich-Dramen*, emphatically insisting *that* it is; or, like Benn's Dr. Rönne, doing both at the same time.[81] This is why some modernist aestheticians insist that, when a point of epiphanic meaning unexpectedly presents itself, it has to be seized and pinned down as precisely as possible. Hence Pound's simultaneous connection of Imagism with "the 'search for oneself,'" definition of an Imagist poem as the recording of "the precise [epiphanic] instant when a thing outward and objective transforms itself, or darts into a thing inward and subjective," and explication of his ideal form of modern art in terms of the equation that, in Cartesian geometry, generates the circle.[82] In a highly confusing, irrational universe, where the self seems to be at best out of control and at worst nonexistent, Pound is advocating opening oneself to, and by means of an aesthetic of impersonality holding on to, those rare instants at which the rift between decentered self and disordered outer world is or seems to be transcended.

But there is a third direction in which the modernist explorer can go, and it is important for my argument because it is the way in which Dada and much postmodernist art and literature would go. It consists in transcending the binarism of Rimbaud's statement quoted above, and once again Mach provides a theoretical lead. If, he argued, we let go of the ego, accept that the boundaries between ego and world are porous, and forget about individual immortality, then we can arrive at "einer freieren und *verklärten* Lebensauffassung . . . welche Missachtung des fremden Ich und

Ueberschätzung des eignen ausschliesst" [a freer and *transfigured* conception of life . . . which will preclude contempt for others' egos and the overvaluation of one's own].[83] Lawrence was struggling to overcome the same binarism when, in the letter to Garnett cited above, he said in respect of *The Rainbow* (which he had finished in mid-May):

> There is another ego, according to whose action the individual is unrecognisable, and passes through, as it were, allotropic states which it needs a deeper sense than any we've been used to exercise, to discover are states of the same single radically-unchanged element.[84]

Judging by his later works, Lawrence did not succeed in this project, not least because he never overcame his need for closure and finality. But recent readings of Joyce and Woolf suggest that they had more success. Tratner, for example, argues that *Ulysses* involves no "unified or autonomous characters"; that Stephen and Bloom are "merely a nexus through which social tides flow"; and that in *The Waves* "human structures become mere snail shells as everything becomes liquid nature or sea."[85] In saying this, Tratner is suggesting that this situation need not be viewed negatively and that Joyce and Woolf are imagining a new, open-ended, fluid kind of subjectivity that neither privileges the rational ego nor succumbs to primal violence, and that somehow manages to combine consciousness with all the other aspects of human nature. Nietzsche was exploring this idea when, in *Jenseits von Gut und Böse* (1885) (*Beyond Good and Evil*, 1907), he rejected the idea of the soul "als etwas Unvertilgbares, Ewiges, Unteilbares, als eine Monade, als ein *Atomon*" [as being something indestructible, eternal, indivisible, as a monad, an *atomon*] and stated:

> Aber der Weg zu neuen Fassungen und Verfeinerungen der Seelen-Hypothese steht offen: und Begriffe wie "sterbliche Seele" und "Seele als Subjekts-Vielheit" und "Seele als Gesellschaftsbau der Triebe und Affekte" wollen fürderhin in der Wissenschaft Bürgerrecht haben.

> *But the road to new forms and refinements of the soul-hypothesis stands open: and such conceptions as "mortal soul" and "soul as multiplicity of the subject" and "soul as social structure of the drives and emotions" want henceforth to possess civic rights in science.*[86]

The early Heidegger, whose philosophical debt to Nietzsche is well known, would explore the same state of being exhaustively in *Sein und Zeit* (1915–27) (*Being and Time*, 1962). Via the concept of *Dasein* [Being-

there] (which emerged in his work in 1920), he evolved his "Field Theory of Being" that dispensed with centered notions of the subject as "a cognition monad," stressed the bodily nature of human being, and envisaged a subject whose boundary lines were fluid.[87]

Nowadays, modernism is often attacked for masculinism. Boyne and Rattansi, for instance, write of the "reality of male domination in constructing and sustaining modernism," and to the extent that the ego and logos of classical modernity were conventionally gendered as male and that it was a male God for whom Schoenberg wanted to write a symphonic requiem in the years 1912–14, the crisis that modernism is perceived to involve is indeed the crisis of institutionalized male identity.[88] In "Mon coeur mis à nu," Baudelaire had gone so far as to say that the "Eternal Venus" was a manifestation of the Devil. Correspondingly, the plethora of demonic or sphinxlike females in modernist literature and art;[89] the threateningly phallic or devouring females to be found in the work of Klimt, Schiele, Picasso, Kirchner, and Dix; the approving re-evaluation of Bluebeard and the popularity of the misogynist horror fiction of Hanns Heinz Ewers during the first two decades of this century;[90] the positive reception of Otto Weininger's crazily misogynist *Geschlecht und Charakter* (1903) (*Sex and Character*, 1906) by people who should have known better; and the revival of interest in the philosophy of the only slightly less misogynist Schopenhauer at around the same time were all, as Alfred Adler realized, reflexes of a phallogocentric culture's anxiety that it was under threat by what it had diabolized.[91]

So given that there is an often overlooked current within modernism that seeks to overcome the binarism of the "JE" (normally gendered as male) and the "autre" (frequently gendered as [menacingly] female), it is worth concluding this section by acknowledging a range of modernist texts that, while attempting to resolve the perceived crisis, began to explore the "bewildering set of questions" about gender that have become so urgent over the last two decades and to evolve an understanding of human subjectivity that deconstructs gender(ed) boundaries.[92] The beginnings of a theoretical move in this direction are evident in Freud's discussions of bisexuality in *Drei Abhandlungen zur Sexualtheorie* (1901–5) (5:40–47) (*Three Contributions to the Sexual Theory*, 1910 [7:141–48]); *Das Ich und das Es* (1922–23) (13:260–63) (*The Ego and the Id*, 1927 [19:31–34]); and *Neue Folge der Vorlesungen zur Einführung in die Psychoanalyse* (1932) (15:120–24) (*New Introductory Lectures on Psycho-Analysis*, 1933 [22:113–17]). They are also visible in Adler's concepts of psychic hermaphrodit-

ism and bisexuality, and in Jung's claim, in *Psychologische Typen* (1913–c. 1918) (*Psychological Types*, 1923), that the human personality involved a male principle or animus (mainly associated with the consciousness) and a female principle or anima (mainly associated with the unconscious).[93] It can, of course, be argued that Freud's conception is conventionally hetero-sexual—that is, that "there are male and female libidinal dispositions in every psyche which are directed heterosexually toward opposite sexes"[94]—and that all three men are reinscribing the conventional gendering of certain psychological qualities, while putting those deemed "female" under a positive rather than a negative sign. But the fact remains that Adler's and Jung's advice to men and phallogocentric culture in general to listen to their conventionally "female" sides would have saved the central figures of more than a few major modernist works a great deal of trouble. Indeed, once one disassociates oneself from the perspective of its main protago-nist—which very few male critics seem willing to do—Kafka's *Das Schloß* can be read as a critique of the Faustian mentality in a way that dovetails precisely with Marshall Berman's analysis of modernity and with feminist critiques of the nightmare which that mentality produces.[95] From a similar perspective, *Berlin Alexanderplatz* becomes a critique of hypermasculinity; *Der Mann ohne Eigenschaften* tells the story of an overly cerebral man who, through developing the affective side of his personality through his rela-tionship with his sister, becomes a more integrated personality; *Die Blen-dung* concerns the disastrous consequences of hyperintellectuality, male violence and the Adlerian Will to Power; and Jahnn's *Perrudja* is a frontal assault on masculinism.[96]

But several modernist works investigate the problem of gender and sexu-ality in a less binary and more radical way than the psychoanalysts. Gianino in Hofmannsthal's *Der Tod des Tizian* (*The Death of Titian*) (1892); Beards-ley's nudes; Kubin's "human being" in *Der Mensch;* Musil's Törless; the child Fränzi in Erich Heckel's paintings; Thomas Mann's Hermes-like Trickster figure Felix Krull; Virginia Woolf's Orlando; Hesse's Hermine in *Der Steppenwolf,* who is said to be like Harry Haller's brother; Jahnn's Per-rudja; Alberto Giacometti's *Boule Suspendue* (*Suspended Ball*) (1930–31); and Brecht's Mother Courage are all, in various ways, androgynous.[97] In "Mach Einen herrlich, Herr, mach Einen gross . . ." ["Make a man splen-did, Lord, make a man great/big with child . . ."] (1903), a poem from the third part of *Das Stunden-Buch* (*The Book of Hours*), Rilke imagines what it would be like for a man to conceive and carry a child. According to Tratner, Eliot's *Preludes* (1909) explore whether he was male, female, or a

neuter object. At the very end of *Women in Love,* Rupert Birkin tells Ursula that to make his life complete, he needs "eternal union with a man" as well as with her. In the "Circe" chapter of *Ulysses,* Bloom confronts his androgyny. Duchamp's "Urinal" is a male pissoir but simultaneously looks like a vagina *and* a castrated male torso; his Mona Lisa in *L. H. O. O. Q.* (1919–30) wears a moustache; and he himself cross-dressed and had himself photographed as "Rrose Sélavy"—a gesture that can be construed in many ways, one of which is, however, a statement to the effect that gender boundaries are fluid, not fixed.[98] These are just a few random examples, but they do indicate that modernist explorations of subjectivity, gender, and selfhood were at times more daring than much secondary literature on modernism and postmodernism would have us believe.

The Changing Understanding of the Relationship between Humanity and Reality

Given the above situation, the modernist understanding of the relationship between human beings and reality is radically different from that of mainstream nineteenth-century thinkers and writers.[99] By and large, thinkers and writers working according to the principles of classical modernity posited, or at least sought to posit, some kind of symbiosis or correspondence between the structure of the material world, the structure of the human logos, and, if they were believers, between those two dimensions and the divine Logos.[100] Correspondingly, while classical aesthetics posited some kind of consonance or correspondence between the world of phenomena and a transcendent realm of beauty and truth, some kind of isomorphism between the assumed unity of the work of art, the unity of the human subject, and the "Sinn-Totalität eines von Gott geschaffenen Kosmos" [the meaningful totality of a divinely created cosmos], the modernist work of art is afflicted by a greater or lesser sense of dislocation of the material, the human, and the metaphysical.[101] This latter sense was already present in Baudelaire's essay on Constantin Guys when he wrote of the permanently unstable and fleeting relationship between the *moi* [me] and the *non-moi* [not-me] and was graphically prefigured by two of his poems that straddle that essay.[102] In "Correspondances" ("Correlatives"/"Correspondences") (c. 1845–after 1851), humanity is at home in the temple of Nature, surrounded by forests of (friendly) symbols that speak to both mind and senses. But in "Le Coucher du soleil romantique" ("The Setting of the Romantic Sun") (1862), that sense of harmony has become a

memory. God is withdrawing; irresistible night is coming on; and the poet finds himself on the edge of a grimpen, haunted by the smell of the grave. Such a sense of dispossession, of not being at home, is central to the modernist experience. It generates the desolate imagery of Eliot's *The Waste Land* and the cry at the end of Rilke's Second *Duineser Elegie:* "Fänden auch wir ein reines, verhaltenes, schmales / Menschliches, einen unseren Streifen Fruchtlands / zwischen Strom und Gestein" [If only we too could find an unsullied, half-hidden, narrow / strip of humanness, a plot of fertile land which was our own / between the torrent and the rocky place].

But, paradoxically, the classical or logocentric model of reality described above, which Heidegger spent the last period of his life trying to reconstruct and for which he would be attacked by Derrida, also involved a sharp distinction between instrumental reason (when that was abstracted from the totality of the logos) and the material world.[103] Thus, once the experience of modernity shattered the grand symbioses involved in the logocentric model, the relationship between instrumental reason and the material world had to change as well. As Mach put it:

> So bald wir erkannt haben, dass die vermeintlichen Einheiten "Körper," "Ich" nur Notbehelfe zur *vorläufigen* Orientirung [sic] und für bestimmte praktische Zwecke sind . . . , müssen wir sie bei vielen weitergehenden wissenschaftlichen Untersuchungen als unzureichend und zutreffend aufgehen. *Der Gegensatz zwischen Ich und Welt, Empfindung oder Erscheinung und Ding fällt dann weg.* . . .
>
> *As soon as we have perceived that the supposed unities "body," "ego" are only makeshifts designed for provisional orientation and for definite practical ends . . . , we find ourselves compelled, in many more advanced scientific investigations, to abandon them as insufficient and inappropriate.* The antithesis between ego and world, sensation or appearance and thing, then vanishes. . . .[104]

The resultant sense of radical alienation manifested itself particularly clearly in the way in which writers and artists of the modernist generation handled four questions: the status of reason, the status of language, the nature of history, and the status of Western culture.

Over and over again within modernism, one finds attacks on or critiques of the supremacy of human reason on behalf of other faculties of human nature. Eagleton is partially correct when he attributes this hostility toward reason to a society "where 'reason' has more to do with the calculation

of self-interest than with some noble dream of emancipation."[105] But it also derived from the sense that reason was incapable of dealing with a highly problematic reality. The fluctuations of non-Euclidean reality and the complexities of human nature, invisible to the eye of empirical reason guided by conventional common sense, could, it was variously claimed, be approached, visualized, and tentatively grasped only by those faculties in human nature that came from below or beyond the rational ones.[106] And it also derived from a sense that instrumental reason was responsible for turning a humanly habitable *Haus* [home] into that Weberian *Gehäuse* [casing/shell] in which so many modernists felt trapped—from a sense that instrumental reason had turned against itself and constructed a complex of allegedly enlightened but actually dysfunctional institutions.[107] In *Die Theorie des Romans* (*The Theory of the Novel*, 1971), which was drafted shortly after the outbreak of the Great War while its author was closely connected with Weber's circle in Heidelberg, Lukács wrote:

> Die Fremdheit der Natur, der ersten Natur gegenüber, das moderne sentimentalische Naturgefühl ist nur die Projektion des Erlebnisses, dass die selbstgeschaffene Umwelt für den Menschen kein Vaterhaus mehr ist, sondern ein Kerker.
>
> *Estrangement from nature (the first nature), the modern sentimental atti-tude to nature, is only a projection of man's experience of his self-made en-vironment as a prison instead of a paternal home.*[108]

The same feeling explains why, throughout modernist literature, one finds so many dysfunctional institutions: schools that corrupt or brutalize, hospitals that facilitate dying, psychiatric hospitals that accelerate madness, administrative systems that work against the people they are supposed to serve, machinery that does not function or turns against its maker, meticulously ordered libraries that turn into prisons for madmen, and cities that enslave. Within this context, Apollonian reason is attacked by disciples of Nietzsche in the name of Dionysiac vitality—or, in the case of Georges Bataille, in the name of acephalic man and an aesthetics of excrement. Bergson evolved the notion of an "integrated reason" that embraced intuition and the imagination.[109] Writers on hyperspace philoso-phy, working under the impact of the new geometries, urged people to develop the same faculty of intuition so that they might "perceive" the hidden fourth dimension that had been occluded by positivism and ma-terialism.[110] Klimt's depiction of Philosophy had such a shocking effect be-

cause it implied that rational mastery had been supplanted by a sense of enigma and impotence in the face of Nature.[111] The Futurists assailed reason in the name of energy, the Dadaists (for whom, Ball relates, Bergson was particularly important during the initial period in Zurich) in the name of spontaneity, intuition, and the imagination, and the Surrealists in the name of dream and the unconscious.[112]

One might well expect such critiques from artists, but it comes as something of a surprise to find mathematicians (like Poincaré) insisting on the centrality of intuition and physicists (like Heisenberg and Planck) spelling out the limitations of reason. The scientist working during the nineteenth century within the Cartesian-Newtonian and Euclidean paradigms had assumed a structural homology between "the 'syntactic' order of semiotic systems (particularly language)," "the logical ordering of 'reason,'" and "the structural organization of a world given as exterior to both these orders" such that the laws of the latter could be—and soon would be —translated exhaustively into abstract formulations by means of the former.[113] But during the latter years of the nineteenth century, the impact of the new geometries began to shake the foundations of mathematics and science so that a sense of the relativity of knowledge began to supersede the belief that it was possible to arrive at truth in some absolute sense.[114] Increasingly after the turn of the century, scientists working in the field of subatomic physics found themselves forced to dispense with the Cartesian-Newtonian paradigm and, following Mach, to accept that reason described not Nature in itself but only Nature that is exposed to our method of questioning. From which it followed that the apparently rational picture that the scientist constructed of Nature involved an element of anthropomorphic subjectivity that could never be removed in any final sense— especially when the scientist was working at the subatomic level where the very act of observing had an effect on what was observed.[115] As Welsch put it, modern scientific thinking is characterized by a multiplicity of models, competing paradigms, and, because of the limitations of reason, the impossibility of unitary and final solutions.[116] All of which means that the doubts about reason that are so characteristic of modernism take many forms: by no means are all of them crazy and only some of them lead to Fascism.

Similarly, language for the modernist proves to be equally limited. When Nietzsche noted: "Ich fürchte, wir werden Gott nicht los, weil wir noch an die Grammatik glauben . . ." [I fear we are not getting rid of God because we still believe in grammar . . .], he was saying epigrammatically

what Ferdinand de Saussure would argue scientifically in his posthumously published *Cours de Linguistique générale* (1907–11) (*Course in General Linguistics*, 1960).[117] Although language feels as though it has some absolute and divinely legitimized status to those who live "inside" it, it is actually a relative and continuously evolving system of arbitrary signs. As such, it has no a priori connection with reality: there is no one-to-one correspondence between immutable material objects and a noun-based syntax that names and orders those objects. For modernist *Sprachkritiker* (critics of language) like Nietzsche, Mach, Fritz Mauthner, Bergson, Ernest Fenollosa, and the Dadaists, no substance exists to substantiate substantives (that is, to cement together the world of language and the world of material objects). Indeed, although at one level Wittgenstein's *Tractatus Logico-Philosophicus* (1914–18) (translated 1922) sets out and refines upon the assumptions of nineteenth-century positivism and its relation to reality, at another (see chapter 5) it deconstructs and offers an alternative set of assumptions that is entirely compatible with Saussure's division of the linguistic sign into the (arbitrary) signifier and the (conventionally agreed) signified. In this context, it is interesting to note the close homology between Saussure's thinking about linguistic exchange and Simmel's thinking about value exchange in *Die Philosophie des Geldes*. In Simmel's view, money, like words, has an exchange value that is entirely dependent on convention. Although it seems to be a stable pole within the *perpetuum mobile* of economic reality, in fact, it merely expresses "die Relativität der Dinge, die eben den Wert ausmacht" [the relativity of things that constitute value].[118] Furthermore, in Simmel's analysis, money, like Saussure's signifiers, is actually less important for what it denotes as a "Wertaufbewahrungs und Werttransportmittel" [means of conserving and transporting value] (189/198) and more important for the "Vorstellungen" [ideas] — Saussure's "signifieds" — that are incorporated in it (190/198). In the megalopolitan world of modernity then, the exchange of increasingly desubstantiated money, like the exchange of words, constitutes a system that meshes with social and material reality but does not correspond with it and is actually becoming increasingly abstracted from it.

During the modernist period, science, dealing with even more elusive matters, ran parallel with philosophy and linguistics on the question of language. When Heisenberg and Bohr first met, in the early summer of 1920, Bohr replied as follows to a question of Heisenberg's about the nature of the language he was using to describe atomic and subatomic relationships: "We must be clear that, when it comes to atoms, language can be used

only as in poetry. The poet, too, is not nearly so concerned with describing facts as with creating images and establishing mental connections." And a subsequent chapter in the same book, "Discussions about Language (1933)" (123–40) (which, interestingly enough, took place outside the "zone of middle dimensions" in the more rarified air of the Bavarian Alps), makes it clear that the inexactitude of language, even mathematical language, was one of the central problems for the most advanced scientists of the time. Here Bohr is quoted as saying: "One could, of course, say that the mathematical formulae with which we theoretical physicists describe nature ought to have this degree of logical purity and strictness. But then the whole problem reappears in different guise just as soon as we try to apply these formulae to nature" (135). And in *Physics and Philosophy,* Heisenberg reiterated the problem by saying that the language in which we talk about atomic events is "not a precise language," but "a language that produces pictures in our mind" which "have only a vague connection with reality . . . , represent only a tendency towards reality."[119] So, in order to get at the "strange kind of reality" that lay behind the world of immediate sense data, Heisenberg formulated his principle of complementarity, according to which the scientist needs to play with logically incompatible, but complementary, pictures (50).

Similar, but in several cases far more devastating, doubts about the adequacy of language occur by accident or design throughout modernist literature. Language fails Conrad's Kurtz, "the great 'voice' who once mastered language, who once wrote eloquent humanitarian texts." Benn's Dr. Rönne becomes increasingly unable to speak and function as a doctor and dreams of inventing a new language. Just before the outbreak of the Great War and his commencement of work on *Der Proceß,* Kafka wrote to his sister: "Ich schreibe jetzt anders als ich rede, ich rede anders als ich denke, ich denke anders als ich denken soll und so geht es weiter bis ins tiefste Dunkel" [I now write differently from how I speak, I speak differently from how I think, I think differently from how I ought to think and thus it goes on further right into the deepest darkness].[120] Furthermore, the impossibility of putting a precise number on the elemental Malabar Caves in *A Passage to India;* the silences of Rimbaud, Valéry, Rilke, and Hofmannsthal's Lord Chandos (see chapter 4); the failure of Mallarmé's *grand oeuvre;* the abstract and nonsense poetry of the Russian Futurists (*Zaum'*), the Dadaists, and the Surrealists; the telegrammatic style of the Italian Futurists and several of the major Expressionist poets and dramatists; the use of nonverbal, sound, and ideogrammatic elements to help out a medium (i.e.,

language) that was felt to be in a bad way; and the ironic attitude toward language and overweening linguistic confidence that is so central to the work of Mann, Joyce, Svevo, and Beckett are all aspects of the modernist awareness of the arbitrariness, inexactitude, and unreliability of language. Although, as we shall see in chapter 5, these problems with language can be experienced as disastrous, the conscious acceptance of the limitations of language can also be highly beneficial. In Kafka's case, for example, that hard-won acceptance enabled him to write the extremely funny, page-long story "Die Sorge des Hausvaters" (1917) ("Worries of a Family-Man," 1945). The "Hausvater"—narrator—is worried because a being called Odradek lives in his house. No one knows the etymology of its name; all attempts to characterize it involve impossible contradictions; it appears to be an object and yet it speaks and has organic attributes; it may or may not have a function; it is like an assemblage and yet is complete in itself; it is simultaneously tiny and life-sized; it may or may not be immortal; and it cannot be accurately described because it is exceptionally mobile and resists being caught. We might be looking at one of Heisenberg's electrons, but whatever we *are* looking at, we are doing so through the eyes of the dismayed patriarch at whose consternation Kafka is gently laughing.

A third fundamental difference between modernists and their nineteenth-century predecessors involves their conceptions of time and history. For the thinker working in the mainstream post-Enlightenment tradition, whether an Idealist like Hegel (the first thinker to grasp modernity's need for self-justification), a Dialectical Materialist like Marx, Evolutionists like Herbert Spencer or Sir James Frazer, or a Christian theologian like Adolf von Harnack, time was a progressive process moving upward in a dialectical or linear manner as humanity brought more space under rational, moral, economic, or cultural control. The experience of modernity from Baudelaire onward increasingly subverted this project so that, as Kern has shown, the more the West attempted to dominate space and standardize time, the more people working across a spectrum of media and disciplines reacted against this project by focusing on the local variations of cultural time, the relativities of scientific time, the fluctuating vagaries of private time, and the nonlinear nature of experience in the quintessentially modern environment of the dystopian city. Einstein's special theory of relativity (1905) envisaged time as manifold and multiplex. Subatomic physics so undermined the Kantian notion of time as a universally valid, a priori category of the transcendental consciousness that Heisenberg envisaged subatomic processes in which certain events seem to take place "en sens in-

verse de l'ordre causal" [in a way which runs counter to causal order].[121] In "Das Unbewußte," Freud wrote that the processes of the unconscious are timeless in the sense that they are not ordered temporally or altered by the passage of time, and have no relation at all with time as that is normally understood (10:286/14:187). And in a range of modernist works, time ceases to be a regular and commonsense process in which a precise but fixed gap, the present, separates the past from the future. Instead, time becomes elastic, "successive waves of compression and implosion," surges of varying duration and power (as in *Die Aufzeichnungen des Malte Laurids Brigge, Der Zauberberg, A la Recherche du temps perdu, Ulysses,* or Schoenberg's *Erwartung*), with the present moment expanding and contracting according to the situation of the observer.[122] Or time becomes incipiently apocalyptic (as in so many early Expressionist poems), or it turns into a kind of simultaneity in which past, present, and future merge into one. Increasingly, the experience of modernity shattered the notion that time and space are independent of one another, with time flowing regularly through static and empty space, and generated the sense that they are interdependent and locked in some kind of endless competition with one another with space dominating in some media (abstract art and architecture) and time in others (film).[123]

By extension, history ceased to be the secure and reliable progress upward so memorably described in the first chapter of Stefan Zweig's *The World of Yesterday* (1943). Nietzsche probably formulated the most radical vision of the sense of history that was superseding progressivist notions when, in a paragraph of startling affective force that was never published in his lifetime, he described "diese meine *dionysische* Welt" [this my *dionysiac* world] as a seething monster of multidirectional, self-contradictory, self-creating, and self-destroying energy.[124] According to this vision, history is a mass of irregular bursts of energies—Foucault's *plis* [folds]—in no single direction so that "historical memory is replaced by the heroic affinity of the present with the extremes of history," and Bergson's vision of time as *durée* involves a similar historical sense.[125] Some modernists welcomed this paradigm shift. Before he went to Berlin in 1912 and began to revert to a classicism as a result of his experience of that ultramodern city, T. E. Hulme had been an enthusiastic Bergsonian, not least because he felt that Bergson's sense of time as an elastic *fluidum* had liberated him from a linear, mechanical, and deterministic view of the universe. In *Apocalypse* (1929), D. H. Lawrence said that he welcomed the overturning of nineteenth-century conceptions of history, describing "our idea of time as

a continuity in an eternal, straight line" as something which "has crippled our consciousness cruelly."[126] And as we shall see in chapter 7, most of the Dadaists affirmed Nietzsche's Dionysiac vision of history for similar reasons. But more often than not, when confronted with a modernity that seemed to have gone critically wrong, modernists, especially in Germany, echoed the cry of Nietzsche's madman in *Die fröhliche Wissenschaft* (1882) (*The Joyful Wisdom*, 1910):

> Wer gab uns den Schwamm, um den ganzen Horizont wegzuwischen? Was taten wir, als wir diese Erde von ihrer Sonne [i.e. the fixed point of reference] losketteten? Wohin bewegt sie sich nun? Wohin bewegen wir uns? Fort von allen Sonnen? Stürzen wir nicht fortwährend? Und rückwärts, seitwärts, vorwärts, nach allen Seiten? Gibt es noch ein Oben und ein Unten? Irren wir nicht wie durch ein unendliches Nichts?

> *Who gave us the sponge in order to wipe away the whole horizon? What were we doing when we unchained this earth from its sun? Whither is it moving now? Whither are we moving? Away from all suns? Are we not plunging continually headlong? And backward, sideways, forward, in all directions? Is there still any up or down? Are we not straying as though through an endless nothingness?*[127]

For a generation reared on the idea of history as progress, the experience of modernity as crisis could easily generate an acute sense of *Kulturpessimismus*, especially at the thought that the desacralization of the world had been for nothing. For all its humor, Hans Arp's best-known poem "kaspar ist tot" (c. 1912–17; revised c. 1953) ("kaspar is dead," 1948) links the death of the mythological kaspar with the cerebralization of the human personality, the demythologization of the world, and imminent apocalypse (see chapter 11). Yeats's "The Second Coming" (1916), with its oft-quoted lines "Things fall apart; the centre cannot hold; / Mere anarchy is loosed upon the world," envisages the end of the Christian era and the birth of the apocalyptic beast. Eliot famously referred in 1923 to "the immense panorama of futility and anarchy which is contemporary history" and spent the rest of his poetic life trying to recapture a vision of a resacralized world in which the Christian sense of history as salvation history had some meaning. And in his equally famous letter to Witold Hulewicz of 13 November 1925, Rilke lamented the loss of a "laric" (i.e., sacralized) world where objects were more than commodities; said that his generation was possibly the last to have known such things; and defined the poet's task as

the recuperation of the invisible.[128] More systematically, Oswald Spengler's *Der Untergang des Abendlandes* (c. 1914–17) (*The Decline of the West*, 1926); Hugo Ball's *Zur Kritik der deutschen Intelligenz* (c. 1917–19) (*Critique of the German Intelligentsia*, 1993); Hans Henny Jahnn's account of Western history in his lecture "Aufgabe des Dichters in dieser Zeit" ("The Poet's Task at This Time") (1935); and Heidegger's account of the history of Western thought in *Einführung in die Metaphysik* as the progressive forgetfulness of Being inverted the notion of history as progress and diagnosed the modern age as fallen and in dire need of redemption.[129] But such a diagnosis was not the prerogative of people who were, in one way or another, attracted to conservative philosophies or the radical Right. For in "Über den Begriff der Geschichte" (1940) ("Theses on the Philosophy of History," 1968), Walter Benjamin specifically attacked the idea of progress and, six months before he took his own life for fear of being handed over to the Gestapo, described history as one single cataclysm that continually piles up wreckage with the Angel of History looking helplessly on. Such an estimation of history inevitably seems overbleak to those who win all the prizes in the consumer carnival that is postmodernity. But to the losers or to those who are excluded altogether, for whom Benjamin was writing, this view may well still speak with greater force.[130]

Finally, from such elastic, decentered, nonlinear, or apocalyptic views of time and history, it was, as thinkers like Benjamin saw, only a short step to a profound doubt in the assured supremacy of Western civilization that had sustained so much nineteenth-century thinking and political action.[131] Max Weber had a strong sense of the validity of Eastern religions in their own right and studied them as a means of getting away from Eurocentric attitudes, and as we saw in chapter 1, Lévy-Bruhl's attitude toward native cultures was deeply ambivalent.[132] Similarly, in *Abstraktion und Einfühlung* (1906) (*Abstraction and Empathy*, 1953), Wilhelm Worringer distinguished between "empathetic" and "abstract" art, arguing that the former was produced in cultures marked by a sense of being at home in the world, while the latter characterized cultures suffering from a sense of being at the mercy of hostile, elemental, or mythological powers. From this Worringer concluded that one should not evaluate "abstract" art (like that of the Middle Ages, the Orient, and so-called "primitive" cultures) in terms of "empathetic" categories derived from Western, post-Renaissance humanism, and that one should certainly not regard nonrealistic, "abstract" art as inferior to representational, "empathetic" art. The implications of Worringer's highly influential thesis are clear. Aboriginal and premodern cul-

tures, though technologically less advanced than the modern West, may in fact be better equipped to deal with the totality of a universe in which humanity is not at home, of which it is not the centerpiece, and in the face of which it inevitably experiences a profound sense of angst.

Rimbaud's cry in *Une Saison en enfer* (c. 1873) (*A Season in Hell*, 1932), "Je retournais à l'Orient et à la sagesse première et éternelle" [I returned to the Orient and to the primal and timeless wisdom] and declared intention of seeking inspiration in "low," premodern and "primitive" sources; Gauguin's journey to Tahiti; Kandinsky's attraction to North Africa and celebration of the art and life of the Russian peasantry (see chapter 6); the similar concern of the Russian Futurist Velimir Khlebnikov and the circle around Sergey Diaghilev;[133] Karl Kraus's essay attacking Eurocentrism, "Die chinesische Mauer" ("The Great Wall of China") (1909); Pechstein's and Nolde's journeys to Palau and New Guinea; Kirchner's paintings of life on the Baltic island of Fehmarn;[134] Delacroix's love of the life of the desert Arabs; the attraction, for so many modernist intellectuals, of pseudotribal communities like that at Worpswede near Bremen or that on the Monte Veritá near Ascona in the years before and after the Great War; Bartók's fascination with the peasant culture of Hungary and Romania during the first decade of the century when he recorded and transcribed approximately ten thousand folk songs; the Expressionist attraction to non-Western and "primitive" art that is encapsulated in the *Almanach der blaue Reiter* (1912) (*The Blue Reiter Almanac*, 1974), Carl Einstein's *Negerplastik* (*African Sculpture*) (1915), and so many paintings, woodcuts, and sculptures by members of the *Brücke* (*Bridge*) group; the neoprimitivism of the Vorticists Henri Gaudier-Brzeska and P. Wyndham Lewis; Eliot's ambiguous interest in anthropology;[135] the Dadaists' experimentation with primitivizing poetry and rituals (see chapter 8); Hesse's and Döblin's fascination with the Orient; Federico García Lorca's celebration of Spanish gypsy culture in *Romancero Gitano* (c. 1923–24) (*Gypsy Ballads*, 1938–53); Buber's attraction to the Chassidic communities of Eastern Europe; and the non-European settings of such novels as Gide's *L'Immoraliste* (1899–1901) (*The Immoralist*, 1930), D. H. Lawrence's *Kangaroo* (1922) and *The Plumed Serpent*; and Forster's *A Passage to India* are all connected. In every case it is felt that premodern and non-Western cultures have not abstracted the logos from the rest of the personality and know how to coexist with rather than dominate external Nature. As such, they are felt to enjoy a freedom and balance that the modernizing West has allegedly lost or is losing because of the dialectical turn that the central project of the

Enlightenment is deemed to have taken. Nowadays, we are aware that this concern with the "primitive" was far from innocent; that the motivation of many modernists who were fascinated by the exotic was voyeuristic; that much modernist "primitivism" was guilty of complicity with colonialism; that the identification of the art of children, pre-Western, and non-Western cultures involved terrible simplifications; that modernist "primitivism" tacitly accepted post-Enlightenment notions of the "primitive" and simply put them under a positive rather than a negative sign; and that, to a considerable extent, the modernist vision of the so-called primitive was an idealized and compensatory reworking of Rousseau's concept of the "noble savage." All that is undeniable, and yet, the postmodern turn against Eurocentrism, colonialism, and racism has some of its roots within the modernist sense that modernity was causing chaos at home and wreaking havoc abroad by destroying ways of life that had sustained themselves reasonably well for centuries. *Pace* Stauth and Turner, Benjamin's alienated intellectual had at least *some* reason to feel melancholy, especially if he had experienced the negative side of modernity of which the Great War was arguably the most harrowing example prior to 1933.[136]

As most modernist writers and artists had grown up with the expectation of an ordered world, it was inevitable that, when subjected to a more or less radical experience of crisis, they should try to understand and resolve it via their work.[137] Some of their more characteristic strategies for dealing with the perceived crisis will be discussed in the next chapter.

3. Modernism as Response

For a variety of reasons, the Great War forms a watershed within modernism. For many writers, artists, and intellectuals it reinforced the sense, already present before the war, that Western civilization had turned against itself and was in a state of terminal decline. For others, until the Great Crash of 1929 and the ineluctable rise of Nazism put an end to their hopes, it generated a desire to salvage something from the ruins. Nevertheless, the sense that modernity was in a state of crisis never entirely vanished after the war, even among those most concerned to reconstruct, and by the early 1930s, especially in German-speaking cultures, it was a commonplace among artists and intellectuals that modernity in the West had reached a crossroads. C. G. Jung's *Seelenprobleme der Gegenwart* (*Spiritual Problems of the Present Day*) (1928–31); Freud's *Das Unbehagen in der Kultur;* Karl Jaspers's *Die geistige Situation der Zeit* (which is heavily indebted to the ideas of Max Weber in praise of whom Jaspers published a little book in 1932); Edmund Husserl's lecture of 7 and 10 May 1935, "Die Krisis des europäischen Menschtums und die Philosophie" ("Philosophy and the Crisis of Modern Man") (1965); and, of course, Heidegger's *Einführung in die Metaphysik* all display a more or less pronounced sense that classical modernity had come adrift from its original moorings and could go in one of two directions.[1] The scientist Max Planck put it thus in a lecture of 12 November 1930:

> Es ist eine seltsame Welt, in der wir leben. Wohin wir blicken, auf allen
> Gebieten der geistigen und der materiellen Kultur, sind wir in eine Zeit

schwerer Krisen hineingeraten. . . . Manche wollen darin den Beginn einer grossartigen Aufwärtsentwicklung sehen, andere wieder deuten sie als die Vorboten des unabwendbaren Verfalls.

We are living in a very singular moment of history. It is a moment of crisis, in the literal sense of that word. In every branch of our spiritual and material civilisation we seem to have arrived at a critical turning point. . . . Many people say that these symptoms mark the beginnings of a great renaissance, but there are others who see in them the tidings of a downfall to which our civilisation is fatally destined.[2]

But *pace* Marshall Berman, who claimed that serious thinking about modernity has reified into these two alternatives, the art and literature of modernism had already gone beyond such a straightforwardly binary reaction to modernity. In 1988, Stauth and Turner registered "four primary solutions" within modernism to the perceived crisis of modernity, but it seems to me that one can identify at least nine broadly distinct types of response—even if some shade over into one another.[3]

First and most negatively, there is the ultrapessimistic or nihilistic response. Faced with a situation that Durkheim had, in *Le Suicide* and *De la Division du travail social,* described as one of anomie and that Simmel, in *Die Philosophie des Geldes,* had described as "Mangel an Definitivem im Zentrum der Seele" [lack of something definitive at the center of the soul], more than a few modernist artists arrived at a highly pessimistic conclusion. An apocalyptic end was approaching beyond which there was only the endless, polar night of icy darkness with which Bartók's *A Kékszakállú herceg vára* and Weber's "Politik als Beruf" conclude. The dethronement of the sovereign Cartesian cogito led inevitably to self-destruction. Human relationships were irredeemably locked into the sadomasochistic double binds that mark Oskar Kokoschka's painting *Mörder, Hoffnung der Frauen* (*Murderer, Hope of Women*) (1909); Kafka's and Franz Jung's prewar prose fiction; and Georg Kaiser's drama *Von morgens bis mitternachts.*[4] On 26 June 1913, the Austrian Expressionist poet Georg Trakl wrote to his patron Ludwig von Ficker:

Ich sehne den Tag herbei, an dem die Seele in diesem unseeligen [sic] von Schwermut verpesteten Körper nicht mehr wird wohnen wollen und können, an dem sie diese Spottgestalt aus Kot und Fäulnis verlassen wird, die ein nur allzugetreues Spiegelbild eines gottlosen, verfluchten Jahrhunderts ist.[5]

I yearn for the day to come on which the soul will no longer want or be able to dwell in this unhappy body which is plagued by melancholia, on which it will want to quit this mockery of a form shaped from shit and putrefaction that is but an all-too-accurate mirror-image of a godless, accursed century.

In late November 1913, Trakl put it even more succinctly: "Es [ist] ein so namenloses Unglück, wenn einem die Welt entzweibricht" (1:530) [It is such a nameless misfortune when one's world breaks asunder]. And it was from just such a feeling, worsened by drugs, depression, and/or physical illness that a significant number of modernists either went insane (Nietzsche, Van Gogh, Jakob van Hoddis, Antonin Artaud); or took their own lives (Virginia Woolf, Jacques Vaché, Jacques Rigaut, René Crevel, Trakl, Ernst Toller, Hans Kalteneker, Vladimir Mayakovsky, Sergey Yesenin); or died prematurely in a state of near total despair (Rimbaud, Alfred Lichtenstein, August Stramm).[6]

Second, several modernists—and this response is particularly typical of the prewar period—sought to relieve their sense of crisis by means of ecstatic experience, sometimes aided by drugs, alcohol, or the excitement of violence. It is no accident that when compiling his anthology *Ekstatische Konfessionen,* Buber consciously concentrated on mystical outpourings that had originated within the discipline of a monastery or a nunnery—out of a sense of constriction that was analogous to the modernist sense of being trapped in a Weberian *Gehäuse.* Similarly, according to Eksteins, Debussy's *L'Après-midi d'un faune* (*The Afternoon of a Fawn*) (1912) and Stravinsky's *Le Sacre du printemps* as staged by Diaghilev celebrated raw, primitive eroticism and erotically charged violence because anything was better than mind-numbing convention, even amoralism and emotional chaos.[7] Following Rimbaud's stated aim in his letters to Izambard and Demeny of May 1871 of arriving at the unknown by deranging all the senses, several early Expressionists, not to mention their alter egos who form the midpoint of their so-called *Ich-Dramen,* would have assented to the view that the poet Georg Heym recorded in his diary on 6 July 1910 and 15 December 1911: that one instant of intoxicated enthusiasm, even though it may lead to death, is preferable to the suffocating banality and oppression of everyday modern life. And Ludwig Rubiner's highly influential manifesto of mid-1912, "Der Dichter greift in die Politik" ("The Poet Intervenes in Politics"), with its call for dynamism, intensity, ecstasy, and the will to catastrophe, was almost certainly one of the immediate stimuli for at least some of the hymns to affective violence that characterize early Expressionism.[8]

One thinks of Albert Ehrenstein's "Der Kriegsgott" ("The God of War") (1911), Alfred Walter Heymel's "Eine Sehnsucht aus der Zeit" ("A Yearning out of Time") (1911), Johannes R. Becher's "Beengung" ("Constriction") (1912), Benn's "Untergrundbahn" ("Underground Train/Railway") (1913), Stadler's "Der Aufbruch" ("The Beginning"/"The Break-Out") (c. 1912) and "Fahrt über die Kölner Rheinbrücke bei Nacht," Ernst Wilhelm Lotz's "Aufbruch der Jugend" ("Youth Bursts Out") (c. 1913–14), and Hans Leybold's "O über allen Wolkenfahnen . . ." ("Oh, Above All the Banners of the Clouds . . .") (1914).[9] In these and similar works, little or no attempt is made to analyze or understand. Rather, the poetic *Ich* seeks to overcome its sense of isolation and constriction by tapping the subrational faculties of the psyche—Nietzsche's Dionysos, Bergson's *élan vital*, Freud's unconscious—regardless of where this may lead.[10] But as Conrad and Thomas Mann had seen more dispassionately via the figures of Kurtz and von Aschenbach, and as Freud would argue in *Jenseits des Lustprinzips,* if one opened up the unconscious, one was as likely to release the destructive power of the death instinct (Thanatos) as the creative, liberating power of the life instinct (Eros). Where Yeats's airman in "An Irish Airman Foresees His Death" (1918) was, after four years of pointless war, aware of the possible price of visionary exultation, the early Expressionists were considerably more naive about the implications of their quest for ecstatic release.

In late autumn 1914, the Expressionist Franz Marc (many of whose most famous prewar paintings celebrate animal vitality) wrote an essay entitled "Im Fegefeuer des Krieges" ("In the Purgatorial Fires of War") that would not be published until April 1916, after his death before Verdun. Here, Marc expressed a certain admiration for the mystical violence of the war and tried to explain it as a purgatorial experience out of which a new, redeemed Europe would arise. But in hoping that the war would solve the problems of modernity, Marc was being more than a little sanguine. The desire for affective release that had fired the war hysteria among so many Expressionists in August 1914 rapidly turned into total disillusion with all forms of violent irrationalism (Rubiner, Lotz, Wilhelm Klemm, Rudolf Leonhard, Kokoschka, and Hugo Ball). It brought others to a state of virtual breakdown (Ehrenstein, Walter Hasenclever, Benn, Ernst Toller, and Franz Jung), and at least one to drug addiction and near suicide (Becher).[11] The Expressionist generation not only learned the inherent dangers of ecstatic mindlessness at first hand, those who survived and lived through the failed German revolution also discovered that war and revolution could not resolve the crisis of modernity by recreating a society in which the

values of classical modernity could come to new life again. Similarly, Georges Bataille's utopian visions of ecstatic, excremental excess on a cosmic scale, like Rubiner's celebration of chaos and catastrophe, owed a great deal to Nietzsche. Indeed, just as Rubiner called upon the outcasts of society to revolt against the reality principle and create havoc, so Bataille celebrated the superfluous waste and the heterogeneous as the prime means of breaking open an alienated, constricting life-world—but, in Habermas's view, to just as little real purpose.[12]

Third, a significant number of modernist writers and artists turned to a wide range of mystical or quasi-mystical sources in an attempt to transcend their sense of entrapment described above. Writing at the time, Simmel said in *Der Konflikt der modernen Kultur* that this phenomenon had been particularly noticeable for two decades, and Klaus Vondung has recently characterized the Expressionist epoch as a time of the renaissance of mysticism.[13] Thus, Kandinsky was influenced by Russian Orthodox spirituality, Theosophy, and Anthroposophy during the decade when he was moving toward abstraction and making the notes that formed the basis of the platonic *Über das Geistige in der Kunst*. Georg Lukács, who corresponded with Buber from 1911 to 1921, was attracted to Chassidic, Christian, and Hindu mysticism around 1912 as a means of dealing with his sense of despair at being trapped in the impure and inauthentic *Gehäuse* of bourgeois modernity. Wittgenstein's war experience, much to Bertrand Russell's dismay, turned him toward mysticism, especially the writings of Kierkegaard and Angelus Silesius (1624–77). Paul Klee's and Hans Arp's work was informed by various kinds of panentheistic mysticism as well as by Kandinsky's aesthetic theory. The work of the Russian Futurists, Piet Mondrian, and František Kupka was profoundly indebted to Theosophy and that of Johannes Itten to Dr. Otoman Zar-Adusht Hanish's doctrine of "Mazdaznan," especially during his Bauhaus years. Pound, Yeats, and Eliot were all, in varying ways and to varying degrees, affected by esoteric hermeticism and occultism. Alfred Döblin began reading Chinese philosophy in about 1913 and incorporated Taoist ideas into his pacifist novel *Die drei Sprünge des Wang-Lun* (*Wang-Lun's Three Leaps*) (1915). The Bakhtin circle in Leningrad in the 1920s was very interested in Eastern philosophy and religion and the quasi-mystical philosophy of Bergson. Kafka was acquainted with the Cabbala, Taoism, and the theology of Kierkegaard. Albert Freiherr von Thimus's *Die harmonikale Symbolik des Altertums* (*The Harmonic Symbolism of Antiquity*) (1868–76) with its doctrine of a harmonically ordered cosmos almost certainly fed into Hans Henny Jahnn's *Perrudja*. And Robert

Musil made extensive use of Buber's *Ekstatische Konfessionen* when trying to put Ulrich's epiphanic experiences of "der andere Zustand" [the other condition of being] into words in *Der Mann ohne Eigenschaften*.[14]

Consequently, a large number of modernist works are either overtly mystical, or have a covertly mystical dimension, or end on a (quasi-)mystical note. For instance, Rimbaud's poem "O saisons, ô châteaux!" (1873) ("O seasons, O châteaux!", 1930) very clearly transcribes a moment of ecstatic, mystical illumination (even though Rimbaud cannot sustain this state during the remainder of the collection).[15] The theatrical theory of Peter Behrens, Georg Fuchs, Max Reinhardt, and Lothar Schreyer envisaged the theater as a place where the desacralized world would be resacralized and the alienation of the audience overcome in a quasi-mystical experience of *Gemeinschaft* [community].[16] The Austrian Expressionist Paul Adler wrote with a similar, recuperative aim in mind. A more or less westernized Eastern mysticism is evident in the blue-eyed people who preside over and survive the final apocalypse of Kubin's *Die andere Seite* (which Kubin wrote under the direct experience of, among things, Buddhism, to which he would become a convert in spring 1916).[17] It is also evident in the immediate postwar work of the Austrian Expressionist Albert Ehrenstein,[18] in the Sanscrit words that conclude Eliot's *The Waste Land,* and, most prominently, in Hesse's *Siddhartha* (1919–22) (translated 1954) and *Narziss und Goldmund* (1927–29) (*Death and the Lover,* 1932). Finally, Eliot's thoroughly mystical *Four Quartets* (1935–42) end on a reference to Dante's *Paradiso* and Dame Julian of Norwich's *Revelations of Divine Love* (c. 1393).

But more secular forms of mysticism are to be found in the background to Hofmannsthal's Chandos letter and Chandos's openness to inexplicable moments of revelation (see chapter 4); in Lawrence's thinking about the body and sexuality; in the episode with the madeleine near the beginning of Proust's *Du Côté de chez Swann;* in the Cubists' reception of non-Euclidean geometry, which, although less mystical than that of the Russian Futurists, functioned as a means of opening up a "fourth dimension"; in Virginia Woolf's "moments of vision"; and in James Joyce's "epiphanies."[19] They are also present in the Surrealists' alchemically inspired quest for the "marvellous," "profane illumination," and "convulsive beauty" as instanced by Breton's *Nadja* (translated 1960); in the music symbolism that runs throughout the work of the Russian Symbolists and *A Passage to India,* and occurs in the concluding pages of *La Nausée,* Thomas Mann's *Doktor Faustus* (translated 1949), and Kafka's "Die Verwandlung" (1912) ("The Metamorphosis," 1936–37); and also in what has been termed the "indi-

vidualist mysticism" and "the aesthetic of transcendence and epiphany" of such works as *Die Aufzeichnungen des Malte Laurids Brigge, My, Das Schloß, Der Steppenwolf,* and *Berlin Alexanderplatz.*[20] In all these cases, we are dealing with attempts to recuperate, affirm, or hold on to a sense that a firm spiritual substratum exists within, beneath, or beyond decentered anomie or the secularized *Gehäuse* of late capitalist modernity. This substratum might be either psychological or transcendental, but once discovered, it could permit what Jung called "integration" and what the Existentialists called the emergence of a sense of Being out of Nothingness. At the first conference of German sociologists in October 1910, Buber formulated the ambivalent importance of mysticism for the modernist period when, responding somewhat obscurely to a lecture by the theologian Ernst Troeltsch, he affirmed that mysticism was

> auf der einen Seite wohl die absoluteste Verwirklichung der *Religiosität* als jener Eigenart der Selbstwahrnehmung und jener Intensität der Selbststeigerung, die eine "Apperzeption Gottes," die Stiftung eines persönlichen Verhältnisses zu einem als Gott empfundenen Seeleninhalt ermöglicht.[21]

> *on the one hand probably the most absolute realization of religiosity as that special form of self-awareness and [on the other] of that intensely heightened sense of self which makes it possible to "apperceive God" and establish a personal relationship with some element within one's soul that is experienced as God.*

Linda Dalrymple Henderson's work on the reception of non-Euclidean geometry suggests that the interest in mysticism was more transcendental before the Great War and more secularized/psychological after it.[22] But this is a question of emphasis since the latter aspect was clearly there during the early modernist period and the former aspect equally clearly there during its later phase. The need for mystical escape from the *Gehäuse* and anomie of modernity did not simply disappear with the liberalization of the hypertrophied semifeudal régimes that had existed in Germany, Austria-Hungary, and Russia.

Fourth, and closely related to the mystical response, is the aestheticist one. The attempt to constitute the category of Beauty went back to the Renaissance, and the project of establishing the arts as autonomous realms, independent from sacred, courtly, and commercial life, went back to the eighteenth century and reached its theoretical apogee in Kant's third Cri-

tique. But during the latter half of the nineteenth century, the rationalization and secularization of the world, combined with a growing sense that modernity was going critical,, generated an aesthetic according to which art was an autotelic enclave of transcendence in a stultifyingly materialist world. This is the aesthetic principle behind the notion of Art for Art's Sake, Symbolism, the George Circle, Imagism, and a great deal of abstract visual work like that of the late Klimt, Kandinsky after the First World War, and, according to Rosalind Krauss, those abstract visual works involving grids.[23] The same aesthetic informs Mallarmé's essay "Averses ou Critique" ("Rainshowers or Criticism," 1886–95), better known as "Crise de vers" ("Crisis in Poetry," 1897); Rilke's book on Rodin (1903–7) (partially translated 1946); and a significant number of statements that Rilke made in his letters. Perhaps the most extreme of these occurs in his 17 March 1922 letter to Gräfin Margot Sizzo-Noris Crouy, in which he said that to use even the most common word in a poem (like "and" or the definite article) was to deprive it of any utilitarian value and to alter its nature "bis in den Kern" [right into its very core]. Hofmannsthal said something similar in "Der Dichter und diese Zeit." In an age when the representative things lacked spirit, the spiritual things did not stand out in relief, and there were no Eleusinian mysteries with which people could lift themselves above everyday life, it was the artist's task to redeem the world by recapturing that lost sense of mystery. Weber was drawn to this aesthetic as a means of escaping the prison house of modernity, and Theodor Adorno, whose account of the totalitarian culture industry is closely related to Weber's pessimistic analysis, adapted it to arrive at his idea that art is the dialectical antithesis of instrumental rationality whose task is to cast a negative, but redemptive-revolutionary light upon a reified world.[24] After the Second World War, a version of this aesthetic became institutionalized in English-speaking universities as the New Criticism and in German-speaking universities as "text-immanent criticism." As a result, a monolithically aestheticized view of modernism grew up that would obscure the diversity and complexity of the phenomenon and, from the late 1960s onward (see chapter 13), act as a target for those advocating a range of alternative methodologies.

From the aestheticizing response, it is a very short step indeed to the fifth response, the decision to turn one's back on the modern age. After the Great War, Rilke, Yeats, and Ball, for instance, expressed that decision in a "flight out of time"—a withdrawal to a "still point" or the fixed center of a "gyre" that was geographically as remote as possible from the confu-

sions, violence, and materialism of modernity.[25] In February 1914, Rilke had written how much he envied the birds their nests because these were almost a kind of external womb.[26] In September 1919, he said how much he hoped to find a little old house with a garden where he could live a solitary existence that he could share with Nature and a few things in which the past still resonated (2:155). So when, in late June 1921, he discovered the little manor house at Muzot, in a remote Swiss valley that reminded him of those Spanish and Provençal landscapes where he had had visionary experiences before the war (2:238 and 250), he knew that he had come home after two very restless decades. Yeats's Muzot was the tower in Galway from which he could, with increasing pessimism, contemplate the fury, mire, ruins, and garbage of contemporary Ireland. And Ball's retreat was the beautiful village of Montagnola in the hills of the Tessin where he became Hesse's secretary and biographer and the proponent of the certainties of an ultra-ascetic, hieratic Catholicism (see chapter 10).[27]

Eliot and Pound, whose early thinking about poetry owed much to Symbolism, expressed a very similar decision in a somewhat different way. After the Great War, both moved backward in time imaginatively and associated themselves with a premodern consciousness, mythology, and system of beliefs, which, they felt, were free from the instability, uncertainties, mob consciousness, and sense of meaninglessness that allegedly marked modernity.[28] In the body of *The Waste Land*, Eliot presented modernity both as an arid desert covered with broken images and falling cities and as a condition that is in danger of inundation by mobs, crowds, and tides.[29] Consequently, in its final section, he resolved this dilemma by concluding that all he could do was put his own lands in order and withdraw. He rationalized that conclusion in his essay "The Metaphysical Poets" (1921) by means of the extremely influential notion of the "dissociation of sensibility" according to which English culture had undergone a historical fall from grace during the seventeenth century from which it had never recovered. On the basis of that conclusion, Eliot committed himself publicly, in his preface to *For Lancelot Andrewes* (1928), a book dedicated to an English divine who had died in the prelapsarian year of 1626, to classicism in literature, royalism in politics, and Anglo-Catholicism in religion—attitudes that Eliot believed to have been most finely developed in the last part of the sixteenth century, before the historical fall. And it was the quintessential spirit informing those attitudes that Eliot sought to celebrate in *Little Gidding* (1941–42), the last of the *Four Quartets*, which takes as its starting point a religious community near Huntingdon that was founded

by Nicholas Ferrar one year before Andrewes's death but looted and dissolved by the Roundheads in 1646. Eliot had, in other words, found a myth which, as he said in his famous review of *Ulysses,* enabled him to control, order, and give a shape and significance to the immense panorama of futility and anarchy that was, in his view, modernity.[30] In *Hugh Selwyn Mauberly* (1919–20), Pound voiced an even deeper disgust at modernity, not least because of the carnage wrought by the war, describing contemporary Europe as "an old bitch gone in the teeth, / . . . a botched civilization." He then left England and, after a stay in Paris, settled in 1924 in Mussolini's Italy (which he saw as a modern version of the corporate medieval state and hence free from the mechanization, systematization, and "the black death of the capitalist monetary system") in order to write his own, latter-day version of the *Divine Comedy:* the *Cantos.*[31] These were, as Schwartz put it, "designed to challenge the corrupted values of Western Civilization and to inspire reverence for the highest values—the eternal state of mind—which will lay the groundwork for a new and more humane society." On the Continent, Paul Adler's project of resacralizing the world led him, like Pound, to set his face against usury and a return to the Middle Ages.[32] Hofmannsthal and George went down paths which led, for analogous reasons, from aestheticism to various forms of high conservatism. After the Russian Revolution, the Christian philosopher Nicolai Berdyaev, in exile in Berlin, wrote *Novoe Srednevekov'e: Razmyshlenie o Sud'be Rossii i Evropy* (1923) (*The End of Our Time,* 1933). Here he diagnosed modernity as Renaissance humanism in a state of advanced decay and rejected both Fascism and Communism on behalf of a neomedieval, theocratic society. Heidegger's apocalyptic vision of modernity in *Einführung in die Metaphysik* caused him to spend the latter half of his philosophical life searching for permanence in a philosophy of Being that was grounded in the values of pre-Socratic Greek civilization—a quest that caused him to associate himself with the Nazis when they first came to power.[33] And Gottfried Benn's overt commitment to hardness, form, coldness, cerebralism, masculinism, and a new ritualism in the early 1930s can be seen as an even more extreme and uncompromising attempt to recuperate classical values in the teeth of a modernity that he diagnosed as being in a state of extreme crisis—with similar, albeit temporary, political consequences.[34]

Where some modernists turned their backs on the complexities and confusions of the present in the name of an ideal, hieratic past, others, especially during the immediate postwar years, did something similar in the name of an ideal, socialist future. This they did on the basis of the

almost totally erroneous assumption that there is a natural affinity be-
tween artists, radicals, and political revolutionaries. Indeed, the more or
less short-lived left-wing utopianism of, for example, Toller, Becher, Leon-
hard, Kurt Hiller, Rubiner, Lyonel Feininger, Bruno Taut, and the mem-
bers of the *Arbeitsrat für Kunst* (Working Council for Art) in Germany, or
of Kandinsky, Mayakovsky, Aleksandr Blok, El Lissitzky, Vladimir Tatlin,
and Aleksandr Rodshenko in Russia, was the obverse of the right-wing nos-
talgia of Eliot, Pound, Hofmannsthal, and George. Both groups of mod-
ernists were marked by a deep yearning for a total, centered world in which
the new human being under Socialism or redeemed humanity under God
could rediscover a secure identity and transcendent sense of purpose.[35]
It is incorrect to say, as some critics have, that all modernist utopianism
issued in a totalitarian commitment. Nevertheless, Pound's extreme right-
wing illusions led him to become the propagandist for a Fascist state; and
Becher's need for ideological certainty and psychological discipline in the
wake of his drug addiction and breakdown between 1918 and 1923 led him
to become a hard-line Communist, the first Minister of Culture of a Stal-
inist state—the German Democratic Republic—and the composer of its
national anthem.[36] At both ends of the political spectrum then, a flawed
problematic could all too easily generate a frighteningly simple, totalitarian
response.

The sixth response can be broadly described using Worringer's concept
of *moderne Primitivität* [modern primitivism] (1911).[37] Non-European, pre-
modern, or popular cultures are used, with an innocence that is no longer
possible or acceptable, not just as sources of aesthetic inspiration but as
cultural models for emulation in the attempt to find "a marvellous escape
from the torpid and numbing predicament of modern living."[38] Accord-
ingly, at the end of Bely's *Petrburg*, the hero, Nikolai Apollonovich Ableu-
khov, flees from a modernizing Russia that is on the brink of revolution to
seek peace as an archaeologist in premodern North Africa. Many outdoor
nude scenes by *Brücke* artists (like Kirchner's *Spielende nackte Menschen
unter Bäumen* [*Nudes Playing under Trees*] [1910]; Otto Müller's *Drei Akte
im Wald* [*Three Nudes in the Forest*] [1911]; and Max Pechstein's *Tanzende
und Badende am Waldteich* [*Dancers and Bathers at a Forest Pool*] [1912]),
often heavily influenced by ethnographic sources, do not celebrate vio-
lent ecstasy, but envisage the possibility of transcending "the rift between
spirituality and materialism which Nietzsche's philosophy had diagnosed
as the tragic dilemma of modern man"—an optimistic dream that gradu-
ally waned once the *Brücke* artists began to move from premodern Dres-

den to metropolitan Berlin in 1911.[39] In Robert Müller's *Tropen,* the engineer/narrator loses his European inhibitions and takes part in an Indian dance that has exactly the same effect as that described by Lloyd:

> Unser aller bemächtigte sich ein harmonischer Rausch, ein Entzücken der Muskeln. Der Tanz, das animalischte, tiefste und befreiendste Kunstwerk, gelang uns spielend und mit einem grenzenlosen Ergötzen. Indem wir uns den ausdrucksvollen Launen unserer Fibern hingaben, gestalteten wir mit allen Fähigkeiten des Leibes unsere menschliche Seele.[40]

> *A harmonious sense of intoxication, a feeling of muscular delight took possession of us. Effortlessly, and with boundless pleasure, we managed the dance, the most animal, most profound and most liberating form of art. By surrendering ourselves to the expressive whims of our fibers, we shaped our human souls with all our bodily faculties.*

In *A Passage to India,* the intuitive, arational cast of mind of the Hindu philosopher Professor Godbole makes him the character who is best adapted to the mysteries, surprises, ambiguities, and open-ended fluidity that Forster designated by the nontopographical shifter "India." In section 2 of Lorca's *Poeta in Nueva York* (1929–30) (*Poet in New York,* 1940), it is the elemental, mythological, "great and desperate" King of Harlem who offers the inhabitants of New York, especially its black community, their only hope of redemption from the anguished frustration and cancerous blood of a perverted modernity. And according to Scott Lash, Artaud's theatrical theory was particularly inspired by Balinese dance theater because of its ritualistic integration into everyday life and ability to synthesize bodily energy and cosmic power.[41] In these and similar cases, we are seeing writers and artists showing a respect—which nowadays we may consider utopian and misplaced—for non-Western peoples' ability to experience that balanced state of "participation mystique" which the West had allegedly lost and needed to rediscover.

The seventh response, aptly characterized by Pär Bergman as "modernolatry," typifies Italian Futurism and the prewar poetry that Henri-Martin Barzun and Guillaume Apollinaire wrote under its impact; early Vorticism; that group of writers, of whom Ernst Jünger is the best known, which Jeffrey Herf described as "reactionary modernists"; and architectural purists and functionalists of the 1920s and 1930s like Amédée Ozenfant and Le Corbusier.[42] Where the first six responses all, in various ways, in-

volve a withdrawal from or transcendence of the contemporary world, this latter response involved an unreserved commitment to it. The Futurists and the reactionary modernists celebrated the modern world both because of its speed, energy, size, and sheer novelty and because of its ability to destroy what had been inherited from the past. The Vorticists did likewise because of the tension they perceived between the massively static, abstract machine forms of modernity and the violence that was stored up within them. But where the Futurists' hymn to the machine, the city, and material energy led several, but by no means all of the major members of the movement toward "embarrassingly reactionary" attitudes such as the inhuman celebration of mechanized warfare, mastery of the environment by machine brutality, and ultimately Mussolini's Fascism, most of the Vorticists moved away from their early attitudes and toward less abstract and more humane modes of art.[43] Indeed, Jacob Epstein (who belongs stylistically to the Vorticist group even though he refused to exhibit with it in June 1915) went so far as to destroy what is arguably the major example of Vorticist sculpture, his massive *Rock Drill* (1913–15), probably because he felt that it celebrated the machine violence that had issued in the Great War.[44] Similarly, although Wyndham Lewis reverted to harder right-wing attitudes in the 1920s (and published an apologia for Hitler as a "Man of Peace" in 1931), his first novel, *Tarr,* can be read as a satirical repudiation of the early Vorticist program.[45]

Unlike Epstein, but like several major Futurists, Jünger failed to develop more humanitarian attitudes from his war experience. Indeed, as he continually revised his books dealing with the war, his attitudes hardened, presumably in an attempt to structure and give meaning to the four years of chaos he had been through.[46] Thus, in books like *In Stahlgewittern* (1920; 2nd ed., rev., 1924) (*The Storm of Steel,* 1932); *Der Kampf als inneres Erlebnis* (1925); and *Der Arbeiter* (*The Worker*) (1932), he actually seems to approve of the process by which human beings lose their autonomy and become "technologified"—that is, aspects of a suprahuman military or industrial machine.[47] Like the early Vorticists, Jünger was increasingly attracted by the static quality and stability of huge machines and this, together with his ingrained aristocratism, generated in the late 1930s the totalitarian (albeit anti-Nazi) "static hierarchy of value" and "haven of paradisiacal permanence" that forms the resolution of his novel *Auf den Marmorklippen* (1939) (*On the Marble Cliffs,* 1947).[48]

A similar failure is noticeable in the work of some—but by no means all of the architectural functionalists. Some modernist architects (notably Le

Corbusier) forgot that buildings exist for people and not people for buildings and came to believe that the modernist architect-hero could solve the problems of modernity by imposing more rational order on the urban masses. Consequently, during the period of economic growth after the Second World War, when much of Europe lay in ruins and there was an acute need for low-cost, standardized buildings, it was all too easy for the more modest, founding ideals of early functionalists like Adolf Loos and Otto Wagner and a commitment to modern materials to be hijacked and transformed, on both sides of the Iron Curtain, into the new brutalism that would be denounced in the 1960s and 1970s by postmodern architects like Robert Venturi, Aldo Rossi, and Charles Jencks.[49] Le Corbusier's "machines for living in" had turned into architectural versions of Weber's *Gehäuse* via a dialectical turn that exactly replicated the one taken by classical modernity as a whole: the solution to a perceived problem had itself become the problem.

The change of heart that most of the Vorticists underwent forms an obvious bridge to the eighth response. The techno-euphoria of the young Soviet avant-garde and the utopian and messianic socialism of the avant-garde in both the Soviet Union and Germany after the Great War evaporated once the real nature of the German and Russian revolutions became apparent. Similarly, uncritical modernolatry became increasingly unacceptable to many modernists because of its blindness or indifference to the reality and implications of machine violence. So, in order to avoid these pitfalls, those modernists who suffered from a sense of cultural crisis but wished to stay with the contemporary world had to develop more modest, ambiguous, and ironic attitudes to the complexities of modernity. In the field of architecture, this desire to negotiate a middle way generated Neoplasticism, Constructivism, and, after summer-autumn 1922, the second phase of the Bauhaus. The adherents of all these movements hoped that a modern classicism and a commitment to modern materials would rescue Western civilization from the barbarism to which it had so recently succumbed. In making this commitment, they were also, whether they realized it or not, trying to reverse the dialectical turn that the central project of the Enlightenment was felt to have taken and bring it back onto its proper course. Hence those early critiques of the dangers of dehumanized functionalism registered by Welsch; hence, too, the attempts of so unlikely a candidate as Kurt Schwitters to reconcile Constructivist design with commercial advertising.[50] All these phenomena are attempts

to bring technology back to manageable human dimensions through the design and construction of aesthetically pleasing cities where imperialist capitalism is not permitted to turn into a chaotic, autonomous system but is, instead, subject to reasonable and humane control. A work that typifies this attitude is Adolf Behne's *Der Moderne Zweckbau* (1923) (*The Modern Functional Building,* 1996) — and anyone who thinks that all forms of modernist functionalism are marred by a disregard for lived human needs and the demands of the environment should read it. This book may not have the visionary power of the theoretical work of Taut or Tatlin, but it is emblematic of contructive modernism at its best and involves what might be described as a "modernist humanism" — a humanism that is purged of its hubris and holds out "the prospect of a more modest modernity." [51] Human beings are reinstated at the center of things but not regarded as the measure of all things. Nature is there to be used but not to be dominated or violated. Human reason, while not dismissed as an aberration, is not overestimated at the expense of the powers of unreason inside and outside of human nature. The architect-intellectual exists to serve the needs of his clients and to converse with them — not to tell them what to do. [52]

Other examples of this new sobriety are Taut's renunciation of visionary utopianism in architecture and acceptance of the post as city architect in Magdeburg; Salomo Friedlaender/Mynona's return to Kantian philosophy and highly critical book on George Grosz (1922) after six years of sympathetic cooperation with the Berlin Dadaists; the move by musical modernists away from "radical change to the language of an art" to "a more pragmatic, audience-orientated compromise with the past"; Sartre's Existentialism; Jung's central doctrine of "integration"; the Vienna Circle's "defense of the Enlightenment against the various forms of irrationalism that were only too visible a feature of post-war Vienna"; Ernst Bloch's humanistic Marxism, especially *Spuren* (*Traces*) (1930), with its emphasis on *Heimat* and awareness of the dire pitfalls of modernism and modernity; Karl Jaspers's notion of a quiet heroism that manifests itself in inconspicuous activity and an inviolable skepticism toward all that is objectively fixed; Döblin's revision of his apocalyptic *Berge Meere und Giganten* into *Giganten* (*Giants*) (1932) (which is much more positive about human autonomy and technological ability); and Hans Henny Jahnn's concept of a "neuer unklassischer Humanismus" [new, nonclassical humanism] that resists heartlessness, arbitrariness, and cruelty and promotes an attitude of mercy toward "Mensch, Tier, Baum und Stein" [people, animals, trees, and

stones].[53] But perhaps, of all major modernist works, it is Thomas Mann's *Joseph* tetralogy (1926–42) (*Joseph and His Brothers,* 1934–45) that most extensively affirms this cast of mind. Here, as Ritchie Robertson put it, Mann does not surrender blindly to the primitive or try to deny its power. Rather, he seeks to "explore and understand it with the aid of his modern consciousness" and so develops an ironic stance as "a means of keeping the primitive at bay while acknowledging its authority and appeal."[54] As Iggers pointed out in his afterword to *Intellektuelle in der Weimarer Republik,* writers, artists, and intellectuals of this persuasion tend to be less fascinating than those whose views are more complex and/or extreme. Nevertheless, they very clearly point forward to Habermas's affirmation of the essential values of the Enlightenment: critical reason; a "non-repressive form of ego-identity" and intersubjectivity; a "dialogic conception of subjectivity and rationality"; "an ethical science based upon the principles of reason, justice and democracy, but without running the risk of alienating or silencing seemingly aberrant minority voices within false or oppressive forms of consensus"; and a more modest, dialogic concept of reason that avoids irrationalism and operational contradiction while encouraging a political practice that is democratic, undogmatic, and therefore subject to continuous critique.[55] For the representatives of this current of thought within modernism, *instrumental* reason may very well be capable of running amok and constructing *stahlharte Gehäuse*. But because there is something within human nature that can never be entirely caged, *critical* reason is capable of discovering how those prisons came to be constructed and either destroying or finding a way out of them. Finally, because there is something within human nature that is not completely immoral, *practical* reason is capable of building something better in their place.

Which brings me to the ninth and final type of response: those modernists who accept that modernity is in crisis but refuse to succumb to despair, mindless irrationalism, or nostalgia; who affirm modernity but reject modernolatry and the desire for closure; and who situate the wellspring of human nature in its subrational faculties while believing—and this is crucial—that in the complete, polyphonic human personality, there should be a creative interplay between critical and instrumental reason and its other, equally important faculties.[56] It is hard to put a label on this type of response, but perhaps the one that fits best goes back to paragraph 42 of *Jenseits von Gut und Böse,* where Nietzsche is discussing "Der freie Geist" [The Free Spirit], and is, quite simply, "experimental." The experiment,

which is not for everybody, involves confronting and accepting as much of modernity and the human personality as possible, even those "low," messy, and ambivalent parts (such as mass culture and its subjective correlative the unconscious) which classical humanism represses, scorns, or simply ignores but which Julia Kristeva would claim to be the basis of *écriture féminine*.[57] It seems to me that this is the position toward which Ulrich, the *Möglichkeitsmensch* [possibilitarian], is making his laborious way in *Der Mann ohne Eigenschaften* and that this is Felix Krull's very condition of being in Thomas Mann's most uncharacteristic novel. On Tratner's reading, Joyce was investigating the same position in *Ulysses* and *Finnegans Wake* and Woolf was doing something comparable in *To the Lighthouse* (1925–27) and *The Waves*, even if, by the time of her last, posthumously published novel, *Between the Acts* (1938–41), she was unable to sustain the experiment and succumbed to terminal melancholy.[58] In my view, Dada involves the same experimental attitude to the human situation within a modernity that is perceived to be in crisis and is best understood as an attempt to envisage what Eliot, in 1919, called a "non-Euclidean humanity" that could live in a "Lobatchevskyan" universe where classical certainties had only a limited validity (see chapter 7).[59] When undertaking this project, most of the Dadaists were buoyed up by a robust, exuberant, and ironic sense of humor that we have learned to call carnivalesque and that enabled them, like Charlie Chaplin and Buster Keaton, two quintessentially modernist (anti-)heroes, to keep some sort of balance in a wildly fluctuating universe.[60] Joyce (who, coincidentally, started work on *Ulysses* in Zurich, the city where Dada began) possessed this quality in abundance—as does the fictional Krull (who is based to a considerable extent on Georges Manolescu, a real-life con man whose memoirs appeared in 1905 and were made into a film starring Conrad Veidt in autumn 1920 and whom, coincidentally, Richard Huelsenbeck honored with the title of Dadaist in *En avant Dada* [1920] [translated 1951]).[61] If this experimental response is deemed irrationalism, it is certainly neither the irrationalism of self-destructive ecstasy nor the irrationalism of Fascism. Indeed, Tratner points out that Joyce's two major novels documented a move "from a position on its way to Fascism to a position close to international socialist pluralism" and that Woolf's politics involved the dream of polyphonic pluralism.[62] Furthermore, as we shall see in chapter 12, Dada's politics were overwhelmingly Anarchist or Anarcho-Communist. With its urge toward heteroglossia, metaleptic mistrust of hierarchies, disrespect for allegedly

impermeable boundaries, instinctive hostility to closure and final solutions, love of the carnivalesque, refusal of binarisms, and rejection of what feminist critics now call "phallogocentrism," this kind of experimentalism feeds, for better or for worse, into both the critical postmodernism of the 1960s and 1970s and also the more ludic, assimilated postmodernism of the Reagan-Thatcher era (see chapter 13).[63]

4. Lord Chandos and His Discontents

In *Das Unbehagen in der Kultur,* Freud argued that Western civilization was caught in a double bind. On the one hand, it suffered from a profound sense of unease/disquiet because its excessively rational nature involved the repression of the "primitive," spontaneous powers of the psyche.[1] But on the other hand, Freud argued, if we try to remedy that sense by de-repressing ourselves and giving free rein to our creative urge, the life instinct (Eros), we would simultaneously let loose aggressive and destructive energies, the death instinct (Thanatos), which would subject us to a different kind of suffering. We are, Freud concluded, caught in a conflict to which there is no resolution except that of sublimation—occluding it by an addiction to work, intellectual pursuits, idealistic moral codes, utopian political ideologies, religious creeds, and aesthetic illusions (14:457/21: 97). According to Freud, then, the very immensity of the West's cultural achievements is the reflex of the extreme violence that we have done to ourselves in order to cover up the psychic suffering that is our inescapable lot. Moreover, because it is impossible in any final sense to repress the primary drives in human nature and the ineluctable conflict between them, our techniques of sublimation have to become ever more novel, sophisticated—and violent. So, Freud concluded, we in the West need to face up to the fundamental conflict that haunts us by losing some of our cultural illusions, lessening the cultural and ethical demands we make upon ourselves, and ceasing to act as though we were gods. Although Freud concluded the first edition of *Das Unbehagen in der Kultur* (1930) with the hope that if we could do this, then "eternal *Eros*" might prove stronger than Thanatos—

the other of the "two 'heavenly powers' " — he added a concluding sentence to the second edition (1931), when the specter of Hitler was looming ever larger, that was significantly less optimistic (14:506/21:145).

Freud's analysis of the state of Western civilization is an excellent way into Hofmannsthal's "Ein Brief" (1902) ("The Letter of Lord Chandos," 1952), a text that is generally seen as central to modernism and whose author has even been called the first postmodernist.[2] The fictional letter, written in 1603 to Francis Bacon, the founding father of modern, empirical science and a major architect of the "phallogocentric" model of reality, tells of a mysterious crisis that has afflicted its author, Philipp Lord Chandos, and it falls into three parts.[3] The first consists in a nostalgic account of the world in which Chandos had lived before his crisis. In the second, Chandos recounts the origins and course of his crisis. And in the third, Chandos attempts to describe his current state of mind. At the individual level, "Ein Brief" can be read simply as an account of a nervous breakdown or as Hofmannsthal's own apologia for ceasing to write poetry.[4] But like Mann's *Der Tod in Venedig*, whose protagonist is representative of bourgeois Europe on the brink of catastrophe, "Ein Brief" can also be read as an analysis of the sublimated illusions with which Western, humanist civilization has sustained itself; a transcription of the process that Freud called "the return of the repressed"; an investigation into the relative power of Eros and Thanatos; and a tentative exploration of some of the directions in which Western humanity, bereft of its illusions of godlikeness, might go.

Before his crisis, Chandos had lived in the thoroughly civilized, anthropocentric world of the Renaissance court in which God or the gods, to the extent that they existed at all, were the same "elegante Synonyme" (elegant synonyms) of the aristocracy that line the avenues of the fifth poem in "Die Parke" ("The Parks") (1907) from Rilke's *Neue Gedichte*. But this world is also extremely artificial and its artificiality is reflected in the neoclassicism of Chandos's literary output. He tells Bacon of the pastorals he had written at the age of nineteen that were marked by an excess of Baroque splendor and whose purpose was presumably to celebrate the life of the court in mythological terms. He also recounts how, at age twenty-three, the inspiration for a highly structured piece of Latin prose had come to him while he was sitting beneath the stone arcades of St. Mark's Square in Venice and how this work had delighted him more than the buildings of Palladio and Sansovino that surrounded him (8/130). This admission is particularly telling since Latin is a dead, not a vernacular, language, and while the German word for arcades is *Laube* (literally foliage or bowers), these *Laube*

are petrified, not organic and alive. Indeed, Chandos automatically thinks of his work in static, architectural terms, and Venice, the quintessential Renaissance city, symbolizes the triumph of rational, conscious order over primal disorder/the unconscious, whose symbol, as in *Der Tod in Venedig*, is the sea.

On the surface, Chandos had had a secure place in a secure world. He had been socially secure—partly because he was a member of the aristocracy and partly because he had functioned as an apologist for his world by fabricating idealized literary images of it (the pastorals described above). He had also been historically secure and had possessed so strong a sense of history as a linear continuum that when he wanted to write a history of the early years of the reign of Henry VIII, his mind instinctively turned to the writings of the Roman historian Sallust. From these he had derived a sense that an inner form, as ordered as music and algebra, ran through both history in the objective sense and the written history that is its record (9/131). Chandos had also been epistemologically secure and had considered compiling a collection of "Apophthegmata," short utterances, like those compiled by Caesar and mentioned in one of Cicero's letters (10/131–32). According to Chandos, this book would have united the most disparate material from a variety of countries, historical periods, classes, and social events. It would have included instances of crime and madness and descriptions of works of architecture. And it would have been entitled *Nosce te ipsum* (*Know Thyself*). Again, Chandos's description is very revealing. The classical precedent indicates that he had thought of himself in imperial terms and assumed in general that reality was a seamless unity, held together by the inner form that he had found in Sallust and that could be replicated in the book he had planned. He had also assumed, like most mainstream Western scientists at the end of the nineteenth century, that reason could master everything, irrespective of its provenance and nature, and that there was a homology between world, book, and self such that knowledge of the world, when mediated by the printed word, entailed knowledge of the self—hence the book's proposed title.[5]

Finally, Chandos had been ontologically secure. He describes how, in his precrisis period (10–11/132–33), the whole of Creation had seemed like one massive unity, with himself at its center in a state of continuous intoxication. Within this Creation there had been extremes but no contradictions. Culture (his library) and Nature (fresh milk from a cow) had interpenetrated one another and enriched his soul in exactly the same way. Objects had been endowed with a firm, assured reality and, in a way that

recalls the "forest of symbols" of Baudelaire's "Correspondances," had all been keys to one another. And he himself, in a state of *participation mystique* that is caught by the complex syntax of his description, had felt at one with everything—like the classic definition of God, at once the midpoint and on the periphery of a totally harmonious cosmos. Moreover, this whole construct had been held together by a metaphysical substance that Chandos calls "Natur" [Nature]—a highly ironic choice of words given what happens later.

This seemingly firm order is actually very fragile, and Chandos gradually loses his ability to think about anything whatsoever coherently (12/133). Indeed, this sense of loss becomes so corrosive that Chandos starts to feel an inexplicable uneasiness [*Unbehagen*] about uttering the words *Geist* [spirit/mind], *Seele* [soul/spirit], and *Körper* [body]—three concepts that form the cornerstones of his conceptual world. Chandos also gradually loses the easy ability to speak in publicly sanctioned discourses. He finds it impossible to pass judgments on matters connected with the court or parliament and discovers that abstract concepts that had formerly tripped so lightly off his tongue now fall to pieces in his mouth like mouldy fungi (12–13/133–34). Or in other words, he realizes that something mysterious is fracturing the unproblematic relationship that he had enjoyed with his society and this in turn causes him to lose his earlier ability to make facile, conventionally accepted moral judgments about good and bad, success and failure, virtue and vice. Indeed, he records that when he now hears a conversation involving such judgments, an inexplicable anger overcomes him because they are mendacious, flawed, and insupportable. Chandos, it seems, is losing his former sense of standing on a fixed, Archimedean point from which it had been possible to survey the human world with sovereign confidence.

But the crisis cuts even deeper still, for Chandos finally loses his faith in the reliability of language as such. One day, when talking to his daughter and trying to impress upon her the necessity of always telling the truth, the concepts emanating from his mouth begin to *zerströmen* (13) [dissolve/dissipate] (134), to take on a *schillernde Färbung* (13) [irridescent coloring] (134), and to flow over into one another so that he is unable to complete the sentence and runs away in a kind of panic. All of which means that Chandos is beginning to realize affectively what Saussure was beginning to formulate scientifically at about the same time: that language is an arbitrary system and that there is a gap between the illusory security afforded by language and the fluid complexity of reality.

Having lost the blinkers imposed upon him by socially sanctioned discourse, Chandos finds himself forced to listen to himself thinking and to scrutinize his language, a process that he describes as *unheimlich*—a German word that literally means "uncanny" but also carries connotations of not being at home. Indeed, Chandos likens this process of self-scrutiny to the experience of looking at the skin on his little finger through a magnifying glass: what he had taken for granted turns into something strange so that his skin looks like a ploughed field full of hollows and furrows. As a result, the familiar world starts to dissolve; everything begins to fragment; and the resultant fragments turn into even smaller fragments that Chandos cannot capture conceptually (14/134). As part of this process of disintegration, language itself becomes strange, and words, when scrutinized closely, induce a sense of vertigo in Chandos that makes him feel he is falling into a void (14/134–35).

But what causes this experience—which is very close to the Nietzschean experience of the death of God? At first it seems gratuitous and unmotivated both to the reader and Chandos. But when we get to the heart of "Ein Brief," it becomes evident that the crisis has been precipitated by the violent irruption into Chandos's harmoniously ordered world of elemental powers that had been excluded from it and that correspond very closely to Freud's concepts of Eros and Thanatos. The key event is, of course, the so-called rats in the cellar episode, unmistakable echoes of which are, incidentally, to be heard in the scenes in which Basini is humiliated and tortured in an attic in Musil's (slightly later) *Törless*.[6] Introducing the episode, Chandos describes how he had recently ordered poison to be put down in the cellar of the dairy of one of his farms and how, as he was out riding one day, the memory of the ensuing events returned with unexpected and unwonted force:

Da, wie ich im tiefen, aufgeworfenen Ackerboden Schritt reite, nichts Schlimmeres in meiner Nähe als eine aufgescheuchte Wachtelbrut und in der Ferne über den welligen Feldern die grosse sinkende Sonne, tut sich mir im Innern plötzlich dieser Keller auf, erfüllt mit dem Todeskampf dieses Volks von Ratten. Alles war in mir: die mit dem süsslich scharfen Geruch des Giftes angefüllte kühldumpfe Kellerluft und das Gellen der Todesschreie, die sich an modrigen Mauern brachen; diese ineinander geknäulten Krämpfe der Ohnmacht, durcheinander hinjagenden Verzweiflungen; das wahnwitzige Suchen der Ausgänge; der kalte Blick der Wut, wenn zwei einander an der verstopften Ritze be-

gegnen. Aber was versuche ich wiederum Worte, die ich verschworen habe! Sie entsinnen sich, mein Freund, der wundervollen Schilderung von den Stunden, die der Zerstörung von Alba Longa vorhergehen, aus dem Livius? Wie sie die Strassen durchirren, die sie nicht mehr sehen sollen . . . wie sie von den Steinen des Bodens Abschied nehmen. Ich sage Ihnen, mein Freund, dieses trug ich in mir und das brennende Karthago zugleich; aber es war mehr, es war göttlicher, tierischer; und es war Gegenwart, die vollste erhabenste Gegenwart. Da war eine Mutter, die ihre sterbenden Jungen um sich zucken hatte und nicht auf die Verendenden, nicht auf die unerbittlichen steinernen Mauern, sondern in die leere Luft, oder durch die Luft ins Unendliche hin Blicke schickte und diese Blicke mit einem Knirschen begleitete!—Wenn ein dienender Sklave voll ohnmächtigen Schauders in der Nähe der erstarrenden Niobe stand, der muß das durchgemacht haben, was ich durchmachte, als in mir die Seele dieses Tieres gegen das ungeheure Verhängnis die Zähne bleckte.

Vergeben Sie mir diese Schilderung, denken Sie aber nicht, dass es Mitleid war, was mich erfüllte. Das dürfen Sie ja nicht denken, sonst hätte ich mein Beispiel sehr ungeschickt gewählt. Es war viel mehr und viel weniger als Mitleid: ein ungeheures Anteilnehmen, ein Hinüberfliessen in jene Geschöpfe oder ein Fühlen, dass ein Fluidum des Lebens und Todes, des Traumes und Wachens für einen Augenblick in sie hinübergeflossen ist—von woher? (16–17)

As I was trotting along over the freshly-ploughed land, nothing more alarming in sight than a scared covey of quail and, in the distance, the great sun sinking over the undulating fields, there suddenly loomed up before me the vision of that cellar, resounding with the death-struggle of a mob of rats. I felt everything within me: the cool, musty air of the cellar filled with the sweet and pungent reek of poison, and the yelling of the death-cries breaking against the mouldering walls; the vain convulsions of those convoluted bodies as they tear about in confusion and despair; their frenzied search for escape, and the grimace of icy rage when a couple collide with one another at a blocked-up crevice. But why seek again for words which I have foresworn! You remember, my friend, the wonderful description in Livy of the hours preceding the destruction of Alba Longa: when the crowds stray aimlessly through the streets which they are to see no more . . . when they bid farewell to the stones beneath their feet. I assure you, my friend, I carried this vision within me, and the vision of burning Carthage, too; but there

was more, something more divine, more bestial; and it was the Present, the fullest, most exalted Present. There was a mother, surrounded by her young in their agony of death; but her gaze was cast neither toward the dying nor upon the merciless walls of stone, but into the void, or through the void into Infinity, accompanying this gaze with a gnashing of teeth!—A slave struck with helpless terror standing near the petrifying Niobe must have experienced what I experienced when, within me, the soul of this animal bared its teeth to its monstrous fate.

Forgive this description, but do not think that it was pity I felt. For if you did, my example would have been poorly chosen. It was far more and far less than pity: an immense sympathy, a flowing over into these creatures, or a feeling that an aura of life and death, of dream and wakefulness, had flowed for a moment into them—but whence? (136–37)

To begin with, it is significant that the episode is triggered by a sunset, for what we are seeing here is directly analogous to what happens in Baudelaire's poem "Le Coucher du soleil romantique": the centerpiece of an ordered, concentric cosmos is disappearing, cutting the poet/Chandos adrift from any fixed point of reference. It is also significant that the ploughed land is described as "tiefen, aufgeworfenen" [deep, churned-up] since this gives the impression that some underground seismic event is about to take place in Chandos's mind as well. Consequently, Chandos describes the cellar full of poisoned, dying rats not as a mere memory, but as though it was actually inside him ("mir im Innern" [within my innermost self])—an image which corresponds to the Freudian unconscious and in which, as we shall see, Eros and Thanatos are also locked in struggle.

As a result of this vision (which is strikingly similar to Nietzsche's vision of a Dionysiac universe governed by the Will to Power and which Marxists would probably see as a mystification of the war of all against all that is capitalism), Chandos's entire mind-set is altered in several fundamental ways.[7] In causing the poison to be put down, Chandos had played God, but the sight of the results of his handiwork makes him realize that he is all-too-human. Consequently, his anthropocentric cosmos is superseded by one that is "göttlicher, tierischer"—by one that involves powers which are both higher (more divine) and lower (more bestial) than the middle zone of experience in which he had lived hitherto. His polite, formal, controlled, courtly world is superseded by one that is governed by acute suffering and such raw, fundamental emotions as panic, fear of death, desperation, rage, sorrow, and defiance. His secure, rational, objective world

is supplanted by one that is seething, disordered, and energetic (with the result that his language is verbal and participial rather than nominal). And his earlier, egocentric sense of *participation mystique* gives way to a rather different experience of participation during which any sense of separation between self and world disappears. Consequently, his monadic ego seems to dissolve, enabling him to empathize powerfully with the violent process that is taking place simultaneously within his memory, before his eyes, and within his own personality.[8] Or in other words, Chandos's vision dissolves linear time and three-dimensional space and forces him to confront both poles of the modernist experience described in chapter 1. On the one hand, he participates in the sense of being imprisoned in a *Gehäuse* (in this case, the closed world of the cellar). On the other hand, he is exposed to a vision of a universe in flux which is full of energies that are both terrifying (Thanatos, "Tod," "Death") and inspiring (Eros, "Leben," "Life"). Where, in Chandos's previous existence, Nature had been something akin to the unifying substance of medieval theology, his sudden vision of the rats in the cellar involves a sense of Nature that is far less reassuring, far less comprehensible, far more violent, and far more awesome. Where Chandos had previously assumed that classical sources were adequate vessels for his experience of reality, now he freely admits that the classical analogies that spring spontaneously to mind are poor means of conveying the scene before him.

Nevertheless, Chandos *can* put the experience into words even while recognizing their inadequacy, and he is *not* destroyed by the experience of what, in Freudian terms, would be called violent de-repression. So, in the final part of the letter, we find him trying to assess where the whole traumatic experience has left him. Most obviously, the experience of Thanatos has been highly destructive. Chandos is now lonely, isolated from society, prone to long periods of inner emptiness, indifference, and spiritual dessication that he is able to hide from other people only because of the discipline instilled in him by his education (19/138). That is to say, for long stretches of time Chandos clings as best he may to the vestiges of the shattered Symbolic Order, the classical values, and the reality principle which, as he himself confesses, he owes to his dead father. But every now and again, quite unexpectedly, he is overwhelmed by Eros, inundated by a tumultuous flood of higher life as a spark jumps between him and some mundane, forgotten object or chance constellation of such objects (15/135). So powerful are these epiphanic moments that they make Chandos shud-

der from the roots of his hair to the soles of his feet, fill him with a sense of the infinite, and render him totally speechless. Chandos's second account of this kind of experience is particularly telling since the object that precipitates it one evening contrasts so dramatically with his precrisis world: a half-empty watering can that a gardener's boy had left by accident under a nut tree with a water boatman skating across the darkening surface of the water that is still in it (17–18/137).

The forgotten watering can is the image of a universe governed by chance rather than a discernible order or plan and the water boatman is the image of the fragility of human existence there. Where Chandos's former life had been full of large, self-confident artifacts and tame domestic animals, the centerpieces of this constellation are a banal object that prefigures Duchamp's readymades and an insignificant, useless insect. Where Chandos's earlier world had been full of interchangeable sources of sweetness (milk) and light (book-derived knowledge), this constellation is characterized by shadows and half-lights. Where Chandos's precrisis life had been marked by cyclical repetition, predictability, and a permanent sense of *participation mystique,* now he tells us that he hardly dares to approach the catalyst of this particular epiphanic experience because he knows that it will not recur to order and because he is afraid of destroying the memory. But above all, Chandos now knows that he can barely put the experience into words and his German reflects this. The description, consisting of one sentence running over twenty lines, has the form of a multiple question with no question mark at its end. It refers to a past event but is cast in the present tense. And it involves nineteen interlocked subordinate clauses whose interrelationships are so complex that they are barely translatable into English. Moreover, and for all his fluent intensity that stretches the syntax to its breaking point, Chandos now knows, too, that he no longer knows what he believes in. Although the experience might be deemed quasi-mystical, Chandos implies that he is by no means certain of this since he says that if he could find the words he needs, they would force angels, in which he no longer believes, to their knees. Chandos, in other words, has turned from a triumphalist humanist into a mystical agnostic.

But paradoxically, this is no bad thing since Chandos's experience of crisis seems to have purged him of much of his earlier hubris. He has developed an appreciation of the lesser members of Creation — "stumme und manchmal unbelebte Kreaturen" (18) [mute and, on occasion, inanimate creatures] (138) like dogs, rats, beetles, a neglected apple tree, a cart track

snaking over a hill, or a moss-covered stone. From being someone who had prided himself on his higher faculties, Chandos's experience of the "entzückendes, schlechthin Widerspiel in mir und um mich" (18) [blissful, never-ending interplay within me and around me] (138) has begun to teach him "mit dem Herzen [zu] denken" (18) [to think with the heart] (138). By which Chandos means that he has developed a capacity of active openness and empathy that is akin to Bergson's concept of intuition (see chapter 5). This then allows him to project himself imaginatively into his environment and see it, as far as that is possible, for what it is rather than in the preset terms that have been legitimized by convention. Chandos understands this and describes his changed relationship to the world as a "neues, ahnungsvolles Verhältnis zum ganzen Dasein" (18) [a new, intuitively aware relationship with the whole of existence] (138). He may be incapable of knowing reality for what it is, let alone put his intuitions into words, but now at least he can try to suspend judgment, listen to what is not himself and, most important, listen to himself listening to what is not himself.

Chandos has acquired, in the broadest sense of the word, an eccentric consciousness. Because of this, he concludes his letter by recalling an anecdote from Plutarch's *Moralia* (which Hofmannsthal probably came across in no. 157 of Bacon's *Apophthegms* in summer 1902).[9] According to this, Lucius Licinius Crassus, the greatest orator before Cicero, was possessed of an inordinate love for a pet lamprey, and this made him the subject of gossip and tempted a fellow senator, Domitius, to try and make a fool of him before the entire Senate (20/139). But Crassus was able to turn the joke back against Domitius, and this story has made a profound impact on Chandos. Crassus's ridiculous, even contemptible infatuation for an ugly fish combined with his clownish wit involve a sympathy for the lower strata of Creation, an emotional honesty, and a sense of the absurd that are perhaps more appropriate and more humane attitudes than the formal solemnity of the most powerful body in the ancient world. This thought brings considerable solace to Chandos in his postcrisis world, for whenever he thinks of Crassus (who, Chandos says, has become part of him), his mind starts to work feverishly and produce thoughts that are more immediate, more fluid, and more glowing than words. Chandos likens these thoughts to vortices or whirlpools, but unlike the vertigo induced in him by closely scrutinized words when he was in the midst of his crisis, these "Wirbel" do not cast him into the void. Rather, they induce in him a deep sense of

peace (21/140) which, if Chandos had not renounced any religious belief, he might have equated with the peace that passeth all understanding.

Because Chandos has arrived on the threshold of a new way of relating to the world, he announces to Bacon that he will never write another book. But he takes this decision not, as Rimbaud had done thirty years earlier, out of a nihilistic sense that Thanatos will always have the final word. Rather, he does so out of a sense of humility and respect before a mysterious creative power, Eros, that from time to time permits him an unexpected, visionary glimpse into a harmony that is far more fluid and elusive than his precrisis sense of harmony. Chandos describes it participially, as a "mich und die Welt durchwebende Harmonie" (18) [harmony weaving through me and the entire world] (138), and it is this verbal quality that distinguishes it from the static, artificial, ego-centered order of his previous existence.

It is not hard to see how Chandos's crisis encapsulates the crisis of modernism as a whole. A man steeped in the values of classical humanism and the Renaissance (which the young Hofmannsthal admired so much) suddenly finds himself in a situation where these no longer work except as a residual shell. Consequently, he has to rethink his understanding of reality, himself, and his relationship with reality, history, reason, language, and civilization in general.[10] At the same time, as Steffen rightly saw, "Ein Brief" is marked by paradox and contradiction and cannot be described in unequivocally straightforward terms—hence the many interpretations.[11] Accordingly, in his efforts to make sense of his crisis, Chandos considers at least eight of the responses identified in chapter 3. He flirts with nihilism; he knows moments of ecstasy and (quasi-)mystical insight; his way of writing about his epiphanies and the inability of language to grasp them reminds us of Symbolist aestheticism; his withdrawal from public life prefigures Rilke's and Yeats's withdrawals from modernity; his enjoyment of simple objects connected with rustic life (20/139) has something of the primitivizing response about it; his loss of hubris connects him with those modernists who tried to reinstate a "more modest humanism" shorn of its illusions together with his experimental, eccentric openness to life; and his positive appreciation of folly and the absurd point forward to Dada and Leopold Bloom.[12] But in all of this, Chandos's desublimation and final farewell to Francis Bacon are particularly significant. Like Hans Castorp in the pivotal "Schnee" ("Snow") chapter of *Der Zauberberg* and Heidegger in *Sein und Zeit*, Chandos discovers that if Thanatos is to be dealt with, then

it has to be recognized, paid due respect, and not hidden behind sublimations, no matter how high-minded. And like so many other male protagonists of modernist texts, he discovers that if he is to find his proper place within Creation, he has to dethrone reason from its earlier position of imperial sovereignty and allow it to find a much less exalted place within the democratic federation of faculties that constitutes the human personality.

5. Modernism, Language, and Experimental Poetry

On Leaping over Banisters and
Learning How to Fly

In contemporary terminology, Hofmannsthal's Chandos was, before his crisis, in thrall to "the myth of the given," according to which "words signify individually by virtue of their reference to an object" and are "attached to their referents by a mind already acquainted with these objects or ideas."[1] He was a product of the "classical episteme of representation" that "presupposed a spectator conception of the knowing self, a designative theory of meaning, and a denotative theory of language."[2] He took a "metaphysics of presence" for granted.[3] But whichever formulation one chooses, the major significance of Hofmannsthal's fictional letter is that its author is experiencing something that is very typical of the whole modernist generation: the realization that "the continuative binding conventions of syntax and logic" within which people habitually live and from which they derive what Samuel Beckett would term "semantic succour" are inherently misleading.[4] But at the same time, equally typically, Chandos is still attached to what he has lost and so lives in a state of openness — in the hope that every now and again, his disenchanted world will be re-enchanted for a brief instant.

It is this complex admixture of loss, nostalgia, and hope that generates experimental and "difficult" modernist poetry. To cite Butler:

As they lose confidence in the power of ordinary syntax to articulate causal processes, they believe less and less in the project of representing the world through the narrative of historical development. The writer's language becomes more and more elliptical, and turns to juxtaposition and the alogical, to the simultaneous and the collaged.[5]

This concise formulation summarizes a general position that has been familiar and accepted for a long time, and possibly because of this, critics writing about experimental or avant-garde twentieth-century poetry often fall into two traps. First, they can write as though experimental or difficult writing were all of a piece and deliberately obscure out of authoritarianism or élitism. J. G. Merquior, for example, claimed that modernism "generally meant obscurity, 'difficult' art and literature" and that this "threw the modern artist, willy-nilly, into a strongly authoritarian position" such that modernist "art was experienced as *a tyranny of the creative imagination* over the public, even the cultivated one."[6] Second, by focusing on the very obviously experimental surface of modernist poetry, they can easily forget that the "anxious attempts" of modernist work to deal with incoherence do not simply derive from "a failure of will, or élitist hauteur," but are "the marks of actual struggles over meaning."[7] Such acts of forgetting not only make modernist poetic experimentation into a more comfortable phenomenon than it originally was. They also permit that experimentation to be assimilated to the less angst-ridden, more ludic modes of postmodernist experimentation with which, in some of its manifestations, it shares a number of surface features. Susan Rubin Suleiman saw this when she took Ihab Hassan to task for allegedly domesticating the modernist text just like the more explicitly ideological proponents of postmodernism.[8] Similarly, writing from the prosperous Federal Republic of Germany of the mid-1980s, Wolfgang Welsch viewed postmodernism as the cultural manifestation of a (relatively unproblematic) contemporary pluralism and, apparently unaware of the years of acute turmoil that generated Hugo Ball's work, mentioned his diary *Die Flucht aus der Zeit en passant* for evincing an early awareness of that pluralism.[9] And although Marjorie Perloff has argued more recently for the persistence of an avant-garde, her sophisticated readings of contemporary avant-garde poetry suggest that this is less the product of a deeply felt sense of crisis and more a series of exercises in ingenuity that make use of modern media.[10]

This means in turn that critics often overlook the fact that much "difficult" or experimental modernist work across a range of genres was fis-

sured in a way that work by the contemporary experimental avant-garde is not. The young Lukács, writing shortly after the outbreak of the Great War and two years of personal crisis, identified one such fissure in the very form of the novel, the characteristic genre of bourgeois society, when he described it as "die Epopoë eines Zeitalters, für das die extensive Totalität des Lebens nicht mehr sinnfällig gegeben ist, für das die Lebensimmanenz des Sinnes zum Problem geworden ist, und das dennoch die Gesinnung zur Totalität hat" [the epic of an age in which the extensive totality of life is no longer directly given, in which the immanence of meaning in life has become a problem, yet which still thinks in terms of totality].[11] But three decades earlier, Nietzsche had identified an even deeper fissure within language itself when he made the remark about God and grammar cited in chapter 2. While the God who controlled the apparent certainties of conventional syntax might have been pronounced dead, his corpse still oppressed the imaginations of many linguistic agnostics and atheists whether they knew it or not. While many modernist experimenters felt that the old linguistic certainties had evaporated, they were simultaneously attached to what appeared to have evaporated or been discarded. As a result, much early modernist writing is informed by the (relatively invisible) desire to hold on to the presuppositions of Realism and Naturalism (according to which language was capable of grasping and mastering the external world) or Symbolism (according to which poets could redeem language from its deformation by convention and turn it into a vessel in which to preserve a sense of the transcendent).[12] But equally, much early modernist writing is informed by the (more visible) awareness that both these projects had become or were becoming impossible.

To take three examples only, the two diametrically opposed conceptions of language that critics have identified in the writings of Karl Kraus indicate that he desired to affirm a pre-established harmony between language and reality even while realizing that such linguistic realism was impossible.[13] And Walter Benjamin's early and posthumously published essay "Über die Sprache überhaupt und über die Sprache des Menschen" (1916) ("On Language as Such and on the Language of Man," 1978) begins by setting out a representational philosophy of language culminating in the assertion "*Das sprachliche Wesen des Menschen ist also, dass er die Dinge benennt*" (143) [*It is therefore the linguistic essence of man to name things*] (110).[14] Two paragraphs then follow in which Benjamin submits this conclusion to a series of searching questions in the second of which he rejects it as "bürgerlich" (144) [bourgeois] (111). He then retracts this dis-

missal by asserting "Der Mensch ist der Nennende, daran erkennen wir, dass aus ihm die reine Sprache spricht" (144) [Man is the namer, by this we recognize that through him pure language speaks] (111); adds that all of Nature is permeated by a language that corresponds to human language and allows human beings to name things; and concludes "Sprache ist dann das geistige Wesen der Dinge" (145) [Language is thus the spiritual essence of things] (112). But having made that Romantic synthesis, he concedes, a mere two pages later, that "Die Sprachen der Dinge sind unvollkommen, und sie sind stumm" (147) [the languages of things are imperfect, and they are mute] (114); that human language is limited (149/116); that there is a multiplicity of human languages (152/118); and that because of the Fall of Man (153–54/119–20) the correspondence between the divine Logos, the language of things, and human language, which, following Hamann, he would like to affirm, is "paradiesisch" (152) [paradisiac] (119). Consequently, in the final pages of the essay, we can sense Benjamin being reluctantly pushed toward the conventionalist, semiotic view of language that he had set out but dismissed (150/116–17) and speaking of "die Traurigkeit der Natur" (155) [the sadness of nature] (121), the tragic relationship between human languages (156/122), and the residuum of the divine Logos in Nature that hangs over human language like a "richtendes Urteil" (157) [judgment suspended over him] (123). Throughout the entire essay therefore, we can see Benjamin affirming and dismantling various theories of language only to end, like Chandos, with a few fragments of melancholic certainty. Analogously, to quote Anthony Giddens, "Heidegger was *forced* to introduce the most tortuous neologisms in order to *recover* a philosophical sense of time (time–space) [my emphases]" because he was dealing with a world that had come off its hinges and so was proving increasingly difficult to grasp linguistically.[15] Like other "difficult" modernists, Heidegger's often impenetrable language is simultaneously the index of his commitment to the "classical episteme of representation" and of his sense that this episteme is invalid in a world where Being-itself has become mere *Dasein*. Indeed, it is precisely because this kind of tension varies in strength so greatly from writer to writer and because it can be resolved so diversely that modernist texts, when closely scrutinized, are, like modernism as a whole, so resistant to reductionism.[16] Once one penetrates the unconventional, experimental, or "difficult" surface of a modernist text, it often transpires that the text has been generated, in part at least, by contradictory assumptions about language which are in urgent need of resolution but which the writer cannot resolve.

In the first half of this chapter, therefore, I shall argue two things. Wittgenstein's *Tractatus* is generally regarded as the summation of the view, which can be traced back to Euclid and Democritus, that there is an isomorphic relationship between language and atomic reality and therefore distinct from his *Philosophical Investigations* (completed 1948).[17] In contrast, I shall show that the *Tractatus* both sets out and simultaneously deconstructs these assumptions. I shall then show how the deconstructive aspects of the *Tractatus* provide, albeit unwittingly, the theoretical basis upon which other, more developed critiques of language are founded. In the second half of this chapter, I shall discuss various modes of modernist poetry against this theoretical background in order to show how they are generated by and attempt, more or less successfully, to resolve the contradiction described above.

The *Tractatus* as a Self-Deconstructing Text

Essentially, the *Tractatus* makes explicit four key assumptions on which mainstream nineteenth-century thinking about language and reality was based. These, *mutatis mutandis,* informed mainstream nineteenth-century scientific thinking together with the literary systems known as Realism and Naturalism (whose rise was closely connected with the translation of pure science into applied technology and the resultant modernization of society). The most fundamental of these is that reality equals material, objective reality—that is, a reality that is composed of irreducible, atomic things: "Das Feste, das Bestehende und der Gegenstand sind eins" [Objects, the unalterable and the subsistent are one and the same] (2.027).[18] The second is that there is a correspondence between the structure of language and the structure of reality:

Sehr klar wird das Wesen des Satzzeichens, wenn wir es uns, statt aus Schriftzeichen, aus räumlichen Gegenständen (etwa Tischen, Stühlen, Büchern) zusammengesetzt denken.
Die gegenseitig räumliche Lage dieser Dinge drückt dann den Sinn des Satzes aus.

The essence of the propositional sign becomes very clear if we imagine it composed of spatial objects (such as tables, chairs, books) instead of written signs.
The reciprocal arrangement in space of these things will then express the sense of the proposition. (3.1431)

Der Name bedeutet den Gegenstand. Der Gegenstand ist seine Be-
deutung. ('A' ist dasselbe Zeichen wie 'A').

*The name means the object. The object is its meaning. ('A' is the same sign
as 'A'). (3.203)*

Ein Name steht für ein Ding, ein anderer für ein anderes Ding und
untereinander sind sie verbunden, so stellt das Ganze—wie ein lebendes
Bild—den Sachverhalt vor.

*A name stands for a thing, another for another thing and they are connected
with one another; thus the whole—like a tableau vivant—presents a state
of affairs. (4.0311)*

Der Satz kann die gesamte Wirklichkeit darstellen

The proposition can represent the whole of reality. . . . (4.12)

Der Satz *zeigt* die logische Form der Wirklichkeit.
 Er weist sie auf.

The proposition shows *the logical form of reality.*
 It displays it. (4.121)

From which it follows that only what conforms to the rules of logic,
grammar, and causality (that is, the "logical form" common to both lan-
guage and reality [4.121]) can be perceived, conceived, and put into words:

Die Grenzen meiner Sprache bedeuten die Grenzen meiner Welt.

The limits of my language *mean the limits of my world.* (5.6)

Die Logik erfüllt die Welt; die Grenzen der Welt sind auch ihre
Grenzen.
 Wir können also in der Logik nicht sagen: Das und das gibt es in der
Welt, jenes nicht.
 Das würde nämlich scheinbar voraussetzen, dass wir gewisse Mög-
lichkeiten ausschliessen und dies kann nicht der Fall sein, da sonst die
Logik über die Grenzen der Welt hinaus müsste; wenn sie nämlich diese
Grenzen auch von der anderen Seite betrachten könnte.
 Was wir nicht denken können, das können wir nicht denken; wir
können also auch nicht *sagen,* was wir nicht denken können.

Logic pervades the world; the limits of the world are also its limits.

So we cannot say in logic: There is this and this in the world, but not that.

For that would appear to presuppose that we are excluding certain possibilities, and this cannot be the case, otherwise logic would have to go beyond the limits of the world, if it could view those limits from the other side as well.

We cannot think what we cannot think; so what we cannot think, we cannot say either. (5.61)

And the corollary of this is that language cannot approach, let alone grasp or conceptualize, what is not reality as that is defined above: "Wovon man nicht sprechen kann, darüber muss man schweigen" [What we cannot speak about we must consign to silence] (7).

At the same time, however, Wittgenstein seems to have realized that these assumptions were questionable for the penultimate proposition of the *Tractatus* reads:

Meine Sätze erläutern dadurch, dass sie der, welcher mich versteht, am Ende als unsinnig erkennt, wenn er durch sie—auf ihnen—über sie hinausgestiegen ist. (Er muss sozusagen die Leiter wegwerfen, nachdem er auf ihr hinaufgestiegen ist.)
Er muss diese Sätze überwinden, dann sieht er die Welt richtig.

My propositions elucidate in the following way: anyone who understands me eventually recognizes them as nonsensical, when he has climbed up by means of them, on them, over them. (He must, so to speak, throw away the ladder after he has climbed up it.)
He must transcend these propositions, then he will see the world aright. (6.54) [19]

Correspondingly, a careful reading of the *Tractatus* reveals propositions that offer an alternative way of thinking about language and reality to the one set out above. This may have had something to do with Mach's exceptional influence on Wittgenstein's Vienna since the attack on isolated, atomic things is central to Mach's neoempiricism. [20] For example, 2.027 (cited above) is followed immediately by a proposition that entertains the idea that reality may be dynamic rather than composed of clearly defined, static objects: "Der Gegenstand ist das Feste, Bestehende; die Konfiguration ist das Wechselnde, Unbeständige" [The object is the unalterable, sub-

sistent; the configuration is what is changing and inconstant] (2.0271); and proposition 6.522, right at the end of the *Tractatus,* concedes: "Es gibt allerdings Unaussprechliches. Dies *zeigt* sich, es ist das Mystische" [There are, however, things that cannot be expressed in words. *They make themselves manifest,* they are the mystical]. Thus, not only may material reality be nonatomic, a transcendent reality may lie behind it.

Similarly, having stated in the first half of 4.01 that "Der Satz ist ein Bild der Wirklichkeit" [The proposition is a picture of reality], Wittgenstein continues in its second half: "Der Satz ist ein Modell der Wirklichkeit, so wie wir sie uns denken" [The proposition is a model of reality according to the way in which we think of it]. The shift is highly significant, for where the first half of 4.01 implies a correspondence between the structures of language and those of reality, the second half implies that there is no a priori link between them and that language simply offers an interpretation ("ein Modell") of reality that is dependent upon the perspective of the subject ("so wie"). In proposition 5.634, Wittgenstein goes even further down the road of epistemological and linguistic relativism:

Das hängt damit zusammen, dass kein Teil unserer Erfahrung auch a priori ist.
　　Alles, was wir sehen, könnte auch anders sein.
　　Alles, was wir überhaupt beschreiben können, könnte auch anders sein.
　　Es gibt keine Ordnung der Dinge a priori.

That is connected with the fact that no part of our experience is also a priori.
　　Everything that we see could be different, too.
　　Everything that we can possibly describe could also be different.
　　There is no a priori *order of things.*

That is to say: not only does reality have no inherent structure, there are also no a priori categories of the understanding to shape our experience of that (disordered) reality in a predetermined manner.

Then again, in proposition 6.4311, Wittgenstein does three things that work against the third assumption described above. He envisages an event, death, which we cannot experience but about which we can speak; he talks about epiphanic moments that we can experience but not describe except through negative categories ("Unzeitlichkeit"/"timelessness"); and he entertains the possibility that despite the limitations of language, the

human power to perceive ("unser Gesichtsfeld"/ "field of vision") may be unbounded:

Der Tod ist kein Ereignis des Lebens. Den Tod erlebt man nicht.
Wenn man unter Ewigkeit nicht unendliche Zeitdauer, sondern Unzeitlichkeit versteht, dann lebt er ewig, der in der Gegenwart lebt.
Unser Leben ist ebenso endlos, wie unser Gesichtsfeld grenzenlos ist.

Death is not an event of life. One does not experience death.
If we understand by eternity not infinite temporal duration but timelessness, then he lives eternally who lives in the present.
Our life is just as endless as our field of vision is boundless.

Furthermore, having stated in proposition 4.12 that language can depict *all* reality, Wittgenstein then identifies one thing language *cannot* depict, the very thing that, in 4.121, he would claim language and reality had in common—"logische Form" [logical form]:

Der Satz kann die gesamte Wirklichkeit darstellen, aber er kann nicht das darstellen, was er mit der Wirklichkeit gemein haben muss, um sie darstellen zu können—die logische Form.

The proposition can represent the whole of reality, but it cannot represent that which it must have in common with reality in order to be able to represent it—logical form. (4.12)

Similarly, the first part of 4.121 cancels out its second part (cited above) by beginning:

Der Satz kann die logische Form nacht darstellen, sie spiegelt sich in ihm.
Was sich in der Sprache speigelt, kann sie nicht darstellen.
Was *sich* in der Sprache ausdrückt, können *wir* nicht durch sie ausdrücken.

The proposition cannot represent logical form, it is mirrored in it.
What is mirrored in language, language cannot represent.
What expresses itself *in language, we cannot express by means of language.* (4.121)

This means that the very concept of "logische Form," the linchpin holding together language and reality, is self-deconstructive, for if the bound-

aries of my language are indeed the boundaries of my world, and if language cannot depict what must inform both itself and reality for it to be able to mirror that reality, then "logische Form," according to positivist criteria, must be beyond sayability and therefore knowability.

Finally, proposition 5.6 (cited above) is equally self-deconstructive, for if one can imagine boundaries, then one can imagine and approach what lies beyond them, as Wittgenstein does in proposition 6.522 (cited above) and, more tentatively, in his final proposition (designated by the sacred number 7). All of this may be a long way from the outright conventionalism of the *Philosophical Investigations,* but already, in the *Tractatus,* we can see Wittgenstein beginning to discard his own positivistic ladder and move toward four radically opposed ideas: (1) reality may be fluid and have non-material dimensions; (2) language may be a perspectival construct whose structures are not isomorphic with those informing reality; (3) there is no a priori structure in the human mind or the external world; (4) there may be a faculty in human nature which allows us to apperceive things that we cannot depict in terms of linear logic.

Pound, Fenollosa, and Bergson

Not long before his death, the sinologist Ernest Fenollosa (1853–1908) wrote an essay entitled "The Chinese Written Character as a Medium for Poetry." In late 1913 his widow passed the manuscript to Ezra Pound who then published it in *Instigations* together with a brief preface he had written in 1918.[21] Although dismissed by professional sinologists (just as Nietzsche's *Die Geburt der Tragödie* had been dismissed by professional classicists fifty years before), Fenollosa's thinking about language and reality prefigures and expands on several of the propositions in the *Tractatus* where Wittgenstein offers alternatives to his positivistic assertions. Moreover, just as the *Tractatus* deconstructs itself, so "The Chinese Written Character," with which Pound was clearly in agreement, since he described it in his preface "as a study of the fundamentals of all aesthetics," deconstructs Pound's thinking about language and reality as that had been set down in the theoretical writings of his Imagist and Vorticist period (c. 1912–15). During the years around the Great War, Pound, like Wittgenstein, was pulled between two fundamentally incompatible ways of thinking about language and reality—a fissure that has also been identified in his poems and prosodic experiments of the period.[22]

The theory expounded by the Imagists was underpinned by a belief in

the reality of things and the ability of language to grasp them in order to produce an image, a double assumption remarked by Graham Hough when he described the Imagist world as being "composed of atomic notations, each separate from the others." In his classic statement, for instance, F. S. Flint defined the first of Imagism's three rules as "direct treatment of the 'thing,' whether subjective or objective." Similarly, the preface to the 1915 anthology *Some Imagist Poets* emphasize the "*exact* word, not the nearly-exact, nor the merely decorative word," "hard and clear" poetry, and "concentration" as the essence of poetry.[23] In his commentary on Flint's piece, which was published immediately after it in the March 1913 issue of *Poetry*, Pound began by assenting to Flint's rules, albeit "not as dogma," and then went on to privilege the concrete over the abstract.[24] But one can sense Pound moving away from the belief in the correspondence between words and things that is implied in that qualified assent when he then defined the essential aim of Imagism as the production of an image that "presents an intellectual and emotional complex in an instant of time" and so generates a "sense of freedom from time limits and space limits" (200). Clearly, Pound had some sense that the (paradoxical) effect of a thing on the imagination, once it has been transformed into an "image," is to subvert the reality of things by transporting the imagination out of the objective world. Seven years later, in "Swinburne," T. S. Eliot, with whose poetry Pound had felt an affinity since at least 1915, would sense the same ambiguous pull. On the one hand, Eliot censures Swinburne for failing to get his words to fit his objects on the (Imagist) assumption that "Language in a healthy state presents the object, is so close to the object that they are one thing." On the other hand, Eliot is attracted to a different, "more important" kind of language: "that which is struggling to digest and express new objects, new groups of objects, new feelings, new aspects, as, for instance, the prose of Mr. James Joyce or Mr. Joseph Conrad."[25] In the last sentence it is very evident that as Eliot thinks about what actually happens in the works of the two novelists cited, he moves increasingly further away from the thing-centered criterion that had informed his discussion of Swinburne.

By late 1914, Pound had distanced himself from Imagism, but in his first Vorticist essay he reaffirmed Imagism's position on the relationship between language and reality by reiterating Flint's three "tenets of the Imagiste faith" and citing approvingly St. Thomas Aquinas's dictum "*Nomina sunt consequentia rerum*" [*Names are the consequences of things*].[26] Despite that, one can also see Pound rejecting any implied correspondence

between words and things even more emphatically when he denies that Imagism and Vorticism are concerned with mimesis and when he stresses, even more forcefully than he had done in his commentary on Flint's piece, that his major concern is with the dynamism that things can release once they have been transformed into verbal images:

> By the 'image' I mean such an equation; not an equation of mathematics, not something about *a, b* and *c,* having something to do with form, but about *sea, cliffs, night,* having something to do with mood.
>
> The image is not an idea. It is a radiant node or cluster; it is what I can, and must perforce, call a VORTEX, from which, and through which, and into which, ideas are constantly rushing. (469)

Like Wittgenstein in the *Tractatus,* Pound was at one and the same time attached to the pre-Saussurean idea that nouns name things (and so form the central link between language and reality) and drawn to the idea that a gap separates language and reality. Hence Pound's ambiguous notion that by grasping things in language with concentrated precision, the poet could make nonobjective energies leap from the page. But where for Pound the Imagist, the effect of this was to create that unmediated sense of real presence about which Wittgenstein spoke more guardedly and abstractly in 6.4311 (cited above), for Pound the Vorticist, the effect of this was to release a more elemental charge of energy.

To a considerable extent, Fenollosa's essay resolved the ambiguity of Pound's prewar thinking by denying the existence of things, decisively severing the link between words and things, and developing the more dynamic aspect of Pound's prewar aesthetic.[27] To the extent that it does so, Fenollosa's essay also prefigures and develops several of Wittgenstein's deconstructive propositions. First, Fenollosa's entire essay focuses on what Wittgenstein would call "das Wechselnde, Unbeständige" [the changing, the inconstant] (2.0271) and so repudiates the idea that reality consists of material things in favor of the idea that reality is in a state of energetic flux which he calls "nature" (364). Fenollosa also develops Wittgenstein's idea that language is "ein Modell der Wirklichkeit, so wie wir sie uns denken" [a model of reality according to the way in which we think of it] since in his view all languages, especially printed Western languages, are simply arbitrarily constructed and hopelessly inaccurate means of getting at and rendering reality (365). Indeed, in Fenollosa's view, European logic is like a brickyard and the European logician like a bricklayer who selects little hard units and sticks them together with "is" or "is not" in order to build

linear linguistic units that are incapable of dealing with interactive, multidimensional "nature" (380 and 382). Consequently, just as Wittgenstein could entertain the thought that there is no "Ordnung der Dinge a priori" [a priori order of things] (5.634), so Fenollosa could say that Nature has no grammar (371) and thus posits no equivalent of Wittgenstein's "logische Form."

Finally, as I have said, propositions 6.4311 and 6.522 tentatively concede that there may be a metaphysical dimension to reality that language can approach, albeit with circumspection. Fenollosa is much bolder over this matter, since in his estimation the complex visual patterns of Chinese ideograms are a more adequate if only approximate image of the workings of Nature (362). Thus, to some extent at least, the visual dimension of the ideogram can compensate for the natural deficiencies of language and so enable us to get much closer than any phonetic language to the fluid, ultimately inexpressible power at work in Nature (378). In Fenollosa's estimation, the lines of a Chinese ideogram, unlike Western phonetic languages, still retain something of the creative process that is within both the Chinese language and Nature itself (379–80). Consequently, if we in the West want to produce poetry that begins to do justice to the complex, dynamic interrelationships of reality, we have to move away from the noun-based syntax that implies the reality of (illusory) things, and develop a more active syntax based on transitive verbs that can make manifest the force within Nature (383–84). In a much less tentative way than Wittgenstein then, Fenollosa posits an apperceptive faculty in human nature that can perceive dynamic patterns inaccessible to the sense of sight and translate them into ideogrammatic, verb-based models.

All this brings Fenollosa very close to Bergson's position as that is set out in "Introduction à la Métaphysique" (1902) (*An Introduction to Metaphysics*, 1913) and *L'Évolution créatrice* (1907) (*Creative Evolution*, 1911).[28] Because, for Bergson, all reality is governed by an *élan vital* and in a state of endless flux, there are no things but only actions (*EC*, 270/261). Consequently, he, too, is acutely conscious of the limitations of human intelligence and language, going so far as to state that "*l'intelligence est caracterisée par une incompréhension naturelle de la vie*" [*the intelligence is characterized by a natural inability to comprehend life*] (*EC*, 179/174). The human mind can, he concedes, impose conceptual patterns on the surface of fluctuating reality and these may look stable and solid enough, but because reality is continually shifting, such constructs can never do justice to its complexity (*IM*, 27/58). The further parallels with Fenollosa's ideas are so obvious as to

need no extensive exposition and it is not hard to see how Bergson's basic position involves a massive extension of the deconstructive aspects of the *Tractatus* discussed above. But unlike Fenollosa and Wittgenstein, Bergson brings into sharp relief a concept that the other two writers simply imply: a faculty of apperception, "intuition," that can make imaginative leaps into what lies beyond the material, objective surface of reality:

> [Notre intelligence] peut suivre la marche inverse. Elle peut s'installer dans la réalité mobile, en adopter la direction sans cesse changeante, enfin la saisir au moyen de cette *sympathie intellectuelle* qu'on appelle intuition. Cela est d'une difficulté extrême. Il faut que l'esprit se violente, qu'il renverse le sens de l'opération par laquelle il pense habituellement, qu'il retourne ou plutôt refonde sans cesse toutes ses catégories. Mais il aboutira ainsi à des concepts fluides, capables de suivre la réalité dans toutes ses sinuosités et d'adopter le mouvement même de la vie intérieure des choses. (*IM*, 27)

> *But the truth is that our intelligence can follow the opposite method. It can situate itself within mobile reality, adopt its ceaselessly changing direction, and in short grasp it by means of that* intellectual sympathy *which we call intuition. This is extremely difficult. The mind has to do violence to itself, has to reverse the direction of the operation by means of which it normally thinks, has perpetually to revise, or rather to recast all its categories. But in this way it will end up with fluid concepts, capable of following reality in all its sinuosities and of adopting the very movement of the inner life of things.* (*IM*, 59; see also *EC*, 192/186)

Bergson's thinking about the nature of reality and the relationship of intuition with reality has, in the context of modernist theorizing about and experimentation with language, five major implications. First, it means that in Bergson's view, there is more to the mind than the consciousness that receives sense data and formulates ideas on the basis of these. Whereas Western thought since Descartes had tended to assign ontological priority to the *cogito*, Bergson inverts this and, like the English Romantics, argues that if the personality is to have a correct relationship with reality, then priority must be assigned to intuition that is integrated with reason (*EC*, 293/285).[29] Second, Bergson's thinking means that chance and disorder are not absolute concepts, but simply concepts relative to the perceiver (*EC*, 255/247) so that it is impossible to say that reality is either ordered or chaotic a priori. Third, although in Bergson's view the artist has the power

to intuit patterns within the flux of reality, any attempt to translate these intuitions into the "concepts fluides" envisaged in the *Introduction* (27/59) or the works of art envisaged in *L'Évolution créatrice* will be provisional and produce only what Wittgenstein referred to as "Modelle" (4.01), approximations that have a more or less loose relationship to reality.

But at an even more fundamental level, Bergson's analysis of the dynamic, shifting, and elastic relationship between human beings and reality as that is mediated through intuition and language opens up the possibility of transcending the sense of crisis and cultural pessimism that haunted so much of modernism, especially during its early phase. For Bergson, as for Mach and Nietzsche, the ego is only a word so that it is an error to believe that one can find a thing behind the word (*IM*, 12/26). In contrast, the faculty of intuition, vague and discontinuous though it may be, can, in Bergson's view, hold the human personality together by giving it some sense of purpose and direction. Bergson describes it as:

> . . . une lampe presque éteinte, qui ne se ranime que de loin en loin, pour quelques instants à peine. Mais elle se ranime, en somme, là où un intérêt vital est en jeu. Sur notre personnalité, sur notre liberté, sur la place que nous occupons dans l'ensemble de la nature, sur notre origine et peut-être aussi sur notre destinée, elle projette une lumière vacillante et faible, mais qui n'en perce pas moins l'obscurité de la nuit où nous laisse l'intelligence. (*EC,* 290)

> . . . *a lamp which is almost extinguished and which only comes to life now and again, for scarcely a few moments. But when all is said and done it does come to life whenever a vital interest is at stake. On our personality, on our freedom, on the place we occupy in Nature as a whole, on our origin and perhaps, too, on our destiny, it throws a guttering and feeble light, but which none the less pierces the darkness of the night in which the intellect leaves us.* (*EC,* 282)

Finally, Bergson's thinking means that what, to the person in whom intuition has been eclipsed by empirical reason, looks like absolute nothingness (*EC,* 320/298) turns out, when apperceived by the intuition, to be total plenitude:

> Que si maintenant nous analysons cette idée de Rien, nous trouvons qu'elle est, au fond, l'idée de Tout, avec, en plus, un mouvement de l'esprit qui saute indéfinement d'une chose à une autre, refuse de se tenir

en place, et concentre toute son attention sur ce refus en ne déterminant jamais sa position actuelle que par rapport à celle qu'il vient de quitter. C'est donc une représentation éminemment compréhensive et pleine, aussi pleine et compréhensive que l'idée de *Tout* avec laquelle elle a la plus étroite parenté. (*EC,* 320; see also 322)

If now we analyse this idea of Nothing, we find that it is, at bottom, the idea of Everything, together with a movement of the mind which keeps jumping from one thing to another, refuses to stand still, and concentrates all its attention on this refusal by never determining its present position except in relation to the one it has just left. It is therefore an eminently comprehensive and full idea, as full and comprehensive as the idea of All, *to which it is very closely related.* (*EC,* 312; see also 314)

It would be wrong to equate Bergson's "Tout" and Fenollosa's "Nature" with Wittgenstein's concept of "das Mystische." Nevertheless, there is a sense, muted and barely thinkable in the *Tractatus,* stronger and more extensively formulated in "The Chinese Written Character" and *L'Évolution créatrice,* that the loss of confidence in ordinary syntax, linear logic, and the power of reason to grasp reality in any final sense may actually be a gain. Certainly, for Fenollosa and Bergson, as for Lord Chandos, this loss can enable human beings to open themselves to a nonobjective reality and form a relationship with it in a way that involves not domination but humility in the face of what is ultimately unsayable. Which is why, as we shall see, Bergson was so important for Dada and why, possibly, he had such an impact on a range of writers that included Eliot, Proust, Joyce, Valéry, and C. G. Jung.[30]

The Problem of Language and Modes of Modernist Poetry

On 5 December 1914, the Austrian Expressionist poet and dramatist Franz Werfel published an article in the major Expressionist periodical *Die Aktion* (*Action*) in which, reviewing the past year, he said:

Wir sind alle hineingestellt in eine fürchterliche Unübersehbarkeit, der Reichtum der Einsichten und Organismen trug Verzweiflung und Wahnsinn in uns hinein, wir stehen machtlos der Einzelheit gegenüber, die keine Ordnung zur Einheit macht, es scheint, das "*Und*" zwischen den Dingen ist rebellisch geworden, alles liegt unverbindbar auf dem

Haufen, und eine neue entsetzliche Einsamkeit macht das Leben stumm.

We have all been put into a frightful situation where we have no overall view of things; the abundance of insights and organisms has brought despair and madness into our souls; we are impotently confronting the individual detail which makes no order into unity; it seems that the "and" between things has become rebellious; everything lies disconnectedly in a heap, and a terrible new sense of loneliness makes life mute.[31]

The echoes of Chandos's letter are unmistakeable and over two years later, after the appalling slaughter at Verdun and on the Somme, Hugo Ball would put matters even more forcefully in his lecture on Kandinsky cited in chapters 1 and 2. Nevertheless, Ball's diary indicates that he was in two minds about how to interpret this crisis. On the one hand, his entry of 8 April 1916 indicates that he felt that it was possible to view it as a liberating experience:

Man kann fast sagen, dass, wenn der Glaube an ein Ding oder an eine Sache fällt, dieses Ding und diese Sache ins Chaos zurückkehren, Freigut werden. Vielleicht aber ist das resolut und mit allen Kräften erwirkte Chaos und also die vollendete Entziehung des Glaubens notwendig, ehe ein gründlicher Neuaufbau auf veränderter Glaubensbasis erfolgen kann. Das Elementare, Dämonische springt dann zunächst hervor; die alten Namen und Worte fallen. Denn der Glaube ist Mass der Dinge, vermittels des Wortes und der Benennung.

One can almost say that when belief in an object or a cause comes to an end, this object and this cause return to chaos and become fair game for everybody. But perhaps it is necessary to have resolutely, forcibly produced chaos and thus a complete withdrawal of faith before an entirely new edifice can be built up on a changed basis of belief. The elemental and demonic then come to the fore first; the old names and words are dropped. For faith is the measure of things by means of the word and of nomenclature.[32]

But on the other hand, his entry of 7 June 1920 reads:

Die Trennung der Vernunft von den Gegenständen . . . bringt eine Katastrophe besonderer Art herauf. Indem man das Wort von den Dingen trennte, entfesselte man die Natur in einer bis dahin unerhörten Weise, und indem man die Form von der Materie abzog, verlieh man der letz-

teren all jene urtümliche Monstrosität, der wir uns überall hilflos ausge-
liefert und bis zum Blutschwitzen überantwortet sehen. (261)

*A catastrophe of a special kind is caused by the separation of reason from real
objects. . . . By dissociating the word from objects, man unleashed Nature
in an unprecedented[ly shocking] way, and by stripping form from matter,
man conferred on the latter all that original monstrousness [to which we are
helplessly exposed everywhere and] which keeps us helplessly in its clutches
until we sweat blood.* (184–85)

Ball's experiences during the decade around the Great War constituted
a prolonged version of Chandos's rats in the cellar experience, and his
profound uncertainty about the meaning of that cultural, existential, and
linguistic crisis (which was resolved only by his re-conversion to a highly
ascetic form of Catholicism in July 1920) is equally paradigmatic for the
entire modernist generation. It was this experience of crisis and uncertainty
that produced so much thinking during the period about language, reality,
and their relationship and generated so many of modernism's abstract, ex-
perimental, and "difficult" poetic texts. But these texts are by no means
all of a piece and can be differentiated and analyzed in terms of the (often
ambiguous) assumptions that their authors make about language, reality,
and the relationship that obtains, or ought to obtain, between them. Ac-
cordingly, in the rest of this chapter, I shall undertake such an analysis and
examine various examples of modernist poetry under three broad headings:
conservative, revisionist, and radical.

(i) Conservative

In 1926, the German critic Kurt Oppert characterized Rilke's *Neue Ge-
dichte* as "Ding-Gedichte" [Thing Poems].[33] In doing this, he was taking
his cue from Rilke's two-part work *Auguste Rodin* (1903 and 1907) (the first
part of which was translated as *Rodin* [1946]), in which Rilke had set out
his metaphysic of art in terms that are more subtle than but not radically
distinct from the Imagist ideas about poetry discussed above. Rilke's key
statement occurs early in part 2 (that is, during the time when he was writ-
ing his *Neue Gedichte*):

Dinge

Indem ich das ausspreche (hören Sie?), entsteht eine Stille; die Stille,
die um die Dinge ist. Alle Bewegung legt sich, wird Kontur, und aus

vergangener und künftiger Zeit schliesst sich ein Dauerndes: der Raum, die grosse Beruhigung der zu nichts gedrängten Dinge.

Things

As I utter that word (do you hear?), a stillness ensues; the stillness that is around things. All movement ceases, becomes contour, and from time that is past and still to come, something lasting closes in on itself: space, the great coming to rest of things that have been compressed to nothing.[34]

Quite apart from its affinities with Imagist ideas, this is a version of the Platonic theory of art, reformulated by Coleridge in his *Lay Sermons* (1816), according to which a symbol has the power to transmit the "translucence of the eternal through and in the temporal," to partake "of the reality which it renders intelligible," and, while enunciating the whole, to abide itself "as a living part in that unity of which it is the representative."[35] In other words, the Rilkean "Ding" like the Coleridgean "symbol" can bind the physical and the metaphysical and it is quite clear that at the level of conscious intention Rilke thought of the *Neue Gedichte* in such terms. But if one brackets out the titles of many of these poems and reads them with one's imagination freed from the expectations generated by the titles, then one frequently makes a surprising discovery. The poems are less about the mediation of a transcendent stillness that inheres in and around a particular, irreducible "Ding" and more about an attempt to conserve a sense of logocentric order in the teeth of elemental energies that threaten to subvert it and evade linguistic control.

Take "Der Turm" ("The Tower") (written 18 July 1907) for instance:

Der Turm
Tour St-Nicholas, Furnes

Erd-Inneres. Als wäre dort, wohin
du blindlings steigst, erst Erdenoberfläche,
zu der du steigst im schrägen Bett der Bäche,
die langsam aus dem suchenden Gerinn

der Dunkelheit entsprungen sind, durch die
sich dein Gesicht, wie auferstehend, drängt
und die du plötzlich *siehst,* als fiele sie
aus diesem Abgrund, der dich überhängt

und den du, wie er riesig über dir
sich umstürzt in dem dämmernden Gestühle,

erkennst, erschreckt und fürchtend, im Gefühle:
o wenn er steigt, behangen wie ein Stier—:

Da aber nimmt dich aus der engen Endung
windiges Licht. Fast fliegend siehst du hier
die Himmel wieder, Blendung über Blendung,
und dort die Tiefen, wach und voll Verwendung,

und kleine Tage wie bei Patenier,
gleichzeitige, mit Stunde neben Stunde,
durch die die Brücken springen wie die Hunde,
dem hellen Wege immer auf der Spur,

den unbeholfne Häuser manchmal nur
verbergen, bis er ganz im Hintergrunde
beruhigt geht durch Buschwerk und Natur.

The Tower
Tour St-Nicholas, Furnes

Earth-inness. As if not till where you still
so blindly climb to where the Earth's outside:
climb in this criss-cross watercourse supplied
by slow upwellings from the groping rill

of darkness which your face is pressing through
like face of one arising from the dead,
and which can suddenly be seen *by you,*
as though it fell from that high-overhead

hanging abyss, which, in the glimmering
belfry gigantically overheeling,
you recognize with start of terror, feeling:
'If, belled there like a bull, it's clambering!'—

You're drawn, though, from the narrow termination
by gusty light. Near-flying, can see here
the sky's scarce-bearable illumination,
and there the depths, all wakeful application,

and little days, like those of Pateni[e]r,
with hours all simultaneously appearing,

through which, like hounds, the bridges are careering
incessantly along the bright road's trail,

which clumsy houses sometimes just avail
to hide till the far background it's steering
calmly through copses and the open dale.[36]

The first three stanzas involve considerable linguistic and semantic confusion that the syntax can barely contain. For example, the exact relationship between two of the six relative pronouns and their antecedents is by no means unambiguous on first reading. Initially, one can read the "die" of lines 5 and 7 as relating to "Erdenoberfläche," "Bäche," and/or "Dunkelheit," and the options are reduced to two only in line 7, when the pronoun "sie" makes it clear that the noun must be singular. But even then, it takes several additional readings to work out that "Dunkelheit" makes better syntactical sense as the relevant antecedent. Moreover, in the absence of a title, one would acquire some sense of the poem's context only in line 10, when one encounters the special word "Gestühle" [belfry]. Upto then, without benefit of title, it is not at all clear whether one is climbing from or to the "Erd-Inneres" [Earth-inness] and whether the climb is a real or metaphorical one [als wäre]. But whatever the level of signification, that ascent is undertaken "blindlings" [blindly] and once the end is reached, the darkness that one suddenly sees appears to be falling *down from* an abyss (line 8): that is, from a location one normally thinks of being below and *into* which things fall. This abyss, which one would also usually assume to be static, then moves in a sudden and terrifying way for no apparent reason ("sich umstürzt"/"overheeling"), and having been described as hanging over the observer's head ("dich überhängt"/"high-overhead"), it invades the belfry itself without warning and threatens to turn into something elemental and violent ("ein Stier"). Reassured by the title, one can opt for a naturalized reading of "Der Turm" and argue that the poem's first half transcribes the feeling of vertigo induced by climbing the spiral staircase of a church tower. But without that securely located, nominal, and talismanic title, one has to cope with a linguistic construct where the stress falls firmly upon verbal elements and with a decentered vision of a reality that pulsates with cosmic energies and elemental powers. Moreover, this vision is marked by several constructions that create a sense of disorientation and indeterminacy "("Als wäre dort," "wie auferstehend," "als fiele sie," "o wenn er steigt" / "As if," "like," "as though it fell," "If . . . it's

clambering"), all of which suggest that the poet is only just managing to transcribe that vision, and the fact that he cannot do so with any finality is indicated by the absence of a full stop from the last line.

The second half of the poem contrasts strikingly with the first half. Not only is it easier to grasp from the point of view of semantics and syntax, it becomes clear very quickly, even without the help of the title, that one is standing on a high place looking out over a landscape, for what one sees are "kleine Tage wie bei Patenier" [little days, like those of Pateni(e)r]. Not only have the cosmic dimensions of the first stanza been reduced to manageable proportions ("klein"/"small"), but Joachim Patenier (c. 1475–1525) was an early Renaissance Flemish painter who helped pioneer the art of painting landscapes *perspectivally*—that is, who helped initiate the mimetic ordering of Nature in terms of its distance from the painter/beholder. Indeed, the entire second half of the poem is centrally concerned to restore perspectival order and overcome the verbal disorder and uncertainty of the poem's first half by the increasing use of securely located, named objects. Thus, the last three stanzas proceed regularly through space until the "Hintergrund" [background] is reached in the final one. Their spatiotemporal relationships become unequivocal ("hier die Himmel . . . und dort die Tiefen" / "here the sky's . . . there the depths"; "Blendung über Blendung"—the English fails completely to catch this; "Stunde neben Stunde" / "hours all simultaneously"). And the nouns become progressively less abstract between the first and third stanzas. Moreover, the darkness of the poem's first half becomes daylight; the wild steer is replaced by dogs; no sudden, threatening transformations take place; and the "schräge[s] Bett der Bäche" [criss-cross watercourse] becomes a "Weg" [trail] that "calms" [beruhigt] the landscape and so offers the reader even more "semantic succour" (Beckett's phrase) as the poem nears its end. The absence of the expected fourth line in the sixth stanza may suggest that the visual and syntactical order that has been restored is more apparent than real, but overall, linguistic confidence has supplanted incipient desperation.

Something similar happens in "Die Fensterrose" ("The Rose Window") (written on or about 8 July 1906). Again, if one brackets out the title and forgets that this poem was inspired by the great rose window in Chartres Cathedral, then for the first eleven lines at least, one finds oneself in a menacing context that has nothing to do with cathedrals and is similar to that of the first half of "Der Turm":

Die Fensterrose

Da drin: das träge Treten ihrer Tatzen
macht eine Stille, die dich fast verwirrt;
und wie dann plötzlich eine von den Katzen
den Blick an ihr, der hin und wieder irrt,

gewaltsam in ihr grosses Auge nimmt, —
den Blick, der, wie von eines Wirbels Kreis
ergriffen, eine kleine Weile schwimmt
und dann versinkt und nichts mehr von sich weiss,

wenn dieses Auge, welches scheinbar ruht,
sich auftut und zusammenschlägt mit Tosen
und ihn hineinreisst bis ins rote Blut—:

So griffen einstmals aus dem Dunkelsein
der Kathedralen grosse Fensterrosen
ein Herz und rissen es in Gott hinein.

The Rose Window

In there: the lazy-pacing paws are making
a silence almost dizzying you; and then
how suddenly one cat-like creature's taking
the glance that strays to it and back again

into its great eye irresistibly, —
the glance which, grasped as in a whirlpool's twist,
floats for a little while revolvingly
and then sinks down and ceases to exist,

when that eye, whose reposefulness but seems,
opens and closes with a raging clasp
and hales it in to where the red blood streams: —

Thus from the darkness there in days gone by
would the cathedrals' great rose-windows grasp
a heart and hale it into God on high.[37]

The first eleven lines involve large predatory animals; eddies of transitory motion that come into being and then vanish; things that appear to be one thing and then, disconcertingly, turn into something else; dis-

embodied movements (we hear about "das träge Treten ihrer Tatzen" [the lazy-pacing paws] three lines before the motion of the German verbal noun [translated by an attributive adjective] is attached to an animal); and puzzling uncertainties (it is by no means clear whose "Blick" [glance] is being referred to in lines 4 and 6). These lines also involve sudden and fantastic events. If, for example, the "Auge" [eye] of lines 5 and 9 belongs to a cat, then how can it shut "mit Tosen" [with a raging clasp]? The language accelerates and becomes increasingly violent until, in the final tercet, after a parenthetical mark, Rilke recalls the centered image of the title to make sense of the bewildering scene that has preceded it. Correspondingly, the indeterminacy and escalating violence of the first eleven lines are resolved, superficially at least, by the unequivocal syntax, visual imagery, and monumental nouns of the last three lines. Moreover, the classically logocentric pattern of the circle is invoked to control a disturbing and confusing world that has been on the point of evading the grasp of language (cf. "die dich fast verwirrt"/ "almost dizzying you" of line 2). Nevertheless, the reassuring analogy introduced by "So" is an aesthetic illusion masking a darker reality since there is all the difference in the world between the voracious, predatory violence with which the first eleven lines conclude and the mystical relationship between God and the soul that the rose window is said to mediate in the final tercet. Where in line 11 "hineinreisst" denotes the carnivorous action of a wild beast ("tears it in" would be far more accurate than the innocuous "hales it in"), the same verb, *reissen,* when used again in line 14, denotes a qualitatively different action on a totally different plane and means "to seize hold of and pull." So again it can be argued that the linguistic confidence with which the poem ends is more apparent than real.

Over and over again, the *Neue Gedichte* are pulled simultaneously in two entirely different directions. On the one hand, Rilke affirms and seeks to conserve the reality of things and the ability of language to grasp and distil a metaphysical essence from them: he "praises" ("rühmt") them, as he would put it in his untitled dedicatory poem for Leonie Zacharias of 20 December 1921. But on the other hand, he does this in a situation where the reality of things and the ability of language to grasp them is under radical threat. Rilke's book on Rodin contains two photographs of two versions of Rodin's sculpture *Le Penseur* (*The Thinker*): one in massive isolation outside the Panthéon in Paris and one, diminutive, above the gates in the vast bronze sculpture *La Porte de l'Enfer* (*The Gates of Hell*).[38] This latter work

is problematic because, having worked on its plaster cast for twenty years, Rodin's relationship with it became so complex after 1900 that he had it disassembled. He became more reconciled with it in the years 1910–12 and had the plaster cast reconstructed by Bénédite in 1916 and 1917 but died before completing the cast or seeing it turned into a bronze (of which several examples exist).[39] To quote Rosalind Krauss, it is a perfect example "on both a technical and conceptual level, of multiples without an original." Thus, she concludes, "as we try to move from the plurality of the casts to the unity of the model, we find this unity, this original, splintering, compounding"—a process that had begun even before the first bronze was cast, since individual figures or groups from the gates themselves had been exhibited independently from 1900 onward.[40] Moreover, when one considers that a seething, grieving mass of disordered, struggling bodies twists across the stark, bronze face of the gates, and that, paradoxically, Rilke had said as much in the first part of *Auguste Rodin,* then the sculpture is not a "Ding," let alone a "Kunst-Ding" in Rilke's sense.[41] For in place of a "Ding," we have an unfinished, assemblagelike cast and subsequent copies. Where there should be "ein Dauerndes" [something lasting], there is a provisional mock-up. Where there should be transcendent stillness, there is the suffering of the damned. The gates themselves are stylistically eclectic; and the impression that the bronze makes on the spectator changes according to the lighting, the time of day, the perspective of the viewer, and the distance from which the gates are seen.[42] But over and above those contextual considerations, the two versions of *Le Penseur* precisely encapsulate the ambiguity at the heart of the *Neue Gedichte* and may help to explain why Rilke was so drawn to Rodin's work while writing them. It is possible to read the *Neue Gedichte* either as the explicit celebration of the power of the human logos to name, entitle, and order, or as an implicit testimony to the smallness, fragility, and relative powerlessness of that selfsame faculty when confronted by infernal, elemental powers. At the conscious level, Rilke clearly thought that his poetry was doing the former, but like the *Tractatus* and even more dramatically, the *Neue Gedichte* involve significant elements that subvert their ostensible project.

(ii) Revisionist

On a surface reading, the principles and practice of Italian Futurism look very radical indeed. Marinetti's "L'immaginazione senza fili e le parole in libertà" (June 1913) ("Destruction of Syntax—Imagination without

Strings—Words-in-Freedom 1913," 1970), for example, looks at first sight like the product of a twentieth-century imagination that has broken decisively with nineteenth-century modes of thinking and writing. It seems to have rejected both the positivist assumption that the noun is the name of the thing and the Platonic/Symbolist assumption that the thing can be transformed into a symbol of the transcendent by the poetic imagination. Now, although the Futurists *did* jettison the latter assumption as "moonshine," a closer examination of their theory and practice reveals that they nevertheless retained the former one. Despite Marinetti's rejection of conventional syntax and punctuation, reduction of all verbs to the infinitive, free expressive orthography, and use of mathematical symbols and nonlinear typography, the Futurists in general were deeply attached, as Wittgenstein's Futurist alter ego might have put it, to the idea that "der dynamische Satz ist ein Bild der dynamischen Wirklichkeit" [the dynamic proposition is a picture of dynamic reality].

When Marinetti reissued the above manifesto in *Noi futuristi* (*We Futurists*) (1917), he followed it with an example of Futurist writing (a depiction of a battle):

Esempio di Parole in Libertá

Avanguardie: 20 metri battaglioni-formiche cavalleria-ragni strade-guardi generale-isolotto staffete-cavallette sabbie-rivoluzione obici-tribuni nuvole-graticole fucili-martiri shrapnels-aureole multiplicazione addizione divisione obici-sottrazione granata-cancellatura grondare colare frana blocchi valanga.[43]

Example of Words in Freedom

Vanguards: 20 meters battalions-ants cavalry-spiders roads-fords general-small island orderlies-grasshoppers sands-uprising howitzers-tribunes clouds-gridirons guns-martyrs shrapnels-haloes multiplication addition division howitzers-subtraction grenades-deletion streaming trickling landslide rock-masses avalanche.

He then expanded it by a factor of five to show how a conservative poet would have dealt with the same subject. But as White rightly states, Marinetti's "telegraphic lyricism" was synonymous in his eyes with the compressed analogies of the "wireless imagination"; the "paragraph ... is dominated by nominal juxtapositions, with verbs in the infinitive ... only taking over from nominal asyndeton in the final description of slaughter"; and

the "reduced syntax becomes a means of indulging in impressionistic pairings, with the hyphen masking a truncated simile."[44] Or to put it another way, Marinetti's strident radicalism masks a fundamental linguistic conservatism. Life may have changed and technological modernity may be the new order (which Rilke detested and excluded as far as possible from his poetry), but instead of going on to see that this new order requires a totally new understanding of reality and the relationship between language and reality, Marinetti opts for a much simpler solution.[45] To begin with, the *dinamismo universale* [universal dynamism] hymned by the Futurists in their manifestos, poems, and visual work is not the same as Fenollosa's vision of an energetic universe in multidimensional flux. Rather, it denotes a Creation that consists of speeded-up, but intact and irreducible, atomic things in linear motion. From this, in Marinetti's view, it follows that if we allow modern words into poetry and strip language down to its essentials (nouns and verbal nouns linked by mathematical signs), then it is possible to retain the assumption that there is a homology between noun-based syntax and thing-based (molecular) reality. As Marjorie Perloff saw, Marinetti remained committed to linguistic mimesis.[46]

This essentially pre-twentieth-century view of things comes through by implication in "Distruzione della sintassi," when Marinetti proclaims "il fondo analogico della vita" [the analogical foundation of life] and says that the Futurist should express "l'infinitamente piccolo che ci circonda, l'impercettibile, l'invisibile, l'agitazione degli atomi, il movimento Browniano, tutte le ipotesi appassionate e tutti i dominii esplorate dell'ultramicroscopia" [the infinite smallness that surrounds us, the imperceptible, the invisible, the agitation of atoms, the Brownian movements, all the passionate hypotheses and all the domains explored by the high-powered microscope].[47] Ball's reference to "the theory of electrons" in his lecture on Kandinsky suggests that he, like Kandinsky (see chapter 6), was to some degree aware of the divisibility of the atomic particle and the disruptive nature of subatomic physics. In contrast, Marinetti nowhere suggests either that the atom may not be the basic building block of matter or that reality may not be accessible to the senses. The microscope he envisages is an advanced version of the conventional one that extends the range of the human eye, not the electron microscope that pictorializes indirectly a subatomic reality inaccessible to the eye. The Futurist poet Pino Masnata made these basic assumptions absolutely explicit when he wrote in a letter (undated) to his co-Futurist Giovanni Acquaviva:

Nelle parole in libertà adopero il sostantivo a *doppio caso* (soggetto del verbo che segue e complemento oggetto del verbo che lo precede); ed adopero l'aggettivo *bivalente* (che si concorda col sostantivo precedente e con il sostantivo susseguente).

Mi sono in tal modo accorto che si può strutturare un nuovo pensiero poetico, legando i sostantivi con altri sostantivi mediante aggettivi o verbi.

Lo stesso comportamento, che avviene nelle molecole.

Posso paragonare i sostantivi ad "atomi" ed il resto a vere e proprie "valenze" componenti e significati.

La "molecola sintattica" che così risulta ha un aspetto statico o reversibile, quando le valenze sono aggettivi.

La molecola verbalizzata diventa invece ruotante, quando le valenze sono verbi.

Viene così iperinterpretata la sintassi tradizionale, costituita da soggetto, verbo e predicato.

In tal modo, creo degli oggetti di poesia veri e propri a due o tre dimensioni, su una superficie, o nello spazio a più dimensioni.

Concludendo: *la sintassi molecolare è la sintassi dell'universo.*[48]

In words-in-freedom I use the two-case *noun (subject of the verb that follows and object complement of the verb that precedes it); and I use the* bivalent *adjective (that agrees with the preceding noun and with the noun that follows it).*

By so doing I have noticed that it is possible to construct a new mode of poetic thinking, linking the nouns with other nouns by means of adjectives or verbs.

The same behavior that occurs in molecules.

I can compare nouns to "atoms" and liken the rest to true and proper "valencies," components and meanings.

The "syntactic molecule" which thus results has a static or reversible aspect, when the valencies are adjectives.

Conversely, the verbalized molecule starts to rotate when the valencies are verbs.

Thus, traditional syntax is hyperinterpreted, made up of subject, verb and predicate.

In such a way I create true and proper three-dimensional objects of poetry in multidimensional space.

In conclusion: molecular syntax is the syntax of the universe.

White points out the fallacy of "positing a similarity between substantives and atoms" and argues that this "effectively limits the potential helpfulness of [Masnata's] insight." But he does not seem to realize that the equation of "*molecular syntax*" with "*the syntax of the universe*" is simply the most extreme formulation of a set of conservative assumptions that informs many Futurist texts. Nor does he seem to see that it legitimizes the charge that Pound had made in his first Vorticism essay. For there Pound had said that when "Futurism gets into art, [it] is, for the most part, a descendant of Impressionism. It is a sort of accelerated Impressionism"—and so, ultimately, backward-looking.[49]

Similar considerations apply to the abstract poetry of the Berlin Expressionist *Sturm-Kreis* [Storm-Circle] (on whose members, initially at least, Marinetti's Futurism made a considerable impact). Following the ideas of Kandinsky as these were set out in *Über das Geistige in der Kunst,* poets such as Herwarth Walden, Lothar Schreyer, Rudolf Blümner, and August Stramm began from the belief that a spiritual world of platonic essences lay just below the surface of the material world. Thus, they argued, if the poet used language abstractly and nonmimetically much as a composer used sound or an abstract painter color, then it was possible to tap into that spiritual world. It was also possible to reveal the substratum of spirituality that inhered in language but had become, as it were, concreted over by the rationalism and technologization of modernity.[50] If, for the Futurists, language stripped of its inessentials could represent an essentially *material* world, then for the *Sturm* poets, language used noninstrumentally and stripped of its descriptive surface could mediate an essentially *spiritual* world precisely because the word as such (the logos) was imbued with spirit (the Logos). So, although there seems, superficially, to be an immense gap between Rilke's thinking about "Dinge" [things] and the *Wortkunsttheorie* [theory of verbal art] of *Der Sturm,* the poetics of *Der Sturm* are in fact a radicalized version of the thinking behind the Rodin essays, with the concept of the abstract "Wort" [word] substituted for that of the concrete "Ding." Indeed, the *Wortkunsttheorie* of *Der Sturm* has an even older history than that, for as Brinkmann noted:

Der Glaube, der magische Glaube, das Wort könne, ganz abgesehen von seiner konventionellen Bedeutung, in bestimmten Konstellationen Sinn hergeben, höheren Sinn über seinen faden landläufigen Aussagegehalt hinaus, könne von neuem Gleichnis werden für etwas jenseits und oberhalb der Erfahrung, dieser im Grunde sehr alte Glaube ist in Frankreich,

aber auch in Deutchland mindestens seit der Romantik neben dem konventionellen Verhältnis zum Wort in verschiedenen Spielarten immer wieder zu finden.⁵¹

The belief, the magical belief, that the word can, in certain constellations and regardless of its conventional meaning, produce meaning—higher meaning over and above its run-of-the-mill ability to signify, that the word can become once more an image of something which transcends experience is basically very ancient. In France, and in Germany, too, at least since the Romantic movement, one encounters it over and over again in different guises and alongside a more conventional attitude to language.

Eugene Jolas expressed this "ancient belief" in his doctrine of Magic Idealism of 1929 and clearly believed that many of the avant-garde contributions that he published in his magazine *Transition* between 1927 and 1938 were expressions of it. But an even more stripped-down version of the same belief is to be found in a highly unexpected modernist context: Ernst Jünger's uncharacteristic little essay "Lob der Vokale" ("In Praise of Vowels") (1934). Just as in *Über das Geistige in der Kunst,* Kandinsky had assigned essential meanings to abstract colors, the basic elements of painting, so Jünger's essay, consciously following Rimbaud's "Alchimie du Verbe" ("Alchemy of the Word") from *Une saison en enfer,* posited "eine reine Lautsprache . . . , die die Wortsprache umfasst und durchdringt" [a language of pure sound . . . , that comprehends and pervades the language of words].⁵² According to Jünger, the basic elements of this language of pure sound were vowels to which essential meanings (rather than colors as in Rimbaud's prose poem) could be assigned (34–45):

Hier schliessen wir unseren Ausflug in das Reich der Vokale ab. Das *A* bedeutet die Höhe und Weite, das *O* die Höhe und Tiefe, das *E* das Leere und das Erhabene, das *I* das Leben und die Verwesung, das *U* die Zeugung und den Tod. Im *A* rufen wir die Macht, im *O* das Licht, im *E* den Geist, im *I* das Fleisch und im *U* die mütterliche Erde an. An diese fünf Laute in ihrer Reinheit und in ihren Trübungen, Vermischungen und Durchdringungen tragen die Mitlaute die Mannigfaltigkeit des Stoffes und der Bewegung heran. Durch wenige Schlüssel erschliesst sich so die Fülle der Welt, soweit sie sich dem Ohr durch die Sprache offenbart. (46)

Here we shall end our excursion into the realm of vowels. A signifies height and breadth; O height and depth; E the void and the sublime; I life and dis-

solution; U procreation and death. By using A, we are appealing to power; by using O light; by using E spirit; by using I flesh; and by using U the maternal earth. The consonants bring to these five sounds in their purity and in their blurrings, minglings and interpenetrations the diversity of subject matter and movement. Thus, by means of a few keys the plenitude of the world can be opened up to the extent that it reveals itself to the human ear through language.

If, for the Futurist, the noun was the essential link between language and material reality, and if, for the *Sturm* theorist, the neologism or abstract lexeme was the link between language and spiritual reality, then for Jünger, the simple vowel was the link between language and a reality that was an admixture of the spiritual and the elemental.

But the theoretical positions of the *Sturm* theorists and Jünger were, to differing degrees, utopian, for, as Michel Beaujour pointed out, such theories "can acquire a semblance of legitimacy only at the heart of a myth which denies the very ground of modern linguistics, namely the arbitrary and systematic character of all natural language." August Stramm, the major *Sturm* poet, was torn simultaneously between a deep-seated belief in that "myth" and a sense that language is simply "arbitrary and systematic," between an Idealist conception of human nature, Creation, and language, and a sense of being increasingly assailed and overwhelmed by what Ball, in his diary, would call the "elemental and demonic." Because of this, he produced a deeply fissured, self-deconstructive poetic *oeuvre* which I have analyzed in detail elsewhere and whose contradictoriness tends not to be noticed, let alone accounted for by critics who opt for a mimetic reading or have their roots in the New Criticism. As with the work of Marinetti, by whose Technical Manifesto of Futurist Literature Stramm was significantly affected in autumn 1913, the radical surface of Stramm's poetry conceals conservative assumptions from which he could not free himself, even though, to refer back to Bergson (*EC*, 255/247), the hold they exercised over his imagination increasingly exacerbated his sense that the world was in a state of absolute chaos, a "Rien absolu" [absolute Nothingness].[53]

(iii) Radical

But there is a third mode of modernist poetry whose practitioners made a much more sustained attempt to discard any version of Wittgenstein's "logische Form" and give up the conservative and revisionist desire to identify nodal points ("Images," "Symbols," "Dinge") or linguistic elements

("Das Wort," "La molecula sintattica," "Vokale") that could be invoked as
the guarantors of some degree of correspondence between language and
reality. One can sense the beginnings of this more radical renunciation in
the ironic, early Expressionist poetry of Jakob van Hoddis, Alfred Lichten-
stein, and Gottfried Benn, all of whom wrote poems that are marked by a
developed sense of the gap between idiomatic banality and a reality that is
almost unspeakable in its apocalyptic horror or pathological gruesomeness.
But on the whole, these and related poets experienced that renunciation as
something profoundly negative and sought to deal with it defensively, by
means of strict form, cerebrality, or black humor.

But there is one early Expressionist poem, by Ernst Stadler, written in
1913, where the reader can see the poet letting go of conservative assump-
tions about language and reality and experiencing that renunciation as
something positive and liberating even though it leads him into uncharted
and dangerous regions:

Fahrt über die Kölner Rheinbrücke bei Nacht

Der Schnellzug tastet sich und stösst die Dunkelheit entlang.
Kein Stern will vor. Die ganze Welt ist nur ein enger, nachtum-
 schienter Minengang,
Darein zuweilen Förderstellen blauen Lichtes jähe Horizonte
 reissen: Feuerkreis
Von Kugellampen, Dächern, Schloten, dampfend, strömend . . .
 nur sekundenweis . . .
Und wieder alles schwarz. Als fuhren wir ins Eingeweid der Nacht zur
 Schicht.
Nun taumeln Lichter her . . . verirrt, trostlos vereinsamt . . . mehr . . .
 und sammeln sich . . . und werden dicht.
Gerippe grauer Häuserfronten liegen bloss, im Zwielicht bleichend,
 tot – etwas muss kommen . . . o, ich fühl es schwer
Im Hirn. Eine Beklemmung singt im Blut. Dann dröhnt der
 Boden plötzlich wie ein Meer:
Wir fliegen, aufgehoben, königlich durch nachtentrissne Luft,
 hoch übern Strom. O Biegung der Millionen Lichter,
 stumme Wacht,
Vor deren blitzender Parade schwer die Wasser abwärts rollen.
 Endloses Spalier, zum Gruss gestellt bei Nacht!
Wie Fackeln stürmend! Freudiges! Salut von Schiffen über blauer
 See! Bestirntes Fest!

Wimmelnd, mit hellen Augen hingedrängt! Bis wo die Stadt mit
 letzten Häusern ihren Gast entlässt.
Und dann die langen Einsamkeiten. Nackte Ufer. Stille. Nacht.
 Besinnung. Einkehr. Kommunion. Und Glut und Drang
Zum Letzten, Segnenden. Zum Zeugungsfest. Zur Wollust. Zum
 Gebet. Zum Meer. Zum Untergang.

On Crossing the Rhine Bridge at Cologne by Night

The express train gropes and thrusts its way through
 darkness. Not a star is out.
The whole world's nothing but a mine-road the night has
 railed about
In which at times conveyors of blue light tear sudden
 horizons: fiery sphere
Of arc-lamps, roofs and chimneys, steaming, streaming—
 for seconds only clear,
And all is black again. As though we drove into Night's
 entrails to the seam.
Now lights reel into view . . . astray, disconsolate and
 lonely . . . more . . . and gather . . . and densely
 gleam.
Skeletons of grey housefronts are laid bare, grow pale
 in the twilight, dead—something must happen . . .
 O heavily
I feel it weigh on my brain. An oppression sings in the
 blood. Then all at once the ground resounds like
 the sea:
All royally upborne we fly through air from darkness
 wrested, high up above the river. O curve of the
 million lights, mute guard at the sight
Of whose flashing parade the waters go roaring down.
 Endless line presenting arms by night!
Surging on like torches! Joyful! Salute of ships over the
 blue sea! Star-jewelled, festive array!
Teeming, bright-eyed urged on! Till where the town with
 its last houses sees its guests away.
And then the long solitudes. Bare banks. And silence.
 Night. Reflection. Self-questioning. Communion.

And ardour outward-flowing
To the end that blesses. To conception's rite. To
pleasure's consummation. To prayer. To the sea.
To self's undoing.[54]

The first half of the poem could be read as an example of Pound's "accelerated Impressionism" — though far from being noun-centered after the manner of Futurist poetry, its syntax becomes increasingly dominated by verbal elements.[55] Thus, its one transitive verb (whose use implies a causal connection between clearly designated objects) comes in line 1. Then, as the first eight lines progress, even intransitive and reflexive verbs lose ground to participial elements so that such nouns as are there become increasingly less substanti(v)al and turn into aspects of a process like that described by Fenollosa and Bergson. Indeed, by the time we reach line 7, the only concrete objects to be found in the poem ("grauer Häuserfronten"/ "grey housefronts") have become an empty shell, a "Gerippe" [skeleton] that is turning pale. Concomitantly, what had begun as a realistic train journey across an identifiable bridge increasingly turns into a metaphorical journey downward, "ins Eingeweid der Nacht / zur Schicht" [into Night's / entrails to the seam] [i.e., of a coal-face in a mine], with all the interpretative indeterminacy that involves. But during line 8, a "Beklemmung" ("constriction" would be marginally more exact than "oppression") breaks and the second half of the poem reads like a poetic version of what is said by Nietzsche's madman in the passage from *Die fröhliche Wissenschaft* cited in chapter 2 — a passage with which Stadler was almost certainly familiar given his extensive knowledge of Nietzsche's work.[56]

In Stadler's poem, the horizon has been wiped out; it takes place at night; it frees itself from its original reference point (the bridge); it becomes increasingly unclear whether we are falling or flying and in what direction; and the poem's last word implies that we may indeed by now be straying through an infinite nothingness. Moreover, although its last two lines consist largely of nouns, they do not name things, temporal events, or specific locations. Instead, carried along by the emotional force of the experience, they suggest that we have entered a dimension that has to do with the elemental, the mystical, and the erotic but whose nature cannot be specified, let alone described syntactically because it surpasses language. This "Death of God" experience (for Nietzsche's madman goes on to proclaim precisely that) certainly involves a loss of belief in grammar, but far from shying away from the experience by ironizing or naturalizing it, Stad-

ler actually celebrates it, retaining only a minimal sense of control via a residual, barely visible rhyme scheme. Here, in other words, Stadler is gradually engaging in what would now be termed "the free play of the signifier"; metaphorically learning to fly; and thereby discovering that what, from one point of view, might seem like a "Rien absolu" could, from another, turn into Bergson's "Tout." What Stadler said of Nietzsche's philosophy in a lecture of 1914 applies exactly to this poem:

> Als Nietzsche den Begriff des Lebens als religiöses Symbol an Stelle des alten Gottesbegriffes setzte und die Umkehrung der indischen Lehre von der Wiedergeburt und Seelenwanderung aus einem Menschheitsfluch in ein Leben bejahendes Princip [sic] vollzog, hatte er diese neue Lebenslehre in qualvollem Ringen gegen sein eigenes menschliches Leiden aufgestellt. . . . Das war es, was er "den Pessimismus zu Ende denken" nannte.[57]

> *When Nietzsche replaced the old concept of God with the concept of Life as a religious symbol and succeeded in transforming the Indian doctrines of rebirth and metempsychosis into a life-affirming principle, he had set up this new, vitalist creed in the midst of a tortured struggle against his own, human suffering. . . . That was what he meant by "thinking pessimism through to the end."*

Stadler's poem suggests that the "Death of God" experience need not lead to the metaphysical pessimism that afflicted so many modernist writers, thinkers, and artists. It could be—though it very rarely was—the occasion of a rebirth that could take suffering and all the dark and difficult elements invoked in the last lines of Stadler's poem into itself.

As Frank Kermode saw, the most decisive break with conservative assumptions about the relationship between language and reality was made by the Dadaists—though profound ambiguities and fissures are present even within this most radical of the historical avant-gardes. In the *Philosophical Investigations,* Wittgenstein would ask: "Kann ich mit dem Wort 'bububu' meinen 'Wenn es nicht regnet, werde ich spazieren gehen'?—Nur in einer Sprache kann ich etwas mit etwas meinen." [Can I say "bububu" and mean "If it doesn't rain I shall go for a walk"?—It is only in a language that I can mean something by something]. Oddly enough, at the first *Dada-Soirée* in Zurich on 14 July 1916, Hugo Ball had already posed a strikingly similar question when he proclaimed: "Jede Sache hat ihr Wort, aber das Wort ist eine Sache für sich geworden. Warum soll ich es nicht finden?

Warum kann der Baum nicht 'Pluplusch' heißen? und 'Pluplubasch,' wenn es geregnet hat?" [Each thing has its word, but the word has become a thing by itself. Why shouldn't I find it? Why can't a tree be called Pluplusch and Pluplubasch when it has been raining?].[58] But where Wittgenstein asked his question in the context of a discussion of language games, Ball's question, like his two diary entries cited above, is more equivocal. On the one hand, he is visibly drawn to the Saussurean ideas that there is no necessary connection between words and things and that a "langue" is simply a conventional system of arbitrary signifiers with which one can do what one likes. But on the other, one can sense his desire to create a redeemed, adamic language in which pristine words, untarnished by corrupt misuse, have a necessary connection with the things they name and so enable "unleashed Nature" to be tamed once more. It was this desire which, on 24 June 1916, had caused Ball to write in his diary that language had become so corrupted that one should withdraw into "die innerste Alchimie des Wortes" [the inner alchemy of the word] and create a brand-new language expressly for one's own use.[59]

The same ambiguity informs the six sound poems that Ball wrote in late June 1916—when his involvement with Dada was becoming critical (not least because he feared ending up like Rimbaud the "rebel"). "Karawane" ("Caravan") has a title that connects what looks like a nonsense poem with objective reality. But even if Ball had not also entitled it "Elefantenkarawane" ("Elephant Caravan") in his diary entry of 23 June 1916 and spoken of the "schleppende Rhythmus der Elefanten" [plodding rhythm of the elephants] that it generated when he recited it in the Cabaret Voltaire, one could still get some sense of what is being pictorialized from the phonetic association of its very first word and the fact that "russula" in line 4 is very close to the German word for an elephant's trunk:[60]

Karawane

jolifanto bambla o falli bambla
großgiga m'pfa habla horem
egiga goramen
higo bloiko russula huju
hollaka hollala
anlogo bung
blago bung blago bung
bosso fataka
ü üü ü

schampa wulla wussa olobo
hej tatta gorem
eschige zunbada
wulubu ssubudu uluwu ssubudu
tumba ba-umf
kusa gauma
ba—umf

But there is more to this poem than phonetic mimesis of a natural pro-
cess. On 3 June 1916, the Dadaists, although it was midsummer, had put
on a Nativity Play (the final scene of which moves to the Crucifixion) in
sound, using a minimum of words. Now, the fifth scene of this play in-
volves the arrival of the Magi (that is, the Feast of the Epiphany), and the
stage directions indicate that they arrive with a caravan that included ele-
phants whose bells went "Bim bim bim . . ."[61] So, in reciting the above
poem, Ball really was experimenting with "verbal alchemy," like a latter-
day Magus making a slow, laborious, metaphorical journey to the source
of the Christianity which he had rejected years before but to which much
of him was still deeply attached.

Immediately after reciting "Karawane" on 23 June 1916, Ball, dressed in
a fantastic, pseudoliturgical costume, recited an even more abstract sound
poem, "Gadji beri bimba," whose title offers no "semantic succour" un-
less you happen, improbably, to know the association of "Bim"—and the
result for Ball was a highly disturbing epiphany:

Gadji beri bimba

gadji beri bimba glandridi laula lonni cadori
gadjama gramma berida bimbala glandri galassassa laulitalomini
gadji beri bin blassa glassala laula lonni cadorsu sassala bim
gadjama tuffm i zimzalla binban gligla wowolimai bin beri ban
o katalominai rhinozerossola hopsamen laulitalomini hoooo
gadjama rhinozerossola hopsamen
bluku terullala blaulala loooo

zimzim urullala zimzim urullala zimzim zanzibar zimzalla zam
elifantolim brussala bulomen brussala bulomen tromtata
velo da bang bang affalo purzamai lengado tor
gadjama bimbalo glandridi glassala zingtata pimpalo ögrögöööö
viola laxato viola zimbrabim viola uli paluji malooo

tuffm im zimbrabim negramai bumbalo negramai bumbalo tuffm i zim
gadjama bimbala oo beri gadjama gaga di gadjama affalo pinx
gaga di bumbalo bumbalo gadjamen
gaga di bling blong
gaga blung[62]

The effect that "Karawane" had already had on Ball's imagination; the almost total freedom from referentiality that marks "Gadji beri bimba"; and the recurrence of the elephant motif with all its associations in line 3 ("bim") and the first two words of line 9 combined to remove what, in Stadler's poem, is called "eine Beklemmung" [a constriction] and bring about what Ball would call "eine letzte Steigerung" [one final, affective intensification]. The resultant experience, about whose precise nature there is some debate, seems to have both freed and frightened Ball, since in retrospect he described his emotional state at the time as "halb erschrocken[e], halb neugierig[e]" [half-frightened, half-curious]. But in the long term, this epiphanic experience of near total linguistic liberation catalyzed the process that would lead him back to Roman Catholicism not long after he had written the diary entry of 7 June 1920 cited above.[63]

In his diary entry of 9 September 1917, by which time he had broken with Dada, Ball noted that the Zurich Dadaists had been very interested in Bergson and his concept of simultaneity at the time of the Cabaret Voltaire. So in the light of this remark one could say that Ball's experimentation with a mode of poetry that assumed and accepted the arbitrary nature of language and the gap between language and reality had confronted him with a dynamic, fluctuating reality that could be interpreted either as a "Rien absolu" or as a "Tout." Ball came increasingly to interpret that reality not just as a "Rien absolu" but as something positively monstrous. For that reason, his diary entry of 9 September 1917 also includes the remark: "Mit [Bergsons] Begriff der 'intuition créatrice' kann ich gar nichts mehr anfangen. Die Intuition als schöpferisches Prinzip: das scheint mir eine unmögliche Position. Ich kann die Intuition nur als ein Wahrnehmnungsvermögen verstehen" [I do not know what to make of (Bergson's) concept of "intuition créatrice" (any more). Intuition as creative principle: that seems to be an impossible position. I can understand intuition only as a perceptive faculty].[64] Or to put it another way, Ball's experience of Dada had caused him to think about Bergson's "lumière vacillante et faible" [guttering and feeble light] (EC, 290/282) only to reject it

in favor of the light emitted by the Word become flesh and which, for Ball at least, shone faintly behind the private language of his sound poems and within his cacophonous Nativity Play.

Other Dadaists were equally radical in their experimentation because of their sense that Western civilization was in a state of crisis but far less ambiguous in their conclusions. The editors of *Dadaco* were totally clear about the conventional status of language:

> Losgelöst von den gewöhnlichen Associationen lassen sich [die einzelnen Worte] beliebig vertauschen und so ist man in der Lage zu verstehen, was man mit der Sprache anfangen könnte, wenn einem nicht von Jugend auf eingepaukt worden wäre, dass das Wort Liebe oder das Wort Hoffnung einen ganz bestimmten Kreis von Empfindungen umfasst.[65]

> *Freed from the usual associations, [individual words] can be swapped around at will and so you are in a position to understand what you could do with language if you hadn't had it drummed into you from your earliest years that the word "love" or the word "hope" involved a totally specific group of sensations.*

Thus, the Dada *poème statiste* [static poem] consisted of a word written in huge individual letters on several large pieces of cardboard that the performers then held up and moved about on stage.[66] The point of doing this was to generate a sense of estrangement, not to say vertigo in the viewer, in the hope of making him or her aware of the arbitrary and mutable nature of the linguistic sign and loosening the hold that conventional language exercised over his or her consciousness.[67] The Dada *poème simultane* [simultaneous poem], which involved several performers reciting totally unrelated texts cacophonously, showed, according to Ball's diary entry of 30 March 1916, not the consonance between language and an objective reality, but "den Widerstreit der vox humana mit einer sie bedrohenden, verstrickenden und zerstörenden Welt" [the conflict of the vox humana (human voice) with a world that threatens, ensnares, and destroys it].[68] The optophonetic poem, whose prototype was allegedly delivered by the Berlin Dadaist, Raoul Hausmann, at a *Dada-Soirée* in the Café Austria on 6 June 1918, was, judging from Hausmann's own retrospective account, a direct challenge to Western logocentric assumptions in its desire to conjure up the prerational, vital energies of human nature:

Das poem [sic] ist eine Geste optischer und phonetischer Art, die untrennbar mit dem Ablauf in der Zeit verbunden ist, wenn auch seine Mittel taktierend oder rhythmisierend gebraucht werden können. Das optophonetische Gedicht ist geboren aus dem [Duk?] tus der Prälogik und teilt, ebenso wie der primitive Tanz der Naturvölker, den Zeitraum in prälogische Zahlwerte, die durch seine Art der schriftlichen Notierung den optischen Sinn orientieren. Jeder Wert dieses poems steht rein für sich und erhält einen Klangwert, indem der Buchstabe, die Laute, die Konsonantballungen in höherer oder tieferer Sprechlage, lauter oder leiser traktiert werden. Um dies in der Typographie darstellen zu können, wählte ich verschieden grosse oder starke Buchstaben, die an Stelle musikalischer Noten stehen.[69]

The poem is a gesture of an optical and phonetic nature that is inseparably bound up with process in time, even if its means can be used in a metronomic or rhythmical way. The optophonetic poem comes into being through the duct of pre-logic and divides, just like the primitive dance of aboriginal peoples, a given period of time into pre-logical units that orient the sense of sight by means of the way in which the notes are written down. Every unit of this poem is purely independent and acquires an aural value according to whether the letter, the sounds, the concentrations of consonants are handled using a higher or lower pitch, more loudly or more quietly. In order to be able to depict this typographically, I chose letters of differing sizes or strengths as substitutes for musical notes.

Six years later, Hausmann wrote two manifestos that echoed Bergson's philosophy and, unwittingly, Fenollosa's critique of Western logic. In one, he said:

Was gegeben werden kann, sind, stets in menschlichen Formeln, Angleichungen an die Bezüglichkeiten des schöpferischen Fluidums des Universums, aber nie dies Fluidum selbst.[70]

What can be given, always in human formulae, are approximations of the multiple relationships of the creative flux of the universe, but never this flux itself.

And in the other, he equated reality with "die Erde" [the Earth] (a portmanteau term which, for Hausmann, denoted a dynamic cosmos in a state of multidimensional, nonlinear flux), and declared that language, as com-

monly understood in the West, disrupted the proper relationship between human beings and that reality.[71] He then went on to characterize language not as a system for pictorializing, replicating, grasping, or naming reality but as a "Mitte," a system of meditation and analogy that enabled people to maintain a balanced relationship with a reality over which language could never exercise exhaustive control:

Der Mensch-Erde-Zustand setzt eine Mitte als Beziehungsausgleich
 in allen Formen.
Diese Mitte ist Sprache.
Mitte und Sprache sind technische Analogie der Funktionalität der
 Dingheit. Sprache soll Mitte bilden. Nicht Begriffe.[72]

The human-earth-condition sets a mediator to ensure a relational
 balance in all forms.
Language is this mediator.
Mediator and language are technical analogies of the functionality
 of object-ivity. Language must act as this mediator. Not concepts.

Which is, as far as I can see, a less elegant way of saying that language constructs perspectively conditioned models of reality (cf. *Tractatus*, 4.01).

Throughout his creative life, Hans Arp (whose work Hausmann certainly knew) also accused the West of being in a state of crisis because it had turned a proper scale of values on its head.[73] Moreover, although Arp never made any theoretical statements about language and was always reticent over questions of influence, his Dada poetry most clearly, consistently, and extensively displays the five major implications to emerge from the discussion in the first half of this chapter. First, it denies the priority of the consciousness and exalts the faculty of imagination (Bergson's "intuition"). Second, in its use of aleatory techniques, it suggests that chance and disorder are relative concepts.[74] Third, it celebrates the power of the imagination to apperceive fleeting patterns within the flux of reality and construct "Modelle," "Konfigurationen," constellations, and readymades—texts that have only a loose connection with reality and make no attempt to pin it down, stabilize it, or control it by means of static images, atomic lexemes, transcendent symbols, or titles that label in the conventional sense. Fourth, by totally and unequivocally dispensing with the "classical episteme of representation" and positivistic assumptions about language, Arp's Dada poetry overcomes that sense of cultural pessimism with which Dada, for all its carnivalesque joie de vivre, was very familiar. And fifth, it under-

stands the flux of reality not as a "Rien absolu" but as a "Tout" that was simultaneously creative and destructive. *Mutatis mutandis,* Amelia Jones's comment about Duchamp's readymades applies equally well to Arp's Dada poetry:

> The readymade, as text-object system, undercuts the desire for continuity between the sign or vehicle and its referent that forms the foundation of Western aesthetics. Not only is the object disassociated from its natural function in the world and, inevitably, from its enunciating signator Duchamp, its written label is also splintered from continuity with the object. It refuses to serve as the traditional, descriptive "anchor" directing the vehicle toward its proper referent.[75]

Like Fenollosa, Arp was deeply influenced by Eastern philosophy, notably the *Tao Te Ching* (a German translation of which, incidentally, was given to Hannah Höch by Hausmann on 11 February 1916), and in Otto Flake's roman à clef about Zurich Dada, appropriately entitled *Nein und Ja* (*No and Yes*) (1920), we see the fictional Arp (Hans) listening to the fictional Ball (Puck) reading out section 29 in which Lao Tzu warns *specifically* against trying to conquer [erobern] or pin down [festhalten] the world.[76] It is from this complex of attitudes that texts like "sein Kinderhut tanzt um die sonne . . ." ["his child's hat dances round the sun . . ."] from *die wolkenpumpe* (*the cloudpump*) (1920) arise.[77] In this semiautomatic poem, as in other texts of the same collection, we have a working verbal model of Nature in multidimensional flux, propelled by a "he" who, although unidentified, is very like the world-spirit of Rimbaud's "Génie" from *Les Illuminations,* which Arp almost certainly knew and about which more will be said in chapter 11.[78] Unlike those modes of modernism that seek fixity amid flux, Arp's poem revels in the process of becoming.[79] It eschews clauses and punctuation marks; makes it hard to be precise about the grammatical status of any given word; slips between the human and the natural, the banal and the cosmic, the adult and the childish; works by association, assonance, puns, and neologisms; and collapses time by its use of archaisms. Because its parataxis involves the total refusal of hierarchies, it is possible to read the seven "und's" as copulas denoting both simultaneous and successive events so that linear time is supplanted by Bergsonian *durée*— which is why the invisible clocks whose ticking is heard in the final line have no hands.[80] Unlike Futurist texts, in which the plus sign is unequivocally additive, Arp's copula invites the imagination to view the linguistic unit *both* as part of a succession of events *and* as one stratum in a dy-

namic agglomeration of overlapping strata. What Bauman said of Simmel's "paratactical" perception of the modern condition applies to this poem precisely: its elements "float, so to speak, with the same specific gravity, are equal to each other, and contain nothing which may suggest an easy choice."[81] If the reader is one of those high-minded members of human-kind who cannot bear very much unreality, then he or she will fling the poem away in a tantrum. But if the reader believes that poetry can be many things, including linguistic fun, and is prepared to use his or her imagina-tion to arrive at a reading of this poem that cannot be definitive, then it is possible to enjoy the powerful sense of free-flowing natural energy that flows through it and does not stop with the coffins (which may be the last, but do not have the final word). During his Dada period—he became more pessimistic in the last twenty years of his life—Arp positively enjoyed being adrift in a fluid world of uncertainties, transformations, and discontinu-ities. For, to paraphrase a later poem, he had climbed over the linguistic banisters, grown wings "im Bodenlosen" [in the unfounded], and learned to fly like the unchained falcons in the poem discussed above.[82]

So had Arp's friend Kurt Schwitters, especially between spring 1922 and spring 1923, when his involvement with Dada reached its height. During this period he wrote two apparently nonsense poems—"Doof" ("Daft") and "Wand" ("Wall")—both of which deconstruct an apparently solid ob-ject by means of repetition in the manner proposed by Kandinsky in *Über das Geistige in der Kunst*.[83] In the first poem, the German word "Dom" [cathedral] is repeated ten times and juxtaposed with banalities that are likewise repeated ("Dof" = "daft"; the meaningless onomatopoeic word "Dau"; the definite articles "Den" and "Die"; and the second-person pro-noun "Du") until it loses its massive monumentality and becomes, like the words with which it is associated via its opening consonant, common-place—a hollow echoing sound. Or, to put it another way, the poem lays bare the "daft" arbitrariness of the signifier and the "daftness" of the ob-ject which it signifies. The title of the second poem suggests that the poem is going to be about another solid object—a barrier, a means of dividing space into fixed segments. But the first line reads "Fünf Vier Drei Zwei Eins" [Five Four Three Two One] so that when "Wand" appears as the poem's one-word second line, it looks like the third-person singular of the past tense of the German strong verb "winden" ("to wind, bind, twist, or writhe") that is governed by the "Eins" immediately preceding it. The pro-cess of deconstruction continues as "Wand" is repeated twelve times in two different typefaces over five lines with the result that an apparently solid

signifier turns into a strange, flat, dull sound that could function either as a noun or as a verb. But then, in line 8, Schwitters puts "Wand" into the plural—"Wände." Visually, this has the effect of turning one thing into many, and aurally, "Wände" sounds exactly the same as the German words "Wende" or "wende." "Wende" means "change" or "turning point," and "wende" could be either the first-person singular of the present tense of the verb "wenden" ("to turn or change") or the second-person imperative of the same verb. "Wände" is then repeated nine times over four lines, and the poem ends with "Wand" being repeated a further fourteen times over eight lines, with the typeface diminishing in size in the process. As the German prefix "Ge-" often denotes a collectivity of objects or actions (as in "Gelächter," "Geländer," "Gemurmel," "Gezeiten"), it might be said that here we have a "Gewand" ("collection of walls") that turns into "Ge-wänder" ("garments," "gowns," "robes," "guises")—a collection of signi-fiers that thinly clothe the illusory object they signify. But this associative pun apart—and it is precisely the kind of linguistic leap that Dada poetry encourages the reader to make—this poem graphically shows how, by wav-ing a magic wand, a linguistic alchemist like Schwitters can transform bar-riers that block the imagination into transparent garments which the inner eye can then strip from the objects they conventionally clothe and dissolve those objects into fluid process.

Schwitters and Arp were among the least political Dadaists and they labored under no grandiose illusions about the transformative power of art in the modern world.[84] But they did realize that if one threw away Wittgenstein's ladder and stopped seeing the slippage of the signifier as something tragic, then it was possible for the individual (poet) to harness "the transformative energy of linguistic play" for the purpose of freeing the imagination "from the tensions and coercions of the socio-linguistic system."[85] There are more subterranean links between Schiller's aesthetic letters, Lewis Carroll's Humpty Dumpty, Dada, and the work of Fredric Jameson than one might ever suspect.

6. Kandinsky's *Oeuvre* 1900–14

The Avant-Garde as Rear Guard

Like many modernist artists who sought to recuperate a sacralized totality that modernity had allegedly destroyed, Kandinsky worked in several media. Not only did he produce theoretical pieces, oil paintings, watercolors, paintings behind glass, colored and black-and-white woodcuts, four abstract dramas, and about fifty poems, he was also deeply interested in crafts, architecture, dance, musical composition, opera, and stage design.[1] Despite this, several major studies have either focused on one medium to the neglect of the others or compartmentalized Kandinsky's interests.[2] But other studies have tried either to interrelate Kandinsky's work in two media; or to cross-relate his work in the context of his concern with the "total work of art" (*Gesamtkunstwerk*); or to locate his *oeuvre* in a cultural context where an avant-garde was grappling, across a range of media, with a set of profound and intractable problems.[3]

In this chapter, I want to pursue the third approach, bearing in mind what was said about modernity in chapters 1 to 3, and in doing so I shall try to avoid four methodological pitfalls. First, I shall be concerned more with the subjective problematic that generated Kandinsky's many-sided *oeuvre* and less with its surface features.[4] Second, given Kandinsky's insistence that the creative process is beyond the control of the conscious mind and his awareness of the inadequacy of his own theoretical writings, I shall not assume that Kandinsky's theoretical pronouncements map neatly with his verbal and visual works.[5] Third, like Johannes Langner and Armin Zweite,

I shall focus on the ambiguities and fissures of Kandinsky's prewar *oeuvre* since, as Kandinsky himself indicated in *Rückblicke* (*GS* 1:41–42; *CWA* 1:372–73), that *oeuvre* was the product of prolonged and complex spiritual conflicts and these tend to generate work that is polyvalent, experimental, and indeterminate rather than unambiguous and triumphalist.[6] Finally, I shall avoid historicist notions of "evolution," "development," and "progress" when discussing Kandinsky's move toward abstraction. Kandinsky himself once described history as a large, forward-moving triangle whose point is formed by the avant-garde artist (*ÜdG*, 29–30; *CWA* 1:133–34). Possibly with this kind of image in mind, art historians have often written as though the history of modernist art involved an upward-moving, "progressive" avant-garde or phalanx (hence the name of the Munich group in which Kandinsky played a leading role from late 1901 to late 1904), which achieved ever higher levels of artistic liberation and spiritual enlightenment and then made their visions available to the broad masses in their train. Whatever one ultimately thinks of postmodernism, it has taught us to be wary of such metanarratives, and within the context established in the previous chapters, Kandinsky's move to abstraction, like other, related examples of modernist experimentation (such as Georg Fuchs's Münchener Künstlertheater [May 1908–14]), combined aesthetic innovation with deeply conservative assumptions.

1900–9

Like so many modernists, Kandinsky had assimilated quasi-religious, classical-idealistic notions about art and reality. So when the premodern world that had sustained these notions began to break down, Kandinsky was afflicted by a Barthian sense of *krisis*.[7] According to *Rückblicke,* this sense was intensified by his awareness that the atom could be split (*GS* 1:33; *CWA* 1:364), and although Kandinsky does not say to which scientific discovery he was referring, he mentions this autobiographical fact in connection with his first experience of Wagner's *Lohengrin* (1896).[8] This probably means that he was thinking of Becquerel's and the Curies' experiments in the years 1896 to 1900, which showed that certain heavy elements decay by emitting radioactivity. Kandinsky also records that this event was tantamount to the collapse of his whole inner world, and it seems to have been the catalyst that caused him to leave his life as a lawyer in Moscow in December 1896 and begin all over again as a painter in Munich. Now, although Wilhelmine society suffered from a fundamental ten-

sion between a rigid, semifeudal political system and growing sociopolitical pressures to modernize, Munich was still a relatively premodern city around 1900. It was also governed by a liberal ministerial régime which, while confronting a culturally conservative parliament, looked favorably on its artistic *bohème*.[9] Consequently, it seemed like a little utopia in a materialistic world to those artists who, like Kandinsky and most of the avant-garde, belonged to the premodern, educated middle class and who were on the whole deeply worried by if not actively antipathetic to modernity.[10] Which meant that Schwabing, not yet fully part of Munich when Kandinsky first went to live there in 1896, seemed even more like "eine geistige Insel in der grossen Welt, in Deutschland, meistens in München selbst" [a spiritual island amid the wide world, in Germany, for the most part even in Munich].[11] Certainly, this is how it was presented in Franziska Gräfin zu Reventlow's novel *Herrn Dames Aufzeichnungen* (*Mr. Dames's Notebooks*) (1913) — as a place where "more than anywhere . . . art was seen as the vehicle for an approaching spiritual revolution."[12] But in 1897, J. J. Thomson discovered that atoms were not the simple entities that had been supposed and involved constituent particles such as electrons; in 1902, Rutherford and Soddy showed that after radioactive emission, one element is changed into another (that is, that matter is not immutable); the Munich liberals were defeated in 1903; the *Jugendstil* movement was past its prime by the same year; and by 1909–10, Munich, like Germany as a whole, had become so nationalistically conservative that it had ceased to be a refuge for Kandinsky and turned into a trauma from which he needed to flee.[13] Like Lord Chandos's world, Kandinsky's *oeuvre* from 1900 to 1914 was increasingly invaded by the sense that an ordered cosmos in which human beings were at home was being overwhelmed by violent, primal chaos so that it was necessary as a person, an artist, and a theoretician to find a new basis, a new way of painting, and a new sense of artistic legitimacy.

From the point of view of theory, Kandinsky dealt with this sense of *krisis* by salvaging and privileging the concept of the creative spirit (*Geist*). This concept was not only the linchpin of classical aesthetics and Idealist ontology, it was, as Weiss points out, current in Munich's artistic circles before Kandinsky appropriated it to translate the (larger) Russian concept of *dukh*.[14] Moreover, it was this concept that shaped his reception of French and Russian Symbolist ideas about the revelatory potential of things and their associated words.[15] Accordingly, in the notes on aesthetics which he compiled between 1904 and 1911 and which eventually became the Russian and German versions of *Über das Geistige in der Kunst*, Kandinsky

countered what he, like Max Weber, perceived as the desacralization of the modern world by driving, in a classically gnostic manner, a wedge between matter and transcendent *Geist*.[16] He relegated the activity of *Geist* to a realm behind the real world and privileged abstract art that had been stripped of its obligation to represent the (fallen) material world as a means of access to that realm. By this move, Kandinsky hoped to conserve certain areas of spirituality in the face of the secularization, functionalism, materialism, and fragmentation that constitute modernity.

The same sense of gathering *krisis* also lay behind Kandinsky's early attraction to the quasi-cultic concept of the *Gesamtkunstwerk,* the theory behind which goes back through Wagner's essays "Die Kunst und die Revolution" (1849) ("Art and Revolution," 1891) and "Das Kunstwerk der Zukunft" (1849) ("The Art-Work of the Future," 1891) to Goethe and Runge, and whose prime example was, for Kandinsky, *Lohengrin* (*GS* 1:33; *CWA* 1:363–64).[17] Combining all the arts synaesthetically, the *Gesamtkunstwerk,* as the mediator of *Geist* to all the senses, was to be the major specific for the ills of modernity.[18] It was this belief that impelled Kandinsky to make the (multimedia) cabaret the main theme of the first Phalanx exhibition (August 1901) and the transformation of life by art that of the second (January–March 1902).[19] It moved him, as early as 1904, to publish *Stikhi bez slov* (*Poems without Words*), a small album of fourteen black-and-white woodcuts described by Weiss as a "miniature *Gesamtkunstwerk.*"[20] It also brought him into close contact with such similarly minded avant-garde groups as the Arts and Crafts Movement, the *Jugendstil* group in Munich, Peter Behrens's Darmstadt Artists' Colony, the George Circle in Munich around Karl Wolfskehl, and the experimental Münchener Künstlertheater.[21] In all cases, an artistic grouping was convinced that modernity involved some kind of a secular Fall and was in need of redemption by art because of the decay of established religion. Thus, despite their differences, all these groups were impelled, in a rapidly modernizing world, to establish utopian *Gemeinschaften* and/or produce a spiritualized art from which a lost past could be re-established and/or a healing power beamed back into the fallen present.

In line with these biographical and theoretical considerations, Kandinsky's visual work from 1900 to 1909 can also be read as a response to the sense of personal and cultural *krisis* brought about by modernization. The nostalgia of such early Biedermeier woodcuts as *Promenade* (*Promenade*) (1902) (*GrW,* 3); the evocation of a fairy-tale medieval world in such woodcuts from *Stikhi bez slov* as *Noch'* (*Night*) (1903) and *Proshchanie* (*The*

Farewell) (1903) (*GrW*, 13 and 15); Kandinsky's fascination with Russian ethnography, folklore, and legends; the old Russian motifs that are so prominent in the woodcuts of 1907; the dream of a medieval totality that was, on Kandinsky's own admission (*GS* 1:28–29; *CWA* 1:359–60), involved in such early paintings as *Alte Stadt I* (*Old Town I*) [Rothenburg ob der Tauber] (1901) (*CR* 1:78); and the premodern settings (Kallmünz [Oberpfalz], Nabburg [Oberpfalz], Sestri [Italy], Rapallo, Tunis, Regensburg, and the Parc St. Cloud [Paris]) of so many paintings from 1903 to 1907 all testify to an imagination that yearned for the magic, spirituality, and hieratic order of an allegedly lost (and largely imaginary) Golden Age.[22] Conversely, the almost total absence of the modern world from Kandinsky's visual work before 1908 (except, most strikingly, the Impressionist *Bahngeleise bei Dresden* [*Railroad Track near Dresden*] [1905] [*CR* 1:153]) entirely bears out Weiss's view that, for the early Kandinsky, the image of St. George and the dragon was the allegorical counterpart of his antipathy to the mundane materialism and irreligiosity of modernity.[23]

Kandinsky's increasingly religious sense of his role as artist and concomitant progress toward abstraction were reinforced by his discovery in spring-summer 1908 of the Upper Bavarian village of Murnau. In the following year, Kandinsky's partner, Gabriele Münter, bought a house there in the Kottmüllerallee, where she lived until her death in 1962 and where Kandinsky also spent considerable periods until his flight from Germany in August 1914. Quite apart from the stylistic changes that then occurred in his visual work and that were partly due to his exposure to the work of the Fauves, Murnau was important for Kandinsky in three major ways.[24] First, it grounded his earlier nostalgia for a lost Golden Age in a real place which, while belonging to an ideal past, existed in the fallen present. Second, it promised to provide him with a refuge from modernity in which he could regain his peace of mind.[25] Third, the view from Münter's house and garden across the (then single-line) railway track to the castle and the Baroque St. Nicholas's Church with its cemetery on the higher ground opposite provided him with an image of a walled city/church on the hill. When synthesized with his memories of hilltop German towns like Rothenburg and Nabburg, domed Russian churches, and walled Russian cities (like the one in *Verfolgung* [*Pursuit*] [1907] [*GrW*, 129]), this image, as in the colored woodcut *Bogenschütze* (*Archer*) (1908–9) (*GrW*, 158)—his most abstract woodcut to date—could be transformed into the ultimate refuge of the Spiritual City of the Book of Revelation. The close connection between this image and Murnau is easily established by a comparison of *Mur-*

nau—Garten I (*Murnau—The Garden I*) (1910) with its accompanying modern photograph (*CR* 1:337). And its importance—Kandinsky himself described it as a symbol of humanity—can be gauged not only from the frequency with which it appears, albeit in a veiled or residual form, in his semiabstract paintings from 1910 to 1914, but also from its presence on the cover of *Über das Geistige in der Kunst*.[26] Thus, in *Murnau—Landschaft mit Regenbogen* (*Murnau—Landscape with Rainbow*) (1909) (*CR* 1:291), Murnau is associated with the postdiluvian image of peace and reconciliation. And in *Murnau—Ansicht mit Burg, Kirche und Eisenbahn* (*Murnau—View with Castle, Church and Railway*), an oil painting from 1909 (*CR* 1:284) which gives the impression that Murnau's castle and church are higher up the hill and closer together than is actually the case, modernity in the shape of an insignificant, toylike train by-passes an embryonic Spiritual City whose onion-domed church soars confidently and serenely into the spiritual heavens above the top edge of the picture.

1909–14

Having arrived, to his own satisfaction at least, at a metaphysically anchored theory of art and found a new and better fortified "spiritual island," a hilltop refuge like that in *Paradies* (*Paradise*) (1909), his first recorded work with a religious title, Kandinsky discovered a renewed confidence that is very evident in his buoyant letters to Münter.[27] This enabled him to participate actively in the *Neue Künstlervereinigung Münchens* (the New Association of Munich Artists) (founded June 1909), to begin the organization of his notes on abstract art into *Über das Geistige in der Kunst,* and to work on his "color operas."[28] It also enabled him to confront the major problem that would occupy him up to the outbreak of war: his growing sense of cosmic or chthonic violence. Before 1908, one occasionally finds a painting like *Kochel—Landschaft mit Haus* (*Kochel—Landscape with House*) (1902) (*CR* 1:102), in which the landscape is alive with violent energy, or *Waldlandschaft mit roter Figur* (*Forest Landscape with Red Figure*) (1902–3) (*CR* 1:108), in which a dehumanized red figure recedes into the background, almost swallowed by the trees, or a woodcut like *Mondnacht* (*Moonlit Night*) (1907) (*GrW,* 117), in which a monster emerges from a lake and looks threateningly toward the walled city on the hill that overlooks it. Nevertheless, most of Kandinsky's pre-1908 works are secure in their anthropocentricity. Human figures and humanized settings predominate.

Nature is subdued or controlled, and the titles make most of the pictures reassuringly comprehensible by relating them to well-defined locations, situations, or sensations. After the move to Murnau, however, a clear shift of vision takes place. Kandinsky's canvasses become much larger. Religious titles and motifs, especially ones connected with the Deluge or the Last Judgment, are used with increasing frequency. Recognizable human figures become minor, faceless inhabitants of huge, cosmic landscapes without a precise or recognizable location. Whether because he sensed the coming of war, or because, as Brinkmann suggests, he was particularly worried by his own irrational sides, or because he was unconsciously aware of the profound social tensions within a modernizing Germany, or because his attachment to a utopian past exacerbated his sense of being in conflict with the realities of modernity, from 1909 onward Kandinsky increasingly painted nonanthropocentric landscapes, full of apocalyptic threat and primal violence.[29] Thus, in *Der blaue Berg* (*The Blue Mountain*) (1908–9) (*CR* 1:240), the first painting in which the apocalyptic element is very pronounced, three stylized figures on white horses ride through a landscape of molten reds and yellows and a blue hill in the background takes on the semblance of a volcano. Similarly, even the 1908–9 Murnau paintings divide into "stable" paintings, like *Murnau—Obermarkt mit Gebirge* (*Murnau—Obermarkt with Mountains*) (1908) or *Winterlandschaft I* (*Winter Landscape I*) (1909) (*CR* 1:221 and 249) and "unstable" ones, like *Murnau—Strasse mit Frauen* (*Murnau—Street with Women*) (1908) or *Riegsee—Dorfkirche* (*Riegsee—Village Church*) (1908) (*CR* 1:206 and 222). In the latter works, more violent colors are in evidence and buildings (even churches) and the landscape seem to be breaking up. In a unique passage from *Über das Geistige in der Kunst* which must have been written sometime between 1908 and 1909, Kandinsky transcribed his sense of incipient seismic upheaval when he said of the present age: "Der alte vergessene Friedhof bebt. Alte vergessene Gräber öffnen sich, und vergessene Geister heben sich aus ihnen. Die so kunstvoll gezimmerte Sonne zeigt Flecken und verfinstert sich, und wo ist der Ersatz zum Kampf mit der Finsternis?" [The old forgotten cemetery quakes. Old, forgotten graves open, and forgotten ghosts rise up out of them. The sun, framed so artistically, shows spots and darkens, and what can replace it in the fight against darkness?] (*ÜdG*, 40; *CWA* 1:142). The Expressionist artist Ernst Barlach very clearly registered the shift that was taking place in Kandinsky's imagination when, in a 28 December 1911 letter to his publisher Reinhard Piper, he expressed

his dislike of *Über das Geistige in der Kunst* (which had, despite its imprint of 1912, just appeared) on the grounds that it stepped outside the orbit of the human.[30]

Theory

Despite Kandinsky's discovery of Murnau and the predominantly metaphysical optimism of *Über das Geistige in der Kunst,* the five years leading up to war was a painful time of quest, doubt, and sometimes despair.[31] Indeed, Kandinsky's *oeuvre* from those years can be understood as a multifaceted attempt to solve one overwhelming problem. How, when destructive cosmic forces seemed to be invading his newfound security and blocking out the last vestiges of light (*ÜdG*, 22–23; *CWA* 1:128), was it possible to deal with those forces? Was there any transcendent power in the universe strong enough to oppose them? Kandinsky solved this problem theoretically by doing two things. On the one hand, he foregrounded and strengthened the religious dimension of the dualistic aesthetic that he had worked out in *Über das Geistige in der Kunst.* On the other, he fused his growing awareness of cosmic violence with his profound aversion to modernity to evolve a more apocalyptic vision of history. From 1909, Kandinsky's vision of the struggle between good (spirituality) and evil (materialism) became a struggle between a chiliastic Christianity and the unholy alliance of demonic powers and materialistic modernity.[32] This latter alliance is strikingly apparent in his oil painting *Murnau—Ansicht mit Eisenbahn und Schloss* (*Murnau—View with Railway and Castle* (1909) (*CR* 1:294), which, like *Murnau—Ansicht mit Burg, Kirche und Eisenbahn,* must have been painted from the garden of Münter's house. Here, a black, threatening train that is much larger and less toylike than the one in the slightly earlier painting not only dominates the foreground, it also trails a gathering darkness behind it that obliterates St. Nicholas's Church from the top right of the painting. As mechanized violence invaded Kandinsky's world, so the power of the Spiritual City came under increasing threat.

Because of his friendship with Münter, Kandinsky had had some contact with Rosicrucian, Theosophical, and Anthroposophical ideas from 1904 onward and these may have fed into *Über das Geistige in der Kunst.*[33] But after his discovery of Murnau, several other factors may have combined to make his theory of art and vision of history more apocalyptically religious: his exposure, via his friendship with the composer Thomas von Hartmann, to Sufism; his continuing connection with the Munich George

Circle; his attraction to religious folk-art from about 1908 onward, especially votive pictures like those from the mid-eighteenth century that he saw in St. Nicholas's Church and paintings behind glass like those of Heinrich Rambold (1872–1953) (one of which, significantly enough a picture of St. George, can still be seen in a room of Münter's house in Murnau) (cf. *GS* 1:37–38; *CWA* 1:369); his knowledge of the work of the mystically inclined second-generation Russian Symbolists, notably Blok, Bely, and Ivanov that was deepened by his stay in Russia October–December 1912; and his friendship, from January 1911, with the similarly inclined Arnold Schoenberg together with his knowledge of the latter's *Harmonielehre* (1911) (*Theory of Harmony*, 1978).[34] Kandinsky's reading of the German translation (1912) of Bergson's "Introduction à la Métaphysique" (a copy of which is still in Münter's library) may also have contributed to this process since, according to Hahl-Koch, of all the mystical and esoteric writers who may have played upon Kandinsky, Bergson was closest to him because of his ideas on intuition. But where Bergson saw intuition as a psychological means of maintaining some kind of balance amid flux, Kandinsky would use the concept in a far more cosmic and mystical way (*GS* 1:53; *CWA* 1:394).

Whatever the sources of Kandinsky's intensified religiosity, its nature is very apparent in his essay "Über die Formfrage" ("On the Question of Form") (*DbR*, 132–82/147–87) that appeared in print only five months after *Über das Geistige in der Kunst*. Where, in his first book, Kandinsky had oscillated between or tried to synthesize historicist and religious views of history, in "Über die Formfrage," the idea of history as a spiritual triangle, slowly moving upward and forward, has been almost entirely occluded by a vision of history as an apocalyptic conflict between light and darkness (*DbR*, 136/150). According to this view, modern humanity, unlike medieval humanity, has rebelled against God and formed a hard crust around its spiritual consciousness through the overcultivation of the intellect and fixation upon the material world. That crust will, however, be broken open apocalyptically by the irruption of God into human history; and after a period of redemptive chaos, a proper consciousness will be reestablished and an "Epoche des grossen Geistigen" [Epoch of the Great Spiritual] inaugurated (cf. *DbR*, 143/154)—an idea that can, incidentally, be traced back as far as Joachimo di Floris (1131–1202).[35]

Correspondingly, the whole of the *Almanach der blaue Reiter* (May 1912), with St. George on its cover and Apollo, the god who taught man-

kind the art of healing, on its second frontispiece, was designed as a *Gesamtkunstwerk* whose purpose was to propagate Kandinsky's religious view of history and offer spiritual hope to the reader.[36] Indeed, the religious motivation behind the *Almanach* was so strong that Kandinsky, in a 2 February 1912 letter to Marc, expressed his unwillingness to allow the Expressionist artists of the Berlin *Brücke* group very much space there on the grounds that they did not share his religious convictions (*KMBr.*, 128). Accordingly, the *Almanach*'s essays and illustrations had a visionary, prophetic, and therapeutic purpose. They were intended to proclaim that behind the materialism and escalating violence of modernity, a transcendent, healing power was at work which, once glimpsed through premodern, non-Western, and abstract artworks, could conjure and exorcise the forces of darkness as had happened in past ages through the communal *Gesamtkunstwerk* of religious ritual.[37] By the time of *Rückblicke* (autumn 1913), Kandinsky's apocalyptic view of history had become even stronger. Where *Über das Geistige in der Kunst* had ended on a brief (and unique) mention of the "Epoche des grossen Geistigen," the last pages of Kandinsky's reminiscences are full of chiliastic hopes of imminent renewal, expressed in overtly Christian language (*GS* 1:46–50; *CWA* 1:378–82). And in 1914, he went so far as to conclude his Cologne lecture by describing the motivating force behind his work as "die Stimme des Herren" [the voice of the Lord] (*GS* 1:59; *CWA* 1:400). How far Kandinsky's *oeuvre* bears out his mystical theory of art and confirms his fundamentally optimistic chiliasm will now be considered.

Drama

In his 19 August 1912 letter to Kandinsky, Schoenberg praised Kandinsky's abstract drama *Der gelbe Klang* (*The Yellow Sound*) (1909–12) because, instead of offering a clear solution, it was a "Rätsel" [puzzle/riddle] that provoked one to use one's "Schöpferkraft" [creative powers] and solve it individually (*KSBr.*, 69). Interpreters of Kandinsky's abstract dramas have certainly done that—with the result that there is absolutely no consensus about what they mean. But overall, one can say four things. First, interpreters have largely restricted themselves to *Der gelbe Klang*.[38] Second, they have nearly always read this play without reference to its position in *Der blaue Reiter* or Kandinsky's other three plays.[39] Third, despite evidence to the contrary, they conclude that this play confirms Kandinsky's apocalyptic theology of history and evinces a cosmic optimism.[40] Fourth,

they tend to dismiss one another's attempts at exegesis fairly dogmatically. Obviously, any interpretation of Kandinsky's dramatic work must be provisional, but if, like Thürlemann, one contextualizes *Der gelbe Klang* and views his four dramas as aspects of an attempt to resolve the cosmic problems outlined above, then a divergent result emerges.[41] Despite the majority consensus, it is by no means clear that when Kandinsky worked with light, color, and sounds—materials that elude conscious control to a greater extent than words—he was as capable of dealing with cosmic violence as the theological optimism of his historicoaesthetic theory would lead one to expect.

All four abstract dramas deal with the apocalyptic collision of four forces: spiritual light, metaphysical darkness, chthonic violence, and bourgeois materialism. According to the color symbolism set out in *Über das Geistige in der Kunst* (87–104; *CWA* 1:177–91), a section of the book that dates from 1904, Kandinsky associated the first force with white and blue, the second with gray and black, the third with yellow, orange, and red, and the fourth with brown and green.[42] Thus, the first tableau of *Der grüne Klang* (*The Green Sound*) (1909), having established the terms of the debate by juxtaposing red, green, and blue, dissolves into apocalyptic clamor, out of which music, another image of spirituality, emerges. Its second tableau involves a white wall and a confusion of strange towers that recall Kandinsky's image of Murnau/the Spiritual City from the same period. At first, a chaotic mass of people dominates the stage, but then the music re-emerges and a monologue is recited that involves images of reconciliation and resurrection and celebrates a timeless mystery. Chthonic figures then rush furiously across the stage; the music stops for a while; and a sick beggar proclaims that he is dying for want of light—whereupon everything turns black, with only the music persisting in the darkness. Clearly, this ending encapsulates the message of *Über das Geistige in der Kunst,* albeit in an attenuated form, but particularly as it is expressed in Kandinsky's Bergsonian statement (cf. chapter 5, *EC,* 290/282) that in the present, materialistic age "nur ein schwaches Licht dämmert wie ein einziges Pünktchen in einem enormen Kreis des Schwarzen" [Only a weak light glimmers, like a single tiny point in an enormous circle of blackness] (22; *CWA* 1:128). The same applies to *Schwarz-Weiss* (*Black-White*), also from 1909. In its first tableau, the problem is stated via the opposition of black and white figures against a background of deep blue mountains. The opening of the second tableau is dominated by a monstrous black mountain and a crowd of men

dressed in black. These are then confronted by a young man and a group of women in white who are then joined by a single woman in black. The two groups freeze and dissolve, leaving the man in white and the woman in black confronting each other; the black mountain then grows and the tableau ends in darkness that seems to obliterate a voice that has tried to make itself heard. In the third tableau, a woman in white lies recumbent on a black hill; a choir chants a highly ambiguous poem in which it is not clear whether the woman is being asked to arise and overcome the blackness or whether the ultimate victory of blackness is being proclaimed; and at the end, total darkness blots out the last vestiges of gray light. But in the final tableau, after much interplay between chthonic colors, a black rider on a white horse, and people dressed in green, the sky is covered in white clouds, the green figures drive away the impending darkness with white torches, and a deep blue bird disappears into the white sky. Even more clearly than *Der grüne Klang, Schwarz-Weiss* proclaims the power of transcendent spirituality to mitigate chthonic violence, enlighten the bourgeois, overcome metaphysical darkness, and resolve confusion and contradiction.[43]

If one sets *Der gelbe Klang* against the above two plays, it is evident that its ending does not involve the same degree of metaphysical optimism—as one would expect of a text that evolved over a three-year period during which Kandinsky's sense of the power of primal violence was growing. The introductory tableau (in which light and blueness triumph over darkness) is very similar in spirit to the final tableau of *Schwarz–Weiss,* and the static fourth tableau (in which a boy in white confronts a man in black) also seems to belong more to the earlier play. But overall, *Der gelbe Klang,* as its name suggests, is much more centrally concerned than the first two plays with coming to terms with chthonic violence, embodied in the yellow giants who dominate tableaux 1, 3, 5, and 6 and the yellow flowers of tableau 2. In the first tableau, the color symbolizing depth, spirituality, and order triumphs. But at the end of tableaux 2, 3, and 5, only unredeemed darkness is left on stage, and in the final tableau a yellow giant grows until he fills the stage, causing its initially blue background to turn black. He then stretches out his arms in the form of a cross—whereupon the stage darkens and the drama ends. Like so many of Kandinsky's visual works from 1909 to 1914, *Der gelbe Klang* does not seem to share the metaphysical faith of *Über das Geistige in der Kunst* that a prelapsarian paradise would emerge after a period of chaos.[44] Rather, it involves the sense that chthonic violence is more potent than spirituality and arrives, more unequivocally

than the two earlier dramas, at the conclusion that the universe is ultimately governed by metaphysical darkness, not redemptive light. Indeed, the ending of *Der gelbe Klang* contrasts strikingly with that sketched out in the one-act manuscript play cited by Hahl-Koch in which the question marks and "immense silence" that bracket its plot are finally superseded by "the first ray of the infinite sun."[45] In *Der gelbe Klang* (which Hahl-Koch believes to be closely associated with this sketch), precisely the opposite happens.

Violett (which the conflicting dates in the French version [83] and the *Bauhaus Quarterly* suggest was written between 1911 and 1914) is the longest, most sprawling, and most naturalistic of the four dramas.[46] Thus, although its individual scenes are relatively easy to understand, it lacks the tightly organized color symbolism, overall direction, and coherence of the other three and is more like a collage of simultaneous, nonconsecutive tableaux. According to Zweite, *Violett* exposes an unfathomable sense of life under threat—a statement that is certainly true of the first tableau in which ramparts and buildings collapse, apocalyptic lights fill the sky, and an urban cacophony invades the cultured bourgeois world in which the action takes place.[47] In the second tableau, this confusion persists, for here the action consists of a plethora of kaleidoscopic images including black walls, a walled city with towers on a hill, a deep blue sky, a motley chaotic crowd, white, red, green, and violet light, a blind, sick beggar seeking redemption, women's and children's voices promising healing and reconciliation through one who, though vanished from sight, lives eternally (90), an old man proclaiming a mystery, a black boat on the waters, fourteen characters from the commercial and scientific worlds, a white crowd, and a green woman. Unlike the earlier three plays, the above events happen with such rapidity that they approach the same kind of apocalyptic simultaneity that characterizes Kandinsky's painting behind glass *Sintflut* (*zu Komposition VI*) (*Deluge* [*for Composition VI*]) (1911) (*CR* 1:413). The same is true of the Entr'acte and tableau 3. After an initial rapid play of colored light, this tableau involves a yellow light, a hill, a red cow, a group of people who look like Russian dolls, a hidden choir, which, in contrast to the first scene, gaily celebrates the collapsing ramparts, a play of violet light, a bassoon, and the proclamation of a redeemer who will lead mankind out of the forest and who is associated with a fountain, white light, and a rainbow. Indeed, were it not for the tableau's ending in total darkness, with only a bass voice, devoid of expression, uttering forlorn cries in its midst, one could see this tableau as the verbal equivalent of those primitivizing paintings, executed

in a sunny, more joyful manner despite their subject matter, that Kandinsky produced in 1910 and 1911 such as *Apokalyptische Reiter I* (*Horsemen of the Apocalypse I*) (1911) (*CR* 1:411). The fourth tableau takes us back to the bourgeois setting of the first tableau. As in part 2 of Eliot's *The Waste Land*, the man and the woman here are unable to communicate since their relationship is sterile (102), causing darkness to descend upon them. But unlike the previous tableau, tableau 4 ends with the re-emergence of light, blasts on wind instruments, the suggestion of an apocalyptic horseman, and a child's voice proclaiming once again the collapse of the ramparts (103). Clearly, this final episode is a veiled version of the Last Judgment. As such, it closely parallels Kandinsky's first painting with an explicitly apocalyptic title, *Das jüngste Gericht* (*The Last Judgment*) (1910) (*CR* 1:342), and also the similarly titled painting behind glass of 1912 with its suggestion of an apocalyptic trumpet in the top right and a horseman in the top center (*CR* 1:441). In all three cases, judgment is being called down upon a world that, in Kandinsky's view, had been deadened by "the obsessive materialism of the merchant middle-classes."[48] The fifth tableau is not cosmic in scope and given its static quality and frozen ending it belongs more to *Der grüne Klang* or *Schwarz–Weiss*. The sixth depicts the banalities, boredom, and discord of small-town life and is also devoid of cosmic events (apart from a ray of blue, perfumed light that falls on the head of the barrel organ player [108]). And the final tableau, although to a large extent a reprise of the opening tableau, ends in total darkness with a woman's voice crying out loudly in fear and amazement and the proclamation of the news that the fallen ramparts are being rebuilt.

In other words, *Violett* suggests conclusions that partly confirm and partly contradict the metaphysical optimism of Kandinsky's historicoaesthetic theory. First, its circular structure indicates that the bourgeois era, having undergone a crisis, will re-establish its shattered ramparts and will not be superseded by the "Epoch of the Great Spiritual." Second, although five of its scenes end in total darkness, the strong images of redemption, especially in the first three tableaux, transmit the sense that a countervailing power exists within or alongside that darkness. Third, Kandinsky's use of veiled apocalyptic imagery within the chaotic events of tableaux 1 through 3 suggests that primal violence is, from a religious point of view, not gratuitously destructive but the negative aspect of an essentially positive salvation event. So in the end, *Violett*, like Kandinsky's understanding of that color, is ambiguous. A mixture of blue and red, violet is said to involve a balance between or synthesis of the spiritual and the chthonic

and yet, at the same time, to be the color of mourning, signifying insta-
bility and the lack of any final, unequivocal certainty (*ÜdG*, 102–3; *CWA*
1:188–89). Similarly, in the drama with this color as its title, apocalyptic
hope and cultural pessimism exist next to one another, as alternative, even
complementary, views of history.

All of this suggests that over a period of five years, Kandinsky's abstract
dramas became less neatly affirmative and more complex. Although they
began from the same sense of cosmic affirmation that marks his theoreti-
cal statements, they increasingly foregrounded that darker sense of history
which haunts so much early Expressionist art and literature. Nor did they
never quite manage to assimilate completely that darkness into an unam-
biguously Christian pattern of resurrection out of cosmic crisis.

Klänge (Sounds): Poetry and Woodcuts

Despite its official publication date of 1913, *Klänge,* Kandinsky's ex-
tremely rare collection of thirty-eight poems, twelve colored woodcuts,
and forty-four black-and-white woodcuts, appeared in autumn 1912.[49] Its
poems, owing much to Stefan George, were written sometime between
1909 and 1912.[50] Four of its woodcuts derive from 1907, five from 1912, and
the other forty-seven from 1911. As I have argued elsewhere, the poems
and woodcuts, like the dramas, are centrally concerned with eschatological
questions and eschew neat, unequivocal answers. But unlike the dramas,
Klänge does not make any systematically allegorical use of color and works
instead through figurative imagery and abstract pattern.[51]

With one or two exceptions, the woodcuts of *Klänge* are marked by a
pronounced sense of dramatic seriousness, an intense feeling of conflict,
and an overpowering awareness of the dark and threatening powers. To
offer five examples only: the black-and-white woodcut between "Hügel"
("Hills") and "Sehen" ("Seeing") (*S,* 19; *GrW,* 195) is characterized by
strong black lines, tension, energy, and starkness and emits a feeling of con-
fusion and fear. In the center of the black-and-white woodcut immediately
above "Offen" ("Open") (*S,* 31; *GrW,* 289), lines of force running from the
top right-hand and bottom left-hand corners seem to collide. "Warum?"
("Why?") is followed by a semiabstract woodcut with strong black lines
(*S,* 143; *GrW,* 125) that are overlaid with patches of royal blue and bright
red so that the color stands in tension with the lines, generating a power-
ful sense of violence, collision, and centripetal force. In the vignette above
"Der Riss" ("In Two") (*S,* 68; *GrW,* 241), a storm beats down upon an ex-
posed mountain village while to the right, a gigantic white face appears

to loom up from behind the horizon. And next to "Lenz" ("Spring"), the colored woodcut *Grosse Auferstehung* (*Resurrection* [*Large Format*]) (*S,* 105; *GrW,* 277) involves an apocalyptic landscape.

Kandinsky deals with the apocalyptic violence of the woodcuts via two dominant images that occur in eighteen of them: crucifixion and, above all, the horse and rider (an image which, according to Weiss, goes back to 1901 in Kandinsky's work and became particularly important for him in 1911).[52] The first image implies that the eschatological events of the woodcuts (also present in their imagery of narrow defiles, bleak deserts, arrivals, turbulent rivers, ascents of mountains, and so on) can, as in the first three tableaux of *Violett,* be seen as an aspect of a redemptive process. And the second image suggests that when the horse, a manifestation of natural vitality, is tamed and ridden, it turns into an image of the human ability to suffuse such powers with spirit (*GS* 1:39; *CWA* 1:370), attain a state of dynamic balance, and successfully negotiate eschatological situations. In illustration of this, *Zwei Reiter vor Rot* (*Two Horsemen against a Red Background*), the frontispiece of *Klänge* (*S,* 15; *GrW,* 191), is formed by a blue horseman on a white and yellow horse. The horse and rider are ringed in a halo of white light and followed by a black, deathlike figure on a horse that rears up just outside the halo as though prevented from entering it by the talismanic power of whiteness.

Within the context of these two dominant image patterns, the illustrations of *Klänge* progress in three ways. First, they become increasingly abstract. Second, after the colored woodcut *Kahnfahrt* (*Voyage in Rowing Boats*) (*S,* 59; *GrW,* 231), an explicitly religious imagery involving pilgrims, churches, and groups of people awaiting baptism becomes more prominent. Third, the pattern of the circle becomes more evident both as the outer form of many of the vignettes and within the woodcuts themselves. Thus, surprisingly in view of its title, the lines in *Jüngster Tag* (*Judgment Day*) (*S,* 89; *GrW,* 293) are neither so black nor so aggressive as those in most of the preceding large woodcuts and seem to be moving toward an as-yet-unclear circular pattern. In the second of the two woodcuts that follow "Kreide und Russ" ("Chalk and Soot") (*S,* 101; *GrW,* 271), overarching black lines tend toward a circular pattern above a vaguely human shape in the foreground. And the abstract woodcut that concludes the collection combines a completed circular pattern with the horse and rider motif. Given that the circle had connotations of spirituality for Kandinsky and that, in his mind, the quest for pure abstraction in painting was synonymous with the quest for the "inner resonance" of pure spirituality, the

inference is clear.[53] Visually, *Klänge* moves gradually and haltingly toward a sense that higher meaning, pattern, and spirituality can emerge out of demonic conflict and the trials of pilgrimage. And this may well be connected with the fact that the very nature of the woodcut involves such a high degree of conscious control.[54]

A similar progression is visible in the strangely dreamlike poems despite the inconclusive and self-deflating nature of some of them. The key to the whole is provided by "Wasser" ("Water"), the central poem (*S, 65–67*), in which a "little thin red man" makes his way with difficulty through a bleak landscape, saying to himself from time to time, "Water . . . Blue water." During his journey, he is subjected to two trials: a green horseman fires an arrow at him that he manages to deflect, and then, as he passes through a narrow defile, a crouching white man drops a rock upon him that he again manages to ward off. After both incidents, the assailants smile as though in approval and the little red man is said to grow. Given the associations of blue and red for Kandinsky, this poem allegorizes the quest of humanity in its natural state for spiritualization and the divinely imposed eschatological experiences that have to be undergone during this quest.

Although no other poem in *Klänge* can be described in so sustained and coherent a way, more than a few involve images and ideas that, even if fragmented, complement or amplify the central concern of "Wasser." "Hügel," for instance, the first poem of the collection, deals with pilgrimage along a path that is narrow and white, connoting spirituality. "Sehen" and "Fagott" ("Bassoon"), the second and third poems, present scenes of apocalypse out of which obscure intimations of meaning emerge ("ein weisser Sprung") [a white crack/leap] in "Sehen" and images of "ein Streben dem Morgen zu" [a striving toward the morning], music, and greening in "Fagott." "Ausgang" ("Exit"), "Frühling" ("Springtime"), and "Unverändert" ("Unchanged") involve images of lightning and storm. "Sehen," "Doch Noch?" ("Still?"), "Frühling," "Warum?," and "Im Wald" ("In the Woods") include references to the cross and crucifixion. "Hügel," "Sehen," "Käfig" ("Cage"), "Das" ("That"), "Unverändert," "Hoboe" ("Oboe"), "Frühling," "Doch Noch?," and "Blick" ("Look") contain, respectively, nightmare features such as obscene swellings, the sense of being trapped in an infinite regression, the experience of being rooted to the spot, the feeling of one's tongue becoming and staying completely dry, the sense of a great disgust, the sight of rapid, but soundless organic growth, the fear of emasculation, the sense of someone's words failing to reach the person to whom they are addressed and hanging "wie nasse Lumpen an den Büschen" [like

wet rags on the bushes] (*S,* 49), and the sense of being observed by a name-less being even though one's eyes are tightly shut. "Fagott," "Käfig," "Früh-ling," and "Klänge" ("Sounds") all involve suffocating clouds. "Käfig," "Doch Noch?," "Der Riss," and "Wurzel" ("Root") use images of impris-onment. "Fagott," "Das," "Unverändert," and "Frühling" involve the de-struction of a house, the place of security. "Offen" deals exclusively with one image of openness ("Rohre" [tubes/reeds]) amid images of constric-tion and oppression. "Hügel," "Fagott," "Glocke" ("Bell"), and "Blätter" ("Leaves") depict bleak landscapes like that through which the pilgrim of "Wasser" is progressing. "Warum?," "Unverändert," "Ausgang," and "Der Turm" ("The Tower") involve the image of a door. And "Einiges" ("A Thing or Two"), "Doch Noch?," "Im Wald," and "Vorhang" hint at re-demption and revelation through the images of the blue flower, "erzählen-des Gold" [speaking gold], "die heilenden Narben" [the scars that mend] (*S,* 79), and the raising of a curtain.[55] In every case, then, the fragmented and sporadic poetic imagery parallels the woodcuts by suggesting aspects of a spiritual journey—struggle through radically negative experiences toward freedom, wholeness, and a sense of meaning.

Although the poems of *Klänge* nowhere involve a single, simple, or tri-umphalist statement, one can discern in them the same loose progres-sion that characterizes the woodcuts. To begin with, it is significant that "Sehen" and "Fagott" (the two most apocalyptic poems), the four poems involving lightning and the destruction of a house, the four poems with the suffocating clouds, four of the five poems containing the image of cru-cifixion, and all but one of the nightmarish poems occur in the first half of the collection—*before* "Wasser." Or again, the collection begins with "Hügel," a poem dealing with pilgrimage that peters out in self-deflation. It then moves through two poems of extreme turmoil, the first of which, "Sehen," ends inconclusively and the second of which, "Fagott," ends am-biguously as the greenness called forth by the instrument becomes poison-ous. The collection then struggles through a series of poems in which the stress is on the negative; reaches a high point of clarity and organization with the central poem, "Wasser"; and then, throughout its second half, be-comes much lighter and affirmative in tone. Accordingly, the stark, bleak landscapes of the first half recede so that even "Weisser Schaum" ("White Foam") and "Blätter," poems that involve demonic apparitions, take place respectively in "flache grüne Wiesen" [flat green meadows] and a blos-soming landscape where, even after the demonic horseman has caused the leaves and the flowers to disappear, red berries still proliferate. "Der Riss"

deals with two men who discover how to break from their bondage and ends with both of them laughing heartily (*S,* 68). The nightmarish sense of constriction experienced by the central figure of "Im Wald" is remedied by reciting "Die heilenden Narben / Entsprechende Farben" [The scars that mend / Colors that blend] (*S,* 79). "Vorhang" deals with the raising of a curtain and ends on a note of joy. "Hymnus" ("Hymn") ends with three lines in which blue waves grow deeper, supplanting dark confusion ("Dunkles Irren") and promising to lay a red cloth to rest. Given the significance for Kandinsky of the colors blue and red, this is an ending that hints at the power of the spiritual to allay the chthonic. "Später," a highly paradoxical poem, culminates in the idea that endings and beginnings are one. "Lenz" contains four images of renewal—the new moon, a star, three lighted windows, blueness that is beneficial to the eyes—and ends in an image of redemptive suffering (*S,* 107). "Lied" concerns a man who is deaf and blind but nevertheless "vergnügt" [content] because he can sense the subtle impulses emitted by the sun, and contains the lines "Was ist gestürzt, / Das steht doch auf. / Und was nicht sprach, / Das singt ein Lied." [Whatever falls / stands up again. / And what was dumb, / It sings a song.] (*S,* 110). "Tisch" ("Table"), like several of the woodcuts in the second half of *Klänge,* evokes a vision of community—here, around a huge, corporate table. "Wiese" ("Bright Field") ends on the cry "Schweigen!" [Silence!], which, strangely enough, has a positive resonance in this poem. And "Blick und Blick" ("Sight [and] Lightning") and "Das Weiche" ("Softness"), the two concluding poems, prefigure Hans Arp's *wolkenpumpe* poems of 1917 to 1920 in their freely associated, almost stream-of-consciousness use of language.[56]

In comparison with Kandinsky's dramas, the poetry of *Klänge* moves much more confidently to an almost joyous sense of affirmation. But unlike Kandinsky's woodcuts, the poems arrive at that sense without the same extensive use of overtly Christian symbolism. And unlike Kandinsky's aesthetic theory, that sense does not involve the gnostic split between spirit and matter. Indeed, in the second half of *Klänge,* we find the beginnings of an almost Dadaist sense that a redemptive power of renewal is at work *within* Nature and the material world—a fact that doubtless explains the Zurich Dadaists' attraction to two of those poems (see chapter 9). Despite several passages in *Klänge* in which repression of the animal is an undeniably important theme, Kandinsky manages, in the collection's second half, to arrive tentatively at the poetic insight that comes through theoretically at certain junctures in "Über die Formfrage." Nature is seen as "anarchic"

in the good sense because it involves inherent patterns and regularities that have not been imposed upon it by phallogocentric force.[57]

The Paintings

Although, as Zweite pointed out, Kandinsky's visual work up to mid-1914 unfolded in a nonlinear way, its inner drive can, like his work in other media, be understood as a series of strategic attempts to deal with a growing sense of primal or apocalyptic violence.[58] This sense was relatively muted in the seminaturalistic landscapes that Kandinsky was still painting during his first year in Murnau (for example, *Murnau—Landschaft mit grünem Haus* [*Murnau—Landscape with Green House*] [1909] [*CR* 1:265]) where a kind of surreal explosion on the right-hand side of the picture threatens the stable house on the left) and the *Impressionen* (*Impressions*) (pictures which "derived from the contemplation of Nature" and the first of which was executed in 1911).[59] But it became increasingly pronounced in the more abstract *Improvisationen* (*Improvisations*) (the first of which was painted in 1909 [*CR* 1:260]) and *Kompositionen* (*Compositions*) (the first of which was painted in 1910 [*CR* 1:306]). It finally manifested itself most starkly in such late works as *Improvisation 30 (Kanonen)* (*Improvisation 30* [*Canons*]) (January 1913) (*CR* 1:440) (which Kandinsky, in a letter to its purchaser, Arthur J. Eddy, written shortly after the outbreak of war, refused to relate to a specific war [*CR* 1:445] and which, according to Washton Long, relates more to Kandinsky's chiliastic anticipation of Armageddon [101]); *Komposition VI* (5 March 1913) (*CR* 1:461); the four murals for Edwin R. Campbell (1914); and *Improvisation Klamm* (*Improvisation Gorge*) (1914) (*CR* 1:495–508).

Of Kandinsky's strategies, the most obvious, as with the woodcuts of *Klänge,* involves religious titles and imagery. During the years 1909 to 1913 and beginning with *Paradies,* Kandinsky painted a large number of works on religious and apocalyptic subjects, with the majority dating from 1911. In all cases, images of redemption like the Spiritual City on the hill and the threatened boat on dark, turbulent water as in *Improvisation 11* (1910) and *Kahnfahrt* (1910) (*CR* 1:312 and 330);[60] or images of balance like the couples in *Improvisationen 25* and *27)* (1912) (*CR* 1:416 and 422) and the horsemen in *Improvisation 12* (1910) (*CR* 1:332); or images of resurrection out of chaos as in *Das Jüngste Gericht* (*The Last Judgment*) (1910) (*CR* 1:342) are set against and act as a theological interpretation of the violence and turmoil of the painting as a whole. But where such images could speak of redemption and security with some conviction in the small-scale, firmly

controlled, and straightforwardly contrastive world of the printed wood-cut, they seem much more pathetic and much less reassuringly potent amid the hectic, multicolored turmoil of such huge oil paintings as the seven *Kompositionen*.[61]

As war approached, the redemptive imagery began to disappear from the surface of Kandinsky's works until, after mid-1912, even the religious motifs there can be identified only with the assistance of sketches and earlier, connected works.[62] In retrospect, Kandinsky saw this separation of art and Nature (*GS* 1:42; *CWA* 1:373) as a positive achievement, and Washton Long, taking over Kandinsky's own perspective, interpreted the disappearance of recognizable imagery as a dual process of "stripping" and "veiling" that enabled the object to become more meaningful (that is, better able to function epiphanically, like one of Rilke's "Dinge").[63] Nevertheless, the sheer difficulty that the layperson with no access to background materials has in understanding the concealed imagery of the abstractly titled paintings and the sheer impression of chaotic violence that such canvasses as *Composition VI* leave in the mind make such a reading debatable. Three comparisons amplify this point. Where, in *Fragment zu Komposition IV* (*Section for Composition IV*) (late 1910) (*CR* 1:347), the Spiritual City still functions as a place of refuge, in *Komposition IV* (1911) itself (*CR* 1:369), it no longer does so with the result that the rainbow motif that formed the center of the *Fragment* has become much smaller. Where, in *Improvisation mit Pferden* (*Improvisation with Horses*) (1911) (*CR* 1:378) — the study for *Improvisation 20* (1911) (*CR* 1:379) — a tottering Spiritual City is still in the back left of the picture, it has disappeared from *Improvisation 20* itself. Where, in *Sintflut* (*zu Komposition VI*), certain unclear forms are managing to survive the Deluge, by the time of the finished version, dark colors and swirling energies have swallowed all recognizable shapes except for the residual suggestion of a boat with oars toward the bottom left-hand corner. Consequently, it is hard to accept Kandinsky's retrospective claim that this latter painting is devoid of a sense of catastrophe and involves a sense of balance and peace.[64] Indeed, when the Spiritual City disappears from Kandinsky's paintings after the crazily reeling version to be found in *Improvisation 30 (Kanonen)* and the exploding version in the top right-hand corner of *Bild mit weisser Form* (*Painting with White Form*) (1913) (*CR* 1:458), we are surely seeing a negative rather than a positive phenomenon. Just as modernity threatened to engulf those premodern contexts in which Kandinsky had felt at home, so modernity, transcribed in terms of apocalyptic violence, threatens the last remaining "spiritual islands" of tra-

ditional, humanly graspable religious imagery to be found in Kandinsky's prewar masterpieces. Although Kandinsky himself accounted for the increasing disappearance of the objective world from his visual work in revelatory terms, to me at least, the dual process of "stripping" and "veiling" looks less like developing painterly technique and more like the desperate attempt of someone, like the rowers in the residual, floundering boat of *Improvisation Sintflut* (*Improvisation Deluge*) (1913) (*CR* 1:460), to contain a sense of imminent inundation. Indeed, I would suggest that this dual process is the painterly equivalent of the strict metrical form in which Expressionist poets like Georg Heym, Alfred Lichtenstein, and Jakob van Hoddis were trying, during exactly the same period, to contain their visions of apocalypse.

Kandinsky's primitivizing paintings behind glass of the years 1910 and 1911, inspired by the work of Upper Bavarian folk artists, implicitly represent a second strategy of containment. Both he and Münter believed that such naive work, rooted in a medieval piety, derived from a more unsullied spiritual tradition than mainstream Western art. Consequently, Kandinsky seems to have felt that if he could only identify with that tradition and work with its forms and images, then he would be better equipped to deal with his growing sense of apocalyptic violence.[65] As a result, his primitivizing paintings become lighter and more triumphalist in mood. Thus, in *Glasbild mit Sonne* (*Glass Painting with Sun*) (1910) (*CR* 1:358), the Spiritual City sits happily on its hill in the center of the work; all violent movement seems to be away from it; and in the top right-hand corner, the dark colors seem to be receding rather than encroaching. In *Gekreuzigter Christus* (*Christ on the Cross*) (1911) (*CR* 1:392), a horseman throws up his hands at the foot of the cross as though in joy. *Allerheiligen I* and *II* (*All Saints I* and *II*) (1911) (*CR* 1:397 and 412) are joyous scenes of resurrection executed in brightly naive colors. In *St. Georg I* and *II* (*St. George I* and *II*) (1911) (*CR* 1:398–99), a stylized saint slays a somewhat laughable dragon in garish, confident colors.[66] And *Apokalyptische Reiter I* (*Horsemen of the Apocalypse I*) (1911) (*CR* 1:411) involves three (rather than the standard four) figures who are almost jolly and slightly comic rather than terrible, and from whose assaults the town in the lower left foreground seems fairly secure. But there is a stylized artificiality about these paintings, and in *Sintflut* (*zu Komposition VI*), the painting behind glass of 1911 that is a study for the apocalyptic oil painting *Komposition VI* of 1913, their somewhat facile, affirmative religiosity is present only as unconnected fragments

that are under threat from the cosmic violence that is so typical of Kandinsky's major painterly work of the period.

When discussing Anarchism in "Über die Formfrage" (*DbR*, 147/157) and the concept of "construction" in his 18 January 1911 and 22 August 1912 letters to Schoenberg (*KSBr.*, 19–20 and 71–72), Kandinsky distinguished between a sense of structure that is imposed geometrically and a nonlogical sense of structure that is inherent; between a harmony that is enforced and a harmony that arises once discord is accepted. In making these distinctions he was contemplating the two major options open to him as a painter once the efficacy of traditional and primitivizing religious imagery had begun to weaken. Thus, on the one hand, one finds paintings in which circular or semicircular forms, reminiscent of earlier rainbows, are struggling to *emerge out of* the dark and chaotic elements in turmoil around them, as in *Bild mit Kreis* (*Picture with a Circle*) (1911) (*CR* 1:391) (Kandinsky's first abstract oil painting and his first title to involve the word "circle");[67] *Bild mit schwarzem Bogen* (*Painting with a Black Arch*) (1912) (*CR* 1:419); *Landschaft mit roten Flecken I* and *II* (*Landscape with Red Spots I* and *II*) (1913) (*CR* 1:452–53 and 459); *Improvisation mit rot-blauem Ring* (*Improvisation with Red and Blue Ring*) (1913) (*CR* 1:475); *Träumerische Improvisation* (*Dreamy Improvisation*) (December 1913) (*CR* 1:487); *Zum Thema Jüngstes Gericht* (*On the Theme of the Last Judgment*) (1913) (*CR* 1:479); *Improvisation mit kalten Formen* (*Improvisation with Cold Forms*) (February 1914) (*CR* 1:482); *Bild mit runden Formen* (*Painting with Round Forms*) (March 1914) (*CR* 1:485); and *Bild mit drei Flecken* (*Painting with Three Spots*) (1914) (*CR* 1:491). But on the other hand, one finds paintings like *Bild mit weissem Rand (Moskau)* (*Painting with White Border [Moscow]*) (May 1913) (*CR* 1:469), modeled, significantly enough, on Walter Crane's painting of St. George fighting the dragon (c. 1894);[68] the *Unbenannte Improvisationen* (*Untitled Improvisations*) (1914) (*CR* 1:505–9); and *Apokalyptische Reiter II* (*The Horsemen of the Apocalypse II*) (1914) (*CR* 1:512), in which more geometrical shapes, mostly tending toward the circular, *frame and contain* a scene of chaos. Where, in the small-scale woodcuts of *Klänge* from two to three years earlier, the sense of imposed form was more tentative and relatively unobtrusive, now, on the eve of war, the urgency of the need to contain has become much greater. Indeed, after the outbreak of war, Kandinsky seems increasingly to have resolved the inner conflicts that mark his early work by greater pictorial stylization and the gradual repression of disturbing, chthonic elements. This process was prefigured by a

highly untypical but very telling comparison in *Rückblicke* of the artist's canvas (which is said to exist in order to be subdued by the [phallic] brush) with wild virgin Nature (which is said to exist in order to be penetrated by the European colonizer, armed with axe, spade, hammer, and saw, and bent in accordance with his will) (*GS* 1:41; *CWA* 1:373). After the war, that phallogocentric urge produced the harder edges, flatter planes, and stricter formal control that characterize his work of the 1920s. Faced with a choice between a (Bergsonian) quest for *immanent form within material flux* or a *realm of pure form above that flux*, Kandinsky was drawn more toward the latter option in his later years. This move is graphically illustrated by *Gelb–Rot–Blau* (*Yellow–Red–Blue*) (1925) (*CR* 2:709), in which a highly stylized head to the left of the picture has deliberately separated itself from the more earthy colors and organic forms to the right. Neither the Great War nor the Russian Revolution had brought about the hoped-for "Epoch of the Great Spiritual" or the "resurrection of the lost paradise" that Kandinsky had foretold in his 10 March and 8 November 1914 letters to Marc (*KMBr.* 253–54 and 265–66). Consequently, he increasingly found himself compelled to cultivate his private visionary world and to dissociate his theoretical hopes for chiliastic renewal from the realities of their surrounding, political context.[69]

Conclusion

From the above discussion, it emerges that Kandinsky's theory of abstraction and increasingly chiliastic conception of history does not completely map with the complexities and contradictions of his *oeuvre* from 1900 to 1914. As Brinkmann concedes, there is no sense in which Kandinsky's poems and paintings work in the mystical, revelatory way described in *Über das Geistige in der Kunst*.[70] It is by no means clear what Kandinsky's abstract dramas mean, so that when performed, they nearly always fall short of the synaesthetic, revelatory hopes that Kandinsky invested in them.[71] There are, *pace* Weiss, clear discrepancies between the highly spiritualized way in which Kandinsky interpreted his works — such as *Komposition VI* and *Bild mit weissem Rand* — and the manifestly unresolved struggle and turmoil of those works.[72] Consequently, it seems more plausible to view Kandinsky's theory of abstraction and conception of history as a set of ideas that sustained him through a period of intense upheaval. These enabled him to preserve a sense of direction and meaning as more and more of his "spiritual islands" were overwhelmed by the violence and chaos

that were, in his mind, inextricably bound up with the materialism of modernity.

It also follows that when some aspects of Kandinsky's visual and literary *oeuvre* from 1909 to 1914 succeeded in reaching positive conclusions, they did so partly because of the nature of the particular medium and partly because of a certain selectivity and simplification. Because the black-and-white woodcut, the written word, and the traditionally determined religious image involve or permit a greater measure of conscious control than abstract color, Kandinsky's works in the three former media could be brought more into accord with his theory. But even when he worked in the fourth medium, Kandinsky, being consciously committed to a mystical aesthetic and a dualistic theology, sought to repress elements that might threaten it—notably anything that was obviously connected with the modern world. Thus, he omitted the clearly visible railway from all but two of the paintings executed in Münter's house and garden in Murnau (cf. *Murnau—Landschaft mit kahlem Baum* [*Murnau—Landscape with a Bare Tree*] [1909] and *Der Garten I* [*The Garden I*] [1910] [*CR* 1:289 and 337]), and he included other overt images of modernity only in *Violett* and the painting *Landschaft mit Fabrikschornstein* (*Landscape with Factory Chimney* (1910) (*CR* 1:323). Conversely, Kandinsky's most unequivocally affirmative work, *Klänge,* can probably be so partly because of the Georgeian inspiration and premodern setting of its poems and illustrations. Indeed, Kandinsky openly admitted in an 11 August 1924 letter to Will Grohmann that he had no interest in the world of real (as opposed to chiliastic) politics and recorded in "Mein Werdegang" (1914) that he deliberately diminished the tragic sense of some of his paintings, like the tumultuous *Komposition II* (1910) (*CR* 1:314), by using "gleichgültigere und gleichgültige Farben" [more indifferent and (totally) indifferent colors] (*GS* 1:55; *CWA* 1:397).[73] Given all of this, it is entirely consistent that he should have disregarded the work of the mentally ill Russian Symbolist painter Mikhail Vrobel, whose disturbing masterpiece, *Demon poverzhennyi* (*The Demon Downcast*) (1902), he probably knew via an essay by Blok.[74]

Throughout the prewar years, Kandinsky negotiated a narrow and difficult path between several sets of extremes: confrontation with and repression of modernity; acceptance and repression of the dark, irrational sides of experience; nostalgia and chiliastic expectation; the quest for immanent structure and the imposition of external structure; fascination with and fear of Nature; metaphysical optimism and pessimism. Consequently, none of his works during this period can be taken as a final statement—

though if we judge them according to their imaginative and emotional power, then his paintings have an authority that his work in the other media does not. This is, I suggest, *precisely* because they are *not* final statements but documents of a powerful, many-sided, spiritual struggle that Kandinsky himself likened to "ein donnernder Zusammenstoss verschiedener Welten" [a thundering collision of different worlds] (*GS* 1:41; *CWA* 1:373). If, after the Great War, Kandinsky decided that a painterly withdrawal onto the plane of controlled spirituality was the most appropriate response to the materialism and violence of modernity after his multifaceted rearguard action of the prewar years, who is to blame him? His decision certainly does not constitute anything as crude as escapism; nor does it detract from the value of his work. It is simply one example of a strategy that is highly typical of the modernist generation, and it still speaks to the contemporary viewer because of its powerfully conflictual and unresolved nature.

7. Radical Cheek, or Dada Reconsidered

Despite the growing interest in Dada since the mid-1970s, Dada is by no means universally loved—which is probably as it should be. Liberal humanist scholars still distrust Dada—not surprisingly given its antipathy to liberal humanism. Marxist scholars still despise Dada—again, not surprisingly, since its politics, such as they are, tend toward Anarchism (see chapter 12). Devotees of "high modernist" art tend to dismiss Dada as childishness. Partisans of Surrealism still regard Dada as a purely nihilistic forerunner. And despite the efforts of critics like Ihab Hassan to show the links between Dada and postmodernism, at least one authority on postmodernism has condemned Dada as élitist in the same breath as Eliot even though, as has generally been conceded since the appearance of Bürger's influential book, Dada involved one of the first major attempts to bridge and even abolish the gap between "high" élitist art and "low" popular culture.[1]

Much of this antipathy is based on prejudice, ignorance of primary sources, and/or an inability to read any languages apart from English and French. But a deeper and more serious reason for the continued antipathy concerns Dada's avowed irrationalism and heterogeneous messiness. Bürger realized that the historical avant-gardes could not be simply ignored or dismissed and one of the possible reasons why his account has proved so acceptable to people who, if they really understood what the avant-gardes were saying, would hate them is that he plays down these aspects. Where Dada saw its significance first and foremost in existential and social

terms and its attack on Art with a capital *A* as something secondary, Bür-
ger presents its attack on the institution of art in bourgeois society and
its attempt to reintegrate art with life as its two defining features.² This
account then makes it possible to accept the historical avant-gardes rela-
tively easily, pigeonhole their projects historically, and then declare them
a failure. Habermas, for example, took over Bürger's analysis in his lec-
ture of 1980, concentrated on Surrealism rather than Dada, and did just
that.³ But if Habermas had understood that Dada and Surrealism were
profoundly irrationalist movements intent on a transvaluation of all values,
then, coming from a culture that had seen a very different kind of irratio-
nalism cause millions of deaths and representing a strain in philosophy that
is both Marxist and humanist, his critique of the historical avant-gardes
would have had to be far less benevolent and far more searching. Indeed,
Habermas would have had to recognize in Dada and Surrealism precisely
that celebration of "die spontanen Kräfte der Imagination, der Selbster-
fahrung, der Affektivität" [the spontaneous powers of imagination, of self-
experience and of emotionality] which he identified in the line of thought
that leads from Bataille via Foucault to Derrida and label it "neoconser-
vative."⁴ Conversely, it seems to me that Hermann Korte's recent, brief,
and well-informed study of Dada has a much better feel for the priori-
ties, force, complexity, and provocativeness of the phenomenon and so will
receive scant attention in scholarly literature—not least because it is writ-
ten in clear German and published in a series of monographs that aims to
popularize.⁵

In following Korte's example within a more limited space, I am aware
that I am trying to give a coherent account of a phenomenon that "does
not exist as an abstract set of rules and principles" and has no clear "roten
Faden" [guiding principle]. As will emerge in chapters 8 and 9, Dada began
in a fairly haphazard way in Zurich in 1916, invented itself as it went along,
and acquired an increasingly complex sense of itself over a period of years.
So although Last was justified in saying that "in a real sense, there are as
many 'Dadas' as there are Dadaists," in my view he was not correct when
he added that Dada existed only "in the most vague and nebulous terms."⁶
Dada may be fluid and diffuse, but involves a complex of paradoxical atti-
tudes that I shall try to characterize in this chapter. In doing this, I also
realize, as is often remarked by friends and foes of Dada alike, that any
attempt to make this complex intelligible also makes it less of a *skandalon*.
But having got this far, I shall follow Frank Kermode's timely suggestion
and try to situate Dada within the "theoretical environment" of modern-

ism established so far.[7] I shall begin by showing how Dada's critique of post-Renaissance Western civilization relates to the broader-based critique outlined in chapter 2. I shall then show how the Dadaists tried to deal with their sense of crisis and come to terms with modernity. And I shall conclude by describing the main features of the antiaesthetic in which Dada's critique of and experimental response to modernity were simultaneously embodied.

Dada as Diagnosis

The negativity for which Dada is best known derived most immediately from the Dadaists' sense of traumatized outrage at the unprecedented, senseless slaughter of the Great War together with the civilization that had allowed it to happen and been unable to stop it.[8] This sense drove some of them into exile and estranged all of them intellectually and spiritually from the society of which, before the war, they had at least been fringe, bohemian members. Thus, even before Dada began, Francis Picabia and Marcel Duchamp made it quite clear, in a long article published in the *New York Tribune* on 24 October 1915, that their firsthand experience of the war, the devastating effect it had had on the artistic life of Paris, and the crude nationalistic sentiments it had generated in the population at large were three of the major reasons why they had left Paris for the United States.[9] Richard Huelsenbeck's two histories of Dada, *En avant Dada* (1920) (translated 1951) and *Dada siegt!* (*Dada Is Victorious!*) (1920), presented Dada both as a violent protest against the war and as an attempt to exorcize its violence and the hypocrisy that had caused it, legitimized it, and allowed it to continue.[10] After visiting the front as a civilian volunteer, being horrified by what he saw, and exchanging Berlin for Zurich in May 1915 (where he lived in abject poverty), Hugo Ball wrote, in an important but rarely cited article:

> Der Krieg hat . . . aber auch die ökonomische Deklassierung der Intelligenz angebahnt, eine Tatsache, von der noch manches zu erwarten ist. Der junge Literat bürgerlicher Herkunft findet heute keinen Boden und kein Publikum mehr. Irgendwie empfindet er in Lebensfragen realer, radikaler als je. [. . .] Irgendwie fühlt er sich ohne Schutz und Subsistenz. Er vertreibt sich die Zeit mit Psych[o]analyse und neigt zur Hochstapelei. Er stänkert in 20 Berufen und zieht sich zurück, um überhaupt zu verzichten.[11]

But the war has . . . also precipitated the economic expulsion of the intelligentsia from their class, a fact that we can expect to have many repercussions. The young literary man from a bourgeois background can nowadays find no ground under his feet and no audience any more. Somehow, where existential questions are concerned, his intuitions are more real, more radical than ever before. . . . Somehow, he feels himself to be without protection and subsistence. He passes the time with psychoanalysis and develops a penchant for conmanship. He stirs it in 20 professions and withdraws in order to give up altogether.

Tristan Tzara was quite adamant that Dada was born out of a sense of disgust at the war. George Grosz's scurrilous, almost demented letters of 1916 and 1917, some of whose manuscripts are littered with crosses like a chaotic battlefield burial ground, make it utterly clear that his hatred of Western civilization, particularly in its German form, which comes through with so much rage in his visual work, was the direct result of his experience of the war, the army, and authority in general.[12]

All the Dadaists knew something of Ball's sense of deracination and Grosz's sense of disillusioned disgust, and out of it they formed the conviction that the epoch that had begun with the Renaissance, flowered during the Enlightenment, and culminated in modernity in its contemporary configuration had come to an end. In 1915, Hans Arp accused the Renaissance of turning a proper sense of values upside down. On 18 September 1916, Ball, like Paul Tillich before Verdun, noted in his diary that the Germany of Idealism had all but disappeared and that the whole of Western civilization had been an illusion—a mood that became even more critical in his lecture on Kandinsky of 7 April 1917. Tzara wrote in 1917, "Nous voulons continuer la tradition de l'art nègre, egyptien, byzantin, gothique, et détruire en nous l'atavique sensibilité qui nous reste de la détéstable [sic] époque qui suivit le quatrocento [sic]." [We want to continue the tradition of Negro, Egyptian, Byzantine, Gothic art, and destroy in ourselves the atavistic sensibility bequeathed to us by the detestable era that followed the quattrocento.] On 18 February and 15 December 1917, Grosz wrote letters to Otto Schmalhausen—Dada-Oz (1890–1958)—in which he expressed his opinion that decaying Western civilization was sailing down to destruction. In March 1921, Raoul Hausmann referred to "die Leichenbitter der abendländischen Kultur" [the gall seeping from the corpse of Western civilization] having asserted, two years earlier, that the feeling of security was beginning to disappear from Western, bourgeois civilization. In 1923,

the Dutch Dadaist Theo Van Doesburg described Western civilization as "een vermolmde en zinkende schuit" [a dilapidated and sinking boat]. And in retrospect Huelsenbeck called Dada the "Abbild und Hinweis auf die zusammenbrechende nach-klassisch bürgerliche Kultur" [image and index of collapsing, post-classical bourgeois culture].[13]

The Dada critique of contemporary modernity did not stop at lurid polemical generalities. It also addressed five of the key assumptions on which classical modernity had rested. Of these, the first and most important was that reality is anthropomorphic—made in the image of humanity and ordered according to humanly intelligible and acceptable notions of order. Echoing Wilhelm Worringer (whom the Cologne Dadaists acknowledged as the "profetor DaDaistikus" [Dada's progenitor] and whose two major prewar treatises had criticized post-Renaissance thinking for privileging Western, "empathetic" art over non-Western, "abstract" modes), Dada maintained that reality is an alien flux in which human beings are not at home.[14] Picabia's *Prostitution universelle* (*Universal Prostitution*) (1916–17), with its depiction of humanity as a mass of mechanized biology driven by forces beyond its control; Grosz's massive painting *Deutschland ein Wintermärchen* (*Germany, A Winter's Tale*) (1918–19, probably destroyed by the Nazis), in whose foreground three figures representing the church, the army, and the conservative educated classes maintain an air of authority, oblivious of the chaos behind them; the Heartfield/Grosz collage *Leben und Treiben in Universal City* (*Life and Commotion/Bustle in Universal City*) (1919); and Hannah Höch's massive photomontage *Schnitt mit dem Küchenmesser Dada durch die letzte Weimarer Bierbauchkulturepoche Deutschlands* (*Slice with the Kitchen Knife Dada through the Last Weimar Beer Belly Cultural Epoch of Germany*) (1919–20) forcefully transcribe this sense.[15] So do extensive passages in Ball's novel *Flametti* (1916); Huelsenbeck's cynical, antibourgeois novel *Doctor Billig am Ende* (*Dr. Billig's Last Gasp*) (c. 1919–20); Hausmann's autobiographical Dada-novel *Hyle* (1926–c. 1942); and the whole of Hausmann's extremely rare manifesto of October 1918, *Material der Malerei Plastik und Architektur* (*Material of Painting Sculpture and Architecture*).[16]

Elsewhere, as in Ball's lecture on Kandinsky, Dadaists described reality as a "Katarakt aus Unsicherheit und Zusammenbruch" [a cataract of uncertainty and collapse], an "ordelooze, tegenstrijdige totaliteit van meest inconsequente en elkaar frappant tegenstellende handelingen" [disorderly, conflicting totality of mainly illogical actions which stand in a strikingly antithetical relationship with one another], "ein ungeheurer Lärm, Span-

nung in Zusammenbrüchen nie eindeutig gerichteter Expressionen" [a monstrous din, tension amid breakdowns of expressions that are never unambiguously directed], and "eine in sich kämpfende in ständiger Bewegung begriffene unübersehbare Reihe von Phänomen[en] . . . , gleich einem buntbewimpelten Strom oder gleich einem Riesenwarenhaus, in dem das Rattern der elektrischen Signale nie abreisst und die bewegten Treppen durch die Stockwerke sausen" [a vast series of phenomena that are in perpetual motion and conflict with one another . . . like a brightly pennanted torrent or like a giant apartment store in which the chattering of electric signals never breaks off and the escalators hurtle between the floors].[17] In such a chaotic universe, objects are not real but a figment of the imagination, not solid but transient constellations of energy. After his experience at the front, Ball noted in his diary on 25 November 1914 that everything had become demonic, and in the first chapter of Ball's fantastic novel *Tenderenda der Phantast* (1914–20) (*Tenderenda the Fantast* [1995]), Donnerkopf says:

> Wahrlich, kein Ding ist so, wie es aussieht. Sondern es ist besessen von einem Lebgeist und Kobold, der steht still, alslang man ihn anschaut. So man ihn aber entlarvet, verändert er sich und wird ungeheuer.
>
> *Verily, nothing is the way it appears. Rather it is possessed of a vital spirit and goblin, which remains motionless as long as one looks at it. But once discovered, it transforms itself and becomes monstrous.*[18]

Ball would repeat this sentiment in his own voice more forcefully and without the protection of ironic archaism (which the English translation does not completely catch), in his lecture on Kandinsky two years later. Moreover, if, as Ball noted in his diary on 13 November 1915, objects are phantasms, then the metaphysical "Ding an sich" [thing in itself] postulated by Kant was a total self-delusion. Consequently, in the second chapter of *Tenderenda* (c. summer 1915), Jopp describes Kant's concept as "heute ein Schuhputzmittel" [nowadays a brand of shoe polish].[19] In *En avant dada,* Huelsenbeck, probably referring to Duchamp's (in)famous readymade, was equally contemptuous of Kantian metaphysics and concluded that "Ein Pissoir ist auch ein Ding an sich" [A urinal, too, is a thing in itself]; and in "Dada ist mehr als Dada" ("Dada Is More than Dada"), Hausmann said that the "Ding an sich" was an object of mirth.[20] For the Dadaists then, modernity in the shape of the war and/or the great city had replaced an anthropomorphic world of organized space in which

stable, metaphysically guaranteed objects moved along predictable trajec-
tories with a wildly fluctuating, multidimensional universe that was full
of violent shocks and alien and unpredictable energies. The parallel with
Chandos's experience is so obvious as to need no explanation, and in 1921,
Hausmann summarized this drastically changed situation when he wrote:

> . . . es kann nicht mehr unsere Aufgabe sein, den schönen Menschen
> zu verherrlichen, der naive Anthropomorphismus hat seine Rolle ausge-
> spielt.[21]

> . . . *it can no longer be our task to glorify the beautiful human being; naive*
> *anthropomorphism has played itself out.*

Walter Serner fled to Zurich from Berlin in late January/early Febru-
ary 1915 where, in October, he founded the short-lived periodical *Sirius*. In
March 1916, even though he was going through a brief religious phase and
deeply critical of the iconoclastic events in the newly opened Cabaret Vol-
taire, he attacked the humanist conception that man is the measure of all
things, the midpoint of Creation, in some sense above and detached from
it.[22] Judging from Ball's diary entries of 2 and 7 March 1916, the Zurich
Dadaists read that issue of *Sirius*, and it may be that Serner's words con-
tributed to the second aspect of their critique of modernity since their
polemic parallels his. Like Serner, the Dadaists denied the idea that human
beings are the midpoint and masters of Creation and asserted that they are
inextricably part of a reality of which they are not the measure but against
which they must measure themselves. Human beings are not gods incar-
nate, but pieces of matter endowed with consciousness, of a kind with the
rest of Creation, whirled along like puppets by powers with which they
must coexist and over which they had no final control. Arp was most ex-
plicit on this. Beginning with the preface that he wrote for the catalogue
of the exhibition in the Galerie Tanner in which he and the Van Rees's
participated (15 November–1 December 1915), he consistently denounced
Western humanity for its hubris, for behaving as though it had created
and could dominate the world, and for losing its sense of the mystical
and indeterminable reality of Nature that surrounded and disposed over
it.[23] Tzara criticized Pierre Reverdy's *Le Voleur de Talan* for assuming that
humanity is central to the cosmos and can become "un dieu-maître . . .
dans son petit monde" [god-master . . . in his little world].[24] In Berlin,
Johannes Baader, writing in a Dadaist vein in advance of Dada, foretold a
new earth and a new race of human beings:

... die wissen, dass sie selbst und alles rings um sie her ein unabgetrenn-
ter Teil eines einzigen Gottes sind, in dessen gewaltigem Spiel sie ihre
eigenen selbständigen Spiele spielen. Menschen, die wissen, dass Jeder
und Jedes die Abteilung eines jeden Andern ist.[25]

*... who know that they themselves and everything around them are an in-
tegral part of one single godhead, in whose mighty game they are playing
their own, independent games. People who know that every person and every
thing are the divided off sections of one another.*

Hausmann said something similar in his notebooks of 1921, claiming
that humanity is not the apex of a pyramid, but a moving point that has to
participate in a dynamic network of relationships that extends outward, on
all sides of it. In the same year, he also criticized the Cartesian separation
of the ego from the rest of Creation and proclaimed that Dada sought to
reestablish a "primitive" relationship between it and humanity.[26]

The monstrous hubris that sets humanity above Nature, Arp claimed,
was the root cause of human catastrophes.[27] But because the flux of Nature
is stronger than the human will, it inevitably reacts convulsively to destroy
overconfident human constructs and bring humanity down to earth again.
And fifty years after Dada, Hausmann, who, as recent research confirms,
remained very much within the Dada spirit all his life, said something
similar:

Aussi longtemps que l'homme prétendra être arrivé au faîte de la civili-
sation et qu'il croira être la couronne de la Création, le seul Être spirituel
dans l'Univers, aussi longtemps ses pensées seront faussées et nuisibles
et ne pourront servir aux fins réelles de l'existence humaine sur la Terre.

*As long as man claims to have reached the pinnacle of civilization and be-
lieves he is the crown of creation, the only Spiritual Being in the Universe,
his thoughts will be perverted and harmful, incapable of serving the true
ends of human existence upon the Earth.*[28]

For the Dadaists, human beings become truly human only when they
accept the smallness of their place within Creation, admit their depen-
dence on the material world, and cultivate a respect for the natural powers
that flow through and around them.

Consequently, the Dadaists assailed the Western humanist belief in the
supremacy of reason, the efficacy of the rational ego, and the essential

goodness of human nature. Franz Jung, writing under the influence of the anti-Freudian Freudian Otto Gross, described the human psyche as one of "verknoteten, wühlenden, treibenden Konflikte" [knotted, seething, surging conflicts].[29] During the period of his involvement with Dada, Van Doesburg described the human psyche as a flux that was inextricably creative and destructive: "een gelijktijdigheid van orde en wanorde, van ja en neen, van ik en niet ik" [a simultaneity of order and disorder, of yes and no, of ego and nonego].[30] And as we shall see, Dada "primitivism" was very close in many respects to ideas of contemporary psychoanalysis about the primacy of the unconscious. Conversely, Ball attributed the sickness of modernity to the overcultivation of the ego and the neglect of the sub- and transrational faculties, which, because they were forgotten, had erupted diabolically in the war.[31] And in a passage that echoes his sentiments in the preface to the Tanner Gallery catalogue, Arp wrote:

> La Renaissance a appris aux hommes l'exaltation orgueilleuse de leur raison. Les temps nouveaux avec leurs sciences et leurs techniques les ont voués à la mégalomanie. La confusion de notre époque est le résultat de cette surestimation de la raison.
>
> *The Renaissance taught men the haughty exaltation of their reason. Modern times, with their science and technology, dedicated them to megalomania. The confusion of our epoch is the result of this overestimation of reason.*[32]

Because, in Arp's view, the rational ego believed itself to be detached from the surrounding universe, it inevitably imposed abstractly conceived schemes upon the flux of Nature that took no account of the patterns immanent within that flux. Although such schemes appeared to be to human advantage in the short term, they inevitably went wrong as dynamic reality reasserted itself. Hausmann, too, whose thinking about human nature also owed much to Otto Gross, claimed that resentment and guilt resulted from the overcerebralization of the personality and the repression of its arational aspects. He satirically described the typical human representative of modernity as "so'ne Art Eisenkäfig in zwei Etagen, mit einem Hometrainer, einem Motorrad in der ersten und einer Leitspindeldrehbank und Stanzmaschine in der zweiten Etage" [a sort of iron cage with two floors, with a keep-fit machine and a motor-bike on the first floor and an engine-lathe and die-stamping machine on the second].[33] Hausmann knew and valued Bergson's theory of laughter (see chapter 5). Now, as Bergson thought that the essence of comedy involved what was alive being treated

as though it were a machine and that a major source of laughter was the encrustation of something mechanical on something living, it is very likely that his ideas inspired Hausmann's famous assemblage *Mechanischer Kopf* (*Mechanical Head*) (1919). For here, a rather dim-looking wooden head, such as might be used by a wig- or hatmaker, has all kinds of measuring instruments and mechanical appendages affixed to it—but to no obvious purpose. In this assemblage, the signs and accoutrements of rationality are presented as absurd, and Hausmann said himself that its point was to show "dass das menschliche Bewusstsein nur aus unbedeutendem Zubehör besteht, das man ihm äusserlich aufklebt" [that the human consciousness consists merely of insignificant accessories which have been stuck onto its surface].[34]

Finally, several Dadaists had firsthand experience of the bestiality that war and the military bring out in human nature, and this is nowhere expressed more graphically than in the visual work of George Grosz from the Dada years. The nightside of the modern city, with its rapists, racketeers, syphilitics, and institutionalized violence was bad enough, but the war brought out and legitimized all the worst aspects of human nature, causing Grosz to vent some of his most vicious spleen on the German army in general and those who sanctioned and profited from their brutality in particular. Hausmann, too, who had never served in the army, transmitted something of the same sense of human bestiality in the image of a gaping mouth filled with carnivorous teeth. This appears in such works as the first version of the photomontage that accompanies *Synthetisches Cino der Malerei* (*Synthetic Cinema of Painting*) (1918–19); the montage *Der Kunstreporter* (*The Art-Critic*) (1919); the advertisement for his book of satires *Hurrah! Hurrah! Hurrah!* that appeared in the periodical *Der Gegner* in 1920; *Dadaphoto* (1920); and the collage *ABCD* (1923).[35] The Dadaists' view of human nature is not a comfortable one. But from an intense sense of outrage, they were doing precisely what Richard Aldington, in his April 1921 review, grudgingly conceded *Ulysses* was doing when he pointed out the proximity of that novel to Dada. According to Aldington, the Dadaists were overstressing "certain aspects of existence which most writers foolishly ignore"—and not gratuitously either, but to warn that if these aspects are not admitted and confronted but concealed under a thin layer of liberal values, then they are likely to be more, not less explosive and destructive.[36]

One should not infer from this that the Dadaists were totally opposed to reason, or that they were ecstatics like some of the early Expressionists. Having rejected Kant, several of them seem to have assimilated the

ideas of Bergson and to have been working their way toward a concept of "integrated reason."[37] Given their awareness of the limitations of reason in a universe characterized by flux, incoherence, and absurdity, they seem to have shared Bergson's view that intuition was the more fundamental human faculty. Given their belief that the sub- and arational aspects of human nature needed more freedom, they seem to have assimilated the view of several leading psychoanalysts that reason needed first to understand and then to guide, as far as that was possible, the unconscious drives within human nature. So they replaced a centered, essentially static model of human nature in which reason was at the apex of a pyramid by a more eccentric, dynamic model of human nature in which reason is engaged in a perpetual dialectic with the fluctuating impressions it receives from without and the surging drives to which it is exposed from within.

From here, it is only a short step to the Dada critique of language discussed in chapter 5—a critique that, it must be stressed, was not undertaken merely to prepare the ground for the production of abstract poetry. If, the Dadaists believed, people forgot the limitations of language and its socially determined conventionality, then language all too easily degenerated into formulaic utterances and ideologically loaded slogans—like those that had helped sustain a catastrophically destructive war and were now propping up a shaky and probably unworkable constitution in Germany.[38] The slogan "Gott mit uns" [God is on our side] was on the belt buckle of every German soldier both during and after the Great War, and this is why Grosz used it as the ironic title of one of his most scathingly satirical collections of lithographs from the Dada period (1920). For here Grosz laid bare the brutality of the German military, the hypocrisy of a left-wing government that had used right-wing *Freikorps* to crush popular insurrections throughout Germany in the immediate postwar period, and the persistence of the authoritarian mentality of Wilhelmine Germany in the new, allegedly democratic Weimar Republic. The same critical impulse explains why several Dadaists built newspaper headlines, political slogans, and advertising copy into their visual work—normally juxtaposed with visual material that satirized or directly contradicted the words—and why other Dadaists, notably Baader and Serner, sent extravagantly false or sensationalist reports to the press. The point was to unmask the unreliability of the printed word and so generate an attitude of skepticism toward "authorities" in general and the authority of the press in particular.

Finally, Dada attacked the idea that human civilization was progressing to ever higher levels of achievement and culture—hence Grosz's tendency

to depict people, especially men and male members of the ruling castes, as semibestial. Like Simmel in the contemporary *Der Konflikt der modernen Kultur*, the Dadaists saw human history as a conflict between the human urge to create fixed forms and the flux that perpetually sweeps them away, leaving things much as they had ever been. As Van Doesburg put it:

> Dada ontkent de evolutie. Elke beweging verwekt een tegen-beweging van gelijke sterkte, die elkander opheffen. Niets verandert wezenlijk. De wereld blijft steeds aan zich zelf gelijk.

> *Dada denies evolution. Each movement provokes a counter-movement of equal force with the one cancelling the other. Nothing changes essentially. The world always remains as it was.*[39]

Indeed, the Dadaists saw their own age as a trough (in both senses of the word) in this never-ending dialectic on the grounds that any civilization that could issue in the Great War with its attendant corruption must be totally rotten. Thus, Huelsenbeck said that when one saw the racketeers sitting on the terraces of the Baur au Lac, Zurich's smartest hotel, one had the feeling that the whole of European civilization stank to high heaven.[40] Most other Dadaists made comparable comments, but Ball went even further, writing two books after his break with Dada in mid-1917 to show that European, and especially German, history had been marked since the Renaissance and Reformation by a loss of the sense of the spiritual dimension of life (see chapter 12).[41] In Ball's view, repressive governments supported by meretricious philosophers who preached the autonomy and divinity of human reason had constructed a machinery of state that stamped out the spirit and left people exposed to the depredations of their material nature.[42] Where most Dadaists saw an open-ended, experimental attitude to life as the way out of this critical situation, Ball returned to an ascetic and hieratic Catholicism on the grounds that the Roman Church alone had preserved the "primal images" that could guarantee the freedom of the spirit against the diabolic assaults of matter and the flesh.

Dada as Remedy

Like many of the early Expressionists, the Dadaists felt they had reached a point of absolute zero. Unlike them, however, the Dadaists believed that if they divested themselves of the illusions inherited from classical modernity and developed a more realistic picture of human nature, contempo-

rary modernity, and the human situation there, then it was possible to come to terms with modernity, "scheinbar aus dem Nihil" [apparently ex nihilo] and without succumbing to Futurist modernolatry.[43] Where early Expressionism was haunted by the apocalyptic sense of an ending, Dada, as I shall show in more detail in chapter 9, confronted that sense in the hope of turning "das Nichts, von dem der Existentialismus spricht" [the nothingness of which Existentialism speaks] into the "Ausgangspunkt einer unübersehbaren Fülle" [the point where an immeasurable plenitude begins].[44] Thus, over and over again, the Dadaists insisted that Dada was neither a new aesthetic school nor a system of abstract principles, but "un état d'esprit" [a state of mind], "eine Revision gegenüber dem Menschenideal, für das die Kunst nur ein Symbol ist" [a revised ideal of what it means to be human of which art is merely a symbol].[45] Brigid Doherty has recently argued that the Dadaists intended their shock art to be a conjuration of traumatic experience and, simultaneously, a means of therapy. In retrospect, Tzara and Arp called Dada "avant tout un mouvement moral" [a moral movement above all] and "a moral revolution" respectively and Otto Flake went so far as to equate the Dadaist concern with subjectivity with "die Heilsfrage der Erlösung" [the soteriological question of redemption].[46]

The Dada understanding of reality described above clearly owed a great deal to irrationalist thinkers like Nietzsche, Haeckel, Bergson, and (possibly) Simmel, and faced with this flux, most Dadaists agreed that the appropriate response was a vitalism or an urban "primitivism."[47] The *Dada Almanach* (1920) (*Dada Almanac*, 1993) included a manifesto entitled "Was wollte der Expressionismus?" ("What Did Expressionism Want?") that stated: "Das Wort Dada symbolisiert das primitivste Verhältnis zur umgebenden Wirklichkeit" [The word Dada symbolizes the most primitive relation to surrounding reality].[48] Although this text was probably composed by Huelsenbeck and Hausmann, it was signed by Tzara, Franz Jung, Grosz, Marcel Janco, Arp, and Walter Mehring, among others. In 1920, Hausmann called Dada "zunächst ein Bekenntnis zur unbedingten Primitivität" [in the first place a commitment to unqualified primitiveness]. A few years after the end of the movement, Huelsenbeck wrote, "Die Primitivität der zwei Silben [Dada] übte eine magische Wirkung aus, wir wollten der in ihrer verständlichen Enge versunkenen Zivilisation etwas Neues, herrlich Primitives entgegensetzen" [The primitiveness of the two syllables (Dada) had a magical effect; we wanted to confront our civilization, sunk as it was in its cerebral narrowness, with something new and splendidly

primitive]. Arp declared that the Dadaists wanted the free play of all that was elemental and spontaneous. Tzara, whose real name was Sami Rosenstock, may have chosen his nom de guerre partly because of its association with the "primitive" *Übermensch* Tarzan, who had first made his appearance in *Tarzan of the Apes* (1912). At the September 1922 Dada-Constructivist Congress in Weimar, he announced, "Ce que nous voulons maintenant c'est *la spontanéité*" [What we want now is *spontaneity*], and at the very first *Dada-Soirée* on 14 July 1916—Bastille Day—he said that in the *poème de voyelles* (sound poetry consisting entirely of vowels), he was hoping to fuse "la technique primitive et la sensibilité moderne" [primitive technique and modern sensibility].[49] Similarly, after his first period of involvement with Dada, Ball described his conception of the movement as "die Idee der absoluten Vereinfachung, der absoluten Negerei, angemessen den primitiven Abenteuern unserer Zeit" [the idea of absolute simplification, absolute negritude, appropriate to the primitive adventures of our time], and Evan Maurer has documented the Dadaists' use of primitivizing elements in their performances and pictures.[50] Although Marianna Torgovnick has pointed out that such works, even those by Höch, were not completely free from stereotyped equations that would nowadays be deeply suspect, it is important to remember that Dada "primitivism" was less about nostalgia for the presumed innocence of non-Western cultures and more about transgressive exploitation of the "primitive" energies of the psyche; less about closet colonialism and more about the decolonization of those parts of the personality that had allegedly been subjugated by the imperialist ego and superego.[51]

In the Dadaists' view, the seething flux of modernity with its continually changing constellations of forces required human beings to respond spontaneously, in defiance of convention, using the most "primitive" (fundamental) powers of their personalities. This is what Franz Jung, writing under the direct influence of Otto Gross, was trying to put into words in his convoluted letter dated 31 [!] February 1917 to Hermann Kasack.[52] Hausmann, who was closely associated with Franz Jung and the *Freie Strasse* (Open Road) group in Berlin between 1915 and 1917 and for whose work from 1917 to 1922 the problem of subjectivity was central, put it more lucidly on 7 August 1919 when he wrote to his lover Höch:

Ich glaube, ich bin revolutionär, weil gerade das Stärkste, Lebensfähigste in mir das Älteste sucht und Gefundenes nur sehr schwer preisgibt.[53]

I believe that I am a revolutionary precisely because what is strongest and most capable of life within me is searching for what is most archaic and surrenders what it finds only with great difficulty.

In "Dada ist mehr als Dada," arguably his most important Dada manifesto, Hausmann implied that if this archaic substratum could be tapped, it would permit the Dadaist not to weep over the "Hopsassa" [rocking-horse ride] of the Nietzschean "Widerkehr alles gleichen" [(eternal) recurrence of the same].[54] In *Dada siegt!* Huelsenbeck wrote, "Eine ungeheure Lust und Wollust nach den Abgründen der Seele hatte uns damals erfaßt" [A gigantic desire for and joy in the depths of the psyche had gripped us at that time]. And in a letter to Emmy Hennings of 2 May 1919 in which he described a *Dada-Soirée* in the Graphisches Kabinett of the Berliner Sezession, Ball confirmed Huelsenbeck's statement by saying that "alle Neger-Instinkte Gross-Berlins [sahen] sich schamhaft erkannt und ans Licht gebracht" [all the African instincts of Greater Berlin saw, shamefacedly, that they had been recognized and brought to the light of day].[55] By following Rimbaud's injunctions in his letters to Izambard and Demeny of May 1871 that people should unhinge all the senses if they wished to arrive at "l'inconnu" [the unknown] — the Dadaists sought to overcome the sense of an ending that so afflicted their generation.[56]

Although there is a clear parallel between Freud's prewar project of derepression and the Dadaists' primitivizing autotherapy, the Dadaists, with the notable exception of Max Ernst, tended to reject Freudianism.[57] Tzara called psychoanalysis "une maladie dangereuse" [a dangerous disease] that lulls our "penchants anti-réels" [antireal inclinations] to sleep and so helps perpetuate bourgeois society; and Hausmann said that the proto-Dadaist group around the periodical *Die freie Strasse* was against Freud "da alle diese Theorien einen patriarchalisch-aggressiven Archetypus als Voraussetzung hatten" [since all these theories presupposed a patriarchal-aggressive archetype as their basis].[58] Rightly or wrongly, the Dadaists felt that while Freud and his followers aimed to tame and assimilate the vital energies of the personality, they themselves aimed to liberate those energies in the belief that they were sustaining and had become destructive only because of their violent suppression by an authoritarian, patriarchal culture.

This is not to say that the Dadaists were sentimental about human nature. Indeed, because they aimed to overturn the Cartesian "cogito ergo sum" and reinstate the culture of the body, they were not ashamed of its

excremental aspects and erotic drives, and they well understood the raw-
ness, aggressiveness, and violence of the *physis*.[59] In *Dada siegt!* Huelsen-
beck said that if one opened up the so-called unconscious, it was by no
means certain that one would release "Güte, Menschlichkeit, Friedensliebe
etc." [goodness, humaneness, love of peace, etc.], and his account of the
Dada-Tournée in Dresden on 19 January 1920 suggests that such events
were consciously designed to make nominally civilized people realize how
easy it is for relatively trivial disappointments and frustrations to catalyze
extreme, even murderous emotions.[60] But paradoxically, most of the Dada-
ists also had a sense that there is another side to human nature that they
tend not to name, that can interact with and temper its rawer, baser sides,
that can cope with flux and uncertainty, and that allows people to tap into
their libidinal energies without being overwhelmed by them. But not every
Dadaist had the same sense of the balance that ought to obtain between the
various sides of human nature. After his brief religious phase, Serner was
increasingly overwhelmed by his awareness of the dark, destructive side
of the human personality and allied himself with Dada in Zurich around
1919 with the aim of turning it into a radically negative movement.[61] Arp
emphasized the constructive, creative side; Grosz the raw, Dionysiac side;
Ernst the erotic side; while for Picabia, a cold self-irony was the last trace
of spirituality that was available to the animated mechanism that, for him,
was human nature.

Partly because he came from a bohemian background, had had little
formal schooling, and so had not assimilated the ideals of classical human-
ism; and partly because of the influence of Bergson, Otto Gross, and the
philosopher Salomo Friedlaender, Hausmann arrived at a sense of the para-
doxical, multistranded, balanced personality with relative ease. And when
Berlin Dada, like Zurich Dada under the impact of Serner and Picabia,
threatened to disintegrate and become too one-sidedly negative after the
Great International Dada Fair of summer 1920, he sustained that sense in
his philosophy of Presentism.[62] Huelsenbeck needed a virtual breakdown
in autumn 1916 and several years of turmoil before he was able to synthe-
size the violence of his primitivizing poems of 1915 and 1916 with the more
spiritualized humanism of his piece "Der neue Mensch" of spring 1917 and
arrive at his aggressively paradoxical Dada attitudes of 1918 to 1920.[63] Tzara,
too, had to undergo a phase of nervous disorder in winter 1916–17 before
he was able to achieve a "convalescence mystique" [mystical convalescence]
and arrive at the Dadaist sense of balance amid opposites that character-

izes his articles, manifestos, and poems of 1917 and early 1918. He then fell prey to the dire sense of apathy that marks his letters to Breton and Picabia of 1919 and reverted to an aggressive nihilism, untempered by any concern with the spirit, during the last year of his involvement with Dada in Zurich and throughout his involvement with Dada in Paris (late 1918–late summer 1922).[64] Schwitters's relationship with Dada oscillated.[65] During his *Merz* periods, he tended to stress the rational, constructive side of the personality, but after he got to know Höch and Hausmann, he tended, from early 1922 to early 1923, to put more stress on its spontaneous side. There is no fixed set of relationships or pattern of development. Just as Dada had no fixed abode and consisted, in the various cities where it thrived, of heterogeneous and amorphous groups whose edges were blurred and whose internal relationships were shifting and often conflictual, so the Dadaists evolved shifting, distinct, but by no means unconnected images of posthumanist subjectivity.[66] This is why one can say with some confidence that Dada primitivism is not the uncontrolled *Rausch* (drunken ecstasy) of early Expressionism that prefers a blind moment of self-destructive sensation to a lifetime of boredom. Nor, while it involves conflict and aggression, is Dada primitivism a Dionysiac will to power over others. And it is a long way indeed from the Futurists' grandiloquent celebration of speed and mechanical energy (see chapter 8). Rather, Dada primitivism seeks to combine and keep a balance between contradictory psychic forces, to hold the demonic, bestial, unconscious, spiritual, and intellectual faculties of human nature in a finely balanced interplay around a hidden "point sublime" that continually moves forward in response to the ever-changing interplay of the dynamic forces that surround and interact with human beings.

Hans Richter said in retrospect that during his Dada period, he was trying to find "not chaos but its opposite, an order in which the human mind had its place but in which it could flow freely."[67] Huelsenbeck, too, tried to characterize the paradoxical nature of the Dada understanding of posthumanist subjectivity when, in his introduction to the *Dada Almanach,* he described it, using Salomo Friedlaender's key term, as "der Indifferenzpunkt zwischen Inhalt und Form, Weib und Mann, Materie und Geist, indem es die Spitze des magischen Dreiecks ist, das sich über der linearen Polarität der menschlichen Dinge und Begriffe erhebt" [the neutral point (of indifference) between content and form, male and female, matter and spirit, since it is the apex of that magical triangle that rises from the lin-

ear polarity of human affairs and concepts]. Or again as "Das Lallen des Kindes und zugleich das letzte Erstaunen des differenzierten Menschen vor der Geistigkeit einer Maschine. . . . Dada ist die Sphärenmusik des Pythagoras so gut wie die Stimme des Viehtreibers in den Dorfstrassen." [The babbling of a child and at the same time the most sophisticated admiration of a discriminating human being at the spiritual intellectualism of a machine. . . . Dada is Pythagoras's music of the spheres as well as the voice of the cattle drover in the village streets].[68] Likewise Hausmann, who defined the typically Dada sense of subjectivity as "die Ambivalenz des Subjekts, die einen primitiven Machtwillen vervielfältigt zu einer Balance in Widersprüchen" [the ambivalence of the subject that multiplies a primitive will to power until it becomes a balance amid contradictions]. Elsewhere, Hausmann proclaimed that the Dadaist holds in balance the explosive realities of this world and does not fall into despair at the way in which values change their meaning in one and the same second, concluding that if he did, "er würde sonst bewegungslos und diese dynamische Statik ist ihm das Lebenselement" [he would otherwise become motionless and this dynamic stasis is his very element].[69] And in September 1922, when he was emerging from his nihilistic period, Tzara said something similar about Dada subjectivity by defining Dada as "le point où le *oui* et le *non* se rencontrent, non pas solennellement dans les châteaux des philosophies humaines, mais tout simplement au coin des rues comme les chiens et les sauterelles" [the point where *yes* and *no* meet, not solemnly in the castles of human philosophies, but quite simply on street corners like dogs and grasshoppers]. Just as life is a "hurlement des douleurs crispées, entrelacement des contraires et de toutes contradictions, des grotesques, des inconséquences" [roar of contorted pains, the interweaving of contraries and of all contradictions, freaks and irrelevancies], so the Dada frame of mind involves the ability to live open-endedly but with integrity amid a mess of confusion, indeterminacy, paradoxes, and constant change.[70] This is why the image of the dance is so important for Dada, and why the cabaret, circus, and music hall with their random, kaleidoscopic sequence of acts were the Dadaists' natural habitat and a major source of inspiration.

Despite the Dadaists' general hostility to Freud, there is a close analogy between their conception of subjectivity and C. G. Jung's idea of the self as "ein sozusagen virtueller Punkt zwischen dem Bewussten und dem Unbewussten" [a virtual point (as it were) between the conscious and the unconscious].[71] Breton (who is normally more closely associated with Freud than Jung) wrote in his 12 June 1919 letter to Tzara: "Vous ne m'avez tou-

jours pas dit en quels termes vous étiez avec le Dr Jung dont vous parlez quelquefois. J'aime l'esprit de Jung" [You have still not told me on what terms you were with Dr Jung—of whom you sometimes speak. I like Jung's cast of mind].[72] Huelsenbeck, who became a psychoanalyst after he emigrated to New York in 1936 and whose later psychoanalytical writings have many of their roots in Dada, wrote in 1956: "Karl [sic] Jungs Lehre von den sich ergänzenden Gegensätzen umschreibt die dadaistische Haltung ebenso wie die Haltung des modernen Menschen" [Carl Jung's doctrine of complementary opposites defines the Dada attitude just as it defines the attitude of the modern human being].[73] And Richter (who in his later years took part in the Jungian *Eranos* conferences at Ascona) said that the desire for anarchy, chaos, and surrender to chance *and* the desire for order had governed his life since at least 1917 and explicitly related this dialectic to Jung's psychoanalytic theory.[74]

Poetically, Dada's theoretical position gave rise to a range of magical beings that I shall discuss in chapter 11. Visually, the same concern to maintain a balance amid opposites is present, for example, in Arp's post-1917 biomorphic forms; Richter's visionary portraits of 1917 (which seek an equilibrium between the polarities of black and white); Richter's and Eggeling's scrolls of 1919 and 1920 (which attempt to balance dynamism and structure); Janco's woodcuts of 1917 and 1918 (which combine architectural strictness and organic forms); Hausmann's colored woodcuts for *Material der Malerei Plastik und Architektur;* Hausmann's photomontages such as *Fiat Modes* (*Let There Be Fashions*) (1920) or *Doppelporträt Baader-Hausmann* (*Double Portrait Baader-Hausmann*) (1920); Höch's photomontages *Bürgerliches Brautpaar—Streit* (*Bourgeois Bridal Couple—Quarrel*) (1919) and *Dada Rundschau* (*Dada Panorama*) (1919); and Picabia's *Composition abstraite* (*Abstract Composition*) (1922).[75] In every case, one finds not rigid geometrical symmetry around a precisely defined central point, but a discreet combination of asymmetry and balance around a center whose location is hinted at and therefore elusive.

In line with their paradoxical, polyphonic conception of subjectivity, the Dadaists often characterize Dada by saying that it consists in the abolition of the "Yes-or-No" on behalf of the "Yes-and-No"—an aversion to binarisms that critics who know Dada only as a negative or oppositional phenomenon tend to overlook.[76] Richter, for instance, said that in Dada's devotion to chance and its search for a new order "the Yes and the No belonged together," and Hausmann said that for Dada, positive and negative were always of equal value.[77] Van Doesburg wrote:

Van elk "ja" ziet Dada gelijktijdig het "neen." Dada is ja-neen: een vogel op vier pooten, een ladder zonder sporten, een kwadraat zonder hoeken. Dada beziet evenveel positiva als negativa.

Dada simultaneously sees the "yes" of every "no." Dada is yes-no: a bird on four legs, a ladder without rungs, a square without angles. Dada possesses as many positives as negatives.[78]

Grosz called his autobiography *A Little Yes and a Big No*—a title that very accurately captures his particular attitude to the dialectic. While in prison in 1921, Franz Jung specifically requested a copy of Otto Flake's roman à clef about Zurich Dada *Nein und Ja,* and in the same year that his novel was published Flake wrote, "den Optimismus der Aufklärung verneinen, bedeutet ebensoviele Dinge positiv sehen" [to say no to the optimism of the Enlightenment means seeing just as many things in a positive light].[79] Louis Aragon explained his "Système Dd" by saying that the first *D* stood for doubt and the second for faith.[80]

This Yes/No formulation is shorthand for three fundamental ideas. First, it means that reality is so full of polyvalent elements and contradictory currents that it cannot be grasped systematically, by means of linear logic, and needs to be approached by means of complementary or dialectical concepts—Heisenberg and Barth were evolving similar ideas at almost exactly the same time. Second, it means that in order to live to the full amid the flux of modernity, it is necessary to say "no" to and abolish all that is rigid, constricting, and anomalous and to say "yes" to all fresh experiences, be they creative or destructive, incomprehensible or easily assimilable.[81] Before lapsing into the melancholia of his final years, Huelsenbeck the psychiatrist put it thus:

Dadaist sein bedeutet zu alledem Ja zu sagen, wofür der Dadaismus sich eingesetzt hat, Unsicherheit, Verlorenheit, Paradoxie der menschlichen Haltung.[82]

To be a Dadaist means saying yes to everything on behalf of which Dada spoke out, uncertainty, lostness, the paradoxical nature of what it means to be human.

But third, and most importantly, it means resisting that binary thinking, which, having divided things up into opposites, puts a positive sign over one term and a negative sign over the other (white/black; day/night;

male/female; culture/Nature; mind/heart; reason/passion and so on). This is why, as four women critics have noted, Dada art is interested in androgyny. Bergius speaks of Dada's "androgynous subjectivity"; comments on the vein of androgyny running through the whole movement; and interprets Schwitters's first *Merz-Bau* (*Merz-Construction*) in this light. Amelia Jones is centrally concerned with Duchamp's "ambiguously sexed identity" as this manifested itself in his alter ego Rrose Sélavy (Eros, c'est la vie—Eros, that's life) and "the antiessentialist, highly eroticized system of sexual interdependencies" that Duchamp elaborated in his work. Lavin shows how gender issues were at the heart of Höch's Dada work; identifies androgynous imagery there; and shows how the question of androgyny became crucial to Höch's work during the time of her lesbian relationship (1926–35) with the Dutch writer Til Brugman. McCloskey locates the most radical, albeit latent, aspect of Berlin Dada in its desire to overcome the conventional distinctions between gender roles, public and private, and politics and sexuality.[83] Conversely, Elizabeth Legge claims that Picabia's *La Sainte Vierge* (*The Holy Virgin*) (1920) "mocks myths of virility"; Doherty shows how a picture by Grosz of 1920 suggests that the trauma of war has put a question mark over masculine notions of potency; and in my view, Hausmann's photographs of himself in self-parodying, hypermacho poses do likewise.[84] Although Hausmann's monocle, which features prominently in such photographs, seems like the quintessential symbol of the arrogant, aggressive male gaze—Grosz's brutal officer-types often wear them—it is actually an index of the opposite since Hausmann's left eye was askew and it was this deficiency that enabled him to avoid military service. Indeed, Grosz's 3 May 1918 letter to Schmalhausen indicates that he was aware of this irony.[85] Thus, at exactly the time when C. G. Jung was developing his theory of psychological androgyny and Adler was developing his critique of hypermasculinity, Dada was doing likewise: attempting to say "yes" to an androgynous human nature and "no" to fixed gender identities and roles. Consequently, it is entirely appropriate that Barry Humphries, one of the best-known female impersonators of the postmodern period, should, while at school and university, have been a passionate devotee of Dada.[86]

In view of Otto Gross's input into Berlin Dada's critique of contemporary culture, the Dadaists' criticisms of Freud, and Dada's interest in androgyny, it is particularly interesting that Hausmann, in a 1970 interview, should have said that Adler sent him a copy of his book *Über den nervösen Charakter* (1911–12) (translated as *The Neurotic Constitution*, 1917) with a

dedication to the effect that he was the only Dadaist who understood any-thing about psychoanalysis.[87] Adler had published a second, "improved" (*verbesserte*) edition of this work in late spring 1919 and would publish a third, "extended" (*vermehrte*) edition in spring 1922. Given that Hausmann published his major essays involving psychoanalytical ideas during 1919; that Adler referred approvingly to the work of Otto Gross in both the sec-ond and third editions of *Über den nervösen Charakter* (even though Gross had died in squalor from drink and drugs in Berlin in 1920); and that, in his preface to the third edition, Adler said that he had intensified his cri-tique of Freud since the previous edition, it seems likely that he sent the third edition of his book to Hausmann. At first glance, it seems odd for a reputable scientist to acknowledge the work of a wacky Dadaist. In fact, however, Dada's diagnosis of the state of Western civilization, especially as formulated by Hausmann the "Dadasoph," is very close to Adler's. Accord-ing to Adler, the neurotic is someone who makes too sharp a distinction between male and female and then overdevelops conventionally "male" qualities (such as the urge to dominate, aggressiveness, and ambition) to the detriment of conventionally "female" qualities (such as the ability to be tender, to love, and to be emotional). From this, a conflictual imbalance re-sults that generates such secondary symptoms as vanity, arrogance, melan-cholia, withdrawal from society, inability to cooperate with others, agora-phobia, compulsive behavior, self-importance, excessive idealism, and even alcoholism and drug addiction. The passages that Adler added to the third edition of his book highlight precisely these points. Conversely, like the Dadaists, especially those who knew the work of Otto Gross, Adler be-lieved that patients who wished to recover their mental health needed to discard the above binarism, accept both sides of their personalities, and thus cease being in permanent conflict with themselves and the world in general (see chapter 12).

One final, elusive dimension to Dada as remedy derives directly from Dada's arational and decentered notions of subjectivity. In his uncom-pleted doctoral thesis on Nietzsche (1909–10), Ball was centrally preoccu-pied with what he called "the Empedoclean problem": if there is no God and no absolutely valid morality, can it be that Nature itself is inherently structured?[88] Although Ball, after his final break with Dada in mid-1917, increasingly rejected any notion of an immanently patterned material world and sought salvation in a gnostic spirituality, at least some of the other Dadaists felt that they could answer Ball's question in the affirma-tive. Thus, although most of the Dadaists subscribed in one way or another

to the idea of subjectivity as balance amid conflicting opposites, from the point of view of metaphysics, they group around two poles. At the one pole, some—notably Serner, Grosz, who claimed in 1925 that it was utter lunacy to believe that an objective Spirit (*Geist*) or any spiritual beings (*Geistige*) ruled the world, most of the French Dadaists in the years 1920 to 1922, Duchamp, and Picabia—viewed Nature as inherently patternless. At the other pole, others—notably the Zurich group up to about mid-1918, Van Doesburg in Holland, Jean Crotti in Paris, and the non-Marxist Dadaists in Berlin—were prepared to affirm or at least countenance the coexistence in Nature of chaos and elusive pattern, dynamism and fluid structure.[89] The former type of Dada is like a zany version of Sartrean existentialism and proclaims the Dada state of mind *against* a background of absurdity and chaos. But the latter type of Dada is more akin to a Westernized, secularized Taoism and declares that the Dada notion of subjectivity makes sense only *within* an environment that is at one and the same time chaotic and yet secretly ordered—hence the Dadaists' interest in mysticism, which will be discussed in chapter 10.

Thus, Tzara, often labelled a nihilist *tout court,* wrote in late 1917:

Ce que je nomme "cosmique" est une qualité essentielle à une oeuvre d'art. Parce qu'elle implique l'ordre qui est la condition nécessaire à la vie de tout organisme.

What I call "cosmic" is an essential quality of a work of art. Because it implies order, which is the necessary condition of the life of every organism.[90]

In December 1918 he congratulated Picabia for having written a book of poems—*L'Athlète des pompes funèbres* (*The Athlete of Funeral Undertakings*) that involved "la force de réduire, de décomposer et d'ordonner ensuite en une unité sévère qui est chaos et ascétisme en même temps" [the power to reduce, to decompose, and then to order into a strict unity which is chaos and asceticism at one and the same time] and added that he had been trying to achieve the same result for some time now, referring Picabia to his Dada Manifesto of 1918.[91] In May 1919, he wrote:

Savoir reconnaître et cueillir les traces de la force que nous attendons, qui sont partout, dans une langue essentielle de chiffres, gravées sur les cristaux sur les coquilles les rails dans les nuages dans le verre à l'intérieur de la neige la lumière sur le charbon la main dans les rayons qui se groupent autour de pôles des magnets sur les ailes.

To know how to recognize and pick up the signs of the power we are await-
ing, which are everywhere; in the fundamental language of cryptograms,
engraved on crystals, on shells, on rails, in clouds, or in glass; inside snow, or
light, or coal; on the hand, in the beams grouped around the magnetic poles,
on wings.[92]

Huelsenbeck introduced the *Dada Almanach* with the following un-
equivocal declarations:

Dada ist der tänzerische Geist über den Moralen der Erde. . . . Dada
ruht in sich und handelt aus sich, so wie die Sonne handelt, wenn sie
am Himmel aufsteigt oder wie wenn ein Baum wächst. . . . Dada ist die
schöpferische Aktion in sich selbst.

Dada is the dancing spirit atop of the world's morals Dada rests within
itself and acts of its own accord, just as the sun acts when it rises in the sky
or when a tree grows. . . . Dada is pure creative process.[93]

Hausmann could still declare in 1921, after he had distanced himself
from the Berlin Dada group:

Vive Dada! Es ist die einzige Lebensanschauung, die dem westeuropäi-
schen Menschen entspricht, weil sie die Identität des gesamten Seins
mit all seinen Widersprüchen durchführt und dahinter, hinter diesem
Schleier von Lachen und Ironie noch das Unerklärbare, dessen man
nicht Herr werden kann, ahnen lässt.[94]

Long live Dada! It is the one and only view of life appropriate for people
in the West because it realizes the identity of the whole of Being with all its
contradictions and yet allows them to intuit behind this veil of laughter and
irony the inexplicable—of which one can never become the master.

On 22 August 1918, the Italian Enrico Prampolini, who was involved
with the beginnings of Dada in Italy, wrote to Tzara of his attempts dur-
ing the past year to achieve "un nouveau [sic] ordre de style architectural
de la nature" [a new order of architectural style (like that) of nature] and
added that he was convinced of the need to enter into the spirit of ma-
terial things in order to give renewed expression to the eternal drama of
things and their life.[95] Arp distinguished between *das Dämonische* (destruc-
tive libidinal energy) and *das Naturhafte* (libidinal energy that is spiritual-
ized and immanently structured) in order to commend the latter and warn

against the former.[96] Before his politicization (1918–24) (see chapter 12), Franz Jung said that the power that resolved psychic conflict and restored psychic balance came from the *Weltatem* [the Breath of the World—i.e., the Brahma of Hinduism].[97] And Richter declared in retrospect:

> Wir spürten, dass wir in etwas anderes hineinreichten, das uns lebhaft umspülte, das Teil von uns wurde, in uns eindrang, so wie wir in ES ausströmten. Das Entscheidende und Merkwürdige dabei war, dass wir uns dabei nicht verloren gingen. Im Gegenteil. Wir zogen ganz neue Energien aus dieser Erfahrung. . . .

> *We felt that we were coming into contact with something different, something that washed around, became a part of us, penetrated us, just as we overflowed into IT. The important and remarkable thing about the experience was that we did not lose our individuality in the process. On the contrary. We drew totally new energies out of this experience. . . .*[98]

This paradoxical sense that Nature is both dynamically chaotic and yet full of elusive, shifting patterns—a sense that is very close to the later Nietzsche's idea that Nature is simultaneously Apollonian and Dionysian and Bergson's vision of *durée*—gives rise to statements such as the following:

> Dada ist das Chaos, aus dem sich tausend Ordnungen erheben, die sich wieder zum Chaos Dada verschlingen.

> *Dada is the chaos out of which a thousand orders arise which in turn entangle to form the chaos of Dada.*[99]

The vision of Nature as a "dialectic of order and anarchy" emerged particularly strikingly in the change that Arp's visual work underwent after winter 1917–18 (when he spent some time in Oedenkoven's Anarchist community on the Monte Verità behind Ascona).[100] Before this juncture, Arp's work—such as the illustrations for the first edition of Huelsenbeck's *Phantastische Gebete* (1915–16) (*Fantastic Prayers*, 1995); the woodcuts in *Dada* 1 (July 1917); and some collages from the same period in which rectangles of paper are arranged according to a mathematical grid—had been characterized by strict symmetrical organization. As such, it forms a good example of "the space of autoreferentiality" that constitutes the "domain of pleasure" of so much modernist art.[101] But after the above juncture, Arp's work, such as the illustrations for Tzara's *Vingt-cinq poèmes* (*Twenty-five Poems*)

(1915–18), does exactly what Krauss says modernist grid-based work does not do: it develops, becomes organic, "biomorphic," freely formed.[102] Before winter 1917–18, it is as though Arp had needed to impose strict form upon Nature on the grounds that it was fundamentally unstructured. But after that date, he seems to have acquired a faith in the inherent, formative power of Nature and hence to have become more willing to allow the creative process to assume what forms it would. Consequently, symmetry becomes asymmetry and strict organization around a static center becomes loose organization around an indeterminate center.[103] This change may well have been helped by the first eight of Tzara's twenty-five poems (written between February 1916 and June 1917), for in these, unlike the other seventeen, images of crystalline form are held in tension with images of protean transformation.[104] Finally, the assumption behind the whole of Hausmann's *Material der Malerei Plastik und Architektur* is that visual works should be models of the structured flux of Nature, combining form and movement, construction and dynamism, geometricity and layered transformations.[105]

The idea that structure and chaos are two complementary aspects of a single, ungraspable reality throws light on the meaning of chance for some of the Dadaists. In some Dada works (Duchamp's provocative readymades, Picabia's ink-blot that became his controversial *La Sainte Vierge*, Tzara's cut-up poems, Johannes Baargeld's and Max Ernst's discovery of pictures within pictures, Schwitters's use of detritus, and Man Ray's rayographs), chance was employed primarily as a technique for producing semiotic indeterminacy.[106] But for other Dadaists, the chance event that overtakes one unexpectedly and proves to be significant or creative is regarded as the shadow of an unseen power at work within and behind the empirical world, ordering events according to a purpose of its own. Richter described chance retrospectively as a magical procedure for overcoming the barriers of causality and conscious volition and opening up the secret processes of the unconscious.[107] He also linked this procedure with C. G. Jung's concept of "synchronicity"—the higher meaningfulness of the apparently random occurrence. Arp wrote most extensively and boldly on chance, claiming that his works were ordered "'elon la loi du hasard' tel que dans l'ordre de la nature" ["according to the law of chance," just as in the order of Nature] and that for him, chance was "une partie restreinte d'une raison d'être insaisissable, d'un ordre inaccessible dans leur ensemble" [a limited part of an ungraspable raison d'être, of an order inaccessible in its totality].[108] Indeed, in his latter years, after converting to Catholicism, Arp

went so far as to describe the chance event as the gift of the muses and similar to the illuminations imparted to the saints, especially when they arose out of the infinite or the void.[109] But it needs to be noted that Richter's and Arp's quasi-mystical statements about chance were made nearly half a century after the event. As several art historians have pointed out, while Arp's work from the Dada period did involve chance, it was constructed far more consciously than his later statements would suggest.[110]

Triune Dada and Carnival Laughter

On the basis of the above discussion, it emerges that the word "Dada" is used at three levels. At the first level, it names an amorphous bohemian movement. At the second level, it characterizes a complex of existential attitudes, which, while varying from person to person, are vitalist and involve the achievement of balance amid fluctuating opposites. But at the third level, it is used by some of the Dadaists to name a life force that is simultaneously material, erotic and spiritual, creative and destructive. Just before he broke with Dada for the first time in July 1916, Ball said as much at the very first *Dada-Soirée* in Zurich when he proclaimed, "Dada ist die Weltseele" [Dada is the World-Soul].[111] Once this third usage is grasped, then a whole series of apparently absurd statements become intelligible: "Dada ist die beste Medizin und verhilft zu einer glücklichen Ehe. . . . Nehmen Sie bitte Dada von uns als Geschenk an, denn wer es nicht annimmt, ist verloren" [Dada is the best medicine and helps create connubial bliss. . . . Please accept Dada from us as a free gift, for whosoever does not accept it is lost].[112] "Am Anfang war Dada" [In the beginning was Dada]; "Bevor Dada da war, war Dada da" [Before Dada was, Dada was]; and "Dada ist der Urgrund aller Kunst" [Dada is the primal ground of all art].[113] "Denn: nicht wir 'machten' DADA—DADA war eine Notwendigkeit" [For it was not we who "made" DADA—DADA was a necessity].[114] "Dat wat in de moderne menschheid latent bleef, komt door Dada tot uitdrukking. Dada heeft altijd bestaan, doch werd erst in dezen tijd ontdekt" [What remained latent in modern man is expressed in Dada. Dada always existed; however, it was discovered only in our own time].[115] "Der *dada* schwebte über den Wassern ehe der liebe Gott die Welt schöpfte, und als er sprach: es werde Licht! da ward es nicht Licht, sondern *dada*. Und als die Götterdämmerung hereinbrach, war der einzige Überlebende der *dada*" [The *dada* hovered above the face of the waters before God created the world, and when he spake: let there be light! lo, there was not light, but

dada. And when the Twilight of the Gods broke in upon us, the only survivor was the *dada*].[116] In Johannes Baader's "Dada-Spiel" ("Dada-Play") (which also appeared in *Der Dada* 1), Dada is equated with "der Schöpfer aller Dinge und Gott und die Weltrevolution und das Weltgericht in Einem gleichzeitig. . . . Und das Spiel, das gespielt wird im Himmel zwischen den Sternen ist das Spiel dada, und alle lebenden und toten Wesen sind seine Spieler." [the Creator of all things and God and the World Revolution and the Last Judgment all in one simultaneously. . . . And the play that is played out in Heaven among the stars is the play of Dada, and all beings, living and dead, are players in that play]. At this third level then, the word is to some extent a parody on the name of God. But the Dadaists—who associated themselves with Nietzsche's concept of the "Hanswürste Gottes" [God's buffoons] and referred to themselves as "half Pantagruel, half St. Francis"—are being serious as well as humorous.[117] During and in the aftermath of a horrendous war, within the context of a modernity that appeared to have gone disastrously wrong and yet was deceiving itself about the true situation, the Dadaists, whether they tended to absurdism or a more or less secularized mysticism, were trying, as Tzara said in his 1918 Manifesto, to find and affirm some kind of sense.[118]

Common to Dadaists at both poles of Dada is a complex sense of humor combining three main elements. First, Dada is typified by an ebullient and anarchic joy in the life force that expresses itself in carnivalesque imagery, absurd and spontaneous actions, and works of anti-Art.[119] When Höch pasted the slogan "Schrankenlose Freiheit für H. H." [Unlimited freedom for H. H.] onto her photomontage *Dada Rundschau,* she was not just proclaiming her own desire for what Frenkel calls the liberation of libidinous and creative energies, she was also making a larger pun.[120] Because the letters "H. H." in German are pronounced "Ha Ha," Höch was also saying that the "Dada Panorama" involved unlimited freedom for carnivalesque laughter—for everyone. Second, Dada cultivated a scathing satirical fierceness in order to prevent its joie de vivre from becoming endearing and therefore socially acceptable. Bergius is right to contrast the institutionalized, tolerated carnival with the Dadaists' desire to stage one that was heretical and antagonistic, offended the bourgeois sense of propriety, and constituted a protest against what Thomas Mann, in the closing lines of *Der Zauberberg,* would call "diese[s] Weltfest des Todes" [this worldwide carnival of death].[121] What kind of civilization is it, the Dadaists were asking, that gets worked up about the ultimately insignificant antics, provocations, and obscenities of a few anarchic *bohémiens,*

while tolerating a war that had caused millions of deaths and untold suffering, great cities full of poverty, vice, violence, and crime, and régimes in which the worst seemed able to rise to the top?[122] Finally, Dada is also marked by a highly developed sense of self-irony whose roots lie, in part at least, in Schlegel's Romantic Irony.[123] Self-irony signifies the Dadaists' awareness that in a world in flux, the subjective point of view and human formulations are relative. This is why Huelsenbeck called Dada "die grosse Parallelerscheinung zu den relativistischen Philosophien dieser Zeit" [the great parallel to the relativistic philosophies of our times]; why Van Doesburg named Einstein as a Dadaist (alongside Charlie Chaplin and Bergson); and why, in the top left-hand corner of Höch's *Schnitt mit dem Küchenmesser*, the word "dada" comes out of Einstein's head.[124] Self-irony guarantees an attitude of flexibility and openness toward a world of uncertainty. Self-irony functions as a means of checking blind enthusiasm and utopian dreams—which is why, in the trial sheets for *Dadaco*, it is said that one began to understand where lack of irony can lead when one remembered how blindly the Futurists had rushed into the war. Self-irony can even help one come to terms with mortality—which explains why the Dadaists cultivated an indifference toward the survival of their own artistic products. But finally, self-irony, the ability to stand back from oneself and laugh, betokens that there is a quality in human nature that is stronger than all the negative and disorienting pressures that play upon it—which is possibly why, in "Was will der Dadaismus in Europa?," Hausmann referred to "die unbesiegbare Macht der Ironie" [the invincible power of irony][125] Ultimately, and despite all its provocative cynicism and uncomfortable subversiveness, the humor of Dada says "yes" to life—even if it cannot solve the philosophical problem that would be inherited by postmodernism of why it should say "yes" to anything at all.

Art and Anti-Art

Everyone knows that the Dadaists were against Art, but few people seem to understand why—or why, having rejected Art, they then created artifacts of their own. So to begin with, we need to understand that the Dadaists were not against the creation of artifacts, but against Art as an institution that was spelled with a capital *A*. First, as Bürger makes very clear, Dada was in reaction against all aesthetic theories that drove a wedge between art and life (understood in either the vitalist sense of Nature or the social sense of everyday life) and elevated the work of art into an auto-

telic object for disinterested contemplation. That is to say, the Dadaists rejected the aesthetic tradition that extends from Kant to Adorno according to which the work of art is the mediator of a transcendent *Geist* or aura. In this spirit Ball noted in his diary on 5 April 1916 that although the Dadaists rejected art as an end in itself, they did regard it as a means for investigating, criticizing, and even awakening their age. Arp wrote retrospectively that "dada is as senseless as nature and life. dada is for nature and against art. . . . dada is moral the way nature is," and Tzara proclaimed in 1922, "L'art n'est pas la manifestation la plus précieuse de la vie. . . . En art, Dada ramène tout à une simplicité initiale, mais [toujours] relative" [Art is not the most precious manifestation of life. . . . In art, Dada brings everything back to an initial, but always (relative), simplicity].[126] Second, the Dadaists objected to the commodification of art on the grounds that this turned it into the preserve of the rich who then used the ownership of a valuable commodity to reassure themselves about the security of their socioeconomic position and legitimize their ideas of possession and tactics of exploitation.[127] Third, the Dadaists objected to museum art situated in a public space that people visited reverentially on Sundays to forget the awful things going on around them.[128] Fourth, the Dadaists were against art that propagated the harmoniously centered and unified classical ideal and the anthropocentric view of the world. They based this rejection on the grounds that such art was inappropriate to a highly fragmented, discordant world where power was held by the kind of brutally ugly ruling class that Grosz depicted in his visual work and venomously described in his 1916–17 letter to Robert Bell.[129] In their view, the classical ideal was in itself a dangerously consoling illusion in such a world and doubly so because it had become the ideological tool of régimes that they held in contempt. On this latter count, for example, Harry Graf Kessler's diary makes it clear that the Communist wing of Berlin Dada was made even more hostile to anything calling itself "art" by its experience of a left-wing government allowing right-wing *Freikorps* to run amok during the revolutionary period in Berlin (see chapter 12).[130] Finally, because Dada instinctively mistrusted binarisms, they objected to any absolute distinction between art and nonart; art and kitsch; art and entertainment; artist and nonartist; artist and spectator. In their view, the invention of the camera and cinematograph made such binarisms arbitrary since the ordinary person, once armed with a camera, scissors, and paste, could declare himself an artist with the whole world as her or his subject. Indeed, Man Ray and Hausmann were themselves remarkably innovative photographers, and Richter

and Eggeling were already experimenting with abstract film during the Dada period itself. Writing in "Das Kunstwerk im Zeitalter seiner technischen Reproduzierbarkeit" (1936) ("The Work of Art in the Age of Mechanical Reproduction," 1966), Walter Benjamin was entirely correct to see that Dada's attack on auratic art was based in part on the realization that the new media of photography and film could do certain things more effectively than older modes. They could shock, sharpen our perceptions of the everyday world, and replace static and detached contemplation of the spiritual with dynamic and tactile enjoyment of the material.[131]

Consequently, Dada's anti-Art involves two major, complementary purposes. First, it aims to create antinaturalistic images of the vital life force.[132] Second, it aims to shock and subvert by violently satirizing human pretensions, the established social order, and the ideological means by which that order seeks to legitimize itself. Some Dadaists, like Arp (who regarded his "concretions" as part of Nature itself), stressed the first purpose. Others, like Grosz in his visual work and Huelsenbeck in his novel *Doctor Billig am Ende* (which Grosz illustrated) stressed the second purpose.[133] But others manage to give more or less equal weight to both purposes or even to oscillate between them. Thus, Picabia's and Duchamp's functionless machines both satirize the illusion that human beings can exercise any final control over the flux of Nature and simultaneously appear as abstract, rhythmic expressions of that flux.[134] Grosz's poem "Kaffeehaus" ("Café") (1917) does something similar but even more violently. Höch's female figures in her photomontage *Dada-Ernst* (*Dada-Seriousness*) (1920–21) can be seen to celebrate Eros and/or criticize the violence that patriarchy does to women. Schwitters's first *Merzbau* can be viewed as an organically developing, androgynous monument to the creative drives or as a satirical comment on a society in which shopping becomes a substitute for sexuality.[135] Hausmann's visual work veers between biomorphic works reminiscent of Arp and fiercely satirical collages and photomontages. All other characteristics of Dada artifacts derive from the above two purposes, and of these, seven merit more detailed discussion.

First, the Dadaists do not conceive of their artifacts as symbols, but as "concretions," "constellations," or "analogues"—Wittgenstein's "models" of proposition 4.01 of the *Tractatus*. Where, since Coleridge at any rate, it is claimed that the symbol partakes of the thing symbolized, the constellation has only a tendency toward the flux of which it is a perspectival model.[136] Where the symbol is constructed around a still center, the constellation is a "heteromorphic," "heteroglossic," asymmetrical amalgam

of moving forces in balanced opposition to which there is no clear center, "eine Gestaltung organisch in Analogie der gesehenen Momente weder nachahmend noch beschreibend" [a construction organically in analogy with the perceived driving forces neither imitating nor describing].[137] Where the symbol aims to fuse disparate orders of reality, the constellation accepts that there are gaps between reality, human perception of reality, and the form in which that perception is cast. So although the Dadaists were committed to their works because they wished them to make a statement, they were also ironic about them because they were aware that they only approximated to a complex reality that surpassed them and believed that to aspire to flawless perfection is a subtle form of presumption.[138] This is why many Dada artifacts have an unfinished, makeshift, provisional quality about them.

Second, because chance is accepted as an aspect of the inexplicable and ungraspable flux of Nature, it is allowed to enter into the selection of materials and the act of creation itself. The Dadaist does not claim to be in complete control of his or her materials and thus regards the *objet trouvé* as having equal value with something that has proceeded from his or her hands.

Third, no attempt is made to render artifacts eternal: rather, their inevitable decay is accepted. Thus, Duchamp accepted the cracking of the *Large Glass* on which he had been working for the best part of a decade and designed his *Unhappy Readymade* (1919), a textbook on Euclidean geometry, to be hung on a balcony and destroyed by the elements. The Dadaists cultivated this disposability partly from the conviction that an artifact that is allowed or even encouraged to decay is a more adequate image of the human situation, and partly so that it is more difficult for their works to be institutionalized in museums and galleries.[139]

Fourth, the Dada artifact has a deeply ambiguous relationship with modernity, the machine, and mass-produced kitsch.[140] On the one hand, the Dadaists—especially the "skyscraper primitives" who formed New York Dada—identified with their age and took issue with those who yearned for an ideal future or a romanticized past.[141] But on the other hand, they were profoundly critical of modernity and technology, partly because of the devastation wrought by industrialized warfare, and partly because of technology's ability to be disastrously dysfunctional. Was it, I wonder, a coincidence that Duchamp conceived his most contemptuously provocative readymade (*Fountain*) and signed it with a pseudonym (R. Mutt) that is reminiscent of the German word for poverty (*Armut*) shortly after

America, where Duchamp had gone to avoid the war, had entered the war? And was it a coincidence that the Dadaists recited Futurist poetry dealing with war and the city at one of the most provocative *Dada-Soirées* in Berlin six years to the day after the *Titanic* had set sail? Certainly, Huelsenbeck would refer to that day in *Dada siegt!* as a "denkwürdiges Datum" [date that is worth thinking about].[142] Although the Dadaists used techniques like collage, assemblage, montage, and photomontage that would be unthinkable without modernity, they did so in order to highlight the catastrophic effects it can have when coupled with poverty of imagination or used by mutts; to subvert progressivist notions of history; and to affront high bourgeois notions of art.[143] Indeed, the mutilated faces of women and children that Höch would collage together from about 1923 onward may have had their source in the photographs of horrendously mutilated war veterans that were exhibited in Ernst Friedrich's *Arbeiter-Kunst-Ausstellung* (Workers' Art Exhibition) (which Höch almost certainly knew through Hausmann). These photographs which then appeared in *Die freie Welt* (*The Free World*), the illustrated weekly supplement of the Independent Socialist newspaper *Die Freiheit* (*Freedom*) on 20 October 1920, and were finally reproduced in Friedrich's two-volume *Krieg dem Krieg* (*War on War*) (1924–25). Just as mechanized warfare had disfigured men almost beyond recognition, so machine civilization, to which Höch was in many ways committed, was capable of doing the same to women and children.[144]

The same ambiguity marks the Dadaists' use of technological imagery and the commodities of modernity. On the one hand, they love the banal things of their age because they can be taken out of their conventional, instrumental contexts and looked at with an eye freed from the blinkers of convention; because they can be experienced as objects that have shape, rhythm, and line and can be combined with other elements to form abstract constellations.[145] In this spirit Hausmann declared in 1922 that he cared nothing for medieval saints and that the art needed by his age was one that began from entirely conventional, entirely contemporary objects like pictures in fashion journals, tailors' dummies, and wig stands.[146] But on the other hand, those objects and images are never used uncritically. Thus, Duchamp's addition of a moustache and goatee beard to a reproduction of the Mona Lisa and rebaptism of the resultant work as *L.H.O.O.Q.* is open to several, irreconcilable interpretations. It can be read as a statement about androgyny, a (sexist) deflation of the desexualized Western ideal of womanhood, an appreciation of how the popular imagination debunks "official" art by graffiti, a piece of anti-Renaissance iconoclasm, a

critical statement about the ability of mass production to turn a master-piece into a cliché, or a wry appreciation of the way in which modernity gives everyone access to art in the age of its technical reproducibility.[147] Similarly, while Duchamp's urinal, bottle dryer, and hat rack never cease to be what they intransigently are, they turn, when viewed with the eye of the eccentric imagination, into, say, the castrated loins of a ceramic man, a vagina, a metallic plant, an abstract monument to nothing in particular, or a monstrous insect—raising all kinds of critical questions about the role of technology in the modern world. And when they are given provocative or punning titles, then further multiple meanings and questions are generated.[148] Indeed, perhaps the ultimate example of Dada's irony is Man Ray's *Cadeau* (*Present*) (1921)—a beautifully shaped flatiron with spikes affixed to its base that interfere with its aesthetic appeal; make it totally dysfunctional as a "present;" and bring out the narrow line between beneficent and maleficent technology. Likewise, when Picabia gendered machines, he was perpetuating the masculine convention of referring to large machines as though they were female, satirizing that convention (which is at the heart of Futurist aesthetics), and commenting critically on modernity's tendency to mechanize human beings so that they fit more efficiently into what may ultimately be an absurd productive process—for it is hard to imagine Picabia's machines actually achieving anything. And when Schwitters built rubbish into his collages, he was simultaneously commenting on the aesthetic potential of the detritus of modernity and the tendency of modernity to generate huge amounts of waste. Dada was not the only form of modernism to cross the high/low divide in its artifacts, but when it did so, it was not simply being iconoclastic or attempting to integrate art and life. Rather, to cite Höch, it was using elements of modernity, notably detritus and defunctionalized machine parts, to create a new and even terrifying dream world and so affirm modernity while highlighting its negative side—which is possibly one reason why Hausmann called Dada "die vollendete gütige Bosheit" [benevolent malevolence in its completed form].[149]

Fifth, Dada art is public and models itself, following Rimbaud, on older or non-Western art forms that are equally public—the carnival, the street or public theater, the fairground, the ritual or tribal chant, the ritual mask, the heraldic device, the mandala, the circus, the variety theater, the old-fashioned newspaper advertisement, the graffiti on lavatory walls. Dada poems are to be read aloud in public places or plastered as posters on walls. Dada theater—and what is and is not Dada theater is very hard to define—

is for impromptu performance not formal venues.[150] Dada visual art aims to take people by surprise, to shock them before they have had the time to immunize themselves against a bout of culture, and to subvert conventional ways of perceiving by confronting the beholders with an alternative value system in that unexpected context. To paraphrase John Cage, Dada aims to make people lose their sense of values and acquire increased awareness by means of what Marjorie Perloff terms its "theatricality."[151]

Sixth, dealing in collage and readymades, Dada is or would like to be anything but "élitist."[152] Rather, Dada asserts that the ability to see a new *Gestalt* in a conventional context is itself a creative and an artistic act. Consequently, Dada is resolutely against the cult of the "genius" since in Dada's view, that cult limits ordinary people's capacity for growth by convincing them that they are incapable of creative activity. Conversely, Dada considers it absurd to put the "genius" on a pedestal. One can, as Huelsenbeck bluntly put it, live without poets but not without street cleaners, and where the "genius" diverts people from the realities of the age he or she is actually of far less value than the street cleaner because he or she is guilty of "sabotaging life."[153] By dethroning the "genius," Dada hoped to increase people's confidence in their own creativity.[154]

Finally, Dada places much more stress on the subjective response of the reader, beholder, or listener, saying in effect that the artifact is what he or she makes of it. What speaks to one person from one society or class at a given point in time will not necessarily speak to another person from a different society or class at another point in time. As we saw above, Dada artifacts are susceptible to a range of interpretations and some of the most interesting Dada criticism is aware of this.[155] But some Dadaists went much further, proclaiming that critics have no right to set up a hierarchy of values and responses, to declare one work superior to another work, and to esteem the person who likes that work more highly than the person who does not. Tzara maintained that criticism was useless because of its subjectivity, and Duchamp said that he considered the beholder as important as the creator when it came to interpretation.[156] This theoretical position is deliberately provocative and ultimately untenable for it not only points forward to the "anything goes" of postmodernism, it also means that by their own criteria the Dadaists had no right to object to, let alone attack, what was, in their view, the misappropriation of art by the ruling classes — a philosophical problem to which I shall return in chapter 13. Such extreme statements may be logically flawed, but they are salutary corrections to critical arrogance and authoritarianism because they challenge the pro-

fessional critic to look more carefully at the basis, appropriateness, and authority of her or his opinions.

Dada was not nihilistic lunacy—though nihilistic lunacy has its place in Dada. Notwithstanding local variations, personal differences, and the fluid history of this leaderless, travelling, carnivalesque movement, Dada's polemical assaults were accompanied by an alternative vision of reality and an alternative (anti)aesthetic. It is no accident that most of the major work on Dada over the past two decades has been done by women; that Heide Göttner-Abendroth's nine principles of a matriarchal aesthetic map to a significant extent with the antiaesthetic of Dada; and that commentators should now be recognizing the proximity of Dada writing to Kristeva's *écriture feminine*.[157] For Dada is the explosive expression of the repressed "semiotic chora" within Weber's *stahlhartes Gehäuse,* the violently exuberant affirmation of Schiller's "Spieltrieb" [ludic drive] within a modernity whose institutions were felt to have turned against their original, emancipatory purpose. To the rationalist, Dada may look at worst like a totally negative, childish phenomenon and at best like radical cheek or the anusface of "high modernism." But a more sympathetic inspection might recognise it as the latter-day inheritor of an oppositional, carnivalesque urge whose roots are very old and run very deep.[158]

8. Dada and Futurism

Although, superficially, Dada and Italian Futurism look very similar, critics who are familiar with the two movements agree that, as I showed in chapter 5 with reference to language, they are distinct in several fundamental respects.[1] But there is equally broad agreement that Dada learned a great deal from Futurism, with one authority claiming that Dada is simply Futurism taken to its ultimate conclusions so that it turns against itself and generates its own antithesis.[2] Accordingly, in this chapter, I shall assess the importance of Futurism for Dada and then show how the two movements, for all their common features, involve distinct responses to modernity.

Influences: Picabia and Duchamp

In José Pierre's view, Futurist ideas had been around in Paris since 1911 and became particularly influential on Picabia and Duchamp in February and March 1912, when the first Futurist exhibition to be staged outside Italy took place in the Galerie Bernheim Jeune.[3] But where Picabia is concerned, the evidence for this claim is slight. Although it is true that his work became nonfigurative in 1912, this almost certainly had less to do with the Futurists and more to do with his contact with the Parisian avant-garde—particularly Guillaume Apollinaire (whom he first met in 1911 and whose opinion of most of the Futurist work exhibited in spring 1912 was not high) and Duchamp (whom he got to know in November 1911).[4] Furthermore, the only element in Picabia's nonfigurative work from

1912 to 1914 that could be said to derive from Futurism is the concern with movement displayed by such works as *Udnie* (*jeune fille américaine; danse*) (*Udnie* [*Young American Girl; Dance*]) (1913) or *"Little" Udnie* (c. 1913–14). But this concern went back to 1905 and Picabia's youthful enthusiasm for Nietzschean vitalism, and it had been developed by his contact with Bergsonianism in 1910 and 1911.[5] Furthermore, the lyrical movement of Picabia's paintings from 1912 to 1914 is very different from the violence of Futurist *dinamismo* and already combined with a certain wry irony that is completely untypical of Futurism. Nor does Futurism seem to have been the inspiration behind Picabia's machinist pictures of 1915, which, far from glorifying the machine and machine civilization, are a sardonic comment on the mechanization of human life in the modern world and the ultimate absurdity of the machine. Indeed, the article "French Artists Spur on American Art" that was published in the *New York Tribune* on 24 October 1915 indicates that Picabia's sudden interest in the machine was precipitated by his experience of North America (where he lived January–April 1913 and May 1915–June 1916).[6] Here, he is quoted as saying that he had become "profoundly impressed by the vast mechanical development in America"; that the machine had changed from a "mere adjustment" to perhaps "the very soul" of human life; and that this is why he had introduced it into his studio.

It is the same with Duchamp, even though there seems more evidence at first sight for Pierre's claim. The difference between Duchamp's pre- and post-1911 work is encapsulated in the two versions of his pivotal work *Nu descendant un escalier* (*Nude Descending a Staircase*), the second of which (January 1912) is markedly more dynamic in inspiration than the first (December 1911). This difference is so great that Raffaele Carrieri ascribed it unequivocally to his encounter with Futurism. But Linda Dalrymple Henderson argues that Duchamp's experiments in analyzing motion had more to do with his contact with František Kupka and that the formal similarities between the second version of Duchamp's painting and Futurist work are relatively superficial. Arturo Schwarz is even more emphatic that the Futurists' influence on Duchamp was negligible for four reasons: (1) Duchamp, unlike the Futurists, was not concerned to create the illusion of movement; (2) Duchamp was concerned to deride the machine, not exalt it; (3) Duchamp's attitude cannot even be described as "a conscious reaction to the Futurist view"; and (4) Futurism for Duchamp was simply "traditional painting with a renovated concept of form and the old aesthetic core." Schwarz also claims that Duchamp's first contact with the

Futurist group in Paris was restricted to a casual meeting with Umberto Boccioni at the end of January 1912 (i.e., *after* the completion of the second version of *Nu descendant un escalier*) and that, during the period when the Futurists were most active in Italy, Duchamp was in Munich, where Futurist influences were much less in evidence, working on the *Large Glass*— a composition that went far beyond the bounds of contemporary avantgarde painting. Likewise John Golding, who points out that Duchamp later denied that Futurism had had any influence on his work at the time and that the Futurists' bombastic optimism and glorification of the machine would have been alien to Duchamp's passively critical attitudes toward life and machine civilization. Although Golding concedes that Duchamp may have been unconsciously aware of the early Futurist manifestos, he suggests that the dynamic succession of form that characterizes the second version of *Nu descendant un escalier* may derive more from Duchamp's avowed interest in chronophotography and motion pictures than from Futurism.[7]

Influences: Dada in Zurich

There is much more evidence for the direct impact of Futurism on the Zurich Dadaists. If any members of the Zurich Dada group were familiar with back issues of *Lacerba* (January 1913–May 1915), published by a Futurist splinter group for a readership that was largely working class,[8] they might have learned from Marinetti's "L'immaginazione senza fili e le parole in libertà" (15 June 1913) ("Destruction of Syntax—Imagination without Strings—Words-in-Freedom," 1973); "Il teatro di varietà 1913" (1 October 1913) ("The Meaning of the Music-Hall," 1913); and "Dopo il verso libero: Le parole in libertà" ("Towards Free Verse: Words in Freedom") (15 November 1913); Luigi Russolo's "Gl'intonarumori futuristi: Arte dei Rumori" ("The Futurist Noise-Machines: Art of Noise") (1 July 1913); "Conquista totale dell'enarmonismo mediante gl'intonarumori futuristi" ("Complete Conquest of Enharmonizing by means of Futurist Noise-Machines" (1 November 1913); and three "Spirali di rumori intonati" ("Spirals of Intonated Noises") (1 March 1914); Aldo Palazzeschi's, Giovanni Papini's, and Ardengo Soffici's "Futurismo e Marinettismo" ("Futurism and Marinettism") (14 February 1915), which advocated irony, clownery, and tightrope walking; and Soffici's manifesto "Adampetismo" ("Adamfartism") (1 May 1915), which advocated imbecility. But there is relatively little evidence that any of the Zurich Dadaists *did* know *Lacerba*, a much

greater likelihood that they derived their knowledge of Futurism from other sources (such as reports in German newspapers), and considerable evidence that they were interested in a relatively narrow range of Futurist concepts.[9] Thus, in 1920, Richard Huelsenbeck (who was in Zurich from mid-February to late autumn 1916 and, like many Dadaists, unwilling to admit anyone's influence at all) wrote that the Zurich Dadaists were in contact by letter with Marinetti; that all knew Boccioni's major theoretical work *Pittura scultura futuriste* (*Futurist Painting and Sculpture*) (1914); and that all gladly assimilated Marinetti's concepts of simultaneity and the "poème bruitiste" even though they rejected his "realistic" view of the world.[10] Forty years later, Hans Richter confirmed what Huelsenbeck had said about bruitism and added that Zurich Dada also learned from the Futurists the art of provocation, the use of the manifesto, nonlinear typography, the use of different fonts, and a general commitment to dynamism.[11]

The particular histories of individual Dadaists apart, there were several readily available sources from which any member of the Zurich Dada group could have derived his or her knowledge of Futurism. Hugo Kersten and Emil Szittya had published Marinetti's "In quest' anno futurista" ("In this Futurist Year"), a prowar manifesto, in the second number of *Der Mistral* that appeared in Zurich on 21 March 1915. Paintings or posters by Augusto Giacometti hung on the walls of the Cabaret Voltaire when it opened.[12] Boccioni's *Pittura scultura futuriste* contained fifty-two black-and-white photographs of paintings and sculptures by Boccioni himself, Carlo Carrà, Russolo, Giacomo Balla, Gino Severini, and Soffici, and the following key manifestos (besides other minor works): *Fondazione e manifesto del futurismo* (1909) (*The Founding and Manifesto of Futurism,* 1973); *Manifesto tecnico della pittura futurista* (1910) (*Futurist Painting: Technical Manifesto,* 1973); *Manifesto tecnico della scultura futurista* (1912) (*Technical Manifesto of Futurist Sculpture,* 1973); and *La pittura dei suoni, rumori, odori* (1913) (*The Painting of Sounds, Noises and Smells,* 1973). Marinetti sent both Ball and Tzara examples of Futurist *parole in libertà* poems in July 1915, and some of these, by Marinetti and Paolo Buzzi, may have been read out in the Cabaret Voltaire on 12 February 1916.[13] It is almost certain that these poems included Francesco Cangiullo's "Addiooooo" (first published in *Lacerba* on 15 November 1913) and Marinetti's "Dune 7.8" (first published in *Lacerba* on 15 February 1914), since both of these poems appeared in the first Dada magazine, *Cabaret Voltaire,* on 24 May 1916. Other newspaper inserts and advertisements indicate that unspecified Futurist items were read out in the Cabaret Voltaire on 5 February 1916, 24 May 1916, and 14 July 1916.[14]

On 23 March 1916, A *Faschingsfest* (party to mark the end of the carnival season) took place in the Cabaret Voltaire at which an unidentified "Futurist comedy" and "Futurist program music" were performed.[15] In January 1917, the Zurich Kunsthaus staged a small exhibition of drawings and paintings by Boccioni; and works by Enrico Prampolini, the initiator of *il secondo futurismo* (the second phase of Futurism), were included in "Graphik, Broderie, Relief" ("Graphics, Embroidery, Reliefs"), the third exhibition in the Galerie Dada that took place from 2 to 29 May 1917. Alberto Spaïni, the Zurich correspondent of *Il resto del carlino,* seems also to have played a mediating role between the two movements. According to Lista, it was he who put Tzara in contact with the Italian Futurists, and he certainly read from Francesco Meriano's *Gemma* at the fourth *Dada-Soirée* (12 and 19 May 1917) — though I can find no hard evidence for Lista's claim either that Marinetti's *Bombardimento di Adrianopoli* (*The Bombardment of Adrianopolis*) (1913) was read out at the second *Dada-Soirée* (*Sturm-Soirée*) of 14 April 1917, or that Spaïni took part in that *Soirée* at all.[16] A further outcome of Spaïni's mediation does seem, however, to have been the inclusion in *Dada* 1 and 2 (July and December 1917) of poems and woodcuts by second generation Italian Futurists (Meriano, Prampolini, Nicola Moscardelli, Maria d'Arezzo [the writer and philosopher Maria Cardini], Gino Cantarelli, and Bino Sanminiatelli), three of whom (Prampolini, Cantarelli, and Sanminiatelli) hovered on the borderline between Italian Dada and *il secondo futurismo.*

Against this general background it is very instructive to consider *how* Futurism was assimilated by individual Dadaists. Ball, for instance, does not seem to have been affected by the first incursions of Futurism into Germany since he was not in Berlin when the Paris Futurist Exhibition moved to Herwarth Walden's *Sturm-Galerie* there (12 April–31 May 1912). Nor was he in Berlin for Severini's exhibition in the same gallery in August 1913 or for Walden's *Erster Deutscher Herbstsalon* in September–December 1913, which included pictures by Balla, Boccioni, Carrà, Russolo, Severini, and Soffici. Nor, until April 1917 (see below), does Ball give any indication that he had read the seven Futurist manifestos published in Walden's Expressionist journal *Der Sturm* between March 1912 and December 1913.[17] Nor, even after he had seen his first examples of *parole in libertà,* did Ball's own poetry show any signs of radical linguistic experimentation for nearly a year (see his diary entries for 3 and 18 June 1916). But we do know that Ball's first real exposure to Futurism took place in late October or early November 1913, when he went to Dresden to be interviewed — unsuccess-

fully as it turned out—for the post of director of the Alberttheater. At the time of Ball's visit, twenty-four of the original thirty-four pictures that had constituted the Berlin exhibition were on show in Emil Richter's *Kunstsalon,* and Ball set down his highly excited reaction to them in a prose piece of mid-November 1913.[18] Nevertheless, it is important to understand that this reaction was couched in typically Expressionist terms, for Ball saw in these pictures not confidence in mechanized civilization, but madness, angst, and horror; not the linear evolution of machine civilization, but its imminent destruction and the abyss; not an ultimate harmony concealed within the lines of force, but "absolute craziness"; not centrifugal or centripetal motion, but chaos, rage, explosions, and destruction; not chemical or material energy, but "tellurische Mystik" [tellurian mysticism], "Bewegung der Spermatozoen" [the movement of spermatozoa], and "Urkraft" [primal force]. Overall, the tone of the piece is one of apocalyptic Expressionist ecstasy, not Futurist bombast.[19]

Indeed, everything suggests that Ball was unable to see any clear distinction between Futurism and the ecstatic Expressionism (of which he himself was an impassioned representative after mid-1913) until mid-1915—that is, *after* he had been through his shattering experiences at the front and taken refuge in Zurich. Moreover, Ball seems not to have been exposed to any material that would have enabled him to make such a distinction during this period. On 6 July 1914, he wrote to his sister:

Das Leben hier [Berlin] ist grandios und überstürzt mich mit Eindrücken und Neuem. Ich sprach bis jetzt: Kerr, Pfemfert, Herwarth Walden, A. R. Meyer, Rubiner, Blei, Else Hadwiger (die Übersetzerin der italienischen Futuristen) und bin mit diesem Kreise täglich zusammen.[20]

Life here [Berlin] is grandiose and overwhelms me with impressions and novelty. So far I have talked to Kerr, Pfemfert, Herwarth Walden, A. R. Meyer, Rubiner, Blei, Else Hadwiger (the translator of the Italian Futurists) and mix with this circle every day.

In 1912, Else Hadwiger had published translations of five poems by Marinetti ("An das Rennautomobil" ["To the Racing Car"], "Der Abend und die Stadt" ["The Evening and the City"], "Die Fanfare der Wellen" ["The Fanfare of the Waves"], "Gegen die Syllogismen" ["Against Syllogisms"], and "Hymnus an den Tod" ["Hymn to Death"]) as one of Alfred Richard Meyer's *Lyrische Flugblätter* (*Lyric Leaflets*). But these poems were

not examples of *parole in libertà*. Rather, they were syntactically straightforward, ecstatic hymns of praise and written in a style very close to that of the Expressionists Theodor Däubler, Ernst Wilhelm Lotz, and Ernst Stadler. The same applies to the French poem "A l'Automobile de course" ("To the Racing Car") that appeared in May 1912 in *Der Sturm;* to the three German translations of poems by Marinetti ("An meinen Pegasus" ["To My Pegasus"], "Der Abend und die Stadt," and "Die heiligen Eidechsen" ["The Sacred Lizards"]) published in Franz Pfemfert's Expressionist magazine *Die Aktion* on 13 and 27 September 1913, respectively, and to various other translations of poems by minor Futurists.[21] If these were the only Futurist poems that Ball knew by mid-1914—and he mentions no others—then there would have been no reason for him to have regarded Italian Futurism as significantly distinct from the rhapsodic German Expressionism with which he was already familiar. Ball's ignorance of the specific nature of Futurism until a relatively late date is also indicated by his diary entry for the New Year 1914–15 when he recounts sitting on the balcony of Else Hadwiger's flat and shouting "Down with war" as a protest against the war.[22] Had Ball been more familiar with the characteristic tenets of Futurism, he would have known that the early Futurists had praised war as a virtue and probably emphasized the irony of demonstrating against the war from the balcony of the flat belonging to Marinetti's translator. As it stands, the diary entry in question emphasizes the intrinsic futility, not the irony, of this gesture.

Similarly, in late July 1914, Ball wrote to his sister that he had organized, with Walden's aid, an exhibition of Futurist, Cubist, and Expressionist paintings that would open in Munich on 1 September. But in writing this, Ball gave no indication whatsoever that he saw any real difference between the three movements and brought all three groups under one heading by describing them as "das radikalste, was es heute auf malerischem Gebiete gibt" [the most radical thing that exists today in the field of painting].[23] And on 11 June 1915, Ball made the following proposal based on the same assumption in a letter to the publisher Kurt Wolff:

> Ich bin mit der Zusammenstellung einer lyrischen Anthologie beschäftigt, zu der ich die Zusagen von Kandinsky, Marinetti, Apollinaire und Rubiner habe. Die Anthologie wird über den Krieg hinweg und ohne im kriegerischen oder politischen Sinne irgendwie aktuell zu sein einen ganz starken Verband der expressionistischen und futuristischen Tendenzen darstellen.[24]

> *I am busy putting together an anthology of poetry to which Kandinsky, Marinetti, Apollinaire, and Rubiner have agreed to contribute. The anthology aims to show the strong link that exists between the Futurist and Expressionist movements and to transcend the war but without having any contemporary relevance as regards the war or politics.*

Finally, although we do not know which poems Ball received from Marinetti and others just after the outbreak of war, it is very probable that no *parole in libertà* poems were among them, since when he *did* receive such abstract poetry on 9 July 1915, his diary entry, involving a meditation on the total collapse of language, suggests that he had seen nothing like them before.[25]

Conversely, after this latter date, the passages in Ball's letters and diaries dealing with Marinetti or Futurism indicate that once he realized that Futurism was considerably more daring in its experimentation than Expressionism, he identified it exclusively with the idea of *parole in libertà*. His diary entry for 18 June 1916 views *parole in libertà* as Futurism's most important step forward on two grounds. First, he says that this technique breathes new life into a language that had been worn out by modernity; and second, he says that it has enabled the Dadaists to develop their idea of a redeemed, magical language. This means that Ball had realized by summer 1916 that Futurist *parole in libertà* and Dada sound poetry were not the same thing. But because he had no quarrel with Futurism, he deleted Marinetti's name from the manuscript of the manifesto that he delivered at the first *Dada-Soirée* of 14 July 1916 when compiling a facetious list of things and people who constituted Dada.[26] Thereafter, Ball's 27 [August] 1916 letter to Tzara shows that even after his first break with Dada, he was still protective toward the examples of *parole in libertà* with which Marinetti had, in his view, entrusted him and did not want them to be used by the major figure of a movement from which he had become temporarily estranged.[27] Similarly, after Ball returned to Zurich in spring 1917 to manage the Galerie Dada (see chapter 9), he had no qualms about allowing Marinetti's *Manifesto tecnico della letteratura futurista* to be read out at the *Sturm-Soirée* of 14 April 1917—probably in the German translation from *Der Sturm* since Ball refers to it in his diary as "Die futuristische Literatur"—presumably because this is one of the major texts where Marinetti sets out the principles behind *parole in libertà*.[28] Although Ball left experimental literature and avant-garde art for political journalism six weeks after this event, his selective encounter with Futurism had helped him through

his Expressionist phase and toward the more radical use of language that precipitated the crisis described in chapter 5.[29]

A broadly similar pattern is evident in Huelsenbeck's reception of Futurism. We now know that his May 1915 letter to N. F. in which he describes the *Expressionisten-Abend* (Expressionist evening) that he and Ball had organized on 12 May 1915 was actually written in 1963.[30] Nevertheless, the reports on the evening that appeared in the *Berliner Börsen-Courier* and the *Vossische Zeitung* (Berlin) on 14 May 1915 and in *Der Tag* (Berlin) on 15 May 1915 together with the manifesto distributed by Ball and Huelsenbeck at the *Gedächtnisfeier* (secular memorial service) on 12 February 1915 suggest that it is not a total fabrication, and taken together, these documents point to several conclusions.[31] First, at this time, Huelsenbeck, like Ball, thought of Futurism and Expressionism as pretty well synonymous. Second, Huelsenbeck and his circle of self-confessed Expressionists (who at that time included Johannes R. Becher) had assimilated Futurist techniques of audience provocation. Third, the use of bruitist techniques on 12 May prefigured the much more radical Dada campaign against art. Fourth, Huelsenbeck was writing what he called "Negergedichte" — primitivizing poetry involving chanted sounds like "Umba! Umba!" — almost a year before his recitation of similar poems in the Cabaret Voltaire. Fifth, this kind of poetry was inseparable in his mind from bruitism. But sixth, both Huelsenbeck and Ball had developed a radically negative attitude toward established society and its official culture because of the war and were desperately looking for something to replace their shattered faith in progress and the liberal values.

In those texts where Huelsenbeck rather grudgingly acknowledges that Dada owed anything to Futurism, he suggests that after his arrival in Zurich his already aggressive and antagonistic brand of Expressionism developed into something even more extreme by the use of two key Futurist techniques: bruitism and simultaneism, both of which were interconnected in Huelsenbeck's mind.[32] Ball's diary also indicates that Huelsenbeck's radicalized use of these two techniques in Zurich accentuated at least three of the characteristics of the two Berlin evenings of 1915 and generated a new mode of poetry. To begin with, the audience provocation of Berlin turned into a much more frontal assault on the audience's sensibilities in Zurich. Then again, the relatively humorous "Negergedichte" of Berlin (which, according to the *Vossische Zeitung,* had been delivered "mit unerschütterlicher Ruhe" [with unshakeable calmness] and caused gales of laughter as well as some indignation) turned into the *concert bruit-*

iste in Zurich.[33] During this first phase, similar poems were declaimed against a cacophonous background in order, according to Ball's diary entry of 11 March 1916, to demonstrate the insignificance of the human logos over and against the primitive power of the unconscious and primal violence. Finally, Huelsenbeck the Expressionist "negativist" who had co-authored a fairly brief, if aggressive manifesto in February 1915, turned into Huelsenbeck the Dada-drummer, the fierce modern descendent of Pickelhering and Hanswurst, who was determined, as Ball put it in his diary entry of 11 February 1916, to drum into the ground the culture that would, on 21 February, embark upon the murderous Battle of Verdun. And from all of this there developed the Dada *poème simultane,* the first of which, jointly written by Huelsenbeck, Janco, and Tzara, was performed in the Cabaret Voltaire on 30 March 1916 and described by Ball in his diary on the same day. Huelsenbeck's contact with Futurism took him well beyond Futurist aesthetics and into very dark areas indeed. Henri-Martin Barzun's experiments with polyphonic simultaneity of 1912 and 1913 were intended as celebrations of modernity, and White describes Russolo's manifesto *L'arte dei rumori* and the effect of Russolo's *intonarumori* (noise-machines) in terms of modernolatry, mimesis, and enjoyment.[34] In contrast, Huelsenbeck's experiments with various forms of bruitism were a simultaneous conjuration and critique of the violence of modernity, attempts not to imitate and celebrate but to enact discordant, chaotic, heteroglossic reality—and they were certainly not meant to be enjoyable.

This process of bruitist experimentation reached a climax fourteen days after the beginning of the Battle of the Somme, on 14 July 1916 when the first self-styled *Dada-Abend* (Dada-Evening) took place in the Zurich Zunfthaus zur Waag. This included not only some of Huelsenbeck's "Negergesänge" but also a *poème simultane* by Tzara entitled *La Fièvre puerpéral* (*Puerperal Fever*) and a lot of bruitist poetry. If one compares the wry newspaper report of 18 July 1916 with Tzara's excited account, it transpires that the evening had a much more disruptive effect upon the participants than the audience since after this evening, Dada in Zurich came to an abrupt halt for eight months.[35] Ball fled to rural Switzerland and, unusually, had *nothing* to say about this pivotal evening in his published diary or letters. Huelsenbeck is also untypically silent about the evening in the stream of articles that he produced in the 1920s and his memoirs of 1957 (*Mit Witz Licht und Grütze*), even though subsequently he had to undergo psychiatric treatment before returning to Germany in late 1916. Hans Richter arrived in Zurich in August 1916 and omits any mention of this evening

from his classic book on Dada, *Dada—Kunst und Antikunst*. Having meta-phorically stormed the psychological Bastille using tactics partly derived from Futurism, it seems that Huelsenbeck also experienced the psychological violence that produced the Terror. Having given birth to Dada in a particularly public and aggressive way, the Zurich Dadaists seem to have undergone a severe attack of postnatal illness that was prefigured by the title of Tzara's *poème simultane*. Ball had originally conceived the Cabaret Voltaire as a place of peace and reconciliation (see chapter 9), but Futurist techniques, when combined with primitivizing and Rimbaldian experimentation and deployed by Huelsenbeck in a particularly extreme way, seemed, as Kemper pointed out, to bring the war itself into that place.[36] Certainly, this is how the Communist writer Henri Guilbeaux reacted to the evening of 14 July and then to Tzara's *La première aventure céleste de Mr. Antipyrine* (*The First Celestial Adventure of Mr. Antipyrine*) (published on 28 July 1916 as part of the *Collection Dada*) in two articles.[37] Here, Guilbeaux accused Dada of corruption, decadence, and militarism—charges that affected Ball particularly deeply. Just as classical modernity had turned against itself and issued in a technological war that was running out of control, so an institution named after Voltaire, one of the major initiators of classical modernity, seemed to have done likewise, leaving some of the original Dada group in a state of deep shock and others wondering what had gone wrong.

Of the other Zurich Dadaists, it is easiest to evaluate the impact of Futurism on Arp since his work shows no Futurist features at all. Nevertheless, he was at the *Dada-Soirée* of 14 July 1916 and as we saw in chapter 7, his work underwent a dramatic change in winter 1916–17. So perhaps the first phase of Dada, with its kaleidoscopic friendships and the intense exchange of ideas described by Ball in his diary entry of 24 May 1916, helped to move him away from symmetrical abstraction and toward biomorphism and to determine that whatever motivated his work, it was certainly not the potentially violent *dinamismo universale* of Futurism. Janco, who was very close to Arp and part of the Zurich group from its inception, also seems to have learned what could happen if one detached Futurist techniques from their positivist moorings, combined them with a "primitivism," and followed Rimbaud's injunction to search for "the unknown" by unhinging the senses through exposure to extreme experiences.[38] He helped to recite the first Dada *poème simultane* on 30 March 1916. He created exotic masks for a *Soirée* of 24 May 1916 (which had to be postponed until 31 May 1916) that were used in a primitivizing dance num-

ber described as "Negermimus" ("Afro-mime") in a newspaper advertisement. He took part in the bruitist Nativity Play that was performed on 3 June 1916 and is described in chapter 5. He produced at least one fairly large charcoal drawing, *Einladung zu einer Dada-Soirée* (*Invitation to a Dada-Evening*) (1916), in which Dada performers are portrayed as African sculptures. He also painted two pictures, *Tanz* (*Dance*) (1916) and *Cabaret Voltaire* (1916), which are immediately reminiscent of Severini's relatively conservative *La Danse du Pan-Pan à Monico* (now destroyed): the second painting depicts the Cabaret Voltaire with Futurist poster poems on the walls.[39]

Ball's diary entry of 24 May 1916 describes "Negermimus" in detail.[40] It consisted of three sections entitled "Fly-Catching," "Nightmare," and "Ritual/Festal Despair," and Janco's masks, made from painted cardboard, had exactly the effect on the performers that Ball's sound poems would have on him on 23 June. They not only weakened their inhibitions, they also, as the three titles imply, released larger than life passions and the terror of the age. Although Ball's diary does not mention Janco again until 3 October 1916, Tzara records that the costumes he designed for the *Dada-Soirée* of 14 July 1916 were Cubist (in contrast to the earlier, primitivizing costumes described by Ball).[41] Thereafter, Janco's work, like his woodcuts for Tzara's *La première aventure céleste de Mr. Antipyrine,* became visibly more Cubist. Indeed, on 28 April 1917, he described his work in precisely such terms when he lectured on it at the third *Dada-Soirée* in Zurich, and the six woodcuts that he produced for *Noi*, no. 1 (June 1917), *Dada* 1 (July 1917), and *Dada* 3 (December 1918) were predominantly Cubist in inspiration, with no obviously Futurist or primitivizing elements.[42] But at the fourth *Dada-Soirée* of 12 May 1917, Janco went so far as to give a lecture on architecture from the fifteenth to the eighteenth centuries with particular reference to Filippo Bruneleschi (1377–1466), Leon Battista Alberti (1404–1472) (who formulated the rules of perspective), and Jacques François Blondel (1705–1774) (who saw architecture as the public expression of rational order). Here, he explicitly connected their work with the visual work that he now wished to produce.[43] In the one major piece on Dada that Janco ever wrote, he gave no details about his encounter with Futurism and "primitivism" (which were clearly connected in his mind by the image of the dance).[44] But all the evidence indicates that Janco, albeit to a lesser extent than Ball and Huelsenbeck, had touched on very raw, frightening emotions during the first phase of Dada in Zurich and spent

its second phase attempting to deal with them by the invocation of more rational, architectural principles.

Of all the Zurich Dadaists, Tzara had the most extensive contact with Italian Futurism and the Italian Futurists. Nevertheless, their influence on him, although of decisive importance initially, seems also to have been very specific in nature and relatively short-lived. According to Lista, Tzara was, with Janco, the last Zurich Dadaist to assimilate Futurism's iconoclastic fury and aim of pulverizing bourgeois culture, and his first recorded contact with Futurism seems to have been in summer 1915 when, having written to Marinetti for poems to include in an anthology he was editing, he received, in Zurich, some examples of *parole in libertà* from the maestro himself.[45] By that time, Tzara was already producing poems which, although overwhelmingly Symbolist and late Romantic in inspiration, pointed forward to the *Vingt-cinq poèmes* (*Twenty-five Poems*) (1915–18) through the presence of lines that seem to have been produced by free association, a lack of punctuation, and an embryonic surrealism.[46] Thus "Viens à la campagne avec moi" ("Come to the countryside with me") (1915) contains lines like:

Immeuble en construction avec des branches
　　sèches comme des araignées dans les échafaudages (1:33)

Block of flats under construction with dry branches
like spiders in the scaffoldings

and:

En moi se cassent des roseaux avec un bruit
　　de papier froissé (1:33)

Within me the reeds snap like a noise
of crumpled paper

And "Le Marin" ("The Sailor") (1915, rev. 1916) is written entirely in this vein (1:210). Indeed, although one of the *Vingt-cinq poèmes*, "Froid jaune" ("Cold Yellow"), has its origins as far back as 1915 or even 1913 (1:104), it is stylistically indistinguishable from the rest of that Dada collection. But although there is a certain continuity between Tzara's pre- and post-July 1915 poetry, his initial encounter with Futurism in the shape of Marinetti's *parole in libertà* seems to have been decisive in four major ways. First, it

stripped away the late Romanticism of his earliest poetry and allowed the already present surreal elements to come to the fore. Second, it encouraged him to go further along the path of experimental and freely associative writing. Third, it encouraged him to make use of onomatopoeic and nonreferential phonemes in his poetry and hence, in spring 1916, to be more receptive to the primitivizing poetry that Huelsenbeck brought from Berlin to Zurich and enthusiastically developed there. And fourth, it increased his general aggressiveness. It is hard to date Tzara's poems because of the number of undated manuscripts in the Fonds Tzara and Tzara's tendency to rework early poems. Nevertheless, a comparison of "Pélamide" (September 1915), the first poem that we can say with certainty postdates his encounter with Marinetti's poems (1:102), with three poems that according to Béhar were almost certainly written between January and July 1915, "Viens à la campagne avec moi" (1:33–34), "Chant de guerre" ("War Song") (1:35–36), and "Dimanche" ("Sunday") (1:40–41), illustrates this shift very well.

Despite their note of humor, the three earlier poems are predominantly late Romantic in inspiration, and despite the occasional dash of embryonic surreality, predominantly reflective and descriptive. In contrast, "Pélamide" (which became one of the *Vingt-cinq poèmes*) is devoid of reflection and Romantic *Stimmung* and instead of presenting a discursive but coherent picture, offers a simultaneous, highly abstract complex of multicolored fragments, neologisms, onomatopoeia, and isolated phonemes. In the earlier poems, Tzara moves beyond straightforward descriptiveness by means of similic constructions that introduce surreal elements. In contrast, "Pélamide" presents the (Bergsonian) surreal directly in relatively daring lines like "morceaux de durée verte voltigent dans ma chambre" [pieces of green duration fly around in my bedroom] or "l'hôpital devient canal" [the hospital becomes a canal]. Besides the linguistic inventiveness prompted by the *parole in libertà,* "Pélamide" displays a more directly Futurist influence in the image of the "machiniste" [mechanic/ machinist] and three references to a "center": "montre le centre je veux le prendre" [point out the center I want to take it]; "mais le capitaine étudie les indications de la boussole" [but the captain studies the compass bearings]; and "et la concentration des couleurs devient folle" [and the concentration of colors goes mad]. Nevertheless, it is equally clear that "Pélamide" is not a Futurist poem in the strict sense for it does not celebrate the machine or machine energy, and unlike the classic Futurist painting, it is not centrifugal or cen-

tripetal in structure. Rather, the machine is seen as a comic aspect of more primitive force, and the three images of the center are more like transient vortices in a fast-flowing river than fixed points of reference.

During the first months of 1916, Tzara, probably via Huelsenbeck and Janco, was exposed to Futurist ideas on simultaneism and bruitism and came across Futurist contributions in Pierre Albert-Birot's *SIC* (which had begun appearing in Paris in January). Then, in summer 1916, he visited the Futurists in Italy—a visit that in Lista's view may have exacerbated his growing sense of crisis.[47] Nevertheless, apart from the *poèmes simultanes* that Tzara produced on his own or with other Dadaists and a heightened tendency toward provocation, his work of 1916 does not show a continuing Futurist influence. Rather, it moves away from the Italian movement and displays an intensified interest in the kind of primitivizing poetry that the Futurists explicitly rejected and that is quite distinct from the barbarism of Marinetti's *Mafarka le futuriste*.[48] Accordingly, two poems that were certainly written in the first months of 1916, "Mouvement" ("Movement") and "La Revue Dada" ("The Dada Review") are distinct from the slightly earlier "Pélamide" in that the onomatopoeic phonemes to be found there have now turned into "primitive" sounds such as "ouhou" and "zoumbaï," and the image of the center has disappeared.[49] In neither of the 1916 poems do we find the celebration of the machine or machine energy. "Mouvement," a title that suggests a typically Futurist concern, is actually an evocation of the chaotic, surreal flux of Nature, and the car that appears in "La Revue Dada" does not crash only to be put back onto the road intact—as happens in Marinetti's *Fondazione e manifesto del futurismo*. Rather, it and its occupants blow into pieces and are seen no more. Similarly, the poems contained in the *Vingt-cinq poèmes* and *De nos Oiseaux* (*Of/From/Some of Our Birds*) that date with certainty from 1916 and 1917 show almost no Futurist influence whatsoever. The image of the spiral in "Soleil nuit" ("Sun Night") (1916) and "Cirque IV" ("Circus IV") (1917) (1:109 and 185) may owe something to Boccioni's theoretical writings on sculpture where the spiral is said to be the ideal form, but the typography of "Ange" ("Angel") (1916); "Sels de minuit" ("Midnight Salts") (1916); and "Les Saltimbanques" ("The Acrobats") (1916) (1:198, 201, and 235) owes more to Apollinaire than to *parole in libertà*.[50] Furthermore, when Tzara introduced the *Dada-Soirée* of 14 July 1916, he very noticeably played down the influence of Futurism, saying that the Dadaists' introduction of "bruit réel" [real noise] into their poetry was the aural equivalent of the real

objects that the *Cubists* collaged onto their canvasses.[51] Notwithstanding Huelsenbeck's later concession in the "Erste Dadarede," Tzara also drew a clear distinction between the "concert de voyelles" [chorus of vowels] to be performed by the Dadaists and the "concert bruitiste" [bruitist chorus] invented by the Futurist Boccioni, and he then went on to identify a parallel between this kind of experimentation and the Cubists' use of diverse materials. Finally, in "Le Manifeste de Mr. Antipyrine" ("Mr. Antipyrine's Manifesto") (1951), first published later on in the same month in *La première aventure céleste de Mr. Antipyrine,* he made the pointed remark that Dada was decidedly against the future.[52]

After summer 1916, Tzara's relationship with Italian Futurism seems at first glance to become more positive. In late September 1916, he apparently revived the idea of producing an anthology of avant-garde poetry that would include poems by Marinetti.[53] On 8 December 1916, he wrote to Meriano: "Écrivez je vous prie à Monsieur Marinetti ma meilleure estime. Si je puis être utile à votre mouvement, je le ferai volontiers" [Send, I beg you, my best regards to Monsieur Marinetti. If I can be of use to your movement, I shall be glad to be so].[54] Furthermore, early in 1917, Tzara began corresponding with Prampolini who was at that time putting together the first issue of *Noi,* and from 15 February 1917 poems by Tzara, all but one of which would later be included in the *Vingt-cinq poèmes,* began to appear in various French and Italian periodicals with a Futurist bent.[55]

The contradiction between Tzara's move away from Futurism in the first half of 1916 and his apparent rapprochement later on that year is, however, more apparent than real. The proposed anthology never materialized and the letter of 8 December 1916 is, as far as I know, the last occasion when Tzara associated himself so warmly with Marinetti's Futurism. Indeed, Tzara's 30 October 1922 letter to Jacques Doucet suggests that Tzara partly blamed his personal crisis of winter 1916–17 on a sense of anomie induced by an excessive use of techniques that could be described as primitivizing and/or Futurist.

> Comme je ne réagissais que par contraste, tous mes poèmes de 1916 n'étaient qu'une réaction contre les précédents, trop doux et soignés; ils étaient d'une brutalité excessive, contenaient des cris et des rhythmes accentués et mouvementés. Je leur trouve un grand défaut: ils sont souvent déclamatoires, faits pour être récités et contiennent des effets extérieurs. Depuis, tout ce qui est pathétique m'est bien désagréable.[56]

As I only reacted by contrast, all my 1916 poems were simply a reaction against my earlier ones which had been too sweet and carefully constructed; they were excessively brutal, contained cries and rhythms that were heavily accentuated and dynamic. In my view they have one major flaw: they are often declamatory, made to be recited, and involve superficial effects. Since then, I find everything that is marked by rhetorical pathos unpleasant.

Finally, Tzara's contribution to reviews with Futurist leanings should not be taken as a commitment to Futurism as such. Rather, Tzara seems to have wanted to make himself known outside Switzerland in reviews that were sympathetic to avant-garde art in general while not being dogmatically Futurist.

To some extent, this latter consideration applied in the case of Prampolini's *Noi,* which described itself as an international collecting point for avant-garde art and whose first number (June 1917) was an admixture of Impressionism, late Romanticism, Futurism, and Dada. Nevertheless, Tzara's relationship with *Noi,* unlike his relationship with other Italian reviews, was prolonged rather than incidental and had deeper foundations, deriving from the fluctuating parallel that both he and Prampolini sensed between the aspirations of the Zurich Dadaists and Prampolini's own.[57] Certainly, the evidence points to this conclusion. Prampolini had begun to experiment in 1914 with collages and montages constructed from found materials. He alone of the Italian Futurists exhibited alongside Dadaists in the Galerie Dada in May 1917. He, with Antonio Marasco, took part in the Dada exhibition organized by Tzara in Berne in 1918. And of the Italian contributors to *Dada* 1 and 2, *none* is a representative of *il primo futurismo* and over half are writers and visual artists associated with *Noi* (Prampolini himself, his coeditor Sanminiatelli, Cantarelli, d'Arezzo, and Moscardelli).[58] Conversely, Prampolini seems to have sensed the same affinity until late 1918 and early 1919, publishing woodcuts by Arp and a poem by Tzara ("Froid jaune") in the first issue of *Noi* and referring enthusiastically in the same number to the exhibition in the Galerie Dada to which he himself had just contributed: "In questa esposizione . . . sono rappresentate le manifestazioni più esuberanti della nuova sensibilità artistica" [In this exhibition . . . the most exuberant manifestations of the new sensibility are represented]. On 20 January 1917, when Prampolini wrote to Tzara thanking him for asking him to contribute to *Dada,* he described himself and Tzara in entirely nonpartisan terms—not as a Dadaist and a Futurist who had agreed to collaborate, but as intellects with an essential

affinity, as two men "qui sont destinés à renouveler et donner à l'humanité la vraie sensibilité" [who are destined to renew humanity and give it back its proper/true sensibility]. On 4 August 1917, Prampolini again stressed the common ground between himself and Dada, and on 19 October 1917 and 30 January 1918, he wrote positively to Tzara about *Dada* 1 and 2.[59]

The passage that most clearly explains the basis of the two-year collaboration between Tzara and Prampolini, *Noi* and *Dada,* is to be found in Prampolini's 22 August 1918 letter to Tzara. He began by thanking Tzara for sending him his *Vingt-cinq poèmes,* praised it fulsomely, and expressed his desire to illustrate one of Tzara's works with his woodcuts. He then described his own attempt over the preceding year to produce work that was simultaneously dynamic and yet marked by "un nouveau [sic] ordre de style architectural de la nature" [a new order of architectural style (like that) of nature].[60] This ideal *exactly* parallels Tzara's ideal — explicitly stated in his lecture introducing the exhibition in the Galerie Corray in Zurich, January–February 1917 — of an art that balanced "la simplicité géométrique" [geometric simplicity] and "la force d'une cascade" [the force of a waterfall].[61] Tzara seems to have held to this ideal until late 1918 since his 4 December 1918 letter to Picabia praised the latter's recently published *L'Athlète des pompes funèbres* in similarly paradoxical terms (see chapter 7). But as the negative aspects of Tzara's brand of Dada became more pronounced and *Noi* moved more toward *metafisica* (Italian Metaphysical Art) and Futurism, so Prampolini lost his sense of affinity with Zurich Dada. Thus, in *Noi* no. 5/6/7, Prampolini was critical of *Dada* 3. He also accused the exhibition in the Salon Wolfsberg, Zurich, in which several Dadaists had taken part in September–October 1918, of being spiritually empty. And he completely revised his assessment of Tzara's *Vingt-cinq poèmes,* calling it a "tuffo nel vuoto senza la possibilità di salvezza" [leap into the void without the possibility of salvation].[62]

After 1918 and the end of his alliance with Prampolini and with the onset of a period of increasing depression, Tzara's attitudes to Futurism became thoroughly negative and remained so for the rest of his time in Zurich. In a 19 March 1919 letter to Picabia, he described Futurism as imbecility and the Futurists, especially Marinetti, as idiots. In a 21 September 1919 letter to Breton, he denied that Dada had anything in common with Futurism or Cubism. No items by Futurists of any kind were included in *Dada* 4/5 (May 1919). On 11 October 1919, the Berlin newspaper *Die Post* (no. 504) reported the Zurich Dadaists, presumably at Tzara's instigation, erecting a hollow, larger-than-life wooden effigy of Marinetti dressed as a

motley beggar in a square just off the Bahnhofstrasse. Someone inside the figure then began a solemn and entirely mendacious eulogy of Marinetti's conversion to Dada after his recent arrival in Zurich—whereupon both figure and occupant were taken into custody by the Zurich police. And in December 1919, just before he left Zurich for Paris, Tzara criticized the Futurists and Cubists in *Littérature* for becoming scientific and academic.[63]

Tzara's relationship with Futurism was not simple. Initially, as with Ball and Huelsenbeck, certain specific features of its first wave helped him along a road down which he had already begun to travel. Futurist techniques—notably extreme bruitism and provocation via outrageous manifestos—then helped to provoke a kind of breakdown out of which Tzara evolved the classically Dada sense of balance amid opposites, *in part* with the help of the initiator of the second wave of Futurism.[64] But under the corrosive impact of Serner and Picabia, that fragile balance was disrupted, causing him to leave Zurich for Paris—where the best-known and arguably the most negative wing of the Dada movement came into being under his tutelage until it, too, fell apart in 1922.[65]

Influences: Dada Elsewhere

The influence of Futurism can be felt elsewhere in Dada: on Van Doesburg in Holland, on Schwitters in Hanover, on Grosz in Berlin, especially 1916–17, and on Julius Evola, the most prominent and most misguided exponent of Dada in Italy.[66] But in no other Dada center did Futurism have the widespread and dramatic impact that it had in Zurich, and it seems that as time went on, Futurism was regarded increasingly negatively outside of Italy. This was partly due to the prowar stance with which Futurism was associated; partly because the ethos of postwar Europe tended toward New Sobriety and Constructivism rather than ecstatic modernolatry and iconoclasm; and partly because of the coalition between Marinetti and Fascism that began in autumn 1919 and that has, unjustifiably, caused the whole movement to be tarred with the same political brush ever since.[67] After the war, from outside Italy, Futurism came increasingly to look like a naive, simplistic, and politically dangerous response to modernity.

But there was one last occasion—the *Dada-Abend* (Dada-Evening) in the Berliner Sezession of 12 April 1918—where Futurism played a decisive role in a public Dada event, and it is worth looking at it in some detail both because of its intrinsic interest and because of the contrast it forms to the *Dada-Soirée* of 14 July 1916 in Zurich. The event began with

Huelsenbeck's "Dadaistisches Manifest," which, according to the critic of the *BZ am Mittag,* took one and a half hours to read—indicating that it must have been considerably longer than the relatively short version published in the *Dada Almanach.*[68] The reports in the *Berliner Börsen-Courier* and *Tägliche Rundschau* (Berlin) suggest that Huelsenbeck said a lot more about Dada's internationalism, affinity with the *demi-monde,* commitment to relativism, antipathy to art, irony, and respect for popular culture (such as film) than he put into the published version. The reports in the *BZ am Mittag* and the *Vossische Zeitung* (Berlin) suggest that he used material that he would later build into *En avant Dada* (compare the references to "Kinderlallen" [the babbling of children], the con man Manolescu, Rimbaud, and the Cabaret Voltaire—all of which occur in his 1920 text).[69] Else Hadwiger then recited, accompanied by Huelsenbeck using drums and a rattle, her translation of all or part of the final section of Marinetti's *Zang Tumb Tumb* ("Bombardimento" ["Bombardment"]) and possibly all or part of its penultimate section ("Treno di soldati ammalti" ["Transport of Wounded Soldiers"]); three poems on Berlin by Buzzi from his *Versi liberi (Free Verse)* (1913); a poem by Libero Altomare that had appeared in *Die Aktion* in 1917 as "Die Häuser sprechen" ("The Houses Speak") (1912); a poem by Luciano Folgore that had appeared in *Die Aktion* in 1916 as "Der Marsch" ("The March") (1912); a poem by Corrado Govini that had appeared in *Die Aktion* in 1916 as "Seele" ("Soul") (1911); Tzara's "Retraite" ("Retreat") (1917) from the *Vingt-cinq poèmes;* and a sound poem by Palazzeschi entitled "Nun lasst mich meinen Spass haben" ("Now Let Me Have My Fun") (1910).[70] According to the program, Grosz then read out poems entitled *Sincopations* which Goergen, correctly I am sure, identifies with the big-city poems Grosz was writing in 1917 and 1918.[71] These reminded the reviewer of the *BZ am Mittag* of Walt Whitman, presumably because of their semiautomatic, rhapsodic style and North American subject matter.[72] They are stylistically very close to the scurrilous letters Grosz was writing to Otto Schmalhausen at the same time, and, most important, they were composed at a time when the influence of Futurism on Grosz was at its strongest. The evening concluded with a manifesto by Hausmann that the program calls "Das neue Material in der Malerei" ("The New Material in Painting") but that is clearly identical with Hausmann's "Synthetisches Cino der Malerei" ("Synthetic Cinema of Painting") (first published in 1972). Like Grosz's poems, this manifesto displays the influence of Futurism, especially Boccioni's work.[73]

But facts and influences apart, what were the Dadaists doing on this

evening? First, they were very obviously distancing and distinguishing themselves from Futurism. At the end of the "Erste Dadarede in Deutschland" that Huelsenbeck had delivered on 22 January 1918, he had described Dada as a movement that had "überwunden" [overcome] the elements of Futurism and Cubism it contained.[74] He did something similar on 12 April by declaring, according to the report in the *Tägliche Rundschau,* that Dada was to Futurism as the Renaissance was to the ancient world. While at least three of the selected Futurist poems glorified war, Tzara's dealt with military retreat. While Grosz's poems, as Herzfelde pointed out, displayed a fascination with North American modernity, they also involved a sense of terror and melancholy and they said a resounding "No" to the dark side of modernity.[75] Similarly, in describing Futurism and Cubism as experiments, Hausmann's manifesto implied that they, unlike Dada, had not gone far enough.[76] Second, the Dadaists were affronting German nationalism. At a critical time of the war, they recited triumphalist poetry by the enemy; poetry (Buzzi's) that was extremely rude about the Brandenburg Gate (built to celebrate Germany's victory over France in 1870) and the changing of the guard in imperial Berlin; poetry that was, at one level at least, positive about the "decadent" United States; a poem (Tzara's) that alluded to Napoleon's victory in Egypt in 1798 and the Battle of Valmy in 1792 (when the French revolutionary army defeated the Prussians while Goethe watched from a windmill); and a manifesto in praise, among other things, of internationalism.[77] The ultra-right-wing *Deutsche Zeitung* (Berlin) was highly sensitive to this aspect of the evening and described Dada not just as an enemy of Germany but as a "poison" so corrosive that it could infect and corrode the entire "Volkskörper" [body of the (German) people]. Third, the Dadaists were trying to give a largely civilian audience a sense of the cacophonous chaos of war and the suffering it brought in a way that would escape the notice of the censor, particularly by means of Marinetti's poem(s). Indeed, according to the report in the *Berliner Lokal-Anzeiger,* these really affected the audience; and according to the report in the left-liberal *Weltbühne,* they caused one soldier in uniform to call out that he wished he were back in the trenches.[78]

But even more fundamentally, it seems to me that on 12 April, the Dadaists were both constructing a working model of modernity as that was discussed in chapter 1 and proclaiming that Dada provided people with the means of coping with modernity. Thus, the program continually linked war with the modern megalopolis. Grosz's poems emphasized the chaotic and violent nature of modernity. In Altomare's poem, the houses of the

city describe themselves as a prison that should be levelled to the ground so that people can know real freedom again. And Buzzi's third poem, "Wertheim," describes one of Berlin's largest and most modern department stores as a devouring monster pulsating with a flood of commodities that the poor can look at but not buy. But at the same time, Dada, as described in Huelsenbeck's and Hausmann's manifestos, was presented as a means of negotiating this chaos, of dealing with these contradictions, and of escaping from this prison. Huelsenbeck described Dada as "das primitivste Verhältnis zur umgebenden Wirklichkeit" [the most primitive relation to surrounding reality]—a striking phrase that was seized upon by several reporters—and then defined that reality as "ein simultanes Gewirr von Geräuschen, Farben und geistigen Rhytmen [sic]" [a simultaneous confusion of noises, colors, and spiritual rhythms]. Similarly, Hausmann began his manifesto (which he had considered naming "Psychoanalytisches Cino der Malerei" ["Psychoanalytical Cinema of Painting"]) by describing life in equally chaotic terms and presented Dada as the means by which people could keep their balance amid contraries and deal with their irrational drives, especially sexuality.[79] And the final poem to be read out, by Palazzeschi, suggested that humor was a key element in this process.

The contrast with the *Dada-Soirée* in Zurich is striking. None of the Berlin Dadaists suffered a breakdown, fled the city, converted to Catholicism, or became more formalistic as a result of the *Dada-Abend*. True, all went quiet on the Dada front for a while afterward, but this was partly because Huelsenbeck was called up to serve as an army doctor in retaliation for his part in the evening whose success, it should be noted, seems to have stimulated the other Dadaists to renewed efforts. The explanation for this contrast between the two evenings emerges from a comparison of the brief "Erklärung" [explanation/ declaration] that Huelsenbeck had given on 14 July 1916 with the "Manifest" he declaimed on 12 April 1918.[80] The earlier piece was ironic rather than provocative and used the word "Dada" overwhelmingly in the first of the three senses described in chapter 7. Only in its final sentences, when Huelsenbeck described Dada as a therapeutic medicine that encourages sexuality and fertility, did he begin to use "Dada" in the second of the three senses. But the later, far more provocative and daring piece consistently used "Dada" in the second sense and actually referred to Dada as "eine Geistesart" [state of mind].[81] One can hear Huelsenbeck starting to move toward this latter position in a piece that he wrote for the press to counter Guilbeaux's articles and then sent to Tzara in autumn 1916:

Es handelt sich darum, unter dem Namen DADA einer neuen vitalen Energie zur Erscheinung zu verhelfen. Es handelt sich darum . . . immer wieder auf die wahren Interessen der Menschen hinzuweisen und Vorkämpfer einer neuen glücklicheren Zeit zu sein.[82]

It is a question of helping a new, vital energy to come into being under the name DADA. It is a question . . . of pointing over and over again to the true interests of humanity and of being in the vanguard of those who are fighting for a new, more happy age.

But by spring 1918, Huelsenbeck and the Berlin Dada group in general were much more confident that there was a power of affirmation in human nature ("Da Da") that could assimilate Futurism and its techniques without being overwhelmed by them and enable the individual to deal with the complexities of modernity. Accordingly, in the program of 12 April, Dada items bracket and, as it were, contain Futurist ones.

Contrasts

The fundamental differences between Dada and early Futurism derive in the first place from the very different situations in which the two movements arose. Italian Futurism emerged before the Great War in Milan. In this city, a recently established industrial capitalism seemed to point the way to a better future and offer the means of transcending a society that was held back by its preindustrial past and extreme cultural conservatism. Huelsenbeck saw this very clearly in the trial sheets for *Dadaco,* and he also recognized that the violence of Futurist rhetoric derived in part from the fact that the Futurists were products of the culture they sought to destroy.[83] Although Huelsenbeck was overstating the situation when he went on to say that the Dadaists were not in that situation, those Dadaists who had come to Dada via Expressionism did have a more developed sense that capitalist modernity brought as many problems as it solved, with its impersonal regimentation on the one hand and its demonic nightside on the other. Furthermore, all the Dadaists agreed that the carnage of the Great War, which had driven so many of them into the cultural no-man's-land of Zurich, was the direct product of the competitive forces driving industrial capitalism, with technological warfare as a monstrous version of the productive process itself. Thus, the Dadaists found themselves in a double dilemma. Not only were they, like the Futurists, in reaction against post-

Renaissance, humanist civilization, they were also profoundly critical of the industrial civilization that the Futurists hymned, seeing it not as the transcendence of that earlier civilization but as a megalomaniac perversion of its fundamental assumptions. The Futurists were in revolt against the past in which they were still enmeshed in the name of the future. But the Dadaists had lost their sense of the past to a much greater extent and so were skeptical about the future, too. As a result, they found themselves thrust into a situation where they had to deal with a powerful sense of groundlessness, dispossession, and alienation within the apparent anomie of the present.

A totally different sense of reality separates Futurism from Dada. For the early Futurists, reality, though dynamic, was a mechanicochemical complex whose basic component, as I argued in chapter 5, was the unsplittable atom. Thus, in *Pittura scultura futuriste,* Boccioni often uses images of the "nuclearity" of matter or refers to the material essence of objects. Correspondingly, while rejecting the Impressionist project of turning the object into a nucleus of vibrations, he does advocate transforming it into a nucleus of radiant forms, thus preserving the atomic idea. Later on in the same work, he draws implicit analogies between the rotation of electrons around a nucleus, the solar system, and the ideal Futurist work of art.[84] In contrast, the Dadaists saw reality as a chaotic intertwining of material, demonic, and spiritual *energies* that, interacting and in dialectical relationship one with another, collided and leapt unpredictably from point to point, zigzagging through space in a bewildering complex of interrelationships. Other fundamental differences derive from this. Despite their sense of the world as *dinamismo universale,* the early Futurists, unlike the Dadaists, never seriously doubted the objectivity of objects. Boccioni, for instance, wrote of the "nucleo centrale dell' oggetto" [central nucleus of the object] in his manifesto on Futurist sculpture, and in the body of *Pittura scultura futuriste,* he tried to reconcile his sense of universal dynamism with his sense of the irreducible objectivity of objects by arguing that although the external appearance of objects may change, every object has a permanent inner form that persists and is made concrete in the Futurist artifact. Because this position is ultimately untenable, it generates "self-contradictory" works like his *Sviluppo di una bottiglia nello spazio (Development of a Bottle in Space)* (1912–13), which, among other things, invites the beholder to look at it *both* from a fixed perspective as though it were an immutable object *and* from different vantage points as though it were a nonobjective constellation of forces.[85]

Furthermore, all the theorists of early Futurism assume that the objects that constitute reality move in linear motion along predictable, continuous trajectories and exist in dynamic harmony with their environment. Boccioni, for example, asserted that the Futurists were creating a new conception of the object, "l'oggetto-ambiente" [the object-environment], that forms "una nuova *unità indivisible*" [a new *indivisible unity*].[86] Similarly, while the five signatories of the *Manifesto tecnico della pittura futurista* proclaimed that everything was in motion, all of them described that motion in terms of regularity and continuity. So although the *dinamismo universale* of Futurist work looked chaotic to the contemporary eye, the early Futurist theorists believed that an ultimate harmony underlay that apparently chaotic surface. The five signatories of the preface to the catalogue of the first Futurist Exhibition wrote:

> Come vedete, c'é in noi, non solo varietà, ma caos e urto di ritmi assolutamente opposti, che riconduciamo non di meno ad un' armonia nuova.
>
> *As you see, there is with us not merely variety, but chaos and clashing of rhythms, totally opposed to one another, which we nevertheless assemble into a new harmony.*[87]

Toward the end of *Pittura scultura futuriste*, Boccioni wrote of the unity of energy, with humanity at its center and linked to everything. Even in *L'arte dei rumori*, Russolo insisted on the *rhythmic* nature of apparently confused and irregular natural noise, thereby suggesting that it involved an underlying pattern which it is the task of the noise artist to bring into relief. And when Severini wrote in "Le analogie plastiche del dinamismo—Manifesto Futurista" (1913) ("The Plastic Analogies of Dynamism—Futurist Manifesto," 1973) that the Futurist artist expresses emotions that are united with the whole universe and that matter encloses this universe in an enormously vast circle of analogies, he was expressing a view of things that is not far in principle from the interconnected harmony of Lord Chandos's precrisis world. Joshua Taylor was, I think, very accurate when he wrote: "In spite of their constant threat of chaos, at the core of each of their compositions, at the climax of every action, they sought an intuitive intimation of an ideal order."[88] Thus, in *Fondazione e manifesto del futurismo*, Marinetti describes how his car crashes as he is driving along a straight road— a Futurist force-line. But because the car is analogous to an atomic object and because the Futurist universe is ultimately harmonious, the car does

not disintegrate and so can be fished out of the ditch and put back on the road again. Or in other words, the "threat of chaos" is not just averted here, it is miraculously transformed into order once more. As I argued in chapters 5 and 7, the Dada sense of reality is quite different. If, as some of them imply, there *is* any order in creation, then it is an elusive one. It manifests itself in fleeting patterns and it coexists with elements of chaos that cannot be abolished, assimilated, or declared superficial and therefore unreal.

The Futurists' and Dadaists' assessment of the mass, technological city derives directly from their respective assessments of reality. On the whole, the early Futurists, whose visual work shows relatively little awareness of the dark side of the modern megalopolis, are positive about technological civilization. They see it as a higher stage in the evolutionary process and express this buoyant optimism in their manifestos and visual work. Thus, in their *Manifesto dei pittori futuristi* (1910) (*Manifesto of the Futurist Painters,* 1910), Boccioni, Carrà, Russolo, Balla, and Severini proclaimed the triumphal march of science and its continuous ability to transform the world for the better. Boccioni, above all, expressed this sense in his sculptural masterpiece *Forme uniche della continuità nello spazio* (*Unique Forms of Continuity in Space*) (1913), which, among other things, celebrates machine man's heroic, triumphant, and inexorable progress. But at the same time, one can detect an undercurrent of fear in Futurist manifestos, paintings, and sculptures. Even Marinetti's *Fondazione e manifesto del futurismo* displays a certain frisson of awe at the noise and power of the modern city.[89] Boccioni's sculpture is dreadful and inhuman in its magnificence. His first major Futurist painting *La città che sale* (*The City which Rises*) (1910) is full of aggression and violence; his *Le forze di una strada* (*The Forces of a Street*) (1911) involves dark colors and threatening energies; and the darkness of the fog in Russolo's *Solidità della nebbia* (*Solidity of Fog*) (1912), which Martin sees as a powerful image of universal dynamism, is also a silent, menacing force that engulfs the street and its man-made light.[90] Once again, the Futurists were caught in a contradiction over the modern city. On the one hand, they saw it as a human creation, shot through with lines of force that human beings had learned to unleash through science and technology. But on the other hand, they knew something of the Expressionist sense that the modern city is running out of control and that the energy flowing through it is a potential threat to those who believed themselves its masters.

As one might expect, given what was said about their attitude to the

machine and mass-produced commodities in chapter 7, the Dadaists were much more consciously ambiguous and ironic about the modern city. They affirmed it because it was their specific milieu and yet they were profoundly critical of it because of the excessively cerebral order it sought to impose and the chaos and human suffering that were caused whether this project succeeded or failed. Grosz's *Metropolis* (*The Great City*) (1916–17) exemplifies this perfectly, not least because of its obvious debt to and yet difference from works like *Le forze di una strada*. It seems to be constructed on geometrical principles, with the lamppost in the middle dividing the painting almost (but not quite) into two equal halves. From this reference point, diagonal lines that are almost (but not quite) symmetrical irradiate backward (perspectivally) and upward (in terms of the real space of the canvas) to the right and left of the Hotel Atlantic, whose walls are almost (but not quite) symmetrical and perspectivally organized. But over, behind, under, and along the lines of this (not quite symmetrical) grid there seethes a violent, chaotic mass of barely human people and hurtling machines. At one level, the painting is funny, with its outrageous juxtapositions and Chaplinesque cartoon characters. But at another level, the painting is deeply disturbing, for the people are faceless, blind, corpselike, vicious, criminal, and downright sinister. Indeed, while working on it, Grosz wrote a letter to Schmalhausen on 30 June 1917 in which he revelled in the strong emotions, excitement, violent technology, and general danger of the great city but in which he also described his picture as a "sausende Strassenfront" [hurtling/whooshing street-front], thereby connecting the scene it depicts with the war—for which he had nothing but hatred. The urban apaches who swarm in Grosz's painting are anything but Boccioni's hypermodern, technoprimitives or Marinetti's barbarically heroic soldier-primitive Mafarka. Rather, they are little people trying to survive, by crime if necessary, and to enjoy themselves, using violence if necessary, within a hostile environment from which there is no escape. As with the city itself, Grosz's relationship with them is simultaneously one of love and hate, comprehension, and criticism: Grosz's "Großstadt" was also Grosz's "Grosz-Stadt."[91]

It is precisely because early Futurism's and Dada's attitudes over a range of fundamental issues were so divergent that Dada experimentation with Futurist techniques went so badly wrong in Zurich. As Huelsenbeck admitted in 1920, the Dadaists of the Cabaret Voltaire took over the Futurist technique of bruitism while rejecting the worldview that underpinned it. Russolo's bruitism, embedded in a progressivist understanding of history, a materialist and ultimately harmonious conception of reality, a largely

positive estimation of human capabilities, and a predominantly uncritical commitment to modernity, is less about the imitation of reality and more about the creation of new order and new harmonies using the widest possible range of raw materials.[92] The Zurich Dadaists failed to understand this. Consequently, although they used bruitism initially as a means of self-exploration and protest, Tzara's description of the events of June and mid-July 1916 in his "Chronique Zurichoise 1915–1919" suggests that it turned into an end in itself, bringing the violence against which they were protesting down on their heads.[93] Similarly, where Futurist simultaneism was rooted in a complex of regularities and involved first and foremost the simultaneous depiction of a linear succession of events that are continuous through time, Dada simultaneism aimed at the cacophonous enactment of events that are not connected causally or spatiotemporally. This is illustrated particularly clearly by two letters from Grosz to Schmalhausen, one from between 1917 and 1918 and the other from 22 April 1918 — the period when the Futurist influence on Grosz was still strong but when he was closely associated with Dada in Berlin. In the second letter Grosz exclaimed: "ja! heilige (mein Gott! ja!) Gleichzeitigkeit" [yes! holy (my God! yes!) simultaneity], but in the earlier letter, he had tacitly admitted how far this concept was from its Futurist equivalent when he said how difficult it was to paint:

> dieses tausende Gleichzeitige des banalsten Heute . . . das Geschiebe der turbulenten Strasse, die fabelhaften Bewegungen der Formate, da sind: Menschen, ihre Maschinen, die Tiere, das Blühen der Bäume, himmelblau oder grau — Pfiffe in der Nähe der Bahnhofs [sic], ratternde Automobile, surrende Propeller (über dir in den Himmeln hängt ein Gotha!).[94]

> *these thousands of simultaneities of the most banal everyday . . . the pushing and shoving of the turbulent street, the fabulous movements of its formats, there are: people, their machines, animals, the blossoming of the trees, sky-blue or gray — engines whistling near the stations, rattling cars, whirling propellors (a Gotha bomber hangs above you in the heavens!).*

By the time of his Dada Manifesto of 1918, Tzara had come to understand the difference between Futurism and Dada even more clearly.[95] But two years before, in Zurich, random and radical experimentation with bruitism, simultaneism, and primitivizing techniques divorced from their theoretical context had exacerbated the Dadaists' sense of being adrift and

embroiled in the very primal violence that they had come to Zurich to escape. Is it, one wonders, an example of *hasard objectif* that line 4 of Ball's poem "Karawane" contains a word that is very close to the name of the *intonarumori?* Although the Dadaists would continue to make more drastic use of bruitism and simultaneism even after the Zurich experience of July 1916, they had to learn that if one wished to deal with a modernity that is dynamic and cacophonous, at best a mixture of order and disorder and at worst downright crazy, then one had to find resources within the human personality that were stronger and more resilient than the forces that the abstracted Futurist techniques had the power to conjure.

9. Dada and Expressionism

The relationship between Dada and Expressionism is ambiguous and this is reflected in the way the subject has been approached over the years. Some critics, Veronika Erdmann-Czapski and Serge Fauchereau, for instance, have pointed to a similarity between the two phenomena, seeing Dada as the last offshoot of Expressionism or a by-product of that movement. In contrast, while Christopher Middleton concluded that Dada and Expressionism were like Tweedledum and Tweedledee, two twins fighting over a fundamentally unreal issue, he drew attention in his pioneering article of 1961 to some major differences.[1] Both approaches have their justification: although Dada in Zurich and Germany was unquestionably rooted in early Expressionism, it came to understand itself in the way described in chapter 7 partly through its polemical encounter with late Expressionism.

Zurich Dada

The influence of early Expressionism is very evident within Zurich Dada. Hans Arp had been in contact with the proto-Expressionist *Stürmer* (*Stormer*) circle (which included Otto Flake and René Schickele) in Strasbourg in 1902; contributed to Marc and Kandinsky's *Almanach Der blaue Reiter* (which appeared in Munich in May 1912); exhibited at the second *Blauer Reiter* exhibition in Munich later that year; published a few pieces in the Berlin Expressionist periodical *Der Sturm;* and almost certainly acquired his commitment to nonfigurative art as a result of these links.[2] The poetry of early Expressionism seems to have left its mark on him as well.

In his later years, Arp paid fulsome tribute to the importance for him of Kandinsky's *Klänge* and valued his own copy so highly that he allowed no one apart from himself and his wife to read it. Arp's three collections of Dada poems, *der vogel selbdritt* (*the bird plus three*) (1920); *die wolkenpumpe* (*the cloud pump*) (1920); and *Der Pyramidenrock* (*The Pyramiddress*) (1924), some of which go back to 1911 and 1912, show traces of or even deliberately parody early Expressionist poems.[3] Like so many contemporary Expressionist poems, Arp's best-known poem "Kaspar ist Tot" (c. 1912–17) contains an image of impending apocalypse (1:25) (see chapter 11). His poem ["die flüsse springen . . ."] ("the rivers leap . . .") (1:41) involves echoes of Georg Trakl and August Stramm. In the line "peitschen knallen und aus den bergen kommen die schlechtgescheitelten schatten der hirten" [whips crack and down from the mountains come the shades of the shepherds their hair badly parted], the image of the ghostly shepherds and the tone of flat, unemotional statement are immediately reminiscent of Trakl; and in the line "flügel streifen blumen," the juxtaposition of words that could be read as either nouns or verbs recalls Stramm's poetry. Furthermore, two critics have argued in detail that "Der gebadete Urtext" ("The Primal Text Bathed") (1:115–16) and "Das Fibelmeer" ("The Primer Sea") (1:115) parody apocalyptic poems by Georg Heym, Jakob van Hoddis, and Alfred Lichtenstein.[4]

While directing the Munich *Kammerspiele* from June 1913 to the outbreak of war, Hugo Ball had become a self-confessed Expressionist and a central figure of Munich Expressionism.[5] As such, he contributed to *Die Aktion;* belonged to the circle around Kandinsky; and under the impetus provided by that friendship developed his notion of Expressionist theater as a *Festspiel* or *Gesamtkunstwerk* that would regenerate society by releasing the pent-up forces of the unconscious.[6] To propagate this theory, he planned, together with Kandinsky, an *Almanach Das neue Theater* that was never published because of the outbreak of war and a performance of *Der gelbe Klang* in the Kammerspiele that never materialized for the same reason. During his Munich period, Ball, together with his friend Hans Leybold, edited the radical Expressionist periodical *Revolution,* five numbers of which appeared between 15 October and 20 December 1913. Leybold died on 9 September 1914, and Ball, who became passionately antiwar as a result of his brief experience at the front as a civilian volunteer, organized, together with Richard Huelsenbeck, a *Gedächtnisfeier* (secular memorial service) on 12 February 1915 in Berlin for Leybold and four other writers who had been killed in the war (Walther Heymann, Ernst Wilhelm Lotz,

Ernst Stadler, and the Frenchman Charles Péguy).[7] Ball opened the evening with a speech in memory of Leybold of which a toned-down version appeared in April 1915. Huelsenbeck spoke on Péguy. And Kurt Hiller, the central figure of the Berlin pacifist group calling itself the *Aktivisten* (Activists), spoke in memory of Lotz. Hiller's philosophy of Activism was based on the meliorist concept of *Geist* and propagated the idea that human nature, being essentially spiritual, was capable of rising to ever higher levels of moral achievement. But when Ball commemorated Leybold, he disclaimed precisely those ideas and spoke in a way that is much closer to the irrationalist conception of human nature that had been proclaimed by Ludwig Rubiner in his highly influential manifesto of May–June 1912 "Der Dichter greift in die Politik." In his speech, Ball said that while *Revolution* had rejected meliorism, Socialism, and Marxism, it had been passionately committed to "jeglichen Fanatismus" [any form of fanaticism] and "jegliche Anarchie" [any form of anarchy] that opposed complacency, materialism, and bureaucracy. At the end of the evening, Ball and Huelsenbeck distributed a "Literarisches Manifest" ("Literary Manifesto") whose tone was considerably fiercer than that of the published version of Ball's speech on Leybold, giving us some sense of the pugnaciousness of the unbowdlerized original (now lost).[8] In this manifesto, the two authors explicitly declared themselves for Expressionism, Futurism, provocation, intensity (a key word in Rubiner's manifesto of 1912), radicalism, activity, and revolution. They also declared themselves against intellectualism, "die Aktionierer" (Hiller's Activists), culture, good taste, Socialism, altruism, beauty in general, and "die Bebuquins." This suggests that when Ball had written in his diary in late autumn 1914 that Carl Einstein's fantastic Expressionist novel *Bebuquin oder die Dilettanten des Wunders* (*Bebuquin or the Dilettantes of the Miracle*) (written 1906–9 and first published in 1912) "pointed the way," he meant that it was something to be reacted against and overcome.[9] Indeed, Ball's own Dada novel *Tenderenda der Phantast,* about which more will be said in chapter 10, relates to *Bebuquin* in just this way. Given that Hiller explicitly described Lotz in his oration as a meliorist and as someone who, as a result of his experience at the front, had rejected the kind of "Rebellionsekstase" [revolutionary ecstasy] advocated by Rubiner, this evening can be said to mark the beginning of (proto-)Dada's bitter polemic against Expressionism that would reach its height in Berlin four to five years later.[10]

Ball and Huelsenbeck staged another literary evening in Berlin's Harmoniumsaal on 12 May 1915. They called it an *Expressionistenabend* and

it was, judging from three contemporary press reports, even more provocative and aggressive than the *Gedächtnisfeier* of 12 February. It began with the recitation of texts set to music by Heymann, Klabund, Nietzsche, and Rilke but then progressed to more challenging Expressionist poetry by Johannes R. Becher, Lichtenstein, and Alfred Wolfenstein.[11] Huelsenbeck then read some of his primitivizing poetry; Ball seems to have read most of the audacious, even obscene and blasphemous poetry that he and Leybold had published in *Revolution;* and the evening ended in a brawl and considerable confusion. Clearly, this so-called *Expressionistenabend* was totally different in spirit from the proto-Expresssionist *Neopathetische Cabarets* that the *Neue Club* (New Club) had staged in Berlin between June 1910 and January 1912.[12] These events had been semiformal, carefully organized, and entirely orderly literary evenings. They were held in fairly fashionable venues and designed in part to bring a young intelligentsia to the notice of the older Berlin literary avant-garde. In contrast, the *Expressionistenabend* of 12 May, like the unrehearsed happenings in the Zurich Cabaret Voltaire in early 1916, was much more a form of autotherapy, a desperate gesture of anger and mourning at the escalating waste of the war.

Although this evening forms a watershed between early Expressionism and Dada, the influence of early Expressionism extended well into the Dada period. Press reports, Ball's diary, and Ball's letter to his sister of 1 March 1916 indicate that poems by Kandinsky (6 February and 24 May), Else Lasker-Schüler (6 February), van Hoddis (7 February and 25 April), Schickele (19 February), Ernst Blass, Heym and Franz Werfel ("Die Wortemacher des Kriegs" ["The Wordsmiths of the War"] and "Fremde sind wir auf der Erde Alle" ["We Are All Strangers on the Earth"]) (26 and 27 February), Erich Mühsam ("Revoluzzerlied" ["Song of the Pseudo-Revolutionary"]) (27 February), Heym and Lichtenstein (30 March), were read out in the Zurich Cabaret Voltaire.[13] Tristan Tzara's "Chronique Zurichoise" adds unspecified and undated work by Gottfried Benn to this list. The magazine *Cabaret Voltaire* (15 May 1916) included two poems from Kandinsky's *Klänge,* "Sehen" ("Seeing") and "Blick und Blitz" ("Sight and Lightning"), and "Hymne" ("Hymn") by van Hoddis.[14] Furthermore, several early pieces by Zurich Dadaists have marked Expressionist traits. Huelsenbeck's poem "Mafarka" (translated 1995) involves an unmistakable echo of one of Heym's best-known apocalyptic poems, "Die Vorstadt" ("The Edge of Town") (1910).[15] Ball's two "Cabaret" poems, both printed in *Cabaret Voltaire,* are a strange mixture of early Expressionism and embryonic Dada. On the one hand, the laconic, throwaway tone, four-line

stanzas, concentration on the corrupt and decadent aspects of urban life, absurd imagery, cynical verbal juxtapositions of the sublime and the ridiculous ("Kleinkalibriges Kamel platonisch" [small-bore camel platonically], outrageous rhymes ("Douceur"/"vor sich her"), and flat, five-stressed lines all show the unmistakable influence of van Hoddis and Lichtenstein. On the other hand, the large number of lines that overflow the classically Expressionist ten or eleven beat pattern, the frequency of enjambed rather than end-stopped lines, and the occasional image of protean flux (like the long wind instrument from which a banner of spittle flows bearing the legend "Schlange" [serpent]) point forward to Arp's *wolkenpumpe* (see chapter 5) or Tzara's *Vingt-cinq poèmes* (published 20 June 1918). Similarly, Huelsenbeck's poems "Der Idiot" ("The Idiot") and "Phantasie" ("Fantasy"), published respectively in *Cabaret Voltaire* and the July 1916 number of the Berlin periodical *Neue Jugend* (*New Youth*), show the marked influence of Heym, van Hoddis, and Lichtenstein. Although the second poem contains a shade more humor than the first, both poems pursue the typically Expressionist aim of holding in place a bewildering vision of movement and violence. In neither poem does Huelsenbeck give himself over to the violent flux of Creation as he would do a short time later in the first edition of his *Phantastische Gebete* (published in September 1916 as part of Tzara's *Collection Dada*) (*Fantastic Prayers*, 1995). Although Huelsenbeck's first collection of poems was, on the whole, far removed in spirit from "Der Idiot" and "Phantasie" and much closer to the Dada poetry of Arp and Tzara, it still contained one poem, "Selige Rhythmen" ("Blessed Rhythms"), whose flat tone, implicit three-stanza form, metrical rhythms, and vocabulary are still those of a typical early Expressionist poem. Huelsenbeck must have realized that it was something of a throwback for it was the only one of the first edition of the *Phantastische Gebete* to be omitted from the second, enlarged edition (1920).[16]

The evidence suggests that Expressionists and Dadaists mingled fairly well in Zurich until about the end of 1916, although on 1 March 1916, Ball recorded in his diary that Arp was hostile to certain aspects of Expressionist painting, and on 2 June, Ball wrote to August Hofmann of his talent for having instant quarrels with the "geistige Menschen" [spiritual/intellectual human beings]—expatriate Expressionists—whom he was meeting.[17] So what, exactly, were the Dadaists doing with the early Expressionist material that fascinated them so much? To begin with, they retained several of its major elements: a mistrust of reason; a hatred of Wilhelmine Germany; a sense of alienation (hence the deployment of Werfel's "Fremde sind wir

auf der Erde Alle"); an interest in primitivizing art and poetry; a black, ironic sense of humor; an interest in the anarchic, absurd, and idiotic; a rejection of figurative art; a desire to provoke; and a deep antipathy toward the ideologues who had perverted language to justify an unjustifiable war (hence Werfel's "Die Wortemacher des Kriegs"). But in taking over and using these elements, it seems to me that the Zurich Dadaists were pursuing three more complex and interrelated aims. First, they were trying to overcome the sense of an apocalyptic ending that haunts so much early Expressionist art and literature. Second, they were trying to find a way of coexisting with a reality that was felt to be chaotic. And third, they were trying to arrive at a conception of human nature that did not privilege the classical humanist notion of *Geist*. The first of these aims explains Arp's dislike of Ludwig Meidner's and Fritz Baumann's apocalyptic paintings noted by Ball on 1 March, Arp's use of parody in poems dealing with apocalypse, and the high incidence of poems used in Dada publications and performances that were either overtly apocalyptic, like Kandinsky's "Sehen" (see chapter 6), or written by early Expressionist poets whose major work is notable for its apocalyptic visions. It also explains why Ball should have wanted to write *Tenderenda*. To begin with, this novel not only seeks to overcome the sense of ultimate nothingness that pervades most of Einstein's *Bebuquin*. More specifically, it includes a chapter, "Der Untergang des Machetanz" ("The Decline and Fall of Swaggerprance") (which Ball read out in the Cabaret Voltaire on 26 March 1916), whose central figure bears a striking resemblance to Leybold, embodies the attitude to life proclaimed in Rubiner's 1912 manifesto, and burns himself out in an orgy of pathological irrationalism.[18] The second of these aims explains Arp's experimentation with semiautomatic verse forms that were designed as analogues of Nature despite his reservations about Marc's animal pictures; Huelsenbeck's and Ball's move away from the typical, formally regular Expressionist verse form to the more free-flowing poetry of the *Phantistische Gebete* and the six sound poems; and the inclusion in *Cabaret Voltaire* of "Blick and Blick," one of the two poems from *Klänge* closest in spirit to Dada (see chapter 6). The third of these aims explains the Dadaists' desire to explore, like Rimbaud and so many major Expressionist poets (on whom Rimbaud was also a major influence), the "unknown" and the darker side of human nature; Ball's irritation with the "geistige Menschen"; and the use of Mühsam's "Revoluzzerlied" on 27 February 1916, which was almost certainly aimed at people like Rubiner (by now converted to Hiller's *Aktivismus*) who entertained dewy-eyed ideas about revolution.[19] All these aims

seem to have coalesced in the first *Dada-Soirée* of 14 July 1916 when Ball made his most positive statement about Dada—"Dada ist die Weltseele" [Dada is the World-Soul]—a conclusion that follows very closely from his meditations in his diary entry of 18 April 1916 on Frank Wedekind's satirical play *O-Aha* (c. 1911) where the eponymous "World-Soul" appears in person toward the end.[20] But as we saw, that Soirée went badly wrong, and the Zurich Dadaists retired from the public arena to work out why.

But when Dada began to regroup in early 1917, it seems that the Dadaists had acquired a strong enough sense of what they stood for to widen the gap between themselves and the Zurich Expressionists. In mid-January, the Expressionist painter Max Oppenheimer (who had allowed one of his works to be reproduced in *Cabaret Voltaire*) removed his pictures from the preview of the exhibition of abstract art that Tzara had organized in the Zurich branch of the Galerie Corray (Bahnhofstrasse 19) because he no longer wanted to be associated with Dada.[21] Once the Galerie Dada had opened in the Galerie Corray on 17 March 1917, the split between the two groups became so great that by June they were sitting at different tables in the Café Odéon.[22] This split is reflected in the programs of the *Dada-Soirées* of spring 1917. Whereas the second *Dada-Soirée* (14 April 1917) included literary items by Kandinsky, van Hoddis, Herwarth Walden, and Albert Ehrenstein, together with Oskar Kokoschka's one-act dramatic *curiosum Sphinx und Strohmann* (*Sphinx and Straw Man*) (1907), the third *Dada-Soirée* (28 April 1917) contained nothing by any Expressionist writer. Indeed, when Ball's friend Ferdinand Hardekopf, the Expressionist most sympathetic to Dada in Zurich, read from *Manon,* one of his prose pieces, at the repeat performance of the fourth *Dada-Soirée* (19 May 1917), a furor ensued since this was construed as a gesture of allegiance to Dada and a flight from the colors of Activism.[23] The final examples of cooperation between Dada and Expressionism in Switzerland were the contributions that Hans Richter wrote and drew for *Das Zeit-Echo* (*The Echo of the Time*), edited in Berne by the reconstructed Ludwig Rubiner, and Hardekopf's poem "Splendeurs et misères des débrouillards" ("Splendors and Miseries of the Ready-witted"), which appeared in *Dada* 4/5 (May 1919). But Richter broke with Rubiner in mid-1917—at exactly the time when the Dada numbers of *Neue Jugend* were appearing in Berlin and the attacks on Expressionism were starting there in earnest. When, in 1975, I asked Richter to account for this break, he explained it to me in a way that maps exactly with what I wrote in chapter 7. By 1917, Richter told me, Rubiner believed that people were spiritual beings, fundamentally good, and wanted

a state based on ethical ideals that corresponded to the highest faculties in human nature. Whereas he (Richter) saw people as material beings, mixtures of good and evil, animality and spirit, and wanted a political order that made allowances for this ambiguity and so helped people to find a balance amid the opposing forces of which they were constituted. Conversely, after spring 1919, Hardekopf became increasingly critical of Zurich Dada, mainly because of the growing importance there of the nihilistic Walter Serner and its general lack of political seriousness.[24]

Despite this split, it is worth dwelling for a little longer on Zurich Dada's reception of Expressionism during its second phase (17 March–27 May 1917) since this will shed more light on the growing antagonism between the Dadaists and Expressionists and help us to understand why Dada in Zurich tore itself apart yet again—leaving bad debts, tremendous ill-feeling, and threats of a legal action.[25] After Ball had agreed to return to Zurich and direct the Galerie Dada, he noted in his diary on 22 March 1917 that the "barbarisms" of the Cabaret Voltaire had been overcome and that all those involved had done a lot of thinking about their experiences of 1916.[26] But he failed to realize that a very wide gap had opened up between himself and Tzara. Ball's "Der Untergang des Machetanz" indicates that profound doubts about his earlier advocacy of anarchic irrationalism were already in his mind in spring 1916. But when he returned to Zurich a year later those doubts had grown massively, and his diary entries of 25 March 1917, 5 May 1917, and 23 May 1917 (144/101, 155/110, and 162/117) indicate that he was increasingly coming to see the animal, the natural, and the demonic as manifestations of evil. Conversely, his diary entry of 8 April 1917 (148/104), the day after he had delivered his lecture on Kandinsky, suggests that he envisaged the Galerie Dada as a place of reconciliation where all the arts would work together to produce a living *Gesamtkunstwerk,* a spiritual enclave, one of Kandinsky's "geistige Insen," where people could take refuge from the barbarity of the war (which, nevertheless, kept thrusting itself into his mind via translations of extracts from Barbusse's novel *Le Feu* (see his entries for 1 and 14 April 1917 [146/103 and 151/108]).

Ball's lecture on Kandinsky reinforces this contention. After its prophetically Nietzschean first section, Ball devoted its other four sections to an interpretation of Kandinsky's *oeuvre* in terms of the concepts of history and art that are built into *Über das Geistige in der Kunst,* the *Almanach Der blaue Reiter,* and *Rückblicke.* Accordingly, he presented that *oeuvre* as "ein Ausweg aus den Wirren, den Niederlagen und Verzweiflungen der Zeit" [an exit from the confusions, the defeats, and the doubts of the

age] and totally ignored its apocalyptic, fissured, and chaotic aspects.[27] A *Sturm* exhibition (including seven works by Kandinsky of which five can be positively identified) had taken place in the Basel branch of the Galerie Corray from 7 February to 7 March 1917. About half of this exhibition seems to have been moved to the Galerie Dada for the first *Sturm* show (17 March–7 April), and the other half seems then to have replaced it for the second *Sturm* show (9–30 April). Most of Kandinsky's seven works featured in both shows, and although they ranged from the relatively tame and representational *Herbst II* to the apocalyptic *Bild mit rotem Fleck,* their mood, as the reviewer noted, tended toward the former rather than the latter pole.[28] Nevertheless, in his lecture, Ball mentioned only one of the seven paintings, *Bild mit rotem Fleck* (which Tzara would reproduce in black and white in *Dada* 4–5 two years later), and he described this indisputably violent complex of colliding jagged lines and primary colors (from which a not quite round, red shape is struggling to emerge) in terms of balance! He then compared the painting to a "water carrier" (a clear image of balance) and went on to associate it with "das rührend einfache, christlich-reine, unberührte, stille und märchenhaft atmende Russland" [the Russia that is movingly simple, Christian in its purity, intact, breathing tranquilly as in a fairy tale]. It is hard to think of a more inappropriate characterization—not least because this painting is totally nonrepresentational. Ball then praised Kandinsky's visual work for its "Ruhe, Friede, Gleichheit . . . Gleichheit, Freiheit, Brüderlichkeit der Formen" [Tranquillity, peace, equality . . . equality, freedom, fraternity of forms]. This last formulation is particularly telling since it shows that Ball was attempting to view Kandinsky's Expressionist work as the manifestation of three of the founding political ideals of classical modernity, when, as I argued in chapter 6, it is nothing so simple as that. In the same spirit, Ball cited Kandinsky's poem "Fagott," one of the two most apocalyptic poems of *Klänge* (see chapter 6), as an example of purified spirituality, and interpreted the highly problematic *Der gelbe Klang* as a work that was characterized by harmony.[29]

But at exactly the same time, Tzara, as we saw in chapter 8, was developing his idea of Dada as a mixture of order and chaos, affirmation and negation, energy and spirituality. As a result of this, the "barbarisms" that Ball thought had been overcome found their way back into the Galerie Dada in a variety of guises: in Tzara's primitivizing poetry ("Neger-Gedichte") (29 March); in some of the Expressionist paintings exhibited there in March and April; in Kandinsky's apocalyptic "Fagott"; in Mari-

netti's *Manifesto tecnico della litteratura futurista;* primitivizing dances; poems by van Hoddis; in Ehrenstein's lecture on Kokoschka (in which, judging by two publications, he would have described him as an "explosionist" and a "Seelenaufschlitzer" [soul-ripper] whose work released the powers of the unconscious); in poems by Ehrenstein (which almost certainly dealt with suffering, hopelessness, loneliness, lovelessness, alienation, and the diabolic, apocalyptic violence of the war) (14 April); in atonal music by Schoenberg; in a chapter from *Tenderenda* entitled "Grand Hotel Metaphysik," which, although written in a humorous, mock-biblical style, is full of images of barely suppressed violence; in a "poème simultan" for seven voices by Tzara (28 April); and in continual reminders of the war and its escalating death toll.[30]

But the event that best points to the deep fault line running through the Galerie Dada is the performance on 28 April of Kokoschka's one-act *Sphinx und Strohmann.* Brandt says that this playlet had little to do with Dada, and Wallas interprets it primarily as a grotesque adaptation of Otto Weininger's theories on the eternal battle of the sexes.[31] While Wallas's reading is politically correct, neither he nor Brandt realizes that the way in which this play was performed (with Ball as Herr Firdusi, the male principle, a huge head made of straw; Emmy Hennings as Anima, the devouring female principle; and Tzara as the parodic parrot and the person responsible for the sound effects) enacted the deep rift in Zurich Dada. From Ball's description—the play was performed in a totally darkened hall with the actors in huge tragic masks designed by Janco that completely covered their bodies—it would seem that he, with Kandinsky's abstract dramas in mind, intended the performance to be taken more seriously than Kokoschka had done when he called his play a *curiosum.* So, given Ball's psychological and metaphysical preoccupations of the war years, Kokoschka's play, in his estimation, must have enacted what happens when seductive, irrational Nature (equated with the female principle) is allowed to overpower disembodied *Geist* (equated with the male principle): death has the last word. But Tzara, already offered an opportunity for subversion by being cast as the parrot, apparently wrecked the performance completely by sounding off his thunder and lightning at the wrong times and generally giving the impression that the resultant confusion was a deliberate part of the show. Or, in other words, Dada anarchy effectively undermined the neat binarism that almost certainly informed Ball's understanding of the playlet and assaulted Ball's conception of what the Galerie Dada stood for. Given this, it is significant that Ball should have decreed that the

next *Dada-Soirée* (12 and 19 May 1917) (when extensive extracts from medieval mystics were read out [see chapter 10] and Janco gave his very un-Dada lecture on architecture [see chapter 8]) should be *geschlossen* (restricted to a small côterie of friends). It is equally significant that while Tzara's "Chronique" records that he recited primitivizing poems at that *Soirée,* Ball's diary makes no mention of Tzara's contribution.[32] Although the Galerie Dada never generated the psychological explosion that the Cabaret Voltaire had, after the performance of *Sphinx und Strohmann,* Ball clearly felt a growing need to defend himself more resolutely against elements that might disrupt the spiritual peace that he had intended should pervade the Galerie Dada. Inevitably, this project failed and Ball fled Zurich in late May in a state of near psychological exhaustion, leaving Tzara at the center of what remained of the Dada group.

A final epitaph on the relationship between Dada and Expressionism in Zurich is provided by the fact that Ball almost certainly conceived the chapter of *Tenderenda* entitled "Der Verwesungsdirigent" ("The Putrefaction Conductor") in direct response to Gottfried Benn's *Erkenntnistheoretisches Drama* [epistemological drama] *Der Vermessungsdirigent* (*The Director of Land-Surveying*).[33] Benn's drama had been written in Brussels in March 1916, during the period of near total despair that also generated the Rönne-*Novellen,* and it evinces a profound skepticism about human reason and a deep disgust at the corruptibility of the flesh. In contrast, Ball's chapter is free from such disgust; makes fun of those poets (like the early Benn) who wallow in human fleshliness and erotic excess; and in its longer, earlier version satirized those poets (like Rubiner) who had made the "surprising" transition from eroticism to humanism.[34] Thus, "Der Verwesungsdirigent" marks Ball's farewell both to the apocalyptic pessimism of early Expressionism (to which he himself had been drawn, albeit unwillingly, from 1913 to 1915) and to the excessive optimism of late Expressionism (of which he had been mistrustful since 1916, especially in its Activist form). In sum then, the fluid and many-faceted encounter between Dada and Expressionism in Zurich is not just a question of influence. In its twists and turns within a highly fraught situation of exile and alienation, it is an exploration of seven possible responses to the perceived crisis of contemporary modernity: ecstatic irrationalism; nihilistic despair; the desire to preserve an aesthetic enclave; neohumanism; withdrawal; primitivizing experimentation; and for Ball, once he had broken with Dada, utopian political commitment.[35]

Berlin Dada

Like Zurich Dada, Berlin Dada had many of its roots in early Expressionism and found itself grappling with exactly the same problems. Hausmann, for example, although a frequenter of the studio of the Expressionist painter Ludwig Meidner (who is best known for his apocalyptic cityscapes [1913–14]), was being violently critical of his work by mid-1915.[36] And during the prewar years, Franz Jung wrote a series of Expressionist stories that dealt with extreme states of mind and hopelessly entangled human relationships before he could progress to his more affirmative work of the mid- and late war years starting with his novel *Opferung* (*Sacrifice*) (1916).[37] But overall, as Hausmann's annotations to *Die Aktion* from 1914 to 1919 indicate, Berlin Dada's relationship with early Expressionism was much less traumatic than had been the case in Zurich.[38] This seems to have been due to six factors: first, the positive input of Otto Gross; second, the positive input of Salomo Friedlaender (the academic philosopher who wrote grotesques under the pseudonym of Mynona); third, the positive input of the primitivizing *Brücke* group; fourth, and closely associated with this, the positive input of Carl Einstein; fifth, the positive reception of the early work of Gottfried Benn, especially by George Grosz; and sixth, the fact that Huelsenbeck was able to feed the lessons into Berlin Dada that he had learned the hard way in Zurich.

As early as 1913, Gross was teaching those who cared to listen that it was possible to tap the unconscious and live creatively from its resouces without falling prey to the ecstatic, potentially destructive irrationalism advocated by Rubiner in "Der Dichter greift in die Politik." Ironically, Gross did this via an extended polemical debate with Rubiner, who, by spring 1913, had already effected the return to humanism that would lead him into the Activist fold after the outbreak of war.[39] In one corner, Gross advocated faith in the unconscious and Nature. In the other, Rubiner attacked psychoanalysis for its indulgence of the inherently weak, its relativization of morality, and its diminution of individual responsibility; and he enjoined human beings to put their faith in *Geist* in order to protect themselves against Nature and the unconscious. Gross's ideas were decisive for the thinking of the proto-Dada *Freie Strasse* (Open Road) group in Berlin (whose name derives from one of Walt Whitman's best-known poems); enabled Franz Jung to resolve the psychological conflicts and double binds that mark his early prose; and permitted Hausmann to develop his pivotal concept of "Erleben."[40]

The work of Salomo Friedlaender was particularly important for Hausmann and Johannes Baader (with whom Friedlaender planned a never-published periodical *Erde* [*Earth*] in 1915) and Hannah Höch, and Baader acknowledged the debt in a recently published letter of 23 February 1915. In particular, his piece "Präsentismus" ("Presentism"), published in *Der Sturm* in January 1913, prefigured the ideas of Berlin Dada in general and Hausmann's similarly titled manifesto of 1921 in particular.[41] The speaker in "Präsentismus" is identified as "Der Erdkaiser" [The Emperor of the Earth]. He is the ruling spirit of Creation and proclaims himself to be the reconciler of yes and no, the child who gives birth to his parents, the one whom mankind awaits without knowing that it does so, and the personification of the neutral midpoint of indifference like a star amid the chaos of all positives and negatives. Although "Der Erdkaiser" is a more static, more aristocratic, less exuberant figure than Dada's Dada in the third usage identified in chapter 7, the affinities are obvious enough to need no elaboration.[42] When Friedlaender's major work *Schöpferische Indifferenz* (*Creative Indifference*) appeared in 1918, it must have reinforced ideas that were already well formed in the minds of the Berlin Dadaists. Huelsenbeck acknowledged this quite explicitly when he described the ideal personality who can keep his balance amid the flux of life as being endowed with "die schöperische Indifferenz, wie Dr. Friedländer-Mynona das nennt" [creative indifference, as (Dr.) Friedländer-Mynona calls it].[43]

Primitivizing influences found their way into Berlin Dada from several sources. Franz Jung had been a member of the Anarchist *Gruppe Tat* (Group Deed) in prewar Munich and had assimilated ideas about the ideal utopian community that is rooted in Nature from Gustav Landauer, Mühsam, and Gross. Walt Whitman was one of Hausmann's favorite poets and a volume of Whitman's poems was one of the few books that he managed to keep with him throughout his life. Carl Einstein's positive evaluation of non-European art certainly fed directly into Berlin Dada. Huelsenbeck's primitivizing poetry may have been partly inspired by Einstein's *Negerplastik* (*African Sculpture*) of 1915, and Hausmann, who encountered Erich Heckel's primitivizing work in the same year, acquired a copy of that book on 13 November 1916 and gave it to Höch on 2 August 1919.[44] For the early George Grosz, the fictitious America of James Fenimore Cooper and Karl May was both the antithesis and, paradoxically, the mirror image of modern-day urban Europe.[45] But because these primitivizing currents fed into a complex of attitudes that were philosophically and psychoanalytically grounded in the proto-Dadaists' home territory of

Berlin, they never had the explosive effects that they did on the less well-prepared exiles in the Cabaret Voltaire. The urban apaches, dilettantes, *flâneurs,* and dandies who inhabited the jungle of Berlin were able to cope with potentially dangerous ideas far better than their contemporaries in the vacuum of Zurich.

Although Ball came to reject Benn and all that he stood for, Benn's early work seems to have made more positive sense to George Grosz. On 17 June 1917, Grosz recommended Benn's "Rapid Drama" *Karandasch* (the Russian word for "pencil"; written in Brussels in March 1917) to Otto Schmalhausen; referred positively to Benn's collection of poems *Söhne (Sons)* (published 1913); and quoted a line from one of his poems, "Räuber-Schiller" ("Robber-Schiller"—a reference to Schiller's first, most uncompromisingly violent drama).[46] *Söhne* included a poem entitled "Nachtcafé" ("Night Café"). Grosz also wrote a poem with that title; he cited a line from Benn's poem in his letter to Schmalhausen of 29 April 1918— "Glaube, Liebe, Hoffnung" [Faith, Hope, Charity]; and he produced a lithograph in 1918 illustrating Benn's poem entitled "Nachtcafé (für Dr. Benn)" ("Night-Café [for Dr. Benn]").[47] It is also very likely that Grosz's tendency to depict human beings with porcine features owed something to the first line of Benn's notorious poem "Der Arzt II" cited in chapter 2. Once one realizes how highly Grosz regarded Benn's early poetry, its affinities with Grosz's visual work of the Dada years are obvious. Nevertheless, there is a significant difference between Benn's contemptuous disgust at human corruptibility and Grosz's satirical misanthropy. While both knew that they were like the subjects of their work and hated it, Grosz was better able to accept the affinity and even be amused by it—as his letters to Schmalhausen show. But apart from the obvious similarities between their work, the particular element that almost certainly drew Grosz to *Karandasch* was the sense of vitality, exuberance even, that distinguishes it from Benn's *Der Vermessungsdirigent* of the previous year. In the "summary" that prefaces *Karandasch,* Benn states that Pameelen, its central figure, is antinoun and pro-verb because the verb is the "Träger der Bewegung" [bearer of movement], and *Karandasch* is indeed carried along by a sense of movement that contrasts very markedly with the sense of entrapment that had characterized so much of Benn's earlier work.[48] This sense and the attitude to language that flows from it not only recall the Dada poetry discussed in chapter 5, they are also very prominent in Grosz's visual work of the Dada period. Here, lines of force run in all directions, and names, labels, and slogans are attached only loosely to the objects they designate.

In other words, where Benn's early work helped to shape Grosz's low view of human nature, *Karandasch* helped communicate to Grosz the energy that he needed if he was to live in and paint a world that was running amok.

Huelsenbeck arrived in Berlin from Zurich via Greifswald in late spring 1917 with an embryonic sense that Dada was about vitalism and as such distinct from apocalyptic Expressionism. Indeed, his letters to Tzara of [May 1917] and 2 August 1917 make it clear that he was largely instrumental in turning *Neue Jugend* from an Expressionist to an overtly Dada periodical.[49] Where its first five numbers (July 1916–March 1917) had been conventional in their format and had contained several poems by well-known Expressionists dealing with the typically early Expressionist mood of despair, the two issues of May and June appeared in broadsheet format and were aggressively Dadaist in their typography and layout.[50] Nevertheless, Huelsenbeck's poem "Die Dichter der Maria" ("The Poets of Maria") (published in *Die Aktion* on 7 April 1917) shows, like "Selige Rhythmen," the unmistakable influence of Heym, van Hoddis, and Lichtenstein and so had probably been written much earlier.[51] But "Schwebende" ("Hovering Beings") (published in *Die Aktion* on 20 January 1917) shows a different kind of Expressionist influence. Its title and dominant image of God in the wind recall sculpture and graphic work by Ernst Barlach, and its fluid verse form and pantheism recall the work of Ernst Stadler and Theodor Däubler. As such, "Schwebende" forms the link between the vitalist position that Huelsenbeck had reached by late 1916 and the "Autoren-Abend" ("Reading-Evening") that he would organize in Berlin on 22 January 1918. At this event, Huelsenbeck read out his relatively tame and largely historical "Erste Dadarede in Deutschland" ("First Dada Lecture in Germany") where Dada is defined as "nichts weiter . . . als die Internationalität der Bewegung" [nothing more . . . than the international nature of the movement].[52] On this evening, Däubler read from his "Mittelmeergedichte" [Mediterranean poems]; Max Herrmann-Neisse read poems that were allegedly characterized by "tänzelnde Rhythmen" [tripping rhythms]; Resi Langer read poems from Stadler's *Der Aufbruch* (*The Beginning/The Break-Out*) (1914), including, almost certainly, "Fahrt über die Kölner Rheinbrücke bei Nacht" (see chapter 5) together with somewhat darker poems by Lichtenstein; and Hans Heinrich von Twardowski read poems by Else Lasker-Schüler.[53] Or in other words, this evening—which, significantly, was *not* designated as a *Dada-Abend* or *Dada-Soirée*—seems largely to have been a relatively controlled exercise in Expressionist vitalism, with only

Huelsenbeck's lecture and reading of "Baum" ("Tree") from the *Phantastische Gebete* pointing toward the much more complex and distinctive *Dada-Abend* of 12 April.[54] Nevertheless, the texts chosen for this evening suggest that Huelsenbeck had overcome the early Expressionist sense of an apocalyptic ending that had haunted the Cabaret Voltaire and had consolidated his hard-won sense that the way forward involved tapping into a "new vital energy."

This is confirmed by comparing van Hoddis's best-known poem "Weltende" ("End of the World") (first published in *Der Demokrat* on 11 January 1911) with Huelsenbeck's "Ende der Welt" (c. 1918–19) ("End of the World," 1951).[55] The poems are similar to the extent that they deal with the same subject and present the reader with a complex of disconnected and surreal events. Moreover, "Ende der Welt" not only mixes in comic references to Wagner's *Ring,* the "Walpurgisnacht" scene from *Faust* I, and Goethe's poem "An den Mond" ("To the Moon") (texts dealing with apocalypse, carnivalesque orgy, and the fluid inconstancy of life), it also contains echoes of Wilhelm Klemm's war poetry of late 1914; Blass's "Abendstimmung" ("At Dusk") (November 1910); Trakl's final poem "Grodek" (October–November 1914); and *Weltende* itself (that is, early Expressionist texts dealing with war, apocalypse, and the city). But whereas in "Weltende" the emphasis is on the sinister nature of the apocalyptic events, in "Ende der Welt" similar events are presented as run-of-the-mill and absurdly insignificant. In "Weltende" the tersely laconic verse form suggests that the poet is using language to control a cataclysmic event that is threatening to overwhelm him, while in "Ende der Welt" the need for tight control has disappeared. The language moves in a leisurely manner from one absurd event to another and no attempt is made to impose metrical or rhythmical shape upon them. In "Weltende" the apocalypse is imminent and the poem is set in the instant immediately before the crisis finally breaks. In "Ende der Welt" apocalypse is seen as an indelible and persisting fact of modernity that, once accepted, ceases to be so radical a threat. In "Weltende" the human world is about to be engulfed once and for all by demonic Nature, but in "Ende der Welt" life goes on and people attain a sense of balance amid persistent chaos—albeit with the help of a cherry-brandy flip. No wonder Grosz replaced Arp as the illustrator of the second edition of the *Phantastische Gebete*: the mood of his illustrations is very close to that of Huelsenbeck's contemporary poetry.

Despite all the positive input from early Expressionism into Berlin Dada and despite Carl Einstein's collaboration on the first issue of the Dada/

Communist *Die Pleite* (*Bankruptcy*) as late as March 1919 (see chapter 12), the rift between the Berlin Dadaists and the late Expressionists is visible from an early date. Hausmann called Wolfenstein a "clot" in his copy of *Die Aktion* of 24 June 1916 and wrote a large number of disparaging remarks about Däubler, Werfel, and Rubiner on his copies of the special issues of *Die Aktion* devoted to their work (18 March 1916, 28 October 1916, and 21 April 1917).[56] Although Bergius cites a 5 August 1916 letter from Hausmann to Höch in which Hausmann acknowledges the importance of Rubiner's "Der Dichter greift in die Politik" and tells of his plan to write an essay on its author for *Neue Jugend* in 1917 entitled "Salut Rubiner," he never did so—presumably because of Rubiner's conversion to *Geist*-centered Activism described above.[57] Indeed, in a review of Rubiner's programmatic piece *Der Kampf mit dem Engel* (*The Struggle with the Angel*) (1917) entitled "Kriegszustand" ("State of War") that appeared in the first Dada issue of *Neue Jugend*, it was remarked that disputes were beginning to take place among people who, for three years, had considered themselves brothers, comrades, friends, and human beings. And for all its expressionistoid title, Huelsenbeck's manifesto, "Der neue Mensch" ("The New Human Being"), published in the same issue of *Neue Jugend*, involved Dada features and satirical echoes of the work of such prominent Expressionists as Hiller and Becher.[58] The late Expressionist "Neuer Mensch" craved a totalitarian utopia as a bulwark against chaos; saw himself as a messianic leader; thought that the power of his *Geist* could change the world; and was attracted to the cosmic and monumental. In contrast, Huelsenbeck's "Neuer Mensch" accepts chaos because he has a principle of order within himself; rejects aristocracies of all kinds; denies the power of *Geist;* and believes in the meaning of the smallest things. From that date on, a violent and penetrating polemic against Expressionism gradually developed in Berlin, reaching its height in 1919 and 1920. As Wieland Herzfelde later put it, the May 1917 issue of *Neue Jugend* marked the transition:

> vom Expressionismus mit seinem Ahnen und Prophezeien, seiner Ich- oder All-Versunkenheit und dem vielfach variierten Vater-Sohn-Konflikt zur radikalen Absage an die mörderische Politik und die Salonkritik der Herrschenden.[59]

> *from Expressionism with its intuitions and prophecies, its immersion in the Self or the All, and the father-son conflict in all its different versions to the radical rejection of the politics which were murdering millions and the armchair critiques of those in power.*

It should be obvious by now that the polemic of Berlin Dada was directed not against the major early Expressionist poets (like Heym, Lichtenstein, and van Hoddis), or the grotesque Expressionist writers (like Klabund, Mynona, Hardekopf, or Einstein), or even Expressionist vitalist writers (like Stadler, Lotz, Leybold, and Däubler). Indeed, when the Berlin Dadaists published a spoof announcement in the *Vossische Zeitung* (Berlin) on 27 January 1918 naming Hardekopf, Däubler, Hermann-Neisse, and the "Individualanarchist" Anselm Ruest as members of the *Club Dada* (which existed only in a virtual sense), they were, at that juncture, being only semifacetious. Rather, Berlin Dada's polemic was aimed at the Activists (like Hiller and Rubiner because of their excessively high view of human nature); the religious ecstatics (like Werfel because of their unworldliness); the sentimental humanitarians (like Leonhard Frank and other authors of *Güte-Romane* [novels about the essential goodness of human nature] because of their refusal to take adequate account of human brutality); and excessively idealistic political poets (like Hasenclever, Becher, and Rudolf Leonhard who seemed, with some justification, to be in flight from their own pathology).[60] To illustrate this, the second Dada number of *Neue Jugend* (June 1917) contained an article by Huelsenbeck, "Dinge and Menschen" ("Things and People"), whose first two sections are a brilliant lampoon of the kind of prose favored by various late Expressionists. Here, Werfel's religious mawkishness, Becher's hysterical outpourings, Ehrenstein's shrill rhetoric, and Rubiner's utopian humanitarianism are so accurately caricatured that one could believe the article was sincerely meant if one did not know Huelsenbeck.

The anti-Expressionist polemic of Berlin Dada centers on the concept of *Geist*—rational, ethical spirit, viewed either as a purely human faculty or as the transcendent power behind Creation as a whole. Writing in the first issue of *Das Ziel* (*The Goal*) (1916), the Activists' yearbook, Hiller used the concept in the first sense:

Wir müssen den Geist ins Unendliche steigern, bis er, auf der Spitze eines unendlich fernen Augenblicks, in sich zusammensinke.[61]

We must intensify the rational spirit to an infinite degree until it, on the summit of an infinitely distant instant, falls back into itself.

Rubiner, expanding his attack on everything Otto Gross stood for and appealing to Kant's second Critique for support, endorsed precisely this view in his essay of 1916.[62] And Max Brod used the concept in the second

sense when he wrote in *Tätiger Geist* (*Active Spirit*) (1917–18), the second *Ziel* yearbook:

Der wahre Rationalismus ist nichts als ein möglichst deutlicher Hin-
weis auf das Weltgeheimnis, praktisch genommen, im rationalistischen
Aktivismus, erstrebt er die möglichst vollständige Einstellung möglichst
vieler Menschen auf das Unendliche, Göttlich-Geistige.[63]

*True rationalism is nothing other than the clearest possible pointer to the
secret of the world. From a practical point of view, by means of the ratio-
nalism of Activism, it strives for the most complete attunement of as many
people as possible to the Infinite, the Divinely Spiritual.*

Early Expressionism had suffered from a sense that humanity was either
being suffocated by Weber's *stahlhartes Gehäuse,* personified in the authori-
tarian father figure who dominates so many Expressionist dramas, or had
been displaced from the center of things and cast into chaos, or had even
been overtaken by both of these fates simultaneously. In contrast, late Ex-
pressionism tried desperately to affirm that human beings could escape
from the *Gehäuse* of modernity by means of their *Geist* and rediscover
an Archimedean point from which they could regain control of anomic
modernity—hence the title of Rubiner's late Expressionist anthology *Der
Mensch in der Mitte* (*Humanity at the Center*) (1917).[64]

Beginning with the *Freie Strasse* group, the Dadaists gradually man-
aged to diminish that sense of entrapment and reduce the castrating father
figure of early Expressionism to the innocuous Dada with whom it was
possible to play.[65] Correspondingly, the Dadaists' experience of the war
and/or the metropolis made it impossible for them to accept late Expres-
sionism's neohumanist attempt to restore imperial *Geist* to its psychologi-
cal throne. As early as 28 October 1916, Hausmann had scribbled on the
special number of *Die Aktion* devoted to Werfel, "warum bringt sich der
'geistreiche' Idiot nicht um!" [why doesn't the "*Geist*-rich" (lexically "intel-
ligent" or "ingenious") idiot do away with himself!], and similar polemical
comments can be found throughout the literature of Berlin Dada. But the
most level-headed explanation of Dada's critique of late Expressionism is
to be found in Huelsenbeck's review of Hiller's *Der Sprung ins Helle* (*The
Leap into the Light*) that appeared in 1932:

Von dem unschuldigen Objektivismus Hillers ist die Welt . . . längst
zu einem Persönlichkeitskonzept übergegangen, das dem irrationalen

Element in der menschlichen Handlung den nötigen Kredit gibt. Es war das tiefere Verständnis für das Irrationale, die Tatsache, dass das Ende anders herauskommt als es im Anfang geplant wurde, es war das Misstrauen gegen eine schülerhafte Auffassung der Omnipotenz der Vernunft, die die Dadaisten damals gegen den Expressionismus auf den Plan rief. Die Dadaisten dachten, dass die "O Mensch"-Haltung der Expressionisten, der kindliche "Kampf gegen die Waffe" (Rudolf Leonhard) eine tiefe Unkenntnis der Welt und des Menschen aufzeigten.[66]

The world has long since moved away from Hiller's innocent objectivism . . . to a conception of the personality that does proper justice to the irrational element in human action. It was this deeper understanding of the irrational, of the fact that things turn out differently from the way they were initially planned, it was mistrust of a jejune conception of the omnipotence of reason that brought the Dadaists into the lists against Expressionism. The Dadaists considered that the "Oh Humanity"-attitude of the Expressionists and their childish "Struggle against Arms" (Rudolf Leonhard) displayed a profound ignorance of the world and of people.

Following Otto Gross then, the Dadaists evolved their more polyphonic, heteroglossic view of human nature described in chapter 7 partly because they felt that its bestial, violent energies are most dangerous when covered up and best dealt with via recognition, ironic acceptance, and, where possible, transformation into creative psychological potential.

But over and above such psychological considerations, the Berlin Dadaists increasingly felt that the neohumanism of late Expressionism was as artificial as the Weimar Republic itself. Just as the late Expressionists tried to cover up the darker sides of human nature by affirming that revolutionary *Geist* was emerging after a disastrous war to create a new, redeemed humanity, so the Weimar Republic, with its claim to be based on the ideals of classical modernity inherited from Goethe and Schiller, actually covered up the fact that nothing in Germany had changed fundamentally. The Kaiser and the regional aristocratic rulers might have been deposed, but the German Revolution (November 1918–May 1919) had actually left the old structures and mentalities largely intact. This is why Grosz depicted Friedrich Ebert (the first Chancellor of postwar Germany and then, from 10 February 1919, its first President) with an imperial crown on his head in "Von Geldsacks Gnaden" ("By Moneybag's Grace"), the illustration on the cover of the first issue of *Die Pleite*. This is also why a death mask of Beethoven adorned with a Kaiser Wilhelm moustache is to be found on the

front cover of Huelsenbeck's *Dada Almanach*. Not only was the composer who had set Schiller's "An die Freude" ("Ode to Joy") now a decomposer, his remains had been appropriated by a ruling class to mask values that were very different from those hymned in Schiller's paean to the classical humanist ideals.

Accordingly, having held their political fire until the publication of *Jedermann sein eigner Fussball* (*Everyone His Own Football*) on 15 February 1919, the Dadaists attacked the late Expressionists' assessment of the political situation in Germany on four counts. First, it was patently untrue. In February 1919, when the German revolution had very obviously failed to alter anything fundamentally, Hausmann wrote that Expressionist talk about the revolutionary emergence of *Geist* was just a "neues Mittel zur Stabilisierung der Bourgeoisie" [a new means for stabilizing the bourgeousie], a mystificatory ideology that served to justify the seizure of political power by the middle classes.[67] Two months later, when the Munich Soviet was on the verge of collapsing, Hausmann put it even more strongly with particular reference to the Expressionist dramatist Fritz von Unruh:

Diese Literatoren, Versemacher leiden am Gallfluss ihrer traurigen Ernsthaftigkeit und bedeckten schon wieder als Aussatz die geistigen Beulen der Ebert-Scheidemann-Regierung, deren elende Phonographenwalzenmelodie sie kakophonisch unterstützten, wie sie einstmals für den preussischen Schutzmann begeisternd gröhlten.[68]

These littérateurs, rhymsters are suffering from a bilious attack of their own melancholy seriousness and once again covered over the spiritual dents in the Ebert–Scheidemann-régime like an attack of leprosy, providing the cacophonic base line for its phonographic roller melody just as in times gone by they had bawled enthusiastically for the Prussian policeman.

Second, their assessment was utopian and as Huelsenbeck said:

Der Dadaist ist also gegen die Idee des Paradieses in jeder Form und einer der entferntesten Gedanken ist ihm der, dass "der Geist die Zusammenfassung aller Mittel zur Verbesserung der menschlichen Existenz sei."

Thus the Dadaist is opposed to the idea of paradise in every form, and one of the ideas farthest from his mind is that "the spirit is the sum of all means for the improvement of human existence." [69]

Third, therefore, their assessment was politically dangerous. If one ignored psychological realities and their political counterpart, one was more likely to play into the hands of politicians who, though seemingly innocent, were definitely not.[70] If one ran away from violence in the name of humanitarian *Geist* and pacifism, one was likely to put oneself at the mercy of those who were not afraid to use violence and thus prepare the ground for future social turmoil.[71] The Dadaists also had a developed sense that all utopian yearnings carry the seeds of totalitarianism because of their desire for closure. Finally, the Dadaists were deeply critical of the role that the late Expressionists had assigned themselves within the above historical scheme, styling themselves as messianic figures who would bring revolutionary *Geist* to the expectant masses through their art. As early as July 1916, Wieland Herzfelde had criticized Becher's collections of poetry *An Europa* (*To Europe*) (1916) and *Verbrüderung* (*Brotherhood*) (1916) for their "platonic radicalism," their call for a spiritual and ethical élite who would guide the masses.[72] Hausmann, already critical of late Expressionist presumptuousness in "Der Proletarier und die Kunst" ("The Proletarian and Art") (1918), was even more so five months later when the time for messianic illusions was visibly passing.[73] When, in April 1919, he sent the draft of "Letzte Nachrichten aus Deutschland" ("Latest News from Germany") to Tzara for publication in *Dada* 4/5 in the following month, he was extremely sardonic about the messianic politics of the Expressionist revolutionaries in Munich and Dresden.[74] And eight months after that, when all hopes of revolution had been dashed, he was even more scathing:

o Expressionismus, du Weltwende der romantischen Lügenhaftigkeit. Unerträglich wurde die Farce erst durch die Aktivisten, die den Geist und die Kunst, die sie vom Expressionismus absahen, dem Volke bringen wollten. Diese Schwachköpfe, die irgendwie mal Tolstoi gelesen und selbstverständlich nicht verstanden haben, triefen nun von einer Ethik, der man nur mit der Mistgabel sich nähern kann. Diese Dussel, die unfähig sind, Politik zu treiben, haben die aktivistische Aeternistenmarmalade erfunden, um sich doch auch an den Mann, hier den Proletarier, zu bringen. Aber so dof, verzeihen Sie, ist der Proletarier garnicht, dass er die unfruchtbare Toberei in lauterer Hohlheit nicht merkte. Kunst ist ihm was, was vom Bürger kommt.[75]

o Expressionism, you turning point in world history made from romantic mendaciousness. The farce became really insufferable with the Activists, who

wished to bring spirit and art, which they picked up from Expressionism, to the people. These airheads, who had sort of once read Tolstoy and, of course, misunderstood him, now dripped with an ethics that one can approach only with a pitchfork. These fools, who are incapable of acting politically, invented the activist puree of aeternism in order to get their message across to people, by which I mean the working class. But, begging your pardon, working-class people are not so daft as to be incapable of spotting fruitless ravings in all their hollow stridency. As far as they're concerned, art is something that comes from the bourgeosie.

As we shall see in chapter 12, the Dadaists had a better understanding of how difficult it was for outsider intellectuals to speak to an alien class and tackled the problem of political engagement in less grandiose, though not always more practicable ways.

How much truth was there in the Dada assessment of Expressionism? On the first count quite a lot—until, that is, the newly elected government under a Majority Socialist President used right-wing *Freikorps* to crush the Munich Soviet in May 1919, causing the death of a thousand workers, and the Expressionists themselves came to understand that they were personae non gratae with the Majority Socialist Party.[76] Ernst Toller wrote his revolutionary drama *Die Wandlung* (1917–18) (*Tranfiguration*, 1935) in a mood of optimistic, revolutionary ecstasy only to have his political hopes dashed by the events in Munich (in which he played a central, not to say fateful role). More than a few writers and artists got involved in the Munich Soviet because of the same deluded belief—with the same disillusioning result.[77] Then again, on 6 February 1919, the actor Otto Sander read poems by Trakl, Werfel, Däubler, Hasenclever, and Lasker-Schüler to a good bourgeois audience in the plush *Rokokosaal* of the Hotel Disch in Cologne. In the middle of the performance, an unidentified member of the Cologne Dada group got up and protested at the ease with which provocative, subversive, and revolutionary poetry was being turned into entertainment for the rich and fashionable—a criticism that was reiterated in the Cologne Dada periodical *Der Ventilator* (*The Fan*).[78] Or again, on 25 March 1919, two months after the murders of Liebknecht and Luxemburg by the *Freikorps* and ten days after Noske's troops had brutally crushed the Spartacist rising in Berlin, a public reading-evening was held in the *Blüthnersaal* there at which Kurt Erich Meurer read his "Aufruf zum Sozialismus" ("Call to Socialism"). Here, Meurer proclaimed the typically late Expressionist value of impassioned brotherhood; declared art to be the new religion; and in-

vited the new state to recognize the messianic artist as "the civil servant of humanity" and reward him as such. To illustrate this, Gerd Fricke of the Dresden State Theater read out Expressionist poems by Hasenclever, Werfel, Becher, and Paul Zech despite the bloody events of the past weeks and despite the fact that, of the four, only Zech was a supporter of the Majority Socialist Party.[79] Surprisingly, given that party's hostility to Expressionism, the event was enthusiastically reported in *Vorwärts* (*Forward*), the Majority Socialist newspaper, on 26 March 1919—an indication of how easily late Expressionist revolutionary poetry could be pressed into the service of a revolution that was one in name only. But after May 1919, as political disillusion increasingly set in among the late Expressionists, the Dadaists' first charge became increasingly hard to sustain—even in respect of the Activists.[80]

The second charge is certainly justified since a large number of late Expressionist poems and plays, not to mention the first phase of the Bauhaus (1919–22), looked to a new, millennial utopia arising from the Armageddon of the war—until, once again, disillusion or a new sense of sobriety set in. The third charge was also justified since most late Expressionists were sickened by violence. This meant that on the whole they detested the Majority Socialist Party because of its support for the War Credits in 1914 and its connivance at counterrevolutionary violence in 1918 and 1919; shied away from the Communist Party because of its commitment to revolutionary violence; and tended toward the short-lived Independent Socialist Party (1917–22) because of its strong pacifist constituency. So, as that party fell to pieces from late 1919 onward, one notes four trends among the late Expressionists. Either they became loftily apolitical; or they went into inner emigration; or they channelled their political energies into ineffective nonpartisan groups on the fringe of real politics; or, in one or two cases, they associated themselves with totalitarian parties on the extreme Right or Left in order to regain a lost sense of order and discipline.[81]

An example of the first trend is provided by Kokoschka who had become a professor in the Dresden Academy of Fine Arts in early 1919. During the *Kapp-Putsch* of March 1920, fighting took place in that city and sixty workers were killed. Kokoschka, however, saw fit to publish a pamphlet in which he pointed out that a stray bullet had damaged a Rubens in the Zwinger during the fighting and appealed to the two sides to do their fighting on the ranges outside the city and not near places where works of human culture were stored. This piece of supercilious tactlessness so enraged the Dadaists (who saw it as a failure on Kokoschka's part

to appreciate why the proletariat were fighting at all) that it caused two of them, Heartfield and Grosz, to publish a vitriolic reply, "Der Kunst-lump" ("The Art Lout"), in Franz Pfemfert's left-radical *Die Aktion* and the Dada/Communist *Der Gegner* (*The Adversary*).[82] In this piece, Heart-field and Grosz pilloried the pacifist, apolitical, Expressionist intellectual "who would have preferred people to meet the be-swastikaed columns dressed in long white shirts, with a candle in one hand and teacher Frank's *Der Mensch ist gut* in the other" in order to drive away "the white saviors" with "spiritual weapons."[83] In the present situation, they argued, violent revolution was needed to overthrow the old order. And if in the course of that, a few works of art were destroyed, that was all to the good since "art" and "the artist" were bourgeois concepts that undermined a sense of human equality and formed part of the ideology sustaining the existing political system. Whether they intended it or not, the authors argued, Ko-koschka and other pacifist intellectuals who dissociated themselves loftily from political events were counterrevolutionaries, implicitly supporting a régime that deserved to be overthrown and ignoring the threat to democ-racy from the radical Right.

The individual biographies of Ehrenstein, Hasenclever, the dramatist Friedrich Wolf, and the painter Ludwig Meidner provide examples of the second trend. Ehrenstein suffered a nervous breakdown in late 1916; spent the rest of the war in Zurich; was in Berlin during the revolutionary period; and gained a reputation as a political activist on the basis of his poetry. But by the end of 1918 he had become a political skeptic and by 1920 he was turning to an apolitical mysticism.[84] Having articulated his political ideal of pacificism in *Der Retter* (*The Savior*) (1915–16) and written at least one major political poem, "Der politische Dichter" ("The Political Poet") (1917), which appeared in *Vorwärts* on 24 June 1917, Hasenclever became totally disillusioned with politics as a result of the failed German revo-lution. He then wrote a drama, *Die Entscheidung* (*The Decision*) (1919), that attacked the new German régime; moved toward Buddhism in his drama *Jenseits* (*The Beyond*) (1919–20); and spent most of the 1920s outside of Germany.[85] After a period of political activity in the Majority Social-ist Party in Dresden and Remscheid between November 1918 and summer 1921, Wolf became disillusioned with politics; spent most of the rest of 1921 in Heinrich Vogeler's rural commune in the Barkenhof at Worpswede; and then withdrew to rural Hechingen, south of Stuttgart, to practice there as an (apolitical) doctor.[86] Meidner became a pacifist as a result of his war experience; wrote pacifist texts during the last two years of the war; and

in 1917 turned from apocalyptic cityscapes to more religious subjects. He then contributed an impassioned manifesto (written in early 1919) titled *An alle Künstler!* (*To All Artists!*), a collection of political statements that appeared in spring 1919. But while advocating revolution and even flirting briefly with the Communist Party, Meidner, like the three literary men, developed serious misgivings about the new régime and politics in general as a result of which he fled from Berlin to his mother's home in the remote hinterland of Silesia until late 1919 and, on returning to Berlin, abandoned politics for religious subjects.[87]

The histories of the *Novembergruppe* (November Group) and the *Bund für proletarische Kultur* (League for Proletarian Culture) illustrate the third trend. The Berlin *Novembergruppe* was a group of humanitarian idealists that had been founded in November 1918 and numbered Max Pechstein, César Klein, Georg Tappert, and Moriz Melzer among its most prominent members. Its first manifesto expressed the group's desire to dedicate their best energies to the ethical development of a young, free Germany. But although there was officially no censorship in the Weimar Republic, the group allowed the Prussian Ministry of Culture to prevent work by Otto Dix and the Communist Rudolf Schlichter from being shown at its exhibition in the Lehrter Bahnhof in summer 1921. Consequently, the group's more radical members, including Hausmann, Höch, and Grosz, broke with it on the grounds that its nebulous humanitarianism had blunted its political edge and allowed it to be taken over by a régime that had used repressive violence to establish itself and perpetuate the exploitation of the proletariat.[88] The *Bund für proletarische Kultur* was founded in Berlin in September 1919 and included Becher, Rubiner, and Leonhard. To realize its aim of a "culture for humanity" and propagate "the eternal values bequeathed by the illustrious spirits of the past," the *Bund* worked initially with the experimental theater *Die Tribüne* that had opened on 20 September 1919. Unfortunately, this theater was dependent upon middle-class finance, and its board of directors, supported by some of the actors, prevented the production of *Die Wandlung* (whose author, Toller, was by then in prison for his part in the Munich Soviet) during the Berlin metalworkers' strike of mid-October 1919. Whereupon the *Bund* broke with *Die Tribüne* and founded its own *Proletarisches Theater des Bundes für proletarische Kultur* (Proletarian Theater of the League for Proletarian Culture), whose purpose was "to be the mouthpiece of the masses" and call the proletariat to direct action. Unfortunately, the one play that it put on was more calculated to reconcile the downtrodden masses to their lot than to incite

them to revolution. In December 1919, the *Bund* staged Herbert Kranz's *Freiheit* (*Freedom*) in the Berlin *Philharmonie*. Here, eight sailors who have been condemned to death for pacifism get hold of their cell key and yet decide not to escape so that they may purify themselves and, in the best tradition of German classical idealism, attain a state of inner freedom. Not surprisingly, the *Bund* and its theater dissolved in early 1920.[89]

The fourth trend is illustrated by the strange case of Herwarth Walden. Walden had always maintained that art had nothing to do with politics and that his periodical *Der Sturm* was, unlike Pfemfert's *Die Aktion*, rigorously apolitical. But in January 1916, he published an essay entitled "Das Hohelied des Preussentums" ("Anthem in Praise of Prussianism") in *Der Sturm* that hymned Prussia for its virtues of obedience and sobriety, its hierarchical social structure, its political order, and its military pride, and then concluded with the following, remarkable thought:

> Lernt die Wunder der Ordnung. Auch die Sonne scheint nicht nach ihrem Belieben. Auch die Sonne ist preussisch. Auch der Mond und die Sterne. (111)

> *Learn the wonders of order. Even the sun does not shine as it thinks fit. The sun, too, is Prussian. Likewise the moon and stars.*

Some recent commentators have read this piece as an exercise in satire, but the Dadaists took it seriously and it so angered them, more suited as it was to the age of Louis XIV than the declining years of the Hohenzollerns, that it was still rankling three years later. Indeed, Hausmann was still sounding off about it half a century later.[90] But even more recent research has revealed that Walden's *Sturm* enterprise was largely financed by his activities as an agent working on behalf of the German government for most of the war and that despite its arguably satirical tone, "Das Hohelied" probably did express Walden's real political beliefs.[91] Once the old régime collapsed, Walden moved by summer 1921 from the authoritarian, monarchist Right to the equally authoritarian Communist Left, probably via the Majority Socialist and Independent Socialist Parties. All of which explains why Grosz uttered dark hints about Walden in his letter to Schmalhausen of 30 June 1917 and never exhibited in his gallery. It also explains why Huelsenbeck expressed mistrust of Walden in his letter to Tzara of early-mid-1920, calling him a "durchaus reaktionäre Erscheinung" [a thoroughly reactionary phenomenon].[92] Because Grosz's Communism derived from a genuine, albeit skeptical populism, he must have sensed that Walden was

temperamentally very different and that his Communism of the Weimar years stemmed from a very different motivation.[93]

Of course, it would be totally absurd to suggest that if a few hundred late Expressionist writers and artists had been more realistically political, Hitler would not have come to power. But the Dadaists, I think, were right to identify the late Expressionists' political attitudes as potentially dangerous since over and over again, their disillusion with the German revolution either tipped over into disillusion with all forms of politics or turned into a political involvement that was more about grand gestures than practical activity. Both attitudes helped, albeit in a very small way, to create that public climate in which Hitler *could* come to power.

The Dadaists' fourth and final charge is also correct since late Expressionism has left us with a body of stridently windy, messianic poetry and a handful of highly improbable plays (such as Rubiner's *Die Gewaltlosen* [*The Pacifists*] [1918–19] and Fritz von Unruh's trilogy [1916–22]). Most farcically at the time, the assumption of spiritual leadership caused Kurt Hiller's *Rat geistiger Arbeiter* (Council of Spiritual Workers) to sit in conclave in the Reichstag in late 1918 and early 1919 solemnly deliberating, amid a state of virtual civil war, on such pressing and relevant topics as "the ethicization and spiritualization of politics," "the politicization of the spirit," and "the intellectualization of the proletariat." But most tragically, it caused a group of writers, artists, and intellectuals in Munich, who had no experience of politics and a dramatically underdeveloped sense of political reality, to encourage a revolution that was doomed from the outset, gained nothing, and caused a deal of unnecessary suffering for a large number of ordinary people.[94]

For all the justice of the four major charges that Dada laid at the door of late Expressionism, the Berlin Dadaists were by and large consistently unfair to the Expressionist poet August Stramm who was killed as a captain on the Russian Front on 1 September 1915. Without knowing of Stramm's death, Huelsenbeck published two parodies of his poetry, "Capriccio" and "Schmerz" ("Pain") in *Die Aktion* on 3 March 1916, and throughout the Dada period thereafter, the Dadaists tended to regard him both as a central member of an ultraconservative group (Walden's *Sturm-Kreis*) and as the originator of the "O-Mensch" poetry that they so abhorred.[95] Indeed, of those concerned with Berlin Dada, only Walter Mehring and Kurt Schwitters, two fringe figures, seem to have been sufficiently impressed by Stramm's work for this to have shown in their own poetry.

Stramm's influence on Mehring was short-lived and acknowledged in

an obscure newspaper article.[96] But with Schwitters (who was associated with the *Sturm-Kreis* from 1918 to 1924 at least), the influence was more sustained, and in 1919, he directly acknowledged it:

> Stramm war der grosse Dichter. Die Verdienste des Sturm um das Bekanntwerden Stramms sind sehr. Die Verdienste Stramms um die Dichtung sind sehr.[97]

> *Stramm was* the *great poet. The services performed by* Der Sturm *to make Stramm better known are great. Stramm's services to poetry are great.*

Stramm's influence is most marked in Mehring's four "Balladen" ("Ballads") (published in *Der Sturm* in July 1918) and the various poems that Schwitters published in *Der Sturm* between May 1919 and January 1920. Here, one finds the staccato rhythms, single-word lines, rhetorical stance, primal violence, and confusion of syntactical function that are so characteristic of Stramm's work. But at the same time, the *Sturm* poetry of both Schwitters and Mehring contains elements that point beyond Stramm. Neither is so desperately involved with his language as Stramm. Neither is so frantically concerned to twist language until it shrieks in order to preserve a precarious syntactical order in an exploding world. Neither is so beset by a sense of nothingness. In "Das Erlebnis August Stramm" ("The Experience of August Stramm") for example, Mehring indicates, by characterizing art as the objectivization of the "Weltwille" [Will which informs the world], that he possesses a sense of meaning beyond the human world that Stramm was increasingly unable to hold on to.[98] Moreover, unlike Stramm, both Mehring and Schwitters knew how to stand back and laugh. Mehring enjoys puns and the gratuitously grotesque (rhyming, for example, two incongruous words like "Sehnengeduckt" and "Viadukt"). Schwitters (who took his *Merz* poetry less seriously than his visual *Merz* work) enjoyed the silly word for its own sake ("Ich taumeltürme" [I tower-reel]) and not infrequently inserted amusing lines that subvert what has preceded them ("O, wenn ich das Fischlein baden könnte!" [Oh, if I could but bathe my little fish!]). To an extent, both Mehring and Schwitters were, in their early poetry, indulging in exercises in an idiom that was standard by then within the *Sturm* group, playing with language for its own sake. Stramm, in contrast, was always deadly serious, and his poems are images of a state of mind in which everything is on the point of disintegrating into nothingness. Where Stramm became increasingly horrified by the chaos around him, Mehring is exhilarated by the Futurist vision of "Höllen-

bahn" ("Railway of Hell"), and Schwitters seems not to mind being blown along like a leaf in "Ich werde gegangen" ("I Am Went") (1974). Where Stramm was increasingly haunted by the feeling that he could no longer relate to people and that everyday objects were falling apart and turning hostile, Mehring preserved without difficulty a sense of the integrity of objects, and Schwitters wrote poems to other people that are entirely free from Stramm's intense angst. Thus, the cheerfully satirical spirit of Mehring's lightweight cabaret verse and the half-serious, half-parodic spirit of Schwitters's "An Anna Blume" (1919) ("Ann Blossom Has Wheels," 1927) are already discernible behind the Strammian surface of their early *Sturm* poetry.[99] So, although neither Schwitters nor Mehring were Dadaists in the complex sense that Tzara, Huelsenbeck, and Hausmann were, both knew something of the freedom from black, defensive irony that distinguishes Dada from early Expressionism and the carnivalesque sense of play that distinguishes Dada from late Expressionism.

Overall then, the encounter between Dada and Expressionism in Berlin is more straightforward than that between Dada and Expressionism in Zurich. Precisely because Berlin Dada had inherited various supports from early Expressionism of which Zurich Dada was ignorant or had lost sight, it was better able, as Hausmann and Baader put it in their manifesto of mid-1919, "Legen Sie Ihr Geld in dada an!" ("Invest Your Money in Dada!"), to survive "the Twilight of the Gods" that had descended upon Europe. Consequently, they did not need to reinstate by rhetorical force a classical humanist view of human nature and a progressivist sense of history in a situation where most of the evidence was weighted against such a project.

10. Dada and Mysticism

In 1994 Klaus Vondung wrote that the Expressionist epoch saw a renaissance of interest in mysticism. This could be extended to the entire modernist period (see chapter 3), and Dada, as a radical modernist movement with its roots in early Expressionism, was by no means untouched by this phenomenon. Indeed, for over thirty years now, scholars, mainly working in Anglo-American contexts, have been pointing out connections between Dada and mysticism despite the powerful prejudice that Dada is nihilistic. Christopher Middleton referred to Dada's "faintly mystical tinge," and Leonard Forster wrote that Dada "stood in a long tradition of mystical utterance." Guenther Rimbach called the mystic desire "the dominant part of Arp's personality." Nancy Wilson Ross connected Dada and Zen while making the very necessary caveat that the comparison should not be taken too far. Virginia Whiles suggested an affinity between Tantric art and Duchamp's readymades on the grounds that Duchamp's found objects, like *Yantras,* "require contemplation towards a sense of enlightenment." Ko Won has written extensively on Buddhist elements in Dada. Erdmute Wenzel White has published several articles on Hugo Ball's mystical interests. And Harriett Watts has worked out in detail how Eastern and Western mysticism affected Arp's visual work, both during and after the Dada period.[1]

Postwar German scholarship, justifiably wary of irrationalism, has been much slower to recognize this aspect of Dada, but Hanne Bergius has documented a mystical strand in Berlin Dada, and Reinhard Nenzel has

shown how Huelsenbeck's *Schalaben-schalabai-schalamezomai* (published in August 1916 as part of Tzara's *Collection Dada*), while in no sense mystical, is full of biblical references.[2] Several Dadaists have made similar retrospective connections less guardedly. Hans Richter, using Rudolf Otto's concept, said that the Dadaists were trying to give back elements of the numinous to works of art and suggested in connection with his own poem "Conjunctio Oppositorum" ("The Conjunction of Opposites") that Nicholas of Cusa's (1401–1464) mystical concept of unity in multiplicity tacitly informed his artistic production during the Dada period. Jean Crotti described Dada as a wonderful liberation that allowed him to seek God through the universe. And in the foreword to the 1960 edition of his Dada poems, Richard Huelsenbeck went so far as to call the Dadaists missionaries who foretold the divine character of humankind.[3] Such retrospective claims, like those concerning the role and status of chance, are easily made but somewhat exaggerated. To begin with, the Dadaists, especially those in Zurich, were experimenters. Prosenc and Kemper pointed out a long time ago that they discovered their goals only after they had come near to attaining them, and all the subsequent evidence suggests that they were not as self-conscious about their aims as the above assertions imply.[4] Furthermore, during the Dada years themselves, the Dadaists never talked about Dada in such unambiguously and unironically religious terms. Quite the reverse: Dada sought to formulate its ideas obliquely, ironically, and in unfamiliar idioms to make it harder for them to be assimilated and deprived of their subversive force.

But although Dada was not a self-consciously religious phenomenon, it was certainly fed from the outset by an interest, often reticent and self-satirizing, in Eastern and Western religion and mysticism. During Walter Serner's brief religious phase, his proto-Dada Zurich periodical *Sirius* included a selection of the gloomier of Pascal's *Pensées* and displayed throughout its short existence (1915–16) a faintly pathological obsession with sin, guilt, evil, and judgment.[5] Franz Jung prefaced the first number of the proto-Dada Berlin periodical *Die freie Strasse* (1915) with a quotation from the beginning of book 2, chapter 10 of *Imitatio Christi* (c. 1413) by St. Thomas à Kempis (1380–1471): "Was suchst du Ruhe, da du zur Unruhe geboren bist?" [Wherefore seekest Thou rest, seeing as Thou are born unto unrest?], and Richard Oehring concluded the third number of the same periodical, published during the darkest days of the war, by quoting Romans 8:19, 22–23.

Dada in Zurich

At least two of the principal Zurich Dadaists—Arp and Ball—were deeply interested in mysticism during the initial Dada period. During his later years, after he had converted to Roman Catholicism, become much more pessimistic about Western civilization, and was suffering from a heightened sense of evil, Arp was increasingly drawn to the neoplatonic mystical tradition that makes a sharp distinction between matter and spirit and stresses the utterly transcendent nature of mystical experience. Thus, in *On My Way* (1948), Arp twice cites from first *Ennead* of Plotinus (205–c. 270)—once from the Eighth Tractate (where Plotinus meditates on the nature of evil) and once from the Sixth Tractate (where Plotinus meditates on the transcendent nature of beauty).[6] Arp was also very deeply affected by the death of his first wife, Sophie Taeuber, in 1943, and after her death, he published three groups of poems to which she is central.[7] Where the first two (written 1943–47 and 1943–45) consist of poems that mourn her loss, the third (written in 1948 and 1959), far from being a collection of threnodies, presents her as an almost angelic being who has soteriological affinities with the Virgin Sophia, Divine Wisdom, or the bride of the soul—a being whom Arp would almost certainly have encountered in *Der Weg zu Christo* (1622) (*The Way to Christ,* 1775) by Jakob Boehme (1574-1624).[8] Looking back, Arp claimed that the Dadaists were attracted by mystical poetry because they yearned for the "unbekümmerte Grund" [unencumbered ground] described by Johannes Tauler (c. 1300–61), a friar-preacher who, like Arp, came from Strasbourg and whose teaching stresses the idea that mystical experience involves the mortification of the flesh.[9] And when he was asked in 1956 which books had particularly influenced him, Arp named the poetry of Rimbaud and Novalis, Hermann Diels's *Die Fragmente der Vorsokratiker* (*The Pre-Socratic Philosophers,* 1946), and St. John's Gospel—the most mystical of the Gospels that presents Christ less as a man and more as the transcendent Logos.[10] But in his earlier years, Arp seems to have been drawn more to mystics from nonplatonic traditions who see God within matter. In 1914 he did a series of illustrations for the *Bhagavad Gita* (c. 800 B.C.). Like the other Dadaists during the time of the Cabaret Voltaire, he would have been attracted to Bergson's philosophy with its quasi-mystical sense of the interpenetration of matter and energy (see chapter 5). He claimed in retrospect that the Zurich Dadaists used mandalas as models, and he appears in Otto Flake's roman à clef about Zurich Dada as a devotee of Jakob Boehme and Lao-Tzu, traditionally re-

garded as the author of the *Tao Te Ching* (*The Book of Virtue and the Way*) (fourth or third century B.C.). And according to Watts, *Aurora*, the *Tao Te Ching*, and Arp's experience of the Monte Verità community near Ascona were decisive for his breakthrough to biomorphism in 1916 and 1917.[11]

Flake was quite open about Zurich Dada's mystical interest in an essay of 1920, and in his novel we also hear Puck (Ball) reading section 29 of the *Tao Te Ching* to Hans (Arp) and Lisbao (Tzara) (see chapter 5).[12] Although Ball's interest in Christian mysticism reached its height after his reconversion to Roman Catholicism in mid-1920 (see below), it was as early as 1915 when he made the connection between the politics of the sixteenth-century Anarchist Thomas Münzer (1498–1525) and the beliefs of the mystics and enthusiasts with whom he associated.[13] The connection between mysticism and radical politics exercised Ball for several years, and in a January 1918 letter to Emmy Hennings, he was mildly critical of his friend Arp for not seeing that German mysticism was essentially "staatsfeindlich" [hostile to the state].[14] But during the year or so leading up to 14 July 1916, Ball's mystical interest seems to have focused most intensively on Wilhelm Jahn's *Saurapurāṇam* (a translation from the Sanscrit of texts dealing with the sun god Shiva that had appeared in Strasbourg in 1908), Bergson, and the pre-Socratic philosopher Heraclitus (whom Ball would describe in his diary entry of 17 April 1917 as "ein Paradoxologe" [a paradoxologist]). As with Arp's attraction to Boehme and the *Tao Te Ching*, Ball seems to have been drawn during this period to mystical texts that and philosophers who do not make a sharp distinction between spirit and matter. White makes the point that the *Saurapurāṇam* (which Ball excerpted in his diary entry of 3 July 1915) is antidualistic, and her description of the world governed by Shiva (who is celebrated in the *Saurapurāṇam* as Atman) is extraordinarily close to Bergson's vision of *durée* and Heraclitus's vision of reality as a paradoxical mixture of form and flux (hence, presumably, Ball's characterization in his diary).[15] So in other words, like Arp, Ball was still wrestling during this period with the "Empedoclean problem" that is so central to Dada (see chapter 7): is reality chaotic, patterned, or a perspectival mixture of chaos and pattern that must be held in balance?[16] This question was not just an intellectual one for Ball: it tormented him until he glimpsed, in his experimental work of 1916, how it might be resolved by a return to the Catholicism of his youth (see chapter 5). So it is no accident that another of his sound poems from 1916, "Wolken" ("Clouds"), should include the line "elomen elomen lefitalominai"—a formulation strongly reminiscent of Christ's cry from the Cross "Eli, eli, lama asabthani" (Matt. 27:46).[17]

It took Ball another four years of turmoil before he finally returned to the church, and over this period, as White shows, the *Saurapurāṇam* found its way into Ball's fantastic novel *Tenderenda* in the form of adapted citations during both phases of his involvement with Dada. But in the light of what we know of the novel's origins, this process of reception virtually ceased once he had finally broken with Dada.[18] The four chapters that form the first part of Ball's tripartite novel can be dated to the period July 1915–late March 1916, but only one of them, the fourth chapter, "Satanopolis," contains (four) adapted passages from the Sanscrit source.[19] None of these four passages says anything about Shiva himself; none of them is as significant as the passages that Ball excerpted in his diary; and the chapter as a whole certainly does not constitute the "Tanz des Schreckens" [dance of terror] that White claims *Tenderenda* to be.[20] If anything, the reverse is the case. In the first passage, Lilienstein, the central figure of this chapter, feels good despite being persecuted and does yogic exercises to protect himself from his persecutors. The second passage concerns a holy phallus. The third deals with the charge brought against Lilienstein in the course of a parodic trial. And the fourth passage, which has only a very loose connection with the original text, details the food that Lilienstein eats while hiding from his persecutors. Similarly, although the third chapter of the first part, "Das Karussellpferd Johann" ("Johann, the Carousel Horse"), was probably written shortly after Ball had excerpted the *Saurapurāṇam* in his diary and does indeed deal with an absurd, acausal, and moderately apocalyptic world, it, too, is a long way from being a "dance of terror."[21] Indeed, although these four early chapters all depict a crazy world, it is essentially a comic one. The carnivalesque devil who appears in "Satanopolis" is far removed from the terrible, protean, unknowable, invincible Shiva who features in the excerpt that Ball had copied down in his diary, and even Lilienstein's crucifixion, a parodic version of Christ's passion and death, is dealt with lightly. So while Ball the man undoubtedly found that his experience of reality increasingly corresponded to the vision of Shiva contained in the *Saurapurāṇam,* during this early stage of his involvement with the Cabaret Voltaire and *before* the word "Dada" had gained wide currency, Ball the narrator attempted to deal with that vision in the same way that Kandinsky the painter had tried to deal with *his* sense of apocalypse — by *masking* it, not in abstraction but in robust, fantastic humor. As we shall see, Ball was unable to use the *Saurapurāṇam* quite so readily during his second Dada period.

Huelsenbeck was temperamentally less religious than Arp or Ball and

his mock-liturgical *Schalaben-schalabai-schalamezomai*—a title that refers to his interest in bruitism through its punning use of the German word "Schall" [sound/noise]—is less about mystical experience and more a grimly humorous attempt to deal with the sense of apocalyptic violence discussed in chapter 9. This explains why, as Nenzel's detailed analysis shows, nearly all the biblical references are to violent events from the Old Testament and the Book of Revelation: the God who presides over Huelsenbeck's poem is the Judeo-Christian equivalent of Ball's Shiva, a wrathful being who judges and destroys rather than redeems.[22]

After his epiphanic experience of late June and the trauma of the *Dada-Soirée* of 14 July 1916, Ball increasingly turned away from irrationalism and began his four-year pilgrimage toward ascetic Catholicism. During the latter half of 1916, he was helped along that path by André Suarès's book (1915) on the French Catholic writer Charles Péguy (who had been killed on 5 September 1914), and he published translated extracts from this book in René Schickele's pacifist periodical *Die weissen Blätter* (*White Leaves*) in October 1916.[23] Suarès's book was anti-German, and some of Ball's extracts were clearly meant to tell critics like Guilbeaux that he, Ball, was no German nationalist.[24] But the extracts also depict Péguy as a true Christian who was alienated from institutional religion, as a natural heretic by virtue of his deep religiosity, and as a profoundly moral being who had attained inner, spiritual freedom by rejecting all fixed systems of morality. As such, he is said to form the antithesis of Rimbaud who embodied "heiliger Fieberwahn, tappend und blind das Genie erstickend" [holy, self-deluding fervor, which, groping and blind, suffocates genius]—and Rimbaud, it will be remembered, was closely and justifiably associated in Ball's mind at that time with the excesses of early Dada.[25]

By the time Ball returned to Zurich in spring 1917 to direct the Galerie Dada, he had gone a long way down the theological path that divides spirit from matter and the passions, and this stricter dualism altered the way in which he used the *Saurapurāṇam* when producing the second part of *Tenderenda*. To begin with, it seems very likely that he wrote the first chapter of the novel's second part, "Grand Hotel Metaphysik," in the aftermath of the abortive performance of *Sphinx und Strohmann* on 14 April, since he read it out, in costume, at the third *Dada-Soirée* on 28 April. This chapter not only contains a larger number of citations (six) from the *Saurapurāṇam* than "Satanopolis" of the year before, but these citations are of a quite different order. The first deals with rage (of which there is no mention in the original) and links this destructive passion with sexuality. The

second and third develop a brief mention of religious observance and mobile shrines in the original text into images of monstrous destruction and a juggernaut. The fourth and fifth make use of passages describing Shiva as the god of destruction and death.[26] And the sixth turns a passage describing the sumptuousness of Shiva's marriage into a passage describing an idol with a pointed head and a low forehead. Or in other words, "Grand Hotel Metaphysik" accords much better with White's global characterization of Ball's novel; dovetails perfectly with the strictures on irrationalism that he had set down in his diary on 25 March, 5 May, and 23 May 1917 (see chapter 9); is considerably less carnivalesque and more violent than "Satanopolis"; and is essentially concerned, as its preface tells us, with the birth of Dada. Thus, "Grand Hotel Metaphysik" constitutes an unequivocal statement on Ball's part that exactly parallels his putative interpretation of *Sphinx und Strohmann:* Dada, as he now understood it, was playing with extremely dangerous, not to say hellish and diabolic fire.[27]

In this context the program of the fourth (closed) *Dada-Soirée* of 12 and 19 March, which, at first glance, appears highly eclectic, becomes an encoded theological debate about the relationship between God/the spirit and Nature/the passions to which there were two distinct sides. The Italian Alberto Spaïni began the evenings by reading work by Jacopone da Todi (c. 1236–1306), a Franciscan mystic, who wrote some of his greatest poems, the *Lauds,* during the last ten years of his life, five of which he spent in a subterranean cell for taking part in a revolt against Pope Boniface VIII. About a century ago, an Italian writer first referred to Jacopone as "Il giullare di Dio" ("The Fool of God") and it is very likely that Spaïni read out poems (such as 74, 76, 82, or 84 of the 1558 edition) that celebrate holy madness; tell of the limitations of human reason; and celebrate a Creation in which God is everywhere.[28] Later on, Arp read from Boehme's *Aurora,* a work that debates in arcane detail whether a principle of meaning and order is at work within the fluctuations and contradictions of material Nature. Although Boehme is convinced that the Holy Spirit is indeed the triumphant, springing, moving spirit in Nature, the two sections read out by Arp deal with the fragility of the order in Nature and the ambiguity of the dynamic powers at work there. In "Von der Kälte Qualifizierung," Boehme posits two necessary but contrary principles in Nature: cold and heat. If either principle becomes too *grimmig* [fierce], it overwhelms the other and becomes destructive. Consequently, the persistence of life depends upon a balance between the two opposing principles. In "Von der bitteren Qualität," Boehme speaks of a bitter quality that per-

meates Nature as "the heart of all things living" and endows them with their quality of greenness. Where this quality dwells *sänfftig* [meekly], it is the "ground of joys or laughter" and dissipates all other evil influences:

Dan so sie beweget wird / machet sie eine Creatur zittern und freudenreich / und erhebet dieselbe mit gantzem Leibe / dan es ist gleich ein anblick der Himlischen freudenreich / eine erhebung des geistes / ein geist und crafft in allen gewächsen auß der Erden / eine Mutter des Lebens. Der H. Geist wallet und treibet mächtig in dieser qualität / dan sie ist ein stück der Himlischen Freudenreich / wie ich hernach beweissen will.

For when the bitter quality stirreth, it causeth the creature to tremble and be joyful, and to be lifted up with its whole body; for it is, as it were, a glimpse or ray of the heavenly Kingdom of joy, an exaltation of the spirit, a spirit and force in everything that groweth upon the earth, a very mother of life. The Holy Ghost surgeth and driveth mightily in this quality, for it is a piece of the heavenly Kingdom of joy, as I shall hereafter demonstrate.

But if this bitter quality becomes "fierce," quitting its rightful place or becoming too preponderant in any creature, it becomes destructive; corrupts all goodness; separates flesh from spirit; and brings about death. The relevance of these texts to Dada's quest for balance amid opposites, poise within absurd flux, should by now be self-evident. In *Aurora,* Boehme sought to envisage the possibility of a balance in Nature between spiritual, material, and demonic powers while understanding the chaos that ensues when this balance is disturbed. Similarly, Arp wanted human beings to achieve an analogous balance between their spiritual, fleshly, and spontaneous energies while being aware of the danger they run when any one energy becomes too preponderant. Like Boehme, Arp understood how fine is the line between balanced freedom on the one hand and unbalanced destructiveness on the other.[29]

On the same evenings, Emmy Hennings, almost certainly prompted by Ball, read extracts from *Das vliessende licht der gotheit* (*The Flowing Light of the Godhead*) (c. 1250–65) by Mechthild of Magdeburg (c. 1212–1283); a passage from *Das puch der siben grâde* (*The Book of the Seven Stages*) (1320?) by the anonymous Monk of Heilsbronn; and part of the *Grosse deutsche Memorial* (*The Great German Memorial*) (1383–84), a posthumously compiled collection of writings by the Alsatian mystic Rulman Merswin (1307–1382).[30] We do not know exactly which passages Hennings read out from

Mechthild's work, but in the light of what has been said so far, she may well have chosen passages from part 1, chapter 2, where Mechthild speaks of "the very greeting of God" that pours out on the world from "the heavenly source, the flowing spring of the Trinity." Like da Todi and Boehme, Mechthild saw a sustaining and ordering power working within the flux of material Nature. Similar considerations may also partly explain why Hennings read from *Das puch der siben grâde*. Ball's diary entry of 12 May 1917 indicates that her reading began at line 1537 of the text with a passage that echoes the dictum "Blessed are the poor in spirit" (whose relevance for the exiled Dadaists living in poverty in Zurich needs no gloss). There then follows an extended description of Christ's love pouring out on the world to redeem sick and failing humanity. Now, although the panentheism that marks the other three mystics discussed so far is still discernible in this fourth text, it is overshadowed by the mawkish spirituality of the Monk's doggerel and an antimaterialistic dualism that is much closer to the theological position that Ball was increasingly taking. In his diary, Ball glossed the fifth and final mystical text to be read out with the epigraph "Grundlos einig sein" [To be boundlessly at one]. Although this does not seem to be a direct quotation from the *Memorial,* it gives a very clear sense of the direction in which Ball's mind was moving since the *Memorial* is even more antimaterialistic and dualistic than *Das puch der siben grâde*. It stresses the inward nature of the spiritual life and has little to say about the activity of God in Nature. Furthermore, Merswin was a rich Alsatian merchant who, in 1347, during an era of considerable upheaval, gave up his secular work in order to devote himself to the contemplative life together with his wife, Gertrud. In 1367 he bought the ruined Benedictine abbey at Grünenwörth near Strasbourg, and in 1371 he passed this property over to the order of St. John. Under Merswin's financial management, the abbey became the center of the Johannite order in Alsace. Given this, an additional motive behind Hennings's and Ball's attraction to Merswin's highly introverted brand of mysticism becomes plain: here were a man and a woman who had withdrawn from a troubled world to find oneness with God in ascetic seclusion and by means of spiritual discipline. This is exactly what Ball would do in 1920 when, with Hennings, by then his wife, he turned his back on modernity and moved to a tiny village in the Tessin to study, among other things, the ascetic Desert Fathers (see below).

Ball's remarks on Boehme in his diary are entirely consistent with the theological debate that was conducted in the Galerie Dada. On 11 May

1917, the day before the first performance of the fourth *Dada-Soirée*, Ball commented on a text by the Catholic theologian Franz von Baader (1765–1841) in which the *Naturphilosophen* [natural philosophers] Paracelsus (1493–1541) and Boehme are discussed. Here he noted that where, as in the case of Boehme, the imagination is not grounded in revelation and tradition, it is the agent of diabolic delusion and leads to the abyss. Similarly, on 12 April 1918, almost exactly a year after the *Sphinx und Strohmann* fiasco and on the very day when the Berlin Dadaists were holding their first major *Soirée*, Ball identified Boehme as one of those philosophers and theologians who want to enslave human beings to Nature and their own natural drives, and commended strict asceticism as the true way to freedom. The fourth *Dada-Soirée* must have brought it home to Ball just how far removed he had become theologically from his friend Arp. For where Arp could affirm transcendent pattern in apparently chaotic Nature and would translate this into visual terms by means of his key image of the "bewegte Ovale" [the dynamic oval], Ball increasingly saw Nature and those human faculties that he considered natural, such as Bergson's intuition, as fallen and godless.[31]

Ball's early and Arp's lifelong attraction to the pre-Socratic philosophers, especially Heraclitus, also has its place within this theological debate. Heraclitus's philosophy involves the paradoxical assertions that while reality is a unity, it also involves the conflict of opposites, and that the innermost substance of matter is a chaotic, moving fire within which a principle of order (Logos) is nevertheless at work. In his uncompleted doctoral thesis on Nietzsche of 1909 and 1910, Ball had approvingly cited Nietzsche's own endorsement of Heraclitus's *"Lehre vom Gesetz im Werden, und vom Spiel in der Nothwendigkeit"* [*doctrine of law in the process of becoming and of play in necessity*], and it was undoubtedly Heraclitus's paradoxical understanding of the flux of Nature that made Diels's edition so important to Arp. Tzara, too, almost certainly got to know Heraclitus's writings through Arp, and although he was less mystically inclined than either Ball or Arp, he would, in 1948, link Zurich Dada with that philosopher's "dialectic."[32]

Traces of this interest in mysticism are evident at several points in the writings of the Zurich Dadaists. The classically mystical image of the dark light, the light which is so bright that it seems like deep darkness, occurs in Arp's poems "kaspar ist tot" and "Pupillennüsse 4" ("Pupilnuts 4"), and the same image can be found in Tzara's poem "amer aile soir" ("bitter wing

evening"), written in mid- to late 1917.[33] Tzara's "Note 14 sur la poésie" (March 1917) ("Note on Poetry," 1977) contains the statement:

L'obscurité est productive si elle est lumière tellement blanche et pure que nos prochains en sont aveuglés.

Obscurity must be creative if it is so pure a white light that it blinds our fellow men.[34]

Earlier on in the same piece, a passage cited in chapter 7 recalls the mystico-alchemical doctrine of signatures according to which everything in Nature is a sign of the in-dwelling God who created it and on which Boehme had published a book, *Signatura Rerum* (1622) (*The Signature of All Things*, 1651).[35]

Dada in Berlin and Elsewhere

An interest in mysticism is also discernible among the Berlin Dadaists. In an (as-yet) unpublished manuscript, Hausmann claimed that from about the age of sixteen he had read the pre-Socratics, Lao-Tzu, Buddhist texts, Meister Eckhart (c. 1260–c. 1327), Boehme, and Angelus Silesius. Up to late 1916, the marginalia in Hausmann's copy of *Die Aktion* indicate either a familiarity with or a desire to read the *Bhagavad Gita*, Pascal, Bergson's *Évolution créatrice,* and Ottokar Březina's *Hymnen* (*Hymns*) (translated into German by Oskar Baum)—poems that recall Whitman's *Leaves of Grass* (to which Hausmann was particularly attached). Hannah Höch's library included Martin Buber's edition of *Reden und Gleichnisse des Tschuang-Tse* (*Sayings and Parables of Chuang Tzu*) and *Die Bahn und der rechte Weg des Lao-Tse,* a German translation of the *Tao Te Ching* that had been given to her by Hausmann on 11 February 1916. Johannes Baader, too, had a genuine, if zany, interest in mystical and chiliastic religion. He published a book in 1914 entitled *14 Briefe Christi* (*14 Letters of Christ*) (in which he identified fairly strongly with the alleged author).[36] Bergius cites a 19 November 1916 letter from Baader to Hausmann in which he wrote:

Die Frucht vom Baume des Lebens hast du gegessen, wenn du beide Seiten Gottes im Gleichgewicht halten und in dir spielen lassen kannst nach deinem Willen.[37]

You have eaten of the tree of life if you can hold both sides of God in balance and allow them to play within you according to your will.

On 30 July 1918, he published his crazily metaphysical *Acht Weltsätze* (*The Eight World Theses*, 1980) in the popular Berlin newspaper the *BZ am Mittag*. In December of that year, he edited the tenth number of *Die freie Strasse*, which abounds in quasi-mystical statements. And after Dada was over, in 1925, Baader wrote several poems in praise of Buddhism and the Buddha.[38] Huelsenbeck's *Dada Almanach* included an item entitled "Zur Theorie des Dadaismus" ("Towards a Theory of Dadaism") by Dada-Daimonides (the Berlin dermatologist Dr. Carl Doehmann [1892–1982]). Of the epigraphs that prefaced the eight sections of this contribution, one is from Pascal's *Pensées;* one is a highly paradoxical piece from chapter five of the second and third-century church father Tertullian's treatise *De carne Christi* (*Concerning the Flesh of Christ*) (c. 206); and one is from section 28 of the *Tao Te Ching*.[39] And Ellen Maurer's research has demonstrated the importance of Bergson's philosophy for the visual work of Höch.[40]

Elsewhere, the interest in mysticism is less pronounced, but in early 1917, Prampolini, like the Zurich Dadaists, was certainly reading Bergson with enthusiasm.[41] The Belgian writer Michel Seuphor, closely associated with Dada in Paris, recorded that, as a young man, he had been particularly impressed by the writings of Lao Tzu's successor Chuang Tzu.[42] There is also a clear element of nature mysticism in the manifesto *Tabu* that was issued in October 1921 by the Paris Dadaist Jean Crotti. Maria d'Arezzo, who was peripherally associated with Zurich Dada, wrote to Tzara in October 1919 that she was doing intensive work on the Greek pre-Socratic philosophers.[43] The foremost Italian Dadaist, Julius Evola, published an Italian translation of the *Tao Te Ching* shortly after his involvement with Dada, and judging from its introduction (written in September 1922), he was already familiar with the works of Meister Eckhart and the Syrian monk Pseudo-Dionysius (otherwise known as Dionysius the Areopagite, c. 500), the father of Western kataphatic mysticism.[44]

During the Dada years themselves, several Dadaists made half-joking, half-serious pronouncements about the relationship between Dada and religion, both Eastern and Western. In 1919, probably in association with Baader or Huelsenbeck or both, Hausmann proclaimed:

dada ist die einzige Sparkasse, die in der Ewigkeit Zins zahlt. Der Chinese hat sein *tao* und der Inder sein *brama*. *dada* ist mehr als *tao* und *brama*. . . . *dada* ist die Kriegsanleihe des ewigen Lebens. . . . Gotama dachte ins Nirwana zu gehen und als er gestorben war, stand er nicht in Nirwana, sondern im *dada*. Der *dada* schwebte über den Wassern

ehe der liebe Gott die Welt schöpfte, und als er sprach: es werde Licht! da ward es nicht Licht, sondern *dada*. Und als die Götterdämmerung hereinbrach, war der einzig Überlebende der *dada*.[45]

dada is the only savings bank that pays interest in eternity. The Chinaman has his tao *and the Indian his* brama. dada *is more than* tao *and* brama. . . . dada *is the defense bond of eternal life. . . . Gotama thought of entering Nirvana and after he was dead, he stood not in Nirvana, but in* dada. *The* dada *hovered above the face of the waters before God created the world, and when he spake: let there be light! lo, there was not light, but* dada. *And when the Twilight of the Gods broke in upon us, the only survivor was the* dada.

In 1920 Hausmann wrote:

DADA, geboren aus der Unerklärlichkeit eines glücklichen Augenblicks, [stellt] die einzig praktische Religion unserer Zeit [dar].[46]

DADA, born from the inexplicability of a fortunate instant, [constitutes] the only practicable religion for our age.

And in 1921:

die teilweise Unerklärbarkeit des Dadaismus ist erfrischend für uns wie die wirkliche Unerklärbarkeit der Welt—möge man nun die geistige Posaune Tao, Brahm, Om, Gott, Kraft, Geist, Indifferenz oder anders nennen—es sind immer dieselben Backen, die man dabei aufbläst.[47]

the partial inexplicability of Dada is refreshing for us like the actual inexplicability of the world—whether you call the spiritual trump Tao, Brahm, Om, God, Energy, Spirit, Indifference, or anything else—you puff out the same cheeks while you do so.

In 1924 Kurt Schwitters characterized Dada as the spirit of Christianity in the realm of art.[48] In 1923 Theo Van Doesburg, who associated the liberating qualities of Dada with the mystical potential of four-dimensional, non-Euclidean geometry, proclaimed that Jesus Christ was the first Dadaist and added later on in the same article:

Wanneer men b.v. in de Upanishade leest dat het universum gelijk is aan een boom wiens wortels in de hemel en wiens kruin in de aarde groeit dan is man hiervoor (vooral bij'n schemerlamp) in groote bewondering.

Als men echter in onzen tijd van dada zegt; dat het is een vogel met vier pooten een kwadraat zonder hoeken, dan is dit klinkklare onzin! Dit is Dada![49]

When one reads in the Upanishads, for example, that the universe is like a tree whose roots grow into the sky and whose top grows into the earth, one is full of admiration (especially by the light of a table lamp). But when we say nowadays that Dada is a bird with four legs, a square without corners, then this is the sheerest nonsense! This is Dada!

(Incidentally, the image of a "square without corners" actually comes from section 41 of the *Tao Te Ching*.) In his speech to the Weimar Dada-Constructivist Congress of September 1922 ("Lecture on Dada," 1951), Tzara called Dada "le retour à une religion d'indifference quasi-bouddhique" [a return to a quasi-buddhist religion of indifference] and asserted that Chuang Tzu was as Dada as we are.[50] And in his introduction to the *Dada Almanach,* Huelsenbeck wrote:

Dada ist die amerikanische Seite des Buddhismus, es tobt, weil es schweigen kann, es handelt, weil es in der Ruhe ist.

Dada is the American aspect of Buddhism; it blusters because it knows how to be quiet; it agitates because it is at peace.[51]

But New York Dada, most of Paris Dada, Cologne Dada, and the work of Picabia after late 1913 seem to have been untouched by any interest in mysticism—a lack that relates directly to the two poles of Dada identified in chapter 7.[52]

Dada and Mysticism

To document this (often self-satirizing) interest in mysticism is not, of course, to identify Dada vitalism with Eastern and Western mysticism *en gros.* There are several distinct strands within these two broad traditions and the Dadaists were by no means drawn to them all. They were not, for example, particularly interested in Western pan-en-henic mysticism or mainstream Christian mysticism. The Dadaists neither underwent nor sought to undergo the pan-en-henic experience of egoless absorption into Nature such as is described in Jean-Jacques Rousseau's *Rêveries d'un promeneur solitaire* (*Reveries of a Solitary Wanderer*) (1776–78) or Richard Jefferies's *The Story of My Heart* (1883). Although the Dadaists sought a

dynamic balance within a fluctuating, polyphonic, and conflictual reality, they did not cultivate ecstatic states like those described in Buber's *Ekstatische Konfessionen* and I know of no reference to this anthology in any Dada text. Indeed, because Buber was centrally concerned with mysticism as a way of achieving "die Einheit des Ich" [the unity of the self/ego] when assembling his anthology, Ball may have had it in mind when, in his diary on 14 May 1917, he compared modern, ego-centered mysticism unfavorably with medieval mysticism.[53] Having recognized the dangers of the Expressionist cult of ecstasy, the Dadaists feared that such ecstatic states of mind would either destroy their sense of balance, or take them away from the realities of society and politics, or lead them toward totalitarianism of one kind or another. This is why, around April 1919, Hausmann made fun of Paul Adler and his books *Elohim* (1914) and *Nämlich* (*Namely*) (1915).[54] Where Adler's project of resacralizing Weber's desacralized world involved the desire to return to the Middle Ages, Hausmann was committed, albeit critically, to the here and now and said so in manifesto after manifesto. Huelsenbeck was scathing about Expressionist Gothicism for similar reasons.[55] For both Hausmann and Huelsenbeck during their Dada years, it was a question not of withdrawing from the harsh realities of modernity, but of confronting them and finding a way of keeping one's balance amid their threats, fluctuations, and contradictions.

So although the Dadaists read and learned from Christian mystical texts, their sense of a force at work within Nature is in no way cognate with the Christian mystic's beatific vision. Where the Christian God is regarded as loving and personal, the *élan vital* that Dada perceives all around is capricious and impersonal. Where the Christian mystic stresses the laborious path upward to enlightenment through moral self-discipline, prayer, spiritual exercises, and periods of spiritual sterility, the Dadaists stress the spontaneous urge of the moment that is beyond good and evil. Where the Christian mystic stresses spiritual inwardness, the Dadaists stress extraverted natural exuberance. Where the Christian mystic is acutely conscious that the soul is a battleground for forces of cosmic good and cosmic evil and can, like the anonymous author of *The Cloud of Unknowing* (c. 1370), go so far as to identify vitalistic urges with diabolic temptations, the Dadaists had little or no sense of cosmic evil—only a sense of the cruelty of Nature and the obduracy and viciousness of human beings. So if, for example, Tzara *did* get to know Boehme's ideas on signatures via Arp, there is all the difference in the world between his affirmative vitalism and Boehme's acute sense of Nature's potential for evil as that is expressed

in *Signatura Rerum*. More fundamentally still, where Christian mysticism must ultimately tend toward a distinction between God and Creation, soul and matter, Dada is much more monistic, affirming the unity of the life force and the material world and the dependence of the human psyche on the body and that world. This is graphically illustrated by an apparently minor alteration to an essay on Hans Arp that Huelsenbeck originally wrote in Zurich in September 1916, a shortened version of which was finally published in *Dada* 3 (December 1918). In his original typescript, Huelsenbeck had written:

> Die Welt ist gross und voller Wunder. Wunder sind die seltsamsten Abstraktionen und geistigen Willenswesen weit über den Dingen.[56]

> *The world is great and full of miracles. Miracles are the strangest abstractions and spiritual beings deriving from the will, far above things.*

But before sending the typescript to Tzara, Huelsenbeck changed "über" [above] to "hinter" [behind], a preposition that implies a closer relationship between the metaphysical world of miracles and the physical world of objects.

Given these distinctions, Dada outside of Zurich tends, like Arp in Zurich, to be drawn toward those Western mystical texts where the emphasis is upon the dynamic activity of God within the world of matter. The verses from *Romans* quoted by Oehring in *Die freie Strasse* 3 speak of the groans and travails of material Creation as it awaits its redemption by the Spirit. Analogously, Dada struggles to integrate the physical and spiritual energies in human nature and, in some cases, to perceive a significant pattern within the apparent chaos of Nature. The sentence from the *Imitatio* that Franz Jung included in *Die freie Strasse* 1 is untypical of that work in that it stresses not "the peace of God that passeth all understanding" or the soul's dialogue with God, but struggle and change—two concepts that are central to Dada. Tertullian wrote *De carne Christi,* from which Dada-Daimonides took one of his epigraphs, against the docetic heretic Marcion who regarded matter as evil; denied the Incarnation; rejected the humanity of Christ; and did not believe in the redeemability of the flesh. So it is obvious why the quotation used in the *Dada Almanach* should have come from a highly paradoxical passage where Tertullian emphatically affirms all those dogmata denied by Marcion. Like the church father, Dada affirms the interpenetration of the material and the spiritual and the possibility of the impossible (in Dada's case the possibility of keeping one's bal-

ance within the flux of the material world).[57] Likewise, Crotti's manifesto *Tabu* contained the statement: "We wish through forms, through colors, through it matters not what means, to express the mystery, the divinity of the universe, including all mysteries."[58] Baader's mysticism, accurately described by Bergius as "monistisch-pantheistisch" [monistically pantheistic], is similar in kind. In his *Acht Weltsätze* of July 1918 we read, for instance, that men are angels and dwell in Heaven, that chemical and physical changes are magical processes, and that the earth is a piece of heaven. And in *Die freie Strasse* 10, Baader solemnly demanded that the doctrine be taught in our schools that human beings spring from the eternal majesty.[59] Again, the link between Dada and Baader's eccentric mysticism is plain: people have angelic status because they already participate in the divine power that interpenetrates with the material world.

The attraction of the Dadaists to Eastern mysticism is more straightforwardly explicable and fits in completely with what has been argued so far. According to an English translator of the *Bhagavad Gita,* the essence of this great poem is the revelation of God in Creation.[60] When Arp produced his series of illustrations for this work in 1914, his naturally panentheistic imagination must have been grasped by Krishna's vision of Brahman:

> Now I shall tell thee of the End of wisdom. When a man knows this he goes beyond death. It is Brahman, beginningless, supreme: beyond what is and beyond what is not.
>
> His hands and feet are everywhere, he has heads and mouths everywhere: he sees all, he hears all. He is in all, and he is.
>
> The Light of consciousness comes to him through infinite powers of perception, and yet he is above all these powers. He is beyond all, and yet he supports all. He is beyond the world of matter, and yet he has joy in this world.
>
> He is invisible: he cannot be seen. He is far and he is near, he moves and he moves not, he is within all and he is outside all.
>
> He is ONE in all, but it seems as if he were many. He supports all beings: from him comes destruction, and from him comes creation.
>
> He is the Light of all lights which shines beyond all darkness. It is vision, the end of vision, to be reached by vision, dwelling in the heart of all. (13.12–17)

Furthermore, the *Bhagavad Gita,* like Arp and several of the other Dadaists, is centrally concerned with balance amid opposites (12.4); involves the sense that reality is a dynamic intertwining of a polyphonic complex of

natural and spiritual powers (8.3; 13.21–22; 14.5; 14.19); and understands the proximity in Nature of creation and destruction (10.21–23; 11.30).

But the Eastern writers who held the profoundest and most consistent significance for Dada were undoubtedly the Taoist sages Lao Tzu and Chuang Tzu. There is, for example, a clear analogy between Dada's vision of reality as unending process and the Taoist concept of the Tao (Way) that flows freely, mysteriously, and indifferently as the creative ground of all things. In the *Tao Te Ching,* the Tao is described as the nameless mother of the myriad creatures (1, 32, 34), which nevertheless claims no possession, gratitude, or merit (2).[61] It is said to be ruthless, treating the myriad creatures like straw dogs (5), and yet spiritual (29). It is empty yet inexhaustible (5, 45), small yet great (34), and free from desire (34). It never acts, yet leaves nothing undone (37). Substitute "Dada" for "Tao," formulate the above characterizations several degrees more ironically and outrageously, and one has a perfect set of Dada dicta about the nature of reality.

There is also considerable similarity between the Dadaists' desire to balance the various forces of the personality around its moving center and the teaching of the Taoist *T'ai I Chin Hua Tsung Chih* (*The Secret of the Golden Flower*). Here, the birth of the "Golden Flower," the integrating center of the personality, is said to take place at the moment of greatest stillness through the marriage of the feminine principle or unconscious (*k'un*) with the masculine principle or consciousness (*ch'ien*). Just as Dada aims to shift the center of the personality from the conscious ego to the unconscious faculties of imagination, spontaneity, and acceptance, so Taoism aims to integrate the psyche around the *hsin,* the autonomous visceral center of the personality so that human beings may "exercise their minds without being toiled" and "respond to everything without regard to place or circumstance."[62] When the *hsin* works in spontaneous harmony with the Tao, balancing the positive and negative principles (*yang* and *yin*) about itself, *te* (virtue) arises. By "virtue," the Taoist does not mean conscious obedience to ethical precepts, but, like the Dadaist, the ability to respond appropriately and intuitively to the given situation. As with Dada, Taoism desires to give freedom to the instinctual processes of the personality without permitting them to overwhelm or annihilate the rational consciousness—a carefree "presentism" that Zen, the descendent of Taoism, celebrated in the two happy, paleo-Dada idiots Kanzan and Jittoku.

For both Taoism and Zen, suspension of the will, nonaction, being fully in the present moment without regard to the future, constitute the whole point of existence. In this spirit, Hausmann said, "DADA *will* nichts . . .

als DA sein" [DADA *wills* nothing . . . but to be THERE].[63] Similarly, the *Tao Te Ching* urges men to have "as few desires as possible" (19) and Chuang Tzu states:

> He who practises the Tao, daily diminishes his doing. He diminishes it and again diminishes it, till he arrives at doing nothing. Having arrived at this non-inaction, there is nothing that he does not do.[64]

Like the Dadaist who dances aimlessly within the flux of Nature, true only to his own spontaneous impulses, the Taoist adept "may be described as acting and yet not relying on what he does, as being superior and yet not using his superiority to exercise any control" (25). Indeed, the ideal person envisaged by Dada has a certain similarity with the old man whom Confucius saw treading water happily in the fierce cataract of Lu. When Confucius marvelled at the old man's ability to swim where no fish could, he replied:

> I enter and go down with the water in the very centre of its whirl, and come up again with it when it whirls the other way. I follow the way of the water, and do nothing contrary to it of myself;—this is how I tread it. (21)

In short, Taoism, like one pole of Dada, advocates a return to a childlike trust in the inherent, if concealed, patterning of apparently absurd experience—which is perhaps why Dada-Daimonides used the following quotation from a German translation of the *Tao Te Ching* as one of his epigraphs in the *Dada Almanach:*

> und er kann wieder umkehren und werden wie ein Kindlein. . . .
> und er kann wieder umkehren zum Ungewordenen (28).

> *and he can turn again and become as a small child . . .*
> *and he can turn again and become that which has never become.*

Like Dada, Taoism loves paradox and mistrusts rigid categories and binarisms; like Dada, Taoism believes that reality, being fluctuating and contradictory, can never be exhaustively grasped in conceptual categories; like Dada, Taoism believes that to name a complex reality is to diminish it. Dada tends to maintain this attitude implicitly, through the very form in which its statements are cast, but Chuang Tzu is more explicit, declaring:

> The Tao cannot have a (real) existence; if it has, it cannot be made to appear as if it had not. The name of Tao is a metaphor, used for the pur-

pose of description. . . . The Tao is the extreme to which things conduct us. Neither speech nor silence is sufficient to convey the notion of it. Neither by speech nor by silence can our thoughts about it have their highest expression.[65]

One could without difficulty compile a list of Dada dicta that parallel the teachings of Taoism and Zen, and Ko Won has done so in respect of Tzara.[66] But the affinity between Dada and these strands of Eastern mysticism comes across most economically in the following little poem. Written in Tunis by Albert Chemia for inclusion in the never published anthology *Dadaglobe* (1921), it contains several of the essential sentiments expressed in the *Tao Te Ching:*

> DADA c'est parler pour ne rien dire
> Dada n'entre ni ne sort, c'est un boudin à ressorts,
> Dada c'est la vie, c'est la mort.
> Dada, quel grand farceur, ni mère, ni père, ni soeur.
> Un sourire enfantin, un ange mystique;
> Dada n'a pas de tics,
> Dada n'est ni végétarien, ni carnivore.[67]

> *DADA is speaking to say nothing*
> *Dada neither comes in nor goes out, is a coiled-up spring,*
> *Dada is life, is death.*
> *Dada, what a great joker, neither mother, nor father, nor sister.*
> *A childish smile, a mystic angel;*
> *Dada has no tics,*
> *Dada is neither vegetarian nor carnivorous.*

The points of contact between one pole of Dada and Taoism should not, however, obscure four important differences. First, Dada attitudes are the product of modernity and as such are less contemplative, more active, rawer, and more aggressive than Taoist attitudes. Even allowing for an element of self-caricature, there is no equivalent in Dada literature of the sage in section 20 of the *Tao Te Ching* who compares his state of enlightened passivity to that of "a baby that has not yet learned to smile" and describes himself as "inactive, drowsy, and blank." Second, although the Dadaists do not regard the individuated consciousness as the principal human faculty, they set more store by it than do the Eastern mystics. Correspondingly, the Dadaists retain a sense that there is an integrating factor within the human personality, a capacity to hold opposites in balance, which,

although elusive, is much harder, much more substantial than the corresponding Eastern doctrine of *anatman* [absence of any self]. Third, where the end of Taoism is the liberation of the ego from the conflict of opposites, the attainment of a state of integrated nonaction (*wu-wei*), Dada aims at the integration of the personality *within* the conflict of opposites, a state of being in which conflicts are accepted but not abolished. For Dada, conflict is real: for Taoism, it is only apparent. Consequently, Dada has no real equivalent of the all-important Taoist/Zen experience of *satori*, the moment of awakening or enlightenment when all conflicts are transcended. Finally, the utterances of even the most mystically interested of the Dadaists are not as explicitly metaphysical as those of the Taoist sages. Dada's language is more naturalistic; its concept of the life force more material; its ideal of the personality that strives toward balance within that life force more psychological. Thus, because Dada cannot be sure that its words have any ultimate authority, it utters them out of a strong sense of self-irony. Where the Taoist sage laughs at himself as the sign of the reality of his liberation from the round of birth and death (*samsara*), the Dadaist mocks himself because he is in considerable doubt about the value of saying anything at all. Because of its emphases, Dada remains a distinctively Western phenomenon. As Tzara and Huelsenbeck realized at the time, it is "the American aspect of Buddhism," a "quasi-Buddhistic religion of indifference"; combining elements of the Eastern and Western mentalities, it balances (or perhaps falls) between the two.

Analogies also exist between the art of Zen and those Dada works (most notably Arp's) in which the satirical element takes second place to the desire to say something about the nature of reality.[68] For both Arp and Zen, the human being is not a spirit imprisoned by Nature but an aspect of the intricately balanced organism that is the material world. Consequently, for both Arp and Zen, a work of art does not exist above Nature as the sign of humanity's ability to dominate and organize matter. Rather, it is itself a product of Nature's workshop and thus analogous to a fruit, clouds, animals, and human beings.[69] Accordingly, the artist must learn to suspend her or his conscious mind and open her or his unconscious faculties to the secret workings of creative chance. Nothing must be forced upon the materials and these must be allowed to take what shape they will, to become icons of the balance between negative and positive principles that prevails (or ought to prevail) throughout Creation.[70] Just as the Zen gardener works as part of his garden and the *bonseki* artist places rocks in the ornamental

garden to look as though they had grown there, so Arp created sculptures which, when placed in a garden, show every sign of having flourished there like stone flowers. Like the Zen artist, Arp aims to present human beings with images of dynamic stillness, to free them from the noise that disguises inner emptiness and the haste that hurries nowhere, to make them aware of the void that is plenitude.[71]

Nevertheless, the comparison between Zen and Arp should not be taken too far either. From fairly early on in his artistic career, Arp's good-natured vitalism was darkened by intimations of a problem that does not ultimately exist for Zen, Taoism, or Eastern thought in general—that of cosmic evil. Where, for the Eastern mind, evil is simply the relative counterpart of good as darkness is of light, Arp lived through an age of such naked evil that it almost needs a diabolic antitheology to explain it. Arp knew of events so dire that to see them as the obverse of the good seemed close to blasphemy. Consequently, in his poetry, evil appears from very early on as a force in its own right, a bewildering phenomenon that seeks to destroy rather than complement the good. Thus, a poem that first appeared in 1919 contains dark lines like "Im Meer beginnt es langsam schwarz zu schneien" [In the sea dark snow slowly starts to fall] and "Den Leuchtturm steckt der Wind in seinen Sack" [The wind stuffs the lighthouse into its sack].[72] Over time, the darkness and pessimism spread, and around 1946 Arp wrote:

Immer tiefer, immer finsterer wird das Schwarz vor mir. Es droht wie ein schwarzer Rachen. Ich kann es nicht mehr ertragen. Es ist ungeheuerlich. Es ist unergründlich.

The black grows deeper and deeper, darker and darker before me. It menaces me like a black gullet. I can bear it no longer. It is monstrous. It is unfathomable.[73]

In one of the poems from *Sinnende Flammen* (*Brooding Flames*) (1961), we read:

Die schwarzen Sterne
im Innern der Menschen
nehmen zu.[74]

*The black stars
in people's souls
are increasing.*

As Rex Last put it, Arp's late work reflects his "misery at his recognition that the eco-system of the universe . . . to whose mysteries he had felt so close throughout his life" was now under radical threat from human evil—which presumably is why he sought solace in a less panentheistic and more transcendent neoplatonic mystical tradition during his final years.[75]

With most of the other Dadaists, the comparison between their artifacts and the art of Zen breaks down almost completely. Although many Dada artifacts are constructed according to the principle of the balanced conjunction of opposites, their hard satirical edge, radical self-mockery, urban idiom, conscious construction, and acute awareness of cruelty and corruption in the world are too much in evidence for one to speak of them in the same breath as Zen. Nor should it be forgotten that the art of Zen derives its serenity from an accepted and extremely rigorous spiritual discipline that has to be borne for years before it can be overcome. In contrast, the anti-Art of Dada is the product of a loose group of virtual dropouts and arises from the inspiration of the moment. Such stillness as can be found there is of a peculiarly precarious kind, unenduring and prone to almost immediate supersession.

Hugo Ball's Post-Dada Mysticism

Although by mid-1917, Ball's interest in mysticism had become a means of disengaging him from Dada, it did not go away but changed its nature. It is probable that Ball wrote the other three chapters of part 2 of *Tenderenda* fairly soon after "Grand Hotel Metaphysik" for, according to White, two of them contain three and four adapted citations from the *Saurapurāṇam,* respectively.[76] But the connection between Ball's adaptations and the original are very tenuous and they involve no reference whatsoever to the terrible Shiva of "Grand Hotel Metaphysik." It is as though Ball were trying to push everything that Shiva represented as far from his mind as possible. Indeed, the poem that concludes part 2 ("Hymnus 2") not only contains *no* citations from the *Saurapurāṇam,* it begins as a parody and ends as a litany, praising God (*not* Shiva) and beseeching deliverance from various dangers. The third chapter of part 3 of *Tenderenda* involves two, almost insignificant references to the *Saurapurāṇam;* its first chapter, "Der Verwesungsdirigent," was, as I argued in chapter 9, almost certainly written *against* the work of Gottfried Benn; and the second and fifth chapters are actually sound poems that had been closely connected with Ball's epiphanic experience in the Cabaret Voltaire of late June 1916 (see

chapter 5). But in the fourth chapter of part 3, Ball's eponymous hero, the religious poet Laurentius Tenderenda, finally appears in what was almost certainly the last chapter of the novel to be written. According to Ball's diary entry of 15 July 1920, this chapter was completed on that day—four years and one day after the traumatic *Dada-Soirée* in Zurich—and it brought him peace of mind and freedom from the doubts and spiritual torments of the preceding years. Nor is it an accident, given Dada's strongly carnivalesque nature, that the same diary entry records Ball's recent visit to Berlin (while the notorious First Grand International Dada Fair was on in Otto Burchard's gallery) that had left him with the feeling one gets after a dissolute *Fasching* (the pre-Lenten Carnival period). Shortly after this, Ball re-entered the Catholic Church, married Hennings, and fled from the modernity that he had encountered in Berlin for the last time and described in the final section of his novel as one of collapse and chaos.[77]

Ball's theological justification for this flight is contained in *Byzantinisches Christentum* (*Byzantine Christianity*) (1923), a study of three ascetic desert saints, John Climacus (d. c. 649), Dionysius the Areopagite, and Simeon Stylites (c. 390–459) that is stringently gnostic. That is to say, Ball the convert has moved away completely from advocating the integration of body, intellect, spirit, and passions around a psychological *point sublime* and has totally renounced the Dada dance amid the contradictions of the flux of Becoming. Instead, he praises men like Simeon Stylites who spent thirty-six years sitting on top of a pillar in the desert in order to disembody the soul, isolate it from the animal passions, and cultivate it in detachment from the fallen world of flesh and matter. Moreover, as recent scholarship has noted, when discussing the writings of Dionysius, Ball was less interested in his *De Divinis Nominibus* (*On the Divine Names*) and *De Mystica Theologica* (*On Mystical Theology*), and more interested in his *De Coelesti Hierarchia* (*On the Celestial Hierarchy*) and *De Ecclesiastica Hierarchia* (*On the Ecclesiastical Hierarchy*).[78] Which means that Ball was less concerned with Dionysius's description of the mystical consciousness, the ecstatic attainment of God, the "Divine Darkness" that is enlightenment, and the "Divine Ignorance" that is absorption in the absolute, and more concerned with hieratic order and the mortification of the (sinful) flesh and passions.[79]

Despite this emphasis, however, *Byzantinisches Christentum* includes one highly uncharacteristic passage where Ball first quotes from and then comments upon the fifteenth chapter of Dionysius's *De Coelesti Hierarchia:*

"... Denn das Feuer erfasst und durchströmt alles ohne Vermischung, unterscheidet sich von allen Dingen, ist gänzlich hell und undurchdringlich zugleich. . . . Es ist nicht zu hemmen, noch zu überwinden, noch zu begreifen. Alles erneuert es mit vitaler Glut, erleuchtet mit offenem Brande. Es ist nicht festzuhalten, noch zu vermengen. Es hat auflösende Gewalt und unterliegt keiner Veränderung." . . . Mit diesem einen, intelligiblen Lichte werden alle Lichter verbunden. Ausstrahlend erzeugt dieses eine, unteilbare Licht die Engelstugenden, bekehrt es die ganze Schöpfung zu sich. Belebt, erwärmt und bewegt es; dringt es in die verborgensten Winkel und Wurzeln. Auch in seiner bekehrenden Kraft ist das Licht nur ein Bild für die Güte. Diese selbst ist "das Licht des Verstandes, über allen Lichtern erhaben." Sie ist aller Erleuchtungen Einheit und Übereinheit; ein Quellstrahl und überfliessender Lichtausguss, der "den ganzen überweltlichen, außerweltlichen und immanenten Geist aus seiner Fülle speist, alle geistigen Mächte erneuert und, über alle ausgespannt, sie alle umfasst. . . ."[80]

"... For the fire lays hold of and streams through all things without adulteration, distinguishes itself from all things, is entirely light and yet impenetrable at one and the same time. . . . It can neither be checked, nor prevailed against, nor conceived. It renews all things with its incandescent vitality, illuminates all things with its naked flame. It can neither be held fast nor dissipated. It has the power to dissolve and cannot itself be changed." . . . All other forms of light are bound to this one intelligible light. As it streams forth, this one, indivisible light begets all the angelic virtues and converts the whole of Creation unto itself. It enlivens, warms, and moves; penetrates into the most secret corners and roots. Even in its power to convert this light is simply an image of the good. And this is "the light of reason, sublime above all other lights." It is the unity and metaunity of all illuminations; a streaming spring and an overflowing outpouring of light that "nourishes the whole metaworldly, otherworldly, and immanent spirit from its fullness; renews all spiritual powers and, extended out beyond all things, comprehends them all. . . ."

In this one passage, Ball's usual distinctions between God and Creation, spirit and matter, soul and body, church and world have disappeared completely. Had Arp or one of the other Dadaists known of it in 1917, they might well have included it in the fourth *Dada-Soirée,* for it speaks of the inexhaustible divine fire that permeates and redeems the whole of material

Creation, the "amor divinus et liquidus" [divine and fluid love] that, a few pages earlier (123), Ball had actually connected with Mechthild of Magdeburg's "flowing light of the Godhead." In other words, even at the height of his ascetic dualism, Ball had not completely forgotten an alternative mystical vision in which the world of matter is actively redeemed by the in-dwelling power of God. Here then, for a brief instant and uniquely in Ball's postconversion writings, the Dada vision of a universe in patterned flux is reconciled with and not abolished by a Christian spirituality.

Although Marshall Berman nowhere mentions Dada, there is a remarkable passage toward the end of his book on modernism where he writes that being a modernist involves—shades of Chuang Tzu's cataract of Lu —making oneself at home in the maelstrom of modernity, making its rhythms one's own, and moving within its currents in search of the patterns that are permitted by its flux.[81] In chapter 7, I argued that Dada was centrally concerned with just that problem, and even if some Dadaists turned away from the quintessentially Dada quest because of a need for hieratic order or a growing cultural pessimism, there is no doubt that during the Dada years themselves, a significant number of them were helped in that quest by an eclectic, but entirely explicable preoccupation with mystical texts.

11. Tricksters, Carnival, and the Magical Figures of Dada Poetry

As I argued in chapter 7, Dada, in some of its variants at least, can be seen as the celebration of a cosmic carnival and there is a clear sense in which the Dadaists themselves were descendants of such fool figures of older, popular culture as Hanswurst, Pickelhering, and Johann Posset. Certainly, many of their more outrageous antics make sense if they are viewed in the context of satirical, carnivalesque protest, and it is no accident that Charlie Chaplin was one of the Dadaists' culture-heroes—not least because his films were forbidden in Germany in 1920.[1] Within this context and because both Jungian psychoanalysis and Bakhtin's rediscovery of Carnival evolved as responses to the secularization and rationalization involved in modernity, Jung's concept of the Trickster or "Schelmenfigur" and Bakhtin's analysis of Carnival shed a large amount of light on the magical figures who populate Dada poetry.[2]

According to Jung, the Trickster enjoys malicious pranks, sly jokes, inverting hieratic orders, and changing his shape.[3] In terms of folklore, he is said to be related to Carnival practices (262) and fool figures who achieve through their stupidity what others cannot through their intelligence (255). Psychologically, he is said to be the representative of an older, undifferentiated, pre-Christian level of the mind (258 and 260) and the embodiment of the collective shadow (262)—all those contents of experience that, coming from below the threshold of consciousness and civilized acceptability, are dark, disorganized, and threatening. Indeed, the Trickster's main trait is

said to be his *un*consciousness (263) by virtue of which Jung associates him closely with the feminine principle, the anima, the part of the psyche that "sums up everything that a man can never get the better of and never finishes coping with" (270–71). Ontologically, the Trickster is a paradox for he is simultaneously sub- and superhuman, animal and divine (255, 263, and 264). Despite his closeness to the anima, he is associated with phallic creativity and despite his anarchic and destructive traits, he possesses soteriological power (255, 263, and 271) inasmuch as he can hold conflicting opposites in a state of balance (267).

According to Bakhtin, the folk festival of Carnival, populated by grotesques and circus figures, was a period of liberation from humanly imposed, officially sanctioned norms, a time when all hierarchical rank, privileges, rules, and prohibitions were suspended, a feast of becoming, change, and renewal, and as such the antithesis of everything that was immortalized and completed.[4] To the extent that it conjured up and celebrated raw, material energies that were simultaneously creative and destructive (11, 21, and 26–27), always in process of transformation (24), intransigently fleshly (18, 27, and 321), and common to all people (19 and 23), Bakhtin claims that Carnival generated a cosmic humor that, juxtaposing opposites (21 and 29), invited people to participate in absurdity (12) and thus accept their own mortality. In Bakhtin's view, Carnival was "the play of time itself, which kills and gives birth at the same time, recasting the old into the new, allowing nothing to perpetuate itself" (82), and its presiding divinity was the playing boy of Heraclitus (82) whose significance for several of the Dadaists was discussed in chapter 10. Clearly, given the irrational but ambiguous powers that Bakhtin sees at work in Carnival, Jung's Trickster would be entirely at home there as its Lord of Misrule.

Dada and its "nonsense poetry" have a close relationship with both sets of ideas. Dada poetry does not deal in human emotions, human contexts, the human spirit, or visions of anthropomorphized divinity. Nor, unlike the automatic poetry of French Surrealism, should it be regarded simply as the transcript of the human unconscious. Rather, where the Dada poets were not simply concerned to highlight the conventional nature of language as such (see chapter 5), they turned their imaginations outward. They did not do this, as Walter Muschg implied in an article written against Dada, to despair over an "unendliche Leere" [infinite emptiness], but in order to celebrate, through the creation of verbal analogues or constellations, the infinite plenitude of the "tumultuöses Fest" [tumultuous festival] of Creation (as Thomas Mann's Professor Kuckuck would put it in

book 3, chapter 5 of *Felix Krull*). And that, I suggest, is another way of talk-ing about Heraclitus's flux, Bergson's *durée*, Bakhtin's "cosmic . . . bodily world in all its elements," and Jung's "world . . . made from the body of a god." Thus, I. K. Bonset, the Dada *persona* of Theo Van Doesburg, declared that his new, abstract poetry "zal altijd een analogie zijn van de 'wordende' totaliteit [van het universum]" [shall always be an analogy of the totality (of the universe) that is in a perpetual state of "becoming"]. Huelsenbeck said that Dada bruitist poetry was "das Leben selbst . . . eine Art Rückkehr zur Natur" [Life itself . . . a kind of return to Nature]. Tzara stated that Dada wanted "l'art pour la diversité cosmique, pour la totalité, pour l'univers" [art for the sake of cosmic diversity, for totality, for the universe], an art that reflected "la vie lente qui existe et dort même dans ce qu'on nomme d'habitude mort" [the slow life that exists and sleeps even in what is usually called dead]. And Hausmann wrote that we needed an art that was "organisch in Analogie der gesehenen Momente weder nachahmend noch beschreibend" [organic in analogy to the perceived mo-ments/impulses neither imitating nor describing]. This means that unlike Futurist poetry, Dada poetry does not imitate the familiar, everyday world that is accessible to the five senses. Rather, it seeks to translate into words magical waves or demonic powers that are accessible only to the imagina-tion that can see beyond matter—which is why Van Doesburg's Bonset, punning on the notion of X rays, entitled his abstract Dada poems "X-Images" ("X-Beelden"). Mary Ann Caws aptly summarized the basic prin-ciple behind Dada poetry when she wrote that its goal is "always to create a kind of vision, not to transcribe a vision already glimpsed."[5]

Because of its experimental nature, quite a lot of Dada poetry—like that of Francis Picabia or Tzara's 1920 collection *Cinéma calendrier du coeur abstrait* (*Cinema calendar of the abstract heart*) is very tedious. But it also generated a series of magical beings who, while seeming to be simple fig-ures of absurdist fun, are, on closer inspection, analogues of the anar-chic flux of Creation. As such, these figures variously embody and com-bine several of the major characteristics of Jung's Trickster and Bakhtin's spirit of Carnival. The figure in Dada poetry who best exemplifies both sets of ideas is without doubt Arp's kaspar in the poem "kaspar ist tot" ("kaspar is dead")—a poem from 1912 that Arp almost certainly modifed before its first publication in 1919, and that he extended for its publication in *Wortträume und schwarze Sterne* (*Word-dreams and Black Stars*) (1953).[6] Kaspar's name links him with the historical Kaspar Hauser, the personifi-cation of unsullied, primal innocence; with one of the three wise men who

visited Christ on the feast of the Epiphany; and with Kasperl, the German Mr. Punch who is often considered to be a residualized and miniaturized version of the Greek god Dionysos. Like Dionysos—who is creative when given his due but prone to outbursts of destructive rage when ignored—and the power of Nature itself that Dionysos personifies, Kasperl is a highly ambiguous figure. He is cruel and comic, senseless and lovable, murderous and phallic, associated with animals (his dog) and excrement (his string of sausages). But he is also capable of evading death and defying authority by hanging the hangman and getting up no matter how often he is knocked down. Forster established that kaspar was also associated in Arp's mind with the Alsatian "Wackés," the folklore spirit of primitive spontaneity and clownish nonsense who was celebrated above all in the spring rite of Carnival and who, in 1930, Arp himself celebrated in his bronze *Tête de lutin dite Kaspar* (*Rogue's Head, Known as Kaspar*).[7] In Arp's poem, especially the 1953 version, kaspar is associated with animals and the fluid, elemental forces of fire, air, and water. He makes the world go round by turning the coffee grinder in the primal barrel and winding up the compasses and the wheels of the wheelbarrows. He overturns oppressive hieratic order by daily cocking a black snook and taking the backbones out of the pyramids (so that, presumably, they fall down). And his activity guarantees the existence of the spontaneously innocent, but anarchic world of childish and unofficial fantasy (so that, after his death, the fairies are incinerated on the funeral pyre). More important, Arp attributes various soteriological functions to kaspar. He frees natural innocence (the deer) from rigidified, man-made structures (the petrified paper bag) and allows us to see patterns in apparently chaotic Nature (the monograms in the stars). He can coexist with evil (eating with phosphorescent—rotting—rats); drive it away when it seeks to do active harm (seduce the horses); and even, like Jung's anima and Bakhtin's process of carnivalization in general, turn what is potentially harmful into something which, because comic, can be coped with. Thus, in the 1953 version, "Haifische" ("sharks") are transformed into harmless and insubstantial "heufische" ("hayfish"—or, to attempt an English pun, "shirks") and the "Schirokkoteufel" ("dust devil") is transformed into the ornately domesticated "schirokkokoteufel" ("siroccoco devil") by virtue of their association with kaspar. When alive, kaspar—a name that is of Persian origin and means, significantly enough, "Keeper of the Treasure"—exercised his redemptive power by maintaining a balance between good and evil, creation and destruction. But now that he is dead, something large, fearsome, and cosmic is thundering toward the skittle alley of the

solar system in order to destroy its unifying center (the sun). The strong-
est pointer to kaspar's soteriological capacity comes in the 1953 version
where the words "warum hast du uns verlassen" [why hast thou forsaken
us] recall, albeit parodically, Christ's words from the Cross (Matt. 27:46).
But the mock-liturgical tone of the poem (which again has its roots in
the carnivalesque religious parodies of the Middle Ages described in de-
tail by Jung and Bakhtin) is Arp's way of suggesting that kaspar's death,
like Christ's in Christian mythology, is not final. Kaspar, it transpires,
is not dead but transmogrified into more elusive forms: "eine kette aus
wasser an einem heissen wirbelwind" [a chain of water on a hot whirl-
wind]; "ein euter aus schwarzem licht" [an udder of black light] (an image,
incidentally, that synthesizes elements from Hindu mythology and Chris-
tian mysticism); or "ein durchsichtiger ziegel an der stöhnenden trommel
des felsigen wesens" [a transparent tile on the groaning drum of rocky
being/essence]. Thus, if kaspar seems to be dead, it is because people have
lost sight of him in the desacralized world of modernity rather than be-
cause he has completely disappeared. Accordingly, there are striking par-
allels between the final burden of Arp's poem, Jung's statement that the
Trickster "obviously represents a vanishing level of consciousness which
increasingly lacks the power to take, express and assert itself," and Bakh-
tin's claim that the "festive element" has been narrowed down in bourgeois
civilization.[8] Thus, the poem's last lines imply that the average good bour-
geois prefers to contemplate a static, representational, and lifeless bust of
kaspar on his domesticated mantlepiece rather than cope with the reality
of kaspar, the protean, carnivalesque, difficult, but life-giving Trickster.

Although Arp first published "kaspar ist tot" in two Dada publications,
and although kaspar himself clearly has a lot to do with Dada, the poem's
muted apocalyptic pessimism points backward to the sense of an ending
that Arp had inherited from early Expressionism and that, as we saw in
chapter 9, the Zurich Dadaists were centrally concerned to overcome. But
it also points forward to Arp's increasingly pessimistic attempts to grapple
with the growing sense of evil that would mark his late work (see chap-
ter 10). Indeed, the three collections of Sophie poems that Arp wrote dur-
ing the sixteen years following the death of his first wife impute character-
istics to the dead Sophie that also mark the allegedly dead kaspar. In the
second version of "kaspar ist tot," Arp asks whether kaspar has become a
star and in the first two Sophie collections, Sophie actually is described as
a star. Sophie's death, like Kaspar's, has contributed to the dessication and
desacralization of the world, and in the third collection, she, like kaspar,

is endowed with the power to make evil go away and connected with the lost, prelapsarian world of natural innocence. But although Sophie, like kaspar, has redemptive powers, even the third collection lacks the strong spirit of uninhibited, parodic, carnivalesque humor that marks both versions of "kaspar ist tot." So when Arp extended that poem in the way he did so late in his life, he was recapturing something of the Dada spirit that, as Last has argued, increasingly drained out of his later work. Indeed, the three "dark, menacing figures" that Last perceived behind a kaspar figure in one of Arp's (uncatalogued) works that he executed shortly before his death look very like the three Fates against whom even kaspar and Sophie are powerless.[9]

But during the Dada years themselves, things had not come to such a pass, and Arp was able to write a large number of poems that can be read as analogues of the flux of Nature. Indeed, four of these involve magical figures who personify that flux, one of whom is present throughout the poem discussed at the end of chapter 5. Another is the "er" [he] of "er rollt die meere fort . . ." ["he rolls the seas along . . ."], who, like kaspar, is a fantastic, carnivalesque figure and whose transformations relate him to the Trickster.[10] "He" is linked with elemental powers (especially the sea), excrement, eggs, animals, and forests; "he" wears fantastic headgear (like a figure in a Carnival procession); and "he" is associated both with fishing (Christian soteriological symbolism) and mummies (the Egyptian cult of the dead). "He" has no fixed identity, being known only by his actions and appendages, and "he" is both one and many, being "das grosse einmaleins" [the great one times one] — a sum where two digits are multiplied in order to arrive at a single product which is, paradoxically, identical with the two original multiplicands. And in the end, "he" is described as "die wohlmeinende schlange von birma" [the benevolent serpent of burma] (a sinuous, non-Western creature that is ultimately good despite its negative potential and that recalls the huge, undulating paper serpents carried in festal processions in the Far East). Then again, although Arp's poems "Der Dadamax" and "Der Baargeld" are ostensibly about the two Cologne Dadaists Max Ernst and Johannes Baargeld (the pseudonym of Alfred Grünwald), they are conceived out of the same spirit.[11] The "Dadamax" is a superhuman figure with one leg who frees himself from the burden of sin and guilt — "den alten adam" [the old adam] — at least twelve times a day. His resting place is a springing fountain. He shows his contempt for the categorization imposed by language by walling up letters. He leads a revolution of sea horses against Hagenbeck's Zoo (for which, ironically, another of the

Dadaists, Johannes Baader, had designed the seal pens). He causes grass to grow up through machines. He blows gigantic heads—another carnivalesque feature—made of multicolored air from his mouth. He is associated with eggs, flowers, and animals, and he wears a "galaschlangenkopf" [carnivalserpentshead] that connects him with the "er" of Arp's "er rollt meere fort. . . ." Likewise "Baargeld," a fantastic figure who, surging on the waves of enthusiasm, gigantic eggs, and clouds, personifies the protean flux of Nature. In all four cases, we are dealing not with a clearly delineated human character, but with a polyphonic, multidimensional, elusive being who, as Bakhtin put it, is not a "closed, completed unit," but "unfinished" and continually transgressing its own limits through its connections with the greater material life of the cosmos.[12]

Other Dada poems contain analogous figures—though none is so complex as "kaspar ist tot." Kurt Schwitters's Anna Blume who appears in "An Anna Blume" and "Hinrichtung" ("Execution"), besides being a very obviously carnivalesque being, is a combination of Trickster and anima. Despite her everyday garb, Anna Blume does not exist with any certainty ("Du bist, bist Du?" [Thou art, art thou?]) and certainly not in the indicative mood for people say of her "Du wärest" [Thou wert/might be—the German subjunctive of hypothetical possibility]. She is mad by normal standards, a "grünes Tier" [green animal] who is perceived with all twenty-seven senses and not just the usual five.[13] Like kaspar, she is a fleeting being. She is characterized by primary colors like a costumed figure in a Carnival procession, and in her acrobatic prowess, she is associated with the circus, a residual, pre-Christian, sacral space that is the Trickster's natural habitat and closely related to Carnival. Anna Blume defies gravity by walking on her hands, convention by wearing her hat on her feet, categorization by causing her name to drip like soft tallow, and enumeration by being "ungezählt" [uncounted/unnumbered—one does not know whether she is one or many]. She also defies the conventions of syntax by resisting address as an object in the accusative case: the poet addresses her using all the cases of the pronominal paradigm ("Du, Deiner, Dich Dir, ich Dir, Du mir, – – – –"), only then to end with the first-person plural pronoun plus a question mark ("wir?" [we?]). But then he rejects even that pronoun ("Das gehört beiläufig nicht hierher!" [That, incidentally, does not belong here!]) because *it* does not quite fit her either. There is more than a hint, too, that Anna Blume, like the Trickster and Mann's Krull, is a bisexual being. The poet says that one can "lesen" her "auch von hinten" [from behind as well] (a remark which, given that the German verb can mean "to pluck" as well

as "to read," surely refers to more than the palindromic nature of her first name). She is also identified with the phallic candle and, at the end of the poem, drips her candle wax caressingly over the poet's back. In "Hinrichtung," Anna's connection with the powers of Nature—gardens, meadows, birds, earth, and leaves—is given even greater emphasis. But because she is the personification of vital life and defies the world of convention, overcerebral men demand her crucifixion. Nevertheless, like kaspar and the Trickster, she has soteriological features and is able to resurrect at the very moment of her death so that the poem ends with the systematically ambivalent statement "Anna Blume grünt das Welken" [Anna Blume greens the withering/the withering greens Anna Blume]. Either way, the attempt to get the better of the anima-cum-Trickster by violence has failed, or, to use Bakhtin's terminology, the "degradation" of Anna Blume "has not only a destructive, negative aspect, but also a regenerating one."[14]

Tzara's cosmic acrobats, who perform their tricks in a circus or carnivalesque arena that is coextensive with the whole of material Creation, are similar in kind.[15] They continually swell up and collapse like clouds or a string of figures in a mathematician's head or a stream of vowels or light flowing along ropes. Just as the Trickster perpetually changes his shape, so Tzara's acrobats take on a variety of transient forms, expanding and contracting before our eyes. They are associated with sounds like "NTOUCA," "MBOCO," "moumbimba," "glwa wawa prohabab," and "nf nf nf tata" as well as with the spontaneity of animals and children. Their connection with farts links them closely with the grotesque world of Carnival, which, according to Bakhtin, focuses upon the "material bodily lower stratum" and its products in order to break down the distinction between the human and the natural and show the link between the expression of waste matter and fertility, death and renewal. Finally, their association with "grand'mères couvertes de tumeurs molles c'est-à-dire de polypes" [grandmothers covered with soft tumors that is to say polyps] reminds us of Bakhtin's "senile pregnant hags" who "combine a senile, decaying and deformed flesh with the flesh of new life, conceived but as yet unformed."[16] Similar considerations apply to the "géant lépreux" [leprous giant] of the first of Tzara's Vingt-cinq poèmes whose body, through the poem's title, is declared to be an analogue of the magical flux of Nature. The giant is associated with microbes, insects, animals, birds, fire, blood, plants, music, "primitive" noises, and the sea. He takes shape, only then to dissolve into process and reform a few lines later in another, equally temporary form. He moves unpredictably, through zigzags, leaps, and eccentric shapes. Like the

Trickster, he personifies the most basic level of undifferentiated conscious-ness that knows no distinctions, beginnings, or ends and exists outside of all man-made moral categories. Like Bakhtin's "grotesque body," his is "a body in the act of becoming. It is never finished, never completed; it is continually built, created, and builds and creates another body."[17]

One of Huelsenbeck's *Phantastische Gebete*, "Mafarka," involves a simi-lar being who, despite his Futurist-inspired name, is quite different from Marinetti's warrior-*Übermensch*.[18] To the extent that Huelsenbeck's Ma-farka has any clear shape or definable nature at all, he is associated with spontaneous procreation, non-European carvings, native North Ameri-cans, primary colors, "primitive" sounds, water, fire, air, random move-ments, dragons, huge areas of space, and the loss of perspective. Although he is also associated with synesthetic and organic blossoming, he is, as the echo of Heym suggests, closer to the apocalyptic beings of early Expres-sionism than any of the other magical or cosmic beings discussed so far, and the Carnival of Creation over which he presides is far less benevolent.[19]

Before breaking with Dada, Ball had contributed a comparable figure to Dada poetry in the shape of Koko the Green God who appears in his poem "Cabaret 3" and the final chapter of *Tenderenda*.[20] In the poem, Koko (who is clearly associated both with the circus clown and the phallic woodwose of pre-Christian folklore) is linked with sexuality, non-Western phallic wind instruments, and serpents. He is the presiding divinity of the cabaret and variety theater—two other carnivalesque contexts within modernity where, as in the circus, normal, common-sense laws are sus-pended and people can make contact with more fundamental, more aban-doned levels of consciousness.[21] And in the end, he has a hand in the apoca-lyptic destruction of the theater where he has performed. In *Tenderenda*, we hear that once Koko whirled through the air in freedom, but that he is now in prison where he is fed on pomade and old women's petticoats. Just as modernity has reduced Arp's kaspar to a lifeless bust on a bour-geois mantlepiece, so Koko's face has dried up because of the logical but lamed existence that he is now forced to lead. But where both versions of Arp's poem suggest that kaspar is not dead but alive, albeit transmuted into more elusive forms, and where Arp succumbed to cultural pessimism relatively late in his life, Ball was far less optimistic about the sustaining power of the natural energies embodied in Koko as early as spring 1916. For although Ball's poem concludes that Koko may one day return to free men and beasts from their sorrows and bewilderment, he is securely bound for the present in the chains (the Weberian *Gehäuse*) of modernity.

Some of the French-speaking Dada poets produced similar images. The central figure of the second poem of Benjamin Péret's *Immortelle maladie* (*Immortal Sickness*) is referred to, as in Arp's poem, exclusively by the third-person singular pronoun.[22] He lives among the stars and the "minéraux inconnus / qui flambent dans les corolles des fleurs fatales" [unknown minerals / which flame in the corollas of the fatal flowers], and he is associated with the elements, huge, cosmic "escaliers bénévoles" [benevolent stairways], and the beak of the dove. In Paul Éluard's and Max Ernst's "Les Ciseaux et leur père" ("The Scissors and their Father"), the central figure ("le petit" [the little one], who is ill and about to die) is described as the being who has endowed us with sight, shut up darkness in the pine forests, and dried out the roads after the storms.[23] He, before whom the pyramids — rigid, oppressive, and hierarchical order — did obeisance, is characterized as "bon" [good] and "doux" [gentle], having never whipped the wind or stamped on the mud for no good reason. The "fugitive" (i.e., "fleeting one") who appears in the final poem of the same collection possesses similar magical properties. For he refuses to sign his name (and thus commit himself to a single identity) or to be tied down to the "usual tugboats," and he is characterized by calm and sweetness.[24] Although none of these poems involves the complex suggestiveness of "kaspar ist tot," their central figures have kaspar's protean elusiveness, creativity, and ability to cope with evil. Although neither Péret nor Éluard is as aware as Arp, Schwitters, or Tzara of the carnivalesque tradition in which their magical figures stand, both have a sense that the human world is permeated by powers of creativity which are ultimately beneficent and over which human reason can exercise no final control. Finally in this connection, one should also mention the principal figure of Francis Picabia's *Jésus-Christ rastaquouère* (*Jesus Christ the Rascal*).[25] Although not so developed as the other figures discussed above, he certainly belongs to the same family, for he is the embodiment of redemptive comic exuberance: at one and the same time Jesus Christ and a picaresque rascal who therefore has close affinities with the Trickster and the world of Carnival.

It may be that some of the magical figures encountered in Dada poetry, besides belonging to an old, unofficial, and half-submerged tradition, also owe something to the more immediate influence of Rimbaud's "Génie" ("Genius"), the sixtieth poem of *Les Illuminations* (c. 1872–73) (*The Illuminations*, 1932), which, in its cosmic optimism, is untypical of Rimbaud's *oeuvre* and very close in spirit to Dada's affirmative vitalism.[26] Arp certainly knew Rimbaud's work. One of his boyhood friends, L. H. Neitzel, records

that at sixteen, Arp's favorite reading was the prose of Lautréamont and the poetry of Rimbaud, and as we saw in chapter 10, Arp identified Rimbaud's poetry as one of the four books that were most important to him.[27] Ball's diary entries of 14 December 1916 and 8 January 1917 indicate that he had been drawn to Rimbaud in late 1915–early 1916 but turned against him because of his confusions after his first break with Dada. According to a 20 February 1916 announcement in the *Neue Zürcher Zeitung*, poetry by Rimbaud was read out in the Cabaret Voltaire on that evening. Huelsenbeck's "Chorus sanctus" of 1916 and claim in 1918 to have invented "das *concert de voyelles*" [the *concert of vowels*] during the time of the Cabaret Voltaire also indicate that he had come across Rimbaud's poetry there.[28] Ernst became an enthusiastic devotee of Rimbaud soon after he began studying French in 1919, and it is almost unthinkable that avant-garde French writers would not have known the work of such an illustrious and notorious forebear.[29] Like the magical figures of Dada, Rimbaud's *Génie* is a more than human, protean figure, and like Jung's Trickster and Bakhtin's spirit of Carnival, he possesses redemptive properties. He is described as the purifier of food and drink, the embodiment of love, primal violence, intense music, and miraculous, unforeseen reason. He is associated with winter and summer, rest and movement. He passes by in the storm sky and the banners of ecstasy, and he is identified with the fertility of the spirit and the immensity of the universe. He is the being who will not go away and who, like all Tricksters, sweeps away the accumulated lumber of the past in order to be active in the present, redeeming the anger of women and the laughter of men.

The nonsensical surface of the Dada poems discussed above conceals a therapeutic purpose. In Jung's thinking, the exteriorization of psychic energies in the archetypes has the same function as the carnivalesque expression of those energies in Bakhtin's thinking. They help maintain the individual and/or collective psychic health in a modernizing world that is marked both by Durkheimian anomie and ever-tightening, Weberian *Gehäuse*. Given the aims behind Dada artifacts discussed in chapter 7, the fantastic and magical figures of Dada poetry are more or less successful attempts, analogous to the thinking of the later Simmel, to negotiate those two extremes.[30] By imagining figures who are in touch with and can make creative use of the *élan vital* that flows through material and human nature, such Dada poems, like Schiller in the *Ästhetische Briefe*, affirm in the teeth of the prevailing reality principle that people are fully human only when they play. Furthermore, they also affirm that the ability to play is, at the

personal level at least, one means of taking the sting out of evil. Sadly, as the twentieth century reaches its close and evil continues to run amok, the carnivalesque naturalism and nontragic sense of life involved in these poems come increasingly to seem like a beguiling, but wishful, protohippie dream.

12. Dada and Politics

In the mid-1980s, when the debate about modernism and postmodernsm was heating up, Andreas Huyssen took academic criticism to task for ossifying the avant-garde "into an elite enterprise beyond politics and beyond everyday life," while Toril Moi censured Julia Kristeva's "grossly exaggerated confidence in the political importance of the *avant-garde*."[1] In this chapter I shall try to avoid both pitfalls but show how a movement that was afflicted by a sense of profound cultural crisis attempted, while trying to resolve it, to develop a political stance that avoided the messianic utopianism of late Expressionism. But before going into detail, I must concede two points. First, not all Dada was politically concerned and the main foci of political involvement were Zurich, Berlin, and, to a much lesser extent, Cologne. Second, while Dada irrationalism by no means led inevitably to Fascist irrationalism, there are points of contact between three Dadaists and the extreme Right. Picabia flirted briefly with Fascism in the mid-1920s—but *after* renouncing Dada and *before* becoming almost totally uninterested in politics.[2] In Italy, Julius Evola, who had thoroughly misunderstood Dada even while considering himself a Dadaist, became an apologist for Fascism for similar reasons that led Ezra Pound down the same road (see chapter 3) and in 1934 published a book entitled *Rivolta contro il mondo moderno* (*Revolt against the Modern World*).[3] And in Germany, Huelsenbeck, *after* repudiating Dada publicly in 1931, applied on 16 November 1933 to join the Nazi *Reichsverband Deutscher Schriftsteller* (Imperial League of German Writers). In his letter of application, he emphasized his non-Jewish origins; assured the authorities that he had been

subscribing to SS funds for four months; and proclaimed himself a good German. Three weeks later, in a letter to George and Eva Grosz (in exile in the United States since May 1932), he praised the Nazi revolution as an attempt "aus dem ständigen rationalen Gleichmass des Alltags auszu-brechen" [to break out of the perpetual rational monotony/regularity of the everyday] and commended the work of Oswald Spengler, Arthur Moeller van den Bruck, and Ludwig Klages.[4] This is particularly surprising since Huelsenbeck had contributed dozens of articles to *Vorwärts,* Germany's major Socialist newspaper, from late 1924 to early 1932; published three travel books between 1928 and 1930 with a markedly anticapitalistic stance; and written a play entitled *Warum lacht Frau Balsam? (Why Is Frau Balsam Laughing?)* that had provoked such a storm in the largely right-wing audi-ence when it was first performed in the Deutsches Künstlertheater (Ber-lin) on 16 March 1933 that on the following day Huelsenbeck had had to flee to Prague for a week.[5] But Huelsenbeck never joined or applied to join the NSDAP, and by 1935, after his regrettable lapse of political judg-ment, Huelsenbeck was on the executive council of the *Gruppe revolutio-närer Pazifisten* (Group of Revolutionary Pacifists).[6] On 3 March 1936, he joined Grosz as a political exile in New York (where he became a thor-oughly democratic citizen and psychoanalyst practicing under the name of Charles R. Hulbeck), and in autumn 1936 he published an article in *Transition* in which, reconciled with Dada once more, he presented the movement as a positive protest against totalitarian régimes in general.[7]

The other politicized Dadaists tended toward Anarchism and Anarcho-Communism, and while Dada never made a major contribution to politi-cal theory, begat left-wing martyrs, or encouraged projects of social re-form, it did implicitly pose three serious political questions. What kind of state is most appropriate to human nature? What political stance should the individual adopt in his everyday life? How, if at all, can art be politi-cal? Furthermore, Dada posed these questions despite its conviction that reality is "irremediably absurd," a flux that permits nothing to remain con-stant or rigid.[8] Lauda, the hero of Flake's Dada novel, was getting at these questions when he asked:

Wie, wenn bei diesen Dingen der Sozialismus, die Republik, die Demo-kratie, der Kapitalismus, also praktische Fragen, gar nicht Kern, sondern Projektion, Symbol, Veranschaulichung sind? Wenn es sich um ganz etwas andres handelt, um den Kampf dynamischer und unmaterieller Energien?[9]

*What if, in these matters, Socialism, the republic, democracy, capitalism—
i.e., practical questions—are not the core but projections, symbols, manifes-
tations? What if it is a question of something quite different, a question of
the struggle between dynamic and nonmaterial energies?*

Haunted by the hollowness of abstract formulations, acutely aware that
people are impelled by powers beyond rational control, and highly con-
scious, as outsiders to both the bourgeoisie and the proletariat, of the
practical insignificance of their ideas, the political thought of Dada is fre-
quently oblique, ironic, and tentative. Dada is by no means uniformly apo-
litical, but its political thinking has often to be disengaged from a mask of
ironic flippancy and self-mockery.

Hugo Ball and Zurich Dada

Although, like all the Dadaists, Ball was consistently and irreconcilably
opposed to the tendency of bourgeois society to stabilize, categorize, stan-
dardize, and devitalize, his positive political thinking was anything but
consistent. Before the war he adopted a typically Expressionist position
(see chapter 9). The stagnancy of contemporary society was to be overcome
through the outpouring into the world of pent-up libidinal energies, and
the theater was to be the principal agent in this process of renewal. And in
May 1914 he described how, in February, a group of younger writers and
actors had come together with just such a vision to found a "Theater der
Neuen Kunst" ("Theater for the New Art") in Munich:

> Hervorragende Vertreter neuer malerischer und theatralischer Ideen sa-
> hen neue Ziele von umstürzlerischer Bedeutung. . . . Es handelte sich
> darum, ein Repertoir aufzustellen, das zugleich in die Zukunft und in
> die Vergangenheit wies, Stücke zu finden, die nicht nur "Dramen"
> wären, sondern den *Geburtsgrund* alles dramatischen Lebens darstellten
> und sich so aus der Wurzel heraus zugleich in Tanz, Farbe, Mimus,
> Musik und Wort entluden. Den Schwerpunkt legte man dabei auf das
> Wort "Entladung," womit sich die Herkunft der Idee aus Kreisen des
> Expressionismus signiert.[10]

> *Outstanding representatives of new painterly and theatrical ideas saw new
> goals of revolutionary significance. . . . It was a question of putting together
> a repertoire that pointed simultaneously into the future and the past, of find-
> ing plays that were not just "dramas" but set forth the primal ground from*

*which all dramatic life is born and so discharged their energies simulta-
neously in dance, color, mime, music, and words. Our central point of em-
phasis was the word "discharge," which indicated very clearly that the idea
had its origins in Expressionist circles.*

In June 1914 Ball proclaimed the idea even more forcefully:

Wir stellen als Gegenideal, zwecks Ueberwindung, den Expressionis-
mus auf, der . . . mit wahnsinniger Wollust die eigene Persönlichkeit
wiederfindet und deren Diktatur ausruft in hintergründigster Selbst-
schöpfung. Theater als Abenteuer, als Weltreferat, als hoher Lyrismus.[11]

*For the purpose of transcending what exists, we offer as a counterideal Ex-
pressionism which . . . rediscovers the human personality in a fit of mad ec-
stasy and proclaims its dictatorship in the most enigmatic act of self-creation.
Theater as adventure, as report to the world, as high lyricism.*

At this juncture, however, Ball's aesthetic politics went hand in hand
with a practical naïveté. In late January 1914, he wrote approvingly of the
German entrepreneurs who worked "for the good of the whole" in the East
African colonies "unter Hintansetzung persönlichen Wohlbefindens ab-
seits von Kultur in oft nicht günstigen klimatischen Verhältnissen" [while
neglecting their own comfort, way away from civilization, in often deleteri-
ous climatic conditions].[12] Or in other words, Ball was not yet able to con-
nect the psychic imperialism that held down Freud's "aboriginal popula-
tion of the mind" in Europe with the economic imperialism that oppressed
native peoples elsewhere.

Ball's experiences as a civilian volunteer at the front in late 1914 altered
all this. His glimpse of the brutality in human nature shattered his hopes
of political redemption through irrationalist art, causing him increasingly
to repudiate the explosive capacities in human nature and to rethink his
politics from first principles.[13] Thus, from late 1914 until his reconversion
to Catholicism in mid-1920, he persistently asked whether there was any
political hope for human nature in a godless world and expressed this con-
cern in four related ways. He flirted with the revolutionary proletariat. He
took a profound interest in Anarchism with special reference to the work
of Mikhail Bakunin (1814–1876). He became a political journalist. And he
investigated the historical roots of the repressive political system on which
he blamed the war. These problems were not distinct in Ball's mind: they
interlocked and drove him to such pessimism about the human condition

that in the end he found an answer only by leaving the relativities and un-
certainties of human politics for the massive simplicity of revealed religion
and an ideal vision of theocratic statehood.

After his experiences at the front, Ball began to pin his hopes for world
peace on "Die Internationale des Proletariats" [The Proletarian Inter-
national] governed by the "Humanitätsideal" [ideal of humanity]—the
values of classical humanism.[14] Three months before his arrival in Zurich,
in a 13 March 1915 letter to his sister, he expressed hope in the "gesamte
geistige und ökonomische internationale Proletariat" [entire spiritual/intel-
lectual and economic international proletariat].[15] On 26 March 1915, he
and Huelsenbeck organized a "political evening" in Berlin's Café Austria
at which Huelsenbeck spoke on Spain's politics and Ball spoke on the Rus-
sian idea of revolution. Although neither lecture has been preserved and
no reports appeared in the Berlin press, we can assume from other contem-
porary evidence that Ball presented the revolutionary Russian proletariat
as motivated by a radicalized and politicized version of the "Humanitäts-
ideal"—a startling contrast to his radical negativism at the commemorative
evening of 12 February and the Expressionist evening of 12 May 1915. By
mid-June, Ball had arrived in Zurich and was attending discussion eve-
nings in Zurich with Dr. Fritz Brupbacher (1874–1933), the editor of the
humanitarian Communist periodical Der Revoluzzer.[16] In July, Ball made
his first contribution to that organ, a letter signed H. B., which antici-
pated the later Dada polemic against Expressionism by attacking those
Majority Socialist leaders who had betrayed the proletariat to the right-
wing establishment by supporting the war.[17] In the same month, an article
(also signed H. B.) appeared in René Schickele's pacifist periodical Die
weissen Blätter reporting on the proceedings of a workers' discussion eve-
ning in the Restaurant "Zum weissen Schwänli" that had been attended by
Brupbacher. Partly, perhaps, to entice Huelsenbeck from Berlin—for the
whole piece is addressed to R. H.—Ball painted a highly idealized picture
of the revolutionary Swiss workers:

> Der deutsche Literat, den ein Zufall in die Versammlung verschlägt,
> ganz ohne Kontakt, ganz voller Abneigung kommunistischen Dingen
> gegenüber, ist tief erstaunt und beschämt und dankt einem Kreise von
> Menschen, in dem sich Gelassenheit und Erfahrung das Rüstzeug schaf-
> fen für den sozialen Kampf der Zukunft.[18]

> *The German man of letters, who happens by chance into the meeting, com-*
> *pletely without contacts, completely full of aversion toward Communist mat-*

ters, is profoundly surprised and abashed and expresses his gratitude to a circle of human beings in whom relaxed confidence and experience are creating the weaponry for the social struggle of the future.

At first sight, Ball's 1 August 1915 letter to Brupbacher expresses similar sentiments. Using formulations that are strongly reminiscent of "Zürich," Ball thanks Brupbacher for introducing him to "einen Kreis von so lieben und interessanten Menschen" [a circle of such dear and interesting human beings].[19] Nevertheless, the letter contains the seeds of disillusion. Ball's slightly desperate insistence that his relationship with Brupbacher and *Der Revoluzzer* has not changed, that he will never forget the *Revoluzzer-Kreis*, and that he will always think of that journal "in erster Linie" [first and foremost] suggests that his idealized image of the Zurich proletariat and the *Revoluzzer* group was beginning to crumble. His experience with the "apaches" of the Flamingo variety troupe during late autumn–winter 1915–16 completed the process. Ball had always feared the *Lumpenproletariat*, and while his experiences among the *demi-monde* may have prompted him to write to his sister on 12 November 1915 that he would like, more and more, to disappear among the people and the life of small things, they also caused these fears to resurface.[20] Human nature, he decided, especially when corrupted by the great city, was fallen and fickle and so, on 11 October 1915, he noted in his diary:

Der Aberglaube, dass im niederen Volk, und gar in dem einer grossen Stadt, die Unberührtheit und die Moral zu finden seien, ist eine arge Täuschung.

The superstition that chastity and morality can be found in the lower classes, and especially in the lower classes of a big city, is a gross delusion.[21]

On 27 October:

Ich . . . finde die sozialistischen Theorien, soweit sie mit einem Enthusiasmus der Massen rechnen, reichlich romantisch und abgeschmackt.

I . . . find the socialist theories rather romantic and tasteless since they count on the enthusiasm of the masses.[22]

And around the same time, in a recently published foreword to his novel *Flametti*, he wrote:

Der kleine Roman, von dem ich spreche [*Flametti*], wendet sich gegen zwei Begriffe, gegen die sich meine ganze Natur empörte [und gegen die sich auch, wenn ich eine Hoffnung aussprechen darf, nicht nur meine, sondern die Natur der menschlichen Gesellschaft mehr und mehr empören muß:] Den Begriff "Lumpenproletariat" und den Begriff "Menschenmaterial."[23]

The little novel of which I am speaking [Flametti] *is directed against two concepts against which my whole being revolted [and against which, too, if I may express a hope, not only my nature but that of human society as a whole must increasingly revolt:] the concepts of* "Lumpenproletariat" *and* "human raw material."

The inclusion of Erich Mühsam's satirical poem "Der Revoluzzer" in the program of the Cabaret Voltaire on 27 February 1916 may well have been a sideswipe at Brupbacher's periodical as well as the Activists, and in May 1916, Ball, again signing himself H. B., published an aggressively élitist poem in *Der Revoluzzer* entitled "Die Ersten" ("The Aristoi").[24] In this poem, which is not included in his *Gesammelte Gedichte* (1963), Ball took a very obviously Nietzschean stance. He attacked the "will-less horde" and "the masses" who are taken in by treacherous politicians, and praised those superior beings who can see through empty slogans, free themselves from the "swarming herd," and pursue their transcendently utopian dreams. After his first break with Dada, Ball again wrote to his sister, on 19 December 1916, that he desired to identify with the poor, suffering, oppressed, and powerless.[25] But the frantic tone of this letter speaks more of desperation and confusion than of real political belief, and the fact remains that after spring 1916, Ball confined his political activity to intellectual, middle-class circles and never again viewed the proletariat as a force for political redemption.

Ball's first contact with Anarchism probably dated back to his work on the short-lived periodical *Revolution* in Munich in late 1913 since the first article of the first issue was by Mühsam—whose notoriety as an Anarchist was matched only by his almost total ineffectualness as a politician. This piece not only involved strong echoes of Rubiner's "Der Dichter greift in die Politik" of mid-1912, it also contained the most famous quotation from Bakunin's essay "Die Reaktion in Deutschland" ("The Reaction in Germany"), which Arnold Ruge had first published in the October 1842 issue of the *Deutsche Jahrbücher für Wissenschaft und Kunst* under the pseudonym of Jules Elysard (see below). But Ball did not know Mühsam well,

for he is never mentioned in Mühsam's copious correspondence and only once, in passing, in Mühsam's lurid diary, and he was certainly not a member of Mühsam's *Gruppe Tat* (for which Bakunin's ideas were of central importance). Although Ball may have come across Mühsam's version of Anarchism via Emmy Hennings and Hans Leybold (who, judging from Mühsam's letters and diaries, were more intimately acquainted with him), the evidence suggests that his serious interest in the subject began only in late 1914, when he began reading the work of Prince Petr Kropotkin (1842–1921) and Bakunin and wrote an article on Thomas Münzer that would appear in late January 1915.[26] For the next five years, despite the occasional mention of Pierre Proudhon (1809–1865) in his diary, Ball's interest in Anarchism focused on Bakunin. In a 9 April 1915 letter from Berlin to Käthe Brodnitz, Ball mentioned his intention of compiling a breviary of Bakunin's writings. His connection with *Der Revoluzzer* must have strengthened this intention since Brupbacher had published a comparative study of Marx and Bakunin in 1913. Brupbacher also possessed both the six-volume Guillaume edition of Bakunin that had appeared in Paris between 1895 and 1913 and a copy of Max Nettlau's massive three-volume German biography of Bakunin, fifty copies of which had appeared in London as a duplicated, bound manuscript between 1896 and July 1900.[27] In the September issue of *Der Revoluzzer*, Brupbacher published a drawing of Bakunin by Max Oppenheimer together with a translated extract from the second version of Bakunin's *L'Empire knoutogermanique* (*The Knoutogermanic Empire*) (1871), and the November issue contained a second translated extract from the same work. In the context of Brupbacher's interest, Ball was able to complain in the August issue of *Der Revoluzzer* that Bakunin was insufficiently known in Germany.[28] To remedy this, he seems to have borrowed Brupbacher's copy of Guillaume and Nettlau in January 1917 and to have worked on his long projected breviary until autumn 1917 (when he gave up because of his growing reservations about Bakunin and his failure to find a publisher).[29] But even then, his interest did not wane for he held onto Brupbacher's Nettlau biography until early August 1919; toyed, about the same time, with the idea of turning his breviary into a book entitled *Michael Bakunin über Deutschland und Karl Marx* (*Mikhail Bakunin on Germany and Karl Marx*); and had not returned Brupbacher's Guillaume edition by late August 1919.[30] Moreover, at some time between autumn 1917 and spring 1918, Ball rediscovered Bakunin's "Die Reaktion in Deutschland." This essay had not appeared in the Guillaume edition (which concentrated on Bakunin's writings between 1868 and 1872), and it

so impressed Ball that he had it printed in *Die freie Zeitung* (*The Free News-paper*) on 13 April 1918; included it as the final article of the *Almanach der freien Zeitung* that he edited in the same year; and quoted its most famous sentence with approbation once more in his *Zur Kritik der deutschen Intelligenz* that appeared in January 1919.[31]

One does not study a writer for over four years and laboriously excerpt his works for translation unless one believes that he has something important and positive to say. Nevertheless, Ball's published diary contains very few clues that might explain his long-standing attraction to Bakunin. Of the fourteen entries that deal specifically with Bakunin, only four contain unequivocally positive statements about him. In December 1914, Bakunin is praised for being a rebel, a leader of the unconscious masses, and a proponent of freedom. In June 1917, Ball cites a letter from Bakunin where he commends the urge to universal freedom that had motivated the French in 1793. In July 1917, Bakunin is again praised for championing the freedom of the individual against the authority of the state and the historical materialism of Marx. And in mid-September 1917, Ball is positive about Bakunin's beliefs in the rights and dignity of man.[32] All of which hardly adds up to four years' work and a two-volume breviary. Ball was either being reticent about his attraction to Bakunin or deliberately obscured the reasons for that attraction when he edited his diary for publication (the pre-1920 manuscript, part of which was destroyed) from his later, Roman Catholic, point of view. Ball's *Kritik* is equally unhelpful.[33] Although it cites Bakunin twenty-three times, only three citations imply a positive attitude to Bakunin as a constructive thinker in his own right. Bakunin is mentioned as a "European Spirit" (12/14); cited as the author of "Die Reaktion in Deutschland" (131/114); and praised as the standard-bearer of revolution and the collectivist society (138/120). For the rest, Bakunin is cited as the critic of Marxian Socialism, German Liberalism, and the German reaction, and as the proponent of the ideas of religious Socialists like Wilhelm Weitling. In other words, the *Kritik* uses Bakunin predominantly for what he has to say about others rather than what he has to say as a thinker in his own right.

Why then *was* Ball so attracted to Bakunin? One can only conjecture. But given Ball's close association with Brupbacher, his stated approval in his diary of Brupbacher's book, and the close association in Ball's mind between Bakunin and Nietzsche, it is likely that Ball's view of Bakunin was very close to Brupbacher's and that Ball sensed that Bakunin's thought, like Nietzsche's, posed the same "Empedoclean problem" with which he had

inconclusively grappled in his Nietzsche dissertation.[34] For Brupbacher, Bakunin was a Don Quixote, a "lebensvoller Idealist" [an idealist who was full of life], a man who was characterized by a "mystische oder, heute würde man sagen, vitalistischer Zug" [mystical or, as one would say nowadays, vitalistic streak].[35] Brupbacher depicted Bakunin as an antiauthoritarian personality who believed that the innate revolutionary instincts of mankind were striving to express themselves freely and creatively and who sought to hasten their liberation (72–73). Most pertinently, however, Brupbacher wrote:

[Bakunin] glaubte an den Satan im Leibe des Menschen, an eine wilde Kraft, die er selbst fühlte und in die ganze Natur hineinlegte. (125)

[Bakunin] believed in the Satan who is within the human body, in an untamed energy that he himself felt and projected into Nature as a whole.

Furthermore, Brupbacher identified Bakunin's "Satan" with Bergson's *élan vital* (87–88). It has often been pointed out that the horned Satan who, within Christian mythology, personifies evil, is a mutant of that other horned god, Dionysos, who, as Nietzsche realized, had a much more ambiguous status within ancient Greek mythology. Consequently, it is probable that for Ball (who, in his diary, twice used the image of Don Quixote with reference to Dada), Bakunin's personality was the embodiment of the irrationalism he had encountered in Dada and the *Lumpenproletariat,* and Bakunin's philosophy was Dada in a political guise.[36] Throughout the Guillaume edition, Ball would have encountered passages like the following that must have seemed to encapsulate the vitalistic naturalism of Dada:

Tout ce qui est, les êtres qui constituent l'ensemble indéfini de l'univers, toutes les choses existantes dans le monde, quelle que soit d'ailleurs leur nature particulière, tant sous le rapport de la qualité que celui de la quantité, les plus différentes et les plus semblables, grandes ou petites, rapprochées ou immensément éloignées, exercent nécessairement et inconsciemment, soit par voie immédiate et directe, soit par transmission indirecte, une action et réaction perpétuelles; et toute cette quantité infinie d'actions et de réactions particulières, en se combinant en un mouvement général et unique, produit et constitue ce que nous appelons *la vie, la solidarité et la causalité universelle,* LA NATURE. Appelez cela Dieu, l'Absolu, si cela vous amuse, que m'importe, pourvu que vous ne donniez à ce mot Dieu d'autre sens que celui que je viens de

préciser: celui de la *combinaison universelle, naturelle, nécessaire et réelle* (mais nullement prédéterminée, ni préconçue, ni prévue) *de cette infinité d'actions et de réactions particulières que toutes les choses réellement existantes exercent incessamment les unes sur les autres.*[37]

All that is, the beings that constitute the indefinable totality of the universe, all things that exist in the world, whatever, moreover, their particular nature may be, whether viewed qualitatively or quantitatively and whether they are very diverse or very similar, big or small, proximate or immensely far away, necessarily and unconsciously act and react perpetually, whether in an immediate and direct way or by means of a process of indirect transmission; and this whole infinite quantum of particular actions and reactions, by combining themselves into one general and unique motion, produces and constitutes what we call life, solidarity and universal causality, *NATURE. Call that God, the Absolute, if that amuses you; what does it matter to me provided that you give to this word God no other meaning than that which I have just outlined: that of the* universal, natural, necessary, and real *(but in no way predetermined, preconceived, or foreordained)* combination of that infinite number of individual actions and reactions that all things which exist in reality incessantly exercise on one another.

Nous ne connaissons et ne reconnaissons pas d'autre esprit que l'esprit animal considéré dans sa plus haute expression, comme esprit humain. (282)

We do not know and do not recognize any spirit other than the animal spirit considered, in its highest manifestation, as the human spirit.

L'homme ne peut donc jamais lutter contre la nature; par conséquent il ne peut ni la vaincre, ni la ma"triser; alors même, ai-je dit, qu'il entreprend et qu'il accomplit des actes qui sont en apparence les plus contraires à la nature, il obéit encore aux lois de la nature. Rien ne peut l'y soustraire, il en est l'esclave absolu. Mais cet esclavage n'en est pas un, parce que tout esclavage suppose deux êtres existant l'un en dehors de l'autre, et dont l'un est soumis à l'autre. L'homme n'est pas en dehors de la nature, n'étant lui-même rien que nature; donc il ne peut pas en être esclave. (286–87)

Man can never struggle against Nature; consequently he cannot either conquer or master her; thus, as I have said, even when he undertakes and suc-

cessfully performs acts which seem to run counter to Nature, he is still obeying Nature's laws. Nothing can remove him from them since he is, in an absolute sense, their slave. But this slavery is no such thing for any slavery presupposes two beings who live separately from one another and of whom one is the slave of the other. Man does not exist outside of Nature, being himself nothing but Nature; consequently he cannot be her slave.

This view of Nature and the proper place of human beings within Nature is extremely close to the fully fledged Dada view of things described in chapters 7 and 10. Ball came closest to assenting to it when he proclaimed Dada as the "World-Soul" in his first Dada-Manifesto on 14 July 1916, and his study of Bakunin's vitalistic Anarchism must, for a time at least, have drawn him to Bakunin's view that the ideal state allowed the total resources of man's "neurocerebral system" to work in spontaneous harmony with the flux of Nature of which he was indissolubly part.

Accordingly, as Ball moved away from Dada, so he did from Bakunin, directing the same criticisms against both. Anarchism, Ball had claimed in his diary on 15 June 1915, was based on a false, Rousseauesque belief in the natural goodness of humanity and the immanent order of Nature when allowed to function under its own momentum.[38] Moreover, although Ball was attracted by Anarchism's desire to decentralize and disestablish, by its commitment to coordination not subordination, by its antipathy to constriction of any kind, and by its high view of human nature, Ball increasingly felt that it did not pay enough attention to the perversity in human nature and evil in the cosmos at large. Ball had entertained such doubts from a relatively early date. The second extract from Bakunin to be published in *Der Revoluzzer* (which spoke of man's perverse tendency to sacrifice his freedom on the altar of state authority) must have helped generate them. Ball's reading of Bakunin's writings from 1868 to 1872 in the Guillaume edition must have strengthened them, for these were the years when Bakunin himself moved to a less optimistic view of human nature as a result of his experiences during the abortive Lyons rising of September 1870. Ball's doubts became insurmountable when he discovered in July 1917 that Bakunin had, for reasons of expediency, supported Bismarck against the Roman Church during the *Kulturkampf* of the 1870s and 1880s — which is a further reason why Ball stopped work on his breviary.[39] But even then, Ball did not completely give up his attraction to Bakunin as a thinker in his own right, for the final passage from "Die Reaktion in Deutschland," to which I have twice alluded above and which appears in the *Kritik* as the

one instance when Ball quotes Bakunin verbatim for what he has to say in his own right, reads as follows:

Lasset uns also dem ewigen Geiste vertrauen, der nur deshalb zerstört und vernichtet, weil er der unergründliche und ewig schaffende Quell alles Lebens ist. Die Lust der Zerstörung ist zugleich eine schaffende Lust.[40]

Let us place our trust in the eternal spirit, that destroys and annihilates only because it is the unfathomable and eternally creative source of all life. The desire to destroy is also the desire to create.

Superficially, this passage is very close to the vision of Nature in dialectical flux to be found in the *Considérations philosophiques.* In fact, a profound difference of spirit separates the book of 1870 from the essay of 1842. The earlier passage is Hegelian and its vocabulary is tacitly dualistic, suggesting a division between matter and spirit that is alien to Bakunin's later naturalism. Thus, while using the above quotation as an epitaph for his interest in Bakunin, Ball was also implicitly moving from the monistic vitalism that he had entertained during his Dada phase to the dualistic spirituality of his last years. During that latter period, as Van Den Berg has shown, Ball's interest in Bakunin became supplanted by an interest in the murdered Anarchist Gustav Landauer—but less because of his Anarchism per se and more because of his antitechnological stance.[41]

Ball's practical involvement with political journalism was somewhat abortive. He worked on *Der Revoluzzer,* but his experiences of 1915 and 1916 convinced him that its leading idea, the belief that the revolution could be brought about by education and the reform of consciousness, was totally unrealistic.[42] Tzara tells us that Platten's return from Moscow to Switzerland with news of the 1917 Revolution caused Ball to take up political journalism once more, and this time he joined the staff of the Bernese *Die freie Zeitung.*[43] This organ was more practical than *Der Revoluzzer,* concerning itself with contemporary events and personalities. Despite this, Ball could not come to grips with political reality—as can be seen from his three wartime articles that he considered important enough to reprint in the *Almanach der freien Zeitung.* The third, "Oesterreichs Kulturmission" ("Austria's Cultural Mission"), says very little of real political substance, dealing as it does with Austria's loss of its sense of being the defender of a theocracy on its most easterly frontier. The second, "Walther Rathenau,"

dismisses the unfortunate Rathenau (soon to be murdered by the extreme Right for the part he would play in signing the Rapallo Treaty with the Soviet Union) as a representative of egocentric German delirium. And the first, "Vom Universalstaat" ("On the Universal State"), would have been almost unintelligible unless the reader had been familiar with the extended argument that Ball would set out in his *Kritik* and had outlined in the *Almanach*'s introduction. Ball's postwar articles for the newspaper were, for all their moral idealism, equally politically unrealistic. Over and over again, Ball proclaimed that Germany must accept Clause 231 of the Treaty of Versailles, confess that it alone was guilty for the war and renew itself morally after this act of contrition.[44] The reason for Ball's attitude to the "Schuldfrage" [question of guilt] is not hard to find: indirectly he is speaking to himself. Through a national act of repentance, Ball was seeking to come to terms with the violence and irrationalism within himself that had led him to excess before the war, to the front at the outbreak of the war, and through Dada during the war. Or in other words, Ball's work for *Die freie Zeitung* represented a final attempt on his part to resolve the crisis of modernity in purely secular terms. By attacking Germany as a political journalist from a moral point of view, Ball hoped to assist at the rebirth of that nation.[45] But the hopes on which he based his attack were too high, too unrealistic, and too subjective, and when they were dashed by the disillusioning events of 1918 to 1920, he, like others of the deeply riven modernist generation, ceased searching for salvation in politics and turned his back on modernity.

Ball's post-Dada political thinking is contained in the *Kritik,* a work that, despite its stated historical intentions, is actually an exercise in demonology. Although lengthy, its argument is simple. In the Middle Ages, European society allowed free expression to the human spirit, being ruled by a priestly hierarchy under God. But at the time of the Renaissance and Reformation, God was replaced by humanity as the supreme authority, and the priestly hierarchy was replaced by a secular one. Consequently, humanity lost the sense both of its own spirituality and of the world as a place of epiphany; the intellect replaced the spirit as the prime human faculty, and the secular state became deified and oppressive:

Jede Art Mystik, jede Art Religion, jede Regung des Seelenlebens und der menschlichen Sehnsucht, alles was dem Menschen heilig ist, wird von diesem System in raffiniertester Weise benützt, um den Menschen zu fassen und gefügig zu machen.[46]

*Every form of mysticism, every form of religion, every movement of the life of
the soul and human yearning, everything that is sacred to human beings is
used by this system in the most sophisticated manner to take hold of human
beings and make them pliable.*

According to Ball, two intellectual traditions were discernible in Eu-
rope. The one, represented by men like Luther, Kant, Hegel, Marx, and
Bismarck, provided the ideological materials from which secular absolut-
ism—Weber's *stahlhartes Gehäuse* of modernity—could be constructed.
But the other, represented by men like Münzer, Tolstoy, Weitling, Franz
von Baader, Péguy, and Dmitri Mereshkovsky, sought to renew humanity's
sense of its spirituality and so loosen the hold of secular authority. Accord-
ing to Ball, these men were the forerunners of a new spiritual hierarchy, the
protagonists of a Christian democracy under God in which people would
find spiritual fulfillment.

Ball's analysis is doubly utopian. On the one hand, it presupposes a past
Golden Age from which the present has fallen, and on the other, it postu-
lates a future Golden Age to which the present may proceed. Such utopian-
ism had always been a part of Ball's highly complex nature. It was evident
in an article of spring 1914 when he envisaged an ideal national theater cul-
ture that would be total and centralized; in his attraction to Kandinsky's
ideas on the *Gesamtkunstwerk;* in his prewar theatrical theory (which is
structurally identical with the politico-religious theory of the *Kritik*); in his
early attraction to political Byzantinism; and in his pre-Dada preference
for the utopian Kurt Hiller (despite his reservations about Activism) over
the Anarchist, populist Franz Pfemfert, the editor of *Die Aktion*.[47] During
Ball's Dada period, the same utopianism is evident in his desire to cre-
ate an adamic language (see chapter 5) and in his view of Kandinsky as
the prophet of a redeemed new age (see chapter 9). After his second break
with Dada and his disillusion with Anarchism and practical, secular poli-
tics, Ball's utopianism became increasingly prominent until his dream of a
theocratic republic finally turned into an apolitical "ecclesiocentrism" and
he identified utopia with the timeless institutions of the Roman Church.
If one were inclined to Freudian analysis, one might say that in 1920, Ball
resolved his struggle with an impersonal father that was represented by his
image of Germany by fleeing to the bosom of an ideal mother that was
represented by Catholicism. Certainly, after Ball's visit to Brupbacher on
20 March 1920 when the two men discussed the political scene in Germany
and Ball's imminent reconversion, Brupbacher noted in his diary:

[Ball] schwärmt für das Sakrament. Bis ins Kleinste, in allen Formen einen positiven Masstab [sic] zu haben. Das hätte das Mittelalter. Wir müssen zum Mittelalter zurück. . . . Er will "Opfer," "Heiligung" und dergleichen. Es ist ein starkes Bedürfnis nach Festem, nach Halt und Regeln. Er findet die psych. Analyse zerstöre nur. Er schwankt zwischen einem fabulierenden Vater, der Freude an Reizen hat und einer furchtbar einfachen kalten Bäuerin (wie er sagt).[48]

[Ball] raves about the sacrament. To have a positive standard, in all forms, down to the smallest detail. He says the Middle Ages had one. So we have to get back to the Middle Ages. . . . He wants "sacrifice," "sanctification" and those sorts of things. There's a powerful need there for fixity, footholds and rules. He reckons that psych. analysis just destroys. He oscillates between a fabulizing father who enjoys sensual stimuli and a fearfully simple, cold peasant woman (as he puts it).

Ball's involvement with politics was a classic attempt to resolve the perceived crisis of modernity, which, at various times during the crucial years of 1914 to 1920, he diagnosed in two opposite but complementary ways. In some texts, he tended toward the Durkheimian analysis of modernity as anomie; in others, he tended toward the Weberian analysis of modernity as a prison. And although, like Simmel with the concept of the "Spieltrieb" [ludic drive], one can see Ball trying to negotiate these positions by means of Bakunin's vitalist Anarchism, the gnostic Catholicism that he had internalized during his youth proved ultimately more powerful—even though his reconversion arguably caused him to do violence to the complex totality of his own nature.

The other Zurich Dadaists were certainly not as politically aware as Ball (who, in a letter to Hennings of January 1918, said that Arp failed to realize the political potential of his work). When trying to refute Henri Guilbeaux's accusation that Dada was pro-German in an article of autumn 1916, Huelsenbeck (who would, once in Berlin, arraign Zurich Dada for having become too aesthetic) flatly denied that Dada had anything to do with politics. And Ferdinand Hardekopf, an Expressionist with leanings toward the antiwar Independent Socialist Party (USPD), continually complained in his letters to Olly Jacques of the political indifference of Dada in general and the political cynicism of Tzara and Serner in particular. In Hardekopf's view, such attitudes offered an open door to the forces of reaction.[49]

Nevertheless, one can discern flickerings of political interest within Dada in Switzerland that burst briefly into flame during the months of the abortive German revolution. Hans Richter drew a head of Bakunin in 1916; contributed a series of antiwar drawings to Rubiner's *Das Zeit-Echo* in 1917; and published a manifesto on the political role of art entitled "Ein Maler spricht zu den Malern" ("A Painter Speaks to the Painters") in the June issue of that periodical (19–23). This manifesto is neither particularly original (defining art as the bearer of ideas), nor particularly Dadaist (rejecting at one point the use of chance). It is also clearer when it discusses what art is not than when it discusses what art ought to be. Nevertheless, it does testify to a genuine, if undeveloped, political concern. After Richter's rejection of Rubiner's views (see chapter 9), he moved toward a different kind of Anarchism.[50] He had slight contact with the small Zurich branch of the Swiss Anarchist group led by the Ticinese Luigi Bertoni, the editor (1900–40) of the Genevan Anarcho-Communist periodical *Le Réveil* (*The Awakening*), but he was affected above all by reading Gustav Landauer's translation of Kropotkin's *Mutual Aid: A Factor of Evolution* (written 1890–96; first published in English in 1902; translated into German as *Gegenseitige Hilfe in der Entwicklung* [1904]), probably in late 1917 or 1918. Ball tells us in his diary that he read the same work in November 1914 but was unimpressed by it. In contrast, Richter seems to have sensed a parallel between his post-1917 quest for an art that balanced chaos and immanent order and Kropotkin's conception of Nature as a balanced intermingling of mutual struggle and mutual aid, aggression and cooperation.[51] By 1918, Richter's positive political ideal seems to have been the small Anarchist community based on mutual cooperation in which people could find freedom from external compulsion, state interference, and the pressure of conventional morality.[52] The end of the war and the growing nihilism of Tzara and Serner (that came to a head in the eighth *Dada-Soirée* of 9 April 1919 when Serner read out his radically negative *Letzte Lockerung* [*Last Loosening: Manifesto*, 1995]), produced a flurry of positive political activity among those Dadaists who were still in Switzerland.[53] On 8 November 1918, immediately after Kurt Eisner had become the first republican Prime Minister of Bavaria, Otto Flake wrote him an enthusiastic letter.[54] Here he said that he was a member of a group of intellectuals in Zurich (i.e., the Dadaists et al.) who were firmly behind Eisner's putsch and political program and that he himself wished to become a member of the USPD. In late November 1918, Fritz Baumann's group *Das Neue Leben* (New Life) staged its first exhibition in the Kunsthalle, Basel, and in Janu-

ary and early February 1919, the same group staged its second exhibition in the Kunsthaus, Zurich. According to newspaper reports, Arp and Picabia contributed work to the first exhibition; Arp, Janco, Picabia, and Sophie Taeuber contributed work to the second exhibition; Janco and Tzara gave lectures on modern art on 16 and 23 January in the context of the second exhibition; and Hans Richter's 3 November 1918 letter from Lugano to Tzara makes it clear that he would have liked to contribute to the first exhibition had he been invited.[55] According to the manifesto accompanying the first exhibition and a lecture by Flake, the major aims of *Das Neue Leben* were the reintegration of art with life; the breaking down of the distinction between high art, decorative art, and craft work; and the aestheticization of everyday life as had allegedly been the case in the Middle Ages.[56] These political aims look utopian, not to say tame, in comparison with those of Berlin Dada, but it has to be remembered that they were formulated during a period of high euphoria when it really did seem, from the safe distance of Switzerland, that a revolution actually had taken place in Germany. But after the murders of Karl Liebknecht and Rosa Luxemburg in Berlin on 15 January 1919 and the assassination of Eisner in Munich on 21 February (when he was, ironically, on his way to the *Landtag* to resign), political disillusion began to set in. I have documented Flake's political disillusion elsewhere and it seems to have been complete by late April 1919.[57] Richter's took only slightly longer. It seems that he went to Munich—by then in a state of political turmoil—in early March. From there, he travelled to Berlin and returned to Munich via Zurich (where he took part in the eighth *Dada-Soirée*) shortly after 9 April 1919 (i.e., *during* the first, USPD-led phase of the Munich Soviet and *before* the Communists, under Eugen Leviné, had taken control after the abortive right-wing putsch of 13 April).[58] While in Munich, he became a leading member of the *Aktionsausschuss Revolutionärer Künstler* (Action Committee of Revolutionary Artists) with special responsibility for painting, and on 22 April he read out his "Manifest radikaler Künstler" ("Manifesto of Radical Artists") to that body when it met in the *Landtag*.[59] Richter explicitly associated himself with this group's utopian Communist aims, which included the promotion of new art, the abolition of the bourgeois monopoly of the press, the revolutionizing of art academies and theaters, the socialization of the cinema, and various expropriations and welfare measures designed to improve the material circumstances of artists.[60] He was then arrested in early May when the *Freikorps* took Munich. Partly because of his family connections, partly because he was not Jewish, and partly because his major preoccupation

during the revolutionary weeks had been with the (nonviolent) reform of the *Kunstgewerbeschule* (School of Arts and Crafts), he was released after two weeks, sent back to Switzerland, and never mentioned these events in print during the remaining fifty-seven years of his life.

Meanwhile, back in Switzerland, a short-lived body that included Arp, Hennings, and Janco and called itself the *Bund Revolutionärer Künstler* (Federation of Revolutionary Artists) had published Richter's "Manifesto" in the *Neue Zürcher Zeitung* on 4 May 1919.[61] The signatories, who also included three non-Dada members of *Das Neue Leben,* designated themselves as the representatives of an essential aspect of culture; asserted their right to be involved in the life of the state; opposed "kraftverzehrende Systemlosigkeit" [destructively enervating lack of system]; and proclaimed that it was their duty to give expression to the deepest will of the people. Theirs was to be an art of brotherhood that would pictorialize the basis of the new humanity and mirror the spirit of the people as a whole. The ponderous language, lack of aggressive irrationalism, and desire for system, integration, and status are a long way indeed from the dissidence of the Cabaret Voltaire and the Anarchism of Bakunin. Indeed, this manifesto is so uncomfortably reminiscent of the Expressionist evening of 25 March 1919 in the Berlin *Blüthnersaal* (see chapter 9) that it can be said to mark the end of political Dada in Zurich. Thus, when *Das Neue Leben* staged its third exhibition in June 1920 in Basel, the one extant press report indicates that the group was no longer interested in aestheticizing politics but in abstract art as an end in itself, and that of the Dadaists only Arp, Taeuber, and Janco contributed to it.[62]

Berlin Dada

Of the many critics writing on postmodernism, only Callinicos has registered the fact that there was a serious political side to Dada in Berlin.[63] A banner ran through the three rooms of the Grand International Dada Fair in Berlin of June 1920 proclaiming that Dada was fighting on the side of the International Proletariat and the catalogue of the same provocative event included the statement that Dadaist man was the radical opponent of exploitation. Nevertheless, the political commitment of Berlin Dada was not uniform but bifurcated—a fact that Schwitters wittily identified when, writing in 1924 in the Polish journal *Blok,* he distinguished between those Berlin Dadaists for whom Dada was a political weapon and those for whom Communism was a Dadaistical weapon.[64] Wieland Herzfelde,

his brother John Heartfield, and Grosz formed the core of the first (Marxist) group. Huelsenbeck, Hausmann, and Baader formed the core of the second (Anarchist) group. While Franz Jung, during his brief but fruitful involvement with Dada (1917–18), occupied an ideological position somewhere between these two groups.[65] Maier-Metz notes an increasing politicization of Berlin Dada during 1917 and 1918, but as in Zurich, its real politicization began only with the German revolution in late 1918 and *unlike* in Zurich, this was given tremendous impetus by the revolution's failure and the violent repression of the Spartacist uprising in Berlin in early 1919.[66] But even after the two major Dada groupings in Berlin had become more ideologically aware, they seem to have been able to collaborate without too much friction for a year and a half. During 1919 they contributed to the same clutch of little magazines (beginning with *Jedermann sein eigner Fussball* [*Everyone His Own Football*] on 15 February 1919). All members of both groups performed in the *Dada-Matinée* that took place in the experimental Berlin Theater *Die Tribüne* on 30 November 1919. And the ideological differences between the two groups seem to have become significantly divisive only after the Grand International Dada Fair.[67]

It is well known that Grosz, Herzfelde, and Heartfield joined the German Communist Party (KPD) when its Spartacist wing split away from the more pacifist, less Marxist-Leninist USPD at the very end of 1918. Herzfelde had founded the Malik Publishing House in March 1917, and this, while never an official organ of the KPD or linked with VIVA (*Vereinigung Internationaler Verlags-Anstalten* [Union of International Publishing Institutions]), produced a growing stream of left-wing literature.[68] Because of censorship, it published only four items with an implicitly left-wing tendency during the war—the two newspaper numbers of *Neue Jugend* (see chapter 9); the *Erste George Grosz-Mappe* (late 1916–early 1917), a folder of nine lithographs (1915–16); and the even more aggressively satirical *Kleine Grosz-Mappe* (autumn 1917), a folder of twenty lithographs (1915–16).[69] During the initial revolutionary period, the Dadaists, unlike the Expressionists, went relatively quiet.[70] But the diary of Harry Graf Kessler (1868–1937), the doyen of liberal Berlin political journalism whom Herzfelde had gotten to know in about 1916, provides us with a very good picture of Herzfelde's politicization and subsequent political development from early 1919 to late 1920.[71] On 18 January Herzfelde openly admitted that he was a member of the Spartacists because, in his view, only Communism was capable of remedying the pauperization of Europe. He also said that he was in favor of revolutionary terror—which did not necessarily

mean a bloodbath—because human nature was not "an sich gut" [good in itself] and needed "Zwang" [compulsion or discipline]. He also saw that the Spartacist uprising (that had cost the lives of Liebknecht and Luxemburg three days previously) had broken out spontaneously, despite the wishes of its leaders (108–9). Driven by this mood of commitment and outrage and the desire "alles, was dem Deutschen bisher lieb gewesen sei, in den Dreck zu treten" [to stamp into the dirt everything that has been so dear to the Germans up to now], he prepared the proofs of the four-page *Jedermann sein eigner Fussball,* the first publication to use photomontage for political purposes, by 28 January (114–15). Kessler may have been slightly bemused by this publication's half serious, half "aristophanic" tone, but it sold seventy-six hundred copies on 15 February between Berlin's Gedächtniskirche and Alexanderplatz before being banned by the authorities.[72] Its sequel, *Die Pleite (Bankruptcy)* first appeared on 1 March and put both Grosz and Herzfelde at real risk because of its markedly Communist and pro-Soviet stance at a time when the SPD-led government was deliberately impeding information on Russia from appearing in the German press. For instance, its first number included the invitation to the First Congress of the Communist International in Moscow (2–6 March 1919) that had been broadcast by the Soviet government on 24 January, and another article in the same issue suggested that modernist artists had achieved a status in Soviet Russia that had not been achieved by comparable artists in revolutionary Germany.[73] As a result, Herzfelde was arrested on 7 March during a period of bloody *Freikorps* activity in Berlin and spent nearly two weeks in prison in extremely brutal conditions. He was released unharmed on 20 March only through Kessler's good offices and described this experience in the second number of *Die Pleite* (a sixteen-page brochure subtitled *Schutzhaft [Protective Custody]* [late March]).[74]

Herzfelde's prison experiences (which were far worse than Richter's in Munich) intensified the Malik-Group's hatred of the political and cultural status quo and generated the even more vitriolic third number of *Die Pleite* (which must have appeared around 12 April).[75] Its front cover consisted of a lithograph by Grosz entitled *Prost Noske—das Proletariat ist entwaffnet! (Cheers Noske—the Proletariat Is Disarmed!).* This showed a triumphant Prussian *Freikorps* officer with his eyes closed, a bloody sword in one hand and a glass of champagne in the other, drinking, in a parody of the figure of Justice, a toast to SPD Defense Minister Gustav Noske, while all around him countless workers' corpses litter the street. Indeed, the antimilitary, antigovernmental stance of this number was so extreme that according

to Kessler's diary the newspaper vendors did not dare sell it on the open streets (176). Although this number of *Die Pleite* marked a hardening of Herzfelde's political stance, it also seems to have coincided with a growing disillusionment on his part with the KPD because it had botched a revolution and failed to prevent the atrocities of early March like that depicted by Grosz. Consequently, Kessler's diary entry of 12 April records Herzfelde advocating a system of government that was based not on parliamentary democracy or a vanguard party, but on self-governing "Gesetzesgemeinschaften" [self-legislating communities]—a system that was theoretically much closer to the gradualist "Räte-System" [Soviet system] propounded by the USPD (177) and of which Kessler himself at that time approved (179). On 17 April, Herzfelde told Kessler that he was moving beyond Bolshevism (179). On 3 May, Herzfelde expressed considerable skepticism about the effectiveness and organizational abilities of the German Communists in comparison with their Russian comrades (186–87). By August and September, after the ratification of the Weimar Constitution, Herzfelde realized that the German revolution had failed (199 and 201). On 12 September, when ultra-left-wing elements within the KPD (especially in Berlin) were advocating noncooperation with institutions like the trades unions and parliament and demanding immediate revolutionary action on the grounds that capitalism was about to collapse, Herzfelde accused one section of the KPD—presumably the ultra-left—of being the worst sort of reactionaries and butchers whose consciousness was in dire need of reconstruction (203).

Given the remarks in Kessler's diary, Herzfelde's ideological position in 1919 was exactly between that of the KPD leadership and the ultra-Left. For although he clearly rejected the "putsch-tactics" of the ultra-Left (soon to be expelled from the KPD at the [illegal] Party Conference that took place in Heidelberg from 20 to 23 October 1919), his remarks of 12 April indicate that he would also have been out of sympathy with the "Leitsätze" [guiding principles] that arose from the same conference. These demanded "straffste Zentralisation" [the tightest centralization] and rejected any form of federalism (like the "Räte-System" propounded by the hated USPD) on the grounds that this weakened the Party and was a very slow way of bringing about revolution.[76] Thus, Kessler's diary records not Herzfelde's disillusion with Communism as such, but his critical attitude toward the two wings of the KPD (in which it was very hard for a middle-class intellectual to gain acceptance).[77] This insight explains why Herzfelde kept the Malik Publishing House at some distance from the KPD and its official organs.

It also sheds light on the politics of the Malik Publishing House and the periodical *Der Gegner* (*The Adversary*) (which Malik began to publish in November and December 1919 and whose coeditorship Herzfelde took over from the Expressionist Karl Otten when *Die Pleite* was banned after its sixth issue in January 1920). Even while Otten was still one of its editors, the extent to which *Der Gegner* focused on Soviet Russia is striking, and until it folded in March 1922, it published articles by leading Soviet theoreticians (such as Leon Trotzky, Yevgeny Preobrashensky, Grigory Sinoviev, and the Hungarian Yevgeny Varga). It also printed articles dealing with the organization of industry through a system of Soviets; reported on events in Russia; commented on questions of revolutionary politics in Germany; and discussed the relationship of art to revolution.[78] After the failure of the Communist uprisings in Germany in March 1921, *Der Gegner* even went so far as to criticize the KPD openly for its poor revolutionary record over the past two years. Similarly, the two major non-Dada items published by Malik in 1920 were a collection of speeches and manifestos by Soviet commissars from the revolutionary winter of 1917 and 1918 and a little book by Sinoviev on Lenin. Reading between the lines, Herzfelde seems to have been using his view of what the Soviet Communist Party *had done and was doing* in the postrevolutionary Soviet Union to show up what the German Communist Party *had not done and was not doing* in allegedly postrevolutionary Germany. By the same token, his publishing strategy implicitly contrasted the stature of the Soviet leadership with the KPD's lack of any comparable leadership after the murders of Luxemburg and Liebknecht, and the willingness of the Soviets to make use of its intellectuals with the KPD's hostility toward that caste in Germany. Furthermore, although *Der Gegner* was based on a commitment to the Communist ideal, a belief in the inevitability of revolution, and a conviction that everyone must work together to bring it about, Herzfelde's Marxism was essentially humane and undogmatic. Accordingly, when he addressed a rally in Berlin on 4 June 1920 and found himself compelled to speak in clichéd fundamentalist terminology, Kessler noted that he sounded unconvincing and incomprehensible.[79]

The orthodox party leadership very obviously sensed that the Malik-Group, though Marxists, were loose canons, not least because its members were associated with Dada (which Gertrud Alexander, the literary editor of the KPD newspaper *Die rote Fahne* [*The Red Banner*], had roundly condemned on 25 July 1920).[80] Accordingly, one looks in vain for any positive appreciation of the work of the group or even any advertisements of their

publications in *Die rote Fahne* until 29 October 1920. On this date, its literary section published a brief report to the effect that the police had raided the Malik Publishing House and confiscated folders of Grosz's antimilitaristic and anti-Hohenzollern prints (presumably *Gott mit uns* [*God with Us*] [June 1920]). This was then followed by a short essay by Hermynia Zur Mühlen (1883–1951) (who would become Herzfelde's secretary and a regular translator for Malik in 1921) entitled, significantly, "Bekenntnis eines ehrlichen Bourgeois" ("Confession of Faith of an Honest Bourgeois"). If one knows how to decode the left-wing press of the time, it becomes apparent that these two articles are the first grudging signs of a rapprochement between the KPD and the Malik-Group. Before that date, however, no such signs are visible and at least two denunciations of the Malik-Group were printed in *Die rote Fahne*. The first appeared on 9 June 1920 when Gertrud Alexander attacked Heartfield and Grosz for their "Kunstlump" article (see chapter 9).[81] The second occurred in an article of 6 July 1920 that reported on a meeting organized by the KPD at which one Comrade Schulz had spoken on "Art and the Proletariat." Here, Schulz used the classic argument that a new proletarian art was possible only when the revolution had brought the classless society into being and that until this had occurred one could only protect what had been inherited from the past and learn to see it with new eyes. He then attacked pseudorevolutionary art and those "Kunstanarchisten" [art anarchists] who wanted to destroy that inheritance. This was not just a tacit denunciation of Grosz and Heartfield for their recent "Kunstlump" article, it was also a sideswipe at the Malik-Group for trying to produce modern, revolutionary art before the revolution had occurred and without being anchored in the proletariat. When a representative "jener Richtung des Kunstanarchismus, der gleichzeitig Dadaist ist" [of that tendency to art anarchism, who is also a Dadaist] — almost certainly one of the Malik-Group — then tried to defend his position, he was promptly censured for his intellectual bankruptcy.[82] This hostility explains why, when *Die rote Fahne* published extracts from Zur Mühlen's translation of Upton Sinclair's novel *100%* on 14 and 16 November 1920, it made no mention of the fact that the entire novel would be published by Malik in the following year. Indeed, it would take the KPD another year to accept that it had at its disposal some of the most talented translators (Zur Mühlen), writers (Franz Jung), visual artists (Grosz and Heartfield), actors/directors (Erwin Piscator), and publicists/theoreticians (Herzfelde) to be found on the German Left and two years to develop a proper cultural policy of its own with the help of just those intellectuals.[83]

By this time, of course, Dada was over, but the Malik-Group brought to their political involvement several characteristics that had been developed during their involvement with Dada: a vitality, a will to experiment with low forms, and a fiercely critical attitude toward late capitalist modernity combined, nevertheless, with a commitment to the here and now.

Like Herzfelde, Grosz was politicized by the German revolution. In his (1916–17) letter to his school friend Robert Bell, he expressed the hope that the awful situation now prevailing would politicize people, but added that he himself had gone beyond Socialism and described himself simply as an individualist.[84] But by mid- to late 1918, his views had altered significantly. Where his first two collections of lithographs published by Malik were largely aimed at the human race in general, by the time of his huge oil painting *Deutschland, ein Wintermärchen* (on which he began to work in July 1918) and his lithographs for *Die Pleite,* his focus had shifted visibly. On the one hand, the object of his satire was now very clearly the ruling class, whom, in the shape of the clergy, the medical profession, the military, and the educational establishment, Grosz accused of perverting the values of classical modernity to justify an unjustifiable war and a corrupt, vice-ridden society.[85] On the other hand, he had gained a new respect for the revolutionary working class; said as much to Kessler on 19 March 1919; and portrayed them as exploited but heroically determined (male) figures in his lithographs of 1919 to 1921.[86] Where Grosz's first two collections of lithographs had portrayed all humanity as semibestial, his collections from the revolutionary years, notably *Das Gesicht der herrschenden Klasse* (*The Face of the Ruling Class*) (published by Malik in spring 1921), differentiated very clearly between the bloated, porcine capitalists and their very obviously human, albeit predominantly male, victims.

Although Grosz was a member of the KPD, he seems to have shared Herzfelde's misgivings about that Party and its competence. On 17 January 1919, two days after the murders of Liebknecht and Luxemburg when it was obvious that the Spartacist rising had failed, he wrote an ironic letter to Otto Schmalhausen in the persona of a conservative bourgeois greeting the re-establishment of peace and order. But the irony is double-edged and when, in the closing lines of the letter, he says that his "bürgerliches Herz" [bourgeois heart] will need to be able to assent to this "konsequenten Sozialismus" [logically thought-out Socialism], Grosz's own doubts about the Communist alternative emerge very clearly since the Spartacist rising had been anything but thought-out and had failed because its leaders were

unable to control it.[87] In 1922 he visited the Soviet Union for five months and, according to Bergius, came back thoroughly disillusioned with what he had seen despite his earlier support for Willi Münzenberg's campaign to publicize the plight of the starving there.[88] These doubts come through in *Die Räuber* (*The Robbers*), a series of nine photolithographs from 1921 and 1922 that he published with Malik in late 1922 or early 1923 but that McCloskey does not discuss. At the most obvious level, the latter-day robbers are the capitalist exploiters depicted in the first six illustrations and the clergyman depicted in the seventh. But Grosz provided each illustration with a quotation from the first version of Schiller's play *Die Räuber*, and if one sets Grosz's illustration against the context from which the quotation is taken, then things begin to look somewhat different.[89] The first three and the last two quotations are spoken by Schiller's villain, Franz Moor, and map well enough with the surface message of Grosz's collection. But the other four quotations are spoken respectively by Razman, citing Schiller's hero Karl Moor after he has just murdered a rich lawyer with evident pleasure; Karl himself when he is denouncing humanity in general; Spiegelberg, the most gratuitously violent member of Karl's band of outlaws; and Karl again when he is denouncing a priest who, with more than a little justification, has been berating the robbers for their terrorist violence. If one then returns to the four corresponding illustrations and reads them against these quotations with one eye on their original context, a discordant, less straightforward message can be heard—especially when one remembers that the hero of Schiller's play is a man who comes to realize that violence begets violence and does as much harm to the innocent as to the guilty. Perhaps, Grosz is beginning to think, one cannot divide the world into good and bad people (as happens in the tales of the Wild West of which he was so fond).[90] Perhaps all humanity is fatally flawed. Perhaps revolutionary politics attract those who like violence for its own sake. And perhaps revolutionaries, once in power, can be as exploitative as the hated capitalists. Grosz would never rid himself of these doubts, and while, throughout the middle Weimar years in such publications as *Der Knüppel* (*The Cudgel*) (1923–27), he assented at one level to the Marxist belief that evil is the product of capitalist institutions, many of his pictures from the same period castigate human nature itself as the irremediable source of that evil.[91]

Like the Marxists, the Anarchists of Berlin Dada produced satirical material. Hausmann, for example, published several prose pieces attacking

the régime and the bourgeois mentality during 1919 and 1920, twelve of which were collected by Malik in 1921 as *Hurra! Hurra! Hurra!*[92] At the same time, the Anarchists went beyond satire sooner than the Marxists, and in 1919, one finds them trying to evolve non-Marxist answers to the questions detailed at the beginning of this chapter. The basis of this attempt was formed by the psychological theories (deriving from the work of Otto Gross) advanced in Franz Jung's periodical *Die freie Strasse,* six numbers of which had appeared between 1915 and 1917. Very simply, *Die freie Strasse* asserted that the moving stream of Nature was fundamentally good and at work within the human personality whether people knew it or not.[93] If this stream was allowed to flow freely, it could free the individual completely from the repressive influence of authority figures—the father, conventional morality, the state, God—and from the guilt feelings that they induce. Jung summarized his teaching thus:

> Sei gut! Hasse Religionen und Gesetze. Und den Gott, der in den Menschen ist. Komm, sieh' den Gott der Welt.[94]

> *Be good! Hate religions and laws. And the God who is in humanity. Come, behold the God of the world.*

The moment at which the individual was emancipated from external authority and felt free to take responsibility for him- or herself was a death and also a resurrection into new, vital life, a liberation from the force of gravity that had hitherto held him or her down. Freed from alien authority, the individual would also be freed from the fear of others and the need to assert him- or herself against others and so enabled to enter into a *gemeinschaft* with others of like mind.[95]

Hausmann's "Anarcho-Communism" was an elaboration of these ideas, and the bridge between his interest in psychology and left-wing thought was formed by his essay "Gegen den Besitz!" ("Against Property!"), published in *Die freie Strasse* 9, in December 1918, where the desire for property, the basis of capitalism, is linked with humanity's fear of its vital potential.[96] The influence of Gross and Jung is evident above all in the presence of the almost untranslatable concept "Erleben" in the title of Hausmann's first political essay (1917) and in the frequency with which the same concept appears in *Die freie Strasse* 9 and the eight theoretical essays that Hausmann published between 26 January and 1 October 1919.[97] For Gross, Jung, and Hausmann, "Erleben" refers both to the activity of the liberating life force

and to the liberated existence of the person and/or *Gemeinschaft* in whom that force flows freely.

Hausmann's eight essays form a single argument that runs as follows. Aided by human beings' fear of their own irrational potential [4], all societies, especially that of industrial capitalism, seek to dam up the "psychophysical" life force by a network of repressive institutions of which the patriarchal family is the most powerful [3]. Such institutions create a dependence upon alien authority and discourage people from relying on their own instinctual vitality [6]. Although this makes for superficial social stability, human nature, innately dynamic, will not tolerate it, and from time to time explosions, of which the Great War is the most recent example, occur ([5]:368/50). But out of such explosions, a new being may be born ([5]:368/50). Indeed, in the turmoil created by the most recent explosion, people had been given the opportunity of learning to do without stability, rational order, and predictability, and of living with variability, irrationality, and the darker aspects of life ([7]:519/70). If people are to become full and autonomous human beings, then they must achieve a dynamic balance that transcends conventional binarisms "über dem Abgrund des Mordes, der Gewalt und des Diebstahls" [above the abyss of murder, violence and theft] ([1]:6/28; [8]:547/81). Where enough people can do that, communities may be formed in which the barriers between self and others disappear ([4]:276–77/43–44) and their members become conscious of being united by a common life force. As Hausmann put it in "Gegen den Besitz!": "Gesellschaft heisst: Lebensgemeinschaft und Gemeinschaft in Erleben" [Society means: life community and community in experience].[98] Nevertheless, after a while, this consciousness will inevitably disappear; old barriers and authorities will reassert themselves; and these will have to be exploded once again so that new communities may be formed ([2]:3/31).

The informally structured Anarchist community is the end of Hausmann's thinking. If reality is in seething and unpredictable flux in all directions, then it is courting disaster to organize it into static, pyramidical hierarchies where the only movement is up or down, or into centralized patterns where everything relates to the central point. Somewhat obscurely, Hausmann summarized his ideas as follows:

Aber diese einseitig vereinfachende Gestaltungstendenz des Mannes, die zum Sinnbild des geistigen und mechanisch–technischen Geschehens die Pyramide setzte,—eine Richtung nur nach oben—eine Mittel-

punkts- und Schwergewichtsverlegung über breiten Schichten oder Massen—diese Richtung, die sich ihrer Einseitigkeit nie gründlich bewusst wurde, die nie eine Gleichzeitigkeit, einen Widerspruch sah oder setzte, ist am Ende ihrer praktischen Ausnutzbarkeit angelangt. ([8]: 544/77–78)

But this one-sidedly simplifying tendency of the male, which made the pyramid the symbol of spiritual and mechanical–technical activity,—one direction only: upward; one relocation of the central point or fulcrum above broad layers or masses—this general tendency, which was never thoroughly conscious of its one-sidedness and which never posited or perceived a simultaneity or contradiction, has reached the end of its practical usefulness.

For Hausmann, the ideal state encourages small communities that come into being as circumstances change: reality in flux demands a fluid society in which miniature revolutions are permanently and diversely in progress. Theoretically, this is all well and good, but practically speaking, Hausmann's ideas were nonstarters. The full history of his relationship with Hannah Höch from 1915 to 1922 has still to be written, but two of the major reasons why it was so full of friction (to put it mildly) and ultimately failed were Hausmann's inability to overcome at a personal level his "einseitig vereinfachende Gestaltungstendenz" and the inability of both partners to break out of stereotyped gender roles and expectations by tapping into that power of "Erleben" that allegedly flowed between them.[99]

Although Hausmann's 1917 article "Menschen. Leben. Erleben" ("People. Life. Experience") had envisaged the possibility of a final proletarian revolution on the left-radical Marxist model, this hope disappeared from the 1919 articles, which differentiated between "Anarcho-Communism" and orthodox Marxism, for four reasons. First, by 1919 Hausmann had come to believe that the motive forces behind revolution were more "psychosexual" than economic ([5]:369/51). Second, Hausmann said that the end of existence was not labor but "Erleben," self-emancipation, and self-expression ([8]:547/81). Third, Hausmann replaced his earlier concept of final revolution with the idea that human history consisted of an unending succession of revolutions ([2]:3/31). Fourth, Hausmann saw no reason for assuming that one class was inherently less exposed to the perils of corruption and the misuse of power than any other. Thus, because of this sense that all classes are fallible and any class rule potentially totalitarian, he increasingly had no room in his thinking for the Dictatorship of the Proletariat (or, as he satirically put it, the "Proktatur des Diletariats") and

the vanguard role that Lenin in particular had assigned to the Communist Party.[100] Consequently, in his satirical pieces, he showed up the weaknesses of the proletariat as well as those of the bourgeoisie.

This combination of skepticism and Anarchist utopianism—which also characterized Höch's thinking while she was involved with Hausmann—made it very hard for Hausmann to get involved with revolutionary politics in any real sense.[101] According to Bergius, he helped to distribute the Lichnowsky memorandum in 1917.[102] Written by the former German Ambassador in London, this document, which revealed the extent of Germany's responsibility for the war, was illegally printed and distributed by the embryonic Spartacist League. In "Zur Weltrevolution" ("On the World Revolution"), he gestured toward the USPD by calling its most characteristic policy (revolution without bloodshed via the "Rätesystem"), the first concept of statehood that was not hierarchical ([5]:369/51). In April 1921 he published an almost totally forgotten article in *Die Arbeit* (*Labor*), one of the official publications of the *Kommunistische Jugendbewegung* (Communist Youth Movement). And an advertisement in *Die rote Fahne* of 23 October 1921 (no. 486) lists Hausmann (together with Piscator) as one of the performers at a "Proletarischer Kunstabend" ("Evening of Proletarian Art") that had been organized for 24 October by the Prenzlauer Berg district of the Berlin KPD to help the starving millions in the Soviet Union—Hausmann apparently contributed a political cabaret. But all these were fringe activities and Hausmann's true attitude to party politics is probably better summed up in a recently published statement of late July 1920 which was written in response to Gertrud Alexander's attack on Dada in *Die rote Fahne* and in which he repudiated all forms of party politics whether of the Left or the Right.[103] Maier-Metz records that after 1921 Hausmann gravitated to the ultra-Anarchist, antipartisan AAUE around Franz Pfemfert, and around 1922 he was part of a group calling itself *Die Kommune* (*The Commune*). The name of this group may possibly have been inspired by that of the pacifist-Anarchist group around the former actor Ernst Friedrich (1894–1967), who ran the *Arbeiter-Kunst-Ausstellung* (Workers' Art Exhibition) in Berlin's Petersburger Strasse from 1920 to at least 1923 (in which Hausmann had performed on 5 November 1921) and Germany's first antiwar museum in Berlin's Parochialstrasse from 1925 to 1933.[104] Although very little is known about *Die Kommune*, it issued two manifestos, the second of which numbered Hausmann among its signatories and included the following statement, which is very close to Hausmann's view that the Anarchist *Gemeinschaft*, by its very lack of formal

organization, is ipso facto a revolutionary challenge to accepted values and a pointer to what is to come:

Die ganze Vergangenheit zu revidieren ist unsere Aufgabe. Nicht durch eine intellektuelle Kritik, sondern indem wir das Anderssein *leben.*[105]

Our task is to revise the entire past. Not by intellectual critique, but by living an alternative existence.

But as the Weimar Republic settled into its stabilization phase after 1922, so Hausmann increasingly moved away from the "carnivalesque delirium" of Dada; withdrew from public life and any real political commitment; and settled down into four years of relatively comfortable domesticity.[106]

After Huelsenbeck returned to Berlin, he remained apolitical for nearly two years. But by 1919 his thinking, though never systematized like Hausmann's, had become similar in spirit. His "Gefühlskommunismus" [Instinctual Communism] was characterized by a love of revolutionary impetus for its own sake; a hatred of institutionalized brutality, injustice, authority, hierarchies, and tyranny; a total skepticism about programs and ideologies; and a refusal to believe that the world can be improved in any final sense.[107] For Huelsenbeck, there was only the struggle to achieve a temporarily improved situation, which had to be struggled against in turn when it became a brake on further movement. Huelsenbeck took the Fourierist view that the ideal state should accept that people are governed by primitive drives and encourage these to be used in creative and individual ways. For Huelsenbeck, the essential political stance involved a permanent revolt against all that was anemic and stale, and the assertion of human freedom within "the movement of life." As he said in the trial sheets for *Dadaco:*

Freiheit ist ein Wort, das nur Sinn hat, wenn man es auf die Tiefen der Persönlichkeit bezieht. Regierungssysteme, Schulordnungen, Riten, politische Agitation sind Schall und Rauch, eins ist die Mutter des anderen und das Eine fällt in das Andere zurück nach Gesetzen, die uns ewig unbekannt bleiben müssen.[108]

Freedom is a word that has meaning only if one relates it to the depths of the personality. Governmental systems, educational systems, religious rites, political agitation are sound and fury; the one gives birth to the other and is

then absorbed by it according to laws that must remain eternally unknown to us.

This, of course, is a vague, Anarchist version of Marx's dialectic, but it was on the basis of such a belief that Huelsenbeck, like Hausmann, supported the revolutionary proletariat after the end of the war. Using a vitalist image that is to be found in both Ball's Dada-Manifesto of July 1916 and Jung's "Vorbedingungen des Zufalls" ("Presuppositions of Chance"), Huelsenbeck justified this support by saying that he heard in this class:

[den] Atem der Weltgeschichte, [den] Sturm des Temperaments, der einen Augenblick vergessen liess, dass man in Gottes auserwähltem Volk ein armseliges Dasein geführt, [den] Schrei, der nach einem Schrei der Befreiung und Menschlichkeit klang, die Wut, die eine Explosion des Geistes zu verkünden schien . . .[109]

[the] breath of world history, the storm of passion which let one forget for an instant that one lived a wretched existence among God's chosen people, the cry which sounded like a cry for liberation and humanity, the rage which appeared to foretell an explosion of the spirit . . .

Indeed, throughout *Deutschland muss untergehen* (*Germany Must Go Under*), revolutionary Berlin is depicted by Huelsenbeck in images reminiscent of an Eisenstein film, as a seething flux of carnivalesque activity in which it was "eine Freude zu leben" [a joy to be alive], and in which people, for one brief moment, had overthrown the class that had repressed them and led them into a disastrous war.[110]

The political attitudes of Hausmann and Huelsenbeck were embodied in the manifesto "Was ist der Dadaismus und was will er in Deutschland?" ("What is Dadaism and what does it want to achieve in Germany?"), which they, together with the Russian composer Jefim Golyscheff (1897–1970), published in *Der Dada* 1 in June 1919.[111] Fifty years later, Hausmann described this manifesto as satirical in intent, and there is a clear sense in which it *is* just a parody of the kind of statement being produced by every artistic group with political pretensions during the revolutionary period in Germany—as one perceptive critic realized at the time.[112] It demanded, for instance, that all creative and spiritual persons should be fed daily on the Potsdamer Platz; that all teachers and clergy should assent to the articles of the Dada creed; that the simultaneist poem should be introduced as the Communist state prayer; that churches should be opened for readings of

bruitist poetry; and that a Dadaist Central Office for Sexual Affairs should be set up to administer sexual relationships. But the joke is a serious one. Although it is true that the "idea of revolution was as much an object of mirth as it was part of the aspirations of some Dadaists," revolution nevertheless formed a genuine part of their aspirations.[113] Consequently, in the same manifesto, the Dadaists demanded the international revolutionary unification of all creative and spiritual persons on the basis of radical Communism, the progressive abolition of labor through mechanization, and the abolition of private property. Dada desired revolution while disbelieving in its ability to achieve anything final; looked for revolution while suspecting that the forces of reaction would nearly always be the stronger; and sided with the revolutionary Left while sensing within it a latent totalitarianism. Hausmann summarized these ambiguities as follows:

Der Kommunismus ist die Bergpredigt, praktisch organisiert, er ist eine Religion der ökonomischen Gerechtigkeit, ein schöner Wahnsinn. . . . Immerhin ist Wahnsinn schöner als blasse Vernunft. . . .[114]

Communism is the Sermon on the Mount organized practically, it is a religion of economic justice, a beautiful insanity. . . . Whatever, insanity is more beautiful than pallid reason. . . .

It was in a similar spirit that the Berlin Dadaists, around 12 November 1919, sent a telegram to the *Corriere della sera* ironically approving Gabriele d'Annunzio's operatically piratical annexation of Fiume.

The political thinking of the Oberdada Baader has been extensively discussed and there is no need to reproduce it here.[115] Suffice to say that it is contradictory (involving an attraction to static, monumental, and utopian structures while declaring the endless flux of reality to be an aspect of divine activity); self-satirizing (taking such zanily extreme attitudes that these caricature themselves); satirical (throwing, by means of lunatically spontaneous actions, an oblique light on established ideologies and institutions); and provocative (forcing well-behaved bourgeois to recognize their own latent violence and irrationality). Its end effect is one of explosive Anarchism, which Baader himself realized, since he wrote to Tzara on 12 December 1920, "Der Oberdada ist nur eine dadaistische Bombe zur Sprengung jeder Nationalität und jeder Herrschaft, allermeist aber der deutschen" [The Oberdada is simply a Dadaist bomb for blowing up every nationality and every rule of power—but above all that in Germany].[116]

Franz Jung, who had been a member of Mühsam's Anarchist *Gruppe*

Tat in Munich before the war, made contact with revolutionary groups after his discharge from the army in June 1915. He developed a political consciousness earlier than the other Dadaists and was actively engaged in party politics while the others were still trying to define their theoretical positions. Understandably therefore, his association with Dada was brief. Although he had considerable influence on Berlin Dada (especially Hausmann) through the first six numbers of *Die freie Strasse,* his Dada activity seems to have been confined to work on *Neue Jugend* in mid-1917 (which took over where *Die freie Strasse* had left off) and a collection of stories entitled *Gott verschläft die Zeit* (*God Is Sleeping the Time Away*) (c. 1918). Maier-Metz regards this collection as pivotal for Jung's development because of its attempt to synthesize Gross's psychoanalytical ideas with Aleksandr Bogdanov's theory of *Proletkult,* and of its six stories (all of which display a more complex and pessimistic understanding of reality than Jung's theoretical essays in *Die freie Strasse*), "Babek" and "Seligmanns Ende" ("Mr. Blessed's End") are the most interesting politically.[117] Seligmann is an efficient, industrious, but bloodless party official who has lost contact with his membership and the rhythms of life and so is toppled from power in a sudden revolutionary upsurge. Seligmann cannot understand why he is so hated, goes home, and is murdered there by a mysterious figure. Meanwhile, the uprising ebbs away outside. This story is doubly ambiguous. It celebrates the spontaneous mass uprising and yet recognizes that such movements inevitably die away. The people are admired for their spontaneity and yet implicitly censured for their ingratitude to a loyal party official. Furthermore, in the strange figure of Seligmann's murderer, the mysterious cries in the corridor that he hears, and the shadow in the street that looks like a dog and evokes an acute feeling of angst, Jung touches on the dark and uncanny elements in experience. "Babek" is the story of a sixteenth-century Arab revolutionary who deposed the caliphs, opened up harems, tried to establish sexual equality, tore down fortified palaces, and proclaimed a reign of "freedom and joy." For a period, the downtrodden united in brotherhood and happiness, but the price of this achievement was the slaughter of one hundred thousand opponents. Furthermore, Babek's revolution soon degenerated and gave way to counterrevolution. Like "Seligmanns Ende," "Babek" is ambiguous. Revolution is welcomed but seen to involve carnage before turning into its opposite, and is shown to bring out both the best and the worst in human nature. Thus, it concludes with the narrator saying that he himself does not really understand the story. In these two texts, there is a clear similarity between Jung's de-

piction of the dialectic of revolution and the Dada Anarchists' vision of reality as a flux that is both creative and destructive. But at the same time, Jung—perhaps because he had served at the front—is far more conscious than Hausmann, Huelsenbeck, or Baader of the human cost of revolution and the destructive potential of human nature. Beneath the throwaway irony that characterizes *Gott verschläft die Zeit,* Jung seems to be pondering whether, given the cost of revolution and the inevitability of counterrevolution, a commitment to revolution can be morally justified and whether, perhaps, it is better to do nothing at all.

After the German revolution of early November 1918, Jung seems to have overcome these fundamental doubts by concluding that the cost of revolution is justified if a qualitatively changed situation can be brought about. Consequently, he identified himself with the revolutionary proletariat, became a left-radical Marxist, and joined the KPD in late November 1918. After he and other left-radicals had been forced out of the KPD in October 1919 because of their refusal to work through existing institutions, their antipathy to party centralism, and their preference for strikes and spontaneous mass action, Jung helped found the German Workers' Communist Party (KAPD) in April 1920. There was massive hostility between the KPD and the KAPD (which Lenin would describe, in his famous tract of 1921, as an "infantile disorder")—and this hostility is possibly one of the reasons why, in his letter to Cläre Jung of 10 July 1921, he expressed considerable mistrust of the Malik-Group whose members were by then collaborating more closely with the KPD.[118] In May 1920, after hijacking a trawler, he sailed to Russia in the hope of persuading the Soviet leadership to accept the KAPD as an independent member of the Third International. This attempt failed and after his return to Germany in summer 1920, Jung was arrested for piracy and sentenced to a term of imprisonment, but was released in February 1921. After taking part in the central German uprisings of March 1921, Jung was again arrested (in Holland) and again released. He then travelled to Russia in late summer 1921 where he stayed until early 1924.

During 1919 and 1920, Jung wrote a series of theoretical articles in which he tried to fuse Communist ideology with the Anarchist psychology of his earlier period and to overcome the fundamental doubts that were latent in his stories of 1918. In these theoretical writings, his earlier sense of the endless dialectic of revolution and counterrevolution is replaced by a belief that everything can be changed, spontaneously and for the better, in one final revolution. Defining the proletariat in psychological (rather than

economic) terms as any group that is oppressed, he envisaged the sponta-
neous eruption of its unconscious powers of intensity and the concomitant
establishment of a revolutionary *Gemeinschaft*. Furthermore, he overcame
his earlier sense of the irreducible cost and waste of revolutionary violence
by justifying these in terms of their necessity within the historical process.
Finally, his sense of the darker, mysterious side of life disappeared almost
entirely. For Jung in other words, greater ideological orthodoxy involved
the repression of his earlier sense of the complexity of political situations
and the ambiguity of political action.[119]

Jung's literary development relates directly to his development as a theo-
retician. Impelled by Bogdanov's version of the theory of *Proletkult*, the
continuing influence of Otto Gross (whose work he wished, in mid-1921,
to edit into a book entitled *Von der geschlechtlichen Not zur sozialen Kata-
strophe* [*From Sexual Need to Social Catastrophe*]), psychoanalysis in gen-
eral, and Anarchist thinkers like Saint-Simon and Fourier, he left behind
him the ironies, problems, and ambiguities of his Dada stories. Instead,
between 1920 and 1923, he wrote plays, novels, and stories that aimed to
embody the "Rhythmus des gemeinsamen, gemeinschaftlichen Erlebens"
[rhythm of the common, communitarian experience] that he found in the
work of Jack London and that, he believed, had the power to shatter the
prevailing ideology and established social structures. Despite Jung's active
work within a party of the radical Left, he was strongly attracted to utopian
thinkers, and in his post-Dada work, this manifested itself in the belief
that a final revolution could come about spontaneously, without that tran-
sitional phase during which, through careful analysis, hard work, shrewd
tactics, and disciplined organization, the Dictatorship of the Proletariat
is secured. But when the hoped-for revolution failed to materialize, Jung
became disillusioned. His open letter of 4 September 1921 shows him dis-
tancing himself from the KAPD because of its anti-Soviet stance, and his
5 December 1921 letter from Moscow to *Die rote Fahne* indicates that this
break had definitely occurred. Nevertheless, his stay in the Soviet Union
ultimately had a similar effect on him to Grosz's visit during the same
period. He discovered that it was not a utopia where people could develop
their psychosexual energies to the full, and when he returned to Germany,
he never re-established links with mainstream Communism.[120]

Politically the most sensitive, experienced, and activist of the Berlin
Dadaists, Jung was caught in a double dilemma that he never managed to
resolve. Drawn, like Huelsenbeck and Hausmann, to Anarcho-Commu-
nism because of its sheer human attractiveness and his conviction that it

did the greatest psychological justice to the complexities of human nature, he understood its political impotence and the concomitant need to affiliate himself with a more effective party. But having experienced the ineffectiveness of the KAPD during the abortive uprising of March 1921, and having realized that orthodox Marxism-Leninism pays scant attention to the irrational wellsprings of the personality or the localized needs of the *Gemeinschaft,* he went back to his Grossian roots.[121] Too unironically committed and too much of a utopian to remain long with Dada, he was also too much of a Dadaist to sustain the long march through bourgeois institutions to the final proletarian revolution.

Elsewhere

Dada in Cologne was born from the state of near civil war that prevailed in many German cities during the first three months of 1919. There, in February and March of that year, Max Ernst, newly demobilized, and Johannes Baargeld, the son of a rich Rhineland industrialist and a member of the USPD, produced six numbers of a periodical, *Der Ventilator* (*The Fan*). This was distributed at factory gates and reached a circulation of twenty thousand before being banned by the British Army of Occupation (whose VI Corps set up its headquarters in Cologne-Lindenthal on 11 March 1919).[122]

The politics of *Der Ventilator* were a strange mixture of Dada hardheadedness and Expressionist idealism. On the one hand, Ernst and Baargeld were under no illusions about the German revolution, seeing it, like their fellows in Berlin, as a sellout by the new republic to capitalism. In their view, no revolution had taken place: power and wealth remained where they had always been and society was as repressive as ever.[123] On the other hand, the editors of *Der Ventilator* provided well-worn Expressionist answers to the basic political questions posed by Dada because they did not, at this stage, start from a clear vision of reality as dialectical flux. Where Berlin Dada looked for freedom, fluidity, growth, and even conflict in human relations, *Der Ventilator* spoke approvingly of people's yearning, "die Beziehungen unter den Menschen nach denselben kosmischen Gesetzen zu regeln, die nun das Planetensystem schon seit Millionen von Jahren reibungslos bestehen lassen" [to regulate interpersonal relationships according to the same cosmic laws that have allowed the solar system to exist without friction now for millions of years]. Behind this innocent formulation lay a desire, more typical of late Expressionism than of Dada,

for a total utopia in which all was order and "frictionless" harmony around a central point. Where Berlin Dada depicted human beings as active participants in the material flux of Nature, *Der Ventilator* equated the sense of being human with the sense of "mit dem Universum verbunden sein" [being linked with the universe], a more abstract and static conception altogether. Where Berlin Dada saw human nature as a dynamic interaction of fleshly, intellectual, and spiritual energies, *Der Ventilator* took a more dualistic and straightforwardly spiritual view, speaking of "ein Unentdecktes, von ihm [humanity] ganz Vernachlässigtes in seinem Innern" [an undiscovered something inside the personality that humanity has totally neglected].[124]

The months between the final number of *Der Ventilator* and the publication of *Die Schammade* in Cologne in April 1920 saw Tzara's move from Zurich to Paris and the inception of Paris Dada. Although Breton declared that the Dadaists were partisans of all revolution, irrespective of its nature, Paris Dada was resolutely apolitical.[125] Although the Paris Dadaists cultivated revolt, spontaneous action, and provocation as ends in themselves, they were unconcerned to base these upon a metaphysic, unwilling to define the aims of their revolt, and disdainful of practical politics and political thinking. For Berlin Dada, spontaneity was a value precisely because it had a metaphysical and/or a political charge. For Paris Dada, it was a matter of indifference whether spontaneity was charged in such a way or not. Indeed, to think about the political implications of their revolt would have seemed to some like betrayal.[126] In practice then, a genuine nihilism, a grand and total carelessness such as Hardekopf had perceived in all the final activities of Zurich Dada was never far from Paris Dada. Of all the publications of German Dada, *Die Schammade* most clearly displayed that mood. Despite extracts from Arp's *der vogel selbdritt* and *die wolkenpumpe* and the vitalistic affirmations of Tzara's "Proclamation sans prétension" ("Proclamation without Pretension," 1951), the tone of *Die Schammade* was predominantly absurdist, nihilist, and apolitical.[127] To affirm the absurd spontaneity of life by concatenating meaningless words and phrases may be philosophically defensible, but over several pages it becomes an empty exercise. To snipe at Kurt Hiller, Franz Werfel, Herwarth Walden, César Klein, and Kurt Pinthus may be fun, but it seems parochial in the context of the political situation in Germany at the time and becomes tiresome when it degenerates into mere vituperation.

In Hanover, Schwitters was even more avowedly apolitical than the Paris Dadaists, not even committed to provocation. Nevertheless, two of his

prose pieces, "Ursachen und Beginn der grossen glorreichen Revolution in Revon" ("Revolution," 1927) and "Die Zwiebel" (1919) ("The Onion," 1993) have political implications. The former, the first chapter of an unfinished novel entitled *Franz Müllers Drahtfrühling* (*Fred Miller's Wire Spring*), will be discussed in the next section.[128] The latter is a somewhat macabre story about the ritual slaughter and revivification of an onion. At the end, when the onion stands there whole once more, two candles are stuck in the belly of the old king who is blown to pieces. One is tempted to say that Schwitters is making an implicitly political point here, affirming the human ability to create out of nothing, heal what is wounded, and destroy what constricts. But at the same time, the strangely obsessive, not to say obscene, tone of "Die Zwiebel" inevitably puts a question mark over this conclusion. Could so positive a statement be made in such a way? Does not the sick tone of the narrative implicitly negate the affirmative conclusion? As he does so often, Schwitters approaches commitment only to draw back from making it unequivocally.

At their most characteristic, the politics of Dada are jubilantly and ironically Anarchist, concerned with releasing the irrational powers in human nature and changing our way of experiencing, seeing, and thinking about reality. For Dada, it was pointless to socialize property and create revolutionary institutions without first destroying people's fear of their own irrational powers—the root of their urge to acquire property, dominate their fellows, and settle within fixed and apparently stable patterns. Thus, the real political force of Dada lies not in any abstract ideas, but in its uncompromising experimentalism within a modernity that is felt not only to have come off its hinges but to have lost those hinges while its ideologues pretended that everything was still in its proper place. By insisting on their right to be themselves to the full and at all costs in their everyday lives, the Dadaists challenged those who lived without passion, dominated by conventional ways of seeing, thinking, and acting. By demonstrating their personal autonomy and psychic freedom, the Dadaists pointed to the possibility of a society that was based upon those values, rooted in modernity, and composed of loosely structured *Gemeinschaften* that were open to permanent revolutionary transformation—a view of things that is not that far distant from the ideal of the "unoppressive city" more recently propounded by Iris Marion Young.[129]

It may be a little unfair to criticize Dada Anarchism for its systemic shortcomings since none of the Dadaists professed to be a systematic po-

litical scientist. Nevertheless, three criticisms can be made, two of which are certainly justified. First, it is sometimes said that Dada is nothing more than individualism. Now while it is true that Dada looked for a psychic revolution in the individual and prized personal autonomy above all else, the Dadaists were not straightforward individualists. Hausmann (with some justification) differentiated his Anarcho-Communism from the Individual Anarchism of the Stirnerians who contributed to Anselm Ruest's periodical *Der Einzige* (*The Individual*).[130] Where Ruest and his coworkers exalted the individual ego, Dada emphasized the powers in human nature that, coming from below the ego, were allegedly common to everyone. That said, however, Dada works far better as an experimental, polyphonic, psychological experiment than as a political program.

Second, it can all too often sound as if Dada encouraged any action provided that it was spontaneous. One could easily be misled into thinking that there was no essential difference in the Dada imagination between the spontaneous decision to read from Gottfried Keller in the middle of the Ku-Damm on the occasion of his one hundredth birthday and the spontaneous decision to ransack a Jewish shop there. Huelsenbeck especially gives this impression. In January 1918 he proclaimed:

Wir waren für den Krieg und der Dadaismus ist heute noch für den Krieg. Die Dinge müssen sich stossen: es geht noch lange nicht grausam genug zu.

We were pro-war and Dadaism is still pro-war today. Collisions are necessary: things are still not cruel enough [by far].[131]

In 1920 he wrote:

Und die Matrosen sind die wahren Hüter der Revolution, sie sind die Einzigen, die die vollkommene Nebensächlichkeit des menschlichen Lebens in dieser [revolutionären] Angelegenheit erfasst haben, sie lassen sich von der Macht ihrer Instinkte werfen, sie brüllen Wut.[132]

And the sailors are the true protectors of the revolution; they are the only people who have grasped the total irrelevance of human life in this [revolutionary] affair; they let themselves be hurled along by the power of their instincts; they roar with rage.

And in *Dada siegt!*:

Der Dadaist aber will das Böse von ganzem Herzen.[133]

But the Dadaist desires what is evil/wicked with his whole heart.

and:

Die Aufgabe des Dadaismus: den Deutschen ihren Güte-, Menschlich-
keits- und Expressionistenschwindel zusammenzuschlagen und dafür
den Typus eines naiven Menschen zu setzen, der ausserhalb der Zweiteil-
ung der konventionellen Moral steht. (53)

The task of Dada: to smash up for the Germans their racket which deals
in goodness, humanity and expression[ism?] and to replace it with the type
of naive human being who stands outside the binarism of conventional
morality.

These are very strong words and taken out of context they seem highly
irresponsible, legitimizing mindless violence for its own sake. At the same
time, they are not typical of Dada as a whole. Only Huelsenbeck made
such aggressive pronouncements, and even within his writings, they are ex-
treme ones. Relatively few Dadaists would have assented to the first state-
ment and it has to be held against more numerous statements that explic-
itly denounce the slaughter of the Great War. The disregard for human
life evinced by the second statement is also untypical of Dada as a whole
and has to be understood in the context of the Marxist belief that revolu-
tion is impossible without violence. When, in the third quotation, Huel-
senbeck uses the word "evil," he means what is anarchic, erotic, irrational,
antisocial—*not* moral evil as such. And the fourth passage has to be under-
stood as part of Dada's polemical onslaught on the illusions and hypocrisy
of the Weimar Republic and late Expressionism's excessively high view of
human nature. In this passage, Huelsenbeck is attacking specific targets,
not advocating hostility to goodness and humanity in general. Three of the
four quotations appeared in publications by the Malik Publishing House
which was, at the time when Huelsenbeck's texts were probably written
(1919), committed to revolutionary violence as the justified means to a
desirable political end—the overthrow of capitalism—and the violence of
Huelsenbeck's formulations reflects this. In Huelsenbeck's view, the tur-
moil in Germany after the end of the war offered the possibility of a new,
more equitable, and less repressive society. But before this could emerge,
the old one had to be destroyed: thus, the conflict inherent in the political
situation there had to become more extreme before it could be resolved.

Nevertheless, these passages do show how short is the step from revolutionary vitalism to political nihilism, and although in practice most of the Dadaists implicitly drew a line between anarchic spontaneity and positive acts of cruelty, none of them ever explained by what criteria or with what justification they did so—a problem that, as we shall see, is at the center of the debate about postmodernism.

Third, and this point is connected with the previous one, Dada had no real conception of evil. The third quotation above is one of the few places in the literature of Dada where evil is ever mentioned at all, and even then, the conception is relatively superficial. Dada knew the meaning of human blindness and cruelty, cosmic absurdity, and the place of destruction within the flux of Creation, but it paid little attention to real, diabolic evil. Where the Marxist wing of Dada conceded its existence as a socially generated phenomenon and enjoined political action to combat it, the Anarchists, apart from Franz Jung, did not even go that far. If their strength is their concern with freedom, then their weakness is their failure to bring that concern to bear on real political situations—a step that would inevitably compel them to see the element of tragedy involved in all revolutionary action. Hence, as Man Ray said, they survived, which is quite an accomplishment nowadays, but mainly because few of them plumbed the depths of political involvement. Their peculiar, postwar political concerns took them parallel with but not, on the whole, very far into real political events.[134] With few exceptions, their irony was that of people who had avoided political tragedy, not that of people who had experienced political tragedy at firsthand and yet retained their commitment in spite of it.

Dada Art and Politics

Dada found itself in a dilemma over the political role of art in a prerevolutionary situation. To begin with, it rejected the revisionist fusion of classical humanism and Marxism that typified mainstream Socialist thinking in Germany and also that of Franz Mehring's pupil Gertrud Alexander.[135] It also rejected the generically similar theory of *Proletkult* that had been evolved by Anatoly Lunacharsky, the Soviet Commissar for the Enlightenment of the People. Several sources of information on this theory were readily available to the Dadaists from spring 1919 onward despite the German government's attempt during that year to stop information on Soviet Russia from appearing in the German press, and the most important of these was undoubtedly the German translation (1919) of *Kul'turnyye*

Zadachi Rabochego Klassa (*The Cultural Tasks of the Working Class,* 1918).[136]
Here, Lunacharsky expounded the idea that the revolutionary proletariat, as the latest branch on the tree of common human culture, did not need to ignore all that had preceded it but could assimilate all art that displayed the quintessential spirit of that culture—a conception that implied that the political task of art was to instil people with certain ideal human values. Gertrud Alexander likewise argued that it was necessary to preserve the art of prerevolutionary epochs because of the "eternal quality" vested in it by the human spirit.[137] Dada was skeptical about the humanism of such ideas because, in its view, humanism led either to a conservatism that tried to dominate the flux of Nature or to an escapism that concerned itself with "spiritual values" without reference to the real world of politics. Thus, Hausmann feared that in practice, *Proletkult* could all too easily become an ally of conservatism by insulating the proletariat against truly subversive art and exposing them only to those works that conformed to the canons of classical humanism. In 1923, Tzara, Christoph Spengemann, Van Does-burg, Arp, and Schwitters, writing at a time when the Soviet government's hostility to abstract and avant-garde art was becoming increasingly clear, confirmed the truth of this prophecy. They accused Soviet Communism of betraying the revolution by attempting to stabilize it and of revealing this betrayal indirectly through a conservative love of superseded artistic modes. In their view, Soviet Russia had become bourgeois in spirit despite its revolutionary proletarian rhetoric.[138]

Nor, with the exception of Franz Jung in his post-Dada period, did the Dadaists accept the ideas of the other major *Proletkult* theoretician Alek-sandr Bogdanov, a collection of whose writings, including the essay "Was die proletarische Poesie ist" ("What Proletarian Poetry Is"), appeared in Germany in mid- to late September 1919 with the title *Die Kunst und das Proletariat* (*Art and the Proletariat*). In Bogdanov's view, the task of art in a prerevolutionary situation was to embody the collective character of prole-tarian consciousness ("Geist der Genossenschaft" [spirit of comradeship]) as a counterweight to the authoritarian and individualistic character of bourgeois consciousness. It has been argued that Bogdanov's ideas fed into Berlin Dada.[139] But none of the mainstream Dadaists ever referred posi-tively to Bogdanov. Carl Einstein broke with Dada after contributing his manifesto "An die Geistigen!" ("To the Intellectuals/Spiritual Elite!") to the first number of *Die Pleite* and the spirit of this manifesto is in any case more Expressionist than Dadaist. Moreover, it nowhere mentions either *Proletkult* or Bogdanov and was published *before* the appearance of any of

the sources of the *Proletkult* theory mentioned above. Similarly, although Piscator was closely associated with the Malik-Group, he never saw himself as a Dadaist.[140] So on balance, it seems to me that this argument is not a strong one. Conversely, it is not hard to see why Bogdanov's theory would *not* have appealed to the Dadaists. It took too neatly functional a view of art to suit the Dada Anarchists, too piously evangelical a view of art to suit the Dada Marxists (who never lost their sense of irony), and too idealized a view of the proletariat to suit either wing. In Bogdanov's demand that the prerevolutionary poet be "seelisch verschmolzen" [psychologically melded] with the joys and sorrows of the proletarian collective, an organizer of his class, Dada as a whole would have heard something of that overblown late Expressionist messianism that they so abhorred.[141]

In contrast, Dada evolved two distinct views on the political role of art. The Marxist wing of Berlin Dada thought that the artist could justify his or her existence in a prerevolutionary situation by creating works that in some way contributed to the revolution. Thus, in a programmatic essay written in November 1920 (i.e., at the time when relations between Malik and the KPD were beginning to improve), Grosz proclaimed:

> Aber Ihr [Künstler] könnt mitbauen an dieser Organisation. Ihr könnt helfen, wenn Ihr nur wollt! Und dadurch könnt Ihr lernen, Euren künstlerischen Arbeiten einen Inhalt zu geben, der getragen ist von den revolutionären Idealen der arbeitenden Menschen.[142]

> *[artists] can help build up this organization. You can help if you only want to! And by doing so you can learn to give your artistic works a content that is borne by the revolutionary ideals of working people.*

In spring 1921—that is, at about the time that Malik was beginning to publish its *Sammlung revolutionärer Bühnenwerke* (*Collection of Revolutionary Stage-Works*), twelve of which appeared between 1921 and 1923, and when Piscator's first *Proletarisches Theater* (*Proletarian Theater*) (14 October 1920–10 April 1921) was folding—Hausmann wrote an uncharacteristically Marxist piece on the same problem for a mainstream KPD periodical.[143] In it, he regretted the lack of proletarian plays that embodied a revolutionary class consciousness; called for the setting up of proletarian drama schools; urged workers to put on plays, even mediocre ones, that increased their class consciousness and self-confidence; and advocated the staging of plays with a clear political message (rather than Naturalist dramas by Hauptmann and Ibsen that had been the staple diet of the

left-wing German stage for the past thirty years). In 1925, Grosz and Herz-felde described "Tendenzkunst im Dienste der revolutionären Sache" [art with a clear political message in the service of the revolutionary cause] as the great new task and as Dada's only alternative to nihilism. Such state-ments were easy to make and in total conformity with the KPD's position on art as formulated in August 1922.[144] But they were difficult to put into practice since, as the Dadaists well knew, "Tendenzkunst" rapidly degen-erated into empty left-wing posturing. But in his important four-part essay "Gesellschaft, Künstler und Kommunismus" ("Society, Artists and Com-munism") of four years previously, Herzfelde had examined the problem more carefully, discussing whether it was possible to produce a revolution-ary Marxist art that was still the free creation of the human imagination.[145]

Herzfelde's argument ran as follows. Art and literature are concepts pro-duced by bourgeois society. That society is passing. Consequently, their more honest practitioners are recognizing the anomalous nature of their position and questioning their role.[146] The results of this questioning are at present largely negative and will remain so until artists recognize that Communism is the only positive content of this period of history (138). Those who reach this conclusion and are prepared to overcome their bour-geois individualism will have a place, albeit a subordinate one (307), within the Communist Party. Their task there will be to unmask bourgeois society so nakedly and compellingly that everyone will be able to recognize it as the destroyer of happiness, justice, and freedom, and as the creator of un-told human misery (305–7). The Communist artist must be prepared to awaken a revolutionary consciousness (370) and the image of completeness by displaying and attacking the incompleteness of the world as it exists (307). In other words, the essential task of the Communist artist was to be social satire, and from 1921 onward, Herzfelde translated this theory into practice by having Malik publish a large number of social-satirical works that included Hausmann's *Hurra! Hurra! Hurra!* and several items by Upton Sinclair, Franz Jung, George Grosz, and Maksim Gorky. Other Dadaists had come to this conclusion even before Herzfelde had formu-lated it systematically. Consequently, Dada periodicals were full of satirical comment which, if sometimes weak, did at least represent a conscious at-tempt to link art and political reality. Similar things could be said of Walter Mehring's puppet play *Einfach klassisch!* (*Simply Classic[al]!*), with puppets designed by George Grosz and executed by John Heartfield, that was put on, not very effectively, at the reopening of Max Reinhardt's little cabaret *Schall und Rauch* (Sound and Fury) in Berlin on 8 December 1919.[147]

For the Anarchists, however, revolutionary art was revolutionary not by virtue of its ideological purity or politically motivated satirical edge, but by virtue of its "otherness"—its commitment to flux, absurdity, experimentation, and psychic freedom and its inherent opposition to the conventionally ordered world.[148] In this spirit, Ball had written in his diary just at the start of his second Dada period:

Die Kunst kann vor dem bestehenden Weltbild keinen Respekt haben, ohne auf sich zu verzichten. Sie erweitert die Welt, indem sie die bis dahin bekannten und wirksamen Aspekte negiert und neue an ihre Stelle setzt. Das ist die Macht der modernen Aesthetik. . . .

Art cannot have any respect for the existing view of the world unless it renounces itself. Art enlarges the world by negating the aspects that were known and in operation up to now, and putting new ones in their place. That is the power of modern aesthetics. . . .[149]

Hausmann said:

Die Heiligkeit des Sinnlosen ist der wahre Gegensatz zur Ehre des Bürgers, des ehrlichen Sicherheitsgehirns. . . .[150]

The sanctity of the senseless is the true antithesis to the honor of the bourgeois and his honest security-brain. . . .

And Richter remarked in retrospect that everything which takes hold of the flux of life for its own purposes is politics.[151] The Anarchist Dadaist holds that truly revolutionary art is like Franz Müller in Schwitters's "Revolution in Revon" who stands functionless in an unexpected place. It alienates the beholder in Shklovsky's sense and provokes a sense of unease and threat by confronting him or her with an alternative way of seeing and experiencing.[152] For the Anarchist Dadaist, the truly revolutionary work of art is revolutionary in two respects. It challenges people to alter their conventionalized consciousness of reality and themselves, and it invites them to explore their own potential, rid themselves of their need for dependency, and shrug off their sense of oppression—in short, become their own footballs.[153]

Because the Dadaists were agreed that late capitalist modernity was in a state of crisis, they evolved two political aesthetics for dealing with the crisis that overlap to a certain extent. On the one hand, satirical social analysis designed to expose the faults and contradictions of the capital-

ist life-world and its ideology; on the other hand, aggressively provocative buffoonery designed to subvert the established order in any and every possible way. To a considerable extent, the debate about postmodernist art and aesthetics recycles this debate with Marxists (like Habermas, Callinicos, and Eagleton) tending toward the former position and vitalist Anarchists (like Lyotard, Deleuze, and Guattari) proffering somewhat less forceful versions of the latter position. Whether their efforts will get through to a wider audience any more effectively than the Dadaists' projects can only be a matter for speculation.

13. Dada and the Last Post of Modernism

The term "postmodernism" dates back to 1875; was used frequently by Charles Olson between 1950 and 1958; became a polemical literary-critical term in North America during the 1960s; and seems to have been first applied to the visual arts by Leo Steinberg in 1968.[1] But it gained really wide currency in the mid- and late 1970s, beginning with the architect Charles Jencks's 1975 essay "The Rise of Postmodern Architecture" and culminating in Jean-François Lyotard's 1979 book *La Condition postmoderne.* This periodization maps very closely with the surge and ebb of the countercultural euphoria of the 1960s and early 1970s, the erosion of the Fordist–Keynesian system in Europe and North America after 1973, the globalization of the economy, and the rise of Reagan and Thatcher in the late 1970s.[2] Furthermore, there is a broad consensus that postmodernism as a cultural phenomenon involved two phases. During the first, it was oppositional, anticapitalist, and antiestablishment. But during the second, not least because of the culture industry's increasingly sophisticated ability to assimilate opposition and protest, its status became much more problematic, generating both Fredric Jameson's first-past-the-post essay of 1984 (in which postmodernism was roundly denounced as the cultural legitimization of late capitalism) and the vast amount of secondary literature in which Jameson's thesis has been accepted, contested, or modified.[3]

Postmodernism raises complex problems, partly because of the broad spectrum of phenomena to which the term is applied, partly because of the confused way in which the term and its cognates are used, and partly because of its ability to generate a range of questions to which there are no

easy answers.[4] But after reading my way through several thousand pages on the subject, it seems to me that five questions are central to the debate: (1) are modernity and postmodernity continuous or disjunct?; (2) are modernism and postmodernism continuous or disjunct?; (3) what is the relationship between poststructuralism, modernism, and postmodernism?; (4) what is the relationship between Dada, modernism, and postmodernism?; (5) what fundamental problems do postmodernism and Dada, to the extent that it prefigures postmodernism, leave us with?

Modernity and Postmodernity

The most cogent answer to the first question seems to me to have been set out by Harvey and to run as follows. Late capitalism or postmodernity *looks* very different from the Fordist system that preceded it. Nevertheless, its three driving principles—growth-orientation, exploitation of living labor (often by a return to more primitive modes of production), and coercive competition to maximize profit—have remained constant even though they now work in a new configuration that Harvey terms "flexible accumulation."[5] This configuration involves far greater flexibility with respect to labor processes and patterns of consumption. It generates new sectors of production and new markets. It intensifies the process of innovation via the new technologies (147). It creates surface diversity (344), and it allows a globalized money market to operate with unprecedented autonomy vis-à-vis the production of commodities and the nation-state (160–65 and 192–94).[6] But although faster and more complex than the Fordist system, Harvey maintains that it is driven by essentially the same urge to rationalize, commodify, ephemeralize, fragment, and secularize (111, 117, and 295). To use an image that is central to Marinetti's *Fondazione e manifesto del futurismo,* life in the period that generated modernism was like a ride in a moderately fast car that was always in danger of coming off a badly made road. In contrast, life in the postmodernity described by Harvey is more akin to riding on a "careering juggernaut" or being swept along by a "maelstrom" or "whirlpool" with all the additional dangers that those metaphors involve—unless, of course, one lives in one of those structurally stagnant areas where, because of the vagaries of the market, very little happens at all.[7]

Consequently, the argument continues, postmodernity replaces old-style imperialism with an economic colonialism that destroys or attempts to destroy indigenous cultures. It also intensifies the individual's sense of

not being in control while surrounding him or her with an increasing range of fetishized commodities that are designed to give their owner the illusion of being in control. And it replaces a world that was mysterious because it was governed by a hidden God with a world that is enigmatic because it is governed by economic forces that even experts are hard put to identify and understand, let alone control. Moreover, within the inherently expansionist world of postmodernity, even intangibles are potential commodities. Those privileged areas and enclaves in which so many modernists sought refuge from modernity—such as art and the aesthetic, tradition and the past, utopia and the future, ecstatic and mystical experience, remote geographical areas, and the allegedly unsullied, "natural," premodern paradise—have long since been invaded by dealers, admen, developers, tour operators, and charlatans.[8] Additionally, postmodernity has succeeded in commodifying the artifacts that were produced by the historical avant-gardes in response to modernity, the shock tactics and estrangement techniques that they pioneered, and the libidinal energies that they conjured as the major means of coexisting with while living in opposition to capitalist modernity.[9] Indeed, postmodernity seems uniquely able to commodify oppositional phenomena—the "live," protest, the subversive, and the marginal—and to recycle them as style or via a media event like the exhibition of the work of forty-two young British artists from Charles Saatchi's collection, which, under the title "Sensation," took place in London's Royal Academy in autumn 1997.[10] On this analysis then, postmodernity may be driven by the same forces that generated Durkheim's disorienting state of anomie and Weber's *stahlhartes Gehäuse,* but it looks very different. It is a massive, almost Rabelaisian carnival of consumption, a polyphonic "casino economy" that creates immense wealth for some and terrible deprivation for others, seemingly at random.[11] It is as though the economies of late-capitalist modernity have absorbed or assimilated the flux of Nature that haunted or inspired the modernist generation and created a way of life where everything is disposable and everything for sale—provided that one has the means to buy it.

Although the weight of the argument indicates that postmodernity is fundamentally continuous with the modernity that preceded it, its most incisive analysts have isolated three major discontinuities. First, it is far less burdened by a sense of the past. As Perry Anderson put it, "After 1945, the old semi-aristocratic or agrarian order and its appurtenances was finished," and that appears to be increasingly the case outside as well as inside Europe.[12] Second, while the power of money has increased and new forms

of value have come into being, money itself, as Simmel foresaw at the turn of the century, has become increasingly independent of any material base, enabling it to be moved through space and regenerate itself with unprecedented speed.[13] Third, because of the all-pervasiveness of the new media and advertising, the aestheticization of everyday life, and the increasing commodification of culture, it has become impossible to draw the classic Marxist distinction between economic base and ideologically saturated cultural superstructure. The two areas now intertwine and interact so systemically that it is extremely hard to disentangle fantasy from reality, consumption from culture, ideology from commodity, and genuine personal aspiration from artificially induced need.[14]

Given all of this, it becomes equally hard, not to say impossible, to distinguish between art and nonart, art and commodity—both as regards the past and the present. When a relatively stable, dominant class determined taste and exercised patronage, it was clear what constituted art. Under these circumstances, monetary value was attached to the labor of the artist rather than the work itself; the social (and therefore ideological) function of art was much more transparent; and a would-be avant-garde had a clear target to attack. But once the old hierarchies disappear, once established artworks become a form of money, and once all areas of life are simultaneously aestheticized and commodified, then art itself becomes problematic. Consequently, the would-be avant-garde finds it more difficult to identify a norm against which to define itself and so has to become far more outrageous even than the historical avant-gardes to produce a comparable shock effect. Duchamp's urinal seems tame in comparison with Damien Hirst's presentation of viscera, and the moral message behind George Grosz's depiction of the *Freikorps* as pigs is straightforward in comparison with the sensitive and complex issues involved in Marcus Harvey's twelve-foot-high portrait of the child murderer Myra Hindley. Within the condition of postmodernity, Lord Chandos's postcrisis situation of radical uncertainty becomes general and generates many highly uncomfortable questions that are easy to brush off ex cathedra or to parody satirically (as in D. J. H. Jones's witty academic whodunnit *Murder at the MLA* [1993]) but very hard to answer sensibly.[15] Were the aesthetics of Kant and Hegel ultimately a rearguard attempt to save art as a privileged enclave in a secularizing world where its established status is under increasing threat? Who establishes canons, by what criteria and for what purpose? How far is the history of Western culture one of exploitation and domination and how far are its aesthetics an attempt to legitimize and/or

mystify this? Are all those fleshy, premodern nudes just so much sexist soft porn? If they had been painted by women, would their status be any different? Are the aesthetics of an Alfa Romeo or a Spitfire different in kind from those of a set of cutlery designed by Kolo Moser or a Bauhaus chair? Is a mass-produced, early Victorian blue-and-white plate a work of art? Is a hand-blown wine glass intrinsically superior in aesthetic terms to one produced by a machine and if so why? If the study of art and literature is supposed to improve human beings, then why do so many professional critics spend so much time bitching uncharitably about one another's work? How can we describe the contemporary experience of art without invoking the aesthetics of a metaphysical tradition in which most people no longer believe or unwittingly penning yet another item for "Pseuds' Corner" in the satirical English magazine *Private Eye* (where the effusions of pretentious critics are regularly ridiculed)? Why bother with art and aesthetics at all when the need to cultivate such nonaesthetic qualities as kindness, generosity of spirit, trustworthiness, decency, and empathy is far more pressing in our world? If Chandos's watering can says more to him than an accepted masterpiece, then is there not a sense in which that watering can is as valuable as, if not more valuable than, the masterpiece? If one tried to provide categorical answers to all these questions, one would almost certainly knot oneself in contradictions very rapidly. Not only are they variant versions of the questions posed by Nietzsche's madman in *Die fröhliche Wissenschaft* and implied by Kafka's story "Josefine, die Sängerin oder das Volk der Mäuse" (1924) ("Josephine, the Songstress, or the Mice Nation," 1942), they are part and parcel of the puzzling, kaleidoscopic experience of postmodernity.

Modernism and Postmodernism

Although the boundaries between modernism and postmodernism are blurred, the debate of the last three decades tends toward the following conclusions.[16] When the concept of postmodernism gained currency in the 1960s and 1970s, it was used contrastively and reactively: by poets and literary critics objecting to the institutionalization of high modernist literature by an academy dominated by the New Criticism; by painters challenging the hegemony of Abstract Expressionism in North America; by theorists protesting against the rift between art and life/mass culture; by dance critics reacting against George Balanchine's neoclassicism; and by architects seeking to overthrow the so-called International Style.[17] Although

most early protagonists of postmodernism defined themselves in contrast to a narrowly selective or reified image of modernism, they had one aim in common. All were attacking the idea that the work of art existed in and for itself, in a state of autotelicity, above the flux and discords of mass culture and the ruptures of a modernity that was itself on the threshold of a major reconfiguration. This is why, as Charles Newman pointed out, one rarely finds the term postmodern used in disciplines where "there is no canonical structure to attack or dismiss."[18] In this context, then, it was no accident that the escalating use of the term "postmodernism" should have coincided with a spate of disaster movies, in the four best-known of which— *The Poseidon Adventure* (1972), *Earthquake* (1974), *The Towering Inferno* (1974), and *Airport '77* (1977)—monumental products and confident inhabitants of what Perry Anderson called the "oppressively stable, monolithically industrial, capitalist civilisation" of Fordism are destroyed or badly damaged by the four elements and dysfunctional technology.[19]

Although early protagonists of postmodernism tended to make reactive contrasts between it and what they thought of as modernism, it has been increasingly recognized since the mid-1980s that postmodernism actually inherited a range of surface features, techniques, and attitudes from all areas of modernism (not just from the historical avant-gardes), as well as from more remote ancestors like Sterne, Blake, the Romantics, and Kierkegaard. These include, among other things, various modes of parody and irony, heteroglossia, simultaneity, paradox, multiple ambiguity, indeterminacy, self-reflexivity, double-coding, plurality of linguistic registers, collage, montage, assemblage, the use of "nonartistic" materials, "low" and popular forms, metalepsis, paranomasia, iconoclastic and shock tactics, self-subversion, chance, and a general readiness to experiment with new materials and media.[20]

Third, it has also become increasingly apparent that what Linda Hutcheon called the problematics of postmodernism are very close to the problematics of modernism as those were set out in chapter 2.[21] The experience of reality as decentered, multidirectional flux; the attack on phallogocentric notions of selfhood, fixed gender roles, and a "coherent and motivated inscription of a unified subjectivity"; and the diminished confidence in reason, language, historical metanarratives, and eurocentrism are present in both phenomena, albeit to differing degrees (160). It has also become increasingly apparent that postmodernism inherited these problematics not just from the avant-garde wing of modernism, but, as several critics have noted, from such "high modernists" as Faulkner, Hofmannsthal, Conrad,

Kafka, Joyce, Eliot, Woolf, Thomas Mann, Proust, Gide, Musil, Brecht, Picasso, and Le Corbusier.[22] Just as postmodernity is in several fundamental respects a speeded-up version of modernity, so postmodernism has inherited the range of "radical epistemological and ontological doubt[s]" that generated the art and literature of modernism.[23]

Nevertheless, there are clear distinctions between postmodernism and modernism, even if they cannot be reduced to reactive contrasts or the table of oppositions originally proposed by Ihab Hassan in 1971.[24] Huyssen rightly said that the problem of continuity or discontinuity cannot be "adequately discussed in terms of . . . an either/or dichotomy"; and Hutcheon echoed this, saying that postmodernism "marks neither a simple and radical break from [modernism] nor a straightforward continuity with it: it is both and neither."[25] Just as postmodernity seems to be a new configuration of modernity, so postmodernism is in some senses a development and in others a transformation of modernism. It all depends whether one looks at the two phenomena in terms of their surface features, the problematic with which they are grappling, or the responses to that problematic which they generate.

As we saw, modernism arose from an acute sense of crisis and the need to resolve that crisis, and Suleiman, Huyssen, and Raulet all identify the origins of postmodernism in a similar sense of crisis.[26] Indeed, Raulet says that postmodernity/postmodernism could be viewed as "eine weitere, wie immer anscheinend radikalere Krisenerscheinung der Moderne" [a further, even apparently more radical manifestation of the crisis of modernity/modernism]. While Raulet is correct to the extent that we now possess the means to blow up or poison our entire planet, it seems to me that the postmodernist generation experiences that crisis in a significantly less drastic form than the modernist generation experienced the shock of modernity and the First World War. The early postmodernists were thoroughly upbeat about revolution in every sense of the word, and although the later postmodernists may be markedly less optimistic, more resigned, and more assimilated than their predecessors, I have the distinct impression that they do not, on the whole, pictorialize the condition of postmodernity anything like so apocalyptically. Thomas Pynchon's *Gravity's Rainbow*, for instance, which appeared in 1973, is set in a violent, devastated Europe in and after the Second World War and deals with a group of characters racing each other through a narratorial maze to find the formula that will launch the super-V2 rocket. But for all its horror, violence, and disconcerting twists and turns, *Gravity's Rainbow*, unlike most major mod-

ernist novels, is essentially comic. Analogously, when Huyssen, one of the most acute, knowledgeable, and insightful commentators on postmodernism, tried to characterize the whole phenomenon, he spoke of "temporal" imaginations displaying "a powerful sense of the future and of new frontiers, of rupture and discontinuity, of crisis and generational conflict."[27] It is particularly telling that this list of characteristics begins with two positive ones; that the word "crisis" appears in fifth place only; and that it is linked with so low-key an issue as "generational conflict." We are, in other words, a long way from Rimbaud's season in hell; Kubin's self-destructing Kingdom of Perle; van Hoddis's best-known poem (see chapter 9); Kandinsky's *Compositions;* Spengler's philosophy, Chandos's rat-filled cellar, and Freud's irreducible sense of Thanatos.

The reason that a potentially more devastating crisis than the Great War should be experienced in a less extreme form is not hard to explain. The postmodernist generation did not grow up in so stable and optimistic a world as the modernist generation. They were not on the whole put through an educational or confessional system that imbued them with such high ideals as those with which the modernists were imbued. They grew up with memories of the Holocaust, Hiroshima, and the Great War and in full knowledge of the gulags and the power of the hydrogen bomb. And they were subject to an increasingly pervasive media system continually transmitting the omnipresence of (mini-)disaster together with the metanarrative of late capitalism according to which everything is constantly improving and there is no (mini-)disaster that cannot be put right or prevented from occurring again by initiative, hard work, money, and technology (cf. Bruce Willis's 1998 film *Armageddon* where this is the central message). Or in other words, I suspect that the postmodernist generation, rather like the Dadaists, had much lower expectations about human nature, culture, and history than their "high modernist" predecessors. Thus, when the hopes of 1968 were dashed and the secularized providentialism legitimizing late-capitalist postmodernity became increasingly incredible, their subjective responses to that process of disillusion were far less extreme even though there were very good objective reasons why they should have been far more extreme. Those critics who see the essential feature of postmodernism as its *acceptance* of postmodernity with its decentered plurality, ephemerality, fragmentation, discontinuities, indeterminacy and, depending on one's point of view, chaos seem to me to have got it precisely right.[28]

This initial major difference then leads to a second major difference be-

tween modernism and postmodernism that has also not gone unremarked: their respective sociocultural situations. Because modernism developed in a Europe that was only partially modernized and within a modernity that was only partially realized, the modernists could, as we saw, imagine and in some cases actually find one of a variety of escape routes. Postmodernism, however, developed in a world that was getting smaller and modernizing with exponential speed; that was busily occupying or commodifying those older escape routes; and that had learned, thanks to the new media technologies, "the high art of integrating, diffusing, and marketing even the most serious challenges."[29] As a result, postmodernism had to confront the problematic inherited from modernism in a "field of tension" where a series of binarisms that the modernists had been able to turn to their advantage were no longer valid and where several of the major older escape routes had been blocked once and for all.[30] The "high modernists"—but not the experimental writers and historical avant-gardes—had, on the whole, been able to believe or persuade themselves either that they lived or could live outside modernity and its attendant mass culture. In contrast, the postmodernists, as Hutcheon saw, found themselves, like the Dadaists before them, in a highly ambivalent relationship with postmodernity, consumer culture, and their own artifacts.[31] Thus, when Welsch tried to set up a clear distinction between a "true" postmodernism (that he calls "precise") and a "false" postmodernism (that he calls "diffuse"), he rapidly had to resort to denunciatory rhetoric (since his distinguishing criteria are so arbitrary and vague) with the result that his argument sounds suspiciously like a latter-day attempt to reinstate precisely the clear divide between "high" and "low" art that postmodernism, we are assured, seeks to abolish.[32]

Just as the philosophers, psychoanalysts, and scientists of the 1930s tended, when trying to come to terms with the perceived cultural crisis, to respond to it in terms of optimism and pessimism, so analysts of postmodernism have often divided that phenomenon into two phases. On this account, the first phase (extending from the mid-1950s to the mid-1970s) involved countercultural opposition and celebratory affirmation, and included such writers and artists as Robert Rauschenberg, Jasper Johns, Jack Kerouac, Allen Ginsburg and the Beat Poets, John Cage, William Burroughs, Donald Barthelme, Andy Warhol, Susan Sontag, the Fluxus group, the Conceptualists of the Situationist International (1957–72), Joseph Beuys, and Henri Chopin.[33] But the second phase, which is frequently connected to the political disillusion of the mid-1970s, is thought, especially by Marxist critics who take their cue from Jameson, to be the ex-

pression of "the experience of defeat," to have lost its critical edge, and so to affirm late-capitalist postmodernity.[34] Indeed, some critics argue that postmodernism has become so "incorporated" into late capitalism during this second phase that its texts either mask or uncritically replicate that system's chaotic impenetrability by means of precisely those eclectic techniques which they inherited from modernism and the historical avant-gardes. Harvey, for instance, draws an analogy between the "superimposition of different [noncommunicating] worlds in many a postmodern novel" and the situation of ghettoized minority populations in the inner cities on both sides of the Atlantic, and Callinicos argues that the playful surfaces of postmodern architecture are simply novel forms of packaging which mark one building out from another but mystify the real forces that have brought them into being.[35] Although some critics argue that a transgressive "postmodernism of resistance" is a possibility or even a reality during the second phase of postmodernism, the fact remains that postmodern texts, in whatever medium, are often so difficult (despite the claim that they cross the high/low divide) that even professionals find it hard to disentangle their possible meanings.[36] I refer the reader to the conflicting evaluations of Charles Moore's Piazza d'Italia in New Orleans, the Bonaventura Hotel in Los Angeles, and Robert Mapplethorpe's photographs, and also to Hutcheon's extremely elaborate readings of a range of postmodern novels and buildings.[37] Is, for example, Andres Serrano's notorious photograph *Piss Christ*—a picture of a crucifix in a jar of urine— gratuitous blasphemy that is merely designed to shock; a statement about the true place of Christianity in a culture that pays only lip service to its values; or a theological statement about Christ's power to redeem even what is regarded as waste and base? Is Harvey's portrait of Hindley gratuitously offensive and doubly so for being built up from the cast of a child's hand used as a stencil? Or is it making a statement about the banality and therefore omnipresence of evil in human nature? The problem becomes even more acute when it is a question of deciding whether any given work or part of a work is "incorporated" or "transgressive."[38] Although Rauschenberg and Warhol are usually seen as part of the first, transgressive phase of postmodernism, Michael Newman regards them as transgressive aesthetically but incorporated sociopolitically inasmuch as they, like Pop Art in general, "mimetically reproduce the attitude required of the postwar consumer."[39] Similarly, Francis Ford Coppola's film *Koyannisqatsi* (1983) can be read as a "transgressive" text. Its title is a Hopi Indian word meaning "crazy life," "life in turmoil," "life out of balance," "life disinte-

grating," and "a state of life that calls for another way of living," and its long, slow, final image of a huge rocket blowing up and a part of it falling to the ground like the torso of a dismembered human body reinforces this message: postmodernity is inherently self-destructive. But there are long passages within the body of the film where this message is far less clear. During these, postmodernity is aestheticized into an interplay of flashing lights and movements that sustain themselves in a state of almost impossible balance. Or again, Jonathan Coe's novel *What a Carve Up!* (1994) is on one reading a highly incisive attack on Thatcherite postmodernity in Britain that uses two popular forms, the whodunnit and a black comedy film of 1961 involving actors from the "low" *Carry On* series, to transmit an uncompromisingly social-critical message. But it could also be argued that this novel, for all its narratological ingenuity and brilliance, is ultimately an "incorporated" text. The wicked family of exploiters ends up dead, but so does the investigative reporter who narrates that family's demise. Moreover, his account turns out to have been published by a vanity press whose publications no one reads, and the system that produced the family is still firmly in place. As in the serial detective fiction that developed during the modernist period as evil became increasingly problematic in a secularizing world, the signifier has perished but the signified—evil, the system—has not been overcome.

To complicate matters still further, there is wide agreement that the art and literature of the second phase of postmodernism is extremely diverse. It cannot be divided up in the way it is possible to differentiate between the historical avant-gardes up to and including Abstract Expressionism, and it involves a very wide range of possible aesthetic responses to postmodernity.[40] Nevertheless, Giddens identifies five broad "adaptive [postmodernist] reactions" to postmodernity: "pragmatic acceptance," "sustained optimism" in the tradition of the Enlightenment, "cynical pessimism," cynicism combined with "desperate hopefulness," and "radical engagement."[41] Of these, the last four map to a considerable extent with the modernist responses described in chapter 3 that do not involve some kind of flight out of time. But unless I have misunderstood the first category, Giddens's taxonomy omits the "adaptive reaction" or aesthetic response that is most generally accepted as typical of postmodernism and that very obviously connects with what I have called the experimental mode of modernism. This response, that I shall call "ludic," involves the nondespairing acceptance of flux, ephemerality, relativity, and nothingness; play amid irreconcilable opposites and shimmering, ambivalent sur-

faces; and the concomitant renunciation of any quest for meaning and final answers either within or outside of the human personality.[42] Jean-Jacques Beineix's brilliantly seductive film *Diva* that appeared in the pivotal year 1981 perfectly encapsulates this mode. The director plays a series of tantalizingly complex games with the viewer, offering highly suggestive and beautifully photographed images that turn out to mean nothing and a story whose ramified narrative line ends in self-parodying cliché. Ultimately, the film goes nowhere, makes no point, and simply invites the viewer to sit back, enjoy the game, and not look for any deeper meaning in its labyrinth of mirrors. Where all forms of modernism—except the nihilistic wing of Dada and related phenomena—sought to rediscover a dimension of depth, however conceived, that was felt to have been excluded from Weber's *stahlhartes Gehäuse* or lost amid Durkheim's anomie, ludic postmodernism abandons this quest and so declares that modernist man's search for a soul, with all its attendant existential angst, was a waste of time.[43] Although this attitude looks like and is often mistaken for Dada, the resemblance is, as chapters 7, 10 and 12 imply, superficial only. But given this similarity, it is very easy to understand why both Dada and ludic postmodernism should attract the odium of humanist and Marxist critics alike.

Poststructuralism, Modernism, Postmodernism

If postmodernism in all its variegated forms is the aesthetic attempt to deal with "the experience of the Post," then poststructuralism, with which it is often too readily equated, is the attempt, as Bauman put it, to theorize postmodernity "according to its own logic."[44] As in the case of postmodernism, critic after critic has noted just how indebted poststructuralists are to modernist thinkers and writers—which ceases to be surprising once one appreciates the deep continuities between the problematics of modernism and postmodernism. Indeed, Huyssen went so far as to call poststructuralism a "neue Theorie des Modernismus" [new theory of modernism] and "eine Theorie des Modernismus im Stadium seiner Erschöpfung" [a theory of modernism in the phase of its exhaustion].[45]

The latter characterization strikes me as an overstatement, since whatever one thinks of their diagnoses, the major poststructuralists were patently trying to theorize the change that Western capitalism was undergoing in the 1970s and 1980s. Nevertheless, the former contention contains more

than a grain of truth. Foucault's attempt to replace the "unities of human-ist historical thought . . . with concepts like discontinuity, rupture, thresh-old, limit and transformation," his genealogical approach to history, and his critique of the foundational subject are profoundly indebted to Nietz-sche.[46] Derrida's and Lyotard's critiques of language follow directly from those developed by Saussure, C. S. Peirce, and Wittgenstein.[47] Lyotard's thinking was clearly affected by his encounter with the works and writ-ings of Duchamp about whom he wrote a series of gnomic pieces in the mid-1970s.[48] Baudrillard's belief that we are hopelessly trapped in a world of simulacra with no access to truth or the real is a softer version of the *Kulturpessimismus* that pervades conservative modernism. And the vital-ism that is central to the thought of Deleuze and Guattari; that becomes increasingly prominent in Lyotard's thought from the late 1960s to his *Economie libidinale* (1974) (*Libidinal Economy,* 1993); and that begins to emerge tentatively via the concept of the desiring body in Foucault's very last work stands in a line of thinking that runs from Nietzsche through Otto Gross and Wilhelm Reich to Herbert Marcuse.[49]

Indeed, there is a very good case for saying that the major poststruc-turalists synthesize and radicalize, for better or for worse, the two clas-sic analyses of modernity discussed in chapter 1. Foucault describes hu-manity's entrapment in a system of discursive structures that generates sexuality only so that it may exercise even greater control over the indi-vidual.[50] Lacan expatiates on the immutable Law of the Father that pro-duces desire in the subject only so that its authority over the subject may be reinforced. Derrida, dynamizing Saussure's model of the sign, sees hu-manity as caught in an endless flow of textuality where signifieds and sig-nifiers perpetually fracture and recombine anew.[51] Consequently, he con-cludes that because there is nothing outside the text, hermeneutical effort can only supplement and never clarify it in any final sense.[52] The later Bau-drillard views postmodernity as an incorporated anticarnival whose power to mystify through ever-changing systems of simulacra is total.[53] In offer-ing this analysis, it seems to me that all four thinkers are doing two things. Implicitly and variously they are fusing the Weberian analysis of moder-nity as a *Gehäuse* with the Durkheimian analysis of modernity as anomic flux. They then radicalize that analysis by saying that there is no way out of the ever-changing, labyrinthine prison of postmodernity because there is no "reality" that could act as a point of reference and because anything that looks like reality is simply part of postmodernity's ever-changing, im-

prisoning system of textuality, discursive structures, and commodified illusions. Thus, it follows that truth is highly relative, meaning highly subjective, and subjectivity a factitious construct.[54]

During the 1980s a large number of academics bought into poststructuralism, producing tortuously prolix texts that wasted a lot of readers' time and that even then, although many of us were too intimidated to say so, looked either like an overstatement in need of a Johnsonian kick or a revved-up version of modernist aestheticism (despite the fact that poststructuralism had begun in France as a political project).[55] But after the publication of Habermas's *Der philosophische Diskurs der Moderne* (1985), an increasing number of critics on the Left began to feel about poststructuralism what Jameson had felt about postmodernism in 1984 and started to dig away at the foundations of the poststructuralist position. As far as I can see, the resultant critique involves five global arguments in addition to the more detailed criticisms that can be levelled against individual poststructuralists. First, if people were as effectively trapped by postmodernity as the poststructuralists claim, then the poststructuralists themselves could not have climbed outside of the Symbolic Order/discursive structures/textuality/systems of simulacra in order to give a critical account of those systems of entrapment and oppression.[56] Second, inasmuch as the poststructuralists attempt to set forth their arguments rationally and believe in their truth, they are presupposing the validity of the central concept of the Enlightenment project that, they claim, postmodernity has brought to an end. Third, if it is true, as some poststructuralists assert or imply, that any normative standpoint is somehow complicit with the coercive system that is postmodernity, then, to the extent that the poststructuralist position is true, poststructuralism must also be complicit with the system. Indeed, to the extent that poststructuralist theory insists on the fragmentation of the subject, it can be said to "reproduce and valorize the very oppression that must be overcome."[57] And although, according to the historian Richard Evans, most poststructuralist historians consider themselves on the Left, their doctrine that "every perspective on the past is as valid as any other" must logically mean "that a fascist or racist perspective is valid too."[58] Fourth, because poststructuralist theory proclaims the end of "grand narratives," it tends to inhibit or prohibit meta- or macrotheories that seek "to come to terms with the historical and geographical truths that characterize capitalism both in general as well as in its present phase" and that are the necessary prerequisite for any alternative political strategies.[59] Consequently, poststructuralism helps clear the site for apologists

of contemporary capitalism like Francis Fukuyama, whose *The End of History*, in which he proclaimed the end of ideology and the triumph of free market capitalism, appeared in 1989. Fifth, the radical relativism of poststructuralism logically undermines itself since "facts about truth independent of particular perspectives are presupposed by the [perspectival] view [of truth] itself" and since, if there is only "a multiplicity of equally valid 'truths,'" then poststructuralists would have logically to concede "that the view that there is only one truth is just as valid as the view that there are many."[60] From this kind of critical perspective—whose confidence and authority began to grow as the Thatcher–Reagan epoch came to an end and was given a huge boost by the Sokal hoax of 1996—poststructuralism is not only a self-contradictory overstatement, it is also a potentially conservative phenomenon that occludes the assumptions it has inherited from the Enlightenment.[61] And as for the two elements that link the more hopeful aspects of poststructuralism very clearly with the historical avant-gardes—vitalist values such as the concern with play, desire, "plaisir," and "jouissance," and Lyotard's Anarchism—the former are criticized as mere affective consolation and the latter as a naive pluralism that takes insufficient account of the radical differences in economic power possessed by competing interest groups.[62] Indeed, both of these elements are seen as symptoms of an inadequate ability to theorize postmodernity on the part of a group of thinkers who suffer from the same political disillusion that afflicted postmodernist writers and artists.[63] Certainly, it seems to be the case that poststructuralist vitalists and Anarchists are more flaccid, more introverted, less politicized, and less exuberantly carnivalesque descendents of their Dada daddies.

Dada, Modernism, Postmodernism

Although it should be obvious by now that Dada is a major link between modernism, postmodernism, and poststructuralism at the level of both problematic and response, it is surprising just how rarely this is conceded or even understood. Pynchon's *Gravity's Rainbow* (which frequently cites Rilke's two most famous postwar collections of poetry) is emblematic in this respect. For although it mentions Zurich's Café Odéon as the haunt of Joyce and Einstein, it omits to say that it was the Dadaists' favorite watering hole, too.[64] And over and over again, writers oppose modernism and postmodernism without realizing that their characterizations of the latter phenomenon apply equally well to the experimental wing of the former

phenomenon. Hutcheon's work on postmodernism illustrates the point very graphically. In her book on postmodernist poetics, she claims that the postmodern "partakes of a logic of 'both/and,' not one of 'either/or' "; states that the postmodern novel puts into question a "series of interconnected concepts that have come to be associated with what we conveniently label liberal humanism"; and singles out Brecht and the alienation effect "as the most important Modernist precursor of postmodernism" — but without realizing that she could just as well be talking about Dada.[65] Only at the very end of her book on postmodernist politics, after a discussion of the disruptive effect of photography on high notions of art and the even more disruptive effect of mixing photographic image with a puzzling, punning, or challenging verbal text, does she concede the pioneering work of Dada in this area (which she then omits from her index).[66] Helmut Lethen, a specialist in Weimar culture, spotted this tendency to exclude as early as 1984; Craig Owens remarked on it again in 1991; and both understood the reason behind it. If one sees the avant-garde as an aspect of modernism, then one has to abandon a whole series of neat contrastive oppositions.[67] Consequently, Lethen's essay, which raises the kind of questions that I have been discussing in this book, is rarely cited, and where critics do understand that Dada prefigures postmodernism, they tend to follow Bürger's strategy described at the start of chapter 7 and draw a line between the historical avant-gardes and "high modernism" without seeing that the problematics of all three phenomena were generated by a sense that capitalist (post)modernity was in some sort of crisis.[68]

Partly because of the currency of Bürger's persuasive thesis and partly because of the early (contrastive) debate about postmodernism (of which Bürger's work is a more sophisticated, worked-out version) began in New York when Marcel Duchamp was still active there, books on postmodernity and postmodernism rarely, when acknowledging Dada, go beyond a discussion of Duchamp's (and occasionally Man Ray's) readymades and the antiaesthetic that derives from them.[69] Although specialists writing on Dada or individual Dadaists know that the Dada antiaesthetic is more complex than Bürger would have us believe and that Dada is not, in the first place, an (anti)aesthetic at all, Amelia Jones was absolutely right to conclude that "discourses of postmodernism from the 1960s through the 1980s tended to reduce Duchamp and his oeuvre to the ready-mades as antiart gestures."[70]

While I would not contest Duchamp's importance as a link between experimental modernism and postmodernism, it does seem to me that Dada gets into postmodernism, especially its first, countercultural phase,

in a greater variety of ways that need more thorough investigation. There are, for example, unmistakable links between the happenings staged by the Fluxus group in Germany during the 1960s, Kurt Schwitters's concept of the "Merzbühne" [*Merz*-stage], and the *Dada-Tournées* of 1920, which, like Wolf Vostell's happenings, aimed to provoke the spectator into confronting the violence that lies just below the veneer of his or her bourgeois respectability.[71] The vitalist postmodernism of Leslie Fiedler, Susan Sontag, and the carnivalized politics of the protest movements of the 1960s may well have owed at least something to the historical avant-gardes. Nicholas Zurbrugg has written detailed studies of the way in which Dada fed into the sound and visual poetry of the first phase of postmodernism.[72] Other connections, to identify but a few at random, have been registered between Arp's collages and Jean Tinguely's autodestructive machines; between John Heartfield's photomontages and postmodernist "photo-graphs"; between Dada and the Brazilian *Noigandres* group of the 1950s and early 1960s; between Dada and the *Stuttgarter Gruppe* around Max Bense of the same period; between Dada and 1970s punk (when one punk rock band was actually called "Cabaret Voltaire"); and between the poetry of Arp, Hausmann, and Schwitters and the work of the *Wiener Gruppe* together with its offshoot the *Forum Stadtpark Graz* in the late 1950s and 1960s.[73] More recently, Zurbrugg has argued that the countercultural impulses of Dada are still alive and kicking during the second, more assimilated phase of postmodernism in the very teeth of totalizing, poststructuralist *Kulturpessimismus*.[74] And there is quite a lot of evidence to suggest that Dada, together with the postmodern fantasies transmitted by the Western media, played a small part in creating the cultural climate that destroyed the GDR, whose atrophied state Socialism was a travesty of the founding values of classical modernity.[75] Much more work could be done in these and related areas—but with two key questions in mind. In any given case, how far does a work or an artist inherit Dada's "theatricality"—its surplus of oppositional energy—rather than just its techniques?[76] To what extent does any given work subvert rather than reproduce attitudes and drives that are needed to keep late-capitalist postmodernity functioning? Within a socioeconomic system that is far more capable of commodifying opposition than that confronted by the marginalized Dadaists, and in which hedonism, shock, satire, and miniaturized apocalypse are the very stuff of consumerism, tabloid journalism, "alternative" comedy, news shows, and soap operas, those questions become increasingly difficult to answer with any definitude.

The Problematic Legacy

Dada was very clear about what it opposed: a modernity that had be-
trayed its founding ideals; issued in a horrendous war; created a visibly
oppressed and exploited industrial proletariat; and was governed by a cor-
rupt, hypocritical, and brutal ruling class. Since the end of the Vietnam
War in the mid-1970s, postmodernism has been increasingly less sure of
what it opposes—partly because the régimes that followed Reagan's and
Thatcher's have a softer image and partly because late capitalist postmoder-
nity has had some visibly positive effects. It has permitted the rediscov-
ery of the body and sensuality; allowed the voices of previously oppressed
or marginalized groups to be heard with greater clarity; brought a higher
standard of living to a larger number of people, especially in the develop-
ing world; improved communications; hastened the collapse of the Soviet
empire; devolved power and made authority more accountable; and badly
shaken the authority and self-confidence of white, male-dominated, het-
erosexual culture. Nevertheless, it seems to me that those critics who are
most positive about the achievements of postmodernity and postmodernist
culture tend to hold down relatively comfortable jobs in countries like Aus-
tralia, Canada, and Germany that have a well-developed federal structure,
a liberal attitude to social issues, and a relatively low level of pauperization.
For instance, Wolfgang Welsch, writing when West Germany's economy
was booming and its political confidence growing, was thoroughly positive
about postmodernity (defined as radical pluralism) and its effects on lit-
erature, architecture, painting, sculpture, sociology, and philosophy. But,
significantly, he omitted economics from that list.[77] Would he, I wonder,
be quite so positive and make the same omission a decade later when the
economy of a united Germany is considerably less buoyant? Conversely,
those critics who are most negative about postmodernity and postmod-
ernism tend to live in less liberal countries with large areas of structural
poverty. They also tend to be more aware that one's ability to enjoy the de-
lights of consumer capitalism depends on how much money one has; where
one is situated in the hierarchy of power; and how well-equipped one is
personally to deal with the Darwinian struggle of what is misleadingly
called the "free enterprise culture."[78] Postmodernity may well be a "field
of possibility" and not simply "a hellish negation of all that is human," but
as Marxist critics consistently point out, it is easier to accept that fact if
one was born in the right place at the right time; was endowed with the
right psychological equipment; and can ignore or repress the dark side of

postmodernity.[79] Or, to use images that have already come up: the "mael-strom" or "whirlpool" of postmodernity is fine if one has been through an expensive surfing course and is a fully paid-up subscriber to the values of *Baywatch;* the "juggernaut" of postmodernity is acceptable provided that one is riding it and not in its way; and the "carnival" of postmodernity is great fun if most of the machines have been programmed in one's favor and one does not mind losing or can afford to lose now and again.

Although an analyst of postmodernity like Giddens is acutely conscious of such contradictions, he seems to be pulled between a positive apprecia-tion of the advantages of postmodernity and an awareness of the damage that his "juggernaut" can inflict on the unlucky and the excluded.[80] More overtly Marxist analysts try to negotiate this situation by exposing the dy-namics that drive the juggernaut and generate the "contradictions to which contemporary capitalism is subject."[81] Harvey, for example, bases his ar-gument on Marx's contention that the three principles driving capital-ism are inherently contradictory in any given configuration and therefore prone to cause overaccumulation and crisis.[82] But unlike Marx, Harvey stops short of predicting how such macroeconomic contradictions might force the kind of qualitative, systemic change that could eliminate or even significantly mitigate the obscene differences in wealth and life chances from which our world suffers. Bauman is more daring over this question, focusing on the increasingly acute ecological problems that beset us and placing his political hopes on more localized, relatively nonviolent seizures of power.[83] But on the whole, discussions of postmodernity have little to say about qualitative social change in Marx's sense or the tendency of un-limited economic expansion to destroy or exhaust the ecological-material system on which it is still, to a large extent, based. Just as the producer of *Miami Vice* said that his main principle when making the program was the elimination of "earth tones," so academics, whether they are the inheritors of a humanist tradition that sets humanity above Nature or of a Marxist tradition that grants value to Nature only after it has been commodified by human labor, frequently commit the same sin of omission.[84] Instead, analyses of the downside of postmodernity tend to focus on less cosmic contradictions: the north–south divide; the tensions that ensue when de-prived and marginalized groups find themselves living alongside extreme wealth and privilege; the inability of the consciousness industry to satisfy the real needs it exploits; the tensions caused by the overproduction of unsatisfied desire within a system that still requires a high degree of self-discipline and conformity; the tensions created when the free market can-

not deliver in reality what it seductively promises to consumers' fantasy; and the general psychological price to be paid for living in a highly stressful and unstable world where less and less can be taken for granted.[85] But are such contradictions powerful enough to change a system qualitatively that is highly adept at inventing new ways of containing contradictions? And just as the First World War erupted into a Europe that was almost totally unprepared for it, could it be that the real contradictions of postmodernity are invisible to all but a few people of whom little notice is taken and that these contradictions will one day erupt just as unexpectedly? I do not know, but if there is one lesson to be learned from modernism, it is the necessity of paying attention to precisely those ideas and phenomena that conventional wisdom disregards, and Dada, in an oblique and exploratory way, was pointing to several of the contradictions identified above over half a century ago—though few people cared to listen or understood what they heard.

But whatever one thinks about the macroproblems of postmodernity, its discontents, and the significance of those discontents, it leaves us, via postmodernism and poststructuralism, with several more specific problems that I can only set out and certainly not solve. The first and most hotly debated of these concerns human subjectivity. Can we simply forget or dismiss the teachings of psychoanalysis about the primacy of the unconscious and the libidinal drives? If the poststructuralist claim that the subject is constituted by the interplay of texts and discourses is an overstatement, then is there some integrating principle in human nature that is not, however, "an immobile centre, a core of self-certainty"?[86] If there is, is it common to all people everywhere and is it transcendental, "quasi-transcendental," or simply psychophysiological?[87] And is it inherently rational, irrational, extrarational, or an elusive admixture of all three—as Dada thought it was? If it is rational, how can it be prevented from turning against itself and creating ever more sophisticated versions of Weber's *stahlhartes Gehäuse?* If it is irrational, how can it be prevented from turning against itself and proliferating anomie? Can Habermas's notion of communicative rationality negotiate these two dangers; make any real impact on those more global problems of which Habermas himself had become more conscious by 1984; and create an arena in which truly autonomous subjects can exchange ideas to some practical purpose?[88] Can Habermas's theory really save the central project of the Enlightenment despite the trenchant critiques of this project that have been mounted

over the last century and, in recent years, by those feminists who regard the Enlightenment ideal of the autonomous, self-legislating subject as "reflective of masculinity in the modern West"?[89] And does not Habermas's theory do less than justice to such extrarational aspects of any communicative act as insight, empathy, intuition, and a willingness to listen behind the words of the other person to what is not said? Do we not need a model of subjectivity that involves a more developed sense of the polyphonic, processual aspects of human nature, and if we do, then where would rationality—whether analytic, instrumental, or communicative—belong in such a model?

The debate is bewildering in its complexity and to every answer there seems to be an objection, equal and opposite. Moreover, it is part and parcel of a complex of debates in which, since Nietzsche, there are no easy answers. If, for example, there is some integrating principle in human nature, then to what extent, if at all, is it inherently moral? What political system does greatest justice to human nature? What constitutes morality and justice and what could legitimize the foundational principles of any system of morality and justice in a secularizing world? Can one arbitrate between different systems of justice and morality by reference to "moral ideals"?[90] If so, where do those ideals come from? Without transcendental legitimation, any answer will be to some degree flawed or unsatisfactory, but this is the postmodern condition, and as Connor sensibly remarked, its relativities do not make questions of value and legitimacy vanish, but lend them a new urgency.[91] One ends up in a similar situation over the question of language. Although it is once again clear that the poststructuralist occlusion of the referent and denials of *any* relationship between discourse and reality were an unwarranted extension of Saussure's ideas, the (post)modernist awareness of the conventional and arbitrary nature of language ought to make us, like Chandos, listen to ourselves think, speak and write with a much more sensitive and finely attuned ear.[92] It ought also, as Evans's article forcefully implies, make us more, not less, attentive to factual evidence.[93] Am I sure of what I am saying? What are my grounds for saying it? Am I using the appropriate words? Am I asking the right questions? Am I simply repeating received slogans? Am I listening to the other person's words or trying to bully him or her into premature agreement? Am I dismissing something out of hand because it is inconvenient and difficult rather than wrong? As with the problem of value and legitimacy, the postmodern situation of extreme complexity and radical uncertainty

ought to make us, as it does Chandos, more, not less, linguistically responsible and responsive, especially if, like Habermas, one believes that genuine communication is a major factor in the creation of a more humane society.

The problem of subjectivity also bears directly on the problem of "resistance." Adorno's and Jameson's analyses of the culture industry and Baudrillard's account of consumer capitalism may be overstatements, but they raise the question of what it is in human nature that enables people to see through such a powerful conditioning system; resist it; go their own way; bend the system for their own ends; and construct enclaves within the hegemonic culture where, for a time at least until the developers move in as happens in the film *Sammy and Rosie Get Laid* (1987), they can be themselves. One answer is, of course, that human beings can resist consumer capitalism because it excludes or lets so many people down in so many ways. Another is that late capitalist postmodernity is riddled with social, psychological, and ecological contradictions that increasingly make themselves felt in our everyday lives. But disillusion and discomfort are one thing and active resistance is another, so what is it that enables people to turn negative pressures into resistance; form oppositional groups; and even turn the new technologies against the system they were designed to perpetuate? At one point, Eagleton states that "what constitutes a human subject as a subject is precisely its ability to transform its own social determinants—to make something of that which makes it," but he is cagey about the nature and origin of that ability.[94] The Dadaists, steeped as several of them were in Grossian psychology, were much more definite about their answer: a combination of "Erleben," intuition, and analysis resulting in violent polemic, countercultural attitudes, and subversive artifacts. Echoes of this answer were still relatively loud during the first phase of postmodernism (especially in the theoretical work of the now almost unread Herbert Marcuse), but critics seem to have greater difficulty in hearing them during the second phase unless they are centrally concerned with popular culture and the cultures of various marginalized groups.[95]

And that, I am afraid, is that. No final flourishes, grand closing chords, or wittily learned jokes. Just the hope that anyone who has bothered to read this far knows a bit more about Dada's energy, skepticism, and anarchic humor; better understands how those qualities have fed into contemporary culture; and sees why they might still be of relevance in a world that is as problematic, challenging, and potentially dangerous as our own.

Notes

Chapter 1

1. Jan Mukařovský, "Dialectic Contradictions in Modern Art" (1935), in *Structure, Sign, and Function,* ed. John Burbank and Peter Steiner (New Haven: Yale University Press, 1978), 129. Monroe K. Spears, *Dionysus and the City: Modernism in Twentieth-Century Poetry* (Oxford: Oxford University Press, 1970), 3. Malcolm Bradbury and James McFarlane, "The Name and Nature of Modernism," in *Modernism 1890–1930,* ed. Malcolm Bradbury and James McFarlane (Harmondsworth, England: Penguin, 1976), 22–23. Douwe Fokkema and Elrud Ibsch, *Modernist Conjectures: A Mainstream in European Literature 1910–1940* (London: Hurst, 1987), 22 and 318. Perry Anderson, "Modernity and Revolution," *New Left Review* no. 144 (March–April 1984): 112.

2. Cf. Alex Callinicos, *Against Postmodernism: A Marxist Critique* (Cambridge: Polity, 1989), 64. Matei Calinescu, *Faces of Modernity: Avant-garde, Decadence, Kitsch* (Bloomington: Indiana University Press, 1977), 112. Marshall Berman, *All That Is Solid Melts into Air: The Experience of Modernity* (London: Verso, 1983), 101. Steven Connor, *Postmodernist Culture: An Introduction to Theories of the Contemporary* (Oxford: Basil Blackwell, 1989), 82. Here, Connor is discussing the ideas of the North American art critic Clement Greenberg and not necessarily assenting to the elision.

3. See Spears, *Dionysus and the City,* 9–10 and 13; see also Maurice Beebe, "What Modernism Was," *Journal of Modern Literature* 3 (1973): 1066.

4. Linda Hutcheon, *A Poetics of Postmodernism: History, Theory, Fiction* (New York: Routledge, 1988), 52 and 141.

5. Berman, *All That Is Solid,* 330; Hal Foster, "Postmodernism: A Preface," in *Postmodern Culture,* ed. Hal Foster (London: Pluto, 1985), xiii.

6. Andreas Huyssen, "Postmoderne—Eine amerikanische Internationale?" in *Postmoderne: Zeichen eines kulturellen Wandels,* ed. Andreas Huyssen and Klaus R. Scherpe (Reinbek bei Hamburg: Rowohlt, 1986), 19.

7. Calinescu, *Faces of Modernity,* 48; David Harvey, *The Condition of Postmodernity* (Oxford: Basil Blackwell, 1989), 20 and 116; Charles Baudelaire, "Le Peintre de la vie moderne," in *Oeuvres complètes,* ed. Claude Pichois, 2 vols. (Paris: Gallimard, 1975–76), 2:683–724. The first version of Baudelaire's essay was published in 1863, the version reproduced here in 1868. Charles Baudelaire, "The Painter of Modern Life," trans. P. G. Konody, in *Constantin Guys: The Painter of Victorian Life,* ed. C. Geoffrey Hulme (London: The Studio, 1930), 15–172 (page citations are to both editions, respectively).

8. Beebe, "What Modernism Was," 1080–84; Bradbury and McFarlane, *Mod-*

ernism 1890–1930, 641–64; and Jean Weisgerber, ed., *Les Avant-gardes littéraires au XXᵉ siècle* (Budapest: Akadémiai Kiadó, 1984), 2:1155–87.

9. Jean-François Lyotard, *La Condition postmoderne: rapport sur le savoir* (Paris: Editions de Minuit, 1979), and *The Postmodern Condition,* trans. Geoff Bennington (Minneapolis: University of Minnesota Press, 1984); Jürgen Habermas, "Die Moderne—ein unvollendetes Projekt," in *Kleine politische Schriften I–IV* (Frankfurt/Main: Suhrkamp, 1981), 444–63; the English version was delivered at New York University on 5 March 1981 and appeared with the title "Modernity versus Postmoderity," in *New German Critique* 22 (winter 1981): 3–14 (page citations are to both editions, respectively). The German term "die Moderne" (which first appeared in print in 1886) can mean either "modernity" in the historical sense or "modernism" in the cultural sense. Although some writers draw a careful distinction between the two meanings (cf. Wolfgang Welsch, *Unsere postmoderne Moderne* [Weinheim: VCH, Acta Humaniora, 1987], 84, and Robert C. Holub, "Confrontations with Postmodernism," *Monatshefte* 84 [1992]: 230), others slip between the two meanings just as English-speaking writers can slip, accidentally or intentionally, between the uses of the word "modernism" (cf. Harvey, *Condition of Postmodernity,* 353) and "modernity" (cf. Calinescu, *Faces of Modernity,* 42). Mutatis mutandis, the same applies to "die Postmoderne," "postmodernism," and "postmodernity."

10. Michael D. Biddiss, *The Age of the Masses* (Harmondsworth, England: Penguin, 1977).

11. Cf. Holub, "Confrontations with Postmodernism," 230.

12. Fredric Jameson, "Postmodernism, or the Cultural Logic of Late Capitalism," *New Left Review* no. 146 (July–August 1984): 53–92. For the importance of Jameson's work, see Douglas Kellner, ed., *Postmodernism/Jameson/Critique* (Washington, D.C.: Maisonneuve, 1989), especially Mike Featherstone, "Postmodernism, Cultural Change, and Social Practice," 117–38. Huyssen, "Postmoderne," 27 and 30.

13. "Common traits," Beebe, "What Modernism Was," 1071; "uncompromising intellectuality," Harry Levin, "What Was Modernism?" (1960), in *Refractions: Essays in Comparative Literature* (Oxford: Oxford University Press, 1966), 292; cf. Beebe, "What Modernism Was," 1066, and Fokkema and Ibsch, *Modernist Conjectures,* 31; preoccupation with nihilism, Spears, *Dionysus and the City,* 14, citing the introduction to Irving Howe, ed., *Literary Modernism* (Greenwich, Conn.: Fawcett, [1967]); "discontinuity," Spears, *Dionysus and the City,* 20; cf. also Alan Wilde, *Horizons of Assent: Modernism, Postmodernism, and the Ironic Imagination* (Baltimore: Johns Hopkins University Press, 1981), 16; "attraction to the Dionysiac," Spears, *Dionysus and the City,* 35; cf. also Lionel Trilling, "On the Teaching of Modern Literature," in *Beyond Culture: Essays on Literature and Learning* (London: Secker and Warburg, 1966), 19, and John Burt Foster Jr., *Heirs to Dionysos: A Nietzschean Current in Literary Modernism* (Princeton: Princeton Uni-

versity Press, 1981); "formalism, . . . reflexivism," Beebe, "What Modernism Was,"
1073; "anti-democratic," Tom Gibbons, "Modernism and Reactionary Politics,"
Journal of Modern Literature 3 (1973): 1150; "emphasis on subjectivity . . . experi-
ence of panic terror," William J. Brazill Jr., "Art and the Panic Terror," in *The
Turn of the Century: German Literature and Art 1890–1915,* ed. Gerald Chapple
and Hans H. Schulte (Bonn: Bouvier, 1981), 531–33; "rift between self and world,"
Wilde, *Horizons of Assent,* 3, 6, 9–10, 16, and 41; "consciousness . . . detachment,"
Fokkema and Ibsch, *Modernist Conjectures,* 60; "the very essence of poetry itself,"
Sanford Schwartz, *The Matrix of Modernism: Pound, Eliot, and Early Twentieth-
Century Thought* (Princeton: Princeton University Press, 1985), 71–74, following
Frank Kermode, *Romantic Image* (London: Routledge and Kegan Paul, 1957), and
Robert Langbaum, *The Poetry of Experience* (London: Chatto and Windus, 1957);
"Saussure's view . . . ," David Lodge, "Modernism, Antimodernism and Postmod-
ernism," in *Working with Structuralism: Essays and Reviews on Nineteenth-Century
Literature* (London: Routledge and Kegan Paul, 1981), 5; "outright . . . modernity,"
Berman, *All That Is Solid,* 42.

14. Gaylord LeRoy and Ursula Beitz, "The Marxist Approach to Modernism,"
Journal of Modern Literature 3 (1973): 1158. Bradbury and McFarlane, "Name and
Nature of Modernism," 26–27. Weisgerber, *Avant-gardes littéraires au XX^e siècle,*
2:643–940.

15. David Bathrick and Andreas Huyssen, "Modernism and the Experience
of Modernity," in *Modernity and the Text: Revisions of German Modernism,* ed.
Andreas Huyssen and David Bathrick (New York: Columbia University Press,
1989), 1–16, especially 4–5.

16. Roy Boyne and Ali Rattansi, "The Theory and Politics of Postmodernism:
By Way of an Introduction," in *Postmodernism and Society,* ed. Roy Boyne and Ali
Rattansi (London: Macmillan, 1990), 6–8 and 39.

17. On modernism as a response to Romanticism, see Mukařovský, "Dialec-
tic Contradictions in Modern Art," 132–33; Spears, *Dionysus and the City,* 16–19,
discussing the views of Edmund Wilson, Northrop Frye, and Frank Kermode;
also Schwartz, *Matrix of Modernism,* 71–74, 104, and 172–73; Robert Langbaum,
The Modern Spirit (London: Chatto and Windus, 1970); and Calinescu, *Faces of
Modernity,* 125. As a reaction against Aestheticism, see Peter Bürger, *Theorie der
Avantgarde* (Frankfurt/Main: Suhrkamp, 1974), passim; *Theory of the Avant-garde,*
trans. Michael Shaw (Manchester: Manchester University Press, 1984) (page cita-
tions are to both editions, respectively). As an inversion of Realism, see Fokkema
and Ibsch, *Modernist Conjectures,* 37, and Schwartz, *Matrix of Modernism,* 174.
And as a reaction against Naturalism, see Calinescu, *Faces of Modernity,* 125. For
modernism and postmodernism, cf. Andreas Huyssen, *After the Great Divide:
Modernism, Mass Culture and Postmodernism* (London: Macmillan, 1986), 182;
Susan Rubin Suleiman, "Naming and Difference: Reflections on 'Modernism
versus Postmodernism' in Literature," in *Approaching Postmodernism,* ed. Douwe

Fokkema and Hans Bertens (Amsterdam: John Benjamin, 1986), 261; Harvey, *Condition of Postmodernity*, 42–43.

18. Linda Hutcheon, *The Politics of Postmodernism* (London: Routledge, 1989), 26; Iris Marion Young, "The Ideal of Community and the Politics of Difference," in *Feminism/Postmodernism*, ed. Linda J. Nicholson (London: Routledge, 1990), 304; E. Ann Kaplan, introduction to *Postmodernism and Its Discontents*, ed. E. Ann Kaplan (London: Verso, 1988), 1; Huyssen, *After the Great Divide*, 182–83.

19. Bürger, *Theorie der Avantgarde;* Habermas, "Moderne," 448/5–6.

20. Calinescu, *Faces of Modernity*, 118–19 and 140.

21. Huyssen, *After the Great Divide*, vii and 162–63.

22. Cf. Peter Bürger, "Das Verschwinden der Bedeutung: Versuch einer postmodernen Lektüre von Michel Tournier, Botho Strauss und Peter Handke," in *"Postmoderne" oder Der Kampf um die Zukunft*, ed. Peter Kemper (Frankfurt/Main: Fischer, 1988), 297.

23. Cf. Russell A. Berman, "Konsumgesellschaft: Das Erbe der Avantgarde und die falsche Aufhebung der ästhetischen Autonomie," in *Postmoderne: Alltag, Allegorie und Avantgarde*, ed. Christa and Peter Bürger (Frankfurt/Main: Suhrkamp, 1987), 59 and 64–65.

24. For the three ways in which history entered the debate, see Spears, *Dionysus and the City*, especially p. 60; Biddiss, *Age of the Masses*, 14; and Bradbury and McFarlane, "Name and Nature of Modernism," 27. Studies on such topoi include Edward Timms and David Kelly, eds., *Unreal City: Urban Experience in Modern European Literature and Art* (Manchester: Manchester University Press, 1985); Klaus R. Scherpe, "The City as Narrator: The Modern Text in Alfred Döblin's *Berlin Alexanderplatz*," in *Modernity and the Text*, 162–79; Christopher Butler, "The City," in *Early Modernism: Music and Painting in Europe 1900–1916* (Oxford: Oxford University Press, 1994), 133–208; Edward Timms and Peter Collier, eds., *Visions and Blueprints: Avant-garde Culture in Early Twentieth-Century Europe* (Manchester: Manchester University Press, 1988); Modris Eksteins, *Rites of Spring: The Great War and the Birth of the Modern Age* (London: Black Swan, 1990); see also Anderson, "Modernity and Revolution," 109.

25. Rosalind E. Krauss, "Photography's Discursive Spaces" (1982), in *The Originality of the Avant-garde and Other Modernist Myths* (Cambridge: MIT Press, 1985), 133; Anthony Giddens, "Modernism and Post-modernism," *New German Critique* 22 (winter 1981): 15–18; Linda Dalrymple Henderson, *The Fourth Dimension and Non-Euclidean Geometry in Modern Art* (Princeton: Princeton University Press, 1983); Stephen Kern, *The Culture of Time and Space 1880–1918* (Cambridge: Harvard University Press, 1983); Anderson, "Modernity and Revolution," 104.

26. Zygmunt Bauman, *Modernity and Ambivalence* (Cambridge: Polity, 1991), 4. See also Berman, *All That Is Solid*, 16–17, and Scott Lash, "Discourse or Figure? Postmodernism as a 'Regime of Signification,'" *Theory, Culture and Society* 5 (June 1988): 312.

27. Berman, *All That Is Solid,* 17; Amelia Jones, *Postmodernism and the Engendering of Marcel Duchamp* (Cambridge: Cambridge University Press, 1994), 2, citing Foucault; Jürgen Habermas, *Der philosophische Diskurs der Moderne: Zwölf Vorlesungen* (1985; Frankfurt/Main: Suhrkamp, 1988), 57 and 104; *The Philosophical Discourse of Modernity,* trans. Frederick Lawrence (Cambridge: Polity, 1987), 43 and 83 (page citations are to both editions, respectively).

28. Charles Newman, *The Post-Modern Aura: The Art of Fiction in an Age of Inflation* (Evanston: Northwestern University Press, 1985), 59; Harvey, *Condition of Postmodernity,* 264 and 261; Calinescu, *Faces of Modernity,* 109. Cf. Habermas, "Moderne," 446/4.

29. On the doubts about modernity, see Terry Eagleton, *Ideology: An Introduction* (London: Verso, 1991), 185; and Friedrich Jaeger, "Theorie als soziale Praxis: Die Intellektuellen und die kulturelle Vergesellschaftung," in *Intellektuelle in der Weimarer Republik,* ed. Wolfgang Bialas and Georg G. Iggers (Frankfurt/Main: Peter Lang, 1996), 38–39. Cf. Jürgen H. Petersen, " 'Das Moderne' und 'die Moderne': Zur Rettung einer literarästhetischen Kategorie," *Kontroversen, alte und neue: Akten des VII, Internationalen Germanisten-Kongresses (1985)* (Tübingen: Niemeyer, 1986), 8:136; Stephen Heath, "Realism, Modernism, and 'Language-Consciousness,' " in *Realism in European Literature,* ed. Nicholas Boyle and Martin Swales (Cambridge: Cambridge University Press, 1986), 114.

30. Spears, *Dionysus and the City,* 42.

31. LeRoy and Beitz, "The Marxist Approach to Modernism," 1159–60.

32. See Gérard Raulet, "Zur Dialektik der Postmoderne," in *Postmoderne,* 133.

33. See Habermas, "Moderne," 451–54/7–9; *Der philosophische Diskurs der Moderne,* passim; Albrecht Wellmer, *Zur Dialektik von Moderne und Postmoderne: Vernunftkritik nach Adorno* (Frankfurt/Main: Suhrkamp, 1985), 101; Zygmunt Bauman, *Intimations of Postmodernity* (London: Routledge, 1992), x and 178; Ottmar Jahn, "Rolle und Bedeutung der katholischen Theologie in der Zwischenkriegszeit," in *Intellektuelle in der Weimarer Republik,* 265.

34. Barry Smart, *Postmodernity* (London: Routledge, 1993), 91.

35. Gianni Vattimo, *The End of Modernity: Nihilism and Hermeneutics in Postmodern Culture,* trans. John R. Snyder (1985; Cambridge: Polity, 1991), 101.

36. Peter Bürger, "The Significance of the Avant-garde for Contemporary Aesthetics: A Reply to Jürgen Habermas," *New German Critique* 22 (winter 1981): 20; Harvey, *Condition of Postmodernity,* 264; Callinicos, *Against Postmodernism,* 36 and 96; Eagleton, *Ideology,* 97–98.

37. Axel Honneth, "Foucault and Adorno: Zwei Formen einer Kritik der Moderne," in *"Postmoderne,"* 135; Wellmer, *Dialektik von Moderne und Postmoderne,* 10; Hartmut and Gernot Böhme, *Das Andere der Vernunft: Zur Entwicklung von Rationalitätsstrukturen am Beispiel Kants* (Frankfurt/Main: Suhrkamp, 1985).

38. Berman, *All That Is Solid,* 36; Anderson, "Modernity and Revolution," 102 and 104–7.

39. Carl E. Schorske, *Fin-de-siècle Vienna: Politics and Culture* (1961; Cambridge: Cambridge University Press, 1985), xxvi, 7, and 118.

40. Anderson, "Modernity and Revolution," 106; Eksteins, *Rites of Spring,* 186.

41. Cf. Richard Sheppard, "Expressionism and Vorticism: An Analytical Comparison," in *Facets of European Modernism,* ed. Janet Garton (Norwich: University of East Anglia Press, 1985), 149–74.

42. Anderson, "Modernity and Revolution," 105; Callinicos, *Against Postmodernism,* 46.

43. Callinicos, *Against Postmodernism,* 46; Dagmar Barnouw, *Weimar Intellectuals and the Threat of Modernity* (Bloomington: Indiana University Press, 1988), 27–30; Schorske, *Fin-de-siècle Vienna,* 304; cf. Peter Booker, "Introduction: Reconstructions," in *Modernism/Postmodernism,* ed. Peter Booker (London: Longman, 1992), 9.

44. Elliot L. Gilbert, " 'A Tumult of Images': Wilde, Beardsley, and *Salome,*" *Victorian Studies* 26 (winter 1983): 133–59; cf. Sheppard, "Expressionism and Vorticism," 150–51.

45. Suleiman, "Naming and Difference," 256; cf. Calinescu, *Faces of Modernity,* 125.

46. Schorske, *Fin-de-siècle Vienna,* 233.

47. Brigid Doherty, " 'See: *We Are All Neurasthenics!*' or, The Trauma of Dada Montage," *Critical Inquiry* 24 (1997): 97–102; Virginia Woolf, "Mr. Bennett and Mrs. Brown," in *The Captain's Death Bed and Other Essays* (London: Hogarth, 1950), 91 and 92. Woolf was referring in the first instance to the opening of Roger Fry's Post-Impressionism exhibition in London, but December 1910 was also the month when the Labour Party took over the Liberal Party's place in British politics. Heym had used the word "Weltstadt" before—for example, in the final version of "Berlin I" (April 1910). But in this pre-Expressionist poem, it is simply used in its normal sense of "cosmopolitan city." For an analysis of the stylistic change that Heym's poetry underwent in December 1910, see Richard Sheppard, "From Grotesque Realism to Expressionism: A Second Turning-point in the Poetry of Georg Heym," *New German Studies* 3 (1975): 99–109.

48. Cf. Berman, *All That Is Solid,* 169–70.

49. Jones, *En-gendering of Marcel Duchamp,* 130; André Breton, "Manifeste du surréalisme," in *Les Manifestes du surréalisme* (Paris: Jean-Jaques Pauvert, [1962]), 22; "Manifesto of Surrealism," in *Manifestoes of Surrealism,* trans. Richard Seaver and Helen R. Lane (Ann Arbor: University of Michigan Press, 1969), 10 (page citations are to both editions, respectively).

50. Albert E. Elsen, *Rodin's Gates of Hell* (Minneapolis: University of Minnesota Press, 1960), 129–38. For a broader discussion of the topos of apocalypse, see Gunter E. Grimm, Werner Faulstich, and Peter Kuon, eds., *Apokalypse: Weltuntergangsvisionen in der Literatur des 20. Jahrhunderts* (Frankfurt/Main: Suhrkamp, 1986).

51. Wassily Kandinsky, *Über das Geistige in der Kunst,* ed. Max Bill, 9th ed. (1912; Berne: Benteli, 1970), 40; *On the Spiritual in Art,* in *Complete Writings on Art,* ed. Kenneth C. Lindsay and Peter Vergo, 2 vols. (London: Faber and Faber, 1982), 1:142; Hugo Ball, "Kandinsky," in *Der Künstler und die Zeitkrankheit: Ausgewählte Schriften,* ed. Hans Burckhard Schlichting (Frankfurt/Main: Suhrkamp, 1984), 42; "Kandinsky," trans. Christopher Middleton, in *Flight Out of Time: A Dada Diary,* ed. John Elderfield (Berkeley and Los Angeles: University of California Press, 1996), 224 (page citations are to both editions, respectively); Edith Weiller, *Max Weber und die literarische Moderne: Ambivalente Begegnungen zweier Kulturen* (Stuttgart: J. B. Metzler, 1994); Max Weber, "Wissenshaft als Beruf," in *Gesammelte Aufsätze zur Wissenschaftslehre,* ed. Johannes Winckelmann, 7th ed. (Tübingen: J. C. B. Mohr [Paul Siebeck], 1988), 605; "Science as a Vocation," *From Max Weber: Essays in Sociology,* trans. and ed. H. H. Gerth and C. Wright Mills, 7th ed. (London: Routledge and Kegan Paul, 1970), 149.

52. David Bathrick, "Speaking the Other's Silence: Franz Jung's *Der Fall Gross,*" in *Modernity and the Text,* 28; Spears, *Dionysus and the City,* 70.

53. Ralph Yarrow, "Anxiety, Play and Performance: *Malte* and the [Post]-Modern," *Orbis Litterarum* 49 (1994): 224.

54. See Richard Sheppard, "Insanity, Violence and Cultural Criticism: Some Further Thoughts on Four Expressionist Short Stories," *Forum for Modern Language Studies* 30 (1994): 152–62. The translation of Döblin's story is to be found in Malcolm Green, ed. and trans., *The Golden Bomb: Phantastic German Expressionist Stories* (Edinburgh: Polygon, 1993), 55–68.

55. Robert Müller, *Tropen: Der Mythos der Reise: Urkunden eines deutschen Ingenieurs,* ed. Günter Helmes (1915; Paderborn, Germany: Igel Verlag Literatur, 1990), 30, 77, 220 and 243–44. Cf. Welsch, *Unsere postmoderne Moderne,* 180. For a discussion of the way in which the institutions of scientific modernity are inverted or become dysfunctional in German modernist literature, see Walter Müller-Seidel, "Wissenschaftskritik und literarische Moderne: Zur Problemlage im frühen Expressionismus," in *Die Modernität des Expressionismus,* ed. Thomas Anz and Michael Stark (Stuttgart: J. B. Metzler, 1994), 21–43.

56. Raulet, "Dialektik der Postmoderne," 132–33.

57. Michael Tratner, *Modernism and Mass Politics: Joyce, Woolf, Eliot, Yeats* (Stanford, Calif.: Stanford University Press, 1995), 8; Kern, *Culture of Time and Space,* 188 and 288.

58. See also Tratner, *Modernism and Mass Politics,* passim.

59. See Huyssen, *After the Great Divide,* 52–53; Butler, *Early Modernism,* 118–19; Jill Lloyd, *German Expressionism: Primitivism and Modernity* (New Haven: Yale University Press, 1991), 153–56.

60. See for instance, Georg G. Iggers, "Einige kritische Schlussbemerkungen über die Rolle der Intellektuellen in der Weimarer Republik am Beispiel der Historiker," in *Intellektuelle in der Weimarer Republik,* 455; cf. Georg Stauth and

Bryan S. Turner, "Nostalgia, Postmodernism and the Critique of Mass Culture," *Theory, Culture and Society* 5 (June 1988): 509–25, especially 513 and 518, where the same point is made about the Frankfurt School.

61. Callinicos, *Against Postmodernism,* 42; Karl Jaspers, *Die geistige Situation der Zeit,* 5th ed., rev. (Berlin: Walter de Gruyter, 1933), 102; *Man in the Modern Age,* trans. Eden and Cedar Paul (London: Routledge and Kegan Paul, 1951), 115–16.

62. Renate Werner, "Das Wilhelminische Zeitalter als literar-historische Epoche," in *Wege der Literaturwissenschaft,* ed. Jutta Kolkenbroch-Netz, Gerhard Plumpe, and Hans Joachim Schrimpf (Bonn: Bouvier, 1985), 215. For confirmatory evidence on the sociological origins of a significant section of German modernists—the Expressionists—see Werner Kohlschmidt, "Zu den soziologischen Voraussetzungen des literarischen Expressionismus in Deutschland" (1970), in *Begriffsbestimmung des literarischen Expressionismus,* ed. Hans Gerd Rotzer (Darmstadt, Germany: Wissenschaftliche Buchgesellschaft, 1976), 427–46; see also Paul Raabe, *Die Autoren und Bücher des literarischen Expressionismus* (Stuttgart: Metzler, 1985), 575–79 and 600–601.

63. Schorske, *Fin-de-siècle Vienna,* 6.

64. Klaus Amann and Armin A. Wallas, eds., *Expressionismus in Österreich: Die Literatur und die Künste* (Vienna: Böhlau, 1994).

65. Bauman, *Modernity and Ambivalence,* 125–26 and 140.

66. Reproduced in Heimo Schwilk, ed., *Ernst Jünger: Leben und Werk in Bildern und Texten* (Stuttgart: Klett-Cotta, 1988), 94; Ernst Toller, *Eine Jugend in Deutschland* (1933), in *Gesammelte Werke,* ed. Wolfgang Frühwald and John M. Spalek, 5 vols. (Munich: Carl Hanser, 1978), 4:13.

67. Anthony Giddens, *The Consequences of Modernity* (Cambridge: Polity, 1990), 131.

68. Calinescu, *Faces of Modernity,* 125; Marianna Torgovnick, *Gone Primitive: Savage Intellectuals, Modern Lives* (Chicago: University of Chicago Press, 1990), 173.

69. Anderson, "Modernity and Revolution," 105.

70. Stauth and Turner, "Critique of Mass Culture," 514; cf. Giddens, *Consequences of Modernity,* 137–38.

71. Elsen, *Rodin's Gates of Hell,* 142.

72. Max Weber, *Die protestantische Ethik und der "Geist" des Kapitalismus* (1904–5), ed. Klaus Lichtblau and Johannes Weiss (Bodenheim, Germany: Athenäum-Hain-Hanstein, 1993), 16 and 153; *The Protestant Ethic,* trans. Talcott Parsons (London: George Allen and Unwin, 1930), 54 and 181; "Zur Lage der bürgerlichen Demokratie in Russland" (1906), in *Gesammelte politische Schriften,* ed. Johannes Winckelmann, 5th ed. (Tübingen: J. C. B. Mohr [Paul Siebeck], 1988), 63; "Bourgeois Democracy in Russia," in *The Russian Revolutions,* ed. Gordon C. Wells and Peter Baehr (Cambridge: Polity, 1995), 108; *Wirtschaft und Gesellschaft* (1922), ed. Johannes Winckelmann (Tübingen: J. C. B. Mohr [Paul Siebeck]:

1985), 835; *Economy and Society,* ed. Guenther Roth and Claus Wittich, 2 vols. (Berkeley and Los Angeles: University of California Press, 1978), 2:1041–42; "Parlament und Regierung im neugeordneten Deutschland," in *Gesammelte politische Schriften,* 331 and 332; "Politik als Beruf," in ibid., 505–60; "Politics as a Vocation," in *From Max Weber,* 77–118. The English translations of Weber's key concept of "Gehäuse" leave much to be desired and vary considerably. I have standardized the translations for the sake of uniformity. For a discussion of the difficulties involved in translating this term, see David Chalcraft, "Bringing the Text Back In: On Ways of Reading the Iron Cage Metaphor in the Two Editions of *The Protestant Ethic,*" in *Organizing Modernity: New Weberian Perspectives on Work, Organization and Society,* ed. Larry Ray and Michael Reed (London: Routledge, 1994), 16–45; see also Max Weber, *Political Writings,* ed. Peter Lassman and Ronald Speirs (Cambridge: Cambridge University Press, 1994), 68 n. 57 and 90 n. 11.

73. "Society in which . . . ," Eagleton, *Ideology,* 98; "world-historical process . . . ," Peter Dews, *Logics of Disintegration: Post-Structuralist Thought and the Claims of Literary Theory* (London: Verso, 1987), 150; Honneth, "Foucault and Adorno," 135–38; Wellmer, *Dialektik von Moderne und Postmoderne,* 101–3; Raulet, "Dialektik der Postmoderne," 132–33; Jameson, "Cultural Logic of Late Capitalism"; Douglas Kellner, "Introduction: Jameson, Marxism, and Postmodernism," in *Postmodernism/Jameson/Critique,* 31.

74. Harvey, *Condition of Postmodernity,* 283, see also 117 and 205; Georg Simmel, *Der Konflikt der modernen Kultur: Ein Vortrag* (Munich: Duncker and Humblot, 1918), 14; "The Conflict in Modern Culture," in *The Conflict in Modern Culture and Other Essays,* ed. K. Peter Etzkorn (New York: Teachers College Press, 1968), 14 (page citations are to both editions, respectively).

75. Friedrich Schiller, *On the Aesthetic Education of Man in a Series of Letters,* ed. Elizabeth M. Wilkinson and Leonard A. Willoughby, bilingual ed. (Oxford: Clarendon, 1967), 96 and 97.

76. Georg Simmel, "Soziologie der Gesellschaft," in *Verhandlungen des Ersten Deutschen Soziologentages vom 19. — 22. Oktober 1910 in Frankfurt a.M.* (Tübingen: J. C. B. Mohr, 1911), 2.

77. Bauman, *Intimations of Postmodernity,* 204.

78. Bürger, *Theorie der Avantgarde,* 12/8 and 97/72.

79. Fredric Jameson, *The Political Unconscious: Narrative as a Socially Symbolic Act* (Ithaca: Cornell University Press, 1981), 42.

80. Huyssen, "Postmoderne," 41; Berman, *All That Is Solid,* 171 and 308; Bauman, *Modernity and Ambivalence,* 9; Dick Hebdige, "Postmodernism and 'The Other Side'" (1986), in *Cultural Theory and Popular Culture: A Reader,* ed. John Storey (London: Harvester-Wheatsheaf, 1994), 389–90; Berman, "Konsumgesellschaft," 61–62. Bathrick and Huyssen, *Modernity and the Text,* 3, 7–8, 38, 50, 65–67, 86, 90–93, 106, 142–43, 156, and 169–71. Michael Newman, "Revising Modernism, Representing Postmodernism: Critical Discourses of the Visual Arts," in

Postmodernism: ICA Documents, ed. Lisa Appignanesi (London: Free Association Books, 1989), 101; cf. Thomas Anz, "Gesellschaftliche Modernisierung, literarische Moderne und philosophische Postmoderne," in *Modernität des Expressionismus,* 2.

81. Berman, *All That Is Solid,* 169.

82. Clement Greenberg, "Avant-garde and Kitsch," *Partisan Review* 6.5 (fall 1939): 36–37; Schorske, *Fin-de-siècle Vienna,* 212; Dews, *Logics of Disintegration,* 226; Wilde, *Horizons of Assent,* 40; Anderson, "Modernity and Revolution," 105; Welsch, *Unsere postmoderne Moderne,* 101; Boyne and Rattansi, "Theory and Politics of Postmodernism," 6; cf. also Alex Callinicos, "Reactionary Postmodernism," in *Postmodernism and Society,* 104.

83. Butler, *Early Modernism,* 25.

84. Cf. ibid., 211–12.

85. Mark Antliff, "Organicism against Itself: Cubism, Duchamp-Villon and the Contradictions of Modernism," *Word & Image* 12 (October–December 1996): 367; Reinhold Heller, "Bridge to Utopia: The Brücke as Utopian Experiment," in *Expressionist Utopias: Paradise, Metropolis, Architectural Fantasy,* ed. Timothy O. Benson (Los Angeles: Los Angeles County Museum of Art, 1993), 72. For the ambiguities of a pivotal Expressionist drama, see Richard Sheppard, "The Foundation of Max Reinhardt's 'Verein *Das junge Deutschland*' and the War-time Reception of Reinhard Goering's *Die Seeschlacht,*" *German Life and Letters* 46 (1993): 42–70; see also Wilhelm Haefs, "'Der Expressionismus ist tot . . . Es lebe der Expressionismus': Paul Hatvani als Literaturkritiker und Literaturtheoretiker des Expressionismus," in *Expressionismus in Österreich,* 481–83. See Torgovnick, *Gone Primitive,* passim; Lloyd, *German Expressionism,* vii, 48, and 187; and Elazar Barkan and Ronald Bush, *Prehistories of the Future: The Primitivist Project* (Stanford, Calif.: Stanford University Press, 1995), passim; Anz, "Gesellschaftliche Modernisierung," 2.

86. Jones, *En-gendering of Marcel Duchamp,* 108; Franz Jung, *Werke in Einzelausgaben,* ed. Lutz Schulenberg et al., 12 vols. (Hamburg: Nautilus, 1981–97), 9/1 (*Briefe 1913–1963*): 398.

87. Berman, *All That Is Solid,* 170. Baudelaire, "Peintre de la vie moderne," 2:712/134; Silvio Vietta, "Zweideutigkeit der Moderne: Nietzsches Kulturkritik, Expressionismus und literarische Moderne," in *Modernität des Expressionismus,* 12–13; Milič Čapek, *Bergson and Modern Physics: A Reinterpretation and Re-Evaluation* (Dordrecht, Netherlands: D. Reidel, 1971), 18–27; Callinicos, *Against Postmodernism,* 46; cf. Eagleton, *Ideology,* 178; Hugo Ott, *Martin Heidegger: A Political Life,* trans. Allan Blunden (1988; London: Fontana, 1994), 384; Detlev J. K. Peukert, *Max Webers Diagnose der Moderne* (Göttingen, Germany: Vandenhoek und Ruprecht, 1989) 43; Stauth and Turner, "Critique of Mass Culture," 516.

88. See Ronald Bush, "The Presence of the Past: Ethnographic Thinking/Literary Politics," in *Prehistories of the Future,* 23–41; Nancy Perloff, "Gauguin's French Baggage: Decadence and Colonialism in Tahiti," in ibid., 226–69; Marie-Denise

Shelton, "Primitive Self: Colonial Impetus in Michel Leiris's 'L'Afrique fantôme,'" in ibid., 326–38; Lloyd, *German Expressionism,* 201–4 and 224–30; Torgovnick, *Gone Primitive,* 168–72; Richard Sheppard, "The Poetry of August Stramm: A Suitable Case for Deconstruction," in *New Ways in Germanistik,* ed. Richard Sheppard (Oxford: Berg, 1990), 211–42.

89. Elsen, *Rodin's Gates of Hell,* 69, 70, and 76; Gilbert, "'A Tumult of Images,'" 154.

90. Robert Musil, *Beitrag zur Beurteilung der Lehren Machs und Studien zur Technik und Pyrotechnik* (1907; Reinbek bei Hamburg: Rowohlt, 1980), 17, 18, 25, 32, 58–59, 78–79, 88–89, 119–25, and 132–33; cf. Henri Arvon, "Robert Musil und der Positivismus," in *Robert Musil: Studien zu seinem Werk,* ed. Karl Dinklage, Eilsabeth Albertson, and Karl Corino (Reinbek bei Hamburg: Rowohlt, 1970), 204–5.

91. Butler, *Early Modernism,* 108–9; Foster, *Postmodern Culture,* 46.

92. Butler, *Early Modernism,* 113–15 and 257; Eksteins, *Rites of Spring,* 86; Richard Sheppard, "Wyndham Lewis's *Tarr:* An (Anti-)Vorticist Novel?" *Journal of English and Germanic Philology* 88 (1989): 510–30.

93. Eric Marson, *The Case against Josef K.* (St. Lucia, Australia: Queensland University Press, 1975).

94. Connor, *Postmodernist Culture,* 121, citing Marjorie Perloff.

95. Tratner, *Modernism and Mass Politics,* 164–65.

96. Connor, *Postmodernist Culture,* 118; cf. 105.

97. Cf. Hutcheon, *Politics of Postmodernism,* 99; cf. Hans Bertens, "The Postmodern *Weltanschauung* and Its Relation with Modernism: An Introductory Survey," in *Approaching Postmodernism,* 26.

Chapter 2

1. Hutcheon, *Poetics of Postmodernism,* 224; Hutcheon, *Politics of Postmodernism,* 15; Schwartz, *Matrix of Modernism,* 5 and 9; cf. Kern, *Culture of Time and Space,* 4–8; and Boyne and Rattansi, "Theory and Politics of Postmodernism," 8.

2. Louis Althusser, *Pour Marx* (Paris: François Maspero, 1965), 64–66, and *For Marx,* trans. Ben Brewster (London: New Left Books, 1977), 67–69. See also Connor, *Postmodernist Culture,* 4; Boyne and Rattansi, *Postmodernism and Society,* 108; and Eagleton, *Ideology,* 137.

3. Cf. Beebe, "What Modernism Was," 1074.

4. Judith Ryan, "Each One as She May: Melanctha, Tonka, Nadja," in *Modernity and the Text,* 96. For examples of critics disentangling the subjective problematic that is embedded in various important modernist works from a deformed, obscured, or repressed objective problematic, see Michael Long, "The Politics of English Modernism: Eliot, Pound, Joyce," in *Visions and Blueprints,* especially 103–5; Barnouw, *Weimar Intellectuals,* 12–13 and 20–21; Jameson, *Political Uncon-*

scious, 266, and "Modernism and Its Repressed: Robbe-Grillet as Anti-Colonialist," *Diacritics* 6.2 (1976): 13–14.

5. Heinz Rölleke, *Die Stadt bei Stadler, Heym und Trakl*, 2nd ed., rev. (Berlin: Erich Schmidt, 1988), 199–263.

6. Alfred Kubin, "Aus meinem Leben" (1911–52), in *Aus meinem Leben*, ed. Ulrich Riemerschmidt (1974; Munich: DTV, 1977), 24–31.

7. Lloyd, *German Expressionism*, 213–30, especially 225; cf. Hal Foster, "The 'Primitive' Unconscious of Modern Art," *October* 34 (fall 1985): 61.

8. See Sheppard, "Poetry of August Stramm," 211–42.

9. Cf. Torgovnick, *Gone Primitive*, 168.

10. Annegret Hoberg, ed., *Wassily Kandinsky and Gabriele Münter: Letters and Reminiscences 1902–1914* (Munich: Prestel, 1994), 70 and 83 (a German edition of the Kandinsky–Münter correspondence is currently in preparation); Rainer Maria Rilke, *Briefe*, ed. Karl Altheim, 2 vols. (Wiesbaden: Insel, 1950), 1:459. For the importance of "veiling" for Kandinsky, see Rose-Carol Washton Long, *Kandinsky: The Development of an Abstract Style* (Oxford: Oxford University Press, 1980), 72–73.

11. Robert Hughes, *The Shock of the New* (London: BBC Publications, 1980), 385.

12. Thomas S. Kuhn, *The Structure of Scientific Revolutions* (Chicago: University of Chicago Press, 1962); cf. Giddens, "Modernism and Post-modernism," 17; and Kern, *Culture of Time and Space*, 6.

13. Cf. Habermas, "Moderne," 453/9; cf. Spears, *Dionysus and the City*, 42; Calinescu, *Faces of Modernity*, 125; Brazill, "Art and the Panic Terror," 533; and Wilde, *Horizons of Assent*, 40.

14. Ball, "Kandinsky," 41/223.

15. Quoted in Heinz Zahrnt, *Die Sache mit Gott: Die protestantische Theologie im 20. Jahrhundert* (Munich: Piper, 1966), 384, and *The Question of God: Protestant Theology in the Twentieth Century*, trans. R. A. Wilson (London: Collins, 1969), 296.

16. Ernst Jünger, *Der Kampf als inneres Erlebnis* (1922), in *Sämtliche Werke*, 18 vols. (Stuttgart: Klett-Cotta, 1978–84), 7:78.

17. Gottfried Benn, "Lebensweg eines Intellektualisten" (1934), in *Gesammelte Werke in acht Bänden*, ed. Dieter Wellershoff, 8 vols. (Wiesbaden: Limes, 1960–68), 8:1904–5. Cited here by permission of Klett-Cotta.

18. Harvey, *Condition of Postmodernity*, 252.

19. See Henderson, *Non-Euclidean Geometry in Modern Art*, 10.

20. Čapek, *Bergson and Modern Physics*, passim; Frederick Burwick and Paul Douglas, introduction to *The Crisis in Modernism: Bergson and the Vitalist Controversy*, ed. Frederick Burwick and Paul Douglas (Cambridge: Cambridge University Press, 1992), 2; Richard Lehan, "Bergson and the Discourse of the Moderns," in ibid., 308–9; and Gregor Schiemann, "Wer beeinflusste wen? Die Kausalitäts-

kritik der Physik im Kontext der Weimarer Kultur," in *Intellektuelle in der Weimarer Republik,* 354 and 363–64.

21. Ernst Mach, *Die Analyse der Empfindungen und das Verhältnis des Physischen zum Psychischen: Zweite vermehrte Auflage der Beiträge zur Analyse der Empfindungen* (Jena, Germany: Gustav Fischer, 1900), 267; *The Analysis of Sensations and the Relation of the Physical to the Psychical,* trans. C. M. Williams and Sydney Waterlow (Chicago: Open Court, 1914), 311–12 (page citations are to both editions, respectively); *Erkenntnis und Irrtum: Skizzen zur Psychologie der Forschung* (1905), 2nd ed., rev. (Leipzig: Ambrosius Barth, 1906), 15; *Knowledge and Error: Sketches on the Psychology of Enquiry,* ed. Erwin N. Hiebert (Dordrecht, Netherlands: D. Reidel, 1976), 8–9 (page citations are to both editions, respectively).

22. Mach, *Analyse der Empfindungen,* 62–63/84.

23. Schiemann, "Wer beeinflusste wen?" 357; Kern, *Culture of Time and Space,* 19 and 81; and Harvey, *Condition of Postmodernity,* 252. For introductions to the scientific revolution that took place during the modernist period, see Fritjof Capra, *The Tao of Physics* (1975; London: Fontana, 1976), and *The Turning Point* (1982; London: Flamingo, 1983); see also John P. Briggs and F. David Peat, *Looking Glass Universe* (1984; London: Fontana, 1985).

24. Henderson, *Non-Euclidean Geometry in Modern Art,* 3–15; Schwartz, *Matrix of Modernism,* 15–16; Werner Heisenberg, *Physics and Philosophy* (London: George Allen and Unwin, 1959), 61; cf. Čapek, *Bergson and Modern Physics,* 130 and 149.

25. Georg Simmel, *Philosophie des Geldes,* 2nd ed., enl. (1900; Leipzig: Duncker and Humblot, 1920), 64, 581, and 583; *The Philosophy of Money,* trans. Tom Bottomore and David Frisby (London: Routledge and Kegan Paul, 1978), 103 and 509–10 (page citations are to both editions, respectively). Lucien Lévy-Bruhl, *Les Fonctions mentales dans les sociétés inférieures,* 3rd ed. (Paris: Félix Alcan, 1918), 107; *How Natives Think,* trans. Lilian A. Clare (London: George Allen and Unwin, 1926), 101.

26. Henderson, *Non-Euclidean Geometry in Modern Art,* 44–116.

27. F. T. Marinetti, "Distruzione delle sintassi—Immaginazione senza fili—Parole in libertà," in *Teoria e invenzione futurista,* ed. Luciano De Maria (Milan: Arnoldo Mondadori, 1968), 64; "Destruction of Syntax—Imagination without Strings—Words-in-Freedom 1913," in *Futurist Manifestos,* ed. Umbro Apollonio (New York: Viking, 1973), 96 (page citations are to both editions, respectively).

28. Wassily Kandinsky, *Rückblicke* (1913; Berne: Benteli, 1977), 15; *Reminiscences,* in *Complete Writings on Art,* 1:364. Cf. chapter 1, n. 51.

29. Ball, "Kandinsky," 41–42/223–24; Tristan Tzara, "Manifeste Dada 1918," *Dada,* no. 3 (December 1918): n.p.; in *Oeuvres complètes,* ed. Henri Béhar, 6 vols. (Paris: Flammarion, 1975–91), 1:367; "Dada Manifesto 1918," in *Seven Dada Manifestos and Lampisteries,* trans. Barbara Wright (London: John Calder, 1977), 13 (page citations are to both editions, respectively).

30. "Dadaistische Aufklärung," *Vorwärts* (Berlin), no. 473 (27 September 1920); see also Henderson, *Non-Euclidean Geometry in Modern Art,* 228; and Lewis Elton, "Einstein, General Relativity, and the German Press, 1919–1920," *ISIS* 77 (1986): 95–103; Tristan Tzara, *Surréalisme et l'après-guerre* (Paris: Editions Nagel, 1948), 17–18, reprinted in Tzara, *Oeuvres complètes,* 5:65.

31. Baudelaire, "Peintre de la vie moderne," 2:692/48.

32. See Arthur Hübscher, *Schopenhauer-Bibliographie* (Stuttgart–Bad Cannstatt: frommann-holzboog, 1981), 24–25 and 151–62, where editions of *Die Welt als Wille und Vorstellung* (*The World as Will and Representation*) and studies of Schopenhauer's philosophy are listed for the years 1819–1916 and 1850–1920, respectively.

33. Kern, *Culture of Time and Space,* 47. See Sheppard, "Expressionism and Vorticism," 151.

34. Arthur Rimbaud, "Les Ponts," in *Oeuvres complètes,* ed. Rolland de Renéville and Jules Mouquet (Paris: Gallimard, 1946), 179; "Bridges," in *A Season in Hell/The Illuminations,* trans. Enid Rhodes Peschel (Oxford: Oxford University Press, 1973), 132–35 (page citations to *Oeuvres complètes* are to these two editions, respectively).

35. Kern, *Culture of Time and Space,* 163.

36. Hugo von Hofmannsthal, "Der Dichter und diese Zeit," in *Prosa,* vol. 2, ed. Herbert Steiner, in *Gesammelte Werke in Einzelausgaben* (Stockholm and Frankfurt: S. Fischer, 1945–59), 272.

37. See Mark Anderson, "Kafka and New York: Notes on a Traveling Narrative," in *Modernity and the Text,* 142–43 and 156–57.

38. Cf. Eksteins, *Rites of Spring,* 295.

39. See Sheppard, "Wyndham Lewis's *Tarr,*" 515.

40. Henderson, *Non-Euclidean Geometry in Modern Art,* 117–63, 210–24, and 328–34.

41. Harvey, *Condition of Postmodernity,* 265.

42. Eagleton, *Ideology,* 161–67. Interestingly, Richard Aldington picked up some of these connections when, in an early review of *Ulysses* ("The Influence of Mr. James Joyce," *English Review* 32 [April 1921]: 333–41), he called it "a tremendous libel on humanity" (338); linked it with Dada (333); and recounted how he had first read some of its episodes in a "most appropriate" situation (337)—the trenches. T. S. Eliot then cited this review in "*Ulysses,* Order and Myth" (*The Dial* 75 [November 1923]: 480–83), where he drew an implicit analogy between Joyce's mythic method and "the discoveries of an Einstein." Here then is another example of critics sensing that modernist literature, the critique of classical humanism, the trauma of contemporary history, and the paradigm shift in the sciences were somehow linked.

43. Virginia Woolf, "Modern Novels," *Times Literary Supplement,* no. 899 (10 April 1919): 189–90.

44. Hermann Broch, "Das Weltbild des Romans" (1933), in *Kommentierte Werkausgabe*, ed. Paul Michael Lützeler, 13 vols. (Frankfurt/Main: Suhrkamp, 1976–81), 9/2:105–6.

45. Spears, *Dionysus and the City*, 98.

46. Rilke, *Briefe*, 2:51.

47. Müller, *Tropen*, 172.

48. Cf. Harvey, *Condition of Postmodernity*, 244; and Henderson, *Non-Euclidean Geometry in Modern Art*, 140.

49. Elsen, *Rodin's Gates of Hell*, 81–82; Kern, *Culture of Time and Space*, 141–42; Spears, *Dionysus and the City*, 23–28; and Fokkema and Ibsch, *Modernist Conjectures*, 39 and 66.

50. Yarrow, "Anxiety, Play and Performance," 219 and 221–22; Butler, *Early Modernism*, 31–37 and 60; Kern, *Culture of Time and Space*, 76–77.

51. Vattimo, *End of Modernity*, 122. The origins of this concept are to be found in Viktor Shklovsky's "Iskusstvo, kak priyom" (1917), translated as "Art as Technique," in *Russian Formalist Criticism*, ed. Lee T. Lemon and Marion J. Reis (Lincoln: University of Nebraska Press, 1965), 3–24; Huyssen, *After the Great Divide*, 14; Hutcheon, *The Politics of Postmodernism*, 34.

52. Benn, "Lebensweg eines Intellektualisten," in *Werke*, 8:1898–99; Schorske, *Fin-de-siècle Vienna*, 281.

53. Giddens, *Consequences of Modernity*, 48. Cf. Vattimo, *End of Modernity*, 31–33; Kern, *Culture of Time and Space*, 34–35, 38, and 137.

54. Mach, *Analyse der Empfindungen*.

55. Friedrich Nietzsche, "Aus dem Nachlass der Achtzigerjahre," in *Werke*, ed. Karl Schlechta, 5 vols. (Frankfurt/Main: Ullstein, 1972), 4:48, 72, 92, 126, 128–29, 204, 369, 434, 442, 455, 487, and 501; *The Will to Power*, trans. Walter Kaufmann and R. J. Hollingdale, ed. Walter Kaufmann (London: Weidenfeld and Nicolson, 1968), 294, 281, 199, 269–70, 413–14, 338, 403, 200, 267, 281, and 308–9.

56. Nietzsche, "Streifzüge eines Unzeitgemässen" (para. 5), *Götzen-Dämmerung* (1889), in *Werke*, 3:993; "Expeditions of an Untimely Man," in *Twilight of the Idols and the Anti-Christ*, trans. R. J. Hollingdale (Harmondsworth, England: Penguin, 1968), 69.

57. Robert C. Holub, "Fragmentary Totalities and Totalized Fragments: On the Politics of Anti-Systemic Thought," in *Postmodern Pluralism and Concepts of Totality*, ed. Jost Hermand (Frankfurt/Main: Peter Lang, 1995), 94.

58. Spears, *Dionysus and the City*, 40.

59. Although Freud denied any early knowledge of Nietzsche, recent research has shown this not to be the case (see Anthony Storr, *Freud* [Oxford: Oxford University Press, 1989], 120). The basis of Adlerian "Individual Psychology," the urge to power, is clearly very close to Nietzsche's concept of the Will to Power. For Jung's debt to Nietzsche, see Paul Bishop, *The Dionysian Self: C. G. Jung's Reception of Friedrich Nietzsche* (Berlin and New York: Walter de Gruyter, 1995). To quote

Henri Ellenberger: "More so even than Bachofen, Nietzsche may be considered the common source of Freud, Adler, and Jung" (*The Discovery of the Unconscious* [London: Allan Lane, 1970], 276).

60. Ellenberger, *Discovery of the Unconscious,* passim; Schwartz, *Matrix of Modernism,* 213; see also Harvie Ferguson, *The Love of Dreams: Sigmund Freud and the Construction of Modernity* (London: Routledge, 1996), 15–19.

61. Sigmund Freud, *Die Traumdeutung, Gesammelte Werke,* ed. Anna Freud and Marie Bonaparte, 18 vols. (London and Frankfurt/Main: Imago, 1940–68), 2/3:617–18. Sigmund Freud, *The Interpretation of Dreams,* in *The Standard Edition of the Complete Psychological Works of Sigmund Freud,* ed. James Strachey and Anna Freud, 24 vols. (London: Hogarth Press and the Institute of Psychoanalysis, 1953–74), 5:613 (volume and page citations are to German and English editions, respectively).

62. The English translation obscures Freud's personification by rendering the accusative masculine pronoun "ihn" ("him" or "it") by the unambiguous "it."

63. Eagleton, *Ideology,* 182.

64. For an introduction to the theological paradigm shift that took place during the modernist period, see Zahrnt, "Die grosse Wende," 13–65; "The Great Turning-Point," 15–54; Rudolf Otto, *Das Heilige: Über das Irrationale in der Idee des Heiligen und sein Verhältnis zum Rationalen,* 17th–22nd ed. (1917; Gotha, Germany: Leopold Klotz, 1929), 13–14; *The Idea of the Holy: An Inquiry into the Non-Rational Factor in the Idea of the Divine and Its Relation to the Rational,* trans. John W. Harvey (1923; Harmondsworth, England: Penguin, 1959), 26–27.

65. Karl Barth, *Der Römerbrief,* 2nd ed., rev. (Munich: Christian Kaiser, 1922), 4; *The Epistle to the Romans,* trans. Edwyn C. Hoskyns (1933; Oxford: Oxford University Press, 1968), 28.

66. Martin Buber, *Ekstatische Konfessionen* (Jena, Germany: Eugen Diederichs, 1909), xxvi.

67. Schorske, *Fin-de-siècle Vienna,* 85 and 226; Rosalind A. Krauss, "No More Play" (1983), in *Originality of the Avant-garde,* 68.

68. T. E. Hulme, "Humanism and the Religious Attitude" (c. 1915–17), in *Speculations: Essays on Humanism and the Philosophy of Art,* ed. Herbert Read, 2nd ed. (London: Kegan Paul, Trench and Trubner, 1936), 70.

69. Jünger, *Kampf als inneres Erlebnis,* 55 and 102. On Bataille, see Krauss, "No More Play," 80. Müller, *Tropen,* 25 and 30; Benn, "Der Arzt II," in *Werke,* 1:12.

70. Ball, "Kandinsky," 41–42/223–24.

71. Beebe, "What Modernism Was," 1074; Rimbaud, *Oeuvres complètes,* 252 and 254; Buber, *Ekstatische Konfessionen,* xii.

72. Cf. Lodge, "Modernism, Antimodernism and Postmodernism," 6.

73. Anderson, "Kafka and New York," 153.

74. Alfred Adler, "Die Individualpsychologie, ihre Voraussetzungen und Ergebnisse" (1914), in *Praxis und Theorie der Individualpsychologie* (Munich: J. F.

Bergmann, 1920), 5–6; "Individual-Psychology, Its Assumptions and Its Results," in *The Practice and Theory of Individual Psychology*, trans. Paul Radin (London: Kegan Paul, Trench and Trubner, 1924), 7–8 (page citations are to both editions, respectively); George J. Zytarok and James T. Boulton, eds., *The Letters of D. H. Lawrence*, 7 vols. (Cambridge: Cambridge University Press, 1979–), 2:183. See also Judith Ryan, "The Vanishing Subject: Empirical Psychology and the Modern Novel," *PMLA* 95 (1980): 857–69.

75. Ball, "Kandinsky," 42/224.

76. Baudelaire, *Oeuvres complètes*, 1:676; "My Heart Laid Bare," *Intimate Journals*, trans. Christopher Isherwood (London: Blackamore Press; New York: Random House, 1930), 59 (page citations are to French and English editions, respectively).

77. Georg Simmel, "Die Großstadt und das Geistesleben," *Die Großstadt: Vorträge und Aufsätze zum Städteleben (Jahrbuch der Gehe-Stiftung zu Dresden)* 9 (1903): 187–206; "The Metropolis and Mental Life," in *Syllabus and Selected Readings: Second-Year Course in the Study of Contemporary Society* (Chicago: n.p., 1936), 221–38.

78. Cf. Fokkema and Ibsch, *Modernist Conjectures*, 43 and 217; T. E. Hulme, "Romanticism and Classicism" (c. 1915–17), in *Speculations*, 128; Benn, "Synthese," in *Werke*, 1:57; Benn, "Lebensweg eines Intellektualisten," in *Werke*, 8:1908, 1910, and 1923–24.

79. Schwartz, *Matrix of Modernism*, 170–73 and 194–203.

80. Wilde, *Horizons of Assent*, 15 and 41; Silvio Vietta and Hans-Georg Kemper, *Expressionismus* (Munich: Wilhelm Fink, 1975), 30–213.

81. Cf. Benn, "Lebensweg eines Intellektualisten," in *Werke*, 8:1898 and 1902.

82. Ezra Pound, "Vorticism [I]," *The Fortnightly Review* 96 (September 1914): 461–71.

83. Mach, *Analyse der Empfindungen*, 17/25.

84. Zytarok and Boulton, *Letters of D. H. Lawrence*, 2:183.

85. Tratner, *Modernism and Mass Politics*, 192, 198, and 229; cf. Ryan, "Empirical Psychology and the Modern Novel," 865–68.

86. Nietzsche, "Von den Vorurteilen der Philosophen" (para. 12), *Jenseits von Gut und Böse* (1885), in *Werke*, 3:577; "On the Prejudices of the Philosophers," in *Beyond Good and Evil*, trans. R. J. Hollingdale (Harmondsworth, England: Penguin, 1973), 25.

87. William Barrett, *Irrational Man: A Study of Existential Philosophy* (1958; London: Murray Books, 1964), 194; Theodore Kiesel, *The Genesis of Heidegger's Being and Time* (Berkeley and Los Angeles: University of California Press, 1993), 117 and 136–37; Edith Wyschogrod, "Towards a Postmodern Ethics: Corporality and Alterity," *Ethics and Aesthetics: The Moral Turn of Postmodernism*, ed. Gerhard Hoffmann and Alfred Hornung (Heidelberg: C. Winter, 1996), 55; cf. Vattimo, *End of Modernity*, 118.

88. Boyne and Rattansi, *Postmodernism and Society*, 31. Schorske, *Fin-de-siècle Vienna*, 358.

89. Baudelaire, *Oeuvres complètes*, 1:693/80. See Edward Timms, *Karl Kraus: Apocalyptic Satirist* (New Haven: Yale University Press, 1986), 91; Gilbert, " 'Tumult of Images,' " 148–50; Elaine Showalter, *Sexual Anarchy: Gender and Culture at the "Fin de Siècle"* (London: Bloomsbury, 1991), 10–11 and 146; and Butler, *Early Modernism*, 115.

90. Schorske, *Fin-de-siècle Vienna*, 224. See Mererid Puw Davies, "The 'Blaubartmärchen' and Its Reception in German Literature of the Nineteenth and Twentieth Centuries" (Ph.D diss., Oxford University, 1998).

91. Alfred Adler, *Menschenkenntnis*, 5th ed. (1927; Zurich: Rascher, 1947), 104; *Understanding Human Nature*, trans. Walter Béran Wolfe (London: George Allen and Unwin, 1927), 130 (page citations are to both editions, respectively). See also Jacques le Rider, *Modernité viennoise et crises de l'identité* (Paris: Presses Universitaires de France, 1990), 93–151, for an extensive discussion of this problem.

92. Jane Flax, "Postmodernism and Gender Relations in Feminist Theory," in *Feminism/Postmodernism*, 43.

93. Adler, "Individualpsychologie," 11–14/16–22; *Menschenkenntnis*, 95–120/120–48.

94. Judith Butler, "Gender Trouble, Feminist Theory, and Psychoanalytic Discourse," in *Feminism/Postmodernism*, 332.

95. Richard Sheppard, *On Kafka's Castle: A Study* (London: Croom Helm, 1973), 127–88; Berman, *All That Is Solid;* and Seyla Benhabib, "Epistemologies of Postmodernism: A Rejoinder to Jean-François Lyotard," in *Feminism/Postmodernism*, 107.

96. See Andrew Webber, *Sexuality and the Sense of the Self in the Works of Georg Trakl and Robert Musil* (London: Institute of Germanic Studies, 1990), 174–75; and Roger Kingerlee, " 'Männliches, Allzumännliches': Images of the Masculine in German and Austrian Novels 1919–1933" (Ph.D. diss., Oxford University, 1997). In this connection, it is particularly revealing that Musil should have called his protagonist Ulrich since this may be a reference to Karl Heinrich Ulrichs (1825–1895), whose concept of "Uranism" is cited by Freud in a footnote in the *Drei Abhandlungen* (5:37 7:139) when discussing bisexuality. In his twelve-volume *Forschungen über das Rätsel mannmännlicher Liebe (Investigations into the Riddle of Love between Men)* (1864–79), Ulrichs had described the "Uranian" or "Urning" as a male in whom a female soul was trapped.

97. Andreas Kramer, "Language and Desire in Musil's *Törless*," in *London German Studies VI*, ed. Edward M. Batley (London: Institute of Germanic Studies, 1998), 287–314; Krauss, "No More Play," 58–62.

98. Tratner, *Modernism and Mass Politics*, 109. See Jones, *En-gendering of Marcel Duchamp*, passim.

99. Cf. Petersen, " 'Das Moderne' und 'die Moderne,' " 141.

100. See Čapek, *Bergson and Modern Physics,* 10, citing Herbert Spencer.

101. Fokkema and Ibsch, *Modernist Conjectures,* 41; Wellmer, *Dialektik von Moderne und Postmoderne,* 27.

102. Baudelaire, "Peintre de la vie moderne," 1:692/48 and 52.

103. Cf. Habermas, *Philosophische Diskurs der Moderne,* 193/163.

104. Mach, *Analyse der Empfindungen,* 9/13–14.

105. Habermas, *Philosophische Diskurs der Moderne,* 55–56/70; Eagleton, *Ideology,* 159.

106. Schwartz, *Matrix of Modernism,* 22–30.

107. See Gerald Graff, *Literature against Itself* (Chicago: University of Chicago Press, 1979), 40–44.

108. Georg Lukács, *Die Theorie des Romans,* 3rd ed. (1920; Luchterhand: Neuwied and Berlin, 1965), 62; *The Theory of the Novel,* trans. Anna Bostock (Cambridge: MIT Press, 1971), 64 (subsequent page citations are to both editions, respectively).

109. Torgovnick, *Gone Primitive,* 189; Joseph Chiari, "Vitalism and Contemporary Thought," in *Crisis in Modernism,* 257.

110. Henderson, *Non-Euclidean Geometry in Modern Art,* 25.

111. Schorske, *Fin-de-siècle Vienna,* 233.

112. Hugo Ball, *Die Flucht aus der Zeit,* 2nd ed., rev. (1927; Lucerne: Josef Stocker, 1946), 187; *Flight Out of Time,* 134 (subsequent page citations are to both editions as follows: *Flucht aus der Zeit,* 187/134).

113. Timothy J. Reiss, *The Discourse of Modernism* (Ithaca: Cornell University Press, 1982), 31; and Čapek, *Bergson and Modern Physics,* 10.

114. Henderson, *Non-Euclidean Geometry in Modern Art,* 17.

115. Werner Heisenberg, "L'Image de la nature selon la physique contemporaine," *Nouvelle Revue Française,* n.s., 7 (1959): 73 and 85.

116. Welsch, *Unsere postmoderne Moderne,* 78.

117. Nietzsche, "Die 'Vernunft' in der Philosophie" (para. 5), *Götzen-Dämmerung,* in *Werke,* 3:960; "'Reason' in Philosophy," in *Twilight of the Idols,* 35.

118. Simmel, *Philosophie des Geldes,* 89–90/121.

119. Werner Heisenberg, *Physics and Beyond,* trans. Arnold J. Pomerans (London: Allen and Unwin, 1971), 41; *Physics and Philosophy,* 156.

120. Torgovnick, *Gone Primitive,* 150; Benn, "Gehirne," in *Werke,* 5:1189; "Die Insel," in ibid., 5:1212. Franz Kafka, *Briefe 1902–1924,* ed. Max Brod (Frankfurt/Main: Suhrkamp, 1966), 130.

121. Kern, *Culture of Time and Space;* Christopher Herbert, "Frazer, Einstein, and Free Play," in *Prehistories of the Future,* 154; Heisenberg, "Image de la nature," 292.

122. Harvey, *Condition of Postmodernity,* 270; Yarrow, "Anxiety, Play and Performance," 220; Kern, *Culture of Time and Space,* 16 and 77; Butler, *Early Modernism,* 113.

123. Cf. Harvey, *Condition of Postmodernity,* 267 and 270.

124. Nietzsche, *Werke,* 4:916–17; *The Will to Power,* 549–50; cf. Harvey, *Condition of Postmodernity,* 274.

125. Habermas, "Moderne," 447/5.

126. Sheppard, "Expressionism and Vorticisim," 151–52; D. H. Lawrence, *Apocalypse* (1931; London: Martin Secker, 1932), 97–98.

127. Georg G. Iggers, "Einige kritische Schlussbemerkungen über die Rolle der Intellektuellen in der Weimarer Republik am Beispiel der Historiker," in *Intellektuelle in der Weimarer Republik,* 455; S. Kalberg, "The Origins and Expansion of Kulturpessimismus: The Relationship between Public and Private Spheres in Early Twentieth-Century Germany," *Sociological Theory* 5 (1987): 150–65; Nietzsche, "Der tolle Mensch," *Die fröhliche Wissenschaft* (1882), in *Werke,* 3:400–402; "The Madman," in *The Gay Science,* trans. Walter Kaufmann (New York: Vintage Books, 1974), 181.

128. Eliot, "*Ulysses,* Order and Myth," 483; Rilke, *Briefe,* 2:482–83.

129. Hans Henny Jahnn, "Aufgabe des Dichters in dieser Zeit" (1935), in *Schriften zur Kunst, Literatur und Politik,* ed. Ulrich Bitz and Uwe Schweikert (Hamburg: Hoffmann and Campe, 1991), 670–72.

130. Walter Benjamin, "Über den Begriff der Geschichte," in *Gesammelte Schriften,* ed. Rolf Tiedemann and Hermann Schweppenhäuser, 7 vols. (Frankfurt/Main: Suhrkamp, 1972–89), 1/2:693–704; "Theses on the Philosophy of History," in *Illuminations,* trans. Harry Zohn, ed. Hannah Arendt (New York: Harcourt Brace, 1968), 255–66 (especially 259–60).

131. Benjamin, "Über den Begriff der Geschichte," 696–97/258–59. See Foster, "The 'Primitive' Unconscious of Modern Art," 58; Torgovnick, *Gone Primitive,* 8; and Perloff, "Gauguin's French Baggage," 234.

132. Peukert, *Max Webers Diagnose der Moderne,* 53–54.

133. Rimbaud, *Oeuvres,* 226/77 and 218/95; Marjorie Perloff, "Tolerance and Taboo: Modernist Primitivisms and Postmodernist Pieties," in *Prehistories of the Future,* 353; and Eksteins, *Rites of Spring,* 61.

134. Lloyd, *German Expressionism,* 125.

135. Ronald Bush, "The Presence of the Past: Ethnographic Thinking/Literary Politics," in *Prehistories of the Future,* 35.

136. Doherty, " 'See: *We Are All Neurasthenics!' "* 105.

137. Cf. Bürger, "Verschwinden der Bedeutung," 301.

Chapter 3

1. C. G. Jung, *Seelenprobleme der Gegenwart* (Zurich: Rascher, 1931). Seven essays from this collection, including the key "Das Seelenproblem des modernen Menschen" ("The Spiritual Problem of Modern Man"), appeared in English in *Modern Man in Search of a Soul,* trans. W. S. Dell and Cary F. Barnes (Lon-

don: Kegan Paul, Trench and Trubner, 1933). Edmund Husserl, "Die Krisis des europäischen Menschtums und die Philosophie," *Husserliana,* ed. Walter Bieme et al., 27 vols. (The Hague: Martinus Nijhoff, 1950–88), 4:315–48; "Philosophy and the Crisis of European Man," in *Phenomenology and the Crisis of Philosophy,* ed. Quentin Lauer (New York: Harper, 1965), 149–92.

2. Max Planck, *Positivismus und reale Aussenwelt* (1930; Leipzig: Akademische Verlagsgesellschaft, 1931), 1; "Is the External World Real?" in *Where Is Science Going?* trans. and ed. James Murphy (London: George Allen and Unwin, 1933), 65.

3. Berman, *All That Is Solid,* 169; Stauth and Turner, "Critique of Mass Culture," 517–18; cf. also Anderson, "Modernity and Revolution," 102–3, where he identifies "five or six *decisive* currents of 'modernism.' "

4. Simmel, *Philosophie des Geldes,* 551/484; see Jakob van Hoddis, "Von Mir und vom Ich" (1907–8), in *Dichtungen und Briefe,* ed. Regina Nortemann (Zurich: Arche, 1987), 65–68; cf. Edward Timms, "Kokoschka's Pictographs—A Contextual Reading," *Word & Image* 6 (January–March 1990): 12–15.

5. Georg Trakl, *Dichtungen und Briefe,* ed. Walther Killy and Hans Szklenar, 2 vols. (Salzburg: Otto Müller, 1969), 1:519.

6. Cf. van Hoddis, "Von Mir und vom Ich"; and A. Alvarez, *The Savage God* (London: Weidenfeld and Nicolson, 1971).

7. Buber, *Ekstatische Konfessionen,* viii; Eksteins, *Rites of Spring,* 59, see also 70 and 84; cf. Tratner, *Modernism and Mass Politics,* 106.

8. Georg Heym, *Dichtungen und Schriften,* ed. Karl Ludwig Schneider et al., 6 vols. (Hamburg: Heinrich Ellerman, 1960–68), 3:138–39 and 164; Ludwig Rubiner, "Der Dichter greift in die Politik," *Die Aktion* 2.21 (22 May 1912): cols. 645–52; and 2.23 (5 June 1912): cols. 709–15.

9. Cf. Klaus Vondung, "Mystik und Moderne: Literarische Apokalyptik in der Zeit des Expressionismus," in *Modernität des Expressionismus,* 144–45. See also Gunter Martens, *Vitalismus und Expressionismus* (Stuttgart: Kohlhammer, 1971), passim.

10. Cf. Sanford Schwartz, "Bergson and the Politics of Vitalism," in *Crisis in Modernism,* 279.

11. Franz Marc, "Im Fegefeuer des Krieges," *Der Sturm* 7.1 (April 1916): 2. For the dating of the essay, see Marc's 24 October and 16 November 1914 letters to Kandinsky in Klaus Lankheit, ed., *Wassily Kandinsky—Franz Marc—Briefwechsel* (Munich: Piper, 1983), 263–64 and 266–67. See Jens-Fietje Dwars, "Ein ungeliebter Ehrenbürger: Johannes R. Becher in Jena: Mit Dokumenten seiner Klinikaufenthalte," *Jahrbuch der Deutschen Schillergesellschaft* 39 (1995): 87–110; *Abgrund des Widerspruchs: Das Leben des Johannes R. Becher* (Berlin: Aufbau, 1998), 100–191.

12. Rubiner, "Dichter greift in die Politik," cols. 647–48; Habermas, *Philosophische Diskurs der Moderne,* 249–78/212–35.

13. Vondung, "Mystik und Moderne," 147–48; Simmel, *Konflikt der modernen Kultur,* 38–39/22. See also Martina Egelhaaf, *Mystik der Moderne* (Stuttgart: Metz-

ler, 1989); and Uwe Spörl, *Gottlose Mystik in der deutschen Literatur um die Jahrhundertwende* (Paderborn, Germany: Ferdinand Schöningh, 1997).

14. Jelena Hahl-Koch, *Kandinsky* (London: Thames and Hudson, 1993), 28, 177, and 386; Michael Löwy, *Georg Lukács: From Romanticism to Bolshevism,* trans. Patrick Camiller (1976; London: New Left Books, 1979), 93–94, 104, 107–9; Marjorie Perloff, *Wittgenstein's Ladder: Poetic Language and the Strangeness of the Ordinary* (Chicago: University of Chicago Press, 1996), 30; Henderson, *Non-Euclidean Geometry in Modern Art,* 32 and 238–99. According to Henderson, the work of Petr Demianovich Ouspensky on "the fourth dimension" was particularly important for the Russian Futurists, Mondrian, and Kupka. Ludger Busch, "Das Bauhaus und Mazdaznan," in *Das frühe Bauhaus und Johannes Itten,* ed. Rolf Bothe, Peter Hahn, and Hans Chrisoph von Tavel (Stuttgart: Gerd Hatje, 1994), 83–90. See George Mills Harper, *Yeats and the Occult* (London: Macmillan, 1976); Graham Hough, *The Mystery Religion of W. B. Yeats* (Brighton: Harvester, 1984); and Leon Surette, *The Birth of Modernism: Ezra Pound, T. S. Eliot, W. B. Yeats and the Occult* (Montreal: McGill-Queen's University Press, 1993). See Weijian Liu, *Die daoistische Philosophie im Werk von Hesse, Döblin und Brecht* (Bochum, Germany: Brockmeyer, 1991); and Bok Hie Han, *Döblins Taoismus: Untersuchungen zum Wang-Lun Roman und den frühen philosophisch-poetologischen Schriften* (Darmstadt, Germany: Dissertations-Druck Darmstadt, 1992). Katerina Clark and Michael Holquist, *Mikhail Bakhtin* (Cambridge: Harvard University Press, 1984), 102 and 277. A copy of von Thimus's book was in Jahnn's *Bornholmer Bibliothek.* See Rüdiger Wagner, "Anmerkungen zur Harmonik im Werk Hans Henny Jahnns: Die Rezeption harmonikalen Denkens in den Jahren 1929 bis 1939," in *Hans-Henny-Jahnn-Woche 27. bis 30. Mai 1980: Eine Dokumentation,* ed. Bernd Goldmann, Hedda Kage, and Thomas Freeman (Kassel, Germany: Stauda, 1981), 87–113; Dietmar Goltschnigg, *Mystische Tradition im Roman Robert Musils: Martin Bubers "Ekstatische Konfessionen" im "Mann ohne Eigenschaften"* (Heidelberg: Lothar Stiehm, 1974), 169.

15. Rimbaud, *Oeuvres,* 224/88–91.

16. See Sylvia Brandt, *Bravo! & Bum Bum!: Neue Produktions- und Rezeptionsformen im Theater der historischen Avantgarde: Futurismus, Dada und Surrealismus* (Frankfurt/Main: Peter Lang, 1995), 121; and Brian Keith-Smith, "Lothar Schreyer—Bauhausmeister," in *Frühe Bauhaus und Johannes Itten,* 101–6.

17. Jürgen Egyptien, "Mythen-Synkretismus und apokryphes Kerygma: Paul Adlers Werk als Projekt einer Resakralisierung der Welt," in *Expressionismus in Österreich,* 379–95. See Kubin, "Aus meinem Leben," 39–40, 43, and 54. See also Salomo Friedlaender/Mynona–Alfred Kubin, *Briefwechsel,* ed. Hartmut Geerken and Sigrid Hauff (Vienna: edition neue texte, 1986), 52–53 and 63–66.

18. See Richard Sheppard, *Avantgarde und Arbeiterdichter in den Hauptorganen der deutschen Linken 1917–1922* (Frankfurt/Main: Peter Lang, 1995), 83.

19. Richard Lehen, "Bergson and the Discourse of the Moderns," 319–20; Henderson, *Non-Euclidean Geometry and Modern Art,* 78 and 267–68.

20. See Michel Carrouges, *André Breton and the Basic Concepts of Surrealism,* trans. Maura Prendergast (Tuscaloosa: University of Alabama Press, 1974), 10–66. On music symbolism in Russian Symbolist work, see Henderson, *Non-Euclidean Geometry and Modern Art,* 263. Barnouw, *Weimar Intellectuals,* 248; Andreas Huyssen, "Paris/Childhood: The Fragmented Body in Rilke's *Notebooks of Malte Laurids Brigge,*" in *Modernity and the Text,* 137.

21. Buber, *Verhandlungen des Ersten Deutschen Soziologentages,* 206.

22. Henderson, *Non-Euclidean Geometry and Modern Art,* 321.

23. See Habermas, "Moderne," 455–56/9–10; and Chiari, "Vitalism and Contemporary Thought," 247–48. See Schorske, *Fin-de-siècle Vienna,* 271–73; and Rosalind E. Krauss, "Grids" (1978), in *Originality of the Avant-garde,* 9–22.

24. Rilke, *Briefe,* 1:290, 2:135, 297–99, and 340; Hofmannsthal, "Dichter und diese Zeit," in *Prosa,* vol. 2:264–98, especially 268–69; Weiller, *Max Weber,* 85 and 148. See Wellmer, *Dialektik von Moderne und Postmoderne,* 13–19; Vattimo, *End of Modernity,* 67. Cf. Huyssen, *After the Great Divide,* ix and 187 (where Adorno is described as "the theorist of modernism par excellence").

25. The references are to the title of Hugo Ball's autobiography-cum-diary; line 62 of Eliot's *Burnt Norton* from *Four Quartets;* and an image central to Yeats's later poetry that also occurs in the title of an important early book on modernism: Joseph Frank, *The Widening Gyre* (New Brunswick: Rutgers University Press, 1963). It is also relevant to note that Rilke used the following dictum of Emerson's as an epigraph to his book on Rodin: "The Hero is he who is immovably centered."

26. Rilke, *Briefe,* 1:489.

27. Tratner, *Modernism and Mass Politics,* 156–57, 163, and 242. See Philip Mann, *Hugo Ball: An Intellectual Biography* (London: Institute of Germanic Studies, 1987), 137–80; and Bernd Wacker, ed., *Dionysius DADA Areopagita: Hugo Ball und die Kritik der Moderne* (Paderborn, Germany: Schöningh, 1996).

28. Cf. Habermas, *Philosophische Diskurs der Moderne,* 166/139, where he identifies the quest for a new mythology as the major and very common correlative of the rationalization, secularization, diremption, and loss of community involved in modernity.

29. Tratner, *Modernism and Mass Politics,* 170.

30. T. S. Eliot, *For Lancelot Andrewes* (London: Faber, 1928), ix; Eliot, "*Ulysses,* Order and Myth," 483.

31. Ezra Pound, *Jefferson and/or Mussolini* (1933; London: Stanley Nott, 1935), 48–49, 63–64, and 128.

32. Schwartz, *Matrix of Modernism,* 148. See also Cairns Craig, *Yeats, Eliot, Pound and the Politics of Poetry: Riches to the Richest* (London: Croom Helm, 1982), 251–89. Pound's anti-Semitism derived directly from this complex of attitudes and

its metaphysical basis is discussed in Bauman, *Modernity and Ambivalence,* 150–52. Egyptien, "Mythen-Synkretismus und apokryphes Kerygma."

33. Habermas, *Diskurs der Moderne,* 251/213; Harvey, *Condition of Postmodernity,* 209.

34. Benn, "Lebensweg eines Intellektualisten," *Werke* 8:1885–1934.

35. See Joan Weinstein, *The End of Expressionism: Art and the November Revolution in Germany, 1918–19* (Chicago: University of Chicago Press, 1990), 64–65 and 70–75. Stauth and Turner speak of Marx's "forward-looking nostalgia" ("Critique of Mass Culture," 514); and Alex Callinicos identifies a right- and left-wing "nostalgia of the whole" ("Reactionary Postmodernism?" in *Postmodernism and Society,* 112). Cf. Barnouw, *Weimar Intellectuals,* 17.

36. See Jens-Fietje Dwars, "Ich habe zu funktionieren . . . : Der Wandel Johannes R. Bechers vom expressionistischen Caféhaus-Dichter zum Vorsitzenden des Bundes Proletarisch-Revolutionärer Schriftsteller," in *Intellektuelle in der Weimarer Republik,* 391–411.

37. Wilhelm Worringer, "Zur Entwicklungsgeschichte der modernen Malerei," *Der Sturm* 2.75 (August 1911): 597–98.

38. Perloff, "Gaugin's French Baggage," 260.

39. Lloyd, *German Expressionism,* 82, also 39, 44, and 116.

40. Müller, *Tropen,* 79.

41. Lash, "Discourse or Figure?" 321–22.

42. Pär Bergman, *"Modernolatria" et "Simultaneità"* (Uppsala: Svenska Bokförlaget, 1962); Kern, *Culture of Time and Space,* 72; Jeffrey Herf, *Reactionary Modernism: Technology, Culture, and Politics in Weimar and the Third Reich* (Cambridge: Cambridge University Press, 1985).

43. John J. White, *Literary Futurism: Aspects of the First Avant-garde* (Oxford: Oxford University Press, 1990), 72.

44. Richard Cork, *Vorticism and Abstract Art in the First Machine Age,* 2 vols. (Berkeley and Los Angeles: University of California Press, 1976), 2:479 and 508–57.

45. Sheppard, "Wyndham Lewis's *Tarr,*" 510–30.

46. Cf. Roger Woods, "Konservative Revolution und Nationalsozialismus in der Weimarer Republik," in *Intellektuelle in der Weimarer Republik,* 126.

47. Vattimo, *End of Modernity,* 38.

48. Barnouw, *Weimar Intellectuals,* 227 and 229.

49. See Berman, *All That Is Solid,* 302–6; Wellmer, *Dialektik von Moderne und Postmoderne,* 119–21; Welsch, *Unsere postmoderne Moderne,* 89–99; Hans-Peter Schwarz, "Architektur als Zitat-Pop? Zur Vorgeschichte der postmodernen Architektur," in *"Postmoderne,"* 253–74; Harvey, *Condition of Postmodernity,* 31–32 and 282–83; Howard Caygill, "Architectural Modernism: The Retreat of an Avant-garde?" in *Postmodernism and Society,* 266; and Dominic Strinati, "Postmodernism and Popular Culture," in *Cultural Theory and Popular Culture,* 431.

50. Welsch, *Unsere postmoderne Moderne,* 97.

51. Cf. Berman, *All That Is Solid,* 314, and Smart, *Postmodernity,* 101.

52. See Adolf Behne, "Dammerstock," *Die Form* 6 (1930–31): 163–66, where Behne criticizes the functionalist architects behind the Dammerstock estate near Karlsruhe for their dictatorial "either–or" mentality.

53. Weinstein, *End of Expressionism,* 229; Lisbeth Exner, *Fasching als Logik: Über Salomo Friedlaender/Mynona* (Munich: belleville Verlag Michael Farin, 1996), 298–307. On musical modernists, see Butler, *Early Modernism,* 258. On Sartre's Existentialism, cf. Vattimo, *End of Modernity,* 23. On the Vienna Circle, see Callinicos, *Against Postmodernism,* 46. See Klaus L. Berghahn, "A View through the Red Window: Ernst Bloch's *Spuren,*" in *Modernity and the Text,* 200–215; and John Miller Jones, *Assembling (Post)modernism: The Utopian Philosophy of Ernst Bloch* (Berne: Peter Lang, 1995), 64, 72, and 77–78; Jaspers, *Die geistige Situation der Zeit,* 157–59; *Man in the Modern Age,* 171–72; Jahnn, "Aufgabe des Dichters in dieser Zeit," 693, 691, and 670.

54. Ritchie Robertson, "Primitivism and Psychology: Nietzsche, Freud, Thoman Mann," in *Modernism and the European Unconscious,* ed. Peter Collier and Judy Davies (Cambridge, England: Polity, 1990), 91. Cf. also Huyssen, *After the Great Divide,* 137, who assesses Peter Weiss's "aesthetics of resistance" in very similar terms.

55. Georg G. Iggers, afterword to *Intellektuelle in der Weimarer Republic,* 456. On Habermas's affirmation of values, see Dews, *Logics of Disintegration,* 152–54 and 225. "Dialogic conception . . . ," Callinicos, *Against Postmodernism,* 97. "An ethical science . . . ," Connor, *Postmodernist Culture,* 38–39. See Robert C. Holub, *Crossing Borders: Reception Theory, Poststructuralism, Deconstruction* (Madison: University of Wisconsin Press, 1992), 198.

56. Cf. Wilde, *Horizons of Assent,* 44–49; Ihab Hassan, "Towards a Concept of Postmodernism," in *The Postmodern Turn* (Columbus: Ohio State University Press, 1987), 84–96; and Barnouw, *Weimar Intellectuals,* 97, 100, and 108.

57. Cf. E. Ann Kaplan, "Feminism/Oedipus/Postmodernism: The Case of MTV," in *Postmodernism and Its Discontents,* 30–33.

58. Tratner, *Modernism and Mass Politics,* 55–56, 73, 121, 131, and 229.

59. See Monika Schmitz-Emans, "Poesie als Antimechanik: Zur Modellfunktion des Zufälligen bei Hans Arp," *Jahrbuch der Deutschen Schillergesellschaft* 38 (1994): 300; T. S. Eliot, "Ben Jonson," *Times Literary Supplement,* no. 930 (13 November 1919): 637–38. When Eliot published this essay in *Selected Essays 1917–1932* (London: Faber, 1932), 147–60, having himself attained classical, "Euclidean" certainty, he cut both references. Between "world" and "They" on p. 156, l. 14 from the bottom, the following sentence has been omitted: "It is a world like Lobatchevsky's; the worlds created by artists like Jonson are like systems of non-Euclidean geometry." On p. 159, ll. 11–12 from the bottom, "two-dimensional life" originally read "non-Euclidean humanity." Cf. Brandt, *Bravo! & Bum Bum!* 70

n. 6, for comments on Dada making a similar connection between Lobatchevsky's discoveries and the historical avant-garde.

60. Cf. Brandt, *Bravo! & Bum Bum!* 128.

61. Joyce had lived in Zurich since 1915 and frequented the Café Odéon (where he almost certainly met some of the Dadaists). When in 1924 he showed a version of "Anna Livia Plurabelle" from *Finnegans Wake* to a friend and the friend "complained it was just *dada*." Joyce did not disagree in so many words but described the piece as "an attempt to subordinate words to the rhythm of water" (Richard Ellmann, *James Joyce,* rev. ed. [Oxford: Oxford University Press, 1982], 409 and 564). See Hans Wysling, "Thomas Manns Pläne zur Fortsetzung des 'Krull,' " *Thomas-Mann-Studien* 3 (1974): 149; Richard Huelsenbeck, *En avant Dada: Die Geschichte des Dadaismus,* 2nd ed., enl. (1920; Hamburg: Nautilus, 1984), 24; "En avant Dada: A History of Dadaism," trans. Ralph Manheim, in *The Dada Painters and Poets,* ed. Robert Motherwell (New York: George Wittenborn, 1951), 34 (page citations are to both editions, respectively). Manheim mistranslates "Hochstapler" ("con man") as "racketeer."

62. Tratner, *Modernism and Mass Politics,* 121, 131, and 240.

63. Cf. Huyssen, *After the Great Divide,* 188–89.

Chapter 4

1. Freud, *Unbehagen in der Kultur,* 14:445–47/21:86–88.

2. Hugo von Hofmannsthal, "Ein Brief," in *Prosa,* 2:7–22; *The Letter of Lord Chandos,* in *Selected Prose,* trans. Mary Hottinger and Tania and James Stern (London: Routledge and Kegan Paul, 1952), 129–41 (page citations are to the German and English editions, respectively). Hofmannsthal died before the publication of *Das Unbehagen in der Kultur,* but the 1923 edition of *Jenseits des Lustprinzips* (in which Freud first gave an extensive account of the Eros/Thanatos dualism) was one of the five books by Freud in Hofmannsthal's library. Unfortunately, Hofmannsthal never annotated this copy (Michael Hamburger, "Hofmannsthals Bibliothek," *Euphorion* 55 [1961]: 27). See Jones, *Assembling (Post)modernism,* 25–27.

3. Briggs and Peat, *Looking Glass Universe,* 17–19; Capra, *The Turning Point,* 40–41; Reiss, *Discourse of Modernism,* 210.

4. See, for example, Allan Janik and Stephen Toulmin, *Wittgenstein's Vienna* (New York: Simon and Schuster, 1973), 114; and Spörl, *Gottlose Mystik,* 369.

5. See Čapek, *Bergson and Modern Physics,* 10 (where Čapek cites statements to this effect by Alfred North Whitehead and Herbert Spencer).

6. There is also such a remarkable similarity between Alfred Kubin's description of his state of mind since 1908 (when he wrote *Die andere Seite*) in his April/May 1916 letter to Salomo Friedlaender and Chandos's account of his crisis that

one cannot help wondering whether "Ein Brief" helped Kubin to shape that account. See Friedlaender/Mynona–Kubin, *Briefwechsel,* 63–66.

7. Like so many of his generation, Hofmannsthal was saturated in the thought of Nietzsche from the early 1890s onward (Hans Steffen, "Schopenhauer, Nietzsche und die Dichtung Hofmannsthals," in *Nietzsche: Werk und Wirkungen* [Göttingen: Vandenhoek and Ruprecht, 1974], 76). The general consensus is that the vitalist aspects of Nietzsche's thought spoke most directly to him (see ibid., 67–68; and Adrian Del Caro, "Hofmannsthal as a Paradigm of Nietzschean Influence on the Austrian fin de siècle," *Modern Austrian Literature* 20.3/4 [1989]: 85). According to Steffen (76), *Zarathustra* was the most important work for Hofmannsthal. Hofmannsthal owned the first, ten-volume edition of Nietzsche's complete works, nine volumes of which had appeared by the time he wrote "Ein Brief," and an individual copy of the second edition of *Zur Genealogie der Moral* (which he heavily annotated). In 1893, under the influence of this latter work, Hofmannsthal made some notes on the concept of the Will to Power that are published in Bruno Hillebrand, ed., *Nietzsche und die deutsche Literatur,* 2 vols. (Tübingen: Niemeyer, 1978), 1:89–91. These begin:

Der Wille zur Macht

überall Kampf sehen. Das Heranfluthen der nächsten Ereignisse éternelle débacle

The Will to Power

to see struggle everywhere. The surging towards me of the next events eternal catastrophe.

Images of flux, fluidity, and water in movement are central to the rats in the cellar episode in "Ein Brief." Moreover, both Steffen (70 and 80–82) and Del Caro (87–88) make connections between Nietzsche and "Ein Brief."

8. "Ein Brief" can be read as a critique of Mach's sensationalist empiricism (Janik and Toulmin, *Wittgenstein's Vienna,* 116 and 119). Nevertheless, Mach's influence on contemporary Vienna was considerable; the young Hofmannsthal attended his lectures (133 and 113); and there is an equally obvious parallel between Chandos's quasi-mystical experiences and Mach's secular belief that there is no absolute distinction between subject and object, self and world.

9. Spörl, *Gottlose Mystik,* 362 and 367.

10. H. Jürgen Meyer-Wendt, *Der frühe Hofmannsthal und die Gedankenwelt Nietzsches* (Heidelberg: Quelle and Meyer, 1973), 20–22.

11. Steffen, "Schopenhauer, Nietzsche und die Dichtung Hofmannsthals," 70. Spörl, *Gottlose Mystik,* 354.

12. Hofmannsthal himself resolved the ambiguities of the ending of "Ein Brief" in a conservative way, by reasserting the Habsburg Baroque tradition, which

he regarded as the basis of universal, humanistic culture (see Janik and Toulmin, *Wittgenstein's Vienna,* 117).

Chapter 5

1. Callinicos, *Against Postmodernism,* 74.
2. Benhabib, "Epistemologies of Postmodernism," 110.
3. Young, "Ideal of Community and the Politics of Difference," 303.
4. Butler, *Early Modernism,* 9; cited by permission of OUP. Samuel Beckett, *Watt* (1945; London: Calder and Boyars, 1972), 79.
5. Butler, *Early Modernism,* 10.
6. J. G. Merquior, "Spider and Bee: Towards a Critique of the Postmodern Ideology," in *Postmodernism: ICA Documents,* 45.
7. Connor, *Postmodernist Culture,* 117.
8. Suleiman, "Naming and Difference," 262.
9. Welsch, *Unsere postmoderne Moderne,* 191–92.
10. Marjorie Perloff, *Radical Artifice: Writing Poetry in the Age of Media* (Chicago: University of Chicago Press, 1991), 200–201. Cf. Connor, *Postmodernist Culture,* 238–39.
11. Löwy, *Georg Lukács,* 93–109. Lukács, *Theorie des Romans,* 53/56. Lukács's essay was first published in 1916 in Max Dessoir's *Zeitschrift für Ästhetik und Allgemeine Kunstwissenschaft* and first appeared in book form in 1920.
12. For Nietzsche's comment on God and grammar, see chapter 2, note 117. Cf. Butler, *Early Modernism,* 5 and 9.
13. See Jay F. Bodine, "Karl Kraus, Ludwig Wittgenstein and 'Poststructural' Paradigms of Textual Understanding," *Modern Austrian Literature* 22.3/4 (1989): 143–85, especially 146–53.
14. Walter Benjamin, "Über Sprache überhaupt und über die Sprache des Menschen," in *Gesammelte Schriften,* 2/1:140–57; "On Language as Such and on the Language of Man," *One-way Street* (1978), trans. Edmund Jephcott and Kingsley Shorter (London: New Left Books, 1979), 107–23 (page citations are to German and English editions, respectively). Cited here by permission of Harcourt Brace and Harvard University Press.
15. Giddens, "Modernism and Post-Modernism," 16.
16. Cf. Anz, "Gesellschaftliche Modernisierung," 2.
17. Čapek, *Bergson and Modern Physics,* 76; and Henderson, *Non-Euclidean Geometry in Modern Art,* 92. See also, for instance, Anthony Kenny, *Wittgenstein* (Harmondsworth, England: Penguin, 1973), 4 and 13; Janik and Toulmin, *Wittgenstein's Vienna,* 184–85; Henry Le Roy Finch, *Wittgenstein: The Later Philosophy* (Atlantic Highlands, N.J.: Humanities Press, 1977), 11–18; and Butler, *Early Modernism,* 9.

18. All English translations are from Ludwig Wittgenstein, *Tractatus Logico-Philosophicus,* trans. D. F. Pears and B. F. McGuinness (London: Routledge and Kegan Paul, 1961). All references in the text are to the numbered propositions of the *Tractatus.*

19. The same image has recently inspired a whole book (1996) dealing with the importance of Wittgenstein's thinking for abstract and experimental poetry: Marjorie Perloff, *Wittgenstein's Ladder.*

20. Janik and Toulmin, *Wittgenstein's Vienna,* 133; and Brian McGuinness, *Wittgenstein: A Life* (1988; Harmondsworth, England: Penguin, 1990), 38–39. Mach, *Erkenntnis und Irrtum,* 15/8–9.

21. Ernest Fenollosa, "The Chinese Written Character as a Medium for Poetry," in Ezra Pound, *Instigations* (New York: Boni and Liveright, 1920), 357–88; cf. Omar Pound and A. Walton Litz, eds., *Ezra Pound and Dorothy Shakespear: Their Letters 1900–1914* (London: Faber and Faber, 1985), 264–65.

22. See Marjorie Perloff, *The Futurist Moment: Avant-garde, Avant Guerre, and the Language of Rupture* (Chicago: University of Chicago Press, 1986), 166–67, 175–76, and 183–84.

23. Graham Hough, *Image and Experience* (London: Duckworth, 1960), 12–13. F. S. Flint, "Imagisme," *Poetry* 1.6 (March 1913): 199–200. [F. S. Flint?], preface to *Some Imagist Poets: An Anthology* (Boston: Houghton Mifflin, 1915), v–viii.

24. Ezra Pound, "A Few Don'ts by an Imagiste," *Poetry* 1.6 (March 1913): 200–202.

25. T. S. E[liot], "Swinburne," *The Athenaeum,* no. 4681 (16 January 1920): 73; cf. Perloff, *Radical Artifice,* 30–32. When this essay was published as "Swinburne as Poet" in *Selected Essays* (London: Faber and Faber, 1932), 323–27, "they are one thing" was replaced by the looser "the two are intertwined" and "Mr. Joseph Conrad" by "the earlier Conrad" (327).

26. Pound, "Vorticism [I]," 462 and 470.

27. Fenollosa, "Chinese Written Character" (page citations are to the *Instigations* edition).

28. H[enri] Bergson, "Introduction à la Métaphysique," *Revue de Métaphysique et de Morale* 11.1 (January 1903): 1–36; *An Introduction to Metaphysics,* trans. T. E. Hulme (London: Macmillan, 1913); *L'Évolution créatrice* (Paris: Alcan, 1907); *Creative Evolution,* trans. Arthur Mitchell (London: Macmillan, 1911) (citations are designated as *EC* or *IM,* followed by page numbers for French and English editions, respectively).

29. Cf. Chiari, "Vitalism and Contemporary Thought," 257.

30. Ibid., 252.

31. Franz Werfel, "Aphorismus zu diesem Jahr," *Die Aktion* 4.48/49 (4 December 1914): col. 903.

32. Ball, *Flucht aus der Zeit,* 83/60.

33. Kurt Oppert, "Das Ding-Gedicht: Eine Kunstform bei Moerike, Meyer und Rilke," *DVjs* 4 (1926): 747–83.

34. Rainer Maria Rilke, *Auguste Rodin* (Leipzig: Insel, 1922), 78. Part 2 of the German original is not included in *Rodin*, trans. Jessie Lemont and Hans Travsil (London: The Grey Walls Press, 1946) (page citations are to German and English editions, respectively).

35. Samuel Taylor Coleridge, "Lay Sermons," in *The Oxford Authors: Samuel Taylor Coleridge,* ed. H. J. Jackson (Oxford: Oxford University Press, 1985), 661.

36. Rainer Maria Rilke, *New Poems,* trans. and ed. J. B. Leishman, bilingual ed. (London: Hogarth Press, 1964), 126–29. Even Leishman's valiant translation cannot do justice to the syntactical complexities, let alone the parataxis of this poem. In particular, he misses the sexual implications of "behangen wie ein Stier" [well-hung like a steer], which he associates, more bucolically, with "an Alpine bull leading its herd up to the summer pastures" (129).

37. Ibid., 80–81.

38. See Rilke, *Auguste Rodin,* plates 40 and 41.

39. Elsen, *Rodin's Gates of Hell,* 71, 86, and 91.

40. Krauss, "Sincerely Yours" (1982), in *Originality of the Avant-garde,* 189.

41. Elsen, *Rodin's Gates of Hell,* 76 and 130; Rilke, *Auguste Rodin,* 36–42/28–33.

42. Elsen, *Rodin's Gates of Hell,* 69–70, 82.

43. Cited in White, *Literary Futurism,* 174–75. Cited here by permission of OUP.

44. Ibid., 175.

45. I have a postcard from the turn of the century depicting the Belgian town of Furnes (where "Der Turm" is set and of which the massive tower of St. Nicholas's Church forms the centerpiece). From the top, Rilke would not have seen a predominantly rural landscape, but a mass of houses packed together, at least one factory with a tall chimney, and the cranes of a dock in the background.

46. Perloff, *Wittgenstein's Ladder,* 96. Cf. also Brandt, *Bravo! & Bum Bum!* 27, 64–65, and 81–82. Perloff also records that when the Russian Futurist Benedikt Livshits heard Marinetti reciting *Zang Tumb Tumb* (1914) in St. Petersburg in winter 1914, he accused him of not really destroying the traditional sentence and informed him that Russian Futurist *Zaum'* poetry (of which Marinetti had not heard) went much further.

47. Marinetti, "Distruzione della sintassi," 70 and 73–74/98 and 100.

48. Cited in full in M[ario] Verdone, *Che cosa è il Futurismo?* (Rome: Ubaldini, 1970), 45.

49. White, *Literary Futurism,* 249; Pound, "Vorticism [I]," 461.

50. See, for example, Herwarth Walden, "Das Begriffliche in der Dichtung," *Der Sturm* 9.5 (1918): 66; Rudolf Blümner, "Die absolute Dichtung," *Der Sturm* 12.7 (1921): 121–23; and Lothar Schreyer, "Das Wort," *Der Sturm* 13.9–11 (1922): 125–28, 141–45, and 168–72. For a discussion of "Wortkunsttheorie" and its debt to

Kandinsky's theory of abstract poetry, see Richard Sheppard, "Kandinsky's Early Aesthetic Theory: Some Examples of Its Influence and Some Implications for the Theory and Practice of Abstract Poetry," *Journal of European Studies* 5 (1975): 25–26 and 37–38.

51. Richard Brinkmann, "Zur Wortkunst des Sturm-Kreises: Anmerkungen über Möglichkeiten und Grenzen absoluter Dichtung," in *Unterscheidung und Bewahrung: Festschrift für Hermann Kunisch,* ed. Klaus Lazarowicz and Wolfgang Kron (Berlin: Walter de Gruyter, 1961), 69.

52. Eugene Jolas, "Logos," *Transition,* no. 16/17 (June 1929): 25–30. Rimbaud, "Une saison en enfer," in *Oeuvres,* 219/77. Ernst Jünger, "Lob der Vokale," in *Werke,* 12:13–46, pages cited are 32 and 20.

53. Michel Beaujour, "Flight Out of Time: Poetic Language and the Revolution," *Yale French Studies* 39 (1967): 44; Ball, *Flucht aus der Zeit.* Sheppard, "Poetry of August Stramm," 211–42, especially 222.

54. Ernst Stadler, *Dichtungen, Schriften, Briefe,* ed. Klaus Hurlebusch, Karl Ludwig Schneider, and Nina Schneider (Munich: Beck, 1983), 169; the English version is to be found in Michael Hamburger and Christopher Middleton, eds. and trans., *German Poetry 1910–1960,* bilingual ed. (London: Macgibbon and Kee, 1962), 44–45; and also in Michael Hamburger, ed. and trans., *German Poetry 1910–1975,* bilingual ed. (Manchester: Carcanet New Press, 1977), 38–39.

55. Pound, "Vorticism [I]," 461.

56. Cf. Stadler's letter to René Schickele of July 1914 (*Dichtungen, Schriften, Briefe,* 519), the one place in his extant writings where he mentions Bergson. Not only does Stadler express a high opinion of Bergson, but he instinctively associates him with Simmel, thus indicating Stadler's clear affinity with philosophical vitalism. In this connection, it is also significant that Stadler thought very highly of Péguy (*Dichtungen, Schriften, Briefe,* 737 n. 429) since Péguy was also an ardent champion of Bergson's philosophy, which, he thought, could liberate French thought from Cartesian rigidity (Kern, *Culture of Time and Space,* 26). Nietzsche, *Werke,* 2:127; "Madman," 181. See especially Stadler's fragmentary lecture on modern German poetry (1914) (*Dichtungen, Schriften, Briefe,* 453–70), where Nietzsche is mentioned on almost every page as *the* decisive influence on that genre.

57. Stadler, *Dichtungen, Schriften, Briefe,* 456.

58. Frank Kermode, "Modernism, Postmodernism, and Explanation," in *Prehistories of the Future,* 370. In this passage, Kermode makes the connection between Dada and, inter alios, Bergson and Wittgenstein. Ludwig Wittgenstein, *Philosophical Investigations,* trans. G. E. M. Anscombe, bilingual ed. (Oxford: Basil Blackwell, 1958), 18 and 18e. Hugo Ball, "Das erste dadaistische Manifest," in *Künstler und die Zeitkrankheit,* 40; "Dada Manifesto," trans. Christopher Middleton, in *Flight Out of Time,* 221 (page citations are to both editions, respectively).

59. Ball, *Flucht aus der Zeit,* 100/71. Besides creating another version of Beau-

jour's "myth" and Brinkmann's "magic faith," Ball certainly had Rimbaud's "Alchimie du Verbe" in his mind when he wrote this statement, since only four days before, on 20 June 1916, he had praised Rimbaud the poet in his diary [96/68]). Furthermore, Ball's diary entry of 14 December 1916 (134/94–95), indicates that he was rereading *Une saison en enfer*, particularly "Mauvais sang" ("Bad Blood") (Rimbaud, *Oeuvres*, 206–11/45–59) and precisely that part of "Alchimie du Verbe" where Rimbaud speaks of "mes sophismes magiques" [my magical sophistry] (220/81).

60. See Ball, *Flucht aus der Zeit*, 98/70. Ball wrote these poems just before he made the June diary entry (see note 59) in which he discusses his desire not to end up like Rimbaud the "rebel." "Karawane" is published in Hugo Ball, *Gesammelte Gedichte*, ed. Annemarie Schütt-Hennings (Zurich: Verlag der Arche, 1963), 28. For title of "Elefantenkarawane" in 23 June 1916 diary entry, see *Flucht aus der Zeit*, 99–100/70–71.

61. See Ball, *Flucht aus der Zeit*, 91/65. Hugo Ball, *Simultan: Krippenspiel*, ed. Karl Riha, *Vergessene Autoren der Moderne* 18, 2nd ed., rev. (Siegen, Germany: Universität-Gesamthochschule Siegen, 1987), 12 and 8.

62. Ball, *Gesammelte Gedichte*, 27.

63. Ball, *Flucht aus der Zeit*, 100/71. See Philip Mann, "Hugo Ball and the 'Magic Bishop' Episode: A Reconsideration," *New German Studies* 4 (1976): 43–52. For an extended discussion of the process that led Ball back to Catholicism, see Mann, *Hugo Ball*, 81–108.

64. Ball, *Flucht aus der Zeit*, 187/134, 186/134.

65. *Dadaco*, an anthology of pieces and visual items by Dadaists from all over Europe and edited by Richard Huelsenbeck, should have appeared in January 1920, but failed to do so for a variety of reasons. For one account of this, see Kurt Wolff, *Autoren—Bücher—Abenteuer* (Berlin: Klaus Wagenbach, 1969), 20–22. The correspondence surrounding *Dadaco* is contained in Richard Sheppard, ed., *Zürich—Dadaco—Dadaglobe: The Correspondence between Richard Huelsenbeck, Tristan Tzara and Kurt Wolff (1916–1924)* (Hutton: Hutton Press, 1981); and, with corrections, in Herbert Kapfer and Lisbeth Exner, eds., *Weltdada Huelsenbeck: Eine Biografie in Briefen und Bildern* (Innsbruck: Haymon, 1996). The unpaginated trial sheets for *Dadaco* were reprinted by Gabriele Mazzota Editore (Milan), the Johnson Reprint Corporation (New York), and the ABC Publishing Company (London). This quotation comes from [6].

66. See Tristan Tzara et al., "Was wollte der Expressionismus?" in *Dada Almanach*, ed. Richard Huelsenbeck (1920; Hamburg: Nautilus, 1987), 39; "What Did Expressionism Want?" trans. Malcolm Green, in *Dada Almanac*, ed. Malcolm Green and Alastair Brotchie (London: Atlas, 1993), 47 (page citations are to German and English editions, respectively).

67. Analogously, in *Philosophical Investigations* (47 and 47e), Wittgenstein described philosophy as a battle against the "Verhexung unsres Verstandes durch die

Mittel unserer Sprache" [the bewitchment of our intelligence by means of our language].

68. Ball, *Flucht aus der Zeit*, 80/57.

69. Raoul Hausmann ["Das dadaistische Manifest . . ."], Andreas Kramer and Richard Sheppard, eds., "Raoul Hausmann's Correspondence with Eugene Jolas," in *German Life and Letters* 48 (1995): 51–52. That Hausmann's poem could have such an impact on a listener is indicated by Hans Richter, *Dada—Kunst and Anti-kunst* (Cologne: DuMont, 1964), 143; *Dada—Art and Anti-Art,* trans. David Britt (London: Thames and Hudson, 1965), 139 (page citations are to both editions, respectively). For a fuller discussion of optophonetic poetry, see Karl Riha, "Raoul Hausmanns optophonetische Poesie," in *Raoul Hausmann,* ed. Kurt Bartsch and Adelheid Koch (Graz, Austria: Droschl, 1996), 31–44.

70. Raoul Hausmann, "Ausblick," *G,* no. 3 (June 1924): 6; reprinted in *Raoul Hausmann: Texte bis 1933,* ed. Michael Erlhoff, 2 vols., Frühe Texte der Moderne (Munich: text + kritik, 1982), 2:99.

71. The equation is clear from Hausmann's six contributions to the periodical *Die Erde* between 15 April and 1 October 1919 (see chapter 12, note 97). Hannah Höch's library, which I was allowed to inspect in the early 1970s, included a copy of Henri Bergson, *Das Lachen* [the German translation of Bergson's treatise on laughter] (Jena, Germany: Eugen Diederichs, 1914). This had been acquired by Hausmann on 17 February 1916 and given to Höch for her birthday on 1 November 1919. Hausmann almost certainly knew more about Bergson because of his friendship with Salomo Friedlaender (see Exner, *Fasching als Logik,* 266–89) and Hannah Höch herself (see chapter 10). Raoul Hausmann, ["Sprache der weissen Rasse ist Begriffsverwirrung . . ."] (1924), in Kramer and Sheppard, "Raoul Hausmann's Correspondence," 52–53.

72. Hausmann, ["Sprache der weissen Rasse ist Begriffsverwirrung . . ."], 53.

73. See, for example, Hans Arp, "Above and Below"/"Oben und Unten" (1915), in *On My Way: Poetry and Essays 1912–1947,* ed. Robert Motherwell, bilingual ed. (New York: Wittenborn, Schultz, 1948), 36 and 82.

74. Cf. Hans Arp, "Dadaland" (1915–20), in *On My Way,* 46 and 88–89; Jean Arp, "Die Musen und der Zufall," *Du* 20.236 (October 1960): 15–16.

75. Jones, *En-gendering of Marcel Duchamp,* 138. Arp recognized this affinity in "Dadaland," 46 and 89.

76. Otto Flake, *Nein und Ja,* ed. Michael Farin (1920; Munich: Renner, 1982), 94. Flake had arrived in Zurich from Berlin by early April 1918 (see Otto Flake, "Schweizer Reise I," *Norddeutsche Allgemeine Zeitung* [Berlin], no. 176 [7 April 1918]). In 1919, he became more closely involved with the Zurich Dada group. He lectured on behalf of the post-Dada *Gruppe Neues Leben* in January, published a sympathetic article in the *Vossische Zeitung* (Berlin) on 17 July, and coedited *Der Zeltweg* in November. It is his house, just outside Zurich, that is referred to in the title of Tzara's poem "maison flake," his first item to be published in Breton's

and Aragon's Paris periodical *Littérature*. In other words, Flake knew Zurich Dada from the inside, and his novel, written in 1919, is probably a fairly reliable source of information about the movement. In Flake's novel, the formulation in question is attributed to the fictional Arp, whom Flake knew particularly well.

77. Hans Arp, [untitled poem from *die wolkenpumpe* (1920)], in *Gesammelte Gedichte*, 3 vols. (Wiesbaden: Limes, 1963–84), 1:73.

78. Rimbaud, *Oeuvres*, 197–98/170–73.

79. Cf. Harvey, *Condition of Postmodernity*, 206.

80. See Bauman, *Modernity and Ambivalence*, 180.

81. Ibid.

82. The many ways in which Arp's Dada poetry can be read are extensively discussed in Carolyn Kenny, "A Study of Images in the Dada poetry of Hans/Jean Arp" (Ph.D. diss., Trinity College, Dublin, 1995). Hans Arp, "Das Geländer," in *Gesammelte Gedichte*, 3:222.

83. For a discussion of Schwitters's ambiguous relationship with Dada, see Richard Sheppard, "Kurt Schwitters und Dada: Einige vorläufige Bemerkungen über einen komplexen Zusammenhang," *Kurt Schwitters Almanach* 1 (1982): 56–64; "Kurt Schwitters and Dada: Some Preliminary Remarks on a Complex Topic," *Dada-Constructivisim: The Janus-Face of the Twenties*, ed. Annely and David Juda (London: Annely Juda Fine Art, 1984), 47–51. Kurt Merz Schwitters, "Doof," in *Die Blume Anna: Die neue Anna Blume* (Berlin: Verlag Der Sturm, [1923]), 28; "Wand," in *Anna Blume Dichtungen*, 2nd ed., rev. (Hanover: Paul Steegemann, 1922), 42; both reprinted in Kurt Schwitters, *Das literarische Werk*, ed. Friedhelm Lach, 5 vols. (Cologne: DuMont Schauberg, 1973–81), 1 (*Lyrik*): 202 and 203.

84. Huyssen, "Postmoderne," 35.

85. Gerhard Hoffmann, "Waste and Meaning, the Labyrinth and the Void in Modern and Postmodern Fiction," in *Ethics and Aesthetics*, 132.

Chapter 6

1. The following abbreviations have been used throughout this chapter to refer to Kandinsky's work:

CR 1 and 2: Wassily Kandinsky, *Catalogue Raisonné of the Oil Paintings*, ed. Hans K. Roethel and Jean K. Benjamin, 2 vols. (London: Sotheby Publications, 1982–84).

CWA 1 and 2: Kenneth C. Lindsay and Peter Vergo, eds., *Kandinsky: Complete Writings on Art*, 2 vols. (London: Faber and Faber, 1982).

DbR: Wassily Kandinsky and Franz Marc, eds., *Almanach der blaue Reiter*, ed. Klaus Lankheit (1912; Munich: Piper, 1965); *The Blaue Reiter Almanac*, ed. Klaus Lankheit (New York: Viking, 1974).

E: Wassily Kandinsky, *Essays über Kunst und Künstler,* ed. Max Bill, 2nd ed., enl. (Berne: Benteli, 1963).

GrW: Wassily Kandinsky, *Das graphische Werk,* ed. Hans Konrad Roethel (Cologne: DuMont, 1970).

GS 1: Wassily Kandinsky, *Die gesammelten Schriften,* ed. Hans Konrad Roethel and Jelena Hahl-Koch, 8 vols. (Berne: Benteli, 1980–), 1 (*Autobiographische Schriften*).

KMBr.: Klaus Lankheit, ed., *Wassily Kandinsky–Franz Marc: Briefwechsel* (Munich: Piper, 1983).

KSBr.: Jelena Hahl-Koch, ed., Arnold Schoenberg, *Wassily Kandinsky: Briefe, Bilder und Dokumente* (1981; Munich: DTV, 1983).

S: Wassily Kandinsky, *Sounds,* trans. Elizabeth Napier (New Haven: Yale University Press, 1981); because of the rarity of the (unpaginated) German original (*Klänge*) and the lack of a paginated facsimile, the page references in the text refer exclusively to this English edition.

ÜdG: Wassily Kandinsky, *Über das Geistige in der Kunst,* ed. Max Bill, 9th ed. (1912; Berne: Benteli, 1970).

2. Frank Whitford, *Kandinsky* (London: Hamlyn, 1967), and Washton Long, *Kandinsky,* say nothing and very little, respectively, about Kandinsky's literary work. Heribert Brinkmann, "Wassily Kandinsky als Dichter" (Ph.D. diss., University of Cologne, 1980), does not discuss the woodcuts in *Klänge.* Cf. Will Grohmann, *Wassily Kandinsky: Life and Work* (New York: Abrams, 1958), 98–102.

3. On Kandinsky's work in two media, see Richard Sheppard, "Kandinsky's Abstract Drama *Der gelbe Klang:* An Interpretation," *Forum for Modern Language Studies* 11 (1975): 165–76; "Kandinsky's *Klänge:* An Interpretation," *German Life and Letters* 33 (1980): 135–46; and Hahl-Koch, *Kandinsky,* 148–52. On Kandinsky's work in relation to the *Gesamtkunstwerk,* see Peg Weiss, *Kandinsky in Munich: The Formative Jugendstil Years* (Princeton: Princeton University Press, 1979), 124 and 126. On his work in a cultural context, see Robert C. Williams, "Concerning the German Spiritual in Russian Art: Vasilii Kandinskii," *Journal of European Studies* 1 (1971): 325–36; John E. Bowlt, "Vasilii Kandinskii: The Russian Connection," in *The Life of Vasilii Kandinskii in Russian Art: A Study of "On the Spiritual in Art,"* ed. John E. Bowlt and Rose-Carol Washton Long (Newtonville, Mass.: Oriental Research Partners, 1980), 1–41; and Hahl-Koch, *Kandinsky,* 224 and passim.

4. Cf. Brinkmann, "Wassily Kandinsky als Dichter," 31–37.

5. Cf., for example, Wassily Kandinsky, "Mein Werdegang" (1914), in *GS* 1:51–59, especially 51 and 58; "Cologne Lecture," in *CWA* 1:393–400, especially 394 and 400. Cf. Washton Long, *Kandinsky,* 3; and Felix Thürlemann, *Kandinsky über Kandinsky* (Berne: Benteli, 1986), where the discrepancies between Kandinsky's theory and practice are registered and discussed.

6. Johannes Langner, " 'Gegensätze und Widersprüche—das ist unsere Har-

monie': Zu Kandinskys expressionistischer Abstraktion," in *Kandinsky und München: Begegnungen und Wandlungen,* ed. Armin Zweite (Munich: Prestel, 1982), 115–16; and Armin Zweite, "Kandinsky zwischen Tradition und Innovation," in ibid., 166.

7. Peg Weiss, "Kandinsky und München: Begegnungen und Wandlungen," in *Kandinsky und München,* 58; and Washton Long, *Kandinsky,* 26.

8. Cf. Sixten Ringbom, *The Sounding Cosmos* (Åbo, Finland: Åbo Akademi, 1970), 37.

9. Peter Jelavich, " 'Die Elf Scharfrichter': The Political and Sociocultural Dimensions of Cabaret in Wilhelmine Germany," in *The Turn of the Century,* 509.

10. See Kohlschmidt, "Zu den soziologischen Voraussetzungen des literarischen Expressionismus in Deutschland," 441; and Raabe and Hannich-Bode, *Die Autoren und Bücher des literarischen Expressionismus,* 575–79 and 600–1. Kandinsky's antipathy to modernity can be gauged from his 8 November 1910 letter to Gabriele Münter in which he describes the quintessentially modern Berlin as "that vile city" (Hoberg, *Wassily Kandinsky and Gabriele Münter,* 83), and Franz Marc's defense of the *Brücke* painters in his 4 February and 22 March 1912 letters to Kandinsky (*KMBr.,* 130–32 and 150). Kandinsky seems to have considered the *Brücke* painters as Impressionist epigones. Moreover, because he equated representationalism with lack of spirituality, he also saw them as tainted by modern, metropolitan materialism. For further indices of Kandinsky's attitude to Berlin Expressionism, see *KMBr.,* 108–9, 115–16, 120–21, 128, 163, and 223–24.

11. Wassily Kandinsky, "Der Blaue Reiter (Rückblick)" [Letter to *Das Kunstblatt* of 1930], in *E,* 133–38; *CWA* 2:745.

12. Weiss, *Kandinsky in Munich,* 131.

13. Zweite, "Kandinsky zwischen Tradition und Abstraktion," 143.

14. Weiss, *Kandinsky in Munich,* 81 and 112. See Hahl-Koch, *Kandinsky,* 173, for a discussion of the relationship between the two concepts.

15. See Brinkmann, "Wassily Kandinsky als Dichter," 479; Washton Long, *Kandinsky,* 67–68; Bowlt and Washton Long, *Life of Vasilii Kandinskii in Russian Art,* 15 and 50–51; and Sixten Ringbom, "Kandinsky und das Okkulte," in *Kandinsky und München,* 84.

16. Hahl-Koch, *Kandinsky,* 172–73.

17. Brinkmann, "Wassily Kandinsky als Dichter," 168–69.

18. Washton Long, *Kandinsky,* 54. See also Wassily Kandinsky, "Über Bühnenkomposition" ("On Stage Composition"), in *DbR,* 189–208/190–206; "Über die abstrakte Bühnensynthese" ("Abstract Synthesis on the Stage") (1923), in *E,* 79–83; *CWA* 2:504–7; "Meine Holzschnitte" ("My Woodcuts") (1938), in *E,* 226–28; *CWA* 2:817–18; and Peter Vergo, *Kandinsky: "Cossacks"* (London: Tate Gallery, 1986), 23.

19. Weiss, "Kandinsky und München," 42.

20. Roethel (*GrW,* 429) registers the existence of five copies, one of which, sold by Kornfeld and Klipstein in 1967, formed the basis of a reprint (Oxford: Warrack and Perkins, 1978). Weiss, *Kandinsky in Munich,* 126.

21. On Kandinsky and the Arts and Crafts Movement, see Weiss, *Kandinsky in Munich,* 7–9, 62, 102, and 124; see also 61–62 and 93 on the Darmstadt Artists' Colony. On the George Circle, see Brinkmann, "Wassily Kandinsky als Dichter," 481–85; Washton Long, *Kandinsky,* 18–19 and 22–25; and Hartmut Zelinsky, "Der 'Weg' der 'Blauen Reiter,'" in *KSBr.,* 224 and 252. On the Münchener Künstlertheater, see Weiss, *Kandinsky in Munich,* 92–95; Washton Long, *Kandinsky,* 52–55; and Weiss, "Kandinsky und München," 57.

22. See Natasha Kurchanova, "Die Volksmythologie: Eine visuelle Sprache?" *Der frühe Kandinsky 1900–1910,* ed. Magdalena M. Moeller (Munich: Hirmer, 1994), 57–69. In *Rückblicke* (*GS* 1:37; *CWA* 1:368–69), Kandinsky describes Russian peasant culture of the Wologda region (which he knew at first hand from his pre-Munich years) as though it were a pre-modern *Gesamtkunstwerk.*

23. Weiss, *Kandinsky in Munich,* 8.

24. Weiss, "Kandinsky und München," 60; and Hahl-Koch, *Kandinsky,* 124.

25. Weiss, *Kandinsky in Munich,* 78.

26. Bowlt and Washton Long, *Life of Vasilii Kandinskii in Russian Art,* 54–55; and Washton Long, *Kandinsky,* 134.

27. Hoberg, *Wassily Kandinsky and Gabriele Münter.*

28. Weiss, "Kandinsky und München," 63.

29. Brinkmann, "Wassily Kandinsky als Dichter," 245 and 301.

30. Ernst Barlach, *Die Briefe 1888–1938,* ed. Friedrich Dross, 2 vols. (Munich: Piper, 1968), 1:393–96.

31. Hahl-Koch, "Kandinsky und Schönberg," *KSBr.,* 191.

32. Cf. Washton Long, *Kandinsky,* 6 and 134.

33. Williams, "Concerning the German Spiritual in Russian Art," 327 and 331–32; Ringbom, "Kandinsky und das Okkulte," 85–101; Brinkmann, "Wassily Kandinsky als Dichter," 121–24; and Washton Long, *Kandinsky,* 15, 28–33, and 39–40. Hahl-Koch, who feels that too much has been made of such alleged sources of inspiration, nevertheless concedes that Kandinsky came under the influence of Theosophy as early as 1901, heard Steiner lecture in Berlin 1907–8, and registers Theosophical influences on him 1909–10 (*Kandinsky,* 155 and 177). She also notes that Münter and Kandinsky bought Steiner's *Theosophie* (1904) and all the issues of Steiner's journal *Luzifer-Gnosis* (177).

34. On Sufism, see Hahl-Koch, *Kandinsky,* 178–79. On his connection to Munich's George Circle, see Washton Long, *Kandinsky,* 25; see also 78; Weiss, "Kandinsky und München," 73; and Rosel Gollek, *Das Münter-Haus in Murnau* (Munich: Städtische Galerie im Lenbachhaus, n.d.), 26–27. On second-generation Russian Symbolists, see Williams, "Concerning the German Spiritual in Russian

Art," 328; Washton Long, *Kandinsky*, 34–40; and Bowlt and Washton Long, *Life of Vasilii Kandinskii in Russian Art*, passim. On Schoenberg, see Hahl-Koch, "Kandinsky und Schönberg," 186; and Zelinsky, "Der 'Weg' der 'Blauen Reiter,'" 258.

35. Cf. Bowlt and Washton Long, *Life of Vasilii Kandinskii in Russian Art*, 9; and Brinkmann, "Wassily Kandinsky als Dichter," 116–17.

36. For a detailed documentation of the origins of *DbR*, see Andreas Hüneke, ed., *Der blaue Reiter: Dokumente einer geistigen Bewegung* (Leipzig: Reclam, 1986). Brinkmann, "Wassily Kandinsky als Dichter," 105–12; and Weiss, "Kandinsky und München," 77.

37. For a detailed reading of *DbR*'s illustrations, see Weiss, "Kandinsky und München," 69–75.

38. To date only one of Kandinsky's four abstract dramas, *Der gelbe Klang* (1909–12), has been published in German and English—at the back of *DbR*, also in *CWA* 1:267–83. A fragment of *Violett* (1914) was published in the Bauhaus quarterly in 1927, but that work, together with *Der grüne Klang* (1909) and *Schwarz–Weiss* (1909), are available in French in Wassily Kandinsky, *Écrits complets*, ed. Philippe Sers, 3 vols. (Paris: Denoël, 1970–75), 3:73–111—to which page numbers in the text refer. *Der grüne Klang* and *Schwarz–Weiss* were first performed on 9 to 12 July 1987 at the Hochschule der Künste in West Berlin. *Der gelbe Klang*, but for the outbreak of war, would have been performed in the Münchener Künstlertheater in summer 1914. It has subsequently been staged at the Guggenheim Museum, New York, on 12 May 1972; the Abbaye de la Sainte Baume, Provence, on 6 August 1975; the Théâtre des Champs-Elysées, Paris, on 4 March 1976; the Marymount Theater, New York, on 9 February 1982; the Altes Oper, Frankfurt/Main, around 7 and 8 September 1982, the Theater im National, Berne, on 12 to 15 February 1987, and the NIA Centre, Manchester, on 21 March 1992. For an anthroposophical account of *Der gelbe Klang* that includes some excellent color photographs of the Berne performance, see Carsten Brockmann, "Der gelbe Klang," *Die Drei* 57.4 (April 1987): 272–96. *Violett*, translated by Shulamith Behr, should have received its first performance in the Whitworth Art Gallery, Manchester, on 18 and 19 March 1994, but was cancelled at the last minute. It was finally performed in the Purcell Room, London, on 10 and 11 November 1994, and reviewed briefly in *The Times* on 14 November 1994.

39. Washton Long, *Kandinsky*, 59–60, forms an exception to this statement, using the illustrations surrounding *Der gelbe Klang* in *DbR* to shed light on the play. See also Sheppard, "Kandinsky's Abstract Drama *Der gelbe Klang*."

40. See Susan Stein, "The Ultimate Synthesis: An Interpretation of the Meaning and Significance of Wassily Kandinsky's *The Yellow Sound*" (Ph.D diss., State University of New York at Binghamton, 1980); Washton Long, *Kandinsky*, 60–61; Hahl-Koch, "Kandinsky und Schönberg," 203; and Hahl-Koch, *Kandinsky*, 151.

41. Thürlemann, *Kandinsky über Kandinsky*. In *Kandinsky*, Hahl-Koch produces (translated) passages from an undated, hitherto unpublished manuscript

by Kandinsky that looks like the draft of an abstract drama and involves cosmic problems (151).

42. Hahl-Koch, *Kandinsky*, 172.

43. For stage and costume designs for these two plays, see "Echo: Kandinsky: Echo," *H[ochshule] d[er] K[ünste] Info* (Berlin) 13.4 (May/June 1987): 18–32.

44. Cf. Washton Long, *Kandinsky*, 25.

45. Hahl-Koch, *Kandinsky*, 151.

46. For publication dates of *Violett*, see note 38 (page citations are to Kandinsky, *Écrits complets*). See Shulamith Behr, "Deciphering Wassily Kandinsky's *Violet:* Activist Expressionism and the Russian Slavonic Milieu," in *Expressionism Reassessed*, ed. Shulamith Behr, David Flanning, and Douglas Jarman (Manchester: University of Manchester Press, 1993), 174–75.

47. Zweite, "Kandinsky zwischen Tradition und Innovation," 163.

48. Behr, "Deciphering Wassily Kandinsky's *Violet*," 179.

49. For the publication history and composition of *Klänge*, see *GrW*, 445–48; Brinkmann, "Wassily Kandinsky als Dichter," 12–13, 24, and 27; Sheppard, "Kandinsky's *Klänge*," 144–46; and Hahl-Koch, *Kandinsky*, 139–40. Because *Sounds* reproduces the twelve colored woodcuts in black and white and because its format is significantly smaller than that of the original, its dramatic impact is correspondingly less.

50. Weiss, *Kandinsky in Munich*, 86–91.

51. Sheppard, "Kandinsky's *Klänge*," 142 and 136. In contrast, Brinkmann sees the poems in more homely terms ("Wassily Kandinsky als Dichter," 459) and is reluctant to accept the polyvalent difficulty of the work as a whole. Indeed, having asserted that the poems and woodcuts form a unity, he says almost nothing about the woodcuts. In "Kandinsky's *Klänge*," I argue that the poems and woodcuts form two parallel strands, each involving a loose progression.

52. These eighteen woodcuts are detailed in Sheppard, "Kandinsky's *Klänge*," 137–38. Weiss, "Kandinsky und München," 69.

53. Whitford, *Kandinsky*, 35; Weiss, *Kandinsky in Munich*, 129–31.

54. Cf. Weiss, "Kandinsky und München," 51.

55. This is an inadequate translation since "heilend" also connotes "heil" [intact, whole], "heilig" [holy], and "Heiland" [Savior].

56. Hahl-Koch (*Kandinsky*, 140) makes essentially the same point, linking Kandinsky's move away from descriptiveness and the conventional use of language with his move toward abstraction in painting.

57. See Brinkmann, "Wassily Kandinsky als Dichter," 235.

58. Zweite, "Kandinsky zwischen Tradition und Innovation," 158–59.

59. Weiss, "Kandinsky und München," 62.

60. Cf. Zweite, "Kandinsky zwischen Tradition und Innovation," 149, 151, and 161.

61. Cf. Washton Long, *Kandinsky*, 108–22.

62. Ibid., 74.

63. Ibid., 72–73; also 71.

64. Wassily Kandinsky, "Komposition 6" (May 1913), in *Rückblicke* (1913) (Berne: Benteli, 1977), 39–42; *CWA* 1:385–88. See also Washton Long, *Kandinsky,* 75 and 88–107.

65. See Washton Long, *Kandinsky,* 78.

66. Weiss, "Kandinsky und München," 79.

67. *Bild mit Kreis* (*Picture with a Circle*) was lost until 1989 and appears in *CR* 1 only as a black-and-white photo. For the story of its rediscovery and a color reproduction, see Hahl-Koch, *Kandinsky,* 181 and 185.

68. Weiss, "Kandinsky und München," 78.

69. See the remarks that Kandinsky was still making in late 1925 about the Epoch of the Great Spiritual (quoted in Washton Long, *Kandinsky,* 151).

70. Brinkmann, "Wassily Kandinsky als Dichter," 494–96.

71. See, for example, the uniformly negative comments in Mel Gussow, "Artist's 'Yellow Sound' of 09 Is Staged," *New York Times* (13 May 1972); Emily Genauer, "Kandinsky as a Happening," *New York Herald Tribune* (28 May 1972); Klaus Geitel, "Holzwurm im 'Gelben Klang,'" *Die Welt* (12 August 1975); Geneviève Bréerette, "Sonorité jaune de Kandinsky," *Le Monde* (6 March 1976); and Frantz Vossen, "Kandinsky-Fiasko," *Süddeutsche Zeitung* (9 March 1976).

72. Weiss, "Kandinsky und München," 76. Kandinsky, *Rückblicke,* 39–45; *CWA* 1:385–91.

73. Letter to Grohman cited in Brinkmann, "Wassily Kandinsky als Dichter," 471.

74. Cf. Bowlt and Washton Long, *Life of Vasilii Kandinskii in Russian Art,* 11.

Chapter 7

1. Helena Lewis, *Dada Turns Red: The Politics of Surrealism* (Edinburgh: University of Edinburgh Press, 1990), x; Hassan, "Towards a Concept of Postmodernism," 91–92; Hutcheon, *Poetics of Postmodernism,* 24; Bürger, *Theorie der Avantgarde.* See also Calinescu, *Faces of Modernity,* 143.

2. Bürger, *Theorie der Avantgarde,* 66–67/49–50. Cf. Maud Lavin, *Cut with the Kitchen Knife: The Weimar Photomontages of Hannah Höch* (New Haven: Yale University Press, 1993), 50–51.

3. Habermas, "Moderne," 457–60/9–11.

4. Ibid., 463/13. Butler does precisely this in *Early Modernism,* 286 n. 103.

5. Hermann Korte, *Die Dadaisten* (Reinbek bei Hamburg: Rowohlt, 1994).

6. See Rex Last, *German Dadaist Literature: Kurt Schwitters, Hugo Ball, Hans Arp* (New York: Twayne, 1973), 162; and Lambert Wiesing, *Stil statt Wahrheit:*

Kurt Schwitters und Ludwig Wittgenstein über ästhetische Lebensformen (Munich: Wilhelm Fink, 1991), 51.

7. Frank Kermode, "Revolution: The Role of the Elders," in *Liberations: New Essays on the Humanities in Revolution,* ed. Ihab Hassan (Columbus: Ohio University Press, 1971), 96.

8. See Rudolf E. Kuenzli, "Dada gegen den Ersten Weltkrieg," in *Sinn aus Unsinn: Dada International,* ed. Wolfgang Paulsen and Helmut G. Hermann (Berne: Francke Verlag, 1982), 87–100; Charlotte Stokes, "Dadamax: Ernst in the Context of Cologne Dada," in *Dada/Dimensions,* ed. Stephen C. Foster (Ann Arbor, Mich.: UMI Research Press, 1985), 117; and Doherty, " 'See: *We Are All Neurasthenics!* " 82–132.

9. "French Artists Spur on American Art," reprinted in *Dada/Surrealism,* no. 14 (1985): 128–35.

10. Huelsenbeck, *En avant Dada,* 9–44/21–48; *Dada siegt! Bilanz und Erinnerung* (1920; Hamburg and Zurich: Nautilus/Nemo, 1985), 14–16.

11. H[ugo] Ball, "Die junge Literatur in Deutschland," *Der Revoluzzer* 1.10 (14 August 1915): n.p.; reprinted in *Künstler und die Zeitkrankheit,* 34.

12. Tzara, *Surréalisme et l'après-guerre,* 17, reprinted in *Oeuvres,* 5:69. George Grosz, *Briefe 1913–1959,* ed. Herbert Knust (Reinbek bei Hamburg: Rowohlt, 1979), 33–34 and 42–54.

13. Hans Arp, "Above and Below,"/"Oben und Unten," in *On My Way,* 36 and 82. See chapter 2, note 15 for Tillich quote in Zahrnt. Tristan Tzara, "Pierre Reverdy: Le Voleur de Talan, roman," *Dada,* no. 2 (December 1917): n.p.; reprinted (slightly altered) in *Oeuvres complètes,* 1:398; "Pierre Reverdy 'Le Voleur de Talan,' " in *Seven Dada Manifestos and Lampisteries,* 63 (page citations are to both reprint editions, respectively). Grosz, *Briefe 1913–1959,* 47 and 57; see also Hanne Bergius, *Das Lachen Dadas: Die Berliner Dadaisten und ihre Aktionen* (Giessen, Germany: Anabas, 1989), 182–85. Raoul Hausmann, "Dada ist mehr als Dada," *De Stijl* 4.3 (March 1921): 42; reprinted in *Raoul Hausmann,* 1:167 (page citations are to both editions, respectively); "Der geistige Proletarier," *Menschen,* no. 8 (17 February 1919): 3; reprinted in *Texte bis 1933,* 1:31. Theo Van Doesburg, *Wat is Dada??????* (The Hague: "De Stijl," 1923), 6; "What is dada??????," trans. Joost Baljeu, in *Theo Van Doesburg,* by Joost Baljeu (New York: Macmillan, 1974), 132 (page citations are to both editions, respectively). Richard Huelsenbeck, "Zürich 1916: Wie es wirklich war," *Die neue Rundschau* 6 (1928): 616; reprinted in Richard Huelsenbeck, *Wozu Dada: Texte 1916–1936,* ed. Herbert Kapfer (Giessen, Germany: Anabas, 1994), 70.

14. *Die Schammade* [no. 1] ([April] 1920): n.p.

15. Cf. William A. Camfield, "The Machine Style of Francis Picabia," *The Art Bulletin* 48 (1966): 318. Grosz's work is reproduced and discussed in Peter-Klaus Schuster, ed., *George Grosz: Berlin–New York* (Berlin: Nationalgalerie and

ARS NICOLAI, 1994), 332–33; and Barbara McCloskey, *George Grosz and the Communist Party: Art and Radicalism in Crisis, 1918 to 1936* (Princeton: Princeton University Press, 1997), 73–75. For an excellent analysis of this collage (which was used on the cover of the catalogue of the first "Grand International Dada-Fair" [24 June–5 August 1920]), see Hanne Bergius, "Zur Wahrnehmung und Wahrnehmungskritik im Berliner Dadaismus," *Sprache im technischen Zeitalter,* no. 55 (July–September 1975): 235–36. Höch's work is discussed in Lavin, *Cut with the Kitchen Knife,* 19–35.

16. See Hugo Ball, *Flametti oder vom Dandysmus der Armen* (Berlin: Erich Reiss, 1918), 102–3. This novel reflects Ball's own experiences with the Flamingo variety troupe during winter 1915 and 1916, and in his diary entry of 13 October 1916 he describes it as a critique of Dada. See Philip Mann, "Einige dokumentarische Randnotizen zur Entstehungsgeschichte des 'Flametti,'" *Hugo Ball Almanach 6* (1982): 133–51; and *Hugo Ball,* 62–66. See Richard Huelsenbeck, *Doctor Billig am Ende* (Munich: Kurt Wolff, 1921), 59–61. The draft of *Hyle,* running into hundreds of pages, is partly in Hausmann's papers in the Musée Départmental de Rochechouart (near Limoges) and partly in the Berlinische Galerie. Part 2 appeared as *Hyle: Ein Traumsein in Spanien* (Frankfurt/Main: Heinrich Heine, 1969). For a discussion of its semi-automatic, semi-stream-of-consciousness narrative style, see Cornelia Frenkel, *Raoul Hausmann: Künstler, Forscher, Philosoph* (St. Ingbert: Röhrig, 1996), 91–135; and Eva Züchner, "Dandy und Tänzer: Ein Spiel der Gegensätze in Hausmanns Antiroman *Hyle,*" in *Raoul Hausmann,* 67–87 and 415–16. Hausmann's manifesto, an example of semi-automatic writing, was first produced in twenty-three copies and is reprinted in *Texte bis 1933,* 1:19.

17. Raoul Hausmann, "Dadaistische Abrechnung," *Die junge Kunst* 1.1 (1919): 10; reprinted in *Texte bis 1933,* 1:49. Theo Van Doesburg, "Dadaisme," *Merz,* no. 2 (April 1923): 29. Raoul Hausmann, "Synthetisches Cino der Malerei" (1918), in *Am Anfang war Dada,* ed. Karl Riha and Günter Kämpf (Steinbach/Giessen, Germany: Anabas, 1972), 27; reprinted in *Texte bis 1933,* 1:14. Huelsenbeck, *Dada siegt!* 53.

18. Hugo Ball, *Tenderenda der Phantast,* ed. Raimund Meyer and Julian Schütt (Innsbruck: Haymon, 1999), 9; *Tenderenda the Fantast,* trans. Malcolm Green, in *Blago Bung, Blago Bung, Bosso Fataka!* trans. and ed. Malcolm Green (London: Atlas, 1995), 93 (subsequent page citations are to both editions, respectively).

19. Ibid., 21/95.

20. Huelsenbeck, *En avant Dada,* 36, cf. 12/[sentence missing from p. 42 of the translation], cf. 26; Hausmann, "Dada ist mehr als Dada," 43/1:168.

21. Raoul Hausmann, "PRÉsentismus," *De Stijl* 4.9 (September 1921): 139; reprinted in *Texte bis 1933,* 2:26.

22. For two excellent accounts of Serner's early years and involvement with Dada, see Raoul Schrott, *Walter Serner (1889–1942) und Dada: Ein Forschungsbericht mit neuen Dokumenten,* Vergessene Autoren der Moderne, no. 41 (Siegen,

Germany: Universität-Gesamthochschule Siegen, 1989); and Jonas Peters, *"Dem Kosmos einen Tritt": Die Entwicklung des Werks von Walter Serner und die Konzeption seiner dadaistischen Kulturkritik* (Frankfurt/Main: Peter Lang, 1995). Walter Serner, "Die Alten und die Neuen," *Sirius,* no. 6 (1 March 1916): 86.

23. Hans Arp, "The Measure of All Things"/"Das Mass aller Dinge" and "Son of Light"/"Fils de la lumière," in *On My Way,* 35, 49–50, 81, and 92–93.

24. Tzara, "Pierre Reverdy: Le Voleur de Talan," 1:399/64.

25. Johannes Baader, *14 Briefe Christi* (Berlin-Zehlendorf: Verlag Der Tagebücher, 1914), 35; reprinted in *Johannes Baader: Oberdada,* ed. Hanne Bergius, Norbert Miller, and Karl Riha (Lahn/Giessen: Anabas, 1977), 26.

26. Raoul Hausmann, "Nous ne sommes pas les photographes," in *Courrier Dada* (Paris: Le Terrain Vague, 1958), 93; "Dada ist mehr als Dada," 44/1:169.

27. Arp, "Son of Light"/"Fils de la lumière," 49 and 92.

28. See Bartsch and Koch, *Raoul Hausmann,* 67–246. Raoul Hausmann, *La Sensorialité excentrique/Eccentric Sensoriality,* bilingual ed. (1968–69; Cambridge: Collection OU, 1970), 21 and 47.

29. See Jennifer E. Michels, *Anarchy and Eros: Otto Gross' Impact on German Expressionist Writers* (Frankfurt/Main: Peter Lang, 1983), 101–19. The thinking of Otto Gross (1877–1920), the first of a line of left-wing, anti-Freudian Freudians like Wilhelm Reich and Herbert Marcuse, was decisive for the work of the *Freie Strasse* group and will be discussed at greater length in chapter 12. See also Arthur Mitzman, "Anarchism, Expressionism amd Psychoanalysis," *New German Critique,* no. 10 (winter 1977): 77–109; and Emanuel Hurwitz, *Otto Gross: Paradies-Sucher zwischen Freud und Jung* (Frankfurt/Main: Suhrkamp, 1979). A police file (E21/6629) dealing with Gross's prewar activities is to be found in the Schweizerisches Bundesarchiv, Berne. The only two known pictures of Gross are to be found in Hartmut Binder, *Kafka in neuer Sicht* (Stuttgart: J. B. Metzler, 1976), 384; and Bergius, *Lachen Dadas,* 68. Franz Jung, "Du bist nicht krank," *Die freie Strasse,* no. 1 (1915): 4; reprinted in *Werke,* 1/1 *(Feinde Ringsum):* 114.

30. Theo Van Doesburg, "Der Wille zum Stil," *De Stijl* 5.2 (February 1922): 30; "The will to style," Baljeu, *Theo Van Doesburg,* 117; quote from "Karakteristiek van het Dadaisme," *Mécano,* no. 4/5 (spring 1923): n.p.

31. Ball, *Flucht aus der Zeit,* 159/113; see also 61/43.

32. Hans Arp, "Dadaland," 40 and 86. See also Hans Arp, "Notes from a Dada Diary," *Transition,* no. 21 (March 1932): 191, and Arp's remarks in *Wir entdecken Kandinsky,* ed. Hans Debrunner (Zurich: Origo, 1947), 57.

33. See Michels, *Anarchy and Eros,* 167–75. Raoul Hausmann, "Schnitt durch die Zeit," *Die Erde* 1.18/19 (1 October 1919): 546; reprinted in *Texte bis 1933,* 1:79–80. Quote from Raoul Hausmann, "Kabarett zum Menschen," *Schall und Rauch,* no. 3 (February 1920): 1; reprinted in *Texte bis 1933,* 1:92.

34. On Hausmann's awareness of Bergson's theory on laughter, see chapter 5, note 71. Quote from Hausmann, "Synthetisches Cino der Malerei," 20.

35. *Synthetisches Cino der Malerei* (*Synthetic Cinema of Painting*) is reproduced in Hausmann, *Am Anfang war Dada*, 29, and the others are in Bergius, *Lachen Dadas*, 118, 119, 122, and 170. Cf. Doherty, " 'See: *We Are All Neurasthenics!* " 118–19.

36. Aldington, "Influence of Mr. James Joyce," 337.

37. Chiari, "Vitalism and Contemporary Thought," 257.

38. Ball, *Flucht aus der Zeit*, 40/29; Tzara, *Surréalisme et l'après-guerre*, 19; *Oeuvres*, 5:65.

39. Van Doesburg, *Wat is Dada???????* 10–11/134.

40. Huelsenbeck, "Zürich 1916," 616; *Wozu Dada*, 70.

41. Hugo Ball, *Zur Kritik der deutschen Intelligenz* (Berne: Der Freie Verlag, 1919); *Critique of the German Intelligentsia*, trans. Brian Harris (New York: Columbia University Press, 1993) (subsequent page citations are to both editions, respectively); *Die Folgen der Reformation* (Munich: Duncker and Humblot, 1924); discussed in Mann, *Hugo Ball*, 137–67.

42. Ball, *Flucht aus der Zeit*, 39–40/28–29.

43. Hausmann, "Dada ist mehr als Dada," 44/1:169.

44. Richard Huelsenbeck, "Dada," *Quadrum*, no. 1 (May 1956): 85.

45. "Un état d'esprit," André Breton, "Géographie Dada," *Littérature*, no. 13 (May 1920): 17; "eine Revision . . . ," Richard Huelsenbeck, *Mit Witz, Licht und Grütze: Auf den Spuren des Dadaismus* (Wiesbaden: Limes, 1957), 147.

46. Doherty, " 'See: *We Are All Neurasthenics!* " 128–32; Tzara, *Surréalisme et l'après-guerre*, 23; *Oeuvres*, 5:69; Arp, "Notes from a Dada Diary," 192. For Flake, see chapter 5, note 76. Otto Flake, "Prognose des Dadaismus," *Der neue Merkur* 4.6 (September 1920): 407.

47. See, for example, Huelsenbeck, *Dada siegt!* 17; Philip Mann, "Ball and Nietzsche: A Study of the Influence of Nietzsche's Philosophy on Hugo Ball," *Forum for Modern Language Studies* 16 (1980): 293–307; Mann, *Hugo Ball*, 15–26; and Esther Beth Sullivan, "Reading Dada Performance in Zurich through Nietzsche and Bergson," *Theatre Studies* 35 (1990): 5–17. Cf. Jacques Rivière, "Reconnaissance à Dada," *Nouvelle Revue Française* 7.83 (1 August 1920): 218; Jacques Bersani, "Dada ou la joie de vivre," *Critique*, no. 225 (February 1966): 112, 113, and 117; and Michel Corvin, "Le Théâtre Dada existe-t-il?" *Revue d'Histoire du Théâtre* 23 (1971): 222, 224, and 227–28.

48. Huelsenbeck, *Dada Almanach*, 38/46.

49. Raoul Hausmann, "Was will der Dadaismus in Europa?" *Prager Tagblatt* (22 February 1920): 3; a shorter version appeared as "Dada in Europa," *Der Dada*, no. 3 (April 1920): n.p.; reprinted in *Texte bis 1933*, 1:94. Huelsenbeck, "Wozu war Dada da?" *Uhu* 3.5 (February 1927): 88; reprinted in *Wozu Dada*, 49. Hans Arp and Sophie Täuber-Arp, *Zweiklang* (Zurich: Verlag der Arche, 1960), 51. Tristan Tzara, [Speech to the Weimar Dada-Constructivist Congress], *Merz*, no. 7 (January 1924): 69; reprinted in *Oeuvres*, 1:421; "Lecture on Dada," in *Seven Dada*

Manifestos, 109. Tristan Tzara, "Le Poème bruitiste," in *Oeuvres*, 1:552 (subsequent page citations are to all three editions, respectively).

50. Hugo Ball, 7 October 1916 letter to August Hofmann, in *Briefe 1911–1927*, ed. Annemarie Schütt-Hennings (Einsiedeln, Switzerland: Benziger, 1957), 66. Evan Maurer, "Dada and Surrealism," in *"Primitivism" in Twentieth-Century Art: Affinity of the Tribal and the Modern*, ed. William S. Rubin, 2 vols. (New York: MOMA, 1984), 2:535–41.

51. Torgovnick, *Gone Primitive*, 102. Cf. Hal Foster, "The 'Primitive' Unconscious of Modern Art," 62–63; and Korte, *Dadaisten*, 20.

52. Jung, *Werke*, 9/1:13.

53. Frenkel, *Raoul Hausmann*, 22. Hausmann quote cited in Bergius, *Lachen Dadas*, 121.

54. This manifesto is discussed extensively in Frenkel, *Raoul Hausmann*, 19–62. Hausmann, "Dada ist mehr als Dada," 43/1:168. Cf. Stauth and Turner, "Nostalgia, Postmodernism and the Critique of Mass Culture," 517–18, where the authors, without mentioning Dada, identify this form of Nietzschean "yea-saying" as one of the "four primary solutions to the problem of modernism."

55. Huelsenbeck, *Dada siegt!* 16. Ball, letter to Emmy Hennings, in *Briefe 1911–1927*, 124.

56. "L'inconnu" was the title, incidentally, of an automatic poem that Hausmann sent to Tzara, himself an admirer of Rimbaud, on 10 February 1919 (cf. Tzara, *Surréalisme et l'après-guerre*, 21; *Oeuvres*, 5:68); see Rimbaud, *Oeuvres complètes*, 252 and 254. Hausmann's poem is to be found in Richard Sheppard, ed., *New Studies in Dada: Essays and Documents* (Hutton: Hutton Press, 1981), 109.

57. Cf. Lavin, *Cut with the Kitchen Knife*, 24–25 and 34. On Max Ernst, see Stokes, "Dadamax," 118–20.

58. Tzara, "Manifeste Dada 1918," 1:364/12.

59. Huelsenbeck, *En avant Dada*, 38/44. Cf. Bergius, *Lachen Dadas*, 20; and Frenkel, *Raoul Hausmann*, 114.

60. Huelsenbeck, *Dada siegt!* 42–43 and 52. See Robert Nye, "Savage Crowds, Modernism, and Modern Politics," in *Prehistories of the Future*, 53–55.

61. See Schrott, *Walter Serner;* and Peters, *"Kosmos einen Tritt."*

62. Barbara Lindlar, "'Der modernste Mann im Lande': Biografie des 'Dadasophen' Raoul Hausmann," in *Raoul Hausmann*, 286–89. See Exner, *Fasching als Logik*, 266–89. Timothy O. Benson, "The Functional and the Conventional in the Dada Philosophy of Raoul Hausmann," in *Dada/Dimensions*, 152.

63. Richard Huelsenbeck, "Der neue Mensch," *Neue Jugend*, no. 1 [first issue in newspaper format] (May 1917): 2–3. Huelsenbeck distanced himself from this piece in *Dada siegt!* 38.

64. See Tristan Tzara, 30 October 1922 letter to Jacques Doucet, in *Oeuvres*, 1:643. His letters to Breton and Picabia are reproduced in Michel Sanouillet, *Dada à Paris* (Paris: Jean-Jacques Pauvert, 1965), 440–502.

65. See chapter 5, note 83.

66. Cf. Bergius, *Lachen Dadas,* 34–35; and Hans-Georg Kemper's remarks about the deep connections between the superficially so different Huelsenbeck and Arp in *Vom Expressionismus zum Dadaismus* (Kronberg/Ts.: Scriptor, 1974), 126.

67. Cleve Gray, ed., *Hans Richter by Hans Richter* (New York: Holt, Rinehart and Winston, 1971), 68.

68. Huelsenbeck, *Dada Almanach,* 4/9–10. Richard Huelsenbeck, "Die dadaistische Bewegung," *Die neue Rundschau* 31 (1920): 975; reprinted in *Wozu Dada,* 36.

69. Hausmann, "Schnitt durch die Zeit," 546/1:81; "Dada ist mehr als Dada," 45/1:170.

70. Tzara, [Speech to the Weimar Dada-Constructivist Congress], 70/1:424/112; "Manifeste Dada 1918," 1:367/13.

71. C. G. Jung, "Einführung," in *Das Geheimnis der goldenen Blüte,* trans. Richard Wilhelm (Munich: Dornverlag Grete Ullmann, 1929), 60; "Commentary," in *The Secret of the Golden Flower,* trans. Cary F. Baynes (London: Kegan Paul, Trench and Trubner, 1931), 123.

72. Cited in Sanouillet, *Dada à Paris,* 446.

73. See Richard Sheppard, "Richard Huelsenbeck, Dada and Psychoanalysis," *Literaturwissenschaftliches Jahrbuch* 26 (1985): 271–305. Huelsenbeck, "Dada," 85.

74. Gray, *Hans Richter,* 67.

75. Cf. Lavin, *Cut with the Kitchen Knife,* 27–29; 35–37. See David Hopkins, "Questioning Dada's Potency: Picabia's 'La Sainte Vierge' and the Dialogue with Duchamp," *Art History* 15.3 (September 1992): 327–29.

76. Cf. Huyssen, *After the Great Divide,* 167–68; and Terry Eagleton, *The Ideology of the Aesthetic* (Oxford: Basil Blackwell, 1990), 372.

77. Gray, *Hans Richter,* 95. Hausmann, *Am Anfang war Dada,* 91.

78. Van Doesburg, *Wat is Dada??????* 11/134.

79. Jung, *Werke,* 9/1:13; Flake, "Prognose des Dadaismus," 405.

80. Louis Aragon, "Système Dd," *Littérature,* no. 15 (July/August 1920): 9.

81. Cf. Richter's poem "Chaos" in Gray, *Hans Richter,* 100.

82. Huelsenbeck, "Dada," 87.

83. Bergius, *Lachen Dadas,* 16, 293–94; Jones, *En-gendering of Marcel Duchamp,* 118, 130, and passim; Lavin, *Cut with the Kitchen Knife,* 17–19, 37, and 187–204; McCloskey, *George Grosz and the Communist Party,* 47 and 102.

84. Elizabeth Legge, "Thirteen Ways of Looking at a Virgin: Francis Picabia's *La Sainte Vierge,*" *Word & Image* 12.2 (April–June 1996): 233; Doherty, " 'See: We Are All Neurasthenics!' " 114.

85. Lindlar, "Modernste Mann im Lande," 287–88; Grosz, *Briefe 1913–1963,* 66.

86. Barry Humphries, *More Please* (1992; Harmondsworth, England: Penguin, 1993), 103–5 and 115–23.

87. Raoul Hausmann, " 'Ich spreche nicht von mir': Gespräch mit Raoul Hausmann" (1970), trans. Adelheid Koch, in *Raoul Hausmann*, 11.

88. Hugo Ball, "Nietzsche in Basel," ed. Richard Sheppard and Annemarie Schütt-Hennings, *Hugo Ball Almanach* 2 (1978): 32.

89. George Grosz, "Abwicklung," in George Grosz and Wieland Herzfelde, *Die Kunst ist in Gefahr* (Berlin: Malik, 1925), 22.

90. Tzara, "Pierre Reverdy: Le Voleur de Talan," 1:399/64.

91. Cited in Sanouillet, *Dada à Paris*, 474.

92. Tristan Tzara, "Note 14 sur la poésie," *Dada*, no. 4–5 (May 1919): n.p.; reprinted in *Oeuvres*, 1:403; "Note on Poetry," *Seven Dada Manifestos*, 75.

93. Huelsenbeck, *Dada Almanach*, 3, 7, and 8/9 and 13.

94. Hausmann, "Dada ist mehr als Dada," 45/1:170.

95. Cited in Giovanni Lista, "Prampolini, Tzara, Marinetti: inédits sur le futurisme," *Les Lettres nouvelles*, no. 3 (September–October 1973): 134–35.

96. Arp, remarks in *Wir entdecken Kandinsky*, 57.

97. Jung, "Du bist nicht krank," *Werke*, 1/1:114. Franz Jung's 15 April 1955 letter to his ex-wife, Cläre Jung, indicates that after his disillusion with party politics, he became drawn in the mid- to late 1920s to the quasi-mystical sexual psychology of Wilhelm Reich (*Werke*, 9/1:490–91). Jung's copious references to Reich in his letters right up to the time of his death indicate that he saw Reich as Gross's spiritual successor (cf. note 29) and that his own interest in Reich hovered between the psychological and the mystical.

98. Richter, *Dada—Kunst und Antikunst*, 52/51.

99. Huelsenbeck, "Eine Erklärung des Club Dada"/"A Declaration from Club Dada," in *Dada Almanach*, 132/136. The German verb "sich verschlingen" has two distinct meanings and the English translation, as it stands, catches only one of them: "devour one another and intertwine" might do the ambiguity more justice. Comparable retrospective statements are to be found in Raoul Hausmann, "Morphopsychologische Indifferenz Dadas," *Manuskripte*, no. 8 (June–September 1963): 20; and Richard Huelsenbeck, "Dada oder der Sinn im Chaos," in *Dada: Eine literarische Dokumentation*, ed. Richard Huelsenbeck (Reinbek bei Hamburg: Rowohlt, 1964), 10.

100. Quote from "Shock-Art with a Purpose," *Times Literary Supplement*, no. 3284 (4 February 1965): 80.

101. Krauss, "The Originality of the Avant-garde," 161.

102. Ibid., 160.

103. See Alastair Grieve, "Arp in Zurich," in *Dada Spectrum: The Dialectics of Revolt*, ed. Stephen Foster and Rudolf Kuenzli (Madison: Coda Press, 1979), 176–205.

104. The first poem of the collection was published in *Le Pagine* 2.7 (15 March 1917): 101–3; the second (dated February 1916) in *Le Pagine* 2.6 (15 February 1917): 87; the third in *Le Pagine* 2.6 (15 February 1916): 85–86; the fourth in *Nord–Sud,*

no. 4/5 (June/July 1917): 27; the fifth in *Nord–Sud*, no. 4/5 (June/July 1917): 28; the sixth in *Cronache letterarie* 4.3/4 (February 1917): 7; the seventh in *Crociere barbare* 1.2 (15 March 1917): 16 and then in *SIC*, no. 21/22 (September/October 1917): 5; and the eighth in *La Diana* 3.1/2 (March 1917): n.p.

105. Hausmann, *Texte bis 1933*, 1:19.

106. Pierre Cabane, *Dialogues with Marcel Duchamp* (London: Thames and Hudson, 1967), 47–48 and 75–76. See also Hopkins, "Questioning Dada's Potency"; and Legge, "Thirteen Ways of Looking at a Virgin."

107. Gray, *Hans Richter*, 33; Richter, *Dada—Kunst und Antikunst*, 57/57.

108. Arp, "Dadaland," 40 and 87.

109. Jean Arp, "Die Musen und der Zufall," *Du* 20.286 (October 1960): 15–16.

110. See Grieve, "Arp in Zurich," 192–94; Harriett Watts, *Chance: A Perspective on Dada* (Ann Arbor, Mich.: UMI Research Press, 1980), 3; Jane Hancock, "Arp's Chance Collages," in *Dada/Dimensions*, 47–82; and Monika Schmitz-Emans, "Poesie als Antimechanik: Zur Modellfunktion des Zufälligen bei Hans Arp," 283–310.

111. Ball, "Das erste dadaistische Manifest," 39/220–21.

112. Richard Huelsenbeck, "Erklärung, vorgetragen im Cabaret Voltaire, im Frühjahr 1916," in *Dada: Eine literarische Dokumentation*, 30.

113. Hans Arp, "Dada-Sprüche," in *Unsern täglichen Traum* (Zurich: Verlag der Arche, 1955), 48 and 50.

114. Hausmann, *Am Anfang war Dada*, 83.

115. Van Doesburg, *Wat is Dada???????* 6/132.

116. [Probably Hausmann and/or Baader], "Legen Sie Ihr Geld in Dada an," *Der Dada,* no. 1 (June 1919): n.p.

117. Huelsenbeck, *Dada Almanach,* 7 and 40/12 and 49.

118. Tzara, "Manifeste Dada 1918," 1:361/5.

119. See Hanne Bergius, "Dada als 'Buffonade and Totenmesse zugleich,'" in *Unter der Maske des Narren*, ed. Stefanie Poley (Stuttgart: Gerd Hatje, 1981), 208–20; and Kermode, "Modernism, Postmodernism, and Explanation," 369.

120. Frenkel, *Raoul Hausmann*, 41.

121. Bergius, *Lachen Dadas*, 18–19.

122. Cf. Hausmann, "Was will der Dadaismus in Europa?" 3/1:94.

123. Otto Flake, "Zum Thema Dadaismus," in *Das vierte Heft* (Munich-Pasing: Roland, 1920), 188.

124. Huelsenbeck, *Dada Almanach,* 3/9; Van Doesburg, *Wat is Dada???????* 9/133.

125. On *Dadaco*, see chapter 5, note 65. Cf. Fritz Usinger, "Der Dadaismus," in *Expressionismus: Gestalten einer literarischen Bewegung*, ed. Hermann Friedmann and Otto Mann (Heidelberg: Wolfgang Rothe, 1956), 343. Hausmann, "Was will der Dadaismus in Europa," 3/1:96.

126. Bürger, *Theorie der Avantgarde*, passim. Ball, *Flucht aus der Zeit*, 81–82/

58–59. Arp, "Notes from a Dada Diary," 192. Tzara, [Speech to the Weimar Dada-Constructivist Congress], 69/1:421/110. "[T]oujours" [always] has been deleted from the later French version.

127. Hausmann, "Synthetisches Cino der Malerei," 12. Raoul Hausmann, "Objektive Betrachtung der Rolle des Dadaismus," *Der Kunsttopf,* no. 3 (September 1920): 64–65; reprinted in *Texte bis 1933,* 1:110–11.

128. Grosz and Herzfelde, *Kunst ist in Gefahr,* 13–14 and 22–23.

129. Raoul Hausmann, "Der deutsche Spiesser ärgert sich," *Der Dada,* no. 2 ([December] 1919): n.p.; reprinted in *Texte bis 1933,* 1:83; Raoul Hausmann, ["Der Vermenschlichungswille . . ." (1921)], in "Neun kurze Beiträge aus den Dada-Jahren von Raoul Hausmann," *Sprache im technischen Zeitalter,* no. 58 (1976): 163; and Grosz, *Briefe 1913–1963,* 42–45.

130. Cf. Huelsenbeck, *En avant Dada,* 42/44. See Harry Graf Kessler, *Tagebücher 1918 bis 1937,* ed. Wolfgang Pfeiffer-Belli (Frankfurt/Main: Insel, 1996), 164–65, entry for 23 March 1919; and Harald Maier-Metz, *Expressionismus—Dada—Agitprop: Zur Entwicklung des Malik-Kreises in Berlin 1912–1924* (Frankfurt/Main: Peter Lang, 1984), 210–11.

131. See Anton Kaes, "Verfremdung als Verfahren: Film und Dada," in *Sinn aus Unsinn,* 71–83. Walter Benjamin, "Das Kunstwerk im Zeitalter seiner technischen Reproduzierbarkeit," in *Gesammelte Schriften,* 1/2:471–508; "The Work of Art in the Age of Mechanical Reproduction," in *Illuminations,* 219–53. Cf. Vattimo, *End of Modernity,* 52–56; and Wellmer, *Dialektik von Moderne und Postmoderne,* 41–42.

132. Cf. Van Doesburg, "Dadaisme," 30.

133. Cf. Bergius, *Lachen Dadas,* 106.

134. Cf. Sullivan, "Reading Dada Performance in Zurich," 14; Hans Arp, "Francis Picabia" (1949), in *Unsern täglichen Traum,* 27–28 and 63–65; and Schmitz-Emans, "Poesie als Antimechanik," 305–6.

135. On Grosz's poem, see Doherty, " 'See: *We Are All Neurasthenics!* ' " 93–97. On Höch, see Lavin, *Cut with the Kitchen Knife,* 8–9. On Schwitter's *Merzbau,* see Bergius, *Lachen Dadas,* 293–96. Cf. Perloff, *Futurist Moment,* 77.

136. See chapter 5, note 35.

137. Cf. Bergius, *Lachen Dadas,* 130–32; Ellen Maurer, *Hannah Höch: Jenseits fester Grenzen* (Berlin: Gebr. Mann, 1995), 103 and 128. Robert Stam ("Mikhail Bakhtin and Left Cultural Critique," in Kaplan, *Postmodernism and Its Discontents,* 128 and 141–42), discussing Bakhtin's carnivalesque aesthetic of dialogism, polyphony, parody, and formal transgression, sees that it can be "easily reconciled [. . .] even with a certain avant-garde," but does not make the link with Dada. See Hausmann, *Malerei Plastik und Architektur,* reprinted in *Texte bis 1933,* 1:19.

138. Cf. Arp, "And so the circle closed"/"So schloss sich der Kreis," in *On My Way,* 77 and 118.

139. Cf. Arp, "I became more and more removed from aesthetics"/"De plus en plus je m'éloignais de l'ésthétique," in *On My Way,* 48 and 91.

140. See Krzysztof Fijalkowski, "Dada and the Machine," *Journal of European Studies* 17 (1987): 233–51; and Camfield, "Machine Style of Francis Picabia."

141. Dickran Tashijan, *Skyscraper Primitives: Dada and the American Avant-garde, 1910–1925* (Middletown, Conn.: Wesleyan University Press, 1975), x.

142. On Duchamp's move to America, see "French Artists Spur on American Art." On the "denkwürdiges Datum," see Huelsenbeck, *Dada siegt!* 40.

143. Cf. Huyssen, *After the Great Divide,* 9–11.

144. See Richard W. Sheppard, " 'Der Schauspieler greift in die Politik:' Five Actors and the German Revolution 1917–1922," *Maske und Kothurn* 39.1 (1997): 45–52. Hausmann performed for Friedrich on 5 November 1921 (48)—i.e., while he was still involved with Höch. See Lavin's discussion of this problem in relation to Höch's *Das schöne Mädchen* (*The Beautiful Girl*) (1919–20) (*Cut with the Kitchen Knife,* 43–46).

145. Cf. Huyssen, *After the Great Divide,* 11; Huelsenbeck, "Dada oder der Sinn im Chaos," 10.

146. Raoul Hausmann, "Lob des Konventionellen," *Die Pille* 3.1/2 (1922): 5; reprinted in *Texte bis 1933,* 2:49.

147. Cf. Jones, *En-gendering of Marcel Duchamp,* 138, and Calinescu, *Faces of Modernity,* 254–55.

148. Jones (*En-gendering of Marcel Duchamp,* 139), for instance, unravels several of the French puns involved in Duchamp's readymade *Peigne* (literally *Comb*) (1916). But she does not realize that the French word could also be heard as the imperative of the verb "peindre" [paint!], or that to the English ear the French word sounds like "pain," or that the initials with which *Peigne* is signed—"M.D."—are the initials that follow the name of a North American physician besides being Duchamp's own. These further associations raise all kinds of questions about the ability of every person to be an artist, the suffering caused by technology, and the power of the imagination, once freed from the blinkers of convention, to mitigate that suffering.

149. "Hannah Höch und die Berliner Dadaisten," [interview with Edouard Roditi], *Der Monat,* no. 134 (November 1959): 64. Hausmann, "Synthetisches Cino der Malerei," 28/1:16.

150. Brandt, *Bravo! & Bum Bum!* 142.

151. John Cage, *Silence* (Cambridge: MIT Press, 1967), 227; Perloff, *Futurist Moment,* 224.

152. Hutcheon, *Poetics of Postmodernism,* 24.

153. Huelsenbeck, "Die dadaistische Bewegung," 974; reprinted in *Wozu Dada,* 35. Hausmann, "Lob des Konventionellen," 5–6/2:49.

154. Cf. Adolf Behne, "Jefim Golyscheff," *Der Cicerone* 9.22 (November 1919): 725–26. Behne (1885–1948), an art critic, architectural theoretician, professional academic, committed Socialist, and tireless popularizer, was one of the few critics of the time to have any insight into the significance of Dada's provocative experi-

ments (see Adolf Behne, "Dada," *Die Freiheit* [Berlin], no. 269 [9 July 1920], and "Bewegungskunst," ibid., no. 452 [27 September 1921]).

155. Cf. Lavin, *Cut with the Kitchen Knife*, 8–9, 24, 43–46, and 68; and Hopkins, "Questioning Dada's Potency," 327. See also Duchamp's statements on this topic in his interview with Cabane, *Dialogues with Marcel Duchamp*, 42.

156. Tzara, "Manifeste Dada 1918," 360–61/5; Cabane, *Dialogues with Marcel Duchamp*, 69–70.

157. Heide Göttner-Abendroth, "Nine Principles of a Matriarchal Aesthetic," in *Feminist Aesthetics*, trans. Harriet Anderson, ed. Gisela Ecker (London: The Women's Press, 1985), 81–94. See, for instance, Hopkins, "Questioning Dada's Potency," 325; and Frenkel, *Raoul Hausmann*, 43–48.

158. See Richard Sheppard, "Upstairs-Downstairs: Some Reflections on German Literature in the Light of Bakhtin's Theory of Carnival," in *New Ways in Germanistik*, 278–315.

Chapter 8

1. See Perloff, *Futurist Moment,* 29 and 35; and Brandt, *Bravo! & Bum Bum!* 42, 64–65, 135–36, 153, and 166–67.

2. See Perloff, *Futurist Moment,* 52, 92, and 111–15; Brandt, *Bravo! & Bum Bum!* 21–66 and 90; and Peter Demetz, *Worte in Freiheit: Der italienische Futurismus und die deutsche literarische Avantgarde (1912–1934)* (Munich: Piper, 1990), 90–98. Lista, "Prampolini, Tzara, Marinetti: inédits sur le futurisme," 122.

3. José Pierre, *Futurism and Dadaism* (1966; London: Heron Books, 1969), 29.

4. See Marc le Bot, *Francis Picabia et la crise des valeurs figuratives 1900–1925* (Paris: Klincksieck, 1968), 48; and William A. Camfield, *Francis Picabia: His Art, Life and Times* (Princeton N.J.: Princeton University Press, 1979), 27. Apollinaire did, however, single out Severini's *La Danse du Pan-Pan à Monico (Pan-Pan Dance at Monico)* (1910–12) (now destroyed) for special mention. See Marianne W. Martin, *Futurist Art and Theory 1909–1915* (New York: Hacker Books, 1978), 103.

5. Le Bot, *Francis Picabia,* 14 and 24; Camfield, *Francis Picabia,* 23.

6. See chapter 7, note 9.

7. Raffaele Carrieri, *Futurism* (1961; Milan: Edizioni del Milione, 1963), 60; Henderson, *Non-Euclidean Geometry in Modern Art,* 107–8; Arturo Schwarz, *The Complete Works of Marcel Duchamp* (London: Thames and Hudson, 1969), 17–18; John Golding, *The Bride Stripped Bare by Her Bachelors, Even* (London: Allan Lane, 1973), 22, 28–29.

8. Perloff, *Futurist Moment,* 36.

9. Futurist events, both at home and abroad, received wide coverage in the Berlin press (cf. note 32), and although I have never undertaken a systematic search for such reports, here are a few items that have come to my notice over the years:

p.m., "Die Conférence des Futuristenführers," *Berliner Tageblatt,* no. 205 (23 April 1912); Hermann Friedemann, "Die Futuristen," *Deutsche Montags-Zeitung,* no. 20 (13 May 1912); Ferdinand Hardekopf, "Futuristenschlacht," *BZ am Mittag,* no. 152 (1 July 1912); Moeller van den Bruck, "Futurismus," *Der Tag,* no. 166 (18 July 1912); F. T. Marinetti, "Das Begräbnis eines Gottes," *Deutsche Montags-Zeitung,* no. 50 (9 December 1912); René Schickele, "Der graue Schrecken," *Berliner Tageblatt,* no. 88 (18 February 1913); "Eine Futuristenschlacht in Rom," *BZ am Mittag,* no. 58 (10 March 1913); "Die Futuristenschlacht in Rom," *BZ am Mittag,* no. 59 (11 March 1913); R.d.F., "Die Futuristenschlacht," *BZ am Mittag,* no. 61 (13 March 1913); Euglielmo Ferrero, "Gibt es in der Kunst einen Fortschritt?" *Vossische Zeitung,* no. 296 (14 June 1914).

10. Huelsenbeck, *En avant Dada,* 11–12/24–25.

11. Richter, *Dada—Kunst und Antikunst,* 33/33–34.

12. "Künstlerkneipe 'Voltaire,'" *Neue Zürcher Zeitung,* Erstes Mittagblatt (4 February 1916); reprinted in Richard Sheppard, ed., *Dada Zürich in Zeitungen: Cabarets, Ausstellungen, Berichte und Bluffs,* Veröffentlichungen zum Forschungsschwerpunkt Massenmedien und Kommunikation, no. 82/83 (Siegen, Germany: Universität-Gesamthochschule Siegen, 1992), 9.

13. See Marinetti's 5 July 1915 letter to Tzara, cited in Giovanni Lista, "Marinetti et Tzara," *Les Lettres nouvelles,* no. 3 (May/June 1972): 85; Ball, *Flucht aus der Zeit,* 35/25. "Künstlerkneipe Voltaire," *Volksrecht* (Zurich) (12 February 1916); reprinted in Sheppard, *Dada Zürich in Zeitungen,* 10. This advertisement specifically states that Hugo Ball will read out Futurist poems by Marinetti, Buzzi, and Palazzeschi.

14. See Sheppard, *Dada Zürich in Zeitungen,* 9, 13, and 14.

15. "Künstlerkneipe Voltaire," *Volksrecht* (Zurich) (17 February 1916); reprinted in Sheppard, *Dada Zürich in Zeitungen,* 11.

16. Giovanni Lista, "Tristan Tzara et le Dadaïsme italien," *Europe* 53.555–56 (July–August 1975): 173. For a discussion of Marinetti's *Bombardimento di Adrianopoli* (*The Bombardment of Adrianopolis*), which exists in at least five versions, see White, *Literary Futurism,* 181–87. Lista may well be thinking of the Berlin *Dada-Abend* of 12 April 1918, which included the version that forms the last part of *Zang Tumb Tumb* (see below).

17. These were: F. T. Marinetti, "Manifest des Futurismus," *Der Sturm* 2.104 (March 1912): 828–29; Umberto Boccioni, Carlo Carrà, Luigi Russolo, Giacomo Balla, and Gino Severini, "Futuristen: Die Aussteller an das Publikum," *Der Sturm* 3.105 (April 1912): 3–4; Valentine de Saint-Pont, "Manifest der futuristischen Frau," *Der Sturm* 3.108 (May 1912): 26–27; F. T. Marinetti, "Tod dem Mondschein," *Der Sturm* 3.111 (May 1912): 50–51, and 3.112 (June 1912): 57–58; "Die futuristische Literatur (Technisches Manifest)," *Der Sturm* 3.133 (October 1912): 194–95; "Supplement zum technischen Manifest der futuristischen Literatur," *Der Sturm* 3.150/51 (March 1913): 279–80; Umberto Boccioni, "Simultanéité futuriste," *Der Sturm* 4.190/91 (December 1913): 151.

18. Although I have not been able to find a catalogue of the exhibition at Richter's *Kunstsalon,* it has been possible to identify thirteen of the pictures exhibited from reports that appeared in the *Dresdner Anzeiger, Dresdner Nachrichten,* and *Dresdner Neueste Nachrichten* on 25 October 1913: Boccioni's *Idolo moderno* (*Modern Idol*) (1911), *La risata* (*The Laugh*) (1911), and *Le forze di una strada* (*The Forces of a Street*) (1911); Russolo's *Una-tre teste* (*One-three Heads*) (1911) (now lost), *I capelli di Tina* (*Tina's Hair*) (c. 1911), *Ricordi di una notte* (*Memories of a Night*) (1911), and *La rivolta* (*The Revolt*) (1911); Carrà's *I funerali dell' anarchico Galli* (*The Funeral of the Anarchist Galli*) (1910–11), *Ragazza alla finestra* (*Girl at the Window*) (1912), *Donna e l'assenzio* (*Woman and Absinthe*) (1911), and *Sobbalzi di carrozella* (*Jolts of a Cab*) (1911); and Severini's *La Danse du Pan-Pan à Monico* (note 4), and *Danzatrice ossessionante* (*Haunting Dancer*) (1911). Hugo Ball, "Die Reise nach Dresden," *Revolution,* no. 3 (15 November 1913): n.p.; reprinted in *Künstler und die Zeitkrankheit,* 11–14.

19. Joachim Kuhn ("Hugo Ball und die Rechtfertigung von Kunst und Künstlertum," *Hugo Ball Almanach* 2 [1978]: 79) makes the same point but without seeing its wider implications for Ball's reception of Futurism.

20. Ball, *Briefe 1911–1927,* 33.

21. See Jeanpaul Goergen, ed., *Urlaute Dadaistischer Poesie: Der Berliner Abend am 12. April 1918* (Hanover: Postkriptum, 1994), 129.

22. Ball, *Flucht aus der Zeit,* 20–21/15.

23. Ball, *Briefe 1911–1927,* 33–34.

24. Bernhard Zeller and Ellen Otten, eds, *Kurt Wolff: Briefwechsel eines Verlegers* (Frankfurt/Main: Kurt Wolff, 1966), 13.

25. Ball, *Flucht aus der Zeit,* 13 and 35/10 and 25.

26. See translator Christopher Middleton's footnote in Ball, "Dada Manifesto," 221.

27. See Kuhn, "Hugo Ball," 64. In Ball's *Briefe,* this letter is dated as 27 September 1916. I have been able to examine the manuscript of Ball's letters to Tzara (in the Fonds Doucet, Paris) and it is probable that this letter was written a month earlier for the following reasons. First, Ball was already resident in Ascona by 17 August 1916, the place where this letter was written. Second, Ball refers in this letter to Henri Guilbeaux's article "L'Art de demain," (*La Guerre mondiale,* 6.580 [18 July 1916]: 4633–34) that Tzara would almost certainly have sent him soon after its publication as it was extremely critical of Dada. Third, in his (as yet unpublished) 16 August 1916 card to Tzara, Ball suggested that Tzara should translate some of his prose into French. Tzara probably reacted positively to this suggestion in his reply, but by the time Ball received this reply, he had changed his mind on this subject and would have wanted to inform Tzara of this at the earliest possible opportunity—which he does in the letter in question.

28. Marinetti, "Die futuristische Literatur (Technisches Manifest)"; see note 17.

29. Cf. Demetz, *Worte in Freiheit,* 95–96.

30. See Kasimir Edschmid, ed., *Briefe der Expressionisten* (Frankfurt/Main: Ullstein, 1964) 68–70; and Herbert Kapfer and Lisbeth Exner, eds., *Weltdada Huelsenbeck: Eine Biografie in Briefen und Bildern* (Innsbruck: Haymon, 1996), 263.

31. These reports are reproduced in Karin Füllner, ed., *Dada Berlin in Zeitungen: Gedächtnisfeiern und Skandale*, Veröffentlichungen des Forschungsschwerpunkt Massenmedien und Kommunikation, no. 43 (Siegen, Germany: Universität-Gesamthochschule Siegen, 1986), 10–14. See chapter 9, note 8 on the manifesto Ball and Huelsenbeck distributed at the secular memorial service on 12 February 1915.

32. See *En avant Dada*, 13–15/25–26 and 29–30/36; the trial sheets for *Dadaco* (chapter 5, note 65); two poems in the first edition of Huelsenbeck's *Phantastische Gebete* (which appeared in Zurich in September 1916), and the "Erste Dadarede in Deutschland" that Huelsenbeck delivered in Berlin on 22 January 1918 (published in Huelsenbeck, *Dada Almanach*, 104–8; "First Dada Lecture in Germany," trans. Derk Wynand, in *Dada Almanac*, 110–13 [subsequent page citations are to German and English editions, respectively]). The remarks in *Dadaco* closely parallel those in *En avant Dada*. One of the two poems is actually entitled "Mafarka," a reference to Marinetti's novel *Mafarka le futuriste,* and the second poem, "Der redende Mensch" ("The Speaking Person"), also contains a passing reference to the same text (Richard Huelsenbeck, Hans Arp, and George Grosz, *Phantastische Gebete,* ed. Herbert Kapfer [Giessen, Germany: Anabas, 1993], 18–19 and 15–16; *Fantastic Prayers,* in Green, *Blago Bung, Blago Bung, Bosso Fataka!* 62 and 64). In the "Erste Dadarede," Huelsenbeck says that Ball was the only Zurich Dadaist to have assimilated the lessons of Futurism and overemphasizes Dada's originality, but admits that he himself had developed the "poème bruitiste" under the inflence of one of Russolo's *Spirali di rumori intonati: Risveglio di una città (Awakening of a Great City)* (106/112). This, together with the other three *Spirali,* had been first performed by eighteen musicians using fantastic instruments in the Teatro Dalverme in Milan on 21 April 1914 and provoked a riot (Martin, *Futurist Art and Theory,* 193). Several reports of it appeared in the Berlin press: see "Das erste Konzert der 'Geräuschmusik,'" *Berliner Tageblatt,* no. 201 (22 April 1914); "Futuristisches Konzert," *Vossische Zeitung,* no. 201 (22 April 1914); "Blutige Schlägerei bei einem futuristischen Konzert," *Die Post,* no. 190 (24 April 1914); Kerbs, "Ein Futuristen-Abend in Mailand," *Berliner Börsen-Courier,* no. 191 (25 April 1914); and Emil Thieben, "Ein Futuristen-Konzert," *Vossische Zeitung,* no. 207 (25 April 1914).

33. Füllner, *Dada Berlin in Zeitungen,* 12

34. Kern, *Culture of Time and Space,* 72; White, *Literary Futurism,* 110 and 338.

35. Hsr., "Dada-Abend," *Neue Zürcher Zeitung,* Zweites Abendblatt (18 July 1916); reprinted in Sheppard, *Dada Zürich in Zeitungen,* 15–16; Tristan Tzara, "Chronique Zurichoise 1915–1919," in *Dada Almanach,* 13–14; "Zurich Chronicle 1915–1919," trans. Terry Hale and Malcolm Green, in *Dada Almanac,* 18–21.

36. Kemper, *Vom Expressionismus zum Dadaismus*, 107.

37. Guilbeaux, "L'Art de demain" (see note 27); and "Marcel Janco [sic]: La première aventure céleste de M. Antipyrine," *Demain* 1.8 (August 1916): 124–25. Cf. Mann, *Hugo Ball*, 92–93.

38. Ball, *Flucht aus der Zeit*, 71/50. See Brandt, *Bravo! & Bum Bum!* 64–65 and 81; and my comments on Futurist poetry in chapter 5.

39. The newspaper advertisment is reprinted in Sheppard, *Dada Zürich in Zeitungen*, 11. Janco's drawing is reproduced in Rubin, *"Primitivism" in Twentieth-Century Art*, 2:536. The two paintings are in Richter, *Dada—Kunst und Antikunst*, fig. 3; Motherwell, *Dada Painters and Poets*, fig. xx. For Severini's work, see Martin, *Futurist Art and Theory*, fig. 72; discussed 102–3 and 141–42.

40. Ball, *Flucht aus der Zeit*, 89–91/63–65.

41. Tzara, "Chronique Zurichoise," 14/21.

42. See Ball, *Flucht aus der Zeit*, 155/110.

43. Ibid., 159/113. Cf. Kern, *Culture of Time and Space*, 140.

44. Marcel Janco, "Creative Dada," in *Dada: Monograph of a Movement*, ed. Willy Verkauf (1957; London: Academy Editions, 1975), 18–30.

45. See Lista, "Marinetti et Tzara," 85 and 87.

46. See Tzara's remarks on his development during this period in his 30 October 1922 letter to Jacques Doucet, in Tzara, *Oeuvres*, 1:643 (subsequent line citations are to this edition).

47. Lista, "Marinetti et Tzara," 89.

48. See note 32; see also White, *Literary Futurism*, 316–21. Tzara's interest in "primitivism" was at its height in 1916 and 1917. Béhar includes two collections of primitivizing poems in Tzara, *Oeuvres*, 1:441–89 and 501–7 (*Poèmes nègres* and *Mpala Garoo*). According to Béhar (714 and 719), these two collections most probably come from 1916, and it seems likely that Tzara's meeting with Huelsenbeck in spring 1916 catalyzed his interest. In this context, it is interesting to note that the word "Mpala" occurs in Huelsenbeck's poem "Ebene" ("Plane") (*Phantastische Gedichte*, 18; *Fantastic Prayers*, 57) which almost certainly originates from 1915.

49. Tzara, *Oeuvres*, 1:89 and 225.

50. See Umberto Boccioni, "La scultura futurista," *Lacerba* 1.13 (1 July 1913): 140, and *Pittura scultura futuriste: dinamismo plastico* (Milan: Edizioni futuriste di "Poesia," 1914), 415–16.

51. Tzara, "Le Poème bruitiste," in *Oeuvres*, 1:551–52; see also 1:643.

52. Huelsenbeck, "Erste Dadarede" (see note 32). Tzara, *Oeuvres*, 1:552; see also 1:81.

53. See Ball, *Briefe*, 64.

54. Cited in Giovanni Lista, "Encore sur Tzara et le futurisme," *Les Lettres nouvelles*, no. 5 (December 1974): 127.

55. Interestingly, the exception is "Marcel Janco" (*Oeuvres*, 1:513 and 722). It may well be that by the time of the publication of the *Vingt-cinq poèmes* on 20 June

1918 as part of the *Collection Dada,* Janco, who is in any case portrayed in Tzara's poem in terms more reminiscent of Cubism than of Dada or Futurism, had moved so far away from Dada that either he or Tzara felt that the inclusion of this poem in an overtly Dada anthology would be inappropriate. Certainly, from late 1918 onward, Janco was a central figure of the *Gruppe Neues Leben* (New Life Group) in Zurich, which, as its name suggests, was more interested in renewal than destruction (see Sheppard, *Dada Zürich in Zeitungen,* 37–49).

56. Tzara, *Oeuvres,* 1:643.

57. Cf. Lista, "Marinetti et Tzara," 90.

58. Cf. Demetz, *Worte in Freiheit,* 93–94.

59. Prampolini, *Noi,* no. 1 (June 1917): 8. Letters cited in Lista, "Prampolini, Tzara, Marinetti," 128 and 131–33.

60. Letter cited in Lista, "Prampolini, Tzara, Marinetti," 134–35; cf. Sanouillet, *Dada à Paris,* 474. Cf. Enrico Crispolti, "Dada a Roma," *Palatino* 11.4 (October–December 1967): 400, who remarks that in 1917 and 1918, Prampolini oscillated between rigidly geometrical works and more dynamic ones like those he contributed to Dada.

61. Tzara, "Note 1 sur quelques peintres," in *Oeuvres,* 1:553. According to reports in the Zurich press (reproduced in Sheppard, *Dada Zürich in Zeitungen,* 17–18), this exhibition included work by Arp, Janco, Richter, and the Van Rees.

62. Tzara's 4 December 1918 letter cited in Sanouillet, *Dada à Paris,* 474. *Noi* 5/6/7 appeared in January 1919, after the publication of *Dada* 3 in December 1918 with Tzara's "Manifeste Dada 1918" where the "No" resounds more loudly than the "Yes." Prampolini's statements in *Noi* occur on pages 27–28.

63. See Sanouillet, *Dada à Paris,* 442, 489, and 491; 19 March 1919 and 21 September 1919 letters in ibid., 485 and 449, respectively. For his comments in *Littérature,* see Tzara, *Oeuvres,* 1:409.

64. See Perloff, *Futurist Moment,* 92 and 107–13.

65. See Robert Short, "Paris Dada and Surrealism," *Journal of European Studies* 9 (1979): 75–98.

66. See Baljeu, *Theo Van Doesburg,* 16. See John Elderfield, "The Early Work of Kurt Schwitters," *Artforum* 10.3 (November 1971): 54–61; and Brandt, *Bravo! & Bum Bum!* 180–92. Dorothea Eimert, *Der Einfluss des Futurismus auf die deutsche Malerei* (Cologne: Kopp, 1974), 249–57. Giovanni Lista, "Dada Italien," in *Dada in Europa: Werke und Dokumente,* part 3 of *Tendenzen der Zwanziger Jahre* (Berlin: Dietrich Reimer, 1977), 117; Enrico Crispolti, "Dada a Roma," *Palatino* 12.1 (January–March 1968): 52; and Richard Sheppard, "Julius Evola, Futurism and Dada: A Case of Double Misunderstanding," in *New Studies in Dada,* 85–94.

67. See Perloff, *Futurist Moment,* 36; and Günter Berghaus, *Futurism and Politics: Between Anarchist Rebellion and Fascist Reaction, 1909–1944* (Providence: Berghahn Books, 1996).

68. Goergen, *Urlaute Dadaistischer Poesie,* 70. See Huelsenbeck, *Dada Almanach,* 36–41/44–49.

69. For these reports, see Goergen, *Urlaute Dadaistischer Poesie,* 70, 74–75, and 77–78.

70. For the program, see ibid., 9. Tzara, *Oeuvres,* 1:97.

71. Goergen, *Urlaute Dadaistischer Poesie,* 9, 126–27. Grosz's poems have been collected in Wieland Herzfelde and Hans Marquardt, eds, *Pass auf! Hier kommt Grosz: Bilder Rhythmen und Gesänge 1915–1918* (Leipzig: Philipp Reclam jun., 1981).

72. Grosz would replay this description of himself as a "Kabaret-Whitman" in his 29 April 1918 letter to Otto Schmalhausen (Grosz, *Briefe 1913–1959,* 66). See Goergen, *Urlaute Dadaistischer Poesie,* 70.

73. Goergen, *Urlaute Dadaistischer Poesie,* 54–56, 65–66, and 128.

74. Huelsenbeck, *Dada Almanach,* 108/113.

75. Herzfelde and Marquardt, *Pass auf!* 13. Ten days after the *Dada-Abend* in question, Grosz expressed precisely this ambiguity in a letter to Schmalhausen (*Briefe 1913–1959,* 60).

76. Hausmann would say this quite explicitly in 1922 (["Neue Wahrheiten . . ."], in "Neun kurze Beiträge aus den Dada-Jahren von Raoul Hausmann," 168).

77. On the poem about changing of the guard in imperial Berlin, see Goergen, *Urlaute Dadaistischer Poesie,* 35–36. On Tzara's poem alluding to Napoleon's victory in Egypt in 1798, cf. Huelsenbeck, *En avant Dada,* 28/35.

78. On the opinions in various contemporary publications, see Goergen, *Urlaute Dadaistischer Poesie,* 79–81, 87.

79. See Huelsenbeck, *Dada Almanach,* 38/46. See Doherty, " 'See: *We Are All Neurasthenics!* ' " 132. Goergen, *Urlaute Dadaistischer Poesie,* 54.

80. On Huelsenbeck being called to serve in the army, see Goergen, *Urlaute Dadaistischer Poesie,* 133. Huelsenbeck, "Erklärung, vorgetragen im Cabaret Voltaire, im Frühjahr 1916," 29–30.

81. Huelsenbeck, *Dada Almanach,* 40/47–49.

82. Richard Huelsenbeck, ["Die Unterzeichneten beehren sich . . ."], in *New Studies in Dada,* 99.

83. See Brandt, *Bravo! & Bum Bum!* 27. See chapter 5, note 65 on the trial sheets for *Dadaco* [5].

84. Boccioni, *Pittura scultura futuriste,* 224 and 328.

85. Ibid., 395–96, 208. Cf. Perloff, *Futurist Moment,* 55–56.

86. Boccioni, *Pittura scultura futuriste,* 110–11.

87. Umbro Apollonio, ed., *Futurismo* (Milan: Gabriele Mazzotta, 1970), 95; *Futurist Manifestos,* trans. Robert Brain, R. W. Flint, J. C. Higgitt, and Caroline Tisdall (New York: Viking, 1973), 49 (subsequent page citations are to both editions, respectively).

88. Boccioni, *Pittura scultura futuriste,* 325. On Russolo and Severini's comments, see Apollonio, *Futurismo,* 131/86 and 171/121. Joshua C. Taylor, *Futurism* (New York: MOMA and Doubleday, 1961), 14.

89. On the triumphal march of science in the Futurist manifesto, see Apollonio, *Futurismo,* 51–53/24–26. On Boccioni's sculpture, see Kern, *Culture of Time and Space,* 121. On Marinetti's manifesto, see Apollonio, *Futurismo,* 44/19.

90. For discussions of Boccioni's works, see Martin, *Futurist Art and Theory,* figs. 52 and 85–86, and figs. 78 and 112. On Russolo, see ibid., figs. 108 and 148–49.

91. Grosz, *Briefe 1913–1959,* 53–54. Cf. Butler, *Early Modernism,* 194; see also White, *Literary Futurism,* 288–358 for an extensive discussion of the two major types of Futurist "primitivism." See Schuster, *George Grosz: Berlin–New York,* fig. IX.8 and 324; and Bergius, *Lachen Dadas,* 171.

92. Huelsenbeck, *En avant Dada,* 11/26. See Luigi Russolo, "Conquista totale dell'enarmonismo mediante gl'intonarumori futuristi," *Lacerba* 1.21 (1 November 1913): 242, where he actually states "nella natura e nella vita i suoni e i rumori *sono tutti enarmonici*" [in nature and in life sounds and noises *are all in harmony*]; see also Apollonio, *Futurismo,* 131/86.

93. Tzara, "Chronique Zurichoise," 12–13/17–21.

94. Grosz, *Briefe 1913–1959,* 52 and 62.

95. Tzara, *Oeuvres,* 1:362/6.

Chapter 9

1. L[eopold] Zahn, "Dadaismus oder Klassizismus?" *Der Ararat* 1.7 (April 1920): 51; and Veronika Erdmann-Czapski, "Hans Arp's 'Pyramidenrock,'" *Das Kunstblatt* 10 (1926): 218. Serge Fauchereau, "Tristan Tzara, Dada et l'Expressionisme," *Critique* 28 (1972): 755. J. C. Middleton, "Dada versus Expressionism or the Red King's Dream," *German Life and Letters* 15 (1961/62): 37–52.

2. See Sheppard, "Kandinsky's Early Aesthetic Theory," 22–23.

3. Hans Arp, "Der Dichter Kandinsky," in *Wie sie einander sahen: Moderne Maler im Urteil ihrer Gefährten,* ed. H[ans] M[aria] Wingler (Munich: Albert Langen and Georg Müller, 1957), 82–83. See Arp's 29 May 1936 letter to Galka Schreyer, Kandinsky, *GrW,* 448. Arp's poetry is published in Hans Arp, *Gesammelte Gedichte,* 1:24–118 (subsequent citations of his poetry are to this edition by volume and page number).

4. Joachim von der Thüsen, "Hans Arp: 'Das Fibelmeer,'" in *Hans/Jean Arp,* ed. Heinz Ludwig Arnold, Frühe Texte der Moderne (Munich: text + kritik, 1986), 99–106; and Erwin Rotermund, "La Parodie dans la poésie de Hans Arp," in *Mélusine,* no. 9 (*Arp Poète Plasticien*), ed. Aimée Bleikasten (Paris: L'Age d'Homme, 1987), 246–47.

5. See Walter Schmähling, "Hugo Ball und der Expressionismus," *Hugo Ball Almanach* 9/10 (1985/86): 1–62; and Mann, *Hugo Ball,* 27–52.

6. For Kandinsky's influence on Ball in the prewar period, see Sheppard, "Kandinsky's Early Aesthetic Theory," 26–28; numerous references in Ball's diary; Ball, *Briefe 1911–1927*, 28–30; Ball's 26 [June 1914] letter to Kandinsky, ed. Richard Sheppard, *Hugo Ball Almanach* 2 (1978): 66–70; and Zeller and Otten, *Kurt Wolff: Briefwechsel*, 11–13. See also Ball, *Flucht aus der Zeit*, 12–13/9–10; "Das Münchener Künstlertheater," *Phöbus* 1.2 (May 1914): 68–74; and "Das Psychologietheater," *Phöbus* 1.3 (June 1914): 139–40. The second of these two essays is reprinted in *Künstler und die Zeitkrankheit*, 19–20.

7. The program is reproduced in Ernst Teubner, ed., *Hugo Ball (1886–1986): Leben und Werk* (Berlin: publica Verlagsgesellschaft, 1986), 116. For a detailed discussion of the evening, see Gerhard Schaub, "Dada avant la lettre: Ein unbekanntes 'Literarisches Manifest' von Hugo Ball und Richard Huelsenbeck," *Hugo Ball Almanach* 9/10 (1985/86): 68–142.

8. For Rubiner's manifesto, see chapter 3, note 8. Hugo Ball, "Totenrede auf Hans Leybold," *Die weissen Blätter* 2.4 (April 1915): 525; reprinted in *Künstler und die Zeitkrankheit*, 25–26. See also *Briefe 1911–1927*, 41. Ball's and Huelsenbeck's "Literary Manifesto" is reprinted in Teubner, *Hugo Ball (1886–1986)*, 116; and Schaub, "Dada avant la lettre," 86. See St[efan] Gr[ossman]'s report on this evening in the *Vossische Zeitung*, no. 81 (13 February 1915); reprinted in Füllner, *Dada Berlin in Zeitungen*, 3.

9. Ball, *Flucht aus der Zeit*, 13/10. See Andreas Kramer, " 'Wundersüchtig': Carl Einstein und Hugo Ball," *Hugo Ball Almanach* 13 (1989): 63–100, especially 73–75 and 83–85.

10. Kramer, " 'Wundersüchtig,' " 83–89. For Hiller's speech, see Gr[ossman]'s report, 4. On this occasion, Hiller read out Lotz's letters to his wife that had been written between 6 and 25 August 1914. These show a remarkable reversal from an ecstatically pro- to a soberly antiwar stance and are published in Ernst Wilhelm Lotz, *Prosaversuche und Feldpostbriefe aus dem bisher unveröffentlichten Nachlass*, ed. Hellmut Draws-Tychsen (Diessen vor München: Joseph C. Huber, [1955]), 63–76.

11. See Schaub, "Dada avant la lettre," 67–68. Gr[ossman] report, 10–14. Looking back, Huelsenbeck implied that this was done quite deliberately. See Richard Huelsenbeck, "Dada als Literatur," in *Dada, Dokumente einer Bewegung*, ed. Karl Heinz Hering and Ewald Rathke (Düsseldorf: Kunsthalle, 1958).

12. Füllner, *Dada Berlin in Zeitungen*, 12–14. Cf. Richard Sheppard, ed., *Die Schriften des Neuen Clubs 1908–1914*, 2 vols. (Hildesheim: Gerstenberg, 1980–83).

13. Press reports reprinted in Sheppard, *Dada Zürich in Zeitungen*, 10–13. Ball, *Briefe 1911–1927*, 52.

14. Tzara's "Chronique Zurichoise" (see note 30); for *Klänge*, see chapter 6, note 1.

15. Stanza 9 of Heym's "Die Vorstadt" involves the two words "Glöckchen" and "Armesündermette." Huelsenbeck's poem synthesizes these into "Armesünder-

glocke." Cf. Heym, *Dichtungen und Schriften,* 1:134; and Huelsenbeck, Arp, Grosz, *Phantastische Gebete,* 18; *Fantastic Prayers,* 64.

16. The poem in question was not included in the 1960 edition of the *Phantastische Gebete* (Verlag der Arche), but it is reprinted in Huelsenbeck, Arp, and Grosz, *Phantastische Gebete,* 23, and in the English translation *Fantastic Prayers* as "Blissful Rhythms," 72.

17. See Hans Joachim Bähr, "Hugo Ball und Leonhard Frank," *Hugo Ball Almanach* 9/10 (1985/86): 181–220, especially 213. See Ball, *Die Flucht aus der Zeit,* 74/53; *Briefe 1911–1927,* 58.

18. Ball, *Flucht aus der Zeit,* 79/57.

19. According to Huelsenbeck (*Dada siegt!* 15), Rimbaud, whose work was read out in the Cabaret Voltaire on 18 March 1916, was one of the cultural heroes of the Zurich Dadaists because of his turbulent life-style. According to Ball's diary (*Flucht aus der Zeit,* 23/17), Rubiner arrived in Zurich in late May 1915. Two years before that, he had turned his back on the ecstatic irrationalism of "Der Dichter greift in die Politik," and in late 1914 he became one of Hiller's *Aktivisten.* He expressed his commitment to this movement in "Zur Krise des geistigen Lebens," *Zeitschrift für Individualpsychologie* 1 (1916): 231–40; reprinted in Klaus Petersen, ed., *Ludwig Rubiner: Eine Einführung mit Textauswahl und Bibliographie* (Bonn: Bouvier, 1980), 127–35. He recognized the rift separating the *Aktivisten* and the Dadaists from an early date since his article "Hören Sie!" (*Die Aktion* 6.27/28 [8 July 1916]: cols. 377–80) is very obviously a veiled attack on Ball.

20. Ball, "Das erste dadaistische Manifest," 39/220–21; *Flucht aus der Zeit,* 97/62.

21. See Ferdinand Hardekopf's 16 January 1917 letter to Olly Jacques, in Richard Sheppard, "Ferdinand Hardekopf und Dada," *Jahrbuch der Deutschen Schillergesellschaft* 20 (1976): 132–33.

22. See Hugo Ball's 26 June 1917 letter to August Hofmann, *Briefe 1911–1927,* 82; and Hans Arp, "Dadaland," 59.

23. Ferdinand Hardekopf, "Manon: Fragmente eines konventionellen Detektivromans," in *Gesammelte Dichtungen,* ed. Emmy Moor-Wittenbach (Zurich: Verlag der Arche, 1963), 77–90. See also Ball's 26 June 1917 letter to August Hofmann (note 22).

24. See Sheppard, "Ferdinand Hardekopf und Dada," 155–61.

25. See Ball's 28 May 1917 letters to Tzara and Emmy Hennings, *Briefe 1911–1927,* 78–79; and Hans Richter's letters to Tzara of 8 June and [summer] 1917, in Sheppard, *New Studies in Dada,* 122–23.

26. Ball, *Flucht aus der Zeit,* 143/101 (subsequent citations from Ball's diary entries are provided in parentheses). On Kandinsky's "geistige Insel," see chapter 6, note 11.

27. Ball, "Kandinsky," 41–53/222–34; see 47/229 and 45/226.

28. According to the catalogue, these were *Komposition I* (1910–destroyed); *Im-*

provisation 13 (31 August 1910); *Improvisation 21* (October 1911); *Herbst II (Autumn II)* (1912); and *Bild mit rotem Fleck (Painting with Red Spot)* (25 February 1914). They are to be found in the first volume of the *Catalogue Raisonné* detailed in chapter 6, note 1 (306, 333, 380, 420, and 489). See the review from the *Neue Zürcher Zeitung* of 26 April 1917 (reprinted in Sheppard, *Dada Zürich in Zeitungen,* 23–24); also chapter 6, note 67.

29. Quotes from Ball, "Kandinsky," 46–47/228, 49/231, and 53/234.

30. According to the reviewer in the *Neue Zürcher Zeitung* of 26 April 1917 (note 28), the Expressionist paintings included work by Alfred Kubin (whose colors he described as "unheilschwanger" [pregnant with disaster]); Lyonel Feininger (whose work he found strange, disturbing, and threatening); and Albert Bloch (one of whose works he found confusing). But he, like Ball, was blind to the apocalyptic elements in Kandinsky's work. Albert Ehrenstein, "Oskar Kokoschka," *Zeit-Echo,* 1.20 (1914/15): 298–307; "Junges Drama," *Die neue Rundschau* 27 (December 1916): 1711–14. Armin A. Wallas, "Ein expressionistisches *Rapidtheater* als Manifestation des théâTRE DADAISTE," in *Dadautriche 1907–1970,* ed. Günther Dankl and Raoul Schrott (Innsbruck: Haymon, 1993), 52. Wallas argues, very convincingly, that Ehrenstein almost certainly read out "Das sterbende Europa" ("Dying Europe") (which he describes as a "cosmology of violence"), since this poem was especially important to him. These details are taken from Ball's diary and Tzara's "Chronique Zurichoise," 10–28/15–34.

31. The play is reprinted in Oskar Kokoschka, *Schriften 1907–1955* (Munich: Albert Langen and Georg Müller, 1956), 153–67. Brandt, *Bravo! & Bum Bum!* 173. Wallas, "Ein expressionistisches *Rapidtheater,*" 56.

32. See Ball, *Flucht aus der Zeit,* 151/106 and 158–61/112–14. Tzara, "Chronique Zurichoise," 19/25–26.

33. According to the weekly list of publications issued by the *Börsenverein der Deutschen Buchhändler zu Leipzig* of 15 May 1919, Benn's *Der Vermessungsdirigent* had just appeared as no. 9 of Franz Pfemfert's *Aktions-Bücher der Aeternisten.* Ball's diary entry of 24 May 1919 (the first entry since 3 March) indicates that he had been in Berlin in early May. His diary entry of 28 May then says that he has been working on "Der Verwesungsdirigent" for several days now. Consequently, it is almost certain that this chapter was sparked off by Benn's drama, which Ball had read or acquired earlier in the month even though his diary does not anywhere acknowledge Benn as a source.

34. Ball's diary entry of 28 May 1919 (*Flucht aus der Zeit,* 232/165–66) contains a much longer prologue to the chapter in question than the published text of *Tenderenda* (45/131) and describes events that are not included in that version.

35. A good sense of the mood of the period is conveyed by Ball, "Die junge Literatur in Deutschland"; reprinted in *Künstler und die Zeitkrankheit,* 32–35.

36. See Hausmann's 24 July 1915 letter to Höch, cited in Bergius, *Lachen Dadas,* 55.

37. See Bergius, *Lachen Dadas*, 66 and 75 (where Bergius tells us that Haus-mann gave Höch a copy of this novel for her birthday on 1 November 1917); Maier-Metz, *Expressionismus—Dada—Agitprop*, 73–108; Wolfgang Rieger, *Glückstechnik und Lebensnot: Leben und Werk Franz Jungs* (Freiburg: Ça-Ira, 1987), 61–72; and Ernst Schürer, "Angst, Aggression, Destruktion und Utopie: Zur Entwicklung der frühen Prosa Franz Jungs," in *Franz Jung: Leben und Werk eines Rebellen,* ed. Ernst Schürer (Frankfurt/Main: Peter Lang, 1994), 51–104.

38. See Richard Sheppard, "Raoul Hausmann's Annotations of *Die Aktion:* Marginal Notes on Some Contributory Sources to Dada in Berlin," *German Life and Letters* 37 (1983): 24–40.

39. Otto Gross, "Zur Überwindung der kulturellen Krise," *Die Aktion* 3.14 (2 April 1913): cols. 384–87; Ludwig Rubiner, "Psychoanalyse," *Die Aktion* 3.19 (7 May 1913): col. 483; Otto Gross, "Ludwig Rubiners 'Psychoanalyse,'" *Die Aktion* 3.20 (14 May 1913): cols. 506–7; Ludwig Rubiner, "Uff . . . Die Psychoanalyse," *Die Aktion* 3.23 (4 June 1913): cols. 565–68; Ludwig Rubiner, "Erwähnung zur Psychoanalyse," *Die Aktion* 3.25 (18 June 1913): cols. 607–8; Otto Gross, "Die Psychoanalyse oder wir Kliniker," *Die Aktion* 3.26 (25 June 1913): cols. 632–34.

40. See Michels, *Anarchy and Eros,* 101–19; and Sheppard, "Raoul Hausmann's Annotations," 27 and 31.

41. See "Johannes Baader an Salomo Friedlaender," in *Scharfrichter der bürger-lichen Seele: Raoul Hausmann in Berlin 1900–1933,* ed. Eva Züchner (Berlin: Berli-nische Galerie, 1998), 47–49; Exner, *Fasching als Logik,* 264–89. Hausmann, "PRÉsentismus," 136–43/ 2:24–30.

42. See Hubert Van Den Berg, "Tristan Tzaras 'Manifest dada 1918': Anti-Manifest oder manifestierte Indifferenz? Salomo Friedlaenders 'Schöpferische In-differenz' und das dadaistische Selbstverständnis," *Neophilologus* 79 (1995): 353–76. Although Friedlaender's philosophy has several very obvious affinities with Berg-son's, he was antipathetic to Bergson's concept of the *élan vital* and criticized it in two articles of 1913 (Exner, *Fasching als Logik,* 215–16). So it is entirely appropri-ate that when Hausmann read Bergson's essay "Über Kunst" ("On Art") in *Die Aktion* of 4 December 1915, he should have annotated it heavily and written in the margin "Houlah! Bravo! Siehste Salomo!!!" [Hurrah! Bravo! D'you see Salomo!!!] (Sheppard, "Raoul Hausmann's Annotations," 25). He presumably meant that he preferred Bergson's more dynamic view of things to Friedlaender's more static philosophy.

43. Huelsenbeck, *En avant Dada,* 37/43.

44. Bergius, *Lachen Dadas,* 50 and 122.

45. Roland März, "Metropolis—Krawall der Irren: Der apokalyptische Grosz der Kriegsjahre 1914 bis 1918," in Schuster, *George Grosz: Berlin–New York,* 128.

46. Grosz, *Briefe 1913–1959,* 53.

47. Herzfelde and Marquardt, *Pass auf!* 44. Grosz, *Briefe 1913–1959,* 65.

48. Benn, *Werke,* 6:1527.

49. Kapfer and Exner, *Weltdada Huelsenbeck*, 17–19. Though in fairness, Franz Jung's input seems also to have played a major part in this transformation (Maier-Metz, *Expressionismus—Dada—Agitprop*, 141–43).

50. Cf. Maier-Metz, *Expressionismus—Dada—Agitprop*, 133.

51. On the poem "Selige Rhythmen," see note 16.

52. Huelsenbeck, *Dada Almanach*, 107/113.

53. These details emerge from the three press reports reprinted in Füllner, *Dada Berlin in Zeitungen*, 15–18. Stadler's poem is identifiable from the reference in the *Vossische Zeitung* to his "Städtezerschlagende und Brückeüberwölbende Kraft" [power which can smash cities to pieces and arch across bridges] (16).

54. Huelsenbeck, Arp, Grosz, *Phantastische Gebete*, 13–14/58–59.

55. Jakob van Hoddis, "Weltende," in *Dichtungen und Briefe*, 15. Huelsenbeck's poem was first published in *Der Dada*, no. 2 (December 1919): n.p., then in the second edition of the *Phantastische Gebete* (Berlin: Malik, 1920). It is to be found in Kapfer's 1993 edition of the *Phantastische Gebete*, 54–55, and in *Fantastic Prayers*, 82–83.

56. Sheppard, "Raoul Hausmann's Annotations," 25–28.

57. Bergius, *Lachen Dadas*, 52.

58. See Reinhard Nenzel, *Kleinkarierte Avantgarde: Zur Neubewertung des deutschen Dadaismus: Der frühe Richard Huelsenbeck: Sein Leben und Werk bis 1916 in Darstellung und Interpretation* (Bonn: Reinhard Nenzel, 1994), 360–63.

59. Wieland Herzfelde, "Über den Malik-Verlag," in *Der Malik-Verlag 1916–1947* (Berlin and Weimar: Akademie der Künste, 1966), 23.

60. Max Ernst, "Lukrative Geschichtsschreibung," *Die Schammade*, n.p.; see also the trial sheets for *Dadaco* (chapter 5, note 65, [3]) and Huelsenbeck, *En avant Dada*, 35/40 (where Hiller is described as the theoretician of the Expressionist epoch); see also 26/33 and 17/28. Cf. also the disparaging references to Frank in Hans Richter's 21 December 1918 letter to Tzara, *New Studies in Dada*, 128; Franz Jung, "Der Einzug der Franzosen in Berlin," *Die Aktion* 9.10/11 (15 March 1919): cols. 166–67, reprinted in *Werke*, 1/1: 217–18; Huelsenbeck, *Dada siegt!* 53; and Grosz and Herzfelde, *Kunst ist in Gefahr*, 42. When Grosz exhibited his work in 1922 in the Galerie von Garvens (Hanover), the catalogue contained a pamphlet entitled "Der Mensch ist nicht gut—sondern ein Vieh" ("Human Beings are not good—but Beasts"). This is a direct riposte to Leonard Frank's antiwar novel *Der Mensch ist gut* (*Humanity Is Good*), which was first published in Switzerland in 1918 and then reissued in Germany in 1919 where, for a while, it was widely read. See Dwars, "Ein ungeliebter Ehrenbürger," 87–110, for an account of Becher's state of mind at the time.

61. Kurt Hiller, "Philosophie des Ziels," in *Der Aktivismus 1915–1920*, ed. Wolfgang Rothe (Munich: DTV, 1969), 37.

62. On Rubiner, see notes 19 and 39.

63. Max Brod, "Aktivismus und Rationalismus," in *Aktivismus*, 77.

64. Cf. Alfred Wolfenstein, "Der menschliche Kämpfer," in *Aktivismus,* 107. The same image occurs twice more in Rothe's anthology in texts by Ludwig Rubiner (56) and Carl Maria Weber (92).

65. Cf. Maier-Metz, *Expressionismus—Dada—Agitprop,* 120. Cf. Hausmann's remarks on Dada's abolition of the Oedipus Complex in *Am Anfang war Dada,* 11.

66. Richard Huelsenbeck, "Kurt Hiller: Der Sprung ins Helle," *Die literarische Welt* 8.33 (12 August 1932): 5.

67. Raoul Hausmann, "Der geistige Proletarier," *Menschen,* no. 23 (17 February 1919): 3; reprinted in *Texte bis 1933,* 1:31.

68. Raoul Hausmann, "Pamphlet gegen die Weimarische Lebensauffassung," *Der Einzige,* no. 20 (20 April 1919): 163; reprinted in *Texte bis 1933,* 1:39.

69. Huelsenbeck, *En avant Dada,* 36–37/42.

70. Trial sheets for *Dadaco,* [3] (see chapter 5, note 65).

71. Huelsenbeck, *Dada siegt!* 51.

72. Wieland Herzfelde, "Johannes R. Becher: 'An Europa,' 'Verbrüderung,' Gedichte (Kurt Wolff Verlag)," *Neue Jugend,* no. 7 (July 1916): 142–43.

73. Raoul Hausmann, "Der Proletarier und die Kunst," *Das Kunstblatt* 2.12 (December 1918): 388–89; reprinted in *Texte bis 1933,* 1:24–26.

74. See Sheppard, *New Studies in Dada,* 112–13 and 118–19.

75. Raoul Hausmann, "Der deutsche Spiesser ärgert sich," 1:83–84.

76. See Richard Sheppard, "The Cultural Policy of the SPD and Its Reception of the Avant-garde 1917–1922," *Internationales Archiv für Sozialgeschichte der deutschen Literatur* 20 (1995): 16–66.

77. See William Bischoff, "The Action Committee of Revolutionary Artists in the Munich Revolution of 1918–19," *Studies in Modern European History and Culture* 3 (1977): 7–36; Weinstein, *End of Expressionism,* 161–218; and Sheppard, " 'Der Schauspieler greift in die Politik,' " 37–45.

78. Max Ernst and Johannes Baargeld, " 'Revolutionäre' Künstler," *Der Ventilator* 1.3 (1919): 8. See also Jörgen Schäfer, *Dada Köln* (Wiesbaden: Deutscher Universitäts-Verlag, 1993), 58–60.

79. See Richard Sheppard, "Artists, Intellectuals and the USPD 1917–1922," *Literaturwissenschaftliches Jahrbuch* 32 (1991): 175–216.

80. See Sheppard, "Cultural Policy of the SPD" and "Artists, Intellectuals and the USPD."

81. On the Independent Socialist Party, see Sheppard, "Artists, Intellectuals and the USPD." Cf. Maier-Metz, *Expressionismus—Dada—Agitprop,* 191–93.

82. John Heartfield and George Grosz, "Der Kunstlump," *Die Aktion* 10.23–24 (12 June 1920): cols. 327–32; *Der Gegner* 1.10–12 (1919–20): 48–56; reprinted in Walter Fähnders and Martin Rector, eds., *Literatur im Klassenkampf: Zur proletarisch-revolutionären Literaturtheorie 1919–1923* (Frankfurt/Main: Fischer, 1974), 47–54.

83. Cf. note 60.

84. Sheppard, *Avantgarde und Arbeiterdichter,* 81–83.

85. Ibid., 10 and 12. See Bert Kasties, *Walter Hasenclever: Eine Biografie der deutschen Moderne* (Tübingen: Max Niemeyer, 1994), 178–277; and Bernhard F. Reiter, *Walter Hasenclevers mystische Periode* (Frankfurt/Main: Peter Lang, 1997).

86. Richard Sheppard, "Straightening Long-Playing Records: The Early Politics of Berta Lask and Friedrich Wolf," *German Life and Letters* 45 (1992): 282–87.

87. Weinstein, *End of Expressionism,* 50–58.

88. The Group's manifesto is reprinted in Helga Kliemann, *Die Novembergruppe* (Berlin: Gebr. Mann, 1969), 56. "Offener Brief an die Novembergruppe," *Der Gegner* 2 (1920–21): 297–301; reprinted in Kliemann, *Novembergruppe,* 61–64. See also John Willett, *The New Sobriety: Art and Politics in the Weimar Period 1917–33* (London: Thames and Hudson, 1978), 83.

89. See Fähnders and Rector, *Literatur im Klassenkampf,* 27–29.

90. Helen Boorman, "Herwarth Walden and William Wauer: Expressionism and *Sturm* Politics in the Post-war Context," in *Expressionism in Focus,* ed. Richard Sheppard (New Alyth: Lochee Publications, 1987), 95. See, for example, "Der prussien als touredos," *Die Schammade,* n.p.; and Walter Mehring, "Enthüllungen," *Dada Almanach,* 70; "Revelations," *Dada Almanac,* 77. Mehring's remark about the "Taifunisten" [Typhoonists] is a reference to Hermann Essig's satirical roman à clef about Walden's *Sturm-Kreis, Der Taifun* (Leipzig: Kurt Wolff, 1919). See also Hausmann, *Courrier Dada,* 25; "dada empört sich, regt sich und stirbt in berlin," *schoengeist = bel esprit* 7.12 (summer 1970): n.p.; and *Am Anfang war Dada,* 64.

91. Kate Winskell, "The Art of Propaganda: Herwarth Walden and 'Der Sturm,' 1914–1919," *Art History* 18 (1995): 315–44.

92. Sheppard, *Avantgarde und Arbeiterdichter,* 104–7; and Hausmann, "Deutsche Spiesser ärgert sich." Grosz, *Briefe 1913–1959,* 54–55. Kapfer and Exner, *Weltdada Huelsenbeck,* 48.

93. Boorman, "Herwarth Walden and William Wauer," 107–8.

94. See Richard Sheppard, "Die Protokolle von zwei Sitzungen des Revolutionären Zentralrats in München am 12. und 16. April 1919," *Literaturwissenschaftliches Jahrbuch* 33 (1992): 212–51; Sheppard, " 'Der Schauspieler greift in die Politik,' " 38–41; "Die Generalsammlung der U.S.P.," *Neue Zeitung* (Munich), no. 65 (10 March 1919); and [Ernst] Toller and [?] Fendl, "Die politische Kundgebung der U.S.P. München," *Neue Zeitung* (Munich), no. 68 (13 March 1919). The two latter articles give an excellent idea of both the influence that Toller wielded in Munich's Independent Socialist Party and the unreality of his ideas on revolution.

95. Nenzel, *Kleinkarierte Avantgarde,* 244–48.

96. Walter Mehring, "Das Erlebnis August Stramm," *Deutsche Montags-Zeitung* (Berlin), no. 36 (4 September 1916). See M. S. Jones, "Kurt Schwitters, *Der*

Sturm and Expressionism," *Modern Languages* 52 (1971): 157–60; Philip Thomson, "A Case of Dadaistic Ambivalence: Kurt Schwitters's Stramm Imitations and 'An Anna Blume,'" *German Quarterly* 45 (1972): 46–56; and Julia Winkelmann, *Abstraktion als stilbildendes Prinzip in der Lyrik von Hans Arp und Kurt Schwitters* (Frankfurt/Main: Peter Lang, 1995), 162–74.

97. Kurt Schwitters, "Selbstbestimmungsrecht der Künstler," *Anna Blume und Ich,* ed. Ernst Schwitters (Zurich: Verlag der Arche, 1965), 87.

98. Mehring, "Erlebnis August Stramm."

99. See chapter 11, note 13 for the source of the English translation of Schwitters's poem.

Chapter 10

1. Klaus Vondung, "Mystik und Moderne," 147. J. C. Middleton, "Dada versus Expressionism or the Red King's Dream," *German Life and Letters* 15 (1961–62): 50. Leonard Forster, *The Poetry of Significant Nonsense* (Cambridge: Cambridge University Press, 1962), 38. Guenther C. Rimbach, "Sense and Nonsense in the Poetry of Jean Hans Arp," *Germanic Quarterly* 36 (1963): 155. Nancy Wilson Ross, *Hinduism, Buddhism, Zen: An Introduction to Their Meaning and Their Arts* (London: Faber and Faber, 1968), 179–80. See also Idris Parry, "Goethe, Dada and Zen," *German Life and Letters* 22 (1968–69): 111–20. Virginia Whiles, "Tantric Imagery: Affinities with Twentieth-Century Abstract Art," *Studio International* 181.931 (March 1971): 105. Ko Won, *Buddhist Elements in Dada: A Comparison of Tristan Tzara, Takahashi Shinkichi and Their Fellow Poets* (New York: New York University Press, 1977). Erdmute Wenzel White, "Das Wunder der Geisteszwiebel: Hugo Ball—Eine Studie in Paradoxologie," in *Sinn aus Unsinn,* 100–119; "Hugo Ball und Novalis: Vom Bewusstsein der Sprache," *Hugo Ball Almanach* 9/10 (1985/86): 295–319; "Hugo Ball und das Saurapurāṅam," *Hugo Ball Almanach* 19 (1995): 90–120. Harriett Watts, "Periods and Commas: Hans Arp's Seminal Punctuation," in *Dada/Dimensions,* 83–109.

2. Bergius, *Lachen Dadas,* 152. Nenzel, *Kleinkarierte Avantgarde,* 306–42.

3. Richter, *Dada—Kunst und Antikunst,* 59/59. Gray, *Hans Richter,* 109. Arturo Schwarz, ed., *Cinquant' anni a Dada: Dada in Italia 1916–1966* (Milan: Galleria Schwarz, 1966), 64. Huelsenbeck, *Phantastische Gebete,* 12.

4. See Miklavž Prosenc, *Die Dadaisten in Zürich* (Bonn: Bouvier, 1967), 64–69; and Kemper, *Vom Expressionismus zum Dadaismus,* 13–25.

5. *Sirius,* no. 2 (1 November 1915): 45–46. See, for instance, Walter Serner, "Inferno," *Sirius,* no. 1 (1 October 1916): 1–4.

6. Rex Last, "Arp and the Problem of Evil," in *New Studies in Dada,* 60–66; and Schmitz-Emans, "Poesie als Antimechanik," 304. Arp, *On My Way,* 36/82 and

51/94. The two quotations are to be found in Plotinus, *The Enneads,* trans. Stephen MacKenna, ed. B. S. Page, 4th ed. (London: Faber and Faber, 1969), 74 and 64.

7. Arp, *Gesammelte Gedichte,* 2:10–17 and 49–51; 3:70–76.

8. See Jacob Boehme, *The Way to Christ* (New York: McGraw-Hill, 1965), 31–33, 41, and 45–52. See note 11 below.

9. Hans Arp, "Dada war kein Rüpelspiel," in *Das war Dada: Dichtungen und Dokumente,* ed. Peter Schifferli (Munich: DTV, 1963), 121.

10. Hans Arp, "Réponses à des questions posées par George K. L. Morris," in *Jours effeuillés,* ed. Marcel Jean (Paris: Gallimard, 1966), 446; "Interview with George K. L. Morris," in *Arp on Arp: Poems, Essays, Memories,* trans. Joachim Neugroschel, ed. Marcel Jean (New York: Viking, 1969), 350. Richard Huelsenbeck confirmed the importance of the pre-Socratics for Arp in "Dada," *Quadrum,* no. 1 (May 1956): 83.

11. Hans Arp, "Sophie Taeuber," in *Unsern täglichen Traum* (Zurich: Verlag der Arche, 1955), 19. On Otto Flake's novel, see chapter 5, note 76. Arp's brother, François, told Harriet Watts that Arp was reading Boehme as a boy but did not specify which texts. Now, there is a considerable difference between the predominantly alchemical mysticism of Boehme's first book *Aurora, oder Morgenröthe im Aufgang* (1612) (*Aurora, That is, the Day Spring or Dawning of the Day in the Orient,* 1656), which brought the wrath of the Protestant authorities in his native Görlitz down on his head, and the more orthodox Christian mystical texts that he began to write in 1619, after a five-year ban, like *Der Weg zu Christo* (1622). Given that Arp turned to orthodoxy in his later life; that, at the fourth *Dada-Soirée* of 12 and 19 May 1917, he read from two sections of the first chapter of *Aurora* entitled "Von der bitteren Qualität" ("Concerning the Bitter Quality") and "Von der Kälte Qualifizierung" ("Concerning the Qualifying Power of Cold"); and that the older Boehme, like the older Arp, was particularly exercised by the problem of evil, it seems likely that *Aurora* was more decisive for Arp's Dada period. See Watts, "Periods and Commas," 86–87.

12. Otto Flake, "Prognose des Dadaismus," *Der neue Merkur* 4.6 (September 1920): 405 and 407.

13. Hugo Ball, "Der grosse Bauernkrieg 1525," *Zeit im Bild* 13.5 (January 1915): 107; reprinted in *Künstler und die Zeitkrankheit,* 166.

14. Ball, *Briefe 1911–1927,* 104.

15. See White, "Hugo Ball und das Saurapurāṅam," 94–95.

16. See Ball, "Nietzsche in Basel," 32.

17. Ball, *Gesammelte Gedichte,* 24.

18. Mann, *Hugo Ball,* 100. White, "Hugo Ball und das Saurapurāṅam," 104–17.

19. Mann, *Hugo Ball,* 100. White, "Hugo Ball und das Saurapurāṅam," 107 and 110.

20. White, "Hugo Ball und das Saurapurāṅam," 102.

21. Ibid., 101.

22. Nenzel, *Kleinkarierte Avantgarde,* passim.

23. André Suarès, "Über Charles Péguy," trans. Hugo Ball, *Die weissen Blätter* 3.10 (October 1916): 49–54.

24. See chapter 8, notes 27 and 37.

25. Suarès, "Über Charles Péguy," 50–51, 53–54.

26. White, "Hugo Ball und das Saurapurāṇam," 107–9, for the first five citations.

27. Images that occur in Ball's diary entries of 7 and 11 May 1917—i.e., in passages that were set down (or subsequently inserted) between the third and fourth *Dada-Soirées.*

28. See George T. Peck, *The Fool of God: Jacopone da Todi* (Montgomery: University of Alabama Press, 1980), 169. English translations are to be found in Jacopone da Todi, *The Lauds,* trans. Serge and Elizabeth Hughes (London: SPCK, 1982), 223–25, 227–28; 239–40 and 241–42.

29. On Boehme's *Aurora* and the sections Arp read, see note 11. Arp prefaced his reading of Boehme with two pieces of a nonmystical nature. The first of these came, in all probability, from the Insel-Bücherei edition of Dürer's account of his journey through the Low Countries (*Tagebuch der Niederländischen Reise*). Although this is largely an account of money spent, towns visited, lodgings rented, and pictures painted and given away, one or two striking passages deal with the warm, enthusiastic, and generous—almost princely—welcome that Dürer the artist received in certain major cities (notably Antwerp, 16–23). Although the exact text used by Arp is nowhere recorded, it is quite possible that he read out one of the latter passages because of the contrast it formed with the situation of the contemporary artist—especially the expatriates in Zurich. The second piece was a chapter from the *Chronik des Herzogs Ernst* (*The Chronicle of Duke Ernest*) (1480), also available as an Insel-Buch (*Historie eines edlen Fürsten Herzog Ernst von Bayern* [*The History of a Noble Prince, Duke Ernest of Bavaria*]), entitled "Wie er in einer Insel mit gar grossen Vögeln stritt und die auch überwandt" ("How He Fought upon an Island with Great Birds and Also Overcame Them"). Here, the chronicler describes how the Duke and his five friends fought with and overcame a race of fierce birds who were making the lives of a tribe of pygmy island dwellers impossible and established a reign of peace. The analogy with the Dadaists' situation and aspirations for the Galerie Dada must have struck Arp: a small group of questers, exiled from their native countries by war, succeed in dealing with the hostility of Nature and establish "an island of spirituality."

30. Johann Friedrich Ludwig Theodor Merzdorf, ed., *Der Mönch von Heilsbronn* (Berlin: Ebeling and Plahn, 1870), 108. Heilsbronn (Halsprunn or Halsbrune) was probably a Cistercian abbey between Ansbach and Nuremburg. In his diary entry of 12 May 1917, Ball describes his final text as "Aus dem Buche 'Der Johanser zum Grünen Werde zu Strassburg.'" This is almost certainly *Das grosse deutsche Memorial,* several sections of which had been published by 1917 (see

Wilhelm Rath, *Der Gottesfreund vom Oberland,* 2nd ed. [Stuttgart: Freies Geistesleben, 1955], 119–24).

31. Watts, "Periods and Commas," 85.

32. Hermann Diels, ed., *Die Fragmente der Vorsokratiker* (Berlin: Weidmannsche Buchhandlung, 1903), 67–68; *The Pre-Socratic Philosophers: A Companion to Diels,* ed. and trans. Kathleen Freeman (Oxford: Basil Blackwell, 1946), 113–14; also 71/109–14 and 73/115–16. Ball, "Nietzsche in Basel," 34. Arp, "Réponses à des questions posées par George K. L. Morris," 446/350. Tzara, *Surréalisme et l'après-guerre,* 19–20; *Oeuvres,* 5:67.

33. The poems "kaspar ist tot" and "Pupillennüsse 4" ("Pupilnuts 4") are in Arp, *Gesammelte Gedichte,* 1:25–27 and 114. Tzara, *Oeuvres,* 1:107–8. According to Béhar (657), "bitter wing evening" owes something to Paracelsus, and it is interesting that its title should pick up on the concept of "bitterness" that had been central to the second Boehme extract read out by Arp at the fourth *Dada-Soirée.*

34. Tzara, *Oeuvres,* 1:405 and 708; "Note on Poetry," in *Seven Dada Manifestos,* 78.

35. See chapter 7, note 92 for the Tzara passage.

36. Maria Reinhardt, "Im Zeitalter des Wassermanns: Das hagiographische Erbe des neuen Menschen," in *Raoul Hausmann,* 165–66. Sheppard, "Raoul Hausmann's Annotations," 30. Martin Buber, ed., *Reden und Gleichnisse des Tschuang-Tse* (Leipzig: Insel, 1910); Alexander Ular, ed., *Die Bahn und der rechte Weg des Lao-Tse* (Leipzig: Insel, 1912). Chuang Tzu (also known as Chuang Chou) was Lao Tzu's successor and died around 286 B.C. Baader, *14 Briefe Christi;* reprinted in *Johannes Baader,* 22–27.

37. Bergius, *Lachen Dadas,* 123.

38. *Acht Weltsätze* and *Die freie Strasse,* no. 10, reprinted respectively in *Johannes Baader,* 43, and Bergius, *Lachen Dadas,* 86–89; *The Eight World Theses,* trans. Lerke Foster (Iowa City: Center Press, 1980). On his poems in praise of Buddhism, see Johannes Baader, *Ich segne die Hölle,* ed. Dieter Scholz, Vergessene Autoren der Moderne, no. 64 (Siegen, Germany: Universität-Gesamthochschule Siegen, 1995), 22 and 33–34.

39. Daimonides, "Zur Theorie des Dadaismus," in *Dada Almanach,* 54–62; "Towards a Theory of Dadaism," trans. Derk Wynand, in *Dada Almanac,* 62–68.

40. Maurer, *Hannah Höch,* passim.

41. See his 3 February 1917 letter to Bino Sanminiatelli, cited in Enrico Crispolti, "Dada a Roma: Contributo alla partecipazione italiana al Dadaismo," *Palatino* 10.3/4 (July–December 1966): 254.

42. Michel Seuphor, "Perspective sur Dada, Années Vingt," *Cahiers Dada/Surréalisme* 1 (1966): 44.

43. Lista, "Tristan Tzara et le dadaïsme italien," 182.

44. Julius Evola, trans., *Il libro della via e della virtù di Lao-Tze* (Carrabba: Lanciano, 1923), x and xi. Evola also went on to write several books on mystical

and hermetic topics: *Saggi sull' idealismo magico* (Todi: Editrice "Atanòr," 1925); *La tradizione ermetica nei suoi simboli, nella sua dottrina e nella sua "Arte regia"* (Bari: Laterza, 1931); *Il mistero del graal e la tradizione ghibellina dell' impero* (Bari: Laterza, 1937); *La dottrina del risveglio: saggio sull' ascesi buddhista* (Bari: Laterza, 1943) (*The Doctrine of Awakening: A Study on the Buddhist Ascesis,* 1951); and *Lo yoga della potenza* (Milan: Fratelli Bocca, 1949).

45. [Probably Hausmann and/or Baader], "Legen Sie Ihr Geld in Dada an!"

46. Raoul Hausmann, "Dada in Europa," n.p./1:95.

47. Hausmann, "Dada ist mehr als Dada," 42/1:167.

48. Kurt Schwitters, "Tran 35," *Der Sturm* 15.1 (January 1924): 32.

49. See Henderson, *Non-Euclidean Geometry in Modern Art,* 328. Van Doesburg, "Karakteristiek van het Dadaisme," n.p.

50. Tzara, [Speech to the Weimar Dada-Constructivist Congress], 1:420 and 422/108 and 110.

51. Huelsenbeck, *Dada Almanach,* 4/10.

52. Cf. Henderson, *Non-Euclidean Geometry in Modern Art,* 218.

53. Buber, *Ekstatische Konfessionen,* xi, xii, xiv, and xvi.

54. Published in Sheppard, *New Studies in Dada,* 112–14.

55. See Egyptien, "Mythen-Synkretismus und apokryphes Kerygma," 379–95. See Raoul Hausmann, "Objektive Betrachtung der Rolle des Dadaismus," 62–68/1:108–13; "Rückkehr zur Gegenständlichkeit in der Kunst," *Dada Almanach,* 147–51/1:114–17, and *Dada Almanac,* trans. Derk Wynand, 151–56. Huelsenbeck, *Dada siegt!* 48–49; "Die dadaistische Bewegung: Eine Selbstbiographie," 976–77; reprinted in *Wozu Dada,* 38.

56. Richard Huelsenbeck, "Die Arbeiten von Hans Arp," in *New Studies in Dada,* 100.

57. The quotation from Tertullian relates directly to this problem: "crucifixus est dei filius: non pudet, quia pudendum est. et mortuus est dei filius: prorsus credibile est, quia ineptum est. et sepultus resurrexit: certum est, quia impossibile." [The Son of God was crucified: I am not ashamed—because it is shameful. The Son of God died: it is immediately credible—because it is silly. He was buried, and rose again: it is certain—because it is impossible.] Ernest Evans, ed., *Tertullian's Treatise on the Incarnation/De Carne Christi,* bilingual ed. (London: SPCK, 1956), 18 and 19.

58. Jean Crotti, "Tabu," *The Little Review* 8 (spring 1922): 45.

59. Hanne Bergius, "Zur phantastischen Politik der Anti-Politik Johannes Baaders oder Die unbefleckte Empfängnis der Welt," in *Johannes Baader,* 182. For the reprint of Baader's *Acht Weltsätze,* see note 38. Johannes Baader, "Wie der Kanzler am 19. Juli 1917 zu sprechen hatte," *Die freie Strasse,* no. 10 (December 1918): 4; reprinted in Bergius, *Lachen Dadas,* 89.

60. Juan Mascaró, introduction to *The Bhagavad Gita* (London: Rider, 1962), 30 (page citations are to this edition).

61. The numerals in parentheses refer to sections of the *Tao Te Ching*.

62. James Legge, trans., Max Müller, ed., *The Texts of Taoism*, 2 vols. (Oxford: Clarendon, 1891), 2 (*The Writings of Kwang Tze*): 63.

63. Hausmann, *Am Anfang war Dada*, 13–14.

64. Legge and Müller, *Writings of Kwang Tze*, 59.

65. Ibid., 130.

66. Ko Won, *Buddhist Elements in Dada*.

67. Albert Chemia, *Cahiers Dada/Surréalisme* 1 (1966): 129

68. For the information on the art of Zen, I am entirely indebted to chapter 4 of Alan W. Watts, *The Way of Zen* (London: Penguin, 1971).

69. Cf. Marian Malet, "Hans Arp and the Aesthetics of the Workshop," in *New Studies in Dada*, 67–74. Arp, "Art is a fruit"/"L'art est un fruit," in *On My Way*, 50 and 93–94; "Konkrete Kunst," in *Unsern täglichen Traum*, 79.

70. Watts, "Periods and Commas," 100–105.

71. Arp, "Holy silence"/"Die heilige Stille," in *On My Way*, 37 and 83.

72. Hans Arp, "Das Fibelmeer," *Der Zeltweg* [no. 1] (November 1919): 12; *Gesammelte Gedichte* 1:117.

73. Arp, "See Reproduction"/"Siehe Abbildung," in *On My Way*, 52 and 95.

74. Arp, *Gesammelte Gedichte*, 3:166.

75. Last, "Arp and the Problem of Evil," 64–65.

76. White, "Hugo Ball und das Saurapurāṅam," 111–15.

77. Ball, *Tenderenda der Phantast*, 60/144.

78. Cf. Kurt Flasch, "Von der 'Kritik der deutschen Intelligenz' zu Dionysius Areopagita," in *Dionysius DADA Areopagita*, 123–24; and Thomas Ruster, "Hugo Balls 'Byzantinisches Christentum' und der Weimarer Katholizismus," in ibid., 195–96 and 202. Ball's need for fixed hierarchies also explains why he increasingly cited Franz von Baader in his diary—a Catholic theologian who advocated theocratic statehood and had been particularly influential on the German Romantics.

79. Cf. the very telling illustration in Mann, *Hugo Ball*, 151.

80. Hugo Ball, *Byzantinisches Christentum* (Munich: Duncker and Humblot, 1923), 126 and 127–28.

81. Berman, *All That Is Solid*, 345–46.

Chapter 11

1. See Schuster, *George Grosz: Berlin–New York*, 410. Grosz's self-portrait of 1919 (which he dedicated to Chaplin) is reproduced on the same page. In *Dada*, no. 4/5 (May 1919): n.p., Tzara said that Chaplin had announced his allegiance to the Dada Movement and in *Wat is Dada???????* 9/133, Van Doesburg also said that Chaplin was a Dadaist.

2. C. G. Jung, "On the Psychology of the Trickster-Figure," trans. R. F. C. Hull, in *Collected Works*, 20 vols. (London: Routledge and Kegan Paul, 1953–83),

9/1:255–72. Mikhail Bakhtin, *Rabelais and His World* (Cambridge: MIT Press, 1968) (subsequent page citations are to these editions).

3. Jung, "On the Psychology of the Trickster-Figure," 255.

4. Bakhtin, *Rabelais and His World*, 4 and 10 (subsequent page citations are to this edition).

5. Walter Muschg, "Der Zauber der Abstraktion in der Dichtung," *Euphorion* 58 (1964): 238. I. K. Bonset, "Over het nieuwe vers en het aaneengeknoopte touw," *De Stijl* 3.8 (June 1920): 71. Bakhtin, *Rabelais and His World*, 27; Jung, "On the Psychology of the Trickster-Figure," 264. Huelsenbeck, *En avant Dada*, 12–13/26. Tzara, "Pierre Reverdy: Le Voleur de Talan," 1:399–400/65. Hausmann, *Material der Malerei Plastik und Architektur*, 1:19. Mary Ann Caws, *The Poetry of Dada and Surrealism* (Princeton: Princeton University Press, 1970), 71.

6. Hans Arp, "kaspar ist tot," *Dada*, nos. 4–5 (May 1919): n.p.; also in *Dada Almanach*, 114–15/119; *der vogel selbdritt* (Berlin: n.p., 1920), n.p.; *Gesammelte Gedichte*, 1:25–27. The earliest English translation (of the first version) known to me is to be found in Arp's *On My Way*, 10.

7. Leonard Forster, "Un 'Wackés' cosmique," *Saisons d'Alsace*, no. 22 (1967): 209–12.

8. Jung, "On the Psychology of the Trickster-Figure," 265. Bakhtin, *Rabelais and His World*, 276.

9. On Arp's "kaspar ist tot," see note 6. For Sophie as a star, see Arp, *Gesammelte Gedichte*, 2:16 and 50; on her death, 2:16; on her power as a good force, see 3:70–76. Last, "Arp and the Problem of Evil," 65.

10. Arp, *Gesammelte Gedichte*, 1:30.

11. Both poems were wrongly attributed to Raoul Hausmann by Michel Sanouillet and myself because of the situation of their manuscripts in the Dossier *Dadaglobe* in the Fonds Doucet (Paris) (see Michel Sanouillet, ed. "Le Dossier de 'Dadaglobe,'" *Cahiers Dada/Surréalisme* 1 [1966]: 118 and 131–32; and Hausmann, "Neun kurze Beiträge aus den Dada-Jahren," 164). Erlhoff compounded this error by printing both poems in Hausmann, *Texte bis 1933*, 2:41–44, as did Hausmann's most recent bibliographers (Bartsch and Koch, *Raoul Hausmann*, 364). But quite apart from the extensive internal evidence that the poems were written by Arp, his as yet unpublished 26 February 1920 letter to Tristan Tzara (Fonds Doucet) makes it quite clear that "Der Dadamax" (and therefore, presumably "Der Baargeld," since Arp worked in Cologne with both Ernst and Baargeld) is by him.

12. Bakhtin, *Rabelais and His World*, 26.

13. The poems were first published in *Der Sturm* 10.5 (August 1919): 72 and *Anna Blume Dichtungen* (Hanover: Paul Steegemann, 1919), 29; reprinted in Schwitters, *Literarische Werk*, 1:58–59 and 65; "Ann Blossom Has Wheels," trans. Myrtle Klein, *Transition*, no. 3 (June 1927): 144–45. A more recent translation is "To Eve Blossom," in *Three Painter-Poets: Arp/Schwitters/Klee: Selected Poems*, ed. and trans. Harriett Watts (Harmondsworth, England: Penguin, 1974), 74–75.

Correctly translated, the line "Anna Blume hat ein Vogel" means "A bird has Anna Blume." Translated, however, without strict regard for grammar in the context of a poem that invites palindromic readings, the sentence means "Anna Blume has a bird" which, in colloquial parlance, means "Anna Blume is nuts."

14. Bakhtin, *Rabelais and His World*, 21.

15. Tzara's "Les Saltimbanques" was first published in *Noi* 3.1 (January 1920): 13. It then appeared in a radically altered form in *Mécano* (blue) (1922): n.p.; reprinted in Tzara, *Oeuvres*, 1:235–36. In *Mécano* the poem is dated 1915; in Tzara's *De nos Oiseaux* (Paris: Éditions Kra, 1929), 108–9, however, the poem is dated 1916. According to Béhar (Tzara, *Oeuvres*, 1:681–82), the poem goes back to 1914 and was modified in 1916 by the addition of primitivizing elements—presumably as a result of Tzara's encounter with Huelsenbeck.

16. Bakhtin, *Rabelais and His World*, 78 and 317; see also 25–26.

17. Tzara's "Le géant blanc lépreux du paysage" was first published in *Le Pagine* 2.7 (15 March 1917): 101–3 and then in *Dada*, no. 3 (December 1918): n.p.; reprinted in Tzara, *Oeuvres*, 1:87–88. Bakhtin, *Rabelais and His World*, 317.

18. Reprinted in Huelsenbeck, Arp, Grosz, *Phantastische Gebete*, 18–19; *Fantastic Prayers*, 64. See chapter 8, notes 32 and 91.

19. On Heym, see chapter 9, note 15.

20. Hugo Ball's "Cabaret 3" was first published in *Cabaret Voltaire* (May 1916): 24; reprinted as "Cabaret 1" in Ball, *Gesammelte Gedichte*, 23. Ball, *Tenderenda der Phantast*, 121–28/148.

21. For a discussion of this point, see Karl Kraus's two essays on the variety theater that appeared in *Die Fackel* on 13 May 1909 (12–13) and 25 October 1909 (17–22) and of which the longer, "Bekannte aus dem Varieté," subsequently appeared in *Die chinesische Mauer* (Munich: Albert Langen, 1910). See also F. T. Marinetti, "Il teatro di varietà," *Lacerba* 1.19 (1 October 1913): 209–11.

22. Benjamin Péret, "Immortelle maladie 2" (1924), in *Oeuvres complètes*, ed. Les Amis de Benjamin Péret, 7 vols. (Paris: Le Terrain vague, 1969–95), 1:36.

23. Paul Éluard and Max Ernst, "Les Ciseaux et leur père," in *Les Malheurs des immortels* (Paris: Editions Librairie Six, 1922), n.p.; reprinted in Paul Éluard, *Oeuvres complètes*, ed. Marcelle Dumas and Lucien Scheler, 2 vols. (Paris: Gallimard, 1968), 1:123.

24. Ibid., 1:133.

25. Francis Picabia, *Jésus-Christ rastaquouère* (Paris: Au sans pareil, 1920); reprinted in Francis Picabia, *Écrits*, ed. Olivier Revault d'Allonnes and Dominique Bouissou, 2 vols. (Paris: Pierre Belfond, 1975–78), 1:236–68.

26. Rimbaud, *Oeuvres*, 197–98/171–73.

27. L. H. Neitzel, "Hans Arp–Sophie Taeuber-Arp," *Das Kunstwerk* 9.2 (1955–56): 9. See chapter 10, note 11.

28. Huelsenbeck, "Chorus sanctus," in *Phantastische Gebete*, 19; *Fantastic Prayers*, 65; "Erste Dadarede," 106/112.

29. Felice C. Ronca, "The Influence of Rimbaud on Max Ernst's Theory of Collage," *Comparative Literature Studies* 14 (1979): 43–44.

30. See especially Georg Simmel, *Lebensanschauung: vier metaphysische Kapitel* (Munich and Leipzig: Duncker und Humblot, 1918), 20–23.

Chapter 12

1. Huyssen, *After the Great Divide,* 4. Toril Moi, *Sexual/Textual Politics: Feminist Literary Theory* (London: Routledge, 1985), 172.

2. Camfield, *Francis Picabia,* 221–22 and 250.

3. Sheppard, "Julius Evola, Futurism and Dada," 85–94.

4. Kapfer and Exner, *Weltdada Huelsenbeck,* 163 and 170.

5. Karin Füllner, "*The Meister-Dada:* The Image of Dada through the Eyes of Richard Huelsenbeck," in *New Studies in Dada,* 25–26.

6. Kapfer and Exner, *Weltdada Huelsenbeck,* 178.

7. Richard Huelsenbeck, "Dada Lives," *Transition,* no. 25 (fall 1936): 77–80; reprinted in Motherwell, *Dada Painters and Poets,* 279–81.

8. Middleton, "Dada versus Expressionism," 46.

9. Flake, *Nein und Ja,* 55.

10. Ball, "Das Münchener Künstlertheater," 73.

11. Ball, "Das Psychologietheater," 140; reprinted in *Künstler und die Zeitkrankheit,* 20.

12. H[ugo] B[all], "Deutsch-Ostafrika und die Kautschukkrise," *Zeit im Bild* 12.3 (22 January 1914): 177.

13. See Ottokar Böhm (pseud. Hugo Ball), "Berthold Schwarz, der Erfinder des Schiesspulvers," *Zeit im Bild* 13.10 (7 March 1915): 230–32; reprinted in *Künstler und die Zeitkrankheit,* 153–60. In this article, which is intelligible only in the light of Ball's experiences at the front in the previous autumn, Ball implicitly censures the inventors of gunpowder. Ball's choice of pseudonym is also significant since it refers to King Ottokar of Bohemia, the hero of Franz Grillparzer's drama *König Ottokars Glück und Ende* (1825), who falls from grace through tragic hubris.

14. Hugo Ball, "Jaurès über die französische Armee," *Zeit im Bild* 12.46 (12 November 1914): 1960–61; reprinted in *Künstler und die Zeitkrankheit,* 194 and 197.

15. Ball, *Briefe 1911–1927,* 40.

16. Ball, *Flucht aus der Zeit,* 24–25/18–19. *Der Revoluzzer* appeared in Zurich between January 1915 and July 1916. Fritz Brupbacher was a left-wing Swiss doctor who had visited Russia in 1910 and married a Russian student. He had been a friend of Kropotkin and was closely associated with left-wing workers' organizations in Switzerland. See Karl Lang, *Kritiker, Ketzer, Kämpfer: Das Leben des Arbeiterarztes Fritz Brupbacher* (Zurich: Limmat, 1975); also Ernst Teubner, ed.,

"Hugo Ball: Briefe und Karten an Fritz Brupbacher und Rudolf Grossmann," *Hugo Ball Almanach* 5 (1981): 117–23.

17. H[ugo] B[all], "Emporkömmlinge," *Der Revoluzzer* 1.8 (July 1915): n.p.

18. H[ugo] B[all], "Zürich," *Die weissen Blätter* 2.7 (July 1915): 939; reprinted in *Künstler und die Zeitkrankheit*, 31.

19. Richard Sheppard, ed., *Hugo Ball Almanach* 1 (1977): 1–3.

20. See Mann, *Hugo Ball*, 60–62. Ball, *Briefe 1911–1927*, 49. Ball's fears about the *Lumpenproletariat* are visible in his remarks about the potential violence of the undisciplined Russian army in "Die Russen in der Mandschurei und—in Polen," *Zeit im Bild* 13.1 (3 January 1915): 15–16; reprinted in *Künstler und die Zeitkrankheit*, 198–202; and in his reservations about the "ungemässigten Bauern" [immoderate peasantry] who had caused their own destruction in "Der grosse Bauernkrieg 1525," *Zeit im Bild* 13.5 (31 January 1915): 109; reprinted in *Künstler und die Zeitkrankheit*, 169. See also Gerhard Schaub, "Der 'latente Bakunist' Hugo Ball: Zum Vorwort seines Romans 'Flametti,'" *Hugo Ball Almanach* 14 (1990): 25–114, especially 40–58.

21. Ball, *Flucht aus der Zeit*, 45/32.

22. Ibid., 53/38.

23. Schaub, "'Latente Bakunist' Hugo Ball," 29. Ball crossed out the text in square brackets in the manuscript.

24. Ball, *Flucht aus der Zeit*, 72/52. Hubert Van Den Berg, "Hugo Ball und der Anarchismus," *Hugo Ball Almanach* 13 (1989): 115. As this book was going to press, an exhaustive study of Dada and anarchism appeared: Hubert Van Den Berg, *Avantgarde and Anarchismus: Dada in Zürich und Berlin* (Heidelberg: C. Winter, 1999).

25. Ball, *Briefe 1911–1927*, 72.

26. Erich Mühsam, *In meiner Posaune muss ein Sandkorn sein: Briefe 1900–1934*, ed. Gerd W. Jungblut, 2 vols (Vaduz: Topos, 1984); *Tagebücher 1910–1924*, ed. Chris Hirte (Munich: DTV, 1994), 151. Cf. Van Den Berg, "Hugo Ball und der Anarchismus," 108; "Gustav Landauer und Hugo Ball," *Hugo Ball Almanach* 19 (1995): 123. Ball, *Flucht aus der Zeit*, 13/11. For his comments on Thomas Münzer, see Ball, "Der grosse Bauernkrieg 1525."

27. Richard Sheppard, ed., "Hugo Ball an Käthe Brodnitz: Bisher unveröffentlichte Briefe und Kurzmitteilungen aus den 'Dada'-Jahren," *Jahrbuch der Deutschen Schillergesellschaft* 16 (1972): 40. Fritz Brupbacher, *Marx und Bakunin* (Munich: G. Birk, 1913); reprinted (Berlin: Verlag Die Aktion, 1922); and Karl Lang, ed. (Berlin: Karin Kramer, 1976) (subsequent page citations are to the third edition). See Ball, *Flucht aus der Zeit*, 136/96; and Teubner, "Hugo Ball," 117–50.

28. Ball, "Die junge Literatur in Deutschland," n.p.; reprinted in *Künstler und die Zeitkrankheit*, 32–33. Here, Ball mentions the availability of the abridged version of Nettlau's biography with an afterword by Gustav Landauer (Berlin: P. Pawlowitsch, 1901) and the *Sozialpolitischer Briefwechsel mit Alexander Herzen und*

Ogarjow, trans. Boris Minzès, ed. Michail Dragomanow (Stuttgart: Cotta, 1895). Apart from these two works, only a few short tracts by Bakunin had appeared in Germany by 1915.

29. On borrowing Brupbacher's texts, see Ball, *Flucht aus der Zeit,* 136/96; and Teubner, "Hugo Ball," 117–50. The breviary survived as a two-volume typescript until the 1970s. In the mid-1970s, Ball's stepdaughter, Annemarie Schütt-Hennings, told me that one of the volumes had been lost a few years previously by the Swiss publishing house to which she had sent it for inspection and that only the volume comprising translated extracts from Bakunin's letters had survived. But judging from a remark by Hans Burkhard Schlichting ("Anarchie und Ritual: Hugo Balls Dadaismus," in *Dionysius DADA Areopagita,* 62), it seems as though the missing volume has been found and both volumes will soon appear in print.

30. See Ball's 1 and 23 August 1919 letters to Brupbacher, in Teubner, "Hugo Ball," 130–33.

31. Ball, *Kritik,* 131/114.

32. For these diary entries, see Ball, *Flucht aus der Zeit* (December 1914), 16–17/12–13; (June 1917) 164–65/118; (July 1917) 170–71/122; (mid-September 1917) 189/136.

33. Ball, *Kritik.*

34. Ball, *Flucht aus der Zeit,* 140/99. Ball, "Junge Literatur in Deutschland," n.p./32. See also Ball, "Nietzsche in Basel," 32.

35. See Brupbacher, *Marx und Bakunin,* 40–41 and 43.

36. Ball, *Flucht aus der Zeit,* 118/84 and 149/105. Cf. Reinhart Meyer et al., *Dada in Zürich und Berlin 1919–1920: Literatur zwischen Revolution und Reaktion* (Kronberg/Ts.: Scriptor, 1973), 91, where the similarity between Bakunin and Ball's Flametti, the embodiment of animal vitality and a member of the *Lumpenproletariat,* is remarked upon. Schaub discusses this connection at greater length (60–95) and more or less agrees with my contention that Ball was a "latenter Bakunist" [closet follower of Bakunin] (79).

37. Mikhail Bakunin, *Considérations philosophiques sur le fantôme divin, sur le monde réel et sur l'homme* (1870), in *Oeuvres,* ed. Max Nettlau (1) and James Guillaume (2–6), 6 vols. (Paris: P. V. Stock, 1895–1913), 3:217–18 (subsequent page citations are to this edition).

38. Ball, *Flucht aus der Zeit,* 25/19.

39. Cf. Ball, *Flucht aus der Zeit,* 17/13; and Brupbacher, *Marx und Bakunin,* 110. See also Ball, *Flucht aus der Zeit,* 172–73/123–24.

40. Ball, *Kritik,* 131/114.

41. Van Den Berg, "Gustav Landauer und Hugo Ball," 127–28, 133 and 137–38.

42. Cf. Richard Huelsenbeck's skeptical comments on the *Revoluzzer-Kreis* in *Dada siegt!* 14.

43. Tzara, *Surréalisme et l'après-guerre,* 51–52; *Oeuvres,* 5:85.

44. See "Walther Rathenau" in Hugo Ball, *Almanach der freien Zeitung* (Berne: Der Freie Verlag, 1918), 180. For postwar articles on Germany's guilt, see, for instance: Hugo Ball, "An die in Berlin," *Die freie Zeitung* 2.96 (30 November 1918): 385; "Die Nationalversammlung," 2.98 (7 December 1918): 393–94; "Die moralische und die Wirtschaftsrebellion," 3.5 (15 January 1919): 17; and "An unsere Freunde und Kameraden," 3.18 (1 March 1919): 69; all four reprinted in *Künstler und die Zeitkrankheit*, 234–36, 241–44, and 250–57.

45. See Hugo Ball, 18 March 1926 letter to Pater Beda Ludwig, *Briefe 1911–1927*, 249.

46. Hugo Ball, "Vom Universalstaat," *Die freie Zeitung* 2.26 (30 March 1918): 106–7; *Almanach der freien Zeitung*, 129; reprinted in *Künstler und die Zeitkrankheit*, 177–79.

47. Hugo Ball, "Theatertrust," *Zeit im Bild* 12 (23 April 1914): 900; see Richard Sheppard, "Sixteen Forgotten Items by Hugo Ball from the Pre-Dada Years," *German Life and Letters* 29 (1976): 362–69, where Ball's attraction to utopian structures is discussed more fully. Ball, *Flucht aus der Zeit*, 18–19/13–14. On his preference for Kurt Hiller, see Ball's 9 April 1915 letter to Käthe Brodnitz (Sheppard, "Hugo Ball an Käthe Brodnitz," 41).

48. Cited in Mann, *Hugo Ball*, 131.

49. Ball, *Briefe 1911–1927*, 108. Huelsenbeck, ["Die Unterzeichneten beehren sich . . ."], 98–99. Sheppard, "Ferdinand Hardekopf und Dada," 132–61; "Artists, Intellectuals and the USPD," 192 n. 58.

50. Richter said more to me on this topic in two letters, dated 13 April and 7 May 1975, both now in the Deutsches Literaturarchiv (Marbach/Neckar).

51. Ball, *Flucht aus der Zeit*, 13–15 and 26/10–11 and 19. Gray, *Hans Richter*, 67; also 30 and 58. Petr Kropotkin, *Mutual Aid: A Factor of Evolution* (Boston: Porter Sargent, 1914), 5, 6, and 57.

52. Letter to me from Hans Richter, dated 31 May 1975, now in the Deutsches Literaturarchiv (Marbach/Neckar). Gray, *Hans Richter*, 32.

53. See Schrott, *Walter Serner*, 11; and the various press reports on the evening reproduced in Sheppard, *Dada Zürich in Zeitungen*, 51–57. The translation of Serner's manifesto is to be found in *Blago Bung, Blago Bung, Bosso Fataka!* 153–60.

54. This letter is in the third folder (*Sympathie–Antipathie: Korrespondenz für-gegen Kurt Eisner*) of file MA 102378 in the Bayrisches Hauptstaatsarchiv (Munich).

55. Sheppard, *Dada Zürich in Zeitungen*, 37–50; *New Studies in Dada*, 127.

56. Sheppard, *Dada Zürich in Zeitungen*, 42 and 49.

57. Sheppard, *Avantgarde und Arbeiterdichter*, 83–88.

58. See his 13 March 1919 letter to Tzara, *New Studies in Dada*, 131.

59. The Bundesarchiv (Stiftung Archiv der Parteien und Massenorganisationen der DDR) (Berlin) holds an undated list on headed notepaper of the twelve members of the *Aktionsausschuss* in which this function is assigned to Richter (ZPA NL

60/123, 78–79). Justin Hoffmann, "Hans Richter und die Münchener Räterepublik," in *Hans Richter 1888–1976*, ed. Rolf Szymanski, Felix A. Baumann, and Armin Zweite (Berlin: Akademie der Künste, 1982), 21–25.

60. Justin Hoffmann, "Hans Richter und die Münchener Räterepublik," 23–24. See also chapter 9, note 77.

61. Sheppard, *Dada Zürich in Zeitungen*, 58. A variant version is to be found in Verkauf, *Dada: Monograph of a Movement*, 47.

62. Sheppard, *Dada Zürich in Zeitungen*, 67–68.

63. Callinicos, *Against Postmodernism*, 23.

64. Cited in Werner Schmalenbach, *Kurt Schwitters* (Cologne: DuMont, 1967), 47. See also Maier-Metz, *Expressionismus—Dada—Agitprop*, 198–99.

65. See Maier-Metz, *Expressionismus—Dada—Agitprop*, 311; Bergius, *Lachen Dadas*, 76; and Jung's letters to Cläre Jung, dated 31 January 1959, and Georges Hugnet, dated [December 1960], *Werke*, 9/1:632–33 and 694–95.

66. Maier-Metz, *Expressionismus—Dada—Agitprop*, 184 and 200.

67. See the press reports in Füllner, *Dada Berlin in Zeitungen*, 33–36, and Maier-Metz, *Expressionismus—Dada—Agitprop*, 236.

68. See the diagram of the organization of VIVA in 1922–23 in the Bundesarchiv (Stiftung Archiv der Parteien und Massenorganisationen der DDR) (Berlin) (ZPA I 2/4/17).

69. Reproduced in Schuster, *George Grosz: Berlin–New York*, 451–55.

70. Maier-Metz, *Expressionismus—Dada—Agitprop*, 200.

71. Peter Grupp, *Harry Graf Kessler 1868–1937: Eine Biografie* (Munich: Beck, 1995), 167 and 182. Kessler, *Tagebücher 1918 bis 1937* (page citations are to this edition).

72. See McCloskey, *George Grosz and the Communist Party*, 55–58.

73. See Kessler, *Tagebücher 1918 bis 1937*, 158 and 162. McCloskey, *George Grosz and the Communist Party*, 59.

74. McCloskey, *George Grosz and the Communist Party*, 62–64.

75. Kessler, *Tagebücher 1918 bis 1937*, 164–65, 176.

76. See file ZPA I 1/1/2 in the Bundesarchiv (Stiftung Archiv der Parteien und Massenorganisationen der DDR) (Berlin).

77. The East Berlin half of the Akademie der Künste holds the papers of the actor/director Gustav von Wangenheim (1895–1975). These contain a seventeen-page-long, typewritten, autobiographical sketch written when von Wangenheim was fifty-six. Although he joined the KPD in the early 1920s and although, unlike many would-be Communists of the time, he applied himself to the study of Marxism-Leninism, he records that the relatively few artists who joined the KPD lived a relatively isolated existence within the party and that "Feindseligkeit und Verständnislosigkeit gegenüber dem Künstler und Intellektuellen war in Arbeiterkreisen und der Partei an der Tagesordnung, die Unterstützung sehr gering" [hos-

tility and incomprehension toward the artist and intellectual was quite normal in working-class circles and the party, and they enjoyed very little support] (4). Cf. also Max Barthel, "Spartakus und die Geistigen," *Die rote Fahne*, no. 76 (13 May 1920).

78. Maier-Metz, *Expressionismus—Dada—Agitprop*, 304.

79. Kessler, *Tagebücher 1918 bis 1937*, 233.

80. Gertrud Alexander, "Dada," *Die rote Fahne*, no. 139 (25 July 1920); reprinted in Fähnders and Rector, *Literatur im Klassenkampf*, 100–102.

81. See McCloskey, *George Grosz and the Communist Party*, 65–67; also Heartfield and Grosz, "Kunstlump." Gertrud Alexander, "Herrn John Heartfield und George Grosz," *Die rote Fahne*, no. 99 (9 June 1920); reprinted in Fähnders and Rector, *Literatur im Klassenkampf*, 55–57.

82. "Kulturprobleme und Diktatur des Proletariats," *Die rote Fahne*, no. 122 (6 July 1920).

83. Grosz's first drawing appeared in *Die rote Fahne* on 1 May 1921; Franz Jung's first literary work was serialized there from 6 July to 7 August 1921; Wieland Herzfelde's first contribution was published there on 27 September 1921 and Piscator's manifesto "An alle Künstler und Intellektuelle[n]" ("To all Artists and Intellectuals") on 8 October 1921. In his 14 September 1921 letter to Karl Radek, Franz Jung, then still a member of the KAPD, graphically describes the hostility between the KPD and splinter groups; comments on the lack of good left-wing literature in Germany; and suggests that he had been allowed to contribute to *Die rote Fahne* in April 1921 only pseudonymously (*Werke*, 9/1:72–75). Jung's pseudonymous contribution to *Die rote Fahne* of 28 April 1921 is reproduced in Jung, *Werke*, 9/2 (*Abschied von der Zeit*): 507–10. Cf. Richard Sheppard, "*Proletarische Feierstunden* and the Early History of the *Sprechchor 1919–1923*," *Internationales Archiv für Sozialgeschichte der deutschen Literatur* 8. Sonderheft (1997): 178.

84. Grosz, *Briefe 1913–1959*, 46.

85. On the origins of this painting, see McCloskey, *George Grosz and the Communist Party*, 73. Cf. Maier-Metz, *Expressionismus—Dada—Agitprop*, 206 and 289.

86. Kessler, *Tagebücher 1918 bis 1937*, 160–61. See Schuster, *George Grosz: Berlin–New York*, 456–58.

87. Grosz, *Briefe 1913–1959*, 80. William A. Pelz, *The Spartakusbund and the German Working-Class Movement 1914–1919* (Lewiston/Queenston: Edwin Mellen, n.d.), 205–7.

88. Bergius, *Lachen Dadas*, 176; and McCloskey, *George Grosz and the Communist Party*, 95–97.

89. Schuster, *George Grosz: Berlin–New York*, 460–61.

90. McCloskey, *George Grosz and the Communist Party*, 24.

91. Beth Erwin Lewis, *George Grosz: Art and Politics in the Weimar Republic* (Madison: University of Wisconsin Press, 1971), 132. McCloskey provides a de-

tailed account of Grosz's increasingly fraught relationship with the KPD from 1924 to 1931 (*George Grosz and the Communist Party*, 104–47).

92. See Maier-Metz, *Expressionismus—Dada—Agitprop*, 323–25.

93. On Otto Gross, see chapter 7, note 29. Franz Jung, "Vorbedingungen des Zufalls," *Die freie Strasse*, no. 1 (1915): 4; reprinted in *Werke*, 1/1:113.

94. Franz Jung, "Rede gegen Gott," *Die freie Strasse*, no. 1 (1915): 8; reprinted in *Werke*, 1/1:120.

95. Jung, "Vorbedingungen des Zufalls," 3–4/112–13.

96. By 1920, two streams were visible in German Anarchism—"Individual Anarchism" (deriving from Max Stirner's *Der Einzige und sein Eigenthum* [1845] and represented at the time by the group around *Der Einzige* [see Dieter Lehner, *Individualanarchismus und Dadaismus* (Frankfurt/Main: Peter Lang, 1988)]) and revolutionary "Anarcho-Communism" (deriving from the works of Bakunin and Kropotkin and represented at the time by Erich Mühsam). Although Hausmann contributed two articles to *Der Einzige* (one pseudonymously [see note 97, below]), his thinking, in parallel with Otto Gross's assimilation of Kropotkin's ideas (Maier-Metz, *Expressionismus—Dada—Agitprop*, 53), moved away from "Individual Anarchism" in 1919 and toward "Anarcho-Communism."

97. Raoul Hausmann, "Menschen. Leben. Erleben" (1917), *Menschen*, no. 10 (15 December 1918): 2; reprinted in *Texte bis 1933*, 1:23. Cf. also Jung's 31 February 1917 [!] letter to Hermann Kasack (*Werke*, 9/1:13), where he discusses the concept of "Erlebnis," and Maier-Metz, *Expressionismus—Dada—Agitprop*, 161. "Erleben" literally means "to experience" or "experiencing." The other eight articles are, in chronological order: (1) "Zu Kommunismus und Anarchie" (signed Panarchos), *Der Einzige*, no. 1 (26 January 1919): 5–7; (2) "Der geistige Proletarier," *Menschen*, no. 23 (17 February 1919): 3; (3) "Der Besitzbegriff in der Familie und das Recht auf den eigenen Körper," *Die Erde* 1.8 (15 April 1919): 242–45; (4) "Der individualistische Anarchist und die Diktatur," *Die Erde* 1.9 (1 May 1919): 276–78; (5) "Zur Weltrevolution," *Die Erde* 1.12 (15 June 1919): 368–71; (6) "Zur Auflösung des bürgerlichen Frauentypus," *Die Erde* 1.14/15 (1 August 1919): 461–65; (7) "Bilanz der Feierlichkeit," *Die Erde* 1.16/17 (1 September 1919): 519–20; (8) "Schnitt durch die Zeit," *Die Erde* 1.18/19 (1 October 1919): 539–47; reprinted in *Texte bis 1933*, 1:27–32, 34–38, 43–45, 50–54 and 62–81. References to these articles in this chapter will be designated by the relevant numeral in square brackets plus the page number from both editions, thus: ([2]: 3/31).

98. All of which throws additional light on why Alfred Adler was drawn to Hausmann's work (see chapter 7, note 87). Indeed, one of the longest passages that Adler added to the third edition of *Über den nervösen Charakter* (1922) comes at the end of chapter I ("Aus den resultierenden [. . .] andern zu denken") and deals with the way in which overdeveloped "masculine" attitudes (notably aggressiveness) prevent the neurotic from being assimilated into a "Gemeinschaft."

99. Lavin, *Cut with the Kitchen Knife*, 16.

100. Although *Die freie Strasse,* no. 9 (which Hausmann edited in November 1918) contained an essay by the Russian Communist Karl Radek (who had recently arrived in Berlin to help found the KPD) on the necessity of the Dictatorship of the Proletariat, Hausmann discarded this concept from his own articles of 1919.

101. Lavin, *Cut with the Kitchen Knife,* 30.

102. Bergius, *Lachen Dadas,* 123.

103. Raoul Hausmann, "Was ist DADA," in *Scharfrichter der bürgerlichen Seele: Raoul Hausmann in Berlin 1900–1933,* ed. Eva Züchner (Berlin: Berlinische Galerie, 1998), 107.

104. Maier-Metz, *Expressionismus—Dada—Agitprop,* 326. See Sheppard, " 'Der Schauspieler greift in die Politik,' " 45–52. McCloskey, *George Grosz and the Communist Party,* 117–18.

105. Reprinted in *Texte bis 1933,* 1:196.

106. Eagleton, *Ideology,* 198. Lindlar, " 'Modernste Mann im Lande,' " 292 and 302–3.

107. Huelsenbeck, "Zürich 1916," 613; *Wozu Dada,* 67. Huelsenbeck, *Mit Witz, Licht und Grütze,* 88; "Zürich 1916," 613; *Wozu Dada,* 67; *Dada siegt!* 50–52.

108. *Dadaco,* [14] (see chapter 5, note 65).

109. See Jung, "Vorbedingungen des Zufalls," 4/113. Huelsenbeck, *Deutschland muss untergehen,* 11–12; reprinted in *En avant Dada,* 51–62 (60).

110. Huelsenbeck, *Deutschland muss untergehen,* 57.

111. Paul Raabe and H. Ludwig Greve, eds., *Expressionismus: Literatur und Kunst 1910–1923* (Stuttgart: Deutsches Literaturarchiv, 1960), 236–37.

112. Hausmann, *Am Anfang war Dada,* 20. L[eopold] Zahn, "Dadaismus oder Klassizismus?" *Der Ararat* 1.7 (April 1920): 50.

113. Last, *German Dadaist Literature,* 25.

114. Hausmann, "Pamphlet gegen die Weimarische Lebensauffassung," 164/1:41.

115. Bergius, "Zur phantastischen Politik der Anti-Politik Johannes Baaders," 181–91.

116. Reprinted in *New Studies in Dada,* 153.

117. See Bergius, *Lachen Dadas,* 70. McCloskey, *George Grosz and the Communist Party,* 28. See Maier-Metz, *Expressionismus—Dada—Agitprop,* 127 on Jung in Berlin and 318–19 on Bogdanov's theory of *Proletkult.* The stories were: "Babek," *Die Aktion* 8.33/34 (24 August 1918): 432–34; "Der Fall Gross," *Die Erde* 2.1 (1920): 29–43; "Zur Klärung"; "Hallo mein Johann"; "Seligmanns Ende"; and "Übungsstück." All six stories are collected in *Werke,* 8 (*Sprung aus der Welt: Expressionistische Prosa*): 293–329. For a detailed discussion of Jung from a Marxist point of view, see Walter Fähnders and Martin Rector, *Linksradikalismus und Literatur: Untersuchungen zur Geschichte der sozialistischen Literatur in der Weimarer Republik,* 2 vols. (Reinbek bei Hamburg: Rowohlt, 1974), 1:160–220.

118. Jung, *Werke,* 9/1:59.

119. Franz Jung, "Zweck und Mittel im Klassenkampf," *Die Erde* 1 (1919): 428 et passim; reprinted in *Werke*, 1/1:226; Jung, "Fertig machen," *Kommunistische Montags-Zeitung* (20 December 1920): 2–3 (this is an extract from *Joe Frank illustriert die Welt* [Berlin: Verlag Die Aktion, 1921], reprinted in *Werke*, 2 [*Joe Frank illustriert die Welt/Die rote Woche/Arbeitsfriede*]: 34–37). In this account, the shooting of a group of captured white officers by revolutionary workers is justified even though there is no need for the executions (see Fähnders and Rector, *Linksradikalismus und Literatur*, 1:187).

120. See Maier-Metz, *Expressionismus—Dada—Agitprop*, 318–19; and Jung's letters to Cläre Jung, dated 26 June 1921, 3 July 1921, and 10 July 1921, *Werke*, 9/1:54, 57, and 60. Franz Jung, "Proletarische Erzählungskunst," *Proletarier*, no. 1 (October 1920): 13; reprinted in *Werke*, 1/1:243. See also his remarks on "Rhythmus" [rhythm] in his letters to Cläre Jung, dated 27 December [1920] and [1920/1921], *Werke*, 9/1:32–35. In this connection, too, it is interesting to note that he thought his revolutionary novel *Die rote Woche* (*The Red Week*) (1921) could easily be turned into a good film (ibid., 37). See his letters to Cläre Jung, dated 26 June 1921 (where he proposes editing a series of books by modern utopian thinkers) and 17 July 1921 (where he expresses a strong interest in utopian theory), *Werke*, 9/1:54 and 61. See Fähnders and Rector, *Linksradikalismus und Literatur*, 1:210; and Horst Denkler, "Der Fall Franz Jung," *Die sogenannten Zwanziger Jahre*, ed. Reinhold Grimm and Jost Hermand (Hamburg: Gehlen, 1970), 100–1. For his letters distancing himself from the KAPD, see *Werke*, 9/1:67–70 and 75–76. Cf. Maier-Metz, *Expressionismus—Dada—Agitprop*, 367.

121. Sigrid Koch-Baumgarten, *Aufstand der Avantgarde: Die Märzaktion der KPD 1921* (Frankfurt/Main: Campus, 1986), 156.

122. See File WO 95/775 in the Public Record Office (London). The files of the units which made up VI Corps (WO 95/1422; WO 95/1434; WO 95/1775; and WO 95/3154) are very thin and have little or nothing to say about their part in suppressing the civil unrest in Cologne in early 1919. Overall, they give the impression that the British troops stayed in their barracks as far as possible and largely left it to the German police to maintain public order.

123. See, for instance, "Das sozialistische Aktionsprogramm des Herrn Kautsky" and "Der Nachfolger," *Der Ventilator* 1.3 (1919): 2–7 and 7–8.

124. Quotes are from "Intellektuelle u[nd] Proletarier oder das System der Entmündung," *Der Ventilator* 1.6 (1919): 3 and 5.

125. André Breton, "Patinage Dada," *Littérature*, no. 13 (May 1920): 9.

126. Cf. Sanouillet, *Dada à Paris*, 415, where Sanouillet stresses the total refusal of the Paris Dadaists to systematize their revolt.

127. Arp, *der vogel selbdritt* and *die wolkenpumpe* in *Die Schammade*, [5–6]; and Tzara, "Proclamation sans prétension" ("Proclamation without Pretension") (1951), in ibid., [23].

128. Schwitters worked on this novel with Arp for many years. "Revolution in Revon" was its first chapter and published in *Der Sturm* 13.11 (November 1922): 158–66. "Die Zwiebel," first published in *Anna Blume* (Hanover: Paul Steegemann, 1919), is more readily available in Schwitters, *Anna Blume und Ich*, 64–72. The English translations of "Revolution in Revon" and "The Onion" are to be found, respectively, in Eugene Jolas's *Transition*, no. 8 (November 1927): 60–76, and Malcolm Green, ed. and trans., *The Golden Bomb: Phantastic Expressionist Stories* (Edinburgh: Polygon, 1993), 238–45.

129. Young, "Ideal of Community and the Politics of Difference," 300–23.

130. Hausmann, "Der individualistische Anarchist und die Diktatur," 276; reprinted in *Texte bis 1933*, 1:43.

131. Huelsenbeck, "Erste Dadarede in Deutschland," 106/112.

132. Huelsenbeck, *Deutschland muss untergehen*, 3–4/52.

133. Huelsenbeck, *Dada siegt!* 51.

134. Man Ray, "Interview with Arturo Schwarz," in *New York Dada*, ed. Armin Zweite, Michael Petzet, and Götz Adrian (Munich: Prestel, 1973), 100.

135. See Sheppard, "Cultural Policy of the SPD," 16–66.

136. These sources were: A[natoly] Lunatscharski, *Die Kulturaufgaben der Arbeiter-Klasse* (Berlin: Verlag Die Aktion, 1919); "Proletkult," *Die Aktion* 9.10/11 (15 March 1919): 145–53; "Die kommunistische Propaganda und der Volksunterricht," *Die Aktion* 9.28 (12 July 1919): 459–62; "Die Aufgaben der sozialistischen Kultur," *Russische Korrespondenz*, no. 10 (1920): 91–94; "Der Proletkult und die kulturelle Sowjetarbeit," ibid., 96–97; Alfons Paquet, *Im kommunistischen Russland: Briefe aus Moskau* (Jena: Eugen Diederichs, [May–June] 1919), 142–49; Alexander Bogdanow, *Die Kunst und das Proletariat* (Leipzig: "Der Kentaur," [September] 1919). For the precise date of publication of the latter work, see the *Börsenblatt für den Deutschen Buchhandel*, no. 210 (26 September 1919): 9153.

137. Lunatscharski, *Kulturaufgaben der Arbeiter-Klasse*, 18; Alexander, "Herrn John Heartfield und George Grosz," 56.

138. Raoul Hausmann, "Puffke propagiert Proletkult," *Die Aktion* 11.9/10 (5 March 1921): 131–34; reprinted in *Texte bis 1933*, 1:161–65. Tristan Tzara, Christoph Spengemann, Theo Van Doesburg, Hans Arp, and Kurt Schwitters, "Manifest Proletkult," *Merz* no. 2 (April 1923): 24–25.

139. See Jung's 26 June 1921 letter to Cläre Jung, *Werke*, 9/1:54. See Bogdanov, *Kunst und das Proletariat*, 21–22. On his ideas feeding into Berlin Dada, see McCloskey, *George Grosz and the Communist Party*, 59–60, 65, 69, and 75.

140. On Einstein and Piscator, cf. McCloskey, *George Grosz and the Communist Party*, 60–62.

141. Bogdanov, *Kunst und das Proletariat*, 27 and 32.

142. George Grosz, "Zu meinen neuen Bildern" (November 1920), *Das Kunstblatt* 5 (January 1921): 14.

143. Raoul Hausmann, "Ueber proletarische Theaterkultur," *Die Arbeit* 1.3 (April 1921): 42–43. This has never been reprinted.

144. Grosz and Herzfelde, *Kunst ist in Gefahr*, 24. Sheppard, "Proletarische Feierstunden," 178.

145. Wieland Herzfelde, "Gesellschaft, Künstler und Kommunismus," *Der Gegner* 2.5 (1920–21): 131–38; 2.6 (1920–21): 194–97; 2.8/9 (1920–21): 302–9; 2.10/ 11 (1920–21): 362–70. Malik produced the essays in book form in 1921, and they have been reprinted in Fähnders and Rector, *Literatur im Klassenkampf*, 134–59. See Christopher Middleton, " 'Bolshevism in Art': Dada and Politics," *Texas Studies in Literature and Language* 4 (1962–63): 422; and Maier-Metz, *Expressionismus—Dada—Agitprop*, 380–87.

146. Herzfelde, "Gesellschaft, Künstler und Kommunismus," 304.

147. On Dada satirical comment in periodicals, cf. McCloskey, *George Grosz and the Communist Party*, 83. Maier-Metz, *Expressionismus—Dada—Agitprop*, 245–51; and Alan Lareau, *The Wild Stage: Literary Cabarets of the Weimar Republic* (Columbia, S.C.: Camden House, 1995), 33–49.

148. See Raoul Hausmann, "Die neue Kunst," *Die Aktion* 11.19/20 (14 May 1921): cols. 281–85; reprinted in *Texte bis 1933*, 1:179–85.

149. Ball, *Flucht aus der Zeit*, 143/101.

150. Hausmann, "Pamphlet gegen die Weimarische Lebensauffassung," 163; *Texte bis 1933*, 1:40.

151. Gray, *Hans Richter*, 170.

152. Cf. Friedhelm Lach, *Der Merz-Künstler Kurt Schwitters* (Cologne: Du-Mont, 1971), 134.

153. Cf. Adolf Behne, "Jefim Golyscheff," *Der Cicerone* 9 (November 1919): 725–26, where Behne says that the effect of Golyscheff's work is to make spectators think that they could do likewise and so increase their faith in their own powers of creativity.

Chapter 13

1. See Michael Köhler, " 'Postmodernismus': Ein begriffsgeschichtlicher Überblick," *Amerikastudien* 12.1 (1977): 8–18; Douglas Crimp, "On the Museum's Ruins," in *Postmodern Culture*, 44; Hans Bertens, "The Postmodern *Weltanschauung* and Its Relation with Modernism: An Introductory Survey," in *Approaching Modernism*, 11–12; Welsch, *Unsere postmoderne Moderne*, 12–43; and Anders Stephanson, "Interview with Craig Owens," *Social Text* 27 (1991): 61.

2. Huyssen, "Postmoderne," 23–24; and Harvey, *Condition of Postmodernity*, 124.

3. Jameson, "Postmodernism," 53–92; Kellner, *Postmodernism/Jameson/Critique*.

4. See Hebdige, "Postmodernism and 'The Other Side,'" 382–83. See Mike Featherstone, "In Pursuit of the Postmodern: An Introduction," in *Theory, Culture and Society* 5.2/3 (June 1988): 207; Martin Donougho, "Postmodern Jameson," in *Postmodernism/Jameson/Critique*, 76–77; and Hutcheon, *Politics of Postmodernism*, 23. Cf. Harvey, *Condition of Postmodernity*, 42.

5. Harvey, *Condition of Postmodernity*, 180 and 187–88.

6. Cf. Bauman, *Intimations of Postmodernity*, 65; and Giddens, *Consquences of Modernity*, 2–3.

7. Quotes are from Giddens, *Consquences of Modernity*, 53. Berman, *All That Is Solid*, 345; and Bauman, *Intimations of Postmodernity*, 189. See also Calinescu, *Faces of Modernity*, 246; Callinicos, *Against Postmodernism*, 4–5; and Smart, *Postmodernity*, 25. On stagnant areas, see Philip Cooke, "Modernity, Postmodernity and the City," *Theory, Culture and Society* 5.2/3 (June 1988): 485 and 491.

8. On art and the aesthetic, see Calinescu, *Faces of Modernity*, 247; Foster, "Postmodernism: A Preface," in *Postmodern Culture*, xv; Huyssen, "Postmoderne," 35; and Strinati, "Postmodernism and Popular Culture," 430. On tradition and the past, see Harvey, *Condition of Postmodernity*, 303. Hoffman, "Waste and Meaning," 125 and 127.

9. Calinescu, *Faces of Modernity*, 120–21; Jochen C. Schütze, "Aporien der Literaturkritik—Aspekte der postmodernen Theoriebildung," in *Postmoderne: Zeichen eines kulturellen Wandels*, 202–3; Callinicos, *Against Postmodernism*, 156–57; Harvey, *Condition of Postmodernity*, 35; and Featherstone, "Postmodernism, Cultural Change, and Social Practice," 130. On libidinal energies, see Featherstone, "In Pursuit of the Postmodern," 203–4; and Bauman, *Intimations of Postmodernity*, 50–51.

10. On the "live," see Connor, *Postmodernist Culture*, 154–55. On protest, see Calinescu, *Faces of Modernity*, 257; and Kaplan, "Feminism/Oedipus/Postmodernism," 36. On the subversive, see Anders Stephanson, "Black Postmodernist Practices: An Interview with Cornel West" (1988), in *Cultural Theory and Popular Culture*, 402. On the marginal, see Connor, *Postmodernist Culture*, 189–90 and 194–95.

11. On the carnival of consumption, see Stam, "Mikhail Bakhtin and Left Cultural Critique," 1371; and Bauman, *Intimations of Postmodernity*, 152–53. On the casino economy, see Harvey, *Condition of Postmodernity*, 332.

12. Anderson, "Modernity and Revolution," 106.

13. Harvey, *Condition of Postmodernity*, 192–94, 297, and 347.

14. Kellner, "Introduction: Jameson, Marxism, and Postmodernism," 27; Connor, *Postmodernist Culture*, 46; and Eagleton, *Ideology*, 26, 37, 184, and 222–23.

15. See Fredric Jameson, "Postmodernism and Consumer Society," in *Postmodern Culture*, 124; Schütze, "Aporien der Literaturkritik," 202; Christa Bürger, "Das Verschwinden der Kunst: Die Postmoderne-Debatte in den USA," in *Postmoderne*, 43; and Featherstone, "Postmodernism, Cultural Change, and Social

Practice," 132. On the relative tameness of the historical avant-gardes, see Greil Marcus, *Lipstick Traces: A Secret History of the Twentieth Century* (London: Secker and Warburg, 1989), 201–3.

16. See the questions raised by Bertens, "Postmodern *Weltanschauung*," 45.

17. Jameson, "Postmodernism and Consumer Society," 111–12; Huyssen, *After the Great Divide*, 189, and "Postmoderne," 17. On painters challenging Abstract Expressionism, see Newman, *Post-Modern Aura*, 22; and Jameson, "Postmodernism and Consumer Society," 111–12. On theorists protesting, see Krauss, *Originality of the Avant-garde*, 3; Huyssen, *After the Great Divide*, 186 and 189; and Michael Newman, "Revising Modernism, Representing Postmodernism," 103. On dance critics, see Newman, *The Post-Modern Aura*, 22. On architects, see Wellmer, *Dialektik von Moderne und Postmoderne*, 123–24; Jameson, "Postmodernism and Consumer Society," 111–12; and Schwarz, "Architektur als Zitat-Pop?" 257–58.

18. Newman, *Post-Modern Aura*, 22.

19. Anderson, "Modernity and Revolution," 106.

20. Calinescu, *Faces of Modernity*, 145; Callinicos, *Against Postmodernism*, 12–13; Hutcheon, *Politics of Postmodernism*, 15 and 99; Bertens, "Postmodern *Weltanschauung*," 18; Helmut Lethen, "Modernism Cut in Half: The Exclusion of the Avant-garde and the Debate on Modernism," in *Approaching Postmodernism*, 235; Huyssen, *After the Great Divide*, 191–94; and Heide Ziegler, "Irony, Postmodernism, and the 'Modern,'" *Sprachkunst* 22 (1991): 288.

21. Hutcheon, *Poetics of Postmodernism*, 224.

22. Calinescu, *Faces of Modernity*, 143; Ihab Hassan, *The Right Promethean Fire: Imagination, Science, and Cultural Change* (Urbana: University of Illinois Press, 1980), 108; Hutcheon, *Poetics of Postmodernism*, 160 and 177; Huyssen, *After the Great Divide*, 203; Callinicos, *Against Postmodernism*, 10–13 and 15; Bertens, "Postmodern Weltanschauung," 20; Harvey, *Condition of Postmodernity*, 116; Suleiman, "Naming and Difference," 261–62; Lash, "Discourse or Figure?" 311; Rosalind Krauss, "In the Name of Picasso" (1980), in *Originality of the Avant-garde*, 38–39; and Rolf Günter Renner, *Die postmoderne Konstellation: Theorie, Text und Kunst im Ausgang der Moderne* (Freiburg i. Br.: Rombach, 1988), 124–44.

23. Bertens, "Postmodern *Weltanschauung*," 35. See also Ferenc Fehér, "Der Pyrrhussieg der Kunst im Kampf um ihre Befreizung: Bemerkungen zum postmodernen Intermezzo," in *Postmoderne*, 24.

24. Ihab Hassan, "POSTmodernISM: A Paracritical Bibliography" (1971), in *Paracriticisms: Seven Speculations of the Times* (Urbana: University of Illinois Press, 1975), 89–124. For a critique of this schema, see Christine Brooke-Rose, *A Rhetoric of the Unreal: Studies in Narrative and Structure, Especially of the Fantastic* (Cambridge: Cambridge University Press, 1981), 346–49; and Suleiman, "Naming and Difference," 260–62.

25. Huyssen, *After the Great Divide*, 182; and Hutcheon, *Poetics of Postmodernism*, 18 (also 49–50).

26. Suleiman, "Naming and Difference," 256. Huyssen, *After the Great Divide,* 191. Raulet, "Dialektik der Postmoderne," 136.

27. Huyssen, *After the Great Divide,* 191.

28. Welsch, *Unsere postmoderne Moderne,* 4; Welsch, " 'Postmoderne': Genealogie und Bedeutung eines umstrittenen Begriffs," in *"Postmoderne,"* 27; and Harvey, *Condition of Postmodernity,* 44.

29. Jameson, "Postmodernism and Consumer Society," 124–25; Newman, *Post-Modern Aura,* 10; Harvey, *Condition of Postmodernity,* 286; and Strinati, "Postmodernism and Popular Culture," 429. Huyssen, *After the Great Divide,* 168; see also "Postmoderne," 20.

30. Huyssen, *After the Great Divide,* 217. Newman, *Post-Modern Aura,* 39.

31. Hutcheon, *Poetics of Postmodernism,* 23.

32. Welsch, *Unsere postmoderne Moderne,* 80–81.

33. Calinescu, *Faces of Modernity,* 146; Berman, *All That Is Solid,* 32–33, 313, 317–25, and 340; Newman, "Revising Modernism, Representing Postmodernism," 105–6. Huyssen, *After the Great Divide,* 188; Huyssen, "Postmoderne," 17 and 20; Bertens, "Postmodern *Weltanschauung*," 14–16; Peter Brooker, "Introduction: Reconstructions," in *Modernism/Postmodernism,* ed. Peter Brooker (London: Longman, 1992), 2; and Nicholas Zurbrugg, *The Parameters of Postmodernism* (London: Routledge, 1993), 73–74.

34. Berman, "Konsumgesellschaft," 58; Callinicos, *Against Postmodernism,* 168 and 171; Harvey, *Condition of Postmodernity,* 38 and 116; Kellner, "Introduction: Jameson, Marxism, and Postmodernism," 23; and Newman, "Revising Modernism, Representing Postmodernism," 109, 110–11 and 142. Huyssen, *After the Great Divide,* 180; see also "Postmoderne," 23–24.

35. Harvey, *Condition of Postmodernity,* 113–14. Callinicos, *Against Postmodernism,* 160.

36. Foster, "Postmodernism: A Preface," xi; Hutcheon, *Politics of Postmodernism,* 17; Hutcheon, *Poetics of Postmodernism,* passim; and Smart, *Postmodernity,* 19–20. See Calinescu, *Faces of Modernity,* 144 and Hutcheon, *Poetics of Postmodernism,* 33.

37. Cf. Welsch, *Unsere postmoderne Moderne,* 115–16; Dana Polan, "Postmodernism and Cultural Analysis Today," in *Postmodernism and Its Discontents,* 57; Harvey, *Condition of Postmodernity,* 96–97; and Connor, *Postmodernist Culture,* 75. Hutcheon, *Politics of Postmodernism.*

38. See Stephan Schmidt-Wulffen, "Auf der Suche nach dem postmodernen Bild," in *"Postmoderne,"* 279; Connor, *Postmodernist Culture,* 158 and 162; Stam, "Mikhail Bakhtin and Left Cultural Critique," 117–18; Angela McRobbie, "Postmodernism and Popular Culture," in *Postmodernism: ICA Documents,* 177; Hutcheon, *Poetics of Postmodernism,* 34–35 and 183; and Eagleton, *Ideology,* 83 and 184–85.

39. Newman, "Revising Modernism, Representing Postmodernism," 102.

40. Krauss, "Notes on the Index, Part 1," 196; Bertens, "Postmodern *Weltanschauung*," 30; and Callinicos, *Against Postmodernism*, 131.

41. Giddens, *Consequences of Modernity*, 134–37.

42. The "nondespairing acceptance of flux [. . .] nothingness," Harvey, *Condition of Postmodernity*, 44; Newman, "Revising Modernism, Representing Postmodernism," 141; and Bauman, *Intimations of Postmodernity*, 30. "[P]lay amid irreconcilable opposites," Kemper, *"Postmoderne,"* 323. "[S]himmering, ambivalent surfaces," Schmidt-Wulffen, "Auf der Suche nach dem postmodernen Bild," 287 and 290; and Hebdige, "Postmodernism and 'The Other Side,' " 390. "[C]oncomitant renunciation," Bürger, "Verschwinden der Bedeutung," in *"Postmoderne,"* 301; Kemper, "Flucht nach vorn oder Sieg des Vertrauten? Postmoderne Tendenzen in Jazz und Avantgarde-Rock," in ibid., 320 and 323; and Hutcheon, *Poetics of Postmodernism*, 6 and 42.

43. Bauman, *Intimations of Postmodernity*, 28.

44. Hebdige, "Postmodernism and 'The Other Side,' " 390. See Bauman, *Intimations of Postmodernity*, 52.

45. Huyssen, "Postmoderne," 31 and 33.

46. The "unities of human historical thought [. . .] transformation," Crimp, "On the Museum's Ruins," 44. Dews, *Logics of Disintegration*, 155–56; and Callinicos, *Against Postmodernism*, 69 and 81.

47. Seyla Benhabib, "Kritik des 'postmodernen Wissens'—Eine Auseinandersetzung mit Jean-François Lyotard," in *Postmoderne: Zeichen eines kulturellen Wandels*, 109; Dews, *Logics of Disintegration*, 123; Callinicos, *Against Postmodernism*, 69; Alex Callincos, "Reactionary Postmodernism?" in *Postmodernism and Society*, 101; and Christopher Norris, "Lost in the Funhouse: Baudrillard and the Politics of Postmodernism," in ibid., 142–43.

48. Collected as Jean-François Lyotard, *Les TRANSformateurs DUchamp* (Paris: Éditions Galilée, 1977).

49. On the vitalism in Deleuze and Guattari, see Raulet, "Dialektik der Postmoderne," 138; Newman, "Revising Modernism, Representing Postmodernism," 113; and Callinicos, *Against Postmodernism*, 84. On Lyotard, see Benhabib, "Kritik des 'postmodernen Wissens,' " 118; Raulet, "Dialektik der Postmoderne," 138; and Dews, *Logics of Disintegration*, 144. See Honneth, "Foucault und Adorno," 139 and 141–42; and Callinicos, *Against Postmodernism*, 83 and 88–89.

50. Dews, *Logics of Disintegration*, 165.

51. See Gregory L. Ulmer, "The Object of Post-Criticism," in *Postmodern Culture*, 88.

52. Bauman, *Intimations of Postmodernity*, 130–31.

53. Ibid., 152–53.

54. Callinicos, "Reactionary Postmodernism?" 100; and Norris, "Lost in the Funhouse," 127.

55. Huyssen, *After the Great Divide,* 207–8. See also Holub, *Crossing Borders,* 42.

56. Dews, *Logics of Disintegration,* 184–85; Callinicos, *Against Postmodernism,* 83; Connor, *Postmodernist Culture,* 9; and Eagleton, *Ideology,* xiv.

57. Butler, "Gender Trouble, Feminist Theory, and Psychoanalytic Discourse," 327. See also Newman, "Revising Modernism, Representing Postmodernism," 114.

58. Richard Evans, "Truth Lost in Vain Views," *The Times Higher Education Supplement,* no. 1297 (12 September 1997): 18.

59. Quote from Harvey, *Condition of Postmodernity,* 355. Boyne and Rattansi, "Theory and Politics of Postmodernism," 39; and Nancy Fraser and Linda J. Nicholson, "Social Criticism without Philosophy: An Encounter between Feminism and Postmodernism," in *Feminism/Postmodernism,* 23.

60. Paul Boghossian, "What the Sokal Hoax Ought to Teach Us," *Times Literary Supplement,* no. 4889 (13 December 1996): 15. Evans, "Truth Lost in Vain Views."

61. See Alan Sokal and Jean Bricmont, *Impostures intellectuelles* (Paris: Odile Jacob, 1997).

62. On vitalist values, see Lash, "Discourse or Figure?" passim. Huyssen, *After the Great Divide,* 209 and 212; and "Postmoderne," 35–36. Wellmer, *Dialektik von Moderne und Postmoderne,* 106–7; Benhabib, "Kritik des 'postmodernen Wissens,'" 120–23; and Connor, *Postmodernist Culture,* 39.

63. Cf. Peter Dews, "From Poststructuralism to Postmodernity: Habermas's Counter-Perspective," in *Postmodernism: ICA Documents,* 39 and Connor, *Postmodernist Culture,* 41.

64. Thomas Pynchon, *Gravity's Rainbow* (1973; London: Vintage Books, 1995), 262.

65. Hutcheon, *Poetics of Postmodernism,* 49, 57, and 220.

66. Hutcheon, *Politics of Postmodernism,* 134.

67. Lethen, "Modernism Cut in Half," 233–34 (all the essays in the relevant volume were originally given as papers at a workshop on postmodernism in 1984); and Stephanson, "Interview with Craig Owens," 56.

68. Cf. Foster, "Postmodernism: A Preface," x; Huyssen, "Postmoderne," 19; and Boyne and Rattansi, "Theory and Politics of Postmodernism," 10.

69. Cf. Calinescu, *Faces of Modernity,* 143 and 254–55; Moira Roth, "The Aesthetic of Indifference," *Artforum* 16.3 (November 1977): 47–48; Hutcheon, *Poetics of Postmodernism,* 142; Merquior, "Spider and Bee," 43; Connor, *Postmodernist Culture,* 110 and 239; Paul Crowther, "Postmodernism in the Visual Arts: A Question of Ends," in *Postmodernism and Society,* 245–47; Stephanson, "Interview with Craig Owens," 56; and Bauman, *Intimations of Postmodernity,* 29. A much fuller exploration of the relationship is to be found in Alfred M. Fischer and Dieter Daniels, eds, *Übrigens sterben immer die anderen: Marcel Duchamp und die Avantgarde seit 1950* (Cologne: Museum Ludwig, 1988).

70. Jones, *En-gendering of Marcel Duchamp,* 64–65.

71. Jürgen Becker, "Einführung," in *Happenings, Fluxus, Pop Art, Nouveau Réalisme,* ed. Jürgen Becker and Wolf Vostell (Reinbek bei Hamburg: Rowohlt, 1965), 7–8 and 15.

72. Nicholas Zurbrugg, "Dada and the Poetry of the Contemporary *Avant-Garde," Journal of European Studies* 9 (1979): 121–43; "Towards the End of the Line: Dada and Experimental Poetry Today," in *Dada Spectrum,* 225–48.

73. On Arp and Tinguely, see Hassan, *Right Promethean Fire,* 19. On Heartfield, see Hutcheon, *Politics of Postmodernism,* 42–45. On Dada and *Noigandres,* see Johanna Drucker, "Experimental, Visual, and Concrete Poetry: Context and Concepts," in *Experimental-Visual-Concrete: Avant-garde Poetry since the 1960s,* ed. K. David Jackson, Eric Vos, and Johanna Drucker (Amsterdam: Rodopi, 1996), 44; and Elisabeth Walter-Bense, "The Relations of Haroldo de Campos to German Concretist Poets, in Particular to Max Bense," in ibid., 354–55. On Dada and *Stuttgarter Gruppe,* see Walter-Bense, "The Relations of Haroldo de Campos to German Concretist Poets," 361. On punk rock, see Dick Hebdige, *Subculture: The Meaning of Style* (London: Methuen, 1979), 65, 105–6, and 110; and Andrew Goodwin, "Popular Music and Postmodern Theory" (1991) in *Cultural Theory and Popular Culture,* 421. See Harriett Watts, "Die Wiener Gruppe: Eine Weiterentwicklung der Dada-Experimente," in *Österreichische Gegenwart: Die moderne Literatur und ihr Verhältnis zur Tradition,* ed. Wolfgang Paulsen (Berne: Francke, 1980), 207–19; Peter Weiermair, "Zeilen eines Zeitgenossen," in *Dadautriche 1907–1970,* 201–7; and Adelheid Koch, *Ich bin immerhin der grösste Experimentator Österreichs* (Innsbruck: Haymon, 1994), 131–226. For a zippy presentation of the way that Dada feeds into contemporary avant-garde, counterculture, and popular culture, see Marcus, *Lipstick Traces,* passim.

74. Zurbrugg, *Parameters of Postmodernism,* passim.

75. See Utz Riese, "Postmodern Culture: Symptom, Critique, or Solution to the Crisis of Modernity? An East German Perspective," *New German Critique,* no. 57 (fall 1992): 158 and 162–63; and Karen Leeder, *Breaking Boundaries: A New Generation of Poets in the GDR* (Oxford: Clarendon Press, 1996), 148, 158, 167–68, and 174. The underground magazine *ariadnefabrik* (which was produced on the Prenzlauer Berg in East Berlin between 1986 and 1988) contains six items directly relating to Dada and Neo-Dada.

76. Cf. Connor, *Postmodernist Culture,* 87, 92, and 134.

77. Welsch, *Unsere postmoderne Moderne,* 5 and 39.

78. See Edward W. Said, "Opponents, Audiences, Constituencies and Community," in *Postmodern Culture,* 136–37 and 156–57; Behabib, "Kritik des 'postmodernen Wissens,' " 121–22; Callinicos, *Against Postmodernism,* 90–91; Harvey, *Condition of Postmodernity,* 171 and 330–31; Geoff Bennington, "Introduction: The Question of Postmodernism," in *Postmodernism: ICA Documents,* 9–10; Feather-

stone, "Postmodernism, Cultural Change, and Social Practice," 132; and Robert C. Holub, "Confrontations with Postmodernism," *Monatshefte* 84 (1992): 236.

79. Vattimo, *End of Modernity*, 12.

80. Giddens, *Consequences of Modernity*, 7–8 and 139.

81. Bauman, *Intimations of Postmodernity*, 116.

82. Harvey, *Condition of Postmodernity*, 180.

83. Bauman, *Modernity and Ambivalence*, 272–79.

84. Strinati, "Postmodernism and Popular Culture," 433.

85. On deprived groups living near wealth, see Harvey, *Condition of Postmodernity*, 138; and Bauman, *Intimations of Postmodernity*, 98. On the consciousness industry, see Stam, "Mikhail Bakhtin and Left Cultural Critique," 143. Cf. Gudrun Klatt, "Moderne und Postmoderne im Streit zwischen Jean-François Lyotard und Jürgen Habermas," *Weimarer Beiträge* 35 (1989): 288. On unsatisfied desire, see Eagleton, *Ideology*, 42–43. On the free market's failure to deliver, see Bauman, *Intimations of Postmodernity*, 198; and Smart, *Postmodernity*, 99. On living in a high-stress world, see Smart, *Postmodernity*, 115.

86. Dews, *Logics of Disintegration*, 32.

87. Ibid., 97 and 194.

88. See Jürgen Habermas, "Die Krise des Wohlfahrtsstaates und die Erschöpfung utopischer Energien" (1984), in *Die neue Unübersichtlichkeit: Kleine Politische Schriften V* (Frankfurt/Main: Suhrkamp, 1985), 143–44. Cf. Holub, *Crossing Borders*, 63.

89. Nicholson, introduction to *Feminism/Postmodernism*, 5; and Christine Di Stefano, "Dilemmas of Difference: Feminism, Modernity, and Postmodernism," in ibid., 72.

90. Christopher Butler, "Postmodernism and Moral Philosophy," in *Ethics and Aesthetics*, 86.

91. Hans Bertens, "Out of the Left Field: The Politics of the Postmodern," in ibid., 108–11. Connor, *Postmodernist Culture*, 8.

92. Callinicos, *Against Postmodernism*, 79; and Christopher Norris, *The Truth about Postmodernism* (Oxford: Blackwell, 1993), 26.

93. Evans, "Truth Lost in Vain Views."

94. Eagleton, *Ideology*, 170.

95. Cf. Huyssen, *After the Great Divide*, 159; Featherstone, "Postmodernism, Cultural Change, and Social Practice," 129; McRobbie, "Postmodernism and Popular Culture," 174–77; Connor, *Postmodernist Culture*, 186 and 203; Crowther, "Postmodernism in the Visual Arts," 255; Zurbrugg, *Parameters of Postmodernism*, 136; Stephanson, "Black Postmodernist Practices," 402; and Goodwin, "Popular Music and Postmodern Theory," 419–20.

Bibliographical Note

As this book ranges across three very large areas, and as I have provided extensive notes for each chapter, it would be superfluous, not to say impossible, to conclude with a standard bibliography. Instead, readers wishing to find extensive bibliographies on modernism are referred to the three published in Maurice Beebe, "What Modernism Was," *Journal of Modern Literature* 3 (1973): 1080–84; Malcolm Bradbury and James McFarlane, eds., *Modernism 1890–1930* (1976), 641–64; Jean Weisgerber, ed., *Les Avantgardes littéraires au XX^e siècle* (1984), 2:1155–87; and to Alistair Davies, *An Annotated Critical Bibliography of Modernism* (Sussex: Harvester, 1982). Excellent bibliographies on postmodernism can be found in Fokkema and Bertens's *Approaching Postmodernism* (1986), 268–89, and Harvey's *The Condition of Postmodernity* (1989), 361–67. These have recently been extensively supplemented by Deborah Madsen, *Postmodernism: A Bibliography, 1926–1994* (Amsterdam: Rodopi, 1995), and Walter Fähnders, *Avantgarde und Moderne 1890–1933* (Stuttgart: Metzler, 1998), 275–309. Dada is an even more diffuse subject. The reader is referred in the first place to Arturo Schwarz, ed., *Almannaco Dada* (Milan: Feltrinelli, 1976), and the bibliographies at the back of Foster and Kuenzli's *Dada Spectrum: The Dialectics of Revolt* (1979), 260–89; Hanne Bergius, *Das Lachen Dadas* (1989), 403–16; and Raimund Meyer, *Dada global* (Zurich: Limmat Verlag and Kunsthaus Zurich, 1994), 443–62. The information here can be supplemented by such works as William A. Camfield, *Francis Picabia: His Art, Life and Times* (1979), 299–347; Werner Spies et al., eds., *Max Ernst: Oeuvre-Katalog* (Houston: Menil Foundation; Cologne: DuMont Schauberg, 1975–87); Aimée Bleikasten, *Arp Bibliographie*, 2 vols. (London: Grant and Cutler, 1981–83); Wolfgang Rieger, *Glückstechnik und Lebensnot: Leben und Werk Franz Jungs* (1987), 238–68; Alfred M. Fischer and Dieter Daniels, *Übrigens sterben immer die anderen: Marcel Duchamp und die Avantgarde seit 1950* (1988), 311–16; Ernst Teubner, *Hugo Ball: Eine Bibliographie* (Mainz: von Hase & Koehler, 1992); Greil Marcus, *Lipstick Traces* (1989), 449–62; Maud Lavin, *Cut with the Kitchen Knife* (1993), 244–53; Reinhard Nenzel, *Der frühe Richard Huelsenbeck* (1994), 425–560; Peter Klaus Schuster, ed., *George Grosz: Berlin–New York* (1994), 562–74; and Kurt Bartsch and Adelheid Koch, eds., *Raoul Hausmann* (1996), 338–416. Mark Pegrum's *Challenging Modernity: Dada between Modern and Postmodern* (Oxford: Berg, 1999), a book that I had the pleasure to read when it was first presented as

a doctoral dissertation at the University of Western Australia and that deals with the same areas as this book, also contains an extensive bibliography. Finally, the reader should be aware of the wide range of information contained in Raimund Meyer, *Dada in Zürich: Die Akteure, die Schauplätze* (Frankfurt/Main: Luchterhand, 1990), and the nine-volume *Crisis and the Arts: The History of Dada* (London and New York: G. K. Hall and Prentice-Hall International, 1996–), four volumes of which have so far appeared under the general editorship of Professor Stephen Foster of the University of Iowa.

Index

467